THE

UNITED ARTISTS

STORY

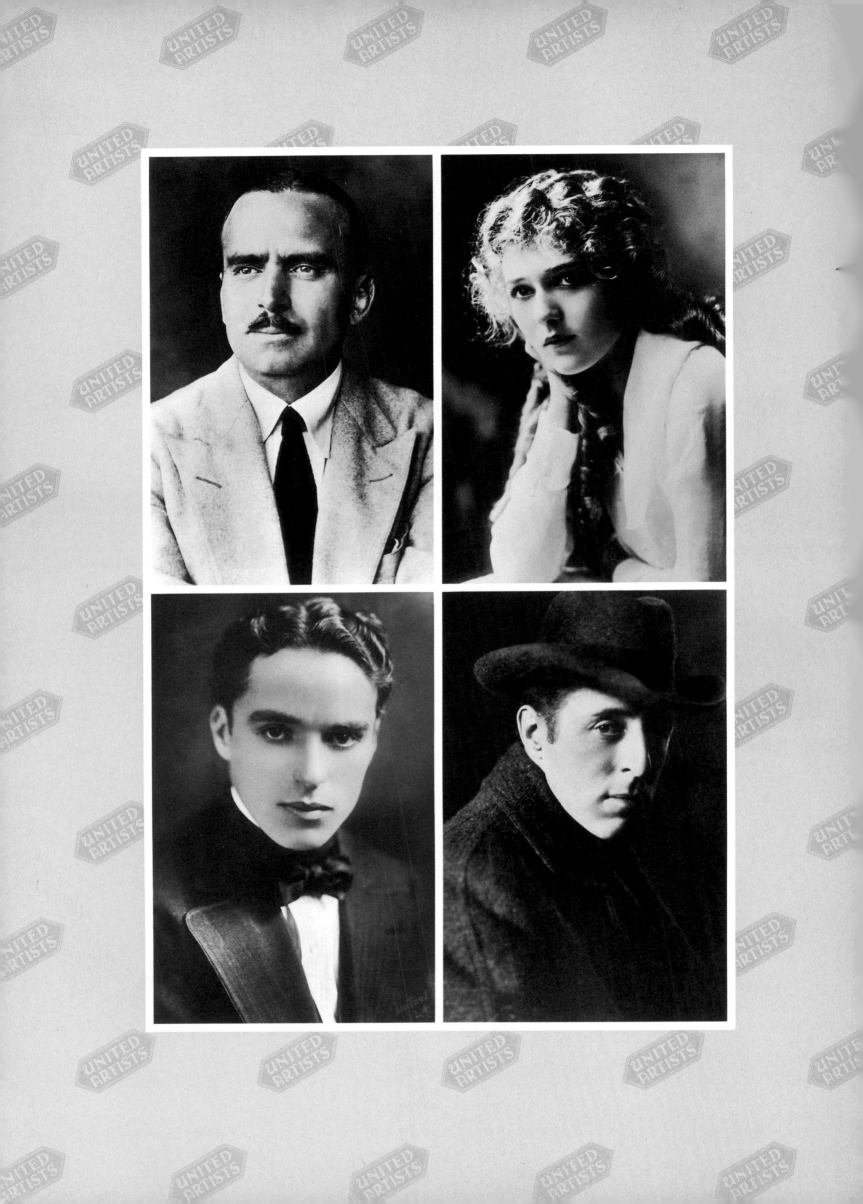

THE
UNITED
ARTISTS
STORY

RONALD BERGAN

OCTOPUS BOOKS

Douglas Fairbanks

Mary Pickford

Charles Chaplin

D.W. Griffith

Editor David Burn
Copy Editor Robyn Karney
Art Editor Pat Sumner
Designer Robin Dodd
Picture Research Celina Dunlop
Production Sara Hunt

Produced under license from
MGM/UA Entertainment Company

First published 1986 by Octopus Books Limited
59 Grosvenor Street, London W1

© Copyright 1986 Octopus Books Limited

ISBN 0 7064 2581 2

First edition

Printed in West Germany by Mohndruck

CONTENTS

For Catriona MacGregor

I first became vaguely aware of United Artists as an important studio when *Marty* won four Oscars in 1955. Other excellent small scale social dramas followed, such as *Twelve Angry Men* (1957), *The Bachelor Party* (1957) and *The Defiant Ones* (1958), and two of America's best screen comedies, *Some Like It Hot* (1959) and *The Apartment* (1960). Through the 60s and 70s more and more UA films began to figure among the finest that Hollywood could provide. There were many bread-and-butter pictures, of course, but there was plenty of caviare in between. Although UA's four illustrious founders had stamped their mark on the company from its beginnings, it was the individual pictures, rather than a corporate identity, that caught the public's interest. I, and millions of others, could easily identify MGM, Fox, Paramount, Columbia and Universal movies, not only by their distinctive logos, but also by their house style and personnel. We were on shakier ground with United Artists whose logo, when used, was a modest lozenge shape with the name printed in the middle. It lacked the instantaneous recognition and graphic impact of, say, the searchlights playing on the gigantic, futuristic letters that spelt out 20th Century-Fox, or the roar of Metro's magnificent lion, or RKO's bleeping radio mast. Yet a studio like MGM, with its most consistently recognisable personality, was also the most feeble in terms of great producers and directors; individuals were subjugated to house style, for better or worse. Although people did work for United Artists over long periods, they had no one specific studio location, contract players or technical staff. That was its strength and its weakness. The reason why its identity seemed less clear to the public at large was not because of the uninspiring logo, but because it acted as patron and distribution company to many independent producers. I hope, however, that this book will bring its particular character into greater focus than ever before.

Every FEATURE LENGTH FILM released by United Artists in the United States is included in the book. For the most part a feature length film is one contained in 5 reels (5,000 feet) or more, which runs for at least 50 minutes. Short films—defined, at least for Oscar purposes, as not longer than 3 reels—are excluded from the book, though I have shown them as part of UA's Academy Award track record. A few films which sit near the top end of the grey area between these two limits are included, mainly on the grounds that, collectively, they occupied a relatively significant place in the story.

My CRITERIA FOR INCLUSION OF FILMS in the main body of the book, excluding appendixes, encompassed the following: 1. American-made features released at least in the USA by United Artists; 2. British-made features released in both the USA and the UK by United Artists, and in which UA had some initial investment or prior distribution arrangement; 3. Foreign features, released at least in the USA by United Artists, that were made for the international market and dubbed into English for American distribution—for example, 'spaghetti' Westerns. Feature films not fulfilling these criteria but nonetheless released in America by UA, are covered in the APPENDIXES. I have not included MGM productions which UA started distributing in 1973. When MGM merged with United Artists in 1981 to become MGM/UA, both companies continued to release films, but under the combined banner; only UA films—that is, those copyrighted by the company—have been included from 1981.

To make economical use of space, some of the films are presented as unillustrated SHORT ENTRIES at the end of a year; I have tried, however, to limit the number treated in this way; They begin to appear only in the 50s, when second features were made in greater profusion. With a very few exceptions they are films of the most minor nature, made as programme fillers or for children's matinees. In the 70s and 80s they are generally films which had limited release and appeal.

The chronological treatment requires that each film be presented under the heading of its YEAR OF RELEASE in the United States. Assigning a film to a year often poses problems, however, as the frequent discrepancies in the literature demonstrate only too clearly. In the main I have placed a film in the year in which it enjoyed its first general release. Films that were nominated for Academy Awards, however, appear under the year in which they qualified for nomination by virtue of their release in the Los Angeles area, regardless of whether this occurred before or after the year of general release. The one exception to this *Limelight* which is presented under 1952, its year of general release, though it won its music Oscar on its re-release in 1972 when, for the first time, its distribution area included Los Angeles.

As United Artists drew from INDEPENDENT PRODUCTION COMPANIES to supply their product more than any other Hollywood studio, I have added the name of the company to the end of each entry throughout the book. Sometimes the name of the producer and that of the company were one and the same—for example, Samuel Goldwyn. Joseph M. Schenk Productions became Art Cinema Corporation in 1926, and London Films, run by Alexander Korda, became Alexander Korda Films during the war. In 1933 Darryl F. Zanuck formed Twentieth Century Pictures, Inc. in which UA boss Schenk was a partner. They released through UA until their merger with Fox Film Corporation in 1935. By the 70s most other studios were releasing the pictures of independent companies.

I have indicated the COLOUR PROCESS, if any, only until the end of the 60s. Thereafter, all films are in colour unless otherwise stipulated.

I wish to thank my supervising editor, David Burn, for masterminding the book through its various complicated stages, and my industrious copy editor, Robyn Karney—a good friend and perfect workmate—for her creative editing throughout and for bringing me and the project together in the first place. I would not have been able to do the book without Graham Scott's meticulous research work which ensured harmony where chaos could have reigned; the helpful and patient staff at the British Film Institute; Clive Hirschhorn for his advice and for allowing me to use his incomparable library; and David Smith at UIP for lending me an invaluable black book. I shamelessly plundered Tino Balio's 'United Artists, The Company Built By The Stars' (University of Wisconsin Press, 1976) and Steven Bach's vastly entertaining and informative 'Final Cut' (William Morrow and Co., 1985). A special thanks to my wife, Catriona, for managing to share the same house with me during the writing of the book.

August 1986

Publisher's Acknowledgements
We would like to acknowledge the friendly advice and the valuable help we received from Herbert Nusbaum of MGM/UA Entertainment Co. throughout the preparation of this book. Thanks are also due to Steve Newman and Colleen Malone, also of MGM/UA, for allowing access to their stills files, and especially to Alan Gavoni, assisted by Michael Kelley, who tackled the daunting job of gathering together the stills with enthusiasm. Other stills were provided by the National Film Archive of the British Film Institute, the Wisconsin Center for Film and Theater Research and the Museum of Modern Art in New York. For help with the identification of stills we are grateful particularly to Markku Salmi and Peter McKriel. Finally we should like to record our lasting appreciation to John Douglas Eames for originating the concept for this series of Hollywood studio histories.

INTRODUCTION

'So the lunatics have taken charge of the asylum,' remarked Richard A. Rowland, president of Metro Pictures, on hearing of the formation of the United Artists Corporation early in the year of 1919. The 'lunatics' were (below, right to left) David Wark Griffith, Charles Chaplin, Mary Pickford and Douglas Fairbanks, the four biggest names in motion pictures at the time.

D.W. Griffith

He was born on 22 January, 1875 on a Kentucky farm. His father, a Confederate soldier, was killed when David was ten. At 21, he joined a travelling theatre company as an actor. In 1907, while trying to sell scenarios to various New York studios, he was given the lead in Edwin S. Porter's *Rescued From An Eagle's Nest* at the Edison company. At Biograph Griffith worked as an actor and scriptwriter before being allowed to direct his first film, *The Adventures Of Dollie* (1908). The 713-foot film proved satisfactory, and Griffith went on to make 448 more at Biograph, many of them featuring Mary Pickford. This prodigious output of short films gave him the opportunity to learn his craft and to extend the technical grammar of the silent cinema.

By 1911, Griffith had used close-ups, dissolves, cross-cutting, deep focus and split screen. His last picture for Biograph was the biblical spectacle *Judith Of Bethulia* (1913), the first American 4-reeler. In 1913, he went to work for the Mutual Film Corporation, where he was given the opportunity to direct his vast Civil War drama *The Birth Of A Nation* (1915). However, when the Mutual board of directors began to baulk at the mounting costs of the picture, Harry Aitkin, president of the company, and Griffith produced and distributed it themselves. The 12-reel epic was a landmark in film-making. 'History written in lightning,' was how President Woodrow Wilson described it.

The Birth Of A Nation cost $100,000 and grossed $18 million in a few years. With the profits, Griffith formed his own company to finance *Intolerance* (1916), even longer (14 reels) and costlier ($2,500,000) than its predecessor. Although it was an impressive achievement, the film's episodic nature and excessive length were not tolerated by the public. Financially ruined, Griffith was forced to join Adolph Zukor's Artcraft company releasing through Paramount. Later he signed a three-picture deal with First National. However, Griffith yearned for more independence ...

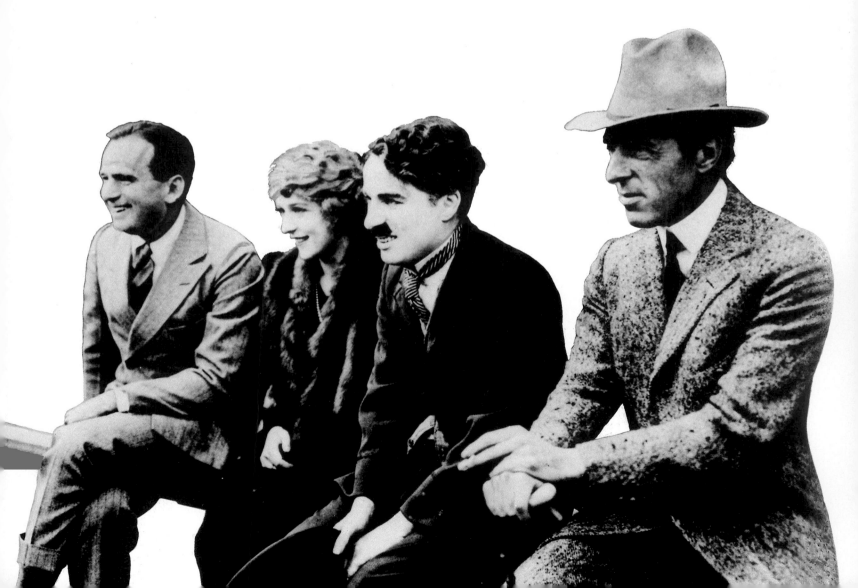

Charles Chaplin

He was born on April 16, 1889 in the slums of London. The son of music hall performers, Charlie was part of a troupe of child dancers by the age of eight, and went on to appear in several London stage plays. At 17, he joined Fred Karno's company in which his half-brother Sydney Chaplin was a leading comic. It was whilst he was touring the USA in 1912 that Mack Sennett saw him and invited him to become a member of Keystone, the famous slapstick comedy film company.

Chaplin made his debut screen appearance playing a villain in *Making A Living* (1914), the first of 35 short films he made at Keystone in one year. During that time, he wrote and directed much of his own material, gradually breaking away from the crude techniques of the Sennett comedies. Chaplin's Little Tramp character came into its own at Essanay in 1915, and matured at Mutual in films like *Easy Street* and *The Immigrant* (both 1917), in which he introduced pathos and social comment into the comedy. Within a few years, Chaplin's salary had rocketed from $500 to $10,000 a week plus a $150,000 bonus. At First National in 1918, under a million dollar contract, he was able to take more time and trouble preparing his films. On the strength of over 60 silent shorts, Charlie had become one of the most famous men in the world. However, Chaplin yearned for more independence ...

Mary Pickford

She was born Gladys Smith on 8 April, 1893 in Toronto. After her labourer father was killed in a work accident, five-year-old Mary found herself the breadwinner of her family (sister Lottie aged three, brother Jack aged two), when her formidable mother Charlotte put her on the stage. Billed as 'Baby Gladys', she toured with various road companies. When she was only 14, David Belasco, Broadway's most successful producer and playwright, gave her a leading role in *The Warrens Of Virginia*, and changed her name to Mary Pickford. When the play ended a 16-month run, Mary decided to try her luck in motion pictures.

Pickford's first screen appearance was in *Her First Biscuits* (1909), a seven-minute comedy directed by D.W. Griffith at Biograph. Although players were still uncredited at the time, she soon gained public recognition as 'Little Mary' and 'The Girl With The Golden Curls'. In 1910, she was earning $175 a week at Carl Laemmle's Independent Motion Picture Company (IMP), and $500 a week at Adolph Zukor's Famous Players. Because of the huge success of films like *Tess Of The Storm Country* (1914), Mary was able to negotiate an extraordinary contract with Zukor in 1915. It resulted in her earning $10,000 weekly, plus a $300,000 bonus, and in the formation of the Mary Pickford Company, an affiliate devoted entirely to the making of her films. In 1917, Mary accepted a $1.1 million offer from First National to make three pictures a year. However, Pickford yearned for more independence ...

Douglas Fairbanks

He was born Douglas Elton Ulman on 23 May, 1883 in Denver, Colorado. His father, a prominent lawyer, left home when Doug was five years old, and his mother reverted to the surname of her first husband, the late John Fairbanks. From the age of 16 Doug began to appear on the New York stage and soon made a name for himself as a juvenile. In the long-running *Hawthorne Of The USA* (1912) by James Bernard Fagan, Fairbanks leaped over a wall, had a fistfight, and jumped out of a window, thus establishing the character of the athletic all-American hero with the flashing smile that would make him a movie star and the silver screen's number one swashbuckler three years later.

It was not until Fairbanks saw D.W. Griffith's *The Birth Of A Nation* that he decided to work in films. At the age of 33 he signed with Harry Aitkin's newly formed Triangle company at $2,000 a week. Griffith, who supervised the making of Doug's first film *The Lamb* (1915), was unimpressed with his antics. Nevertheless, Triangle chose to open the new Knickerbocker Theater in New York with the picture. It was a big hit, Fairbanks became a star overnight, and his salary rose to $10,000 a week. After a series of hugely successful comedies, Fairbanks left Triangle to form the Douglas Fairbanks Film Corporation, releasing via Paramount. However, Fairbanks yearned for more independence ...

The Making of United Artists

In April 1918, Mary Pickford, Douglas Fairbanks, Charles Chaplin and cowboy star William S. Hart raised millions of dollars by travelling around the country selling Liberty Loans to help the war effort. During the tour, adulation of the stars reached its highest pitch. They knew that it was their personalities that had made the major film companies rich. Although the four stars and director D.W. Griffith had considerable control over their productions, they were still subject to the will of distributors, who also took a large slice of the profits. Rumours of a merger between First National and Paramount began to worry them. If the two giants got together, they would be able to slash the high salaries being paid to performers. Thus the artists conceived the imaginative idea of forming their own motion picture company.

Controversy still exists as to who was actually the first to think of it. Cap O'Brien, the theatrical lawyer and later vice-president of UA, is said to have advised his clients Fairbanks and Pickford to form an artist-controlled company. During the Liberty Loan drive, Secretary of the Treasury William Gibbs McAdoo and his assistant Oscar A. Price (UA's first president) suggested Fairbanks distribute his own films. Chaplin later wrote that it was his brother Sydney's brainwave, but B.P. Schulberg, one time Zukor publicity man, won an out-of-court settlement when he claimed he had outlined the plan to senior executive Hiram Abrams (UA's first general manager), who presented it to Pickford. Whatever the genesis, it was the artists themselves who would take the risk of standing up against the moguls and going it alone.

According to Charlie's memoirs, Sydney Chaplin hired an attractive girl to pick up a film executive in order to get him to reveal details of the rumoured First National-Paramount merger. After three dates she reported back that a link up was indeed imminent. This was enough to convince the stars of the need for immediate action. They were also told of the time and place the big brass were to hold a convention. One evening in January 1919, John D. Williams, head of First National Exhibitors Circuit, walked into the dining room of the Alexandria Hotel in Los Angeles to be greeted by the sight of Pickford, Fairbanks, Hart, Chaplin and Griffith deep in conspiratorial conversation at an ostentatiously central table. He quickly retreated into the lobby where other executives were gathering and told them what he had seen. Each in turn then peered round the doorway to look for themselves, only to be greeted by laughter from the five objects of their attention. Reporters covering the executive dinner approached the small group and were told of the plan to combat the threatening trusts and combinations.

A few weeks later, on 5 February, the following statement was released officially to the press:

A new combination of motion picture stars and producers was formed yesterday, and we, the undersigned, in furtherance of the artistic welfare of the moving picture industry, believing we can better serve the great and growing industry of picture productions, have decided to unite our work into one association, and at the finish of existing contracts, which are now rapidly drawing to a close, to release our combined productions through our own organization. This new organization, to embrace the very best actors and producers in the motion picture business, is headed by the following well-known stars: Mary Pickford, Douglas Fairbanks, William S. Hart, Charlie Chaplin and D.W. Griffith productions, all of whom have proved their ability to make productions of value both artistically and financially. We believe this is necessary to protect the exhibitor and the industry itself, thus enabling the exhibitor to book only pictures that he wishes to play and not force upon him (when he is booking films to please his audience) other program films which he does not desire, believing that as servants of the people we can thus serve the people. We also think that this step is positively and absolutely necessary to protect the great motion picture public from threatening combinations and trusts that would force upon them mediocre productions and machine-made entertainment.

Griffiths, Pickford, Fairbanks and Chaplin had realized their dream. (W.S. Hart soon disappeared from the scene when Zukor offered him $200,000 a picture, an offer Hart seemed unable to refuse.) Like all manifestos, it did not always live up to its ideals, but the name of United Artists still exists 67 years later, a proud monument to its four legendary founders.

The brand new independent company of United Artists came roaring in with the 20s, and its four founders – Charles Chaplin, D.W. Griffith, Mary Pickford and Douglas Fairbanks – were sitting on top of the world.

When the decade began, however, the Great War was still fresh in most people's memories, so escapism was the order of the day. At first, there was still room, in the more cynical Jazz Age, for the old-fashioned melodramatics of Griffith's *Broken Blossoms* (1919) and *Way Down East* (1921). No matter how much Mary Pickford struggled against her little girl persona, attempting more sophisticated roles like *Rosita* (1923) and *Dorothy Vernon Of Haddon Hall* (1924), the public forced her back into curls and short dresses in sentimental comedies such as *Pollyanna* (1920), *Little Lord Fauntleroy* (1921) and *Little Annie Rooney* (1925). But it was the more full-blooded romanticism of Douglas Fairbanks that drew the biggest audiences. He broke the embargo on costume films with *The Mark Of Zorro* (1920), following up its success with *The Three Musketeers* (1921), *Robin Hood* (1923) and *The Thief Of Bagdad* (1924). But whatever garb he wore, or whatever exotic locale he found himself in, 'Doug' remained the smiling All-American optimist. Other romantic heroes that emerged at the same time were Rudolph Valentino, Ramon Novarro, John Barrymore, John Gilbert, Ronald Colman and Gilbert Roland, usually opposite mysterious and beautiful heroines such as Greta Garbo and Vilma Banky. Most of the product of the era was set in faraway places and distant times. The contemporary world hardly got a look in. Since the commercial failure of *Intolerance*, epics had become a rarity, until Cecil B. DeMille reintroduced them in a big way with *The Ten Commandments* (Paramount, 1923) and *King Of Kings* (Pathé, 1927), while MGM presented *Ben Hur* (1925). Griffith himself did make a return to the broader canvas of *Orphans Of The Storm* (1922), which he set during the French Revolution, and *America* (1924), a failed attempt at a 'prequel' to *The Birth Of A Nation*. However, the former, with the remarkable Gish sisters, was one of the best spectacles of the epoch.

From its beginnings, United Artists had no shortage of box-office hits, only a shortage of product. Of the four founders of the company, only Fairbanks was free from previous contractual commitments and ready to work for the new venture. Both Chaplin and Pickford had a number of pictures to complete for First National. Griffith, too, had signed a three-picture contract with First National. *Broken Blossoms* had been made for Famous Players, but Adolph Zukor, thinking it too down-beat to please audiences, rejected it. Thus Griffith was able to release his poetic masterpiece with two Fairbanks movies through UA in its first year of existence. But, up to 1924, they were still only releasing an average of eight films annually, far too few to fulfil their obligations to various theatres. Much of the product was supplied by Pickford and Fairbanks. Griffith left to do three films for Zukor, and Chaplin was notoriously slow in making his pictures. In seven years, he made only three features, *A Woman Of Paris* (1923), *The Gold Rush* (1925) and *The Circus* (1928). Things began to change when Joseph Schenck joined the company in November 1924.

Following Oscar Price, and then Hiram Abrams, as president of UA, Schenck agreed to deliver six pictures featuring his then wife Norma Talmadge (she only made four more films, in fact). He also brought in brother-in-law Buster Keaton, who made three comic classics for them, *The General* (1927), *College* (1927) and *Steamboat Bill Jr* (1928). Gloria Swanson had been Paramount's biggest attraction, but she turned down their offer to double her salary and joined UA as an independent producer. Samuel Goldwyn was also added to the roster and became a full partner by 1927. He brought with him an uncanny feel for the public's tastes while keeping a high standard of production. His first big hit for UA was *Stella Dallas* (1926), followed by a number of films starring the popular romantic duo, Ronald Colman and Vilma Banky. The young Howard Hughes was given a distribution contract by Schenck, and he furnished *Two Arabian Knights* (1927), the first UA film to win an Oscar. Valentino had left Famous Players after quarrels with Zukor, and Schenck snapped him up for his last two pictures, *The Eagle* (1925) and *The Son Of The Sheik* (1926), the latter literally cashing in on the 'great lover's' premature death. UA began 1928 with a $1 million deficit and ended the year with a $1.6 million surplus, thanks to such smashes as *The Gaucho*, *The Circus*, and *Tempest*, the company's first film with synchronized sound.

Of course, when Warners' *The Jazz Singer* opened in October 1927, with its few scenes of spoken dialogue and songs, the nature of the industry changed. None of the four founders of UA was thrilled by the innovation. Although Griffith had used sound on discs as early as 1921 in *Dream Street*, and experimented with it in *Lady Of The Pavements* (1929), he was not at ease with this new-fangled device. His narrow view of the world, the advances made by younger directors and the coming of sound, combined to make one of the most important figures in the history of film seem one of the most outdated. Fairbanks made a token gesture to sound by introducing a spoken introduction and epilogue to *The Iron Mask* (1929), but as he was now approaching fifty, he would make few talkies, one of them *The Taming Of The Shrew* (1929), co-starring his wife. Although Pickford won the Best Actress Academy Award for *Coquette* (1929), UA's first all-talking picture, she was only to make three further films. Even Mary Pickford had to call a halt and break the spell of her Peter Pan existence by finally growing up and retiring. Gloria Swanson adapted quite well to sound and was nominated for an Oscar for *The Trespasser* (1929), but she would always remain a personality of the silent screen. Her classic role as faded silent star Norma Desmond in *Sunset Boulevard* (Paramount, 1950) only underlined this, as she watched herself in scenes from *Queen Kelly* (1928). Lillian Gish, probably the greatest of all actresses of the silent era, made only intermittent appearances in sound movies (although these would, remarkably, continue into the 1980s). Norma Talmadge, Vilma Banky and John Gilbert, among others, fell by the wayside when the sound barrier was broken. Chaplin, alone, managed not only to survive the revolution, but to resist using spoken dialogue until *The Great Dictator* (1940), 13 years after *The Jazz Singer*.

United Artists was created near the beginning of the decade by four of the silent cinema's supreme artists. At the end of the golden era, Griffith was ruined and Pickford and Fairbanks were heading for divorce and retirement. Despite further masterpieces, Chaplin's divorce cases and politics were to tarnish his reputation. Thus, 'the company built by the stars' was beginning to pass out of their hands. It was producer-businessmen-showmen such as Schenck, Goldwyn, Hughes, Selznick and Korda who were to dominate United Artists in the 30s and keep its reputation alive.

UNITED ARTISTS

1919

▷The United Artists story got off to a well-publicized start when the company's first film, **His Majesty, The American** opened the newly-built Capitol in New York – then the world's largest movie theatre – on 1 September 1919. Douglas Fairbanks, whose public popularity was steadily growing, produced and starred in this Ruritanian comedy-romance, and (under the name of Elton Banks) co-wrote it with director Joseph Henabery. The likable and lively Fairbanks (illustrated) played a New York man-about-town who is heir to the throne of a small European kingdom. Arriving there to take up his unlikely new position, he uses his All-American know-how (and the renowned Fairbanks gymnastics) to overcome political conspirators, and wins the hand of the princess, played by winsome Marjorie Daw (illustrated). Among the various aristocrats, devious and otherwise, were Frank Campeau, Lillian Langdon, Jay Dwiggins and Sam Sothern. Henabery, who impersonated Lincoln in D.W. Griffith's *The Birth Of A Nation* (Epoch 1915), and had already directed Fairbanks in a couple of previous pictures, kept the action moving against the fairly spectacular papier-mâché sets. As usual, Fairbanks smiled throughout – and with good reason, for this movie, made for only $300,000, recouped more than a modest profit. (FAIRBANKS)

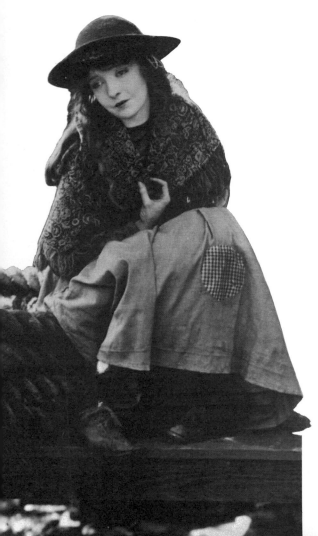

◁D.W. Griffith produced **Broken Blossoms** (from his own screenplay based on *The Chink And The Child*, a short story from Thomas Burke's *Limehouse Nights*) for the Famous Players–Lasky Corporation, but Adolph Zukor, the president, said, 'Everybody in it dies. It isn't commercial.' United Artists paid Zukor $250,000 for the picture that only cost $88,000 to make, but what an investment it proved to be. The film was proclaimed a masterpiece and eventually earned a profit of $700,000. It also demonstrated that the public could accept an intimate poetic film with a tragic ending. Set in a fog (and studio) bound Limehouse, it told of the 'pure and holy' love of a Chinese boy (Richard Barthelmess) for a young girl (Lillian Gish, illustrated) who lives with her brutish boxer father (Donald Crisp). One night, after learning that his daughter is living under the protection of 'a chink', he beats her to death. Discovering this,

◁'I mean to take human life in the cause of science', says the evil Dr Metz (Herbert Grimwood) at the opening of **When The Clouds Roll By**, Douglas Fairbanks' second production for United Artists. Psychoanalysis was still a novel word in 1919, and Fairbanks' scenario catered to the popular misconceptions of its sinister aspects in one of his most inventive and surreal pictures. The star (illustrated) played Daniel Boone Brown, an exceedingly superstitious young man who unwittingly becomes the guinea pig of Dr Metz, whose machinations drive him almost to suicide. In a weird dream sequence, Fairbanks is pursued by giant-sized versions of the food he has consumed at dinner, slow-motion revealing his extraordinary athleticism as he leaps and bounds away from a huge Welsh Rarebit! The film ended with his common sense restored after saving his girlfriend (Kathleen Clifford) from a flood. As they perch on a roof, a priest comes floating by on a church steeple to marry them. Other inhabitants of this bizarre world were Frank Campeau, Ralph Lewis, Daisy Robinson and Albert MacQuarrie. It was the first feature directed by Victor Fleming, the future director of *Gone With The Wind* (MGM 1939). (FAIRBANKS)

the boy kills the father and then himself. That this dated, morbid and melodramatic tale (with overripe intertitles), should be transformed into a classic of the silent cinema was due not only to Griffith's sensitive direction and Billy Bitzer and Hendrick Sartov's atmospheric photography, but also to the poignancy of Gish and Barthelmess's performances. Gish, in particular, not yet fully recovered from Spanish 'flu, gave one of her best fragile waif portrayals, only able to smile by forcing her lips apart with two fingers. Other actors discernible in the London fog were Arthur Howard, Edward Peil, George Beranger and Norman 'Kid McCoy' Selby. The film was completed in 18 days, soon after World War I, and made a plea for both non-violence and racial tolerance. Griffith began to direct a British remake in 1936 with Emlyn Williams and Dolly Haas, but left after disagreements over production. (D.W. GRIFFITH)

UNITED ARTISTS

1920

▽Mack Sennett, the master of short, rapid, irreverent and crazy slapstick comedies, was hard put to sustain the laughs and tempo over the five reels of **Down On The Farm**. As usual with a Sennett movie, it was the stunts and trick photography that held the interest and not the story – of a wild girl (the eccentric Louise Fazenda, illustrated) whose stern father (Bert Roach) wants her to marry a banker (the irascible James Finlayson) instead of her rustic suitor (Harry Gibbon). Other familiar Sennett faces were cockeyed Ben Turpin, Marie Prevost and Billy Armstrong, plus two remarkable animals, Teddy the dog, and Pepper, a Maltese cat. Erle C. Kenton (with the help of Ray Gray) directed the often funny proceedings as if they were a series of back to back shorts. To help fill United Artists' programme, Fairbanks secured the rights of the film by guaranteeing the producers a hefty advance of $200,000. The picture just about made it up. (MACK SENNETT)

▷For sheer movement and excitement, there is little in the silent cinema to equal the climax of the Douglas Fairbanks production of **The Mollycoddle**. Fairbanks (illustrated), as a wealthy playboy, refutes his reputation in the West as the weakling of the title (gained because he was brought up in England and on the French Riviera) by rescuing heroine Ruth Renick (illustrated) from the attentions of wicked diamond smuggler Wallace Beery. Doug leaps from a cliff to the top of a tree and hurls himself on Beery. They roll down a hill and over a waterfall before our hero emerges victorious. Along the way in this adaptation by Fairbanks and Tom Geraghty of Harold McGrath's *Saturday Evening Post* serial, Doug is suspected of being a spy, is caught in a fish net, and almost has his head chopped off. Victor Fleming's action-packed direction gave ample opportunity for a range of Fairbankian athletic antics. However, because he had sprained a wrist while vaulting over a horse in an early scene, Doug had to suppress his thirst for action and got a double to do the more dangerous stunts at the finale. Nobody noticed, and the film was another success for the star. Others in the cast who contributed to it were Paul Burns, Lewis Hippe, Albert MacQuarrie, Betty Bouton and Morris Hughes. (FAIRBANKS)

△Two cheaply and quickly made romances of the South Seas, *The Idol Dancer* and **The Love Flower** were produced and directed by D.W. Griffith for First National in the same year, and shot on location in Florida and the Bahamas. After the preview of the latter, however, Griffith decided to add scenes and release it through his United Artists partnership. These consisted of a few extra close-ups of the simpering heroine, Griffith's 'discovery' and current girlfriend Carol Dempster (illustrated), and shots of her stripping off her dress, diving, and then swimming under water. Hardly enough to turn a mediocre movie into a masterpiece. The screenplay, based on the story *The Black Beach* by Ralph Stock, told of how Richard Barthelmess, sailing the South Seas, discovers an island where an unspoiled young girl (Dempster) lives alone with her father (George MacQuarrie), a fugitive from the law. The island idyll is interrupted by the arrival of a detective (Anders Randolf) looking for the father. Even Billy Bitzer's luminous photographic creation of a pseudo-South Seas locale failed to prevent Griffith from waving Aloha to any profit. (D.W. GRIFFITH)

▽For **Romance**, D.W. Griffith bought the motion picture rights to Edward Sheldon's recent Broadway hit play for $150,000 with its star Doris Keane (illustrated) included in the package. He produced the picture at his own studios at Mamaroneck, New York, and supervised the direction of Chet Withey. Griffith was to have had a large share of the profits but, alas, there were none. The picture lost $80,000, and not without reason. It was a stodgy affair which told of a pastor's love for Madame Cavallini, a great opera singer. When he learns that she has been the mistress of his old friend, he banishes her from his life and works himself up into a religious frenzy. Later, when trying to convert her to the love of God, he gives in to more profane desires and starts kissing her passionately. Now it is her turn to reject him. Miss Keane re-enacted her stage role of the diva without managing to adapt to the change of medium. English actor Basil Sidney as the priest, and Norman Trevor (illustrated) as his friend, gestured wildly. They were drowning, not waving. (D.W. GRIFFITH)

▷ 'America's Sweetheart' Mary Pickford's first production for the company she helped to found was **Pollyanna**. Screenwriter Frances Marion adapted Eleanor Porter's saccharine-coated, late 19th-century children's novel to suit Mary's popular 'little girl' screen image and, although almost 27 years old, recently divorced from her alcoholic actor husband Owen Moore, and about to embark on her second marriage to Douglas Fairbanks, Pickford, under Paul Powell's direction, managed to get away with playing the ringleted 12-year-old 'glad girl'. Indeed, she made it one of her best remembered roles. 'Little Mary's' extended childhood was kept bearable by her comic timing and good humour, which just held the grotesque at bay in a storyline which had Pollyanna promising her missionary father, who literally dies laughing, that she will always be glad whatever the circumstances. Sent to stay with her curmudgeonly Aunt Polly (Katharine Griffith, seated, spanking Mary), she melts the hearts of everyone around her with her charm and philosophy. Laughter turns to tears, however, when she is injured while trying to save a child from being run over by an auto. She soon learns to walk again and, at the fade-out, a romance is suggested with orphan boy Howard Ralston. J. Wharton James, William Courtleigh, Herbert Prior and Helen Jerome Eddy were among those who found Miss Pickford irresistible. So did the public who flocked to see it. Walt Disney remade it successfully in 1960 with Hayley Mills in the title role. (PICKFORD)

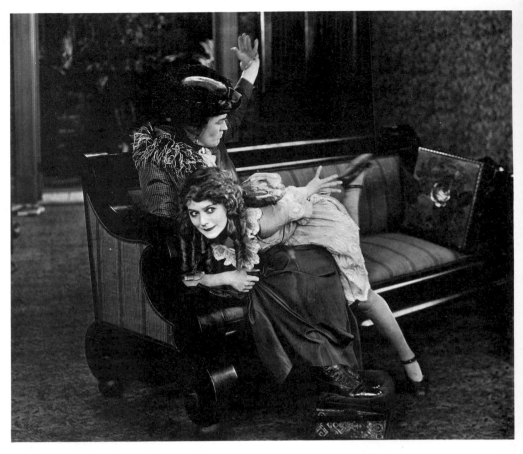

△ **Suds** was a soap opera in more than one sense. Mary Pickford (illustrated), mugging mercilessly throughout, played a Cockney laundry girl with a lively imagination. She tells the other girls that she is really the daughter of an archduke who has turned her out of the family mansion in order that she be loved for herself and not her wealth. She spends her time mooning after a swell (Albert Austin, one of Chaplin's favourite comedy stooges), while a delivery boy (Harold Goodwin), in turn, pines for her. Adapted by Waldemar Young from a one-act play called *Hop O' My Thumb* by Frederick Fenn and Richard Pryce, and directed by John Francis Dillon, this profitable Pickford production contained some good camerawork from Charles Rosher, particularly in a sequence when Mary dreams of herself as nobility. Surprisingly, the picture did not have a 'Cinderella' ending, but left the little launderess with a broken heart and the audience with damp handkerchiefs. (PICKFORD)

▽ A pulp magazine story called *The Curse of Capistrano* by Johnston McCulley, provided Douglas Fairbanks with the source of **The Mark Of Zorro**, which began his series of costume spectaculars, and from which he emerged as a major sex symbol. The scenario by Fairbanks himself (written under his favourite *nom-de-plume* Elton Thomas), told of Don Diego Vega, an effete nobleman in 19th-century California, who disguises himself as the dashing masked Zorro, protector of the weak and innocent. Both as the yawning fop and the swashbuckling Zorro, Doug (illustrated) was at his brilliant bouncy best, playing up the comic possibilities of two sides of the same character. Senorita Lolita (Marguerite De La Motte) forced to marry the humdrum version, falls for Zorro when he rescues her from the lascivious clutches of Captain Juan Ramon (Robert McKim). Only in the final moments does she learn that they are one and the same. Charles Hill Mailes and Claire McDowell were the girl's worried parents, and Noah Beery the sergeant whom Zorro always outwits. Director Fred Niblo kept the pace lively and the film was an immediate success, with police having to control the crowds outside New York's Capitol Theatre during the first weeks of its run. Fairbanks followed it up with a sequel, *Don Q, Son Of Zorro* in 1925, and the masked crusader has been the subject of numerous movies, most notably in the 1940 Fox remake starring Tyrone Power. (FAIRBANKS)

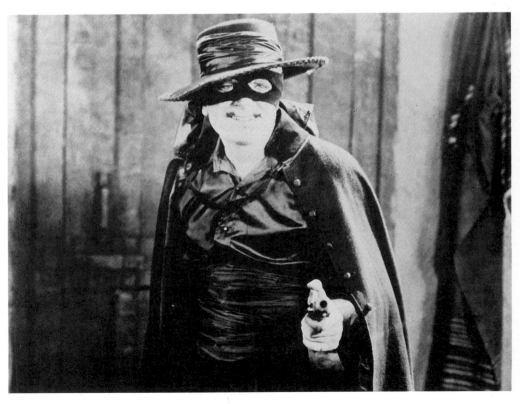

UNITED ARTISTS
1921

▷Mary Pickford (illustrated) now 27 and just married to Douglas Fairbanks, found a role more fitting to her age than usual in **The Love Light**, written and directed by her friend Frances Marion, and proved that she was capable of more than just smiling sweetly and shaking her curls. She played an Italian lighthouse keeper during the Great War who falls in love with and marries a man whom she believes to be an American sailor. He turns out to be a German spy and is put to death, after which she becomes insane until the return of a former lover, blinded in the war, restores her reason. The director laid much emphasis on the role of the spy, which was not surprising as it was played by her husband, Fred Thomson, making his screen debut. This former army chaplain later became a top cowboy star, before dying of pneumonia in 1928, aged 38. Edward Phillips was the blinded lover, with Evelyn Dunn, Albert Frisco, Raymond Bloomer and Georges Rigas filling other roles. Although it was not a box-office failure, the fans still preferred to see Little Mary Sunshine. (PICKFORD)

▽'Our people are dream people, who look from wistful windows or walk with visions on the Street of Dreams,' states an early and grandiloquent title in D.W. Griffith's **Dream Street**, a *mélange* of melodrama, allegory and poetry. Using two short stories from Thomas Burke's *Limehouse Nights*, the same source as the earlier more successful *Broken Blossoms*, Griffith (under the name of Roy Sinclair) wrote a screenplay that lent iself to a stylized conception. Good and Evil were personified by a street preacher (Tyrone Power Sr) and a masked violinist (Morgan Wallace) while three men struggled for the heart, soul and body of Gypsy Fair (Carol Dempster, illustrated), a dancer at the local casino. The men are two brothers, one a bully (Ralph Graves, illustrated), the other sensitive (Charles Emmett Mack), and a wily Oriental (Edward Peil). When the latter's evil designs are revealed to the police in the end, Dempster says, 'After this, you let white girls alone.' A marked contrast to the sympathetic portrayal by Richard Barthelmess of a Chinese in *Broken Blossoms*. Despite Griffith's mastery of the medium, the characters were no more than puppets in the murky plot, which induced sleep rather than dreams among both public and critics. (D.W. GRIFFITH)

△**The Iron Trail** was the railroad that the hero (Wyndham Standing, illustrated) and the villain (Thurston Hall) were battling against each other to build in Alaska. What was disconcerting about Rex Beach's story and screenplay was that the villain seemed to have right on his side and the hero might. However, the hero was clean cut and got the girl (Alma Tell, illustrated), and the villain had dark rings under his eyes and bullied his wife and stepdaughter. Whitman Bennett's production and Roy William Neill's direction took the well-trodden route through adventure movie territory, ending with the hero, his side-kick (Reginald Denny) and team completing a railway bridge in the nick of time as ice comes rushing down the river to threaten it. It left both critics and public cold. (WHITMAN BENNETT)

△The title of **Carnival** referred to that of Venice where this first British-made film released by United Artists was shot. English actor-manager Matheson Lang (illustrated) recreated his stage role (from his play co-written by H.C.M. Hardinge) as the thespian who believes his wife (Hilda Bailey, illustrated) to be unfaithful in real life while they are playing Othello and Desdemona on stage. He actually tries to throttle her during a performance, but they are finally reconciled in a gondola. The location shooting, unusual for the period, counteracted the theatricality of the acting. The good-looking villain was played by Welsh writer-composer-matinee idol Ivor Novello, and Victor McLaglen appeared in his second film. Harley Knowles directed. A similar plot was used in Alexander Korda's *Men Are Not Gods* (1937) with Rex Harrison, and *A Double Life* (Universal 1947) starring Ronald Colman. (HARLEY KNOWLES)

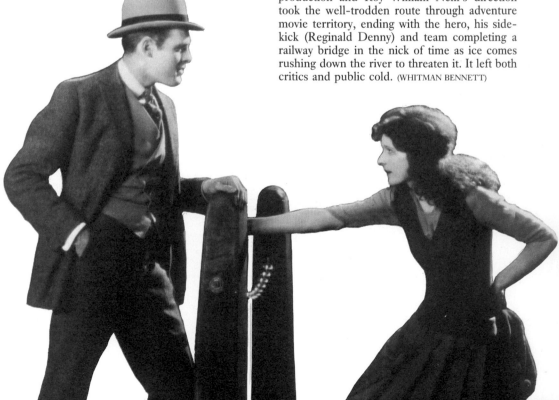

△Little Mary Pickford (right) was at it again, spreading sweetness and light in **Through The Back Door**. Marion F. Fairfax's made-to-measure screenplay told of how Mary, stolen as a child by a Belgian peasant woman, is sent to work as a kitchen maid for her wealthy mother (Gertrude Astor) in America when war breaks out in Europe. Naturally, her haughty parent is unaware of her identity but, by the end, she has not only revealed herself, but has reunited her mother and weak father (Wilfred Lucas), exposed a blackmailer, and married the boy next door (John Harron). A pleasant, sentimental comedy, the movie also featured Helen Raymond (illustrated), C. Norman Hammond, Elinor Fair and Adolphe J. Menjou (soon to gain stardom and drop his middle initial forever). Mary, who was also the producer, gave her somewhat dissolute 24-year-old brother, Jack Pickford, the chance to direct for the first time (with the aid of Alfred E. Green). (PICKFORD)

△Before Douglas Fairbanks decided to put his modern dress into mothballs, he produced **The Nut**, the last of his satires on contemporary life. Just as *When The Clouds Roll By* attacked psychology, this one had a go at sociology and the New Woman. The latter was embodied by a bobbed-haired Marguerite De La Motte (illustrated), setting out to prove that she could turn delinquent slum children into respectable citizens with her new theories. Although Doug (illustrated) made a botch of things trying to help her, he redeemed himself, in the usual silent screen manner, by saving her from a man forcing his attentions upon her. Gerald Pring (as a con man), Morris Hughes (as reporter Pernelius Vanderbrook), William Lowery and Barbara La Marr gave good support. The screenplay was by William Parker, Lotta Woods and Elton Thomas (Doug's pseudonym) from a story by Kenneth Davenport, and it was directed by Ted Reed, soon to become Fairbanks' production manager. The film moved rapidly through a series of great visual gags from the Keatonesque opening scene when Doug wakes up and gets machines to run his bath, wash him, and dress him. The whole mirthful mixture went down well with Fairbanks fans, but it was with his following films that he really moved into the big time. (FAIRBANKS)

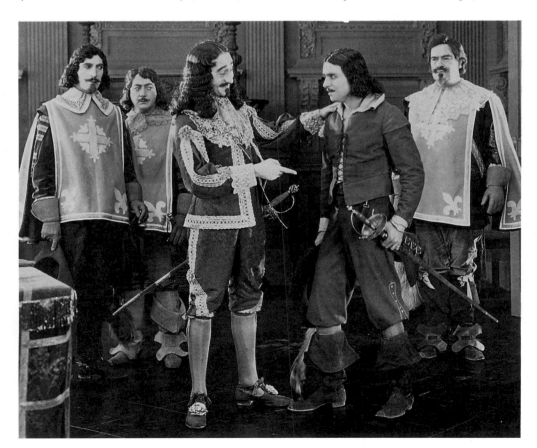

◁Douglas Fairbanks (centre right) was born to play D'Artagnan, 'the best swordsman in France', in **The Three Musketeers**, his most ambitious production to date. Adapted from Alexandre Dumas's novel by English playwright Edward Knoblock, and directed by Fred Niblo in vast sets representing 17th-century France, it started a successful trend towards million-dollar period spectaculars, and Fairbanks seldom donned modern dress on screen again. In a plumed hat, long curly wig and wearing a moustache for the first time, he swashbuckled his way through this stirring, entertaining movie, with Leon Barry (Athos, left), Eugene Pallette (Aramis, 2nd left) and George Siegmann (Porthos, 2nd right) at his side. Already an expert fencer, Fairbanks continued to train for months for this production as well as perfecting his horsemanship and acrobatics. His efforts were amply rewarded by a $1.5 million gross for the picture. Marguerite De La Motte played the damsel he rescues from distress, Nigel de Brulier was the scheming Cardinal Richelieu, Adolphe Menjou (centre left) and Mary MacLaren the King and Queen, and Barbara La Marr Milady de Winter. The film still stands out among the many screen versions of this popular tale, including those with the D'Artagnans of Walter Abel (RKO, 1936), Don Ameche (Fox, 1939), Gene Kelly (MGM, 1948) and Michael York (Fox, 1973). Fairbanks reprised the role eight years later in *The Iron Mask*. (FAIRBANKS)

▽An American lady tourist in Westminster Abbey in the 20s remarked on seeing the monument to **Disraeli**, 'My, what a lovely statue of George Arliss.' It was an understandable error as Arliss had played the part on stage in his native England and in the USA for some years before recreating it on film in Forrest Halsey's adaptation. He returned to the role again in the 1929 Warner Bros. sound version, for which he won an Oscar. In between trying to acquire the Suez Canal for Queen Victoria by outwitting the Russians and the governor of the Bank of England (E.J. Ratcliffe), the monocled and gaunt Arliss, as the English prime minister, spends time matchmaking for a young couple (Louise Huff, 2nd right and Reginald Denny, right). Henry Kolker, the director, showed little ingenuity in making Louis Napoleon Parker's play cinematic, but Arliss (centre), who also produced, brought humour and dramatic strength to his portrayal. His wife Florence (billed as Mrs George Arliss, left), Margaret Dale, Frank Losee, Henry Carvill and Grace Griswold gave support. (ARLISS)

△A week after her husband's triumph in *The Three Musketeers*, Mary Pickford's moment of glory came with her production of **Little Lord Fauntleroy**, Bernard McConville's screen adaptation of the popular children's novel of 1886 by Frances Hodgson Burnett. The familiar tale (remade in 1936 and 1980) tells of a little boy, Cedric, who lives with his widowed mother, Dearest, in a modest district of an American city. Dressed in a velvet suit, lace collar and wearing gold ringlets, he naturally attracts the derision of the neighbourhood boys, although he can hold his own in a fight. One day, he is informed that he has inherited an English title. He takes up residence with his crotchety grandfather (Claude Gillingwater) in a huge ancestral castle where he exposes an imposter to his title and wins the old man's affection. By taking on the roles of both Cedric and his mother, Mary was able to play a mature adult while keeping her public happy with another child imitation, and the picture grossed a healthy $900,000 at the box-office. The dual role (both Marys illustrated) produced a rarely surpassed example of trick photography achieved by Charles Rosher. It took 15 hours to shoot the scene where the boy kisses his mother and, in a spectacular example of the trick, the little Lord jumps into his mother's arms. As Dearest, Mary had to wear ten-inch platform shoes to make her appear much taller than her son. Joseph Dowling played Grandpa's lawyer, and Rose Dione an adventuress, with the part of *her* little son being taken by screenwriter-director Frances Marion. Alfred E. Green co-directed with the assistance of Mary's actor brother, Jack Pickford, although the latter was drinking heavily since the suicide of his young actress wife Olive Thomas. (PICKFORD)

◁The unprecedented sum of $175,000 was paid for the rights of Lottie Blair Parker's creaky Victorian melodrama **Way Down East**, which D.W. Griffith (and his co-scenarists Anthony Paul Kelly and Joseph R. Grismer) turned not only into a tremendous box-office hit, but into one of the classics of the silent screen. Although the budget reached $1 million, it eventually made the same amount in profits, putting Griffith into the black for the last time in his career. The public responded avidly to the hoary tale of a young orphan girl (Lillian Gish, illustrated), seduced and abandoned by a rake (Lowell Sherman), then sent out into the frozen wastes of New England by the farming family for whom she works when her past is discovered. She is rescued from drowning in the icy river in the nick of time by the farmer's son (Richard Barthelmess, illustrated) who finally marries her. The climax is justly famous. Griffith, using exciting cross-cutting, and alternation of close-ups and long shots, built up the tension as the girl floated down the river on a cake of ice while the boy stepped from one floe to another towards her. These gripping scenes, as well as those of the blizzard, were shot on location in real winter conditions, with Miss Gish having to be thawed out from time to time. She gave one of her most touching performances, helped by the reality of the surroundings and the fine camerawork by Billy Bitzer and Hendrick Sartov. The supporting cast included such Griffith stalwarts as Burr McIntosh and Kate Bruce as the farmer and his wife, together with Creighton Hall, Vivia Ogden and Porter Strong. (D.W. GRIFFITH)

UNITED ARTISTS

1922

▽Madame Alla Nazimova, the Russian *grande dame* of the stage, and known simply as Nazimova (illustrated), produced and took the role of Nora in Peter M. Winter's silent screen adaptation of Henrik Ibsen's masterpiece **A Doll's House**. In an attempt to make the wordy play more filmic, much of its structure was altered, showing the beginning of Nora's married life to the stolid Torvald (Alan Hale), as well as other action that is off-stage in the original. Instead of the 19th-century liberated woman, Nazimova's Nora began as a 20s sex kitten and became more and more stylized as the film progressed. Director Charles Bryant, the star's English-born husband, concentrated mostly on his wife's emoting, while Wedgewood Nowell (illustrated) as Krogstad the money lender, Florence Fisher as Kristine, Nora's friend, and Nigel de Brulier as Dr Rank managed a look-in from time to time. Ibsen's drama had previously been filmed in 1917 with Dorothy Phillips and 1918 with Elsie Ferguson, and there were two versions in 1973, one with Claire Bloom, and the other with Jane Fonda. (NAZIMOVA)

▷The **Fair Lady** of the title was attractive brunette Betty Blythe (illustrated) in this Kenneth Webb directed picture adapted by Dorothy Farnum from Rex Beach's adventure novel *The Net*. (Co-incidentally, Miss Blythe, then aged 71, appeared briefly in the ballroom scene of *My Fair Lady*, Warner Bros., 1964). Set in New Orleans, the intricate plot had her involved with a Mafia gang infiltrated by Count Modene (Macey Harlam) who is actually an Italian secret service agent. The head of the gang is revealed as an Italian banker (Thurston Hall) after the obligatory car chase. The supporting cast included Robert Elliott, Gladys Hulette, Florence Auer and Walter James. Whitman Bennett's production made the public an offer they quickly refused. (WHITMAN BENNETT)

▽George Arliss, who made a name for himself on stage and screen portraying great historical figures such as Disraeli, was **The Man Who Played God** (aka **The Silent Voice**). How he did so, was told entertainingly under Harmon Wright's direction in this Arliss production, adapted by Forrest Halsey from Jules Eckert Goodman's 1914 play. Arliss was an eminent pianist who is made deaf by an anarchist's bomb which explodes during a command performance for a European king. The affliction ruins his career, and he spends his time seated at his apartment window, lip-reading people's conversations at a distance with the aid of field glasses. Through his 'peeping Tom' methods, he 'hears' of the economic hardships suffered by an elderly couple (Margaret Seddon and J.B. Walsh), and a young husband (Pierre Gendron) confessing to his wife (16-year-old Mary Astor in her first feature) that he has TB. Anonymously, Arliss (illustrated) helps them out of their difficulties. The syrupy, religious ending had him regaining his hearing in a church. Effie Shannon (illustrated) played his wife and Edward Earle her ex-flame. This successful silent film about deafness was remade twice by Warner Bros. – in 1932, with the same pair of titles and with the 64-year-old Arliss repeating his role, and in 1955 as *Sincerely Yours* starring Liberace. (ARLISS)

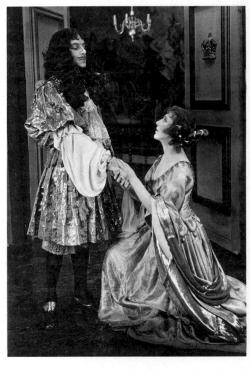

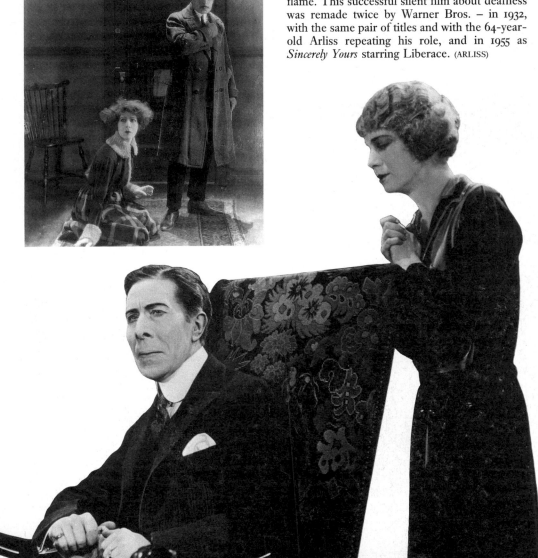

△**The Glorious Adventure** was the first of three costume pageants that pioneer producer-director J. Stuart Blackton made in England. Blackton, who had experimented with animation and editing in the early years of the century, now used a 'natural' colour process called Prizma for this rambling tale set in the England of Charles II, which he wrote with Felix Orman. The Merry Monarch himself was played by William Luff (illustrated), while Lennox Pawle and Lois Sturt impersonated Samuel Pepys and Nell Gwynn. However, the main action (or inaction) concerned the claims to a title by a feeble hero (Gerald Lawrence) and a glowering villain (Cecil Humphreys), rivals for the hand of Lady Beatrice Fair (woodenly played by Lady Diana Manners, illustrated). The film climaxed with the Great Fire of London into which the blue-blooded baddie was cast by Victor McLaglen, leaving the hero free to marry Lady Fair and claim his title in the end. Despite the dominant reds and blueish-greens, and the Fire, the acting was colourless and the audiences gave the film only a lukewarm reception. (J. STUART BLACKTON)

▽The **Ruling Passion** of millionaire George Arliss (right) was work. So, when his doctor and family prevail upon him to retire and enjoy his fortune, his health deteriorates. Taking on another identity, and pretending to have a modest income, he becomes the partner of a young man (Edward J. Burns, left) in a filling station. An unscrupulous rival (J.W. Johnston) opens a similar business opposite, but the never-more-youthful Arliss manages to outwit him. His identity is revealed and the young man marries his daughter (Doris Kenyon). Ida Darling played his patient wife, and the undistinguished direction was by Harmon Wright (from a screenplay by Forrest Halsey based on Earl Derr Biggers' *Saturday Evening Post* story), but the movie gave ample opportunity for Arliss to display his considerable acting talent. (ARLISS)

△D.W. Griffith bought the rights of the Victorian melodrama *The Two Orphans* by Adolph D. Ennery for $5000, changed the title to **Orphans Of The Storm**, the setting to the French Revolution, and wrote the screenplay under the name of Gaston de Tolignac. Almost 14 acres of sets depicting the Palais Royale, Notre Dame and the Bastille were built at Griffith's Mamaroneck studios as background to the historical 'storm'. It was the perfect vehicle for the Gish sisters, Dorothy (illustrated) and Lillian, as vulnerable girls who get caught up in murders, orgies, kidnappings and fates worse than death. Lillian, the protector of her blind sister, is sent to the guillotine for hiding her nobleman lover (Joseph Schildkraut, the German-Jewish stage actor making an impressive screen debut). In one of Griffith's favourite devices – the last minute rescue – Lillian's lovely neck is saved by no less a personage than Danton (Monte Blue). Brilliantly photographed by Hendrick Sartov, and full of spectacular set-pieces, it remains one of Griffith's most enduring films, despite the over-sentimentality and heavy-footed comedy. Sidney Herbert was a suitably evil Robespierre, and Lucille La Verne was Mother Frochard. Although the film did well at the box-office, large exploitation costs and road-show losses pushed it into the red. On top of which William Fox had bought the European rights of the play, and Griffith had to pay him for the film's distribution abroad. German and Italian versions of the same plot were made at the same time. (D.W. GRIFFITH)

▽Charles Ray, who had been popular in the early silents, thought he had found a tailor-made vehicle to revive his flagging career with **A Tailor Made Man**. It didn't, and he would soon find himself as a $7.50 a day extra. Here, he played a tailor's assistant (left) who tries to pass himself off in high society by wearing some of his rich customer's clothes. He becomes an immediate success, until he realizes that his true self lies back in the tailor's shop with the simple girl he loves (Ethel Grandin, illustrated). Among the corrupt and superficial upper crust were Irene Lentz, Jacqueline Logan, Thomas Ricketts, Victor Potel and Frank Butler. Joseph De Grasse directed this moralizing comedy-drama, produced by Ray, and adapted by him from the play of the same name by Harry James Smith. MGM remade it in 1931. (CHARLES RAY)

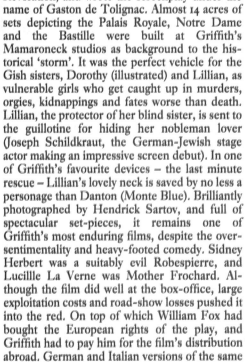

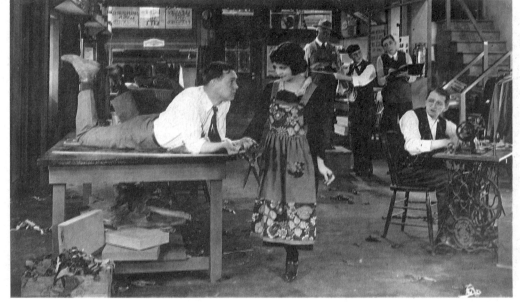

▽A storm rages, people are murdered, bodies disappear, bookcases revolve, groping hands come through doorways during **One Exciting Night** in an old Southern mansion where half a million pounds has been hidden. Every member of the house-party is after the loot, including a suspicious Scotland Yard detective. The guests included Carol Dempster, Henry Hull, Morgan Wallace, C.H. Croker-King, Margaret Dale, Charles Emmett Mack and a blacked-up Porter Strong (illustrated) playing the stock, wide-eyed Negro terrified by every sound. D.W. Griffith's screenplay (written under the pseudonym of Irene Sinclair, 'a young Kentucky authoress') drew heavily on the current Broadway murder-mystery hit *The Cat And The Canary*, as well as borrowing its star Henry Hull, and was one of the first 'Old Dark House' movies. Also, for the first time in the cinema, audiences were requested not to reveal the solution. However, so confusing was the plot, that many might not have been able to do so even if they had so wished. After the large-scale *Orphans Of The Storm*, Griffith had hoped to make an economical and commercial film. Alas, this too lost money on road shows, but less than some of the other Griffith pictures of the period. (D.W. GRIFFITH)

▷The painfully contrived pun of the title **The Three-Must-Get-Theres** disguised a witty slapstick burlesque of Alexandre Dumas' *The Three Musketeers*, directed, written, produced and starring the matchless French comic Max Linder (centre). He played Dart-In-Again (Ouch!), and his fellow musketeers were called Walrus, Octopus, and Porpoise, the roles being taken by Jack Richardson, Charles Metzetti and Clarence Werpz, members of the Metzetti acrobatic troupe. Bull Montana was Cardinal Rich-Lou, Frank Cooke and Catharine Rankin, the King and Queen, and Jobyna Ralston was Connie. It followed the Douglas Fairbanks version of the previous year, but parodying each scene. For example, when Linder is surrounded by 20 or so of the Cardinal's guards, he ducks and they stab each other to death. This was the last, and most successful of the six films he made in the USA. Two years later, his career on the wane, he and his wife took their own lives. (MAX LINDER)

◁Mary Alden (illustrated), who played the mulatto housekeeper in *The Birth Of A Nation*, found herself playing an unpaid skivvy to her husband (Holmes Herbert, illustrated), two daughters (Louise Lee, Dorothy MacKail), and son (Albert Hackett) in **A Woman's Woman**. When her husband spends most of his money on another woman, poor Mary opens a tea shop to supplement the family's income. She soon rebels, smartens herself up and goes into politics, where a Washington senator (J. Barney Sherry) falls for her. But when her second daughter commits suicide, she goes back to her place in the home where – the creaky scenario (by Raymond Schrock after the play by Nalbro Isadorah Bartley) suggests – she belongs. It was produced and directed by Charles Gyblyn, who also cast Rod La Rocque, Horace James and Cleo Madison in support. (CHARLES GIBLYN)

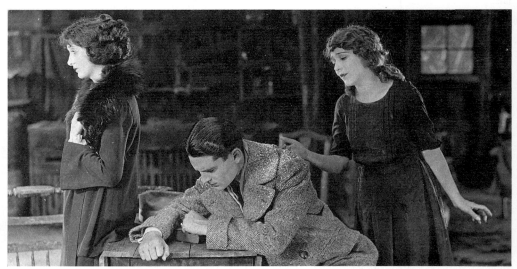

△In **Tess Of The Storm Country**, Mary Pickford (right) returned to the role that had made her a household name in the Famous Players film of 1914. Paramount now charged her $50,000 for the rights of the Grace Miller novel which Mary herself had made valuable. It was worth it, as it earned over $1 million for UA and further increased Mary's reputation as an actress. John S. Robertson's craftsmanlike direction and Charles Rosher's camerawork added quality to the rather treacly artificial scenario by Elmer Harris in which, as usual, curly-headed Mary scampered and skipped about, this time as fisherman's daughter Tessibel Skinner. Tess is in love with the son of the despotic landowner who wishes to deprive the fisherfolk of their livelihood by buying up all the land and excluding them from it. Of course, Mary manages to soften the old man's heart by the end. Lloyd Hughes (centre) made something of the young hero, David Torrence glowered as the patriarch, and Forrest Robinson was touching as Tess's father, while Jean Hersholt played a brutish mariner who aspires to possess Tess. Gloria Hope (left) was also featured. Janet Gaynor was Tess in the 1932 Fox version, and Diane Baker appeared as the heroine in the 1960 20th Century-Fox remake. (PICKFORD)

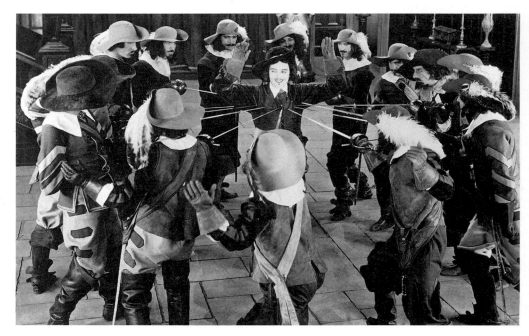

▽Mary's younger brother Jack Pickford (standing centre) produced and starred in **Garrison's Finish**, a cliched horse racing yarn with the usual ration of race track skulduggery, sentimentality, romance and a few thrills. Pickford, a talented little actor, played Billy Garrison, a jockey who loses his memory when hit on the head during a bar-room brawl. Under another name, he wins the Kentucky Derby and the girl (Madge Bellamy) who believes in him, and regains his memory at the same time. The picture, however, was forgettable. Clarence Burton, Charles Ogle (left), Charles A. Stevenson and Ethel Grey Terry played various horsy types in the Elmer Harris scenario (from the W.B.M. Ferguson novel) under Arthur Rosson's direction. (JACK PICKFORD)

▽What happened when European sophisticate Ernst Lubitsch met America's corn-fed sweetheart Mary Pickford was seen in **Rosita**. She was instrumental in bringing him to Hollywood in the hope that he could transform her from Pollyanna into Pola Negri. She lived to regret it. 'The worst picture, bar none, that I ever made,' Mary (illustrated) later recalled. Perhaps she confused the troublesome making of it with the end product which was a lavish, sentimental Spanish romance containing many delightful 'Lubitsch touches' of atmosphere and characterization. The scenario by Edward Knoblock and Hans Kraly (story by Norbert Falk) was laid in 18th-century Toledo, where the King of Spain (Holbrook Blinn) falls in love with Rosita and wants her as his mistress. But she is in love with the handsome nobleman Don Diego

(George Walsh, director Raoul's younger brother) who has been sentenced to death for treason. He is saved at the last moment by the Queen's intervention, and happiness is granted Rosita. Also cast: Irene Rich, Charles Belcher and Snitz Edwards. By playing Rosita, the dark-haired dancing girl, Pickford hoped to start a new phase in her career, but in the following year she regressed to childhood again. The film was shot in conflict. Lubitsch wanted to control the lighting, but Charles Rosher refused to let anyone else light Mary's face. When Lubitsch was over-ruled by producer Pickford, after demanding the film end tragically, he tore all the buttons off his coat in a fury. Despite the flying fur and buttons, and the mixed reviews, it grossed a respectable $900,000 and launched Lubitsch's Hollywood career. (PICKFORD)

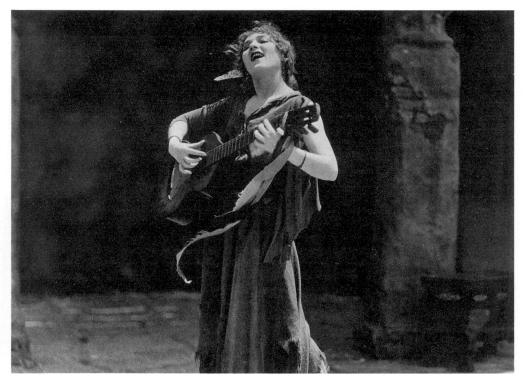

▽Marriage was the *unhappy* ending of **The Girl I Loved**, based on James Whitcomb Riley's poem. Charles Ray (illustrated), reverting to his once popular country boy character, loves the girl his mother adopted in infancy. But she (Patsy Ruth Miller, illustrated) loves him only as a brother, and he has to endure her marriage to another (Ramsey Wallace). Director Joseph De Grasse was successful in capturing the realistic bucolic setting, from which our hick hero escaped by daydreaming of requited love. Edyth Chapman and William Courtwright gave good support in this Charles Ray production. However, it did little to rescue Ray's career. (CHARLES RAY)

▽The young Irish-born producer Herbert Wilcox brought D.W. Griffith heroine Mae Marsh to Britain to star in **Paddy, The Next Best Thing**, a romantic comedy derived from Gertrude Page's novel by Eliot Stannard and Wilcox, and set in London and Ireland. Marsh, (illustrated) the Paddy of the title, refuses the attentions of a young playboy (George K. Arthur, illustrated) with whom her sister (Nina Boucicault) is in love. But she succumbs when he rescues her from a quagmire in which she has

sunk in the hills of Ireland. Graham Cutts' direction and the good location work, kept the film afloat. Also cast were Haidee Wright, Marie Ault, and Sir Simeon Stuart. It was remade in 1933, starring Janet Gaynor and with the locale changed to the USA. (HERBERT WILCOX)

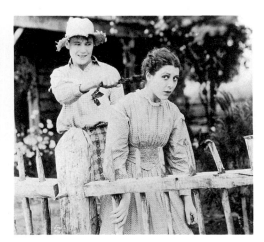

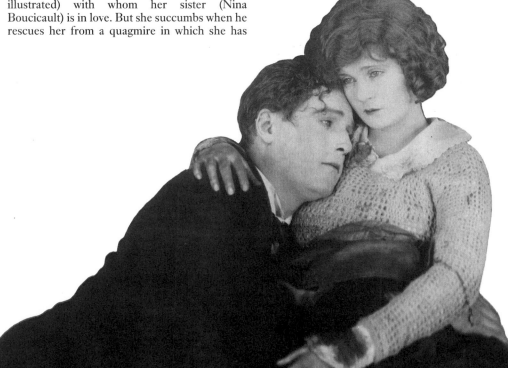

▽Wallace Beery (right) repeated his role as **Richard The Lion-Hearted** which he had played so successfully in Douglas Fairbanks' *Robin Hood* the previous year. Alas, without the dashing Douglas and a healthy budget, one needed a lion heart to sit through it, and a few inserts from the Fairbanks picture only worked to the film's detriment. The story, loosely adapted by Frank Woods from Sir Walter Scott's novel *The Talisman*, told of what happened to the king on the Crusades while Robin Hood was fighting to keep his name alive in England.

Marguerite De La Motte (illustrated) as Lady Edith Plantaganet provided the love play, which interrupted the sword-play and horse-play, under Chet Withey's direction. Kathleen Clifford was Queen Berengaria, and Charles Gerrard Sultan Saladin. John Bowers (left) Clarence Geldert and Wilbur Higby were an assortment of knights. It was the first of three pictures made by Associated Authors Inc (the other two were released in 1924), financed partly by the Bank of Italy. Costs overran on all of them, and none was a financial success. (ASSOCIATED AUTHORS)

△Her reputation damaged by press reports of her drug addiction, and her involvement with the mysteriously murdered director William Desmond Taylor, Mabel Normand (illustrated) was given a chance to retrieve her fortunes in **Suzanna**. Normand's Svengali and ex-lover Mack Sennett, who wrote and produced it, gave her the job but, sadly, it was the attractive, dark-eyed and gifted comedienne's penultimate picture. Still retaining something of her country tomboy image, Mabel played a peasant girl in love with the son of a ranch owner in Old California. They cannot marry because of their different stations in life but, as Mabel is about to march to the altar with a bullfighter (Leon Barry), her lover (Walter McGrail) swoops her up onto his horse and a typical Sennett chase ensues. Naturally, it turns out that Mabel is not really a peon after all, but the daughter of the wealthy Don Diego (Eric Mayne). It was directed with a light comic touch by F. Richard Jones, a veteran of many Sennett two-reelers, but the picture fared poorly, a fact which Sennett laid at the door of UA, accusing them of poor salesmanship. (MACK SENNETT)

▽After *Paddy, The Next Best Thing*, Mae Marsh (illustrated) renewed her long-awaited working partnership with D.W. Griffith in **The White Rose**. Although she brought a moving intensity to the role of the orphan girl (Griffith clearly had a thing about orphans!) seduced by a fallen minister, her days as a leading lady were numbered. As the minister, Ivor Novello (illustrated), billed as 'the handsomest man in England', wore a gloomy expression throughout. The rest of the cast, including Carol Dempster, Neil Hamilton,

Lucille La Verne and the blacked-up Porter Strong, were equally ill at ease. The best scenes were those shot on location in the Bayou Teche country of Louisiana, but this sentimental and contrived piece (written by Griffith, again as Irene Sinclair) was merely a faint echo of some of his earlier rural masterpieces. The great man's talent was coming to resemble the faded rose that symbolized the heroine's seduction in the film. Needless to say, it was another financial disaster for him. (D.W. GRIFFITH)

△Oscar Wilde might have approved of Nazimova's (illustrated) flamboyant portrayal of his perverse heroine **Salome**, in the Peter M. Winters adaptation of his play. Although, at 44, she was not exactly the pubescent Biblical stripper of Wilde's imagination, her campy facial expressions and gestures were reminiscent of Sarah Bernhardt for whom it was originally written. The highlight, of course, was her dance of the seven veils which stopped in time to avoid the censor's scissors. Watching her lustfully was Mitchell Lewis as Herod (illustrated), and jealously Rose Dione as Herodias. Nigel de Brulier lost his head as Jokannaan. Mme Nazimova's husband, Charles Bryant, directed with the right bizarre touch in her own production. They were divorced soon afterwards. (NAZIMOVA)

▷As he was still under contract to First National, Charles Chaplin had to wait four years before he was able to make a film for the company he had helped to found. Instead of a comedy starring himself, he chose **A Woman Of Paris**, a sophisticated love triangle melodrama (from his own screenplay) in which he himself appeared only briefly, heavily disguised as a railway porter. Chaplin the director treated the rather musty story in a subtle, almost Chekhovian style. Edna Purviance (illustrated) played Marie, a girl from a small French town who leaves her weak lover (Carl Miller) and runs away to Paris where she becomes the mistress of a rich man (Adolphe Menjou, illustrated). When her boyfriend meets her again in Paris, he discovers she is a kept woman and commits suicide. The boy's mother (Lydia Knott) tries to kill her but relents, and the two women settle in the country caring for orphans. The film ended ironically with Marie sitting on the back of a cart on the road while her former sugar-daddy passes her in his Rolls, and neither recognizes the other. Chaplin hoped that the film would launch Purviance, his leading lady in almost 30 comedies, on a career of her own. However, it did much more for Menjou's career than hers. She made only two more films, besides being employed by Chaplin as an extra in *Monsieur Verdoux* and *Limelight*. The film was a critical success, but only grossed $634,000, about the same amount as the least successful releases of Fairbanks and Pickford. The public was obviously more interested in Charlie the Tramp than Edna the Tramp. Chaplin refused to allow it to be shown again for 50 years, during which time its reputation grew far beyond its actual quality. (CHAPLIN)

△Following the wild success of Rudolph Valentino in *The Sheik* (Paramount, 1921), 'king of comedy' producer Mack Sennett cooked up a story and scenario called **The Shriek Of Araby** for his cross-eyed comic Ben Turpin. But the five-reeler, directed by Sennett favourite F. Richard Jones, was held back by UA for over a year, somewhat diminishing any topicality it might have had. Turpin (illustrated) played a bill-poster at a movie house who dreams himself into the Sahara. Clad as a sheik he rescues heroine Kathryn McGuire (illustrated) from the clutches of villainous Dick Sutherland, with the help of magician George Cooper. Along the way, the pint-sized comedian (whose famous eyes were insured against uncrossing) goes fishing in the desert, comes face to face with a lion and finds himself in a harem. Ray Grey was an arab prince and Louis Fronde the cop who breaks the spell and stirs our hero from his slapstick slumbers. There was little, however, to wake up the box-office and the film failed to enhance Turpin's career or UA's profits. (MACK SENNETT)

▽Playwright Robert Sherwood called Douglas Fairbanks' **Robin Hood** 'the high-water mark of film production – the farthest step that the silent drama has ever taken along the high road to art.' Although not really justifying Sherwood's hyperbole, the film does bowl one over with its sheer exuberance and technical wizardry. Almost entirely financed by Fairbanks himself, it cost over $1.5 million to make. At a new studio at Santa Monica Boulevard, art director Wilfred Buckland built the biggest sets ever conceived for a silent picture, including a gigantic castle with 90 foot high walls which needed 500 workmen to construct. It seemed even higher on screen because the top of the castle was painted onto glass and fitted to Arthur Edeson's camera lens. Many of the action scenes surpassed any Fairbanks (right) had done before, with hidden trampolines being used to give more lift to his leaps, particularly one across a 15-foot moat. There was plenty of bounce in Allan Dwan's direction as well. Dwan agreed to work for five per cent of the profits, an unusual step in those days. It was a shrewd move, as UA made a tidy profit from the picture, unlike the eponymous hero who robs the rich to give to the poor. The scenario by Fairbanks (again billed as Elton Thomas), Dwan and Lotta Woods, told of Robin's attempts to unseat the usurper Prince John (Sam de Grasse), do battle with Sir Guy de Gisbourne (Paul Dickey), woo Maid Marion (Enid Bennett), and pave the way for the return of King Richard (Wallace Beery, centre). Alan Hale played Little John, a role he would play again in *The Adventures Of Robin Hood* (Warner Bros.) with Errol Flynn in 1938. (FAIRBANKS)

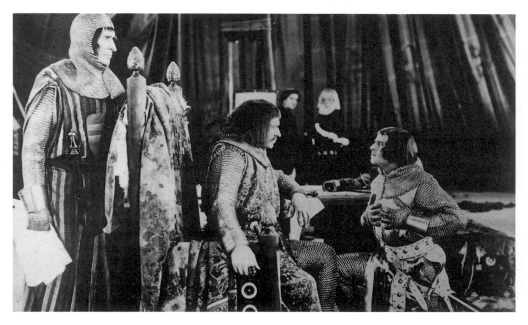

▽A film called **America** (GB: **Love And Sacrifice**) can be nothing if not ambitious, but it was a failed attempt by D.W. Griffith to return to a broad historical canvas and repeat the success of *The Birth Of A Nation*. As in the earlier film, Griffith tried to set a personal story in the midst of great public events, in this case the American War of Independence. The story, written for him by historian-novelist Robert Chambers (adapted for the screen by John Pell), was approved by The Daughters of the American Revolution and The War Department – which was perhaps why the film seldom became more than a ponderous patriotic pageant peopled with one-dimensional characters. However, aided by a team of photographers led by Billy Bitzer and Hendrick Sartov, Griffith showed, with the reconstructions of the battles of Lexington and Concord, that he had not lost his eye for the grandiose. Much of it repeated the structure and montage effects of previous Griffith spectacles, with the now mandatory final ride to the rescue. The central love story was unconvincing, made more so by the inadequate performances of Carol Dempster and Neil Hamilton. Only Lionel Barrymore (illustrated) as the wicked lip-smacking Captain Butler enlivened a cast which included Arthur Donaldson (King George III), Frank Walsh (Thomas Jefferson) and Arthur Dewey (Washington). The public did not respond to this history lesson, although after years of distribution and the sale of stock footage, it earned back its costs. Far too late, however, to help Griffith safeguard his independence. (D.W. GRIFFITH)

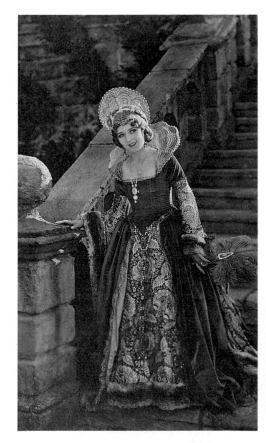

△'Der iss too many qveens' was Ernst Lubitsch's reason for not directing **Dorothy Vernon Of Haddon Hall**, which Mary Pickford had originally intended for him before *Rosita*. Instead Marshall Neilan was given the job of mounting this historical romance. Neilan was one of Hollywood's highest paid directors before the demon drink caused his downfall. In fact, Mary herself (illustrated) directed a couple of sequences while the director and her brother went on a two-day binge. Pickford, the actress, was as lovable as ever in the title role of the 18-year-old English aristocrat torn between her lover (Allan Forrest), a supporter of Mary, Queen of Scots (Estelle Taylor), and her own loyalty to Queen Elizabeth (Clare Eames). There was a climactic ride, in which Dorothy rescues her lover from execution, as exciting as anything in Griffith. If the fanciful Waldemar Young screenplay (from Charles Major's novel) stretched historical facts somewhat, Mitchell Leisen's costumes were so authentic that it took Miss Eames half an hour to go to the lavatory. Others decked out in splendour were Marc MacDermott, Wilfred Lucas, Courtenay Foote and Lottie Pickford Forrest, Mary's younger sister and wife of her co-star. The film cost $750,000, but made one hundred per cent profit in the western hemisphere alone. (PICKFORD)

▽'There's coal in them thar hills' and Jed (Jack Pickford, illustrated), **The Hillbilly**, is determined to keep it from a bunch of city slickers. He is in love with pretty Emmy Lou (Lucille Ricksen) who is forced into marriage with her dreadful cousin Aaron (Ralph Yearsley). Jed interrupts the marriage and Aaron is accidentally shot. Jed stands trial for murder, but is acquitted when almost everyone among the mountain community admits to the killing. Frank Leigh, Jane Keckley and Snitz Edwards played characters named Groundhog, Mother McCoy and Tabb Tafel. Marion Jackson's screenplay (from the story by John Fox Jr) was a pleasant moonshine mixture of comedy and pathos, enacted against pretty mountain scenery with an appealing performance from Pickford who also produced. The director George W. Hill, the second husband of famed screenwriter Frances Marion, committed suicide in 1934. (JACK PICKFORD)

▽Audiences prone to *mal de mer* would have been well advised to stay away from **Loving Lies**, a salty tale adapted by Thompson Buchanan from Peter B. Kyne's novel *The Harbour Bar*. The lies of the title are those told by a tug boat skipper (Monte Blue, illustrated) who never informs his nervous wife (Evelyn Brent, illustrated) when he has a dangerous piece of work to do. This leads to complications when he rescues a young girl and her baby from the sea. Charles Gerrard played his employer, and Joan Lowell, the girl. W.S. Van Dyke, already gaining a reputation as an outdoors action director, filmed much of it on the North Pacific coast, although the numerous storms at sea were studio manufactured. The film itself produced hardly a ripple. (ASSOCIATED AUTHORS)

△Mae Marsh, the fragile, put-upon heroine of early D.W. Griffith features, once again suffered a-plenty as Dorothy in **A Woman's Secret** (aka **Flames Of Passion**). Seduced by her father's chauffeur (Herbert Langley), she gives birth to a child who is given to the chauffeur's wife (Hilda Bayley). The chauffeur, on a drunken binge, murders the child, unaware that it is his own. Meanwhile, Dorothy has married a lawyer (C.

Aubrey Smith, right, pointing) who prosecutes the chauffeur, gets him the death sentence, and everyone else lives happily ever after. Eva Moore, Allan Aynesworth and George K. Arthur (left, in witness box) also appeared in this improbable British-made melodrama. Graham Cutts directed in a stilted manner from a script by producer Herbert Wilcox (written with his brother M.V. Wilcox). (HERBERT WILCOX)

▽Hunger, malnutrition, breadlines, riots and poverty in defeated Germany between 1918 and 1923, seem to give the lie to the title **Isn't Life Wonderful?**, D.W. Griffith's last independent production. But after following the trials and tribulations of a young Polish refugee couple in Berlin, which include having nowhere to live and being robbed of their potatoes, the film states that 'Love makes beautiful all that it touches … for where there is love there is hope and triumph.' Griffith based his screenplay on a short story by Major Geoffrey Moss who had witnessed many of the events depicted, and it was shot in the streets of Old Berlin and its environs, using the inhabitants as extras in what was, to a large extent, their own story. Although Griffith's liking for Victorian melodrama and sentimentality were apt to drown some of the semi-documentary effects, the picture had an influence on the social realism movement that was growing in the German cinema. Carol Dempster and Neil Hamilton (both illustrated), in shabby clothes and hunger make-up, were touching as the lovers; Helen Lovell, Erville Alderson, Frank Puglia, Marcia Harris and Lupino Lane also looked as though they could do with a square meal. Again Griffith miscalculated the public's taste, and the film lost money. He thus had to give up his independence and go to work at Paramount for Adolph Zukor, who had put up some of the money for the film. (D.W. GRIFFITH)

△Made for the then unprecedented sum of $2 million, **The Thief Of Bagdad** was the most ambitious and opulent of all the films of Douglas Fairbanks. In order to embellish the screenplay written by Lotta Woods and Elton Thomas (Fairbanks' *nom de plume*), based on an *Arabian Nights* story, designer William Cameron Menzies constructed magnificent mammoth sets including towering minarets and Moorish buildings which reflected in glazed floors, giving the film an exotic, fairy-tale atmosphere. The picture set new Hollywood standards for special 'magical' effects, which still astonish despite Alexander Korda's impressive 1940 Technicolor remake. Fairbanks as Ahmed the Thief (illustrated), stripped to the waist of his harem pyjamas and wearing golden earrings, gains entrance to the Palace of the Caliph by means of a Magic Rope. There he falls in love with a beautiful princess (Julanne Johnston), but before he can earn her love, he must go through a series of tests. The

star's renowned muscular athleticism was given ample scope as he braved the Caverns of Fire and the Valley of Monsters, climbed the Flight of a Thousand Stairs, and rode the Flying Horse, emerging, as ever, grinning and victorious. The final shot showed Fairbanks and his princess sailing over the house-tops on a Magic Carpet while the stars in the sky spelled out 'Happiness Must Be Earned.' Incidentally, the carpet was hung by piano wires from a crane that swung it high over the sets. Producer Fairbanks' showmanship was evident in every scene, and director Raoul Walsh kept the action flowing. Also in the cast were Snitz Edwards as the thief's evil associate, Charles Belcher as The Holy Man, and 16-year-old Anna May Wong as The Mongol Slave. Strangely, it earned a good deal less than many previous Fairbanks movies, but over the years has gained in profit and reputation, and seems to be enjoying a new lease of life in the 1980s. (FAIRBANKS)

▽When Matt Moore (illustrated) was thrown over by vamp Kathleen Clifford, he resolved to have **No More Women** in his life. But he didn't take account of wealthy Madge Bellamy (illustrated), who is determined to pursue him until he marries her. She poses as a waitress at the restaurant where he eats, tracks him down to his retreat in the hills and, needless to say, gets him to march down the aisle with her in the end. Stanhope Wheatcroft, George Cooper and Clarence Burston were also mixed up in the misogynistic proceedings. This light comedy, written and produced by Elmer Harris, and directed by Lloyd Ingraham, had three good performances and pleasant locations, but managed to raise only a few laughs. (ASSOCIATED AUTHORS)

▽One of Joseph Schenck's first productions after becoming chairman of the UA board in November, 1924, was **The Eagle**, a Rudolph Valentino vehicle. The reputation of 'the screen's greatest lover' was becoming rather tarnished, owing to his arrest on a charge of bigamy as well as the failure of his two previous films for Famous Players. But this witty treatment by scenarist Hans Kraly of Alexander Pushkin's unfinished semi-satirical Russian romance *Dubrovsky*, gave Valentino's career a much-needed boost. Unfortunately, it was to be the famous male vamp's penultimate film. As a young Cossack lieutenant disguised as a bandit known as The Black Eagle to avenge his father's death, the star (illustrated) was at his romantic, self-mocking best, spurning the advances of the Czarina Catherine II (Louise Dresser) in favour of a young girl he rescues from a runaway carriage. The alluring occupant was played by the Hungarian star Vilma Banky (illustrated – borrowed from her discoverer Sam Goldwyn) in her second American movie. William Cameron Menzies designed the opulent mock-Russian sets, and Adrian supplied the camp Kremlin costumes. Clarence Brown, soon to become Garbo's favourite director, established his reputation for glossy elegance with this picture. Giving support were James Marcus, George Nichols, Clark Ward, Michael Pleschkoff and Spottiswoode Aitken. (ART FINANCE)

▷Charles Chaplin called **The Gold Rush** 'the picture I want to be remembered by.' He got his wish, for it has remained the most widely-shown, popular and profitable of all his features. (It grossed $4 million worldwide in its first two years.) When it was reissued in 1942 (drastically reduced from 142 minutes to 72) with a musical score and narration added by its producer-writer-director-star, the public flocked to see it once again. Charlie (illustrated) played a lone prospector who comes to Alaska at the turn of the century in search of gold. He is forced by a snowstorm to take refuge in a cabin with another prospector Big Jim McKay (Mack Swain in his most famous role.) The scenes of their near starvation have become anthology pieces. Driven mad by hunger, Big Jim sees Charlie as a giant chicken and chases him around the enclosed space, but cannibalism is prevented by the cooking and eating of a shoe, with the leather,

nails and laces standing in for meat, bones and spaghetti respectively. (The shoe, in fact, was made of licorice, and the nails of candy.) When the storm subsides, Charlie goes to a mining town where he falls deeply in love with a beautiful dancing girl called Georgia (Georgia Hale, in her second screen role) but she hardly notices him. At the climax, Charlie, now wealthy from a gold find, meets her on a ship, and they seem to have a future together. Some of the most celebrated scenes were not, in fact, all that original – the hilarious and thrilling cabin teetering on the edge of a cliff owed much to Harold Lloyd, and the dance of the rolls was a routine used years before by Fatty Arbuckle in *The Cook* – but they were transformed in the context by Chaplin's brilliant timing and personality. Tom Murray, Henry Bergman, Malcolm Waite and Betty Morrissey also appeared in this comic monument. (CHAPLIN)

◁Years before **Little Annie Rooney**, Mary Pickford (illustrated) had said, 'I hate these curls. I'm in a dramatic rut eternally playing this curly-headed girl. I loathe them! I loathe them!' Yet, here she was, at 32, in short frocks, curls and smudgy face once again, providing the public with their beloved 'Little Mary' in her own production, and demonstrating her phenomenal artistry as a child impersonator. As the daughter of Rooney the cop on the east side of New York at the turn of the century, she led a street gang of kids which included Abie (Spec O'Donnell) and Spider (Hugh Fay), as well as running the house for her widower father and her brother (Walter James and Gordon Griffith). One night, on her pop's birthday, an officer comes round to tell her he has been shot by a hoodlum. Her boyfriend (William Haines) is wrongly accused, but just before the close, the real killer is found. Hope Loring and Louis Leighton's screenplay, under William Beaudine's direction, proved that there was life in the Catherine Hennessey story yet. The box-office returns suggested that Mary Pickford could continue to play a 12-year-old until her dying day. (PICKFORD)

▽While **Waking Up The Town** didn't exactly do what the title promised, this light, Jack Pickford-produced comedy didn't put it to sleep either. The picture followed the vicissitudes of a small-town Edison (Pickford, illustrated) who invents all sorts of strange contraptions, tries to harness the local waterfall for power, and gets an eccentric amateur astronomer (Alec B. Francis) to believe that the end of the world is nigh. Less inventive was the scenario by James Cruze (who also directed) and Frank Condon from Condon's story. Romance was provided by rising star Norma Shearer (illustrated), while other roles went to Claire McDowell, Herbert Pryor, Ann May and George Dromgold. (JACK PICKFORD)

▽The Son Of ... sequels have now become a standing Hollywood joke, but when Douglas Fairbanks produced **Don Q, Son Of Zorro**, a follow-up to his hit 1920 movie *The Mark Of Zorro*, the idea was in its infancy. The screenplay by Jack Cunningham (from the novel *Don Q's Love Story* by K. and Hesketh Prichard) provided Fairbanks fans with the usual high standard of action, romance and comedy. As Don Cesar de Vera (illustrated), Doug dashed around 19th-century Madrid, hoping to win the hand of Dolores (Mary Astor), who is also loved by the dastardly Don Sebastian. Donald Crisp played the latter, also managing to direct the film while dodging the hero's flashing blades. The star proved to be no mean hand with a whip either, using it on an escaped bull and various sinister senors. Jack MacDonald, Warner Oland, Jean Hersholt, and Lottie Pickford Forrest (Fairbank's sister-in-law) were good foils to the central performances. Technically superior to the earlier film, it apparently found greater favour with the audiences as well, and raked in more money at the box-office. (FAIRBANKS)

△George K. Arthur, the young British actor, got an unknown assistant director to help him make his American screen debut in **The Salvation Hunters**. Although often ponderous and pretentious ('Our aim has been to photograph thought', says an opening title), it was a remarkable first film by Joseph von Sternberg, who produced, directed, wrote and edited. Shot rapidly in actual locations, mainly around the mud flats of San Pedro, with a cast and crew of semi-amateurs, it dealt with the world of waterfront derelicts in a detached and stylized way. An unemployed youth (Arthur, right) meets an unhappy girl (Georgia Hale) and an abandoned child (Bruce Guerin, left). They go in to the big city, but return when they find that life is even more pitiful there. Sternberg's *chutzpah* persuaded Chaplin, Fairbanks and Pickford to watch it. They were impressed, bought it for more than it cost to make (a paltry $6000), and released it through UA, although it was more prestigious than profitable. (ACADEMY)

▽The land rush of hundreds of homesteaders along the Cherokee Strip between Oklahoma and Texas in **Tumbleweeds**, one of the silent cinema's great action sequences, added to the growing respect for Westerns as a genre. William S. Hart, its producer and co-director (with King Baggot), had done much to bring this about, always insisting on authenticity where possible, while his strong, unsmiling performances made him into the first Western star. As usual, Hart (illustrated) played a sharp-shootin', righteous hero, the protector of the weak (in this case, Barbara Bedford, illustrated) and the scourge of villains (J. Gordon Russell and Richard B. Neil) in C. Gardner Sullivan's adaptation from a Hal G. Evarts story. All the smiling was left to his comic sidekick called Kentucky Rose (Lucien Littlefield). Other parts went to Jack Murphy, Lillian Leighton and George Marion. Although the film was a critical and commercial success, Hart sued UA for what he claimed was their negligent handling of the distribution. He won $278,000 damages, and retired from the movie business to write Western novels. He reissued the film in 1939 with sound effects and a prologue spoken by himself. (WILLIAM S. HART)

△Dogged by the fame of Rin-Tin-Tin who was bow-wowing the public at Warner Bros., producer John W. Considine unleashed his own canine counterpart, Peter the Great, in **Wild Justice**, a typical sub-Rinty adventure set in the Far North. C. Gardner Sullivan's screenplay (from his own story) involved Frances Teague, a young woman who has to take refuge in a cabin during a blizzard with villainous Frank Hagney. Meanwhile, on her trail comes George Sherwood, the handsome hero, and his trusty hound (both illustrated). The dog star managed to sniff out the heroine even through the snow, thus rescuing her from a fate worse than death. However, director Chester Franklin could not rescue the picture from barking up the wrong tree. (JOSEPH M. SCHENCK)

UNITED ARTISTS

1926

▽ After signing a contract with UA on 25 August 1925, Samuel Goldwyn delivered three films the following year, all directed by Henry King, of which **Partners Again** was the most modest. George Sidney (not the director of the same name, left) and Alexander Carr (right) co-starred as the Jewish duo, Abe Potash and Mawruss Perlmutter again after making *Potash And Perlmutter* (1923) and *In Hollywood With Potash And Perlmutter* (1924), also for Goldwyn. This one dealt with their mishaps when they become partners in an auto firm, but have to escape their creditors by hanging onto the wings of an aeroplane. Frances Marion's script (from the play by Montague Glass and Jules Eckert Goodman) injected the ethnic comedy with a suitable dose of thrills and tears along the way. Betty Jewel, Allan Forrest, Robert Schable, Lillian Elliott and Lew Brice were cast in character roles. (GOLDWYN)

▷ **Son Of The Sheik** was released opportunely at the time of Rudolph Valentino's funeral during which thousands of his mourning female fans caused a near riot. The box-office was also besieged and, within a year, the picture had grossed $1 million, soon doubling that amount. Apart from interest aroused by Valentino's premature demise (he was 31), Joseph Schenck's production had much to recommend it. The plot, adapted by Frances Marion and Fred de Gresac (from Edith Maude Hull's novel *Sons Of The Sheik*), told of the desert doings of the arab-garbed Rudi (illustrated) who falls for Vilma Banky (illustrated) as a nomadic dancer. 'Who are you my lord? I do not know your name,' she says. 'I am he who loves you. Is not that enough?' he replies, staring at her with those hypnotic brown eyes. When he is captured and tortured, he believes she has tricked him, but soon learns that she really loves him, and rides off with her to his sheikdom. Valentino also took the role of his own father the sheik, Agnes Ayres reprised her part as his wife in *The Sheik* (1921), and Montagu Love played the son's rival, with George Fawcett, Karl Dane, William Donovan and Bull Montana lending support. George Fitzmaurice directed. (JOSEPH M. SCHENCK)

▽ After playing extras and bit parts in two-reelers, a young man was suddenly cast as a last minute replacement for one of the leads in **The Winning Of Barbara Worth**. 'Gary Cooper is a youth who will be heard of on screen and possibly blossom out as an ace lead,' prophesied *Variety* in September 1926. Against the background of an expedition for the reclamation of desert lands, Cooper was a local Arizona boy and rival of an Eastern engineer (Ronald Colman, right) for the hand of the eponymous heroine (Vilma Banky). Samuel Goldwyn bought the rights of Harold Bell Wright's best-seller for $125,000, and spent a further $1 million in the making of it. The epic tale, screenwritten by Frances Marion and shot in the Nevada desert, offered sandstorms, floods and romance, and earned Goldwyn a tidy profit. Colman and Banky, paired for the second time, worked well together, vaudevillians Clyde Cook and Erwin Connelly supplied the comic relief, and E.J. Ratcliffe (left) was the heavy. Director Henry King increased his reputation as one of the best craftsmen around, aided by the fine camerawork of George Barnes and his 22-year-old assistant of whom more would be heard, a young man by the name of Gregg Toland. (GOLDWYN)

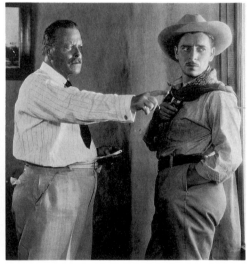

△ Tullio Carminati made his US debut as the detective on the trail of $200,000 stolen and hidden in an old dark house in **The Bat**. Producer, director and adapter Roland West paid a great deal for the film rights of Mary Roberts Rinehart and Avery Hopwood's mystery farce, something D.W. Griffith couldn't afford to do in 1922 forcing him to concoct *One Exciting Night* from many of its elements. These included secret panels, disappearing bodies, ghosts, and a criminal dressed as a bat. Everyone in the house was under suspicion, including Louise Fazenda (as a comic maid), Eddie Gribbon, Jewel Carmen (illustrated), Andre Berenger, Charles Herzinger, Jack Pickford, Emily Fitzroy, Arthur Houseman (illustrated) and Robert McKim. This economically made film did well at the box-office, but most of it was as creaky as the house in which it took place. West made a talkie sequel called *The Bat Whispers* (1930), and Vincent Price starred in a 1958 version. (JOSEPH M. SCHENCK)

△Douglas Fairbanks' **The Black Pirate** was the first full-length two-tone Technicolor movie, but this was not its only claim to fame. It also contained one of the silent screen's most spectacular stunts when, in order to capture a ship, Doug climbed up a mast and descended to the deck by piercing the wide sail with his sword, ripping the canvas as he went. There is still speculation as to how it was done. Other stunts in this boisterous piratical picture included 50 pirates swimming under water, and the hero leaping onto the side of a ship. Fairbanks (as Elton Thomas) wrote himself a story about an aristocrat who joins a pirate crew in order to avenge the death of his father, and rescues a princess (Billie Dove, foreground right) along the way. As his chest was exposed for most of the film, the hirsute star had to have it shaved every morning before shooting. Also cast, chests exposed or otherwise, were Tempe Pigott, Sam de Grasse, Anders Randolf, Charles Stevens, and Donald Crisp (foreground left). The latter was the original director, but he fell out with Fairbanks (centre) and was replaced by Albert Parker, an old friend of the producer, who kept everything satisfactorily afloat. (FAIRBANKS)

▽Charles Dickens' novel of the worst excesses of the French Revolution, *A Tale Of Two Cities*, provided the plot for the British-made **The Only Way**, based by Freeman Wills on his own play. It was neither the best nor the worst of films, but there were some fine sets by N.G. Arnold. It starred famous stage actor Sir John Martin Harvey (illustrated) as the world-weary boozing lawyer Sydney Carton, a part played by William Farnum (1917), Ronald Colman (1935) and Dirk Bogarde (1958). That Harvey bore no resemblance to Frederick Cooper as Darnay, making nonsense of their being mistaken for each other, didn't seem to bother producer-director Herbert Wilcox. J. Fisher White (Manette), Betty Faire (Lucy, illustrated), Frank Stanmore (Dr Lorry), Mary Brough (Miss Pross) and Ben Webster (Evremonde) attempted to bring life to characters that Dickens had conveyed far more vividly on the printed page. (HERBERT WILCOX)

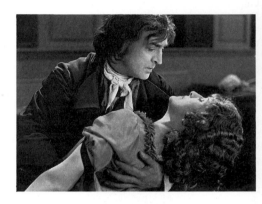

▽Although Mary Pickford's name was virtually flop proof, **Sparrows** fared less well at the box-office than many of her previous productions. Perhaps the scenario (by C. Gardner Sullivan from the story by Winifred Dunn) about a baby farm deep in the alligator-infested swamps of Louisiana, was too strong for some stomachs. But there was always Little Mary (left) to bring a ray of light into the gloom. As 'Mama' Mollie, she is the oldest of ten abandoned waifs at the farm of the cruel Grimes (Gustav von Seyffertitz, centre). In due course, Mollie leads the children to freedom across the swamps, and Grimes sinks to his death while pursuing them. A scene where Mary carries a baby over a log surrounded by snapping alligators, was said to have incurred Douglas Fairbanks' wrath. He accused director William Beaudine of endangering his wife and the child. In fact, the baby was a dummy, and the huge reptiles were filmed nowhere near the star. Nevertheless, Mary perpetuated the myth in order to rival her husband's stunts. Charlotte Mineau played Mrs Grimes, Spec O'Donnell (right) and Mary Louise Miller were two of the children, and Roy Stewart the millionaire who cares for them all in his mansion at the happy ending. (PICKFORD)

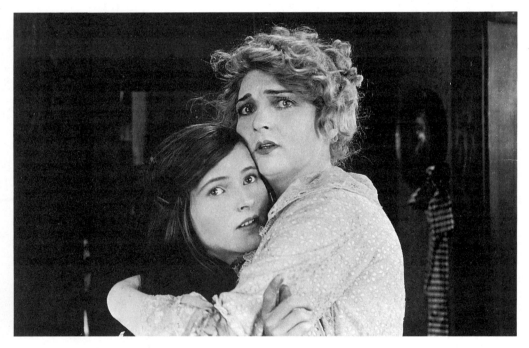

△Belle Bennett (right) jumped at the chance of playing the title role in **Stella Dallas**, and squeezed a vast quantity of tears from audiences everywhere. Frances Marion's screenplay (from Olive H. Prouty's best seller) told of how a man from the upper crust (Ronald Colman) is forced into marriage with the rather vulgar, uneducated Stella. Her unrefined ways become an embarrassment to her teenage daughter (Lois Moran, left) who is making her way in high society. Aware of the situation, the mother finally sacrifices her own happiness by stepping out of her daughter's life. Memorable scenes, directed by Henry King in a stylish, unfussy manner, were the daughter's birthday party which nobody attends, the grossly overdressed mother being ridiculed at a fashionable resort in front of her daughter, and the final moments when Stella watches her daughter's wedding through the window. Although the film showed sympathy for Stella, it came down uncomfortably on the side of social respectability. (This was even more marked in the equally tearjerking 1937 King Vidor version with Barbara Stanwyck.) Lois Moran, in her Hollywood debut, did well in having to age from 11 to womanhood. Excellent support came from 16-year-old Douglas Fairbanks Jr as her beau, appearing in his fifth film. Alice Joyce, Jean Hersholt and Vera Lewis also turned in capable performances. It was the first of producer Samuel Goldwyn's many successes for UA. (GOLDWYN)

▽D.W. Griffith was called in by producer Joseph Schenck to improve **Topsy And Eva** ten days before the picture was to be shown to the public, but only divine intervention could have saved it. Lois Weber, who adapted the Catherine Chisholm Cushing play (derived from Harriet Beecher Stowe's *Uncle Tom's Cabin*), had been set to direct it, but was replaced by Del Lord at the last moment. The future director of Three Stooges shorts introduced some grotesque comedy into the film, which opened with two storks delivering babies. The white stork delivered Little Eva, while the black one dropped Topsy into a barrel. The Duncan Sisters, Rosetta (left) and Vivien (right) took the title roles, Gibson Gowland played the cruel slave owner Simon Legree, Noble Johnson was poor Uncle Tom, Marjorie Daw Legree's niece, and Swedish actor Nils Asther (Vivien Duncan's husband making his US debut) played the man who marries her. The picture, which cost $300,000, was a cotton pickin' disaster. (ART CINEMA)

△A railway engine took the title role in **The General**, loved and cared for by Buster Keaton (illustrated) as Johnny Gray, its brave little Southern engineer during the American Civil War. When the train, together with Johnny's girlfriend, Annabelle Lee (Marion Mack, illustrated), is hijacked by Northern troops, our stone-faced hero sets out to rescue his two loves in one of the great comic pursuits in cinema history. What raises the film to classic status, aside from Keaton's supreme bodily grace and timing, is its pictorial beauty and authentic historical background. What made the comic effect more credible, was that Keaton himself performed the often dangerous stunts on real moving trains. Glen Cavender, Jim Farley, Frederick Vroom and Joseph Keaton (Buster's brother) filled other roles. The star edited, co-directed (with Clyde Bruckman), and co-wrote the screenplay (with Al Boasberg and Charles Smith) based on *The Great Locomotive Chase* by William Pittenger. (Walt Disney used the title and plot of the latter for his 1956 production). This was the first of three masterpieces Keaton made for his brother-in-law producer, Joseph Schenck, at UA during 1927/8. (Buster was married to Natalie Talmadge, sister of Joe's wife, Norma.) Yet, at the time, this most famous of all Keaton's pictures made less money than his previous films and received the notorious 1927 review in the journal *Motion Picture Classics* which referred to it as 'A mild Civil War comedy, not up to Keaton's best standard.' (KEATON)

▷The first film made by Gloria Swanson's own production company (formed with the aid of financier Joseph Kennedy, father of the future president and one of Gloria's lovers) was **The Love Of Sunya**, which opened the new Roxy Theater, the world's largest picture palace. Unfortunately, the palace received better reviews than the picture, although Miss Swanson's reputation as an actress of range remained unscathed. Earl Browne's scenario (adapted from the play *The Eyes Of Youth* by Charles Guernon and Max Marcin) provided the heroine (illustrated) with a crystal ball in which she could see her future with the different men in her life. Each episode showed the results of marrying for fame, wealth or love. Needless to say, the first two end in tragedy, the last in happiness. The various men were portrayed by John Boles, Andres De Segurola, Anders Randolph, Raymond Hackett, Ivan Lebedeff (illustrated) and Ian Keith, while Florabelle Fairbanks, Doug's niece, played a flapper. It was directed by Albert Parker, unfortunately at a snail's pace that was enlivened only by certain mystical special effects. (SWANSON)

▽**The Night Of Love** was offered by Samuel Goldwyn as part of a deal to deliver a number of pictures starring the popular pair of Ronald Colman and Vilma Banky (both illustrated), before he became a full UA partner in October 1927. Lenore Coffee cooked up the story and scenario for this costume drama in which Colman enacted a gypsy, complete with dark curly wig and golden earrings. A dastardly duke (Montague Love) snatches his bride away from him on his wedding night, so Romany Ronald does the same when the villain weds a fairhaired Princess in the shape of Vilma Banky. He takes her to his gypsy camp where there is some hanky panky with Banky. Gypsy camp aptly describes much of this lavish nonsense, entertainingly directed by George Fitzmaurice. Others in the cast included prima ballerina Natalie Kingston and famous fan dancer Sally Rand, along with John George and Laska Winter. (GOLDWYN)

△Mercy killing was the controversial subject of **Sorrell And Son**, adapted by the director Herbert Brenon from Warwick Deeping's best selling novel of life in England after the Great War. H.B. Warner (right), fresh from playing Jesus in Cecil B. DeMille's *King Of Kings*, suffered again, this time as Captain Sorrell who comes home from the war to find his wife (Anna Q. Nilsson) about to leave with another man. With a young son to bring up, the proud soldier is forced to take a job as a hotel porter. Kit, his son, grows up to be a famous surgeon, and it is he who administers an extra dose of morphine to save his father from pain in his last illness. Nils Asther played Kit stoically, supported by Mickey McBan (Kit as a child, illustrated) Carmel Myers, Lionel Belmore, Norman Trevor, Louis Wolheim, Alice Joyce and Mary Nolan. The Joseph Schenck production was a well-mounted weepie, and the director received an Oscar nomination. It was remade six years later with H.B. Warner repeating his role. (ART CINEMA)

▷Gilda Gray (illustrated), the 'Shimmy Queen' was **The Devil Dancer** in this Samuel Goldwyn piece of Hollywood hokum set in the Himalayas. Anthropologist Harry Hervey's original story was turned by scenarist Alice Duer Miller into a melodrama about a white girl (Gray) brought up in the faith of the Lamas. Along comes an English explorer (stiff-upper-lip specialist Clive Brook, illustrated) who sees her dancing at a ritual ceremony while poor Anna May Wong is being buried alive. Not a nice thing for a white girl to be participating in, so he takes her away from it all in chivalrous fashion, much to the annoyance of the evil chief (Michael Vavitch) as well that of his own prissy sister (Clarissa Selwynne). Fred Niblo took over the film after six weeks shooting, but received sole director's credit. He was welcome to it. (GOLDWYN)

△Few critics were surprised that **Resurrection** (aka **Prince Dimitri**) did not do justice to Leo Tolstoy's great novel of the same name. Nonetheless, producer-director Edwin Carewe and his co-writer Finis Fox, who faced the task of reducing this vast literary panorama of Russian life into a silent movie that would appeal to cinema audiences, made a good stab at it. While not exactly emulating the mile-long lines of Siberian exiles marching through the snowy wastes in the picture, the patrons were plentiful enough to keep the box-office healthy. Rod La Rocque (illustrated, soon to wed Vilma Banky) played the wealthy Prince Dmitri who, while

◁Buston Keaton (illustrated) was such an athletic performer that it was inevitable he would make **College** a film in which sports events play a major part. Keaton played a bookworm who is rejected by his girlfriend (Anne Cornwall) for being a weakling. He therefore has to prove that he can muscle his way in to her heart, and the rest of the film was given over almost exclusively – and hilariously – to Buster's attempts to master baseball, football, running and rowing. Ironically, the great comic, when supposedly inept, performed with the skill, timing and grace of the best of sportsmen. Finally, when his girl has been locked in her room by the star athlete and rival for her affections (Harold Goodman), he manages to rescue her by means of athletic feats he has been unable to achieve on the playing field. Also seen were Snitz Edwards, Florence Turner (illustrated), Flora Bramley and Grant Withers. Credited were James W. Horne as director, and Bryan Foy and Carl Harburgh (who also played the rowing coach) as writers, although Keaton later claimed to have done almost everything himself. However, Joseph Schenck was the undisputed producer. (KEATON)

serving as a juror in a murder trial, recognizes the accused as the girl he had seduced in his youth. Overcome with remorse, he gives up his worldly goods and follows her to Siberia. As the girl was portrayed by Carewe's beautiful Mexican discovery, Dolores Del Rio (illustrated), one could understand the Prince's actions. Among others in the cast were Lucy Beaumont, Vera Lewis, Marsh MacDermott, and Count Ilyha Tolstoy, the author's son, who had advised on the script. It was remade by Carewe in 1931 and by Rouben Mamoulian in 1934. There were also four silent versions, as well as a Russian one in 1961. (INSPIRATION)

▽**Beloved Rogue** was a title that could have been as aptly applied to its star, John Barrymore, as to the French beggar poet, Francois Villon, whom he portrayed in this Joseph Schenck production. Paul Bern's screenplay, derived from Justin Huntly McCarthy's play *If I Were King*, was obviously forged to suit Barrymore's extravagant personality. The star first appeared with a long nose, bushy eyebrows and whiskers, but wiped it all off to reveal 'The Great Profile'. As the romantic hero (illustrated), he rescued Charlotte (Marceline Day, illustrated), King Louis XI's ward, from marriage to the scheming Duke of Burgundy (Lawson Butt) by besieging the duke's castle with his vagabond army. Alan Crosland, who had directed Barrymore the year before in *Don Juan* at Warner Bros., kept the proceedings light and lavish. The distinguished German actor Conrad Veidt made his Hollywood debut as the King, with Henry Victor, Slim Summerville, Mack Swain, Lucy Beaumont and Dick Sutherland in other roles. Villon was also the subject of films of 1920 and 1938 under the title of McCarthy's stage play, and of Rudolf Friml's operetta *The Vagabond King* filmed in 1930 and 1956. (ART CINEMA)

▽The long screen kiss in **My Best Girl** between Charles 'Buddy' Rogers (centre) and Mary Pickford (right) could be attributed to the fact that they were falling for each other in fact as well in fiction. However, it was nine years before they were to be married. Meanwhile, their love scenes displayed sincerity in this charming small-town comedy directed by Sam Taylor and written by Hope Loring (from a Kathleen Norris story). Mary played the 18-year-old white sheep of a shiftless family consisting of her put-upon mailman father (Lucien Littlefield, left), funeral-loving mother (Sunshine Hart), and flighty sister (Carmelita Geraghty). She works in the Five-and-Dime where the new clerk (Rogers) is really the boss's son and they fall in love with predictable results. Other denizens of the town were played by Hobart Bosworth, Evelyn Hall and Mack Swain. (PICKFORD)

▽Lewis Milestone, at the beginning of his directorial career, won the Oscar for the best comedy direction (the only time this award was given) for **Two Arabian Knights**, in the first-ever Academy Awards ceremony. This profitable World War I farce, was only the second production of the 22-year-old owner of a multimillion dollar tool company. It was Howard Hughes who gave Milestone the job, chose the Donald McGibney story, and hired James T. O'Donohue and Wallace Smith to adapt it. The film told of the constant rivalry between a tough sergeant (Louis Wolheim, left) and a smart private (William Boyd, right) who seem to hate each other more than the enemy. But when they are captured by the Germans, they make their escape disguised as arabs and get shipped to Arabia where they rescue a maiden (Mary Astor) from the evil Bey (Michael Vavitch). Also contributing to the fun were Ian Keith, DeWitt Jennings, and Boris Karloff, the latter still some years from recognition. (HOWARD HUGHES)

▽The team of producer Samuel Goldwyn, director Henry King, and stars Ronald Colman and Vilma Banky (both illustrated) came together again for **The Magic Flame**, another plush, puerile, pleasing costume romance. Rudolph Lothar's novel and play, *King Harlequin* (adapted by June Mathis), offered Colman the first of his many dual-role assignments. Here, he was a clown with a travelling circus who happens to bear a striking resemblance to a corrupt prince of a medieval state. The clown kills the aristocrat in his castle during a fight to rescue the honour of a trapeze artist (Banky). Naturally, the clown takes the victim's place, becomes king, rules benevolently and marries the girl. Augustino Borgato, Gustave von Seyffertitz, Harvey Clarke and Shirley Palmer were other inhabitants of this make-believe world. (GOLDWYN)

UNITED ARTISTS
1928

▷One of the most notorious but seldom seen films of the silent era was Erich von Stroheim's baroque, erotic, sado-masochistic truncated masterpiece, **Queen Kelly**. The financially and artistically extravagant director had shot only a third of the picture (four hours worth!) when Gloria Swanson (illustrated), the star and producer fired him after $600,000 had already been spent. For an extra $200,000, she had the film hastily recut, and added an arbitrary ending and music. Stroheim repudiated this version and, with the coming of talkies and censorship problems, it was not released in the States. However, enough of it remains to see what it might have been. It contains Stroheim's usual obsessions with perversion, decadence, and love across class barriers. Swanson played Patricia Kelly, a convent girl, noticed by the debauched prince (Walter Byron, illustrated) of a small European country when her knickers fall down accidentally. He carries on an affair with her much to the chagrin of his fiancee, the mad Queen Regina (Seena Owen). In one celebrated scene, she lashes out at Patricia with a whip, chasing her across an enormous hall, down a grand flight of steps, and out of the palace. The film was to have moved from Europe to Africa after Kelly becomes Queen, showing her second marriage and her end in a brothel. Other roles that mostly ended up on the cutting room floor were taken by Tully Marshall, Sidney Bracey and William von Brincken. Some of Stroheim's story, screenplay and art direction also remained. (SWANSON)

▽Some critics consider Gloria Swanson's **Sadie Thompson** (illustrated) as one of her greatest roles. Certainly, she put her heart, body and soul into her portrayal of Somerset Maugham's famous floozie. The Hays Office had considered *Rain*, the short story and play, too racy to be filmed, but director, scenarist and co-star Raoul Walsh managed to save Swanson's pet production by making certain acceptable changes without diminishing its power. Sadie still played havoc with the men on the island of Pago Pago, until a reformer (changed from a priest for the film) tried to dampen her *joie de vivre*. Needless to say, he too succumbed to the sins of the flesh, and tragedy ensued. Lionel Barrymore (illustrated) was believable as the puritan, Blanche Frederici played his wife, and James Marcus and Charles Lane also contributed. Walsh, who portrayed the good-humoured Sergeant Tim O'Hara, constantly hitching up his pants, directed with a real feel for the milieu, and the picture grossed $850,000. It was remade as *Rain* (1932) with Joan Crawford, and as *Miss Sadie Thompson* (Columbia 1953) with Rita Hayworth as the naughty lady. (SWANSON)

▽D.W. Griffith returned from Paramount to the UA fold for a pallid tale of sexual passion called **Drums Of Love**. Producer Joseph Schenck demanded script approval before shooting began, and somehow gave it to Gerrit Lloyd's adaptation of the 14th-century Italian melodrama *Francesca Da Rimini* updated to 19th-century Latin America. As the adulterous lovers (both illustrated), renamed Emanuella and Leonardo, Mary Philbin, in a blonde wig, was wooden, and Don Alvarado (a sort of bargain basement Valentino) lacked subtlety. The voyeuristic jester who spies on them was well played by Tully Marshall, but it was Lionel Barrymore as the hump-backed cuckolded husband that brought fire to the screen. Other performers caught up in the drama were Eugenie Besserer, William Austin, Charles Hill Mailes and Rosemary Cooper. The double death ending of the lovers was considered bad box-office after the first showings, so an incongruous happy ending was shot. It did not improve the takings. Despite the weaknesses, there were a few splendid Griffith moments, especially Barrymore's first sinister confrontation with his wife in her chamber. (ART CINEMA)

△Samuel Goldwyn's **Two Lovers** was the last of the five pictures that Ronald Colman and Vilma Banky made together and, like the other four, it was a romantic costume drama. Baroness Orczy's novel *Leatherface* (adapted by Alice Duer Miller) provided the usual elements of a masked avenger tale that the public continued to enjoy. Colman (right) as Mark Van Rycke, a Flemish patriot in 1572 when Spain ruled his country, had his work cut out appearing in leather jacket and mask to protect the Prince of Orange (Nigel de Brulier, left), defend helpless Flems from Spanish brutality, fight the evil Duke of Azar (Noah Beery) and, naturally, woo and win Donna Lenora (Banky). It is she who rides Paul Revere style on a stormy night to warn the Flemish about the Spanish plan to burn Ghent. Paul Lukas, making his Hollywood debut, played the Spanish captain she rejects with other parts going to Virginia Bradford, Helen Jerome Eddy and Eugenie Besserer. Fred Niblo directed the familiar material as if he had done it all before. He had – in *The Mark Of Zorro*. (GOLDWYN)

▽D.W. Griffith, desperately needing a commercial success, looked back on his past glories and came up with **The Battle Of The Sexes**, a remake of his 1914 hit which had starred Lillian Gish. But Griffith, now drinking heavily, was out of touch with the changing Hollywood, and the old melodrama of infidelity, based on the novel *The Single Standard* by Daniel Carson Goodman (adapted by Gerrit Lloyd), looked pretty musty, despite attempts to revamp it. This included a synchronous music track with sound effects and a theme song rendered by its star, Phyllis Haver

(illustrated). She played a gold-digger who gets a middle-aged property man (Jean Hersholt, illustrated) to leave his wife (Belle Bennett) and children (Sally O'Neil and William Bakewell), although she is simultaneously carrying on with a gigolo (Don Alvarado). Of course, it all ends predictably in tears, followed by the inevitable family reconciliation. The production moved at a snail's pace and the attempts at comedy were crude. In a nice irony Miss Haver, a former Mack Sennett beauty, left the screen a year later to marry a millionaire. (ART CINEMA)

▽**The Garden Of Eden** not only referred to the place where Eve started it all, but also to the verdure around the Eden Hotel at Monte Carlo where most of this high society comedy-drama took place. Hans Kraly's screenplay (based on the German play by Rudolph Bernauer and Rudolph Oesterreicher) told of how a young girl rises from working in a bakery to becoming a baroness. In short, a case of from rolls to Rolls. Corinne Griffith (illustrated), known as the 'Orchid Lady', played the girl who becomes a dancer, rejects the advances of a corrupt count, is adopted by a penniless baroness, then marries the wealthy man she loves. Louise Dresser (the Baroness), Lowell Sherman (the Count) and Charles Ray (the Boyfriend, illustrated) contributed fine characterizations under Lewis Milestone's expert direction. Miss Griffith merely looked beautiful throughout in John W. Considine's production. (ART CINEMA)

▽When Norma Talmadge (illustrated) came to UA to play a dance girl known as **The Dove** in her ex-husband Joseph Schenck's production, her career was on the wane. Nevertheless, her name still helped the picture to do moderately well at the box-office despite the lukewarm reviews it received. The honours, however, went to William Cameron Menzies who became the first art director to receive an Oscar for his creation of a country 'somewhere on the Mediterranean coast.' That 'somewhere', in fact, was the usual Never-Never land of romantic melodrama, ruled over by Noah Beery (illustrated) as the ruthless Don José. He lusts after the dancer, but she loves a gambler. Therefore, Don José has her lover face a firing squad, but just as the triggers are about to be pressed, she mockingly questions her tormentor's virility. For some inexplicable reason, this prompts him to free the couple in time for the happy ending. Gilbert Roland, who had played Armand to Talmadge's Camille the year before, appeared as the gambler, while Eddie Borden, Harry Myers and Michael Vavitch contributed further Latin types. The film, directed by Roland West, who also adapted the scenario from Willard Mack's play, was strong on atmosphere, weak on characterization. (JOSEPH M. SCHENCK)

▽Douglas Fairbanks' production of **The Gaucho** was one of the biggest money spinners of the year. Made for $500,000, this tale of a Robin Hood of the Pampas grossed $1.4 million. True to type, Doug (illustrated) played the leader of a band of outlaws seeking to unseat an evil usurper (Gustave von Seyffertitz) who runs Miracle City where he exploits the natives who come to worship at the shrine of the Madonna. Fairbanks' original screenplay (written as Elton Thomas) was inspired by a visit to Lourdes, and he got his wife Mary Pickford to appear briefly as the Madonna. As expected, the film provided a

good percentage of daredevil stunts plus a cattle stampede and a house being moved by 100 horses. Instead of the usual wan heroine opposite the virile star, Lupe Velez, the 'Mexican Spitfire' (illustrated), was cast in her first feature film, almost matching Doug in athletic prowess and humour. It was a stunning start to an uneven career which ended, via marriage to Johnny Weissmuller, in suicide in 1944. Also cast were Michael Vavitch, Charles Stevens, Nigel de Brulier and Albert MacQuarrie. F. Richard Jones, a veteran director of Mack Sennett two-reelers, helped the action along. (FAIRBANKS)

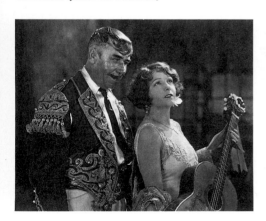

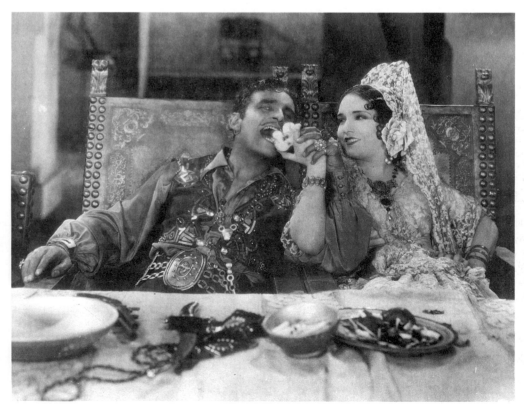

▷Buster Keaton was **Steamboat Bill Jr**, who returns from college to help tough Bill Sr run an old tub on the Mississippi. The father's disappointment in his effete son is worsened when he learns that the young man's girlfriend is the daughter of a rival steamboat captain. The gags came fast and furious as Buster (illustrated) adapted to his new life, and the film climaxed with one of his greatest sequences – the cyclone. In bed, Buster finds himself being blown along the streets of a devastated town. Brilliantly using an old vaudeville routine, he has the whole facade of a house fall on top of him, but due to an open window, he remains standing. Ernest Torrence was suitably dour as the father, with Marion Byron as the dotty girlfriend, Tom McGuire her father, and Tom Lewis the boat's first mate. Charles F. Reisner and Carl Harburgh were credited as director and screenwriter respectively, although Keaton seemed to have done most of their work for them. A scene at the beginning of the picture had Buster selecting a suitable hat, but when he comes across his famous boater he rejects it. By going to MGM, 'the biggest mistake of my life' as he referred to it afterwards, he was on his way to losing his identity. This Joseph Schenck production was one of the last monuments to his genius. (KEATON)

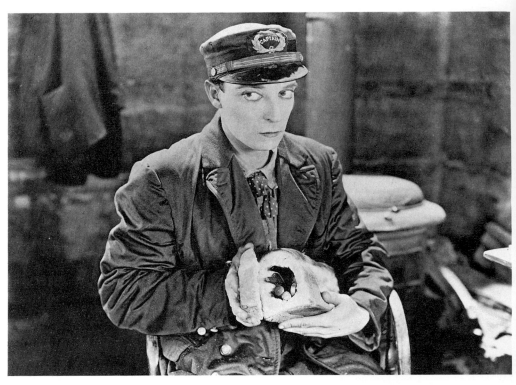

▽Charles Chaplin (illustrated) was awarded a special Oscar 'for versatility and genius in writing, acting, directing and producing **The Circus**,' at the first ever Academy Award ceremony. He was also nominated for best actor and best comedy director. However, the great clown of the cinema was never to win a regular Oscar. In many ways, the picture was inferior to, and less ambitious than, his two previous films for UA, *A Woman Of Paris* and *The Gold Rush*, but it was still indeed touched with his 'versatility and genius'. The irrepressible comic set pieces included Charlie trapped in a lion's cage, Charlie in the hall of mirrors, Charlie on the tightrope and trapeze. The straightforward plot had Charlie the tramp becoming a circus clown, literally falling for the pretty equestrienne (Merna Kennedy) who in turn loves Rex, King of the High Wire (Harry Crocker). Charlie's love is hopeless, and when the circus leaves town, he remains behind alone. Henry Bergman played an old clown and Allan Garcia the circus owner. Despite the scandal of Chaplin's bitter divorce case with Lita Grey, the film earned over $1 million. The public obviously welcomed this return to the earlier comic style of their idol. (CHAPLIN)

△**The Woman Disputed** was Norma Talmadge (centre), in her last silent film, as a girl raised up from the gutter by two young officers, one Austrian (Gilbert Roland, left), the other Russian (Arnold Kent, right). When the Russians invade her city, she submits to the lustful Russian officer in order to save three prominent citizens, including a priest (Michael Vavitch), from the firing squad. She is forgiven by the Austrian officer when he learns (from the lips of the dying Russian) that she did it for patriotic reasons. Also wading through this turgid stuff were Gustave von Seyffertitz, Boris De Fas and Gladys Rockwell. Miss Talmadge's tear-stained face was beginning to show the strain of all her years of screen suffering, but she retained some measure of her box-office appeal. This Joseph Schenck production, adapted by the ubiquitous C. Gardner Sullivan from Denison Clift's play, was directed by Henry King and Sam Taylor in tandem, proving that one head is better than two. (JOSEPH M. SCHENCK)

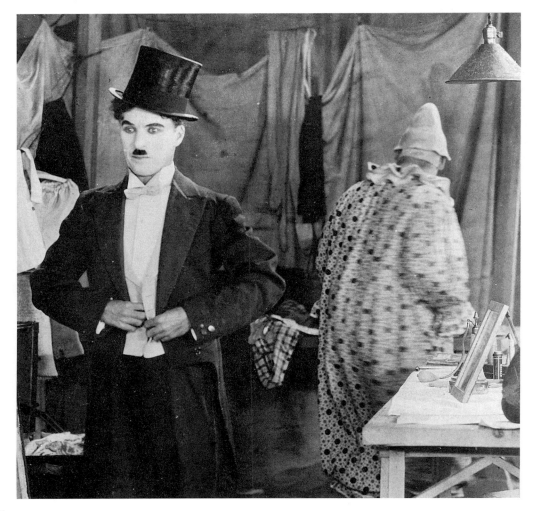

▽There were storms a-plenty behind the scenes of Joseph Schenck's production of **Tempest**. It began as a project for Erich von Stroheim, but after the *Queen Kelly* fiasco, nobody would hire him. Russian *emigré* director Victor Tourjansky began shooting the C. Gardner Sullivan script, set during the 1914 Bolshevik uprising, but his painstaking working methods ran up the costs and it was completed by Sam Taylor, who got sole credit. Also replaced was Dorothy Sebastian – by blonde German actress Camilla Horn (illustrated), Schenck's current girlfriend, making her US debut as Princess Tamara. Opposite her, as the army officer who loves her, was John Barrymore (illustrated). Their love affair started passionately with the Princess whipping the sergeant across his bare chest, to which he responds to with a kiss but, come the Revolution, she is jailed, he is accused of treason, they manage to flee to Austria ... Other Russians, white and red, were played by Louis Wolheim, Boris De Fas, George Fawcett and Ulrich Haupt. William Cameron Menzies won the best art direction Oscar (jointly with *The Dove*) for his spectacular settings against which this richly romantic piece of hokum was played. It was the first UA picture to have synchronized music and sound effects. (ART CINEMA)

△Producer-director Edwin Carewe saw **Ramona**, adapted by Finis Fox and Helen Hunt Jackson's best-seller, as obvious material for his protegee, raven-haired Dolores Del Rio (illustrated). In the title role of the half-Indian girl, she elopes with an Indian sheep shearer in defiance of her stern guardian. Her baby dies because a white doctor refuses to treat a Redskin, and her husband is murdered in cold blood by white bandits. Warner Baxter played the husband, Vera Lewis the guardian, and Roland Drew was Dolores' white foster brother to whom she is finally restored after many hardships. John J. Prince (illustrated) and Michael Visaroff took other parts, while Miss Del Rio suffered beautifully against vivid Southern California backgrounds. The story was filmed twice before (in 1910 and 1916), and again in 1936 by Fox in Technicolor. (INSPIRATION)

▽Ten years after the Great War it was acceptable, in Samuel Goldwyn's **The Awakening**, to have a German officer hero in love with a heroine from the disputed Alsace-Lorraine territory. Vilma Banky (illustrated) starred as Marie Ducrot, a country girl disgraced by this love affair. When her father dies, she enters a convent, contriving to have the German believe she has died. However, with the aid of a faithful Frenchman, he finds her, and they leave the nunnery together. English actor Walter Byron (illustrated) made his official Hollywood debut as the German, although he had already made the unseen *Queen Kelly*. He and Banky made a good-looking couple, while unprepossessing Louis Wolheim, as La Bete the Frenchman, could only look on enviously. Also cast were George Davis, William Orlamond and Carl Hartmann. Victor Fleming's direction made much of this operatic stuff convincing, hampered though he was by Carey Wilson's screenplay (based on a story by Frances Marion). (GOLDWYN)

△**Revenge** was a sort of *Taming Of The Shrew* with a Hungarian flavour. As Rasha, the bear tamer's daughter, Dolores Del Rio (illustrated) flashed her brown eyes and wielded a leather whip on any man or beast that dared approach her. But along comes a macho Magyar (Leroy Mason, illustrated) who cuts off her braided hair, and kidnaps her. The more she puts salt in his coffee or throws boots at him, the more he loves her. So, like most of her father's bears, she is tamed in the end. James Marcus played the father, and Sophia Ortiga, Sam Appel, Rita Carewe and Jess Cavin were other assorted gypsies. Finis Fox's scenario (based on Konrad Bercovici's *The Bear Tamer's Daughter*), provided a lively vehicle for Miss Del Rio under producer-director Edwin Carewe's guidance. (ART CINEMA)

▽Douglas Fairbanks (illustrated), now 45, returned to the role of D'Artagnan in **The Iron Mask** eight years after *The Three Musketeers* hit the screen. His script (written as Elton Thomas), derived from Alexandre Dumas' *The Man In The Iron Mask*, allowed for older and wiser, but still agile, comrades-in-arms fighting to restore the real King Louis XIV to the throne. The scheming De Rochefort (Ulrich Haupt) has imprisoned the real king, locked his head in an iron mask, and put his bad twin brother in his place. Nigel de Brulier (Richelieu), Leon Barry (Athos) and Marguerite de la Motte (Constance, illustrated) reprised their roles from the previous film, while Dorothy Revier (Milady de Winter), Stanley Sandford (Porthos), Gino Corrado (Aramis), Rolfe Sedan (Louis XIII), and Belle Bennett (the Queen) took over the other parts, and William Bakewell played the twins. The film's only acknowledgement of sound dialogue was in Fairbanks' speech at the beginning and end (re-recorded by his son for the reissue in 1974). This tongue-in-cheek sword-in-the-hand romance, which included breathtaking stunts such as Doug catapulting to a window out of a tree, grossed $1.5 million. It was the last of the 11 pictures director Allan Dwan made with the producer-star, marking the end of the great silent era. James Whale directed a 1939 remake, *The Man In The Iron Mask*. (FAIRBANKS)

▽As producer Joseph Schenck had lost faith in leaving D.W. Griffith to his own devices, he handed him a complete shooting script of **Lady Of The Pavements** (aka **Lady Of The Night**) written by Sam Taylor (based on a story by Karl Volmoeller). But this romance, set in the Paris of Napoleon III, needed the lightness of a Lubitsch, not the gravity of a Griffith. It dealt with a Countess (Jetta Goudal, 2nd right) who determines to make her aristocratic lover (William Boyd, left) pay for saying he would rather marry a woman of the streets than her. She takes a Spanish cabaret dancer (Lupe Velez, 2nd left) and passes her off as a lady in high society. However, the experiment rebounds on the Countess when her lover falls for the dancer, remaining true even when he learns of her social origins. Albert Conti (right), George Fawcett, Henry Armetta and Franklin Pangborn were also cast. Griffith experimented with sound in the songs and a few talking sequences by increasing and decreasing the volume according to the character's relative distance from the camera. There was also an elaborate multi-exposure scene in which 13 William Boyds appeared at once. One Boyd, the future Hopalong Cassidy, would have been quite enough. (ART CINEMA)

▽Barbara Stanwyck (illustrated), making only her second feature, was the best thing about **The Locked Door**. She played a noble wife who confesses to a crime she thinks her husband committed. He (William Boyd), in turn, assumes guilt in order to protect her. However, by the end, nobody cared too much who shot the caddish playboy (Rod La Rocque), who exonerates them both on his deathbed. Director George Fitzmaurice and screenwriter C. Gardner Sullivan failed to stray too far from the Channing Pollock play *The Sign On The Door* (the title of the 1921 film version), and made the cinematic mistake of retaining much of its theatricality. Light relief was provided by ZaSu Pitts as a telephone girl, and other parts were taken by Betty Bronson, Harry Stubbs (illustrated), Harry Mestayer and Mack Swain. (ART CINEMA)

△Mary Pickford (illustrated) won the Best Actress Academy Award in her (and UA's) first all-talking feature **Coquette**. With bobbed hair and convincing accent, she took the challenging role of a spoiled Southern flirt who lies in court to save her father from a murder charge. But despite cameraman Karl Struss's 'wrinkle eradicator' light below the lens, the 35-year-old Mary did seem a little too mature for the part of the college girl. John Sainpolis played the father who shoots her sweetheart (Johnny Mack Brown, illustrated) in the belief that he has besmirched her name. He finally kills himself when he discovers that she is still pure. Also in the cast were Matt Moore, William Janney, Henry Kolker, George Irving and Louise Beavers. Pickford, seeing the potential in the leading role (played on stage by Helen Hayes), had shrewdly bought the rights of the Broadway play by George Abbott and Ann Preston Bridgers. Her production earned nearly $1.5 million, despite its handicap of the rather stagey direction by Sam Taylor of an equally stagey screenplay by John Grey and Allen McNeil. (PICKFORD)

▷While the coming of sound ruined the careers of many stars, it only enhanced that of Ronald Colman whose impeccable English voice was heard for the first time in Samuel Goldwyn's money-making **Bulldog Drummond**. Debonair and witty, Colman came nearest on screen to capturing Sapper's gentleman adventurer (others who played the role over the years included Jack Buchanan, Ralph Richardson, Ray Milland, John Howard, Tom Conway, Walter Pidgeon and Richard Johnson.) In fact, Colman (right) was nominated for a Best Actor Oscar (together with his performance in *Condemned*) as ex-war hero Captain Hugh Drummond who advertises in the London *Times* for adventure. He is approached by an American girl (a blonde Joan Bennett in her first major role) to rescue her uncle who is being held prisoner by a villainous trio (Montagu Love, Lawrence Grant and Lilyan Tashman) in a fake nursing home. The plot involved Drummond's outwitting of the fiends, despite being disadvantaged by the bungling of his monocled friend Algy (Claude Allister, above centre, making his US debut). The sophisticated dialogue was supplied by Wallace Smith and Sidney Howard adapted from the play by Sapper (H.C. McNeile). It was the last film and only talkie made by F. Richard Jones who directed somewhat primitively. (GOLDWYN)

△Roland West who financed, produced and directed his own films, made **Alibi** (aka **Nightstick**) one of the best of the early all-dialogue gangster movies. The rather familiar plot, based on the play *Nightstick* by John Wray, J.C. Nugent and Elaine Sterne (adapted by West and C. Gardner Sullivan), was given a boost by the authenticity of its settings and characters. The plot had a cold-blooded ex-con searching his underground contacts for an alibi for a warehouse robbery he has committed. He is quick to shoot anyone in the back but, when finally cornered, he becomes a snivelling coward. On the side of law and order were Regis Toomey and Pat O'Malley (illustrated) as a detective and police sergeant. Eleanor Griffith (illustrated) and Mae Busch were the women who get kicked around, and Elmer Ballard, Harry Stubbs, Irma Harrison and Al Hill took other parts. Both Chester Morris, making his adult screen debut as the gangster, and the production, were nominated for Oscars. (ART CINEMA)

▽**Evangeline** was the last of seven films that producer-director Edwin Carewe dedicated to the beauty of Dolores Del Rio, the woman he loved. He was then reunited with his wife, and Dolores married MGM art director Cedric Gibbons. The film, an attempt by Finis Fox to translate Longfellow's narrative poem into a silent screen drama, also told of the separation of lovers. Miss Del Rio, in the title role (illustrated) was the Arcadian maiden about to celebrate her engagement to Gabriel (Roland Drew) when the British troops descend upon the Grand Pré area, burning farms and villages. Gabriel is exiled, and Evangeline spends the rest of the film searching for him. The sweethearts are only reunited when she, now a Sister of Mercy, is called to his deathbed. Also taking part in this sobby saga were Alec B. Francis, Donald Reed (illustrated), Paul McAllister, James Marcus, George Marion and Bobby Mack. There was no spoken dialogue, but the heroine sang twice, the title song and a French chansonette. It had previously been filmed in 1919. (ART CINEMA)

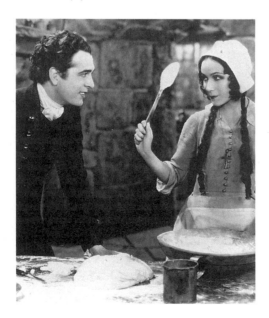

△Devil's Island, the notoriously legendary French penal colony in South America, was the inhospitable setting of Samuel Goldwyn's production of **Condemned**. Not the place one would normally expect to find the gentlemanly presence of Ronald Colman (left) as a thief who manages to wangle his way into the warden's house and into the heart of the warden's wife. When the wife decides to depart for France, he escapes through the steaming jungle to join her at the nearest port. Blonde Ann Harding, as the wife, gave a cool performance in the heat, with Dudley Digges (screen debut) as the warden, conveniently murdered in the end by Louis Wolheim (right) as a brutish inmate, and William Elmer as another prisoner. Wesley Ruggles directed the piece rather stiffly, but at least had the advantage of distinguished photography (George Barnes and Gregg Toland), atmospheric sets (William Cameron Menzies) and a literate screenplay (by Sidney Howard) based on Blair Niles' novel *Condemned To Devil's Island*. (GOLDWYN)

1929

▽The long-awaited co-starring of the King and Queen of Hollywood, Douglas Fairbanks and Mary Pickford (both illustrated) finally came about in **The Taming Of The Shrew** by William Shakespeare – 'with additional dialogue by Samuel Taylor.' Although it made over $1 million profit, and the critics generally approved, it was not an altogether happy experience in the making. Their marriage and careers were both coming to an end, and Doug was apparently as cruel to Mary off screen as his Petruchio was to her Kate on screen. He failed to learn his lines, turned up late and undermined her confidence by being hypercritical. Director – and scribe – Sam Taylor tried to keep the peace and the piece together. As the shrew, Mary did her nut, smashing windows and mirrors, wielding a whip and throwing mud pies. As the tamer, Doug was smugly virile, and threw in a few characteristic leaps onto horses for good measure. If their voices were not very appealing, there was fun to be had from seeing the duo tackling the Bard. The smaller parts were well taken by Edwin Maxwell (Baptista), Clyde Cook (Grumio), Joseph Cawthorn (Gremio), Geoffrey Wardwell (Hortensio) and Dorothy Jordan (Bianca). There have been at least eight versions of this minor Shakespeare comedy, including the Elizabeth Taylor–Richard Burton attempt for Columbia in 1967. It was also the inspiration behind the Cole Porter musical *Kiss Me Kate*, filmed by MGM in 1953, with Kathryn Grayson and Howard Keel. (PICKFORD-FAIRBANKS)

△Norma Talmadge's first talkie, **New York Nights**, had to be postponed for some months while she took lessons in diction at the behest of producer Joseph Schenck. She needn't have bothered. It was not only her thinly disguised Brooklyn accent and limited acting ability that sank the film, but the stilted dialogue and weak script by Jules Furthman (adapted from Hugh Stanislaus Stange's play *Tin Pan Alley*). Lewis Milestone directed this hackneyed mixture of gangster and backstage drama, which had Tal- madge as a musical comedy star married to a young composer who hits the bottle more often than his piano. She gets involved with a crook who gets nasty when she walks out on him, but he is captured in a shootout and the husband promises to reform. Gilbert Roland (centre right), co-starring with Norma (centre left) for the fourth time, played the husband, and John Wray the gangster. Also cast were Lilyan Tashman (left), Mary Doran (right) and Roscoe Karns (2nd right). (JOSEPH M. SCHENCK)

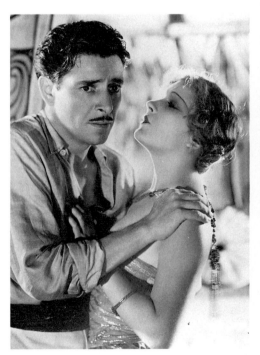

△One of Samuel Goldwyn's many European 'finds' was French actress Lili Damita (illustrated), whom he introduced to the American public in **The Rescue**. She responded well to Herbert Brenon's direction as Lady Edith Travers in a triangular love drama based on a Joseph Conrad story (adapted by Elizabeth Meehan), set in the exotic locale of Java. The other points of the triangle were Alfred Hickman as her wealthy husband, and Ronald Colman (illustrated) as a stoical gun-runner. During the course of an exciting tribal war, Colman saves the husband from hostile natives, and later puts honour before love by giving up Lady Edith. Theodore Von Eltz and Bernard Segal played other whites, while John Davidson, Sojin and Duke Kahanamoku appeared as savages. Sound effects were limited to a few choral numbers during various ritual dances. (GOLDWYN)

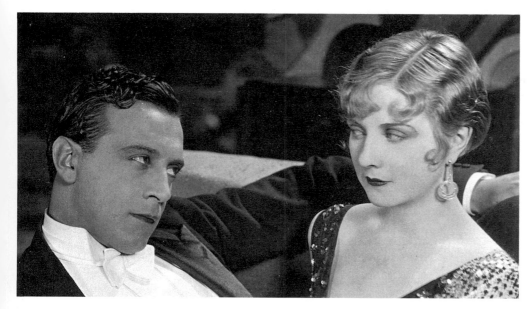

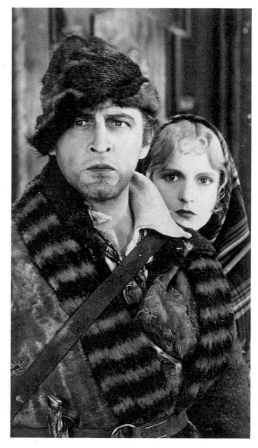

△One had to be reminded during **The Three Passions**, a turgid 'trouble at mill' drama, that Rex Ingram was once called by Erich von Stroheim, 'the world's greatest director.' Made in Britain, this silent film (with sound effects) was produced, directed and written by Ingram from a story by Cosmo Hamilton, with his wife Alice Terry (illustrated) in the lead. As Lady Victoria, she tries to get the Hon. Phillip Wrexham to leave the priesthood and take over his father's mill in order to stop a strike after a workman is killed. He returns from a mission, halts the strike and marries the fair Lady. Ivan Petrovitch (illustrated) played the young English aristocrat and Shayle Gardner the capitalist father, with Claire Eames, Leslie Faber, Gerald Fielding and Andrew Engleman in other roles. It was the Ingrams' penultimate picture, one of the few they made after leaving Hollywood for Nice in the mid-20s. (ST GEORGE'S)

▽Ernst Lubitsch's second film in the USA was an uncharacteristically sombre affair called **Eternal Love**, set in the Swiss Alps in 1812, but shot in the Canadian Rockies. It had no spoken dialogue, only sound effects, therefore there wasn't much sound generated by coins hitting the box-office counter. Good to look at and well-acted, the movie's screenplay by Hans Kraly (based on John Christopher Heer's novel) seemed rather old-fashioned. Both John Barrymore and Camilla Horn (both illustrated) played characters forced into marriages they do not want. When he is accused of murdering her husband, they flee together into the mountains pursued by a posse of righteous villagers, but the lovers meet their fateful doom in an avalanche. Mona Rico and Victor Varconi were the unloved spouses, with Hobart Bosworth, Bodil Rosing and Evelyn Selbie as other villagers. Joseph Schenck produced. (ART CINEMA)

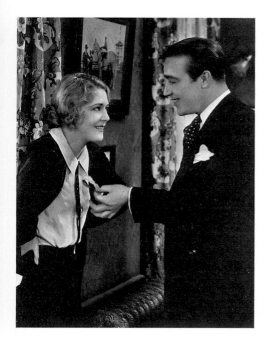

▽Trench warfare, the battle of the sexes and quickfire comedy were the ingredients of **She Goes To War**, produced and directed by Henry King. King's genuine feeling for the milieu of World War I and for the minor characters were the picture's strong points. Al St John as a doughboy, Glen Walters as a soldier too worn out for love-making, and Alma Rubens as Rosie Cohen with her ukelele, provided the comedy. The less sympathetic leads were Eleanor Boardman as a spoiled socialite who goes off to France in search of glory, Edmund Burns as her cowardly fiance (both illustrated), and John Holland as a rough-and-ready lieutenant who teaches her that social position isn't everything. The film, with 10% spoken dialogue, was written by Madame Fred De Gresac from a Rupert Hughes story. It was heroin addict Alma Rubens' last film before her death of pneumonia two years later at the age of 33. (INSPIRATION)

△Producer Samuel Goldwyn urged Vilma Banky (illustrated) to improve her English before making her first sound movie **This Is Heaven**, but her thick, high-pitched Hungarian accent indicated that she had ignored his advice. He therefore let her sit out the remainder of her contract at $5000 a week for the next few months. She made only two further films before settling down as Mrs Rod La Rocque. Nevertheless, the scenario by Hope Loring (based on a story by Arthur Mantell) did provide her with the role of a Hungarian immigrant in New York who gets a job in a restaurant on Fifth Avenue. She meets and falls for a man she believes to be a chauffeur. Of course, he turns out to be a millionaire, rescuing her from drudgery and her rascally uncle from debt. James Hall (illustrated) played the young man, Lucien Littlefield the uncle, with Richard Tucker and Fritzie Ridgeway in other roles. Albert Santell directed this pleasant piece of fluff. (GOLDWYN)

▽Although Gloria Swanson made less than a dozen sound movies, she proved in **The Trespasser**, her first talkie, that she could handle dialogue well and carry a tune. She helped writer Laura Hope Crews and director Edmund Goulding with the original screenplay, providing herself with a meaty role for which she was Oscar-nominated, and as the film's producer, with a $1 million hit. The well-made but wearisome weepie, told of how the marriage of a secretary (Swanson, illustrated) to the son of a multi-millionaire is broken up by his father. She is left literally holding the baby. Later, made wealthy by an inheritance and using her son as bait, she attempts to reclaim her former husband who has remarried. British actress Kay Hammond played the crippled second wife who sacrifices her husband in the end, and William Holden (no relation to Swanson's later co-star in *Sunset Boulevard*) was the heavy father. For the young man, Swanson chose uninspiring Robert Ames (who died two years later) over Clark Gable whom she felt was not patrician enough. Good support came from Purnell Pratt, Blanche Frederici and little Wally Albright. Goulding remade the film in 1937, retitled *That Certain Woman* and starring Bette Davis. (SWANSON)

△Robert Montgomery (right), Claude Allister (centre) and Charles McNaughton (left) played the **Three Live Ghosts**, in a lighthearted comedy set mainly in London's Cheapside. The contradictory title is explained by the story (adapted by the producer Max Marcin from the play by Frederic S. Isham) of three soldiers who were reported killed in action during the Great War, but had actually been captured by the Germans. The humour arose from the complications involved in their return to civilian life. Aside from the three excellent leads, Beryl Mercer, Joan Bennett, Harry Stubbs and Hilda Vaughn were effective in supporting roles. Thornton Freeland handled his first assignment as director slowly but surely. (ART CINEMA)

▽Constance Talmadge (illustrated) made her last film, **Venus**, a year before her older sister Norma bid farewell to the screen. This rather artificial and predictable French-made silent (Constance never made a talkie) was produced and directed by Louis Mercanton, from a screenplay by Jean Vignaud adapted from his own novel. Surprisingly, the title role was not taken by the attractive Miss Talmadge, but by a luxurious yacht which, as the Princess Beatrice Doriani, she owns. The captain of the vessel (Jean Murat) fights a duel over her, kills his rival, then joins the Foreign Legion. The lovers are reunited in North Africa. André Roanne, Max Maxudian and Jean Mercanton (the director's 10-year-old son) played other roles. (MERCANTON)

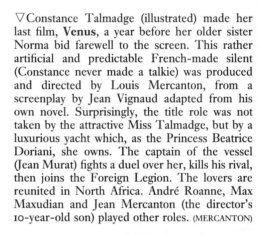

'The infant industry has taken the ribbons from her hair. She has put away some of her bright toys – she is growing up,' said director Edmund Goulding in 1929. And in a topsy-turvy manner it 'just growed and growed' in the 30s, the most significant period in Hollywood's history. When movies began to speak, the community was invaded by actors, writers, musicians and designers from Europe and Broadway who moulded the cinema into the most popular of the arts, and expanded its artistic potential.

Five great studio giants – MGM, Warner Bros., Fox, Paramount and RKO – squatted in the Los Angeles hills, giving birth to between 40 and 60 pictures a year. The Big Five also owned or controlled over 3,000 of the 23,000 theatres in the country. In their shadows were Universal and Columbia, neither of which had their own cinema chains, but helped the majors to fill their programmes with low cost pictures and double features. Only the little orphan UA had no studio, no actors, directors or technicians under contract, and no theatres. They did have the use of the Pickford-Fairbanks owned United Artists Studio, bought by Samuel Goldwyn in 1935, but it was also rented out to other producers.

That UA weathered the storm of the Depression, and the Big Five monopoly, was mainly due to the managerial talents of Joseph Schenck, who kept rescuing it from the railroad tracks just as the train of financial disaster rapidly drew near. At first, it seemed that UA would be harder hit than other studios by the coming of talkies. Their four founders, plus Gloria Swanson, Lillian Gish, Buster Keaton and Norma Talmadge, who had helped to build the company's reputation in the 20s, were all prodigious in silent films. But when the novelty of talkies wore off by 1931, attendances plummeted, and all the studios were badly affected. UA's output dwindled from 18 pictures in 1929, to 15 in 1930, 13 in 1931, and 13 in 1932. Sales dropped to the lowest ebb for seven years. Yet, in the two doldrum years for the industry, 1931 and 1932, there were huge hits such as MGM's *Grand Hotel*, RKO's *Cimarron*, Paramount's *Shanghai Express*, Warner's gangster movies *Little Caesar* and *I Am A Fugitive From A Chain Gang*, and Universal's horror pictures, *Dracula* and *Frankenstein*. UA made money with Goldwyn's *Palmy Days*, Howard Hughes' *The Front Page* and Chaplin's *City Lights*, the latter making $5 million on its first release, despite Chaplin's rebuff of spoken dialogue.

In many ways, 1933 was an important year for UA. Schenck decided that instead of merely giving advances to independent producers, loans secured by the rental fees of the pictures, he would now finance future productions, and demand interest as well as a share of the profits. Looking to Britain to increase UA's output, Schenck bought Alexander Korda's *The Private Life Of Henry VIII* (1933), and gave it a world premiere in New York. It enjoyed an unprecedented success for a British film in America, and resulted in Korda being signed to a 16-picture contract, becoming a full partner in the company in 1935. A year later, this talented Hungarian producer-director (brother of designer Vincent and director Zoltan) built his own 165-acre Denham Studios outside London. At the same time as Korda joined UA, Darryl F. Zanuck, production head, at Warner Bros., left his job after a violent row with Jack Warner. Schenck teamed up with Zanuck to form Twentieth Century Pictures, Inc. in April 1933. Zanuck was appointed first vice-president in charge of production, and William Goetz, a son-in-law of Louis B. Mayer, was associate producer.

They promptly delivered a dozen movies, including such money-spinners as *The Bowery*, *The House Of Rothschild* and *Bulldog Drummond Strikes Back*, thus saving the 1933–1934 season for UA.

Although Twentieth Century helped UA to show a $1.1 million profit in 1934, Pickford, Fairbanks and Chaplin refused to give it stock in the company. Schenck restrained Zanuck from distributing elsewhere, but eventually Schenck resigned from UA, and Twentieth Century merged with the Fox Film Corporation. With the departure of Twentieth Century, which had accounted for half of UA's business, a wide gap in their quota had to be filled. Goldwyn increased his productions to include another Eddie Cantor hit, *Kid Millions* (1934) and William Wyler's splendid *Dodsworth* (1936).

After Schenck's departure, Al Lichtman became a weakened president, working beside Mary Pickford, as first vice-president. David O. Selznick now enters the United Artists story. Selznick, MGM vice-president and producer, and another of Louis B. Mayer's sons-in-law, set up his own company in 1935, agreeing to release all his pictures through UA until 1939. He kicked off in 1936 with *Little Lord Fauntleroy*, a highly successful remake of Mary Pickford's 1921 hit, and followed it the same year with the moneymaking *The Garden Of Allah*, then *A Star Is Born* (1937), *The Prisoner Of Zenda* (1937), *Nothing Sacred* (1937) and *The Adventures Of Tom Sawyer* (1938). To all intents and purposes, *Gone With The Wind* (1939) should have been the jewel in United Artists' crown. After buying the rights of Margaret Mitchell's book for the ludicrously low sum of $50,000, Selznick was determined that MGM contractee Clark Gable should play Rhett Butler and no-one else. Mayer insisted that if his son-in-law wanted Gable, not to mention a $1.5 million loan to make the film, he had to give MGM the distribution rights to the picture and half the profits. The rest is cinema history, as they say. However, Selznick did return to produce a few more films for UA afterwards.

Walt Disney, who had been with Columbia Pictures since 1929, decided to form his own production company and in a mutually profitable deal, UA started releasing his Technicolor cartoon shorts in 1932. At the time of the contract renewal in 1936, however, the company maladroitly lost Disney to RKO because of a quibble over the retention of TV rights.

Other beneficial additions to the UA roster were two contrasting producers, sophisticated Walter Wanger and madcap comedy king Hal Roach. Among Wanger's successes were *Trade Winds* (1938), starring his future wife Joan Bennett, and John Ford's landmark Western *Stagecoach* (1939). Meanwhile, Alexander Korda's London Films were losing money in America and, in 1938, he was forced to sell Denham Studios. The most severe blow to UA, however, came when Goldwyn left in 1940 after an unsuccessful bid to buy the company and bitter wrangles with the three main stockholders. He had supplied them with a remarkable 50 films in 14 years, the majority of which were both critical and commercial triumphs. So the Titans of the industry – Zanuck, Selznick, Korda and Goldwyn forsook UA one by one. Of the greats, only Chaplin remained to make a mere two films in the 40s.

In the very last month of the decade, Douglas Fairbanks died sadly and very prematurely in his sleep, aged 56, of a heart attack. UA itself seemed on the verge of collapse. Nevertheless, the company somehow managed to stagger on through the painful war years, emerging at the other end, bloody but unbowed.

1930

▽The line most people remembered from Howard Hughes' production of **Hell's Angels** was 'Excuse me while I slip into something more comfortable,' uttered by 19-year-old Jean Harlow, who shot to stardom in only her second feature. Actually, the film began over two years previously as a silent movie with Greta Nissen, but she was replaced because of her thick Norwegian accent when it was turned into a talkie. Yet, what was really memorable about the picture was not the hackneyed story and stiff dialogue by Howard Estabrook and Harry Behn, or Hughes' often commonplace direction (even though he was assisted by Howard Hawks and James Whale), but the spectacular flying footage unequalled even by today's standards. The authenticity of the aerial dogfights was achieved by the use of real World War I pilots, a few of whom were killed during the filming. Ben Lyon (illustrated), who played the hero, was himself a pilot, and shot some of his own scenes in the air. However, he was less convincing on the ground as an Oxford graduate in love with an English girl (Harlow, illustrated) engaged to his brother (James Hall) before war intervenes. Lucien Prival, Roy Wilson and John Darrow were also in the cast. The picture cost $3.2 million, but recouped costs within a year. (HUGHES)

△Gloria Swanson (illustrated) lived up to the exclamation mark in **What A Widow!** as the wealthy Tamarind Brooks who changes her men as often as the variety of attractive costumes she wears. Among the many beaus to her string are a lawyer (Owen Moore, illustrated, Mary Pickford's first husband), a violinist (Gregory Gaye), a Spanish baritone (Herbert Braggiotti), and a nightclub dancer (Lew Cody). All these flirtations take place in New York, on a luxury liner, and in France. After many tedious complications in James Gleason and James Seymour's screenplay (story by Josephine Lovett), she settles for the lawyer. Also at the service of the producer-star were Margaret Livingstone, William Holden and Nella Walker. Allan Dwan directed swiftly as if unwilling to dwell on the unfunny sequences. Miss Swanson sang a couple of songs and looked as though she was enjoying herself. Few others did, and its box-office failure caused a rift between Swanson and her patron Joseph Kennedy which ended their association. (SWANSON)

▽Irving Berlin's title song for **Puttin' On The Ritz** became a big hit for entertainer Harry Richman in his feature film debut. His face may not have been familiar to cinema audiences, but they had seen the plot many times before. The story by producer John W. Considine Jr, who wrote the screenplay with William K. Wells, was the oft-told backstage saga of a has-been vaudevillian (Richman, illustrated) who succeeds on Broadway and develops an inflated ego, but reforms in time for the final clinch with his neglected girl (Joan Bennett, illustrated). The latter was the centre of the movie's best sequence, an 'Alice in Wonderland' number in Technicolor. Richman, who made only two further films, was pleasing. So were James Gleason, Lilyan Tashman, Aileen Pringle, Purnell Pratt and Richard Tucker. Edward Sloman directed. (ART CINEMA)

▽The subject of **Abraham Lincoln** lay close to D.W. Griffith's heart, and he started his first talkie with enthusiasm. But the director was soon describing the production as 'a nightmare of the mind and nerves.' He and Gerrit Lloyd mangled the original poetic script by Stephen Vincent Benet so that it became an episodic film of undramatic tableaux, with Lincoln quotations clumsily inserted. The film attempted to include the whole of its subject's life from birth to death, but the material was too familiar to American audiences. Nevertheless, it found favour with some critics. *The New York Times* voted it one of the ten best films of the year, and *Film Daily* called it 'a great achievement'. There were certainly moments of greatness in Walter Huston's performance in the title role (illustrated), and in the more spectacular visual sequences, but moments were not enough in 90 minutes. The rest of the cast included Una Merkel (Ann Rutledge), Kay Hammond (Mary Todd Lincoln, illustrated), E. Alyn Warren (Stephen Douglas), Hobart Bosworth (General Lee), Fred Warren (General Grant), Ian Keith (John Wilkes Booth), Frank Campeau, Francis Ford, Lucille La Verne and Helen Freeman. Better films about the President were John Ford's *Young Mr Lincoln* (1939) with Henry Fonda, and John Cromwell's *Abe Lincoln in Illinois* (1940) with Raymond Massey. (ART CINEMA)

△Una Merkel (left), Lillian Gish's stand-in in the silent days, was given the chance to play a Gish-like role as Sybil, a simple mountain girl, in **The Eyes Of The World**. Sol Lesser's production, however, should have remained hidden from the eyes of the world. Harold Bell Wright's story (adapted by Clark Silvernail and N. Brewster Morse) concerned itself mainly with Gertrude (Fern Andra) married to an elderly millionaire (Brandon Hurst), but in love with a young artist (John Holland). During a trip by the threesome to the mountains, the artist falls for the aforementioned Sybil. Gertrude, in a fit of jealous fury, gets her dissolute art critic brother (Hugh Huntley) to seduce the girl. But true love won through in the end, after many melodramatic goings-on under the direction of Henry King. Also in it were Nance O'Neil (right), Frederic Burt and Eulalie Jensen. (INSPIRATION)

▽It was difficult to judge whether the title of Joseph Schenck's production of **The Bad One** referred to a miscast Dolores Del Rio (illustrated) as Lita, who works in a French brothel but keeps herself pure, or Edmund Lowe as Flannigan from New York, who gets into a fight over her and lands in prison. Even more appropriately, it could have applied to the heavy-handed direction of George Fitzmaurice, and screenwriters Cary Wilson and H.M. Rogers, whose flat script was derived from a story written by John Farrow (father of Mia) some years before he became a director. In it, Lita goes from whorehouse to jailhouse, hoping to free Flannigan. She agrees to marry a cruel guard but, during a prison riot, the lovers escape and head for Brooklyn. Others involved were Ulrich Haupt, Don Alvarado (illustrated), Yola D'Avril, Harry Stubbs, George Fawcett, Blanche Frederici and Charles McNaughton. (ART CINEMA)

▽According to the story by Rita Johnson Young (adapted by Fred de Gresac, N. Brewster Morse and Clark Silvernail), **Hell Harbor** is situated on a Caribbean island and populated by the descendants of Sir Henry Morgan's notorious band of pirates. Morgan's grandson (Gibson Gowland, left) is now forcing his temperamental daughter (Lupe Velez) to marry an odious moneylender (Jean Hersholt, right), but along comes a handsome young American sailor (John Holland) to rescue her from the unsavoury match and cause havoc in the process. Al St John and Paul E. Burns played other seafaring folk in this rollicking yarn. Although the performances of the principals were as broad as a pirate's cutlass, producer Henry King's direction was as sharp. (INSPIRATION)

▷Saucer-eyed singing comic Eddie Cantor (illustrated), along with the rest of the cast of **Whoopee!**, were the same as in Florenz Ziegfeld's Broadway hit. Ziegfeld sold the rights to Samuel Goldwyn and received credit as co-producer of this Technicolor musical. Although it cost around $1.3 million to make, it soon earned $1.5 million profit, and turned Cantor into a movie star. Goldwyn had the insight to bring Broadway dance director Busby Berkeley to Hollywood to choreograph the numbers. Berkeley immediately put his individual stamp on the opening routine with an overhead shot revealing an abstract pattern as the Goldwyn Girls, in Red Indian headgear, followed a 14-year-old Betty Grable in a dance. Aside from the inventive dance numbers the picture, directed by Thornton Freeland, was a static transposition of the enjoyable stage show. A play by Owen Davis called *The Nervous Wreck* formed the basis for the musical by William Anthony McGuire, Walter Donaldson and Gus Kahn, which William Conselman adapted (slightly) for the screen. It gave Cantor plenty of comic scope as a hypochondriac living on an Arizona ranch full of cowboys, Indians and chorus girls. Also involved was the romance between a white girl and an Indian brave, who turns out to be a paleface in the end. Eleanor Hunt, Paul Gregory, John Rutherford, Ethel Shutta (illustrated), Spencer Charters, Albert Hackett and Chief Caupolican (whose dialogue mainly consisted of 'Ughs') performed well in support. (GOLDWYN)

△Movie buffs might have recognized, in the heartless ribbing of the actress whose screechy Brooklyn voice was inappropriate to the 18th-century French setting of the film within a film in *Singin' In The Rain* (MGM 1952), something of Norma Talmadge's problem as **Dubarry, Woman Of Passion**. In fact, this tale, based by director Sam Taylor on a play by David Belasco, uncomfortably resembled the parody in the later film. La Talmadge (illustrated) was totally inadequate as La Dubarry, the French milliner who rises to become hostess of a gambling house and then mistress of King Louis XV (William Farnum). But she really loves the Duc de Brissac (Conrad Nagel), and the lovers die a double death. The Joseph Schenck production also died the death, and Miss Talmadge retired hastily from the screen at the age of 33 to live on her fortune. Hobart Bosworth, Ulrich Haupt (illustrated), Alison Skipworth, E. Alyn Warren and Edgar Norton, sporting variable French accents, took other roles. Ernst Lubitsch had been far more successful in 1919 with Pola Negri as *Madame Dubarry*. (ART CINEMA)

▽**Lummox** was the unflattering soubriquet given to a Swedish drudge called Bertha Oberg, played by Winifred Westover, William S. Hart's former wife. Director Herbert Brenon attempted to transfer the lachrymose qualities of Fanny Hurst's tear-jerking novel to the screen, but much of Elizabeth Meehan's dialogue, its halting delivery, and the absurd situations were more likely to provoke tears of laughter. The story told of the consequences of the seduction of a servant girl by a reprobate poet called Rollo Farley (Ben Lyon). A baby is born and the poor girl gives it out for adoption, watching from a distance as her son grows up to be a great pianist, and never revealing her true identity. Miss Westover (illustrated), who had not appeared in a film for nine years, gave an admirable performance, while other less interesting and sketchy roles were taken by Dorothy Janis, Myrtle Stedman, Lydia Titus, Robert Ullman, William Collier Jr and William Bakewell. It was a Joseph Schenck production. (ART CINEMA)

△Roland West returned to Mary Roberts Rhinehart and Avery Hopwood's creepy war-horse *The Bat*, retitling it **The Bat Whispers**. His scenario differed little from the silent version he had directed in 1926, containing just as many ghosts, disappearing bodies, mysterious chambers and secret panels, but boasting the addition of spooky sounds, audible screams, creaking floors and doors, and some witty spoken dialogue. Grayce Hampton was Mrs Cornelia Van Gorder, the hostess of the old dark house party which included suspicious guests played by Chester Morris (right), Una Merkel, Chance Ward, Richard Tucker, Maude Eburne, Wilson Benge, DeWitt Jennings (left), Spencer Charters and Gustave von Seyffertitz, one of whom enjoys dressing up as a giant bat and killing people. Joseph Schenck produced. *The Bat* stretched its wings again in a 1959 remake with Vincent Price and Agnes Moorehead. (ART CINEMA)

▷'You can't help liking him,' says Inspector McKenzie of Scotland Yard after being defeated once again by gentleman thief **Raffles**. The remark could also be applied to Ronald Colman's captivating performance as the character created by E.W. Hornung in his turn-of-the-century novel *The Amateur Cracksman*. Scenarist Sidney Howard updated it slightly, but it still took place in a foggy London, much of the fog created by the elusive rascal around himself. Nobody in London connects the daring exploits of the cracksman with Mr Raffles, man-about-town and famous cricketer. When caught red-handed by his girlfriend (Kay Francis), he only seems even more romantic in her soulful eyes (see illustration). But he makes his escape ingeniously and continues to baffle the police. The befuddled Inspector was played by David Torrence, and Bramwell Fletcher, Francis Dade, Alison Skipworth and Frederick Kerr were members of the upper crust duped by our likeable hero. Harry d'Abbadie d'Arrast and George Fitzmaurice directed this Samuel Goldwyn hit. John Barrymore in 1917, House Peters in 1925, and David Niven in 1939 also played the screen stealing role. (GOLDWYN)

◁Ferenc Molnar's Ruritanian romance *The Swan*, has been filmed three times, here entitled **One Romantic Night**, and twice under the original title – starring Frances Howard in 1925 (Paramount) and as Grace Kelly's swan song in 1956 (MGM). Lillian Gish (illustrated) made her talking picture debut as the Princess betrothed to a foreign Crown Prince but in love with her brothers' tutor. In the end, she sacrifices love for duty. Only duty could make one sit through this stilted and artificial film (screenplay by Melville Baker), which even Miss Gish's warmth failed to kindle into life. Both leading men, Rod La Rocque as Prince Albert and Conrad Nagel (illustrated) as the tutor, proved insufferable. However, there was some pleasure in the smaller roles taken by Marie Dressler, O. P. Heggie, Albert Conti, Edgar Norton and Billie Bennett. In vain was George Fitzmaurice brought in to improve the film directed by Paul Stein. (ART CINEMA)

△Nobody came out of **The Lottery Bride** a winner. Neither the director Paul Stein, the producer Joseph Schenck, the screenwriters Horace Jackson and Howard Emmett Rogers, nor the cast headed by Jeanette MacDonald (illustrated). Even the songs, especially written by Rudolph Friml, were duds. Based on a story called *Bride 66* by Henry Stothard, it told of how a Norwegian girl (MacDonald) becomes the wife of a miner (Robert Chisholm) in the Yukon, only to discover that she loves his younger brother (John Garrick, illustrated). Joe E. Brown and ZaSu Pitts provided comic relief from the operatic situations. Also cast were Joseph Macaulay, Harry Gribbon and Carroll Nye. (ART CINEMA)

◁That funny girl Fanny Brice (illustrated, with Harry Green) worked hard to get laughs plus a few tears in **Be Yourself!**, a mediocre musical melodrama. The bright spots came when Miss Brice (then Mrs Billy Rose) sang five songs by her husband. In between, she suffered as the wife of a boxer (Robert Armstrong) who strays into the arms of a more attractive woman (Gertrude Astor). But, paradoxically, when he is KO'd in a climactic big fight, he comes to his senses – a condition that failed to grip producer Joseph Schenck and director Thornton Freeland before embarking on the project. Freeland and Max Marcin adapted it for the screen from *The Champ* by Joseph Jackson. (ART CINEMA)

▽Samuel Goldwyn continued the successful formula begun with *Whoopee* (1930) in **Palmy Days**, starring Eddie Cantor surrounded by The Goldwyn Girls, and Busby Berkeley staging the numbers. One of the latter was called 'Bend Down Sister', and had the camera moving along the cleavage of each girl as she did what the song suggested. The screenwriters, Cantor, Morris Ryskind and David Freeman, bent over backwards to allow the ocular comedian to do a blackface routine and get himself up in drag. Both disguises enable him to escape from a gang of phony spiritualists led by George Raft, with whom he has accidentally become involved. High-kicking Charlotte Greenwood (illustrated) played a physical culturalist who tries to knock Eddie (illustrated) into shape, while others taking part were Spencer Charters, Barbara Weeks, Charles B. Middleton, Paul Page and Henry Woods. The film, directed by Edward Sutherland, created plenty of audience appreciation and made money at the box-office. (GOLDWYN)

▽**The Front Page** instigated the kind of rapid-fire, wise-cracking dialogue that became a conspicuous ingredient of many comedies of the 30s, and also began a vogue for stories set in newspaper offices. Actually, the film took place in the press room of a criminal court where newsmen are gathered to report on the execution of an anarchist for killing a cop. The screenplay by Bartlett Cormack and Charles Lederer, based closely on Charles MacArthur and Ben Hecht's play, was also a satire on political corruption and journalistic ethics. The superb cast was headed by Adolphe Menjou (left) as the ruthless editor Walter Burns, Pat O'Brien (right) as Hildy Johnson, the top reporter who can't get away to get married, Mae Clarke as the pathetic callgirl Molly Malloy and George E. Stone as the condemned man. Edward Everett Horton, Frank McHugh, Walter Catlett and Slim Summerville were other newshounds on the scent of a story, and Mary Brian (centre) was the waiting bride. Howard Hughes' production, Lewis Milestone's snappy direction and Menjou's performance all received Oscar nominations. Howard Hawks' remake, *His Girl Friday* (Columbia 1940) somewhat eclipsed this version. Billy Wilder's tired *The Front Page* (Universal 1974) was overshadowed by both. (HUGHES)

△**Indiscreet** was the first of a two-picture deal offered to Gloria Swanson (illustrated) by Joseph Schenck on which she would be paid a straight salary. Unburdened by the role of producer, she was able to concentrate on the role of a society girl who tries to open her younger sister's eyes to a cad on the make. By not admitting that she herself has had an affair with him, she is accused of jealousy by her sibling. All is revealed by the end, when both sisters get the men they deserve: Ben Lyon for Gloria and Arthur Lake for Barbara Kent. Monroe Owsley (illustrated) played the nasty piece of work, and Maude Eburne, Henry Kolker and Nella Walker took other parts. Swanson herself approached the dramatic moments with intensity and the comedy with sophistication, and also sang two songs by the scenarists Buddy DeSylva, Ray Henderson and Lew Brown. This glossy double-triangular romance directed by Leo McCarey, who also helped with the script, did well at the box-office, but not sufficiently so to make Miss Swanson regret she was on a salary rather than a percentage of the takings. (ART CINEMA)

▽Take two Pulitzer prizewinning writers, Louis Bromfield and Sidney Howard, an experienced director, George Fitzmaurice, a ravishing British musical-comedy star, Evelyn Laye, making her Hollywood debut, a handsome baritone, John Boles, and call it **One Heavenly Night** and what have you got? ... a flop. The excellent ingredients mixed together by producer Samuel Goldwyn made an indigestible operetta. The Hungarian goulash plot concerned a tempestuous cabaret star called Fritzie (Lilyan Tashman) who is exiled from Budapest to the country where the police feel she can cause no harm. Loth to leave the capital, she gets a flower girl (Laye, illustrated) to impersonate her. The imposter meets and falls in love with a Count (Boles, illustrated), and after the usual mistaken identity crises, marries him. Wobbly-legged comedian Leon Errol provided some broad comedy with support from Hugh Cameron, Marion Lord, Luis Alberni and Lionel Belmore. Miss Laye, who alone got good notices, made one more film in the USA before returning to England. (GOLDWYN)

▷Douglas Fairbanks (left) sported modern dress on screen for the first time in ten years in Joseph Schenck's production of **Reaching For The Moon**. He not only cast off his period clothes, but attempted to try on a new persona for at least some of the picture. As a girl-shy Wall Street millionaire, he takes lessons in love from his valet (Edward Everett Horton, right) in a hilarious scene of homosexual innuendo then, plucking up his courage, he follows an aviatrix (Bebe Daniels) to Europe on a luxury liner. Most of this breezy film took place on board the glittering Art Deco ship whose passengers included Claude Allister (as the flyer's silly-ass fiance), Jack Mulhall, June MacCloy, Walter Walker and Helen Jerome Eddy. In order to prove to the public that Fairbanks had lost little of his agility, the reticent hero takes a love potion which causes him to do acrobatic stunts all over the place. In mid-ocean, he hears he has lost all his money in the Crash, but the heroine falls for him notwithstanding, *and* turns out to be filthy rich. The director was Edmund Goulding, who also wrote the screenplay, based on a story by Irving Berlin. The latter supplied one song, rendered by Bing Crosby in his first solo film appearance without the Paul Whiteman band. A film with the same title had been made by Fairbanks in 1917 before the foundation of UA but it had a completely different plot. (ART CINEMA)

▽No wonder that **Kiki** was the first Mary Pickford production to lose money since UA was formed. Mary's portrayal of the French chorus girl of the title (illustrated) was as bumpy as her oo-la-la accent. Sexy and saucy, she wasn't! A pity, because Sam Taylor's direction and script, based on the David Belasco play, was often lively and amusing. In one delightful number, directed by Busby Berkeley no less, Mary, disguised as a chorus boy in top hat and tails, joins male dancers in a routine which she finds unfamiliar, and finishes up by falling into a bass drum. The plot, virtually the same as the Norma Talmadge vehicle of 1926 but without the pathos, had Kiki chasing a married impresario (Reginald Denny, illustrated). Finally, he instals her in an apartment from which he then tries to expel her for most of the film. Support came from Joseph Cawthorn, Margaret Livingstone, Phil Tead, Fred Walton and Edwin Maxwell. (ART CINEMA)

▽Producer-director Roland West would surely have preferred a better farewell to the film industry than **Corsair**, an implausible drama about bootlegging. The timeworn script by Josephine Lovett (from the novel by Walon Green) contained not one sympathetic character. Lantern-jawed Chester Morris (right) played a college football champ who turns to crime in an attempt to prove to his spoiled girlfriend, and her Wall Street father, that he can make enough money to keep her in the manner to which she is accustomed. The film ended in the manner to which audiences were well accustomed, when the heel turns hero. Perhaps to dissociate herself from the whole affair, Thelma Todd, in the role of the girl, acted under the name of Alison Lloyd. Emmett Corrigan, William Austin, Frank McHugh (left), Fred Kohler, Frank Rice, Ned Sparks, Mayo Methot, Gay Seabrook and Addie McPhail, however, failed to seek refuge behind pseudonyms. (ART CINEMA)

▽**Street Scene** proved that seemingly intractable material for screen treatment never deterred producer Samuel Goldwyn. The fact that both Elmer Rice's Pulitzer prizewinning play, and the film had only one set – a New York street on a hot summer's night – was a challenge for director King Vidor. He met it with partial success by changing camera angles and setups as much as possible to overcome the static nature of the playwright's own scenario. Alfred Newman's musical score also underlined the action, often too emphatically. The dated but still rather touching picture focused on the lives of the inhabitants of a tenement building and, in particular, the Maurrant family – the studious daughter (Sylvia Sidney, illustrated), the salesman father (David Landau) and the sluttish mother (Estelle Taylor). The climax comes when the jealous husband shoots his wife and the man he finds with her in their apartment. William Collier Jr (illustrated), Max Montor, Russell Hopton, Greta Granstedt, Beulah Bondi, John Qualen, Walter Miller and Nora Cecil played assorted neighbours. (GOLDWYN)

△30-year-old Broadway actor Melvyn Douglas was brought to Hollywood by Samuel Goldwyn to make his screen debut in **Tonight Or Never** opposite Gloria Swanson (illustrated). Recreating the part he played on stage in the Lili Hatvany play, the dapper Douglas immediately established himself as an adept actor of light romantic comedy. Swanson, too, carried off her role of a prima donna with aplomb. While in Venice with her docile nobleman fiance (Ferdinand Gottschalk, illustrated), the singer becomes interested in a young man (Douglas) who admires her from afar. One night he insinuates himself into her apartment and declares his love. She thinks he is a Venetian gigolo, but all is made clear when he turns out to be a great impresario from the Met. Fine support came from Alison Skipworth, Boris Karloff, Robert Greig and Greta Mayer. Mervyn LeRoy, borrowed by Goldwyn from First National, directed the Ernest Vajda script airily. This lavish production was Swanson's last film of any consequence until she starred in *Sunset Boulevard* for Paramount almost 20 years later. (ART CINEMA-GOLDWYN)

▽Ronald Colman (right) added to his portrait gallery of charming cads in Samuel Goldwyn's **The Devil To Pay**. The public, like the characters in the movie, found him irresistible. As Willie Leeland, the profligate son of an English Lord (Frederick Kerr, left), he returns home to London from South Africa where his father had sent him to keep out of mischief. He instantly falls in love with his sister's friend (Loretta Young), although she's engaged to the Grand Duke Paul (Paul Cavanagh). As expected in comedies of this nature, misunderstandings multiply as he tries to ditch an actress he has been involved with (Myrna Loy in a blonde wig), and tries to settle down. Florence Britton, David Torrence, Mary Forbes and Crauford Kent played other roles. Of the witty dialogue by English playwright Frederick Lonsdale, his first for the screen, *Variety* commented, 'For the sticks, his very English and somewhat highbrow phrasing is likely to sail over without landing.' However, both city dwellers and hicks paid to see it. George Fitzmaurice directed this comedy of stuffed shirts rather stiffly. (GOLDWYN)

▽As dreamed up by the witty screenplay by Ben Hecht and Charles MacArthur, **The Unholy Garden** was the name given to an oasis in the Sahara where a group of international criminals gather. One of them is a doctor (Lawrence Grant) who has murdered three wives and keeps the skull of one in a tobacco jar. Along comes an English gentleman crook called Barrington Hunt who masterminds a plan to rob a blind baron (Tully Marshall, left) and his ward (Fay Wray) of their fortune. It is enough to say that, as Hunt was played by Ronald Colman (right), he falls for the girl, captures the members of his own gang, and turns honest in the end. Among the many disreputable characters who turned up in support were Estelle Taylor, Warren Hymer, Ulrich Haupt, Henry Armetta, Kit Guard and Lucille LaVerne. George Fitzmaurice directed with enough drive to make this Samuel Goldwyn production a reasonable success. (GOLDWYN)

△After preparing **City Lights** for two years, Charles Chaplin, who felt that dialogue would damage his style of comedy and weaken his universal appeal, made the courageous decision not to turn it into a talkie. However, he did write a musical score and added sound effects, the latter being used to comic effect when Charlie swallows a whistle. The star's gamble paid off handsomely, as the film made a profit of $5 million on its first release. Although the film's technique is of the 20s, Chaplin's scenario was rooted in the Depression. Charlie, the Little Tramp, buys a flower from a blind girl (Virginia Cherrill) with his last cent (see illustration). In order to pay for an operation to restore her sight, Charlie takes a job as a streetsweeper and a boxer. With money obtained from a millionaire whom he has saved from drowning, he is able to pay for the successful operation. Seeing the rather ridiculous-looking tramp for the first time, and not knowing that he is her benefactor, the girl puts money in his hands and recognizes his touch. Chaplin's special touch was unmistakable in the brilliantly choreographed boxing sequence, and in his ability to shift from satire to pathos, from slapstick to didacticism with Dickensian ease. Virginia Cherrill, a beautiful society girl who had never acted before, was poignant, and Harry Myers was hilarious as the millionaire who, only when drunk, recognizes Charlie. The well-chosen supporting cast included Hank Mann, Florence Lee, Allan Garcia, Eddie Baker, Henry Bergman, Albert Austin, 15-year-old Robert Parrish (the future director), and Jean Harlow in a bit part shot before she starred in *Hell's Angels*, released a year earlier. (CHAPLIN)

△Howard Hughes' production of **The Age For Love** seemed to take an age to run its tedious course. The only real surprise was that Robert E. Sherwood, seven times Pulitzer prizewinning dramatist, was involved in the writing of the script, together with the film's director Frank Lloyd and Ernest Pascal (adapted from the latter's novel). The plot had pretty Billie Dove agreeing to give up her job and marry Charles Starrett, on condition that she can remain childless. She has seen the effects of children on the marriage of their friends Adrian Morris (Chester's brother) and Lois Wilson. Later, Starrett decides he wants a child, so he divorces Billie and remarries. By the end, everyone realizes they have made mistakes. No worse than the mistake of making the movie in the first place. Edward Everett Horton (illustrated) was his usual amusing double-taking self as the families' friend, and Mary Duncan (illustrated), Betty Ross Clarke, Jed Prouty, Joan Standing and Andre Berenger took other roles. (HUGHES)

UNITED ARTISTS

1932

▽Howard Hughes' production, **Cock Of The Air**, never really got off the ground. Besides, there was only one flying sequence, the familiar comedy routine of a plane being flown by a man who has never sat at the controls before. The rest was uninspired comedy with Chester Morris (left) as an aviator who gets involved in a battle of the sexes with a seductive French actress, played by Billie Dove, who, in fact, makes a play for any male in uniform. The mundane direction was by Tom Buckingham, and the story and dialogue came from the pens of Robert E. Sherwood and Charles Lederer. Others in the cast were Matt Moore (right), Walter Catlett, Luis Alberni, Katyr Sergeiva, Yola D'Avril and Vivian Oakland. It was Miss Dove's last film appearance for 30 years. Box-office takings were as disappointingly low as some of the humour. (HUGHES)

▷Samuel Goldwyn, always on the look out for prestigious source material, needed little persuasion to make **Arrowsmith**, from Sinclair Lewis' Nobel prizewinning novel of the same name. Sidney Howard did a good job in adapting the episodic story to the screen but, although competently made, it was not one of director John Ford's most personal films. Ronald Colman (left) plodded rather monotonously through the saga of Dr Martin Arrowsmith, a dedicated medical researcher who fights a bubonic plague epidemic in the tropics. Inspired by his professor (A.E. Anson, right), and a Swedish scientist (Richard Bennett), he remains true to his ideals despite the death of two of his colleagues and his young wife (Helen Hayes). On the way to the upbeat ending, he rejects the advances of a bored socialite (Myrna Loy). Others in the cast were Claude King, Russell Hopton, Bert Roach, Charlotte Henry, James Marcus, DeWitt Jennings, Beulah Bondi, John Qualen and David Landau. The production earned an Oscar nomination for best picture. (GOLDWYN)

▷Howard Hughes' **Sky Devils** was a curious hybrid of *Hell's Angels* (1930) and *Two Arabian Knights* (1927), two of the producer's earlier successes. It contained a few spectacular aerial sequences, as well as some buddy-buddy low-grade army comedy. The buddies concerned were Spencer Tracy (left) and George Cooper (right) as two lifeguards who try to avoid signing up for World War I service. Naturally, they end up as heroes, having blown up a German ammunition dump from the air. Love interest was provided by Ann Dvorak (real name Ann McKim) whom Hughes transformed from a chorine to a dramatic actress. Hate interest was supplied by William 'Stage' Boyd (not to be confused with William 'Hopalong Cassidy' Boyd) who played a top sergeant. Billy Bevan, Yola D'Avril, Forrester Harvey and Jerry Miley also appeared. The director Edward Sutherland contributed to the script by Joseph Moncure March, with additional dialogue (presumably the funny bits) by Robert Benchley. (HUGHES)

△The title of D.W. Griffith's final film, **The Struggle**, accurately reflected the last decade of his working life and beyond. Blaming his recent failures on a lack of independence, Griffith decided to produce it cheaply and quickly himself, in a rented Bronx studio. The picture cost $300,000 but grossed little over $100,000. It was laughed off the screen, and certain papers refused to review it out of respect for Griffith's former reputation. The reviews that did appear were generally hostile. *Variety* called it 'valueless' and 'an utter bore', but at this distance, the film appears far better than one would expect. There are good realistic sequences in a 20s jazz cafe, a factory and in the slums of the Bowery. Granted, the story based on Emile Zola's *The Drunkard* is rather maudlin and naive. Anita Loos and her husband John Emerson meant their screenplay to be humorous, but Griffith rewrote much of it as a morality tale, stressing the evils of drink, that good old stand-by of Victorian melodrama. A millworker gives up alcohol when he marries, but later begins to take an occasional drink with his fellow workers, gradually becoming an alcoholic on bootleg liquor. He finally dries out and gets his job back after being a bum. Hal Skelly (illustrated), a little known stage actor, gave a convincing demonstration of a man deteriorating physically. The inexperienced Zita Johann (illustrated), as his wife, was less good. Also contributing were Charlotte Wynters, Jackson Halliday, Edna Hagan, Charles Richman, Helen Mack, Scott Moore, and Evelyn Baldwin whom Griffith married in 1936. (D.W. GRIFFITH)

▽**Mr Robinson Crusoe** provided a good excuse for Douglas Fairbanks to take a trip to Tahiti. It also permitted him to show off his physique, do his jumping jack routine, and remain on screen, often solo, throughout the picture. Despite his ego being as much in evidence as the abundant coconuts, most of the movie, directed by Edward Sutherland, provided good innocent fun. The producer-star (illustrated) wrote the story (again under the name of Elton Thomas), and Tom J. Geraghty contributed the sparse dialogue. The film told of a wealthy young man's attempts to stay on an island for a year alone, in order to win a bet. In four months, he manages to build a house with all the comforts of home (including a radio) out of the raw material around him. He meets a Girl Friday (Maria Alba, illustrated) whom he takes to Broadway, when the year is up, to become a dancer in the Follies. William Farnum, Earle Brown and genuine natives made up the rest of the cast. Audiences, however, revealed they were not so keen to spend over an hour on a tropical island with Doug. (FAIRBANKS)

△**The Greeks Had A Word For Them** – and so did the Americans. They were called gold-diggers, and this bouncy Samuel Goldwyn production was concerned with three of the New York species. (The film had an alternative title, **Three Broadway Girls**.) Ina Claire's Jean (illustrated) has no scruples about stealing her friends' lovers or sugar daddies; Joan Blondell as Shatze has not only a gold-digger's heart but a heart of gold, and Madge Evans as Polaire finally finds true love in the arms of a young playboy (David Manners). The ladies, who were dressed by Chanel, were waited upon by Phillips Smalley, Sidney Bracy and Lowell Sherman (illustrated, who also directed). Betty Grable put in a brief appearance as well. The film, based by Sidney Howard on the play by Zoe Akins, influenced the series of *Gold-Diggers* musicals of the 30s at Warner Bros. (GOLDWYN)

▽**White Zombie** came in on the crimson tide of horror movies that flowed in the 30s. Bela Lugosi (illustrated), who had made a toothsome hit in *Dracula* (Universal) the previous year, continued on his chilling way in the role of Murder Legendre, a sugar mill owner who has zombies working for him in Haiti. He has a young white girl (Madge Bellamy, illustrated) kidnapped by one of his zombies and holds her in suspended animation. She is rescued by her husband (John Harron) and a priest (Joseph Cawthorn), but only when Murder is killed is she released from his hypnotic powers. Both Garnett Western, the scenarist, and Victor Halperin, the producer-director, allowed not only animation to be suspended, but disbelief as well. Robert Frazer, Clarence Muse, Brandon Hurst, Dan Crimmons and John Peters also moved through the eerie atmosphere. (HALPERIN)

▷In the same year that she made her debut as Jane in the 'Tarzan' films, Maureen O'Sullivan (illustrated) found herself in a concrete jungle in **The Silver Lining**, playing a rich proprietor of ramshackle tenements who refuses to carry out repairs. The notorious landlady is beaten up in the park by a thug, and her condition is mistaken for drunkenness. After 30 days in the jug, she comes out a reformed woman, makes amends – and the necessary repairs – and marries her lawyer (John Warburton, illustrated). This implausible tosh, directed by Alan Crosland, was not helped by the star's unsure performance, or Gertrude Orr's screenplay (based on a story by Hal Conklin). The only silver lining was Betty Compson's portrayal of a fellow prisoner. Also cast were Montagu Love, Mary Doran, Wally Albright and John Holland. The producer was Walter Camp. (PATRICIAN)

▷When **Scarface** was released, it immediately ran into censorship trouble. Some of the many violent scenes had to be cut and the subtitle *Shame Of The Nation* added. The reviews were generally unfavourable, the public, reacting against crime films, stayed away, and producer Howard Hughes soon withdrew it. Yet, today, it is considered to be one of the great classic gangster movies. The French 'New Wave' have acknowledged its influence, and it was remade in 1983 starring Al Pacino. Perhaps an explanation for its rejection in the early 30s (and its later acceptance) was the ambiguous cruelty and the underlying theme of incest. A team of writers – Ben Hecht, W.R. Burnett, John Lee Mahin and Seton I. Miller – adapted the novel by Armitage Trail which was based on the life of notorious racketeer Al Capone, here named Tony Carmonte. Paul Muni in the title role (right) was at once brutish, childish, arrogant, sinister and often touching. Other gangland characters were played by Boris Karloff, whose death was stylishly symbolized by a falling bowling pin, Vince Barnett (left), Henry Armetta, Osgood Perkins (Anthony's father) and George Raft, introducing the coin flipping that was to become his trademark. Ann Dvorak was the sister of whom 'Scarface' is too fond, and Karen Morley was a moll. Howard Hawks' tough direction appealed to intellect as well as emotion. (HUGHES)

△Joan Crawford, with curly blonde hair, thick make-up, a large beauty spot, gaudy dresses, jingling bracelets and high heels, had a good shot at playing Sadie Thompson in Joseph Schenck's production of **Rain**. The part had been rewarding for Gloria Swanson in *Sadie Thompson* (1928), but the public did not accept Crawford (illustrated) as the celebrated South Sea tart quite so readily. It didn't matter how much the director Lewis Milestone moved his camera around, the film remained stagey and stodgy, while the studio rain kept pouring down and the men on the trading post at Pago Pago got pretty steamed up over Sadie. Walter Huston, who played his part more hammy than holy as fire and brimstone missionary Alfred Davidson, also grew hot under the collar (though not a dog collar as in the play by John Colton and Clemence Randolph from the Somerset Maugham story). But William Gargan, Guy Kibbee, Walter Catlett, Beulah Bondi, Matt Moore, Kendall Lee and Ben Hendricks were somewhat more satisfying in smaller roles. Maxwell Anderson was responsible for the screenplay. Rita Hayworth also attempted the role in *Miss Sadie Thompson* (Columbia) in 1953. (ART CINEMA)

▽When the doorman at London's seedy Balham cinema was asked how well **Goodnight Vienna** (aka **Magic Night**) was doing, he replied, 'As well as *Goodnight Balham* would do in Vienna.' This trite British-made operetta starred a wan Anna Neagle as a little flower girl in love with a dashing titled officer (Jack Buchanan) in Vienna just before World War I. He goes off to war while she becomes a top singer, thinking he has deserted her. After hostilities between the nations, hostilities between the lovers (both illustrated) are ended over some champagne. However, producer Herbert Wilcox's direction lacked sparkle, as did the script by Holt Marvell and George Posford. Lending support were Clive Currie, William Kendall, Joyce Bland, Herbert Carrick, Gibb McLaughlin and Clifford Heatherly. (BRITISH AND DOMINIONS)

▽In order to increase its low output in 1932, UA acquired **Congress Dances**, made in Germany in three different language versions. The setting of this frothy operetta was the 1814 Congress of Vienna, although it was more concerned with romantic than political intrigues. Erich Pommer's production allowed for plenty of scenes in ornate drawing rooms and beergardens, at grand balls and the opera, always with anachronistic waltzes in the background. Blonde Lilian Harvey wins the affections of Czar Alexander, otherwise Henry Garat (both illustrated), but complications occur when he returns to Russia leaving his double in his place. Conrad Veidt played a scheming Prince Metternich with his usual subtlety. Others in the international cast were Lil Dagover, Gibb McLaughlin, Reginald Purdell, Jean Dax, Helen Haye, Olga Engel, and Tarquini D'Or. Norbert Falk and Robert Liebman wrote the featherweight script, while Eric Charell directed with equivalent weight. (UFA)

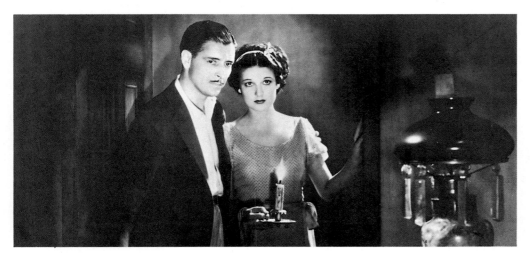

△The title of **Cynara** comes from the poem by Ernest Dowson which contains the line, 'I have been faithful to thee, Cynara; in my fashion.' The film, therefore, like the play by H.M. Harwood and Robert Gore Brown (adapted by Frances Marion and Lynn Starling) was about adultery. The triangle consisted of an English barrister, his wife who leaves him alone in London to holiday in Venice, and the shop girl who fills the vacuum. It ends tragically with the suicide of the girl when he decides to return to his wife. Henry Stephenson played the cynical bachelor who encourages the affair. Florine McKinney, Clarissa Selwynne, Donald Stewart and Paul Porcasi were also in the cast. Ronald Colman (illustrated) played the lawyer rather gloomily, Kay Francis suffered nobly as the wife, and Phyllis Barry (illustrated) was too genteel as the girl. King Vidor directed this dated production with a veneer of class. (GOLDWYN)

▷**Roman Scandals** was something of a spoof on Cecil B. DeMille's *The Sign Of The Cross* (Paramount 1932), and was the perfect vehicle for Samuel Goldwyn's big moneyspinning star, Eddie Cantor (centre). He played a delivery boy in a mid-western town who is hit on the head and dreams himself into Ancient Rome where he becomes the food-tasting slave to the cruel Emperor Valerius (Edward Arnold, left). As the Empress Agrippa (Verree Teasdale) is trying to poison her husband, the job has its drawbacks. Gloria Stuart and David Manners were the two lovers little Eddie helps, and the climax of the picture was a Keystone-style chariot chase. The scriptwriters Arthur Sheekman (Miss Stuart's husband-to-be), William Anthony McGuire and George Oppenheimer (story by George S. Kaufman and Robert E. Sherwood) had no problem in getting Cantor into blackface when disguised as a eunuch in a ladies' bath house, eye-catchingly filled with The Goldwyn Girls. A slave market number with nude girls wearing long blonde wigs almost down to their knees and chained to pedestals, allowed dance director Busby Berkeley to indulge in one of his more extreme erotic fantasies. Also appearing in togas were Ruth Etting (in the first of her three features), Alan Mowbray (right) and Jane Darwell. Frank Tuttle directed the lively proceedings with appropriate brio. (GOLDWYN)

▷**Samarang**, an hour-long silent film (with music), and an amateur cast of South Sea Islanders, was not the sort of picture to bring the public running. It didn't. However, Bennie F. Zeidman's production contained some excellent underwater photography, with sharks, jelly fish and other fauna of the deep outacting the humans. The simple story told of a pearl diver (Ahmang) too poor to win the hand of the chief's daughter (Sai-Yu). In the end, he kills the shark that killed his little brother (Ko-Hai), gets a large pearl, and the girl. Ward Wing directed the film based on a story by his wife Loria Bara (Theda's sister), adapted by Tom J. Geraghty. (ZEIDMAN)

▽**Hallelujah, I'm A Bum** (GB: *Hallelujah, I'm A Tramp*, TV: *Heart Of New York*) fell into the 'seemed-like-a-good-idea-at-the-time' category. The time: the Depression. The place: Central Park where a group of hobos live, led by their self-styled mayor, Bumper (Al Jolson, right), who rescues a girl (Madge Evans) from drowning. In the shock, she loses her memory, but shows the tramp affection. When, however, she recovers her memory, she doesn't know him (or want to), and goes back to the Mayor of New York (Frank Morgan) whose mistress she is. This Chaplinesque story by Ben Hecht was weighed down by S.N. Behrman's screenplay in rhyming couplets, and the uninspiring 'musical dialogue' by Richard Rodgers and Lorenz Hart. Production difficulties might have hindered di-

rector Lewis Milestone from infusing life into this soft-centred social fable. Roland Young fell ill during filming and his scenes had to be reshot with Frank Morgan. Two versions of the title song were recorded, because the word 'bum' was deemed unacceptable to British audiences. Bum or not, the film itself was not accepted by audiences on either side of the Atlantic. Much of the $1.25 million cost of the picture went on Jolson's salary. Joseph Schenck had agreed to pay him $25,000 a week when he signed a contract for a three-picture deal (the other two were never made). The rest of the cast, which included Harry Langdon (left), Bert Roach and Chester Conklin, all once famous silent screen comedians who had seen better days, came far less expensive. (ART CINEMA)

△Soon after *Goodnight Vienna* (1932), producer-director Herbert Wilcox and lanky debonair Jack Buchanan were back in the Austrian capital for **Yes, Mr Brown**, but this time without the onerous presence of Anna Neagle. Douglas Furber's screenplay (based on a German farce by Paul Frank and Ludwig Hirschfeld) dealt with the problems of Nicholas Baumann (Buchanan, right), the manager of the Viennese branch of an American company, when his wife (Margot Grahame) walks out on him just as his boss Mr Brown (Huntley Power) is walking in on him from the USA. So, he gets his secretary (Elsie Randolph) to pretend to be his beloved at a dinner party. Vera Pearce and Clifford Heatherly (left) had other roles. Despite Buchanan's impeccable performance, and two good musical numbers, the film took some while to get going and too long to end. No, Mr Wilcox, it didn't really come off. (BRITISH AND DOMINIONS)

▷The **Bowery** was the first of 18 films made by Darryl F. Zanuck's new company 20th Century Pictures in association with Joseph Schenck, before it merged with the Fox Corporation in 1935. The film was set in the 'Gay 90s', a favourite period of the later 20th Century-Fox movies. Director Raoul Walsh brilliantly recreated New York's Bowery, as remembered from his own childhood – a rowdy and animated world of beerhalls, barroom brawls, barefisted boxing matches and barrel organs. The screenplay by Howard Estabrook and James Gleason (from the novel by Michael L. Simmons and Bessy Roth Solomon) also caught the bustling flavour of the milieu and language, adding a nice dose of sentiment. The story concentrated on the rivalry between two saloon owners, richly played by Wallace Beery and George Raft. Beery, his belly bursting from his tight, vulgar suit, talking of 'skoits' and continually taking a pugilist's stance, was effectively contrasted with Raft the dandy. They also became rivals for the love of Fay Wray, as a respectable girl down on her luck, and for the affection of orphan boy Jackie Cooper (illustrated). Fine character performances came from Pert Kelton as Beery's saloon sweetheart, Herman Bing, Oscar Apfel, Ferdinand Munier and George Walsh (the director's brother) as John L. Sullivan. The picture's success helped save the year for UA. (20TH CENTURY)

△Alexander Korda's first major British film, **The Private Life Of Henry VIII**, earned him a 16-picture contract with Joseph Schenck and, finally, a full partnership in UA two years later. The film achieved an international commercial success unprecedented in British cinema history. Charles Laughton (illustrated) became the first actor in a British film to win an Oscar, and Korda's production was also nominated. The appeal lay not only in Laughton's superb burlesquing of the gluttonous king, but in the irreverent and witty treatment of history in Lajos Biro and Arthur Wimperis' screenplay, Georges Perinal's expert photography, and in the apparent lavishness of Vincent Korda's art direction. In fact, Alexander Korda directed it rather quickly and cheaply. The film only dealt with five of Henry's six marriages, (Catherine of Aragon was omitted for being too respectable), the wives being played by Merle Oberon (Korda's future wife) as Anne Boleyn, Elsa Lanchester (Laughton's wife) as Anne of Cleves, Binnie Barnes (Catherine Howard, illustrated), Wendy Barrie (Jane Seymour) and Everly Gregg (Catherine Parr). Robert Donat made an impression as a member of the court, which also included Claude Allister, Franklin Dyall, Miles Mander and John Loder. (LONDON FILMS)

▷The great black actor-singer Paul Robeson (illustrated) made a powerful screen debut in **The Emperor Jones**, the role he had created on stage in 1921 at the personal request of playwright Eugene O'Neill. Although he expressed misgivings about the film's stereotyped treatment of negroes, it was one of the rare Hollywood movies of this particular period to star a black performer. The screenplay by DuBose Heyward expanded the original to include the early life of the ambitious Pullman porter Brutus Jones who kills a man in a crap game. Convicted of murder, he escapes from a chain gang to the Caribbean island where he sets about establishing himself and eventually becomes its megalomaniac ruler. Dudley Murphy's direction retained some of the compulsion of the O'Neill play, but did not have its unrelenting, expressionistic impact. Also cast in this John Krimsky-Gifford Cochran production were Dudley Digges, Frank Wilson, Fredi Washington, Ruby Elzy, 'Moms' Mabley, 'Blue Boy' O'Connor, George H. Stanter and Brandon Evans. (KRIMSKY-COCHRAN)

△**Perfect Understanding** marked the end of Gloria Swanson's career as a producer, and almost ruined her screen acting career as well. Although UA advanced her $75,000 to get this British-made picture started, her company ran out of money, and had to borrow an additional $100,000 from English sources. The film lost its entire investment and received uniformly bad reviews. Deservedly so. The screenplay by Miles Malleson and Michael Powell (story by Malleson), told of a couple (Swanson and Laurence Olivier, both illustrated) who marry on condition that they will never disagree with one another. Much of the film takes place on the Riviera where suspicions of infidelity spoil the perfect marital set-up. Neither the luxurious settings, nor the star combination, could do anything for the dull direction by Cyril Gardner or the silly plot about silly people. John Halliday, Nigel Playfair, Genevieve Tobin, Nora Swinburne, Charles Cullum and Michael Farmer (then Swanson's husband) all bravely pretended to be madly enjoying themselves. (SWANSON)

'What A Perfect Combination' sang Eddie Cantor (right) in **The Kid From Spain**, expressing exactly the quality of the various contributors to the film's enormous success: producer Samuel Goldwyn, director Leo McCarey, screenwriters Burt Kalmar, Harry Ruby and William Anthony McGuire, dance director Busby Berkeley, and the cast headed by Cantor with Lyda Roberti, Theresa Maxwell Conover (left), Robert Young, Ruth Hall, John Miljan, Noah Beery, J. Carrol Naish, Robert Emmett O'Connor, and The Goldwyn Girls who included Paulette Goddard, Lucille Ball, Betty Grable and Virginia Bruce in their ranks. These beauties made unlikely college students who rise from their luxurious satin beds in transparent nighties in what is supposed to be a dormitory. Cantor and Young are expelled from the college (no wonder!), are implicated in a bank robbery, flee to Mexico where Eddie is mistaken for a famous matador (naturally!). Somehow, he also managed his obligatory blackface routine. In other words, everything the public wanted and expected it got. The picture recouped its cost of $1.4 million within a year. (GOLDWYN)

▽One Ronald Colman per film was seldom enough for audiences, so in Samuel Goldwyn's **The Masquerader**, he played Sir John Chilcote, an English politician, and his lookalike journalist cousin (illustrated). The unpleasant Member of Parliament gets his relative to impersonate him while he is trying to recover in a hideaway from a drink and drug problem. With only a faithful butler (Halliwell Hobbes) in the know, the charade is so successful that 'Sir John's' career is enhanced, and his wife (Elissa Landi) finds her love for her 'husband' is rekindled. When the real M.P. conveniently dies, the reporter takes over his identity completely. This improbable tale (based on John Hunter Booth's dramatization of Katherine Cecil Thurston's novel) had a literate screenplay by Howard Estabrook and Moss Hart, despite the platitudinous speech in parliament intended to bring the House down. There were good performances from both Colmans, as well as from the other leads and David Torrence, Creighton Hale, Helen Jerome Eddy (illustrated), Eric Wilton and Montague Shaw. Richard Wallace handled the direction a little too ponderously for the subject. (GOLDWYN)

△Much of the way 30s audiences perceived newspaper reporters derived from the fast-talking portrayals of Lee Tracy (illustrated) in films like **Advice To The Lovelorn**. Here, as a newsman who has disgraced himself by literally sleeping through an earthquake, he is relegated to writing an agony column. He is such a success at it that a racketeer puts pressure on him to advertise certain goods in his column. How he extricates himself from the situation and gets caught up in the lives of some of his correspondents, was the main business of Leonard Praskins' screenplay, a very loose adaptation of Nathanael West's novel *Miss Lonely Hearts*. Albert Werker directed at a brisk pace, but made the mistake of falling headlong into sugary sentimentality by the end. Others cast were Sally Blane (illustrated, Loretta Young's sister), Sterling Holloway, Jean Adair, Paul Harvey, Matt Briggs, Charles Levinson, C. Henry Gordon, Isabel Jewel, Ruth Fallows and May Boley. No producer was credited. (20TH CENTURY)

△Events surrounding **Broadway Thru A Keyhole**, a minor musical from producers William Goetz and Raymond Griffith, were far more interesting than the film itself. The story, by top columnist Walter Winchell (screenplay by Gene Towne), which told of a nightclub star's involvement with a gangster and a crooner at Texas Guinan's cabaret, seemed to parallel Ruby Keeler's beginnings in show business. As a result, Al Jolson punched Winchell on the nose for writing what he saw as something snide being aimed at his wife. Constance Cummings, however, bore no resemblance whatsoever to Miss Keeler, and nobody could have mistaken the film for having any relation to real life. Texas Guinan, playing herself, died soon after the film's completion, and Russ Columbo (illustrated, who played the crooner) and the director, Lowell Sherman, both died the following year. Paul Kelly, who took the role of the gangster, had actually spent two years in prison in the 20s for manslaughter. The intriguing cast also included Gregory Ratoff, Frances Williams, Eddie Foy Jr, Hobart Cavanaugh, Billy Gilbert and Blossom Seeley. Incidentally, Betty Hutton, for Paramount, impersonated both Misses Guinan and Seeley in the films *Incendiary Blonde* (1945) and *Somebody Loves Me* (1952) respectively. (20TH CENTURY)

▽**Blood Money** was one of the most hard-boiled of early sound underworld movies. George Bancroft (illustrated) dominated as a man in the bail bond racket who gets involved with a variety of shady customers. Among them, Frances Dee, a society girl who shoplifts for thrills, and Chick Chandler who robs banks at whim. Judith Anderson (illustrated) made her screen debut in the uncharacteristically glamorous role of a saloon owner. (She only returned to movies seven years later with her famous portrayal of Mrs Danvers in *Rebecca*). Blossom Seeley delivered two numbers as a nightclub singer, and Etienne Girardot, George Regas and Theresa Harris also appeared. The convoluted story was written by the director, Rowland Brown, who wrote the screenplay too (with Hal Lang). It was the last of the films directed by Brown. William Goetz and Raymond Griffith were associate producers. (20TH CENTURY)

▽**I Cover The Waterfront** opened with the legend 'The unique and personal experiences of a newspaper reporter covering a Pacific waterfront.' Edward Small's production, based on journalist Max Miller's book, was neither unique nor very personal, but director James Cruze perfectly caught the atmosphere where 'everything smells of dead sardines', and much of the dialogue was tough and witty. Wells Root and Jack Jevne's screenplay was more concerned with detailing the love affair between a boatman's daughter and the reporter who is trying to expose

her father's smuggling activities. Ben Lyon and Claudette Colbert (both illustrated) made an excellent duo, although she was too sophisticated for the role. Ernest Torrence, in his last film before his death, gave a larger than life performance as the nefarious father who thinks nothing of throwing a man overboard or spitting out someone's cigarette from a distance. Excellent support came from Hobart Cavanaugh as a never-sober reporter, Purnell Pratt, Wilfred Lucas, Harry Beresford, Maurice Black and George Humbert. (RELIANCE)

◁'In every marriage,' says Mary Pickford in grey hair and squeaky voice at the end of **Secrets**, 'there are secret joys, secret sorrows, lovely and dreadful secrets.' The last adjective could aptly be applied to the film. It had been a Norma Talmadge vehicle in 1924 directed by Frank Borzage and written by Frances Marion. Pickford (illustrated) asked the same pair to return to this story of an indomitable woman pioneer in California, who loses her first baby, and stands by her philandering husband through half a century of marriage. At the time, Marys' real-life husband, Douglas Fairbanks, was doing some philandering of his own. Frances Marion explained that 'Mary saw herself in a great dramatic role, making an impact on Doug as well as the public. She would be faithful to one man on screen, through three generations. She felt it would be a vehicle through which she could prove herself all over again.' In the event, all she managed to prove in this musty saga, based on the play by Rudolph Besier and May Edginton, was that her acting technique belonged to an earlier period. Leslie Howard (illustrated) was uncomfortable in the role of the husband, having to utter lines like 'If they break in here, they'll kill you. Perhaps worse' to his wife. No-one emerged with any credit, including C. Aubrey Smith, Blanche Frederici, Doris Lloyd, Herbert Evans, Ned Sparks, Allan Sears, Mona Maris, Huntley Gordon and 15-year-old Virginia Grey. It was Mary Pickford's final film. (PICKFORD)

◁Herbert Wilcox not only produced and directed **Bitter Sweet**, but also had a hand in writing the screenplay (with Lydia Hayward and Monckton Hoffe) adapted from Noel Coward's operetta. Anna Neagle (illustrated), still ten years away from becoming Mrs Wilcox, took the role of a girl who elopes with her penniless music teacher to the Vienna of 1875. There they live in picturesque poverty until tragedy strikes and he is killed in a duel with a gambler. Now a grey-haired woman, the widow advises a young girl to marry for love not money. The French actor Fernand Gravey (changed here to Graavey, in case audiences pronounced it 'gravy' and later to become Gravet in the US) made his English language film debut as the musician (illustrated). Other parts were taken by Esme Percy, Clifford Heatherly, Ivy St Helier, Miles Mander, Pat Paterson, Hugh Williams and Kay Hammond. This soppy superficial story, with a few good tunes, was dusted off again by MGM in 1940 as a vehicle for Jeanette MacDonald and Nelson Eddy. (BRITISH AND DOMINIONS)

▽The plot of **Looking For Trouble**, involving telephone line repair men, was about as clear as two simultaneous crossed-line conversations. Leonard Praskins and Elmer Harris' screenplay (story by J.R. Bren) managed to include a fire, a bank robbery, a car crash, a murder, a double romance and, just for good measure, an earthquake. Somewhere in all this were Spencer Tracy and Jack Oakie as linesmen, and Constance Cummings as Tracy's girl wrongly accused of the murder of a gangster (Morgan Conway, right). But the crook's moll (Judith Wood, centre), injured in the earthquake, survives just long enough to confess to the crime. Arline Judge played a telephone operator and Oakie's love interest, with Joseph Sauers (later Sawyer), Franklyn Ardell and Paul Harvey completing the cast. It was not one of director William Wellman's most inspired movies. (20TH CENTURY)

▷**Born To Be Bad** was bound to be bad with such a trashy screenplay by the actor Ralph Graves and Harrison Jacobs (story by Graves). Not even the two attractive stars, Loretta Young (illustrated) and Cary Grant, could redeem it. She was an unwed mother who tricks Grant, a wealthy married dairy farmer, into adopting her child, and then makes a play for him. In the end, however, she realizes her errors and retreats from the scene not wishing to disrupt his marriage further. It is surprising she didn't vanish earlier, because the child – a thoroughly unlikable brat played by Jackie Kelk (illustrated) – steals, and rollerskates around the house. Grant's patient, unreal wife was Marion Burns, and the rest of the cast included Henry Travers, Russell Hopton, Andrew Tombes and Harry Green. It was directed by Lowell Sherman and co-produced by William Goetz and Raymond Griffith. (20TH CENTURY)

▷The idea that a husband wouldn't know if his wife's twin sister took her place was the feeble comic theme in **Moulin Rouge** exploited by scenarists Nunnally Johnson and Henry Lehrman (story by Johnson). Predictable complications occur when the substitution takes place, giving the marriage a new lease of life. Constance Bennett (centre) was amusing as the vaudeville twin sister act, and Franchot Tone (right) played the confused husband. Tullio Carminati (left) was the one sister's suitor, and Helen Westley (screen debut), Andrew Tombes, Russ Brown, Hobart Cavanaugh, Ivan Lebedeff and Russ Columbo took other parts. The Boswell Sisters added three further siblings to the picture. This Darryl F. Zanuck-produced musical was serviceably directed by Sidney Lanfield. Two British films with the same title but different plots were made in 1928 and 1952. (20TH CENTURY)

△After many attempts to entice Robert Donat (illustrated) from England to Hollywood, producer Edward Small finally got him to accept the choice lead in **The Count Of Monte Cristo**. He was the finest of the many interpreters of Alexandre Dumas' hero Edmond Dantes. Others have included Frenchmen Pierre-Richard Wilm (1942), Jean Marais (1953) and Louis Jourdan (1961), and Americans Hobart Bosworth (1912), John Gilbert (1923) and Richard Chamberlain (1976). This famous story of the imprisonment of an innocent man, his escape, and his subsequent revenge on those who caused his incarceration, was excellently adapted by Philip Dunne, Dan Totheroh, and the film's director Rowland V. Lee. Elissa Landi, Louis Calhern, Sidney Blackmer, Raymond Walburn, O.P. Heggie, William Farnum, Luis Alberni and Irene Hervey played those whose lives are changed by the mysterious Count. Donat refused to change his life, and returned to England immediately afterwards. (RELIANCE)

▽**Palooka** (aka **Joe Palooka** GB: **The Great Schnozzle**) was inspired by Ham Fisher's comic book pugilist, Joe Palooka. It took five screenwriters – Gertrude Purcell, Jack Jevne, Arthur Kober, Ben Ryan and Murray Roth – to come up with the plot wherein Joe (Stuart Erwin, right) falls for a Spanish vamp (Lupe Velez) while training for a fight. Thanks to the finagling of his manager Knobby Walsh (Jimmy Durante, left) he manages to win the World championship because his opponent (William Cagney, Jimmy's younger brother) is too drunk to stand up when hit. Durante, in his first starring role, gave a knockout performance and rendered his song, 'Inka Dinka Doo' as a bonus. Marjorie Rambeau as Joe's former burlesque queen mother, Mary Carlisle as his girl back home, Robert Armstrong, Thelma Todd, Guinn Williams and Franklyn Ardell gave sterling support. Benjamin Stoloff directed this musical farce for producer Edward Small. (RELIANCE)

△Like its subject, **The House Of Rothschild** made a lot of money. Nunnally Johnson's screenplay (based on an unproduced play by George Hembert Westley) was not only a paean of praise to acquisitiveness, but also a family chronicle of survival. The picture, dutifully directed by Albert Werker, began in a Frankfurt ghetto in the mid-18th century. When old Mayer Rothschild dies, his five sons go out into the world to make the family's fortune. The story concentrated mainly on Nathan, head of the London branch of the banking firm, who makes a killing by lending money during the Napoleonic wars. George Arliss, having already portrayed Disraeli, Alexander Hamilton and Voltaire on screen, continued to give exactly the same performances in the dual role of Mayer and son Nathan. Some private drama intervened when Nathan's daughter (Loretta Young) falls for a non-Jewish English officer (Robert Young), but the father's initial opposition to the marriage soon melts. He himself is assimilated into the English Establishment when he is made a baron by the Prince Regent (Lumsden Hare) in a final Technicolor sequence. Other historical figures represented were the Duke of Wellington (C. Aubrey Smith), Metternich (Alan Mowbray) and Talleyrand (Georges Renavent). Florence Arliss (the star's wife) was Mrs Nathan Rothschild, Helen Westley was Gundula, the sons' mother, and Boris Karloff played Baron Ledrantz. It was a Darryl F. Zanuck production. (20TH CENTURY)

▽A musical revue and a murder mystery on board an ocean liner in **Transatlantic Merry Go Round** took up most of the voyage. Jack Benny (illustrated), the master-of-ceremonies in the revue, introduced such turns as Nancy Carroll (illustrated), 14-year-old Mitzi Green, Frank Parker, The Boswell Sisters, Sid Silvers, and Jimmy Grier and his orchestra. Also on board were an unfaithful wife (Shirley Grey) oblivious to the fact that her husband (Ralph Morgan) has come along too, a crooked gambler (Sidney Blackmer), a thief (Gene Raymond) and a detective (Robert Elliott). When someone is shot dead in a cabin, most of them become suspects. Other passengers included Sam Hardy, William 'Stage' Boyd and Carlyle Moore. The writers Joseph Moncure March and Harry W. Conn (story Leon Gordon) managed to unravel it all by the time this Edward Small production glided painlessly into port under the direction of Benjamin Stoloff. (RELIANCE)

△Samuel Goldwyn spent $47,000 on a publicity campaign to launch his latest discovery, Russian-born Anna Sten (illustrated), in **Nana**. *Variety* wrote that she had 'beauty, glamour, charm, histrionic ability and vivid s. a.' Unfortunately, she never had box-office appeal and, in time, became known as 'Goldwyn's folly'. In the title role of this (very) free adaptation of Emile Zola's novel by Willard Mack and H.W. Gribble, she displayed a definite allure and competent acting ability, yet somehow she lacked the screen presence of a Garbo or a Dietrich. In fact, the style of Dorothy Arzner's direction owed something to Josef von Sternberg's Dietrich pictures. Nana, a vivacious Parisian gutter-snipe rises to become the toast of Paris in the 1870s through her liaison with a famous impresario (Richard Bennett). She also comes between two military brothers, Colonel André Muffat (Lionel Atwill) and Lieutenant George Muffat (Phillips Holmes). Her love for the latter leads to heartbreak and, in the end, she is driven to taking her own life. Mae Clarke and Muriel Kirkland played her friends Satin and Mimi, and Reginald Owen, Jessie Ralph and Lawrence Grant (illustrated) took other roles. The film was less interesting than Jean Renoir's 1926 version featuring his wife Catherine Hessling, but better than Christian-Jacque's of 1954 starring his wife Martine Carol. (GOLDWYN)

△King Vidor's **Our Daily Bread** (GB: **The Miracle Of Life**) was a brave if raw attempt to inject contemporary issues into the escapist American cinema of the 30s. Yet it was so politically ambiguous that the Hearst press called it 'pinko', and the Russian papers thought it 'capitalist propaganda.' Vidor's story (screenplay by Elizabeth Hill) placed his urban couple, John and Mary from *The Crowd* (MGM 1928), into a rural setting, offering a solution to the problem of unemployment. They inherit a derelict farm, and decide to start an agricultural co-operative for the many dispossessed craftsmen hit by the Depression. The Utopian ideal, and the film, hits snags when a floozie tries to lure John back

to the big city, and when the farm begins to stagnate without proper irrigation. Vidor used what he called 'silent music', a technique of rhythmic editing, for the celebrated upbeat climax of the film as the farmers save the parched crops by frantically digging an irrigation canal. The colourless leads were Tom Keene and Karen Morley, both illustrated (Keene, who was George Duryea until 1931, became Richard Powers in 1944.) Others parts were played by Barbara Pepper (the vamp), John Qualen, Addison Richards and Harry Holman. The film was independently produced by King Vidor with limited funds. After its box-office failure, he returned to commercial cinema. (VIDOR)

◁'The directing skill of Rouben Mamoulian, the radiance of Anna Sten and the genius of Samuel Goldwyn have combined to bring you the world's greatest entertainment' – was the publicity line for **We Live Again**. When Goldwyn read it, he exclaimed, 'That's the kind of advertizing I like. Just the facts. No exaggeration.' Yet, though there's no denying the truth of the first three statements, the entertainment was far from great. Three distinguished writers – Preston Sturges, Maxwell Anderson and Leonard Praskins – managed to be faithful in their fashion to Leo Tolstoy's *Resurrection*, while Gregg Toland's camerawork and the decor of Broadway stage-designer Serge Soudeikin created a Russia of baroque splendour. Mamoulian lingered too long over the story of the conscience-stricken nobleman's love for a peasant girl, and how he tries to find redemption for his past sins. Sten (illustrated) was poignant as Katusha, but Fredric March's Prince Dmitri (illustrated) was a trifle dull. Jane Baxter (Dmitri's fiancee), C. Aubrey Smith (a cruel Czarist judge), Sam Jaffe (a revolutionary), Cecil Cunningham, Jessie Arnold, Fritzi Ridgeway, Leonid Kinsky, Ethel Griffies, and Jessie Ralph gave good support. Other American versions of the story were Edmund Carewe's of 1927 and 1931. (GOLDWYN)

▽**The Runaway Queen** (aka **The Queen's Affair**) was hardly a runaway success for producer-director Herbert Wilcox. Derived from an operetta by Ernst Marischka, Bruno Granichstaedtin and Oscar Strauss by Monckton Hoffe and Samson Raphaelson, it was set in a middle-European Never-Never land. However, it needed more than beautiful outdoor scenery and elegant costumes to keep audiences from Slumberland. The artificial plot had an exiled Queen and the revolutionary leader who deposed her both staying incognito at a mountain retreat and falling in love. In the end they marry, so the kingdom is ruled by both a Queen and a dictator. Anna Neagle was superficial as the monarch, and Fernand Gravey (billed as Graavey), both illustrated, looked bemused. Gibb McLaughlin, Miles Malleson and Muriel Aked also took part in this sorry affair. (BRITISH AND DOMINIONS)

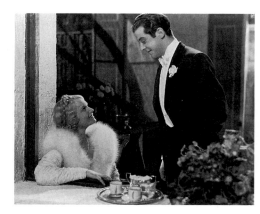

▽H.B. Warner (illustrated) returned to the role of Captain Stephen Sorrell in **Sorrell And Son** which he had played seven years previously in the silent version. Sound did not add much to the quality of this Herbert Wilcox production, although it had the advantage of being shot in England. Warner's rather unsubtle acting was nevertheless affecting as the war hero having to scrub floors in a hotel, while enduring the bullying of the hall porter (Wally Patch), and resisting the advances of the hotel's owner (Ruby Miller, illustrated). His son Kit (Hugh Williams) becomes a leading Harley Street surgeon, and takes the decision to terminate his father's life during a fatal illness. The pedestrian direction by Jack Raymond, and the episodic script by Lydia Hayward, based on Warwick Deeping's novel, almost killed the film off as well. Others in the supporting cast were Peter Penrose (Kit as a child), Winifred Shotter, Margot Grahame, Donald Calthrop, Evelyn Roberts, Hope Davy and Louis Hayward (just before his departure for Hollywood). (BRITISH AND DOMINIONS)

▽Despite the obvious air of self-mockery, Douglas Fairbanks' last film, **The Private Life Of Don Juan**, was a dispiriting affair. According to the heavily ironic screenplay by Frederick Lonsdale and Lajos Biro, Don Juan has grown tired of amorous adventures, stages his own funeral and retires to an anonymous existence. But, wounded by the many plays and books about him, he returns to Seville to prove he is still a great lover. However, no-one believes him to be Don Juan, and he retreats into a life of domesticity, a broken man. The ageing Fairbanks (centre), claiming interminably that he was the legendary character, was too close to reality for comfort. There was not enough of the Fairbanks of old, and too much of old Fairbanks. Alexander Korda, who produced and directed this lifeless costumer, surrounded his star with a bevy of lacklustre English ingenues posing as senoritas. Among them, Merle Oberon (left), Diana Napier, Patricia Hilliard, Natalie Lelong, Joan Gardner, Anne Esmond and Benita Hume. More lively were Binnie Barnes, Athene Seyler, Barry MacKay, Melville Cooper (right, making his screen debut as Leporello), Gibson Gowland, Margaretta Scott and Clifford Heatherly. Shortly after the picture's release, the private life of Douglas Fairbanks was invaded by a divorce suit brought against him by Lord Ashley, husband of ex-chorus girl Sylvia Ashley. Doug married her in 1936. (LONDON FILMS)

△**The Affairs Of Cellini** continued the vogue set by *The Private Life Of Henry VIII* (1933) for opulent and farcical history chronicals with modern dialogue. Fredric March in a pointed beard, romanced, duelled, leapt from chandeliers and over walls, as the 16th century fiery Florentine. Cellini – if you can follow the drift – is infatuated with a girl of the people (Fay Wray), who is made mistress of the Duke of Florence (Frank Morgan, illustrated) whose wife (Constance Bennett, illustrated) is cuckolding him with Cellini. Morgan's huffing, henpecked husband won him an Oscar nomination. Other phony Florentines were Vince Barnett, Jessie Ralph, Louis Calhern, Jay Eaton, Paul Harvey and John Rutherford. Bess Meredyth derived the humorous screenplay from Edwin Justus Mayer's play *The Fireband*, the director Gregory La Cava kept it bawdy and breezy, and Darryl F. Zanuck produced. (20TH CENTURY)

◁Laughs were abundant in **The Last Gentleman** before George Arliss (illustrated), as an eccentric octogenarian millionaire, had the last laugh on his rapacious family. His relatives included his sisters (Edna May Oliver and Janet Beecher) and his son (Donald Meek) who await his death with impatience. The old man slyly tries to get his young niece (Charlotte Henry) to marry his sister's adopted son (Frank Albertson) in order to disinherit the others. Edward Ellis played Arliss' ex-con butler, while Ralph Morgan, Rafaela Ottiano, Joseph Cawthorn and Harry C. Bradley appeared in smaller roles. Leonard Praskins wrote the screenplay (based on a story by Katharine Clugston) and Sidney Lanfield capably handled the direction of this pleasant little comedy for producers William Goetz and Raymond Griffith. (20TH CENTURY)

▷**The Mighty Barnum** may not have been the greatest show on earth, but it was a diverting enough biopic of the more colourful of the two mighty showmen who established the famous Barnum and Bailey circus. The William Goetz-Raymond Griffith production opened at the Big Top of 1934, then flashed back 100 years to the time when Barnum ran a general store in New York. Wallace Beery (right) immediately established Barnum as a big, lovable, simple-minded fellow who seems to be fascinated by freaks of all kinds. He signs up a bearded lady (May Boley) and George Washington's nursemaid (Lucille La Verne), but they both turn out to be fakes. Then he starts to make money from Mr and Mrs Tom Thumb (George and Olive Brasno). Gene Fowler and Bess Meredyth's screenplay got a bit sticky, and Walter Lang's direction slowed down when Barnum neglected his wife (Janet Beecher) and his freaks for Swedish soprano Jenny Lind (Virginia Bruce). However, when Barnum joined his old friend Bailey Walsh (Adolphe Menjou, left), a reformed drunk, in setting up the touring circus, he (and the movie) came back to earth and returned to form. (20TH CENTURY)

△Eddie Cantor (illustrated) continued to make millions for himself and producer Samuel Goldwyn in **Kid Millions**. He played a kid from the lower East Side of New York, who inherits $77 million from his archaeologist father. The snag is, the money is hidden somewhere in Egypt, where Eddie finds various shady characters attempting to deprive him of it. Despite the presence of the likable Cantor and the booming Ethel Merman, the absence of Busby Berkeley numbers was keenly felt, something which the eye-filling Technicolor finale in an ice-cream factory failed to compensate for. Much of Arthur Sheekman, Nat Perrin and Nunnally Johnson's screenplay strained for laughs, unaided by Roy Del Ruth's five-and-dime direction of the million dollar subject. Ann Sothern and George Murphy (making his screen debut) played young lovers, with Jesse Block, Eve Sully, Berton Churchill, Warren Hymer, Paul Harvey, Edgar Kennedy and, of course, The Goldwyn Girls in other roles. (GOLDWYN)

△Ronald Colman's first sound film had been *Bulldog Drummond* (1929), and his first assignment for Darryl F. Zanuck was **Bulldog Drummond Strikes Back**. As the dashing amateur sleuth (foreground), Colman's *sang froid* and timing again set the tone for a witty and fast-moving picture, directed by Roy Del Ruth. The action in Nunnally Johnson's scenario (based on a Sapper story) all took place one eventful fogbound night in London where Captain Hugh Drummond's main concern is to prevent the sinister Prince Achmed (Warner Oland, standing) from bringing ashore furs from a ship which

has a case of cholera aboard. The entertaining plot also involved a mysterious house from which bodies keep disappearing, and the continual kidnapping and rescuing of Loretta Young, as a girl who knows something. Drummond's quest is predictably hindered by Inspector Nielson of Scotland Yard (C. Aubrey Smith), and the silly ass Algy (Charles Butterworth). The rest of the splendid cast included Una Merkel (as Algy's bride of one day), E.E. Clive and Halliwell Hobbes (as comic policeman), Kathleen Burke, George Regas (left), Ethel Griffies and Mischa Auer (right). (20TH CENTURY)

▷The role of the Czarina Catherine of Russia attracted, among others, Pola Negri (1924), Marlene Dietrich (1934), Tallulah Bankhead (1945), Viveca Lindfors (1958), Bette Davis (1959), Hildegard Neff (1962) and Jeanne Moreau (1968). In 1934, Elisabeth Bergner essayed it in **Catherine The Great** (aka **The Rise Of Catherine The Great**) for Alexander Korda, who hoped to repeat the triumph of *The Private Life Of Henry VIII* (1933), and invested the large sum (for Britain) of $400,000 in a lavish production. But where his earlier film was brisk and humorous, this was slow and sober. Also, the screenplay by Lajos Biro and Arthur Wimperis (from a play by Melchior Lengyel) was rather more threadbare than its predecessor, yet the film succeeded in recouping its cost. In her first English language film, the Austrian Miss Bergner (illustrated) turned on her girlish charm to a nauseating degree, encouraged by the indulgent direction of her Hungarian husband Paul Czinner. Douglas Fairbanks Jr (illustrated) coped quite well as the Grand Duke Peter who marries her and then gradually loses his wits, while other parts went to Gerald Du Maurier, Irene Vanbrugh, Joan Gardner, Dorothy Hale, Diana Napier and Gibb McLaughlin. However, it was Flora Robson as the Empress Elizabeth who made the most impression. (LONDON FILMS)

△Mother-love, a favourite theme of soap operas, was the subject of the William Goetz-Raymond Griffith production of **Gallant Lady**. The stylish direction of Gregory La Cava, and the acting of Ann Harding (illustrated) as an unmarried mother forced to give her son out for adoption, were superior to the prosaic story by Gilbert Emery and Douglas Doty (screenplay by Sam Mintz). In one of those coincidences that often happen in the movies, the mother meets her little boy (Dickie Moore) five years later while travelling abroad. The boy immediately takes to her, not knowing she is his mother. Meanwhile, the adoptive father (Otto Kruger) has become a widower and plans to marry a woman (Betty Lawford) whom the child dislikes. No prizes for guessing whom he marries in the end. 'English gentleman' heart-throb Clive Brook (illustrated) was cast against type as a drunken, unshaven doctor, but Tullio Carminati was his usual mooning self as a love-sick Count. Janet Beecher, Ivy Merton and Theresa Maxwell Conover were also cast in support. It was remade as *Always Goodbye* (20th Century-Fox 1938) starring Barbara Stanwyck. (20TH CENTURY)

▷Darryl F. Zanuck's **Clive Of India** was a tribute from one Empire builder to another. The screenplay by W.P. Lipscomb and R.J. Minney avoided political complexities, concentrating rather on the complexities of the personality of Robert Clive, 18th-century soldier and politician, who consolidated the British Raj. Some spectacular scenes such as the Black Hole of Calcutta, the monsoons and the Battle of Plassey, well handled by director Richard Boleslawski, were too often interrupted by lengthy marital discussions between Clive and his long-suffering wife. She wants him to give up his power in India and settle down as a country gentleman in England. The film concludes with the fictional reunion of the couple after a long separation, and not with Clive's suicide, as in reality. One concession to authenticity required Ronald Colman (left) in the title role to shave off his pencil-line moustache. The British were represented by C. Aubrey Smith (who else?), Colin Clive, Francis Lister, Lumsden Hare, Ferdinand Munier (right), Gilbert Emery, Montagu Love, Leo G. Carroll, and Loretta Young as Lady Clive. Cesar Romero and Mischa Auer were thinly disguised as rival maharajahs, and there was not a real Indian in sight. Plenty of non-Indians paid to see it, though. (20TH CENTURY)

▷Left-wing and liberal groups picketed **Red Salute** (aka **Her Enlisted Man**, aka **Runaway Daughter**, GB: **Arms And The Girl**), though most of it was too silly and unsubtle to be taken seriously. The screenplay, by Humphrey Pearson and Manuel Seff, was a bad imitation of *It Happened One Night* (Columbia 1934), but director Sidney Lanfield was no Frank Capra. Barbara Stanwyck (illustrated) played the daughter of a US General (Purnell Pratt) who is shipped off to Mexico to get her away from her radical boyfriend (Hardie Albright). There she meets AWOL soldier Robert Young, and they help each other get back to the States, falling in love on the way. Later, he proves himself to be a red-blooded Red-hating American by breaking up a meeting of the Liberal League of International Students organized by her erstwhile sweetheart. Also taking part in this lumbering comedy were Cliff Edwards, Ruth Donnelly, Gordon Jones, Paul Stanton, Nella Walker, Henry Kolker and Arthur Vinton in supporting roles. Edward Small produced. (RELIANCE)

◁Leslie Howard (illustrated) was a delight in the role of Sir Percy Blakeney, a mincing Regency dandy alias **The Scarlet Pimpernel**, who leads a double life by rescuing aristocrats from the guillotine in France during the Revolution. So artful is he, that not even his wife (Merle Oberon) suspects that her weak husband and the daring hero are one and the same. He also outwits the suspicious French ambassador Chauvelin (Raymond Massey). Actual historical figures in this romantic adventure based on Baroness Orczy's novel were Robespierre (Ernest Milton), St Just (Walter Rilla), the Prince Regent (Nigel Bruce) and the artist Romney (Melville Cooper). Fictional characters were played by Joan Gardner, O.B. Clarence, Anthony Bushell, John Turnbull and Bramwell Fletcher. Alexander Korda's British-made production matched most of what Hollywood had to offer, while American-born Harold Young's direction and Robert Sherwood, Arthur Wimperis, Sam Berman and Lajos Biro's screenplay kept it brisk and witty. UA's revival *The Return Of The Scarlet Pimpernel* (1938), and *The Elusive Pimpernel* (British Lion, 1950) were both less successful attempts to capture the elusive hero on the cinema screen. (LONDON FILMS)

▽No memory lingered on of **The Melody Lingers On**, a trite soap opera with an operatic background. The unstarry cast and shaky script (by Ralph Spence and Philip Dunne from the Lowell Brentano novel), didn't help Edward Small's production or David Burton's direction. Josephine Hutchinson (left) played a piano virtuoso in Italy who has an illegitimate child by her fiance, an opera-singing captain in the Italian army. George Houston, a singer from opera and Broadway in his screen debut, was the Italian who gets killed saving Miss H's life. Their son (David Scott), brought up by foster parents, grows up to be a musician without knowing who his mother, now in a convent, is. Helen Westley and Laura Hope Crews (right) briefly enlivened the generally pedestrian proceedings with Mona Barrie, William Harrigan, Walter Kingsford, Ferdinand Gottschalk and Grace Poggi making up the numbers in other roles. (RELIANCE)

▽**Folies Bergere** (GB: **The Man From The Folies Bergere**) was Hollywood's farewell to Maurice Chevalier before his return to Europe where he remained for the next 21 years. As a homage to the great French star, Dave Gould staged a number which used Chevalier's famous straw hat as a motif, and which won the choreographer an Oscar for Best Dance Direction. Ironically, producer Darryl F. Zanuck's first choice for the starring role had been Charles Boyer, but the musical, directed by Roy Del Ruth, fitted Chevalier like a kid glove. He played a dual role as a Parisian millionaire and a comedian at the Folies Bergere, the latter engaged by the former to impersonate him at a ball while he's away at a secret business meeting. Double trouble arises concerning the millionaire's wife (Merle Oberon in her Hollywood debut) and his showgirl mistress (Ann Sothern, illustrated centre with Chevalier). Also confused were Eric Blore, Walter Byron, Lumsden Hare, Robert Greig, Halliwell Hobbes and Phillip Dare. The origin of the plot was a play called *The Red Cat* by Rudolph Lothar and Hans Adler, adapted for the screen by Bess Meredyth and Hal Long who made it less fun than it sounds. 20th Century-Fox hauled it out twice more with different titles and locales as *That Night In Rio* (1941), starring Don Ameche, and *On The Riviera* (1952), with Danny Kaye. (20TH CENTURY)

△Samuel Goldwyn first chose the title of **Barbary Coast** and then asked his screenwriters Charles MacArthur and Ben Hecht to write a story to fit it. They came up with a tale of a dance hall queen (Miriam Hopkins) who links up with a crooked gambler (Edward G. Robinson, both illustrated), but falls for a young, honest gold prospector (Joel McCrea). Howard Hawks directed with a feeling for the bustling, bawdy milieu of San Francisco in her early days, and succeeded in drawing spirited performances from the three leads. Adding to the film's merits were several excellent vignettes from Walter Brennan as a barfly, Brian Donlevy as a bouncer and Frank Craven as a newspaper proprietor. Also present and correct were Harry Carey, Clyde Cook, Matt McHugh, Otto Hoffman, Rollo Lloyd, Donald Meek and J.M. Kerrigan. David Niven, at the start of his screen career, appeared fleetingly. (GOLDWYN)

▽So insufferable was the family portrayed in Samuel Goldwyn's **Splendor**, that the film was almost unendurable. It was rescued, however, by a splendid performance from Miriam Hopkins as an outsider, and director Elliott Nugent's gentle guiding of the dated screenplay by Rachel Crothers. The once-wealthy Lorrimore family consisted of snooty mother (Helen Westley), her favourite son, Brighton (Joel McCrea), the shallow daughter (Katherine Alexander), and the useless younger son (David Niven). The lofty dowager's hopes that Brighton will wed a sausage heiress (Ruth Weston) are dashed when he brings home a country girl (Hopkins, illustrated), as his wife. When the young bride is asked by the family to use her charms on a rich broker (Paul Cavanagh, illustrated) to help her husband's business, she leaves the menage. The husband makes his own way and the couple get together again. Billie Burke, Ivan Simpson, Arthur Treacher and Torben Meyer also contributed in supporting roles. (GOLDWYN)

▷Elisabeth Bergner (illustrated) took the lead in **Escape Me Never**, a role she had created on stage in London and New York in the play especially written for her by Margaret Kennedy. Director Paul Czinner (the star's husband), and screenwriters Carl Zuckmayer and R.J. Cullen, kept it very much as a vehicle for Miss Bergner's rarefied talent. In this archetypal weepie, the waifish Bergner played the mother of an illegitimate child who marries a caddish composer (Hugh Sinclair, illustrated, repeating his stage role). He abandons her for the aristocratic fiancee (Penelope Dudley-Ward) of his brother (Griffith Jones). Others in the cast were Lyn Harding, Rosalinde Fuller, Leon Quartermaine and Irene Vanbrugh. With settings in Venice, The Dolomites and London, this Herbert Wilcox production somehow clicked with the public. It was Bergner's most successful venture and she was nominated for an Oscar. Warner Bros. shaky 1947 remake starred Ida Lupino and Errol Flynn. (BRITISH AND DOMINIONS)

◁Fans of cops 'n robbers pictures were not too disappointed by **Let 'Em Have It** (GB: **False Faces**). What the Joseph Moncure March-Elmer Harris screenplay lacked in originality, the cast made up for in personality. Femininity was represented by Virgina Bruce as a Washington society belle, wisecracking Alice Brady was her aunt, and Dorothy Appleby a saucy gangster's moll. Richard Arlen (foreground left) played the beefy FBI agent who tracks down gang leader Bruce Cabot (right). Cabot, posing as Miss Bruce's chauffeur, robs a bank and shoots his kid brother (Eric Linden) who has joined the FBI. Director Sam Wood contrasted some of the more improbable events with some documentary footage on the workings of the Bureau. Edward Small's production also featured Harvey Stephens, Joyce Compton, Gordon Jones, J. Farrell MacDonald, Bodil Rosing and Paul Stanton. (RELIANCE)

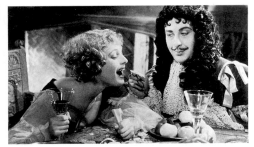

△The best joke in **Nell Gwyn** came in the credits which stated that Miles Malleson wrote the screenplay 'in collaboration with King Charles II, Samuel Pepys and Nell Gwyn.' Cedric Hardwicke (illustrated) made a good attempt at the king and Esme Percy was an acceptable Pepys, but the oh-so-refined Anna Neagle (illustrated) was embarrassingly deficient as the sexy, saucy mistress of the monarch. Malleson himself appeared as Chaffinch, the king's stooge, Jeanne de Casalis was the Duchess of Portsmouth whom Nell ousts as the king's favourite, and Helena Pickard was Mrs Pepys. Other parts went to Laurence Anderson, Moore Marriott, Hugh E. Wright and Abraham Sofaer. Producer Herbert Wilcox had to add a prologue to satisfy the Hays Office, showing the 17th-century trollop paying the price of immorality by ending her days in dire poverty. This was nothing to the poverty of Wilcox's direction. Inexplicably, the film was almost as successful as his production of the same story with Dorothy Gish in 1926. (BRITISH AND DOMINIONS)

△Thornton Freeland, the director of *Flying Down To Rio* (RKO, 1933), tried to inject something of that film's spirit into Herbert Wilcox's British-made production of **Brewster's Millions**. It even had an overblown fiesta scene featuring a dance called 'La Caranga'. But the picture lacked more than Fred Astaire and Ginger Rogers. Winchell Smith and Byron Ongley had adapted George Barr McCutcheon's story for the stage in 1906. For this musical version, an armada of writers including Arthur Wimperis, W. Wilhelm, Michael Joseph, Clifford Grey and Donovan Pedelty, helped sink it. However, it did provide a perfect part for the debonair Jack Buchanan who sang, danced and jested with aplomb. The plot concerned the attempts of Jack Brewster (Buchanan, right) to spend a quarter of a million dollars in six months as specified in his uncle's will. If he can, he stands to inherit much more. Unluckily, he strikes lucky and finds his wealth increasing. Lili Damita played a gold-digging chorus girl and Nancy O'Neil his true love, while Sidney Fairbrother, Ian McLean (left), Fred Emny, Allan Aynsworth, Sebastian Shaw and Dennis Hoey appeared in other roles. The story was filmed in Hollywood in 1914, 1921, 1945 and 1984 and it was remade in Britain as *Three On A Spree* (1961). (BRITISH AND DOMINIONS)

▷It was inevitable that George Arliss (right) should take the title role in Darryl F. Zanuck's production of **Cardinal Richelieu**, a part he had performed some years before on stage in Edward Bulwer-Lytton's play. His hammy style and sly wit was well-suited to the character of the plotting prelate who fought to defend, by fair means and foul, the power of Louis XIII. Despite the fact that Edward Arnold as the monarch calls him 'Rishyloo', he prevents the king's brother (Francis Lister), aided by the evil Baradas (Douglass Dumbrille) from usurping the throne. Other players in the game of intrigue were Violet Cooper and Katherine Alexander as Queens Marie and Anne, Maureen O'Sullivan and Cesar Romero (left), as young lovers, Robert Harrigan, Lumsden Hare, Russell Hicks and Halliwell Hobbes. Director Rowland V. Lee brought some air into the stuffy drama, which was opened up beyond the walls of the court in the screenplay by Cameron Rogers, Maude Howell and W.P. Lipscomb. (20TH CENTURY)

△Samuel Goldwyn lavished $2 million on **The Wedding Night** in a last attempt to make Anna Sten into a great star. The money was wasted, and Goldwyn terminated her contract after the film's release. That the public didn't clamour for more of her was not entirely her fault. Here, Sten (centre) was lumbered with the role of a naive Polish farm girl in the Connecticut tobacco country, subjugated by her old-fashioned father (Sig Rumann) and affianced to the neighbour's loutish son (Ralph Bellamy, left). She falls in love with a heavy-drinking married novelist (Gary Cooper, right) who has descended on the old-world community to study them for his next book. King Vidor's direction signalled a tragic ending long before the girl is killed in a brawl between the novelist and the fiance. Cooper was none too comfortable in the part, but Helen Vinson (above right) was perfect as his city-slicker wife. Esther Dale, Leonid Snegoff, Walter Brennan and George Meeker took other ethnic roles. The ponderous screenplay by Edith Fitzgerald was based on a story by Edwin Knopf. The unfortunate Miss Sten continued to appear in Hollywood films over the next 27 years but only sporadically. (GOLDWYN)

◁Much of Alexander Korda's production of **Sanders Of The River** was shot on location in East Africa with real natives as extras (the future leader of Kenya, Jomo Kenyatta, had a bit part), but it starred American Paul Robeson in a loin cloth and beads. As Bosambo, a chief loyal to the British, he got to sing a number of English arrangements of African songs, while Nina Mae McKinney as his wife – both illustrated – would have seemed more at home in a Harlem nightclub. The screenplay by Lajos Biro, Arthur Wimperis and Jeffrey Dell turned the stern British administrator of the Edgar Wallace stories into a benevolent white father caring for his black children. Leslie Banks in the role carried the white man's burden rather lightly, effortlessly capturing two nasty traders (Robert Cochran and Martin Walker) who have sold gin and guns to the tribes, and rescuing Bosambo from the clutches of Mofolaba (Tony Wane), a rebellious chief. Richard Grey, Eric Maturin and Allan Jeayes also appeared in this dated relic of the British Empire directed by Zoltan Korda, the producer's brother. (LONDON FILMS)

◁Darryl F. Zanuck's **Les Miserables**, the story of Jean Valjean the eternal loser, was a winner all the way. W.P. Lipscomb's screenplay competently telescoped Victor Hugo's sprawling 19th-century novel, although Valjean's sentence in the galleys was doubled to ten years. The poor man's sufferings begin when he steals a loaf of bread to feed his sister's starving family. Released from the galleys, he slowly and painfully becomes a respectable member of the community but is shadowed throughout his life by the sinister Inspector Javert. Fredric March (illustrated) expressed nobility as the hunted man, and a shaven-headed Charles Laughton exuded evil as the hunter. Cedric Hardwicke made a brief but impressive Hollywood debut as the Bishop whose candlesticks Valjean steals. Others in the large cast were March's wife Florence Eldridge (the pathetic Fantine), Marilynne Knowlden (Fantine's daughter, Cosette, whom Valjean 'adopts' as his own), Rochelle Hudson and John Beal (Cosette as a young woman and her lover Marius – a revolutionary rescued from the barricade by Valjean), Jessie Ralph (Madame Malgloire), John Carradine, Ferdinand Gottschalk, Jane Kerr, Frances Drake and Leonid Kinsky. The director, Richard Boleslawski, controlled both the intimate and epic moments with equal dexterity in this Oscar-nominated 20th Century production. It is perhaps the most filmed of all classic novels, some of the many other versions being the French-made pictures of 1934, 1957 and 1982, and 20th-Century Fox's miserable remake of 1952. (20TH CENTURY)

▽Charles Boyer (right), that most Gallic of stars, tried hard to be convincing as a Japanese naval officer in **Thunder In The East** (aka **The Battle**, aka **Hara-Kiri**). At least, Merle Oberon already had a certain oriental look that compensated for her wooden performance as his wife, asked by her husband to make herself attractive to a British government representative (John Loder, left), while he tries to steal a copy of a report on the Japanese fleet from the Englishman's apartment. Sadly, they fall in love and Boyer commits hari-kiri. V. Inkijinoff, Miles Mander and Henri Fabert were also disguised as Japanese. However, nothing could disguise the artificiality of Leon Garganoff's French-made production. The Japanese setting of Robert Stevenson's screenplay (from a novel by Claude Ferrere), had a certain novelty value but little else. Nicholas Farkas directed. (LIANOFILM)

△**Call Of The Wild** was the last Darryl F. Zanuck-20th Century Picture for UA, before its union with the ailing Fox Film Corporation. It left on a high note. William Wellman's direction captured the boisterous flavour of the late 19th century Klondike gold rush of Jack London's novel, but the Gene Fowler-Leonard Praskins screenplay added some romantic mush to the book's call to the sled dogs. As the romance was provided by Clark Gable (left) and Loretta Young, it didn't detract too much from the action, during which he rescues her from the snowy wastes while hungry wolves surround her. Later, Miss Young's husband (Frank Conroy) whom she had thought dead, turns up to ruin the love affair. Jack Oakie (right) quipped merrily in a 1930's manner as Gable's partner in prospecting, and Reginald Owen made an effective villain. Able support was given by Sidney Tyler, Katherine DeMille (Cecil B's adopted daughter), Charles Stevens, James Burke and Duke Green. There was a 1923 silent version, and a 1972 remake with Charlton Heston. Both of these pictures were closer to the book but neither was as enjoyable. (20TH CENTURY)

△'A sockeroo woman's picture' is what *Variety* of September 1935 called **The Dark Angel**, but time has rather faded the initial impact of this old-fashioned melodrama. Guy Bolton's play had been filmed in 1925 with Vilma Banky and Ronald Colman for Samuel Goldwyn, and Goldwyn produced once again, this time with a script by Lillian Hellman and Mordaunt Shairp, directed by Sidney Franklin. Fredric March played the man who is blinded in World War I, but pretends to have been killed in order not to be a burden to his wife. The best scene is when March (left), having been discovered alive, acts as if he can see, after having carefully arranged everything in the room before his wife's visit. Merle Oberon as the wife (centre right) emoted sufficiently well to receive an Oscar nomination, and Herbert Marshall (centre left) did what he could as the other man in love with her. The cast also included Janet Beecher (right), John Halliday, Henrietta Crosman, Frieda Inescort, Claude Allister, Lawrence Grant and David Torrence. The film looked good too, and art director Richard Day won an Academy Award for his mock English sets. (GOLDWYN)

UNITED ARTISTS
1936

▽According to Hollywood, homosexuality did not exist in America until the 60s, therefore **These Three**, based by Lillian Hellman on her play *The Children's Hour*, was divested of its lesbian undercurrent. Instead, an appalling child (Bonita Granville) tells her grandmother (Alma Kruger) that one of the two women who run her school is having an affair with the fiance of the other. The fuss the communuty makes about the rumoured relationship – it is untrue – now seems rather quaint. Merle Oberon (illustrated) and Miriam Hopkins were well contrasted as the two principals, but Joel McCrea (illustrated) was unhappy as the man between. Also in it were Catherine Doucet, Marcia Mae Jones, Margaret Hamilton and Walter Brennan. Producer Samuel Goldwyn brought together for the first time director William Wyler and cinematographer Gregg Toland whose deep focus photography gave Wyler's films henceforth a definition they might not otherwise have had. Wyler remade the picture in 1962 as *The Children's Hour* (GB: *The Loudest Whisper*), with Shirley MacLaine and Audrey Hepburn, but more frankness did not yield more quality. (GOLDWYN)

△Howard Hawks was dismissed by Samuel Goldwyn after completing all but ten minutes of **Come And Get It** (aka **Roaring Timber**), so William Wyler was called in and given a co-director credit. The changeover didn't seem to affect the unity of this full-blooded, if rather lumbering epic of the lumber industry in Wisconsin in the late 19th century. Jules Furthman and Jane Murfin's screenplay eliminated one generation from the dynasty in Edna Ferber's rambling novel, concentrating on the rise of Barney Glasgow from lumber camp boy to timber tycoon. Edward Arnold (left) gave another of his powerful plutocrat portraits as the ruthless man who lacks love in middle age. He becomes infatuated by the daughter of the woman he once lost and loved, but loses her, too, to his son (Joel McCrea, right), Frances Farmer gave a creditably sympathetic performance playing the parts of both mother and daughter. Andrea Leeds, Frank Shields, Mady Christians, Mary Nash, Clem Bevans, Edwin Maxwell and Cecil Cunningham were also in the cast, along with Walter Brennan who, as the tycoon's Swedish buddy, was awarded the first ever Best Supporting Actor Oscar. (GOLDWYN)

△Mary Pickford, taking over as first vice-president of UA, produced (with Jesse Lasky) **One Rainy Afternoon**, a fast-moving romantic comedy. Like many similar pictures of the 30s, it relied heavily on character actors for laughs. These were provided by Roland Young as a movie producer, Hugh Herbert, his stooge, Erik Rhodes, a funny foreigner, Mischa Auer, a ham actor, and Donald Meek, a judge. The scenario by Stephen Morehouse Avery (from the story *Monsieur Sans-Gene* by Emeric Pressburger and Rene Pujal) dealt with the consequences that arise when an actor (Francis Lederer, illustrated) kisses a girl (18-year-old Ida Lupino) by mistake in a darkened cinema while under the spell of the picture. The frivolous furore that follows involves the President of the Purity League (Eily Malyon, illustrated), the girl's pompous publisher father (Joseph Cawthorn), the actor's mistress (Countess Liev de Maigret), the women of Paris, and a farcical trial. Rowland V. Lee directed the frantic fun. (PICKFORD-LASKY)

66

△**Dodsworth** was one of Samuel Goldwyn's classiest productions, expertly adapted by Sidney Howard from Sinclair Lewis' novel about a self-made man from the Mid-West who finds a new set of values on a trip to Europe. Walter Huston (illustrated), Ruth Chatterton (in her last Hollywood film, alas) and Mary Astor (illustrated) gave accomplished performances as Sam Dodsworth the retired magnate, Fran, his empty and vulgar wife, and Edith Cortright, the intelligent American widow who offers Dodsworth sympathetic companionship. William Wyler directed sensitively, getting the most from his three leads as well as from Paul Lukas, David Niven and Gregory Gaye (as the men Fran flirts with to prove she is still attractive), Maria Ouspenskaya, Odette Myrtil, Kathryn Marlowe, Spring Byington and John Payne (in his screen debut). The production, sound recording, Howard, Wyler, Huston and Ouspenskaya were all Oscar-nominated, but only art director Richard Day, for the second year running, won the award for his recreation of a stylized Europe. (GOLDWYN)

▽Few Americans could have appreciated **The Last Of The Mohicans** without having read James Fenimore Cooper's semi-historical literary classic about the Indian wars in colonial America. Although they might have been pleased by Edward Small's elaborate production and George B. Seitz's well-paced direction, they would have been disappointed by the many elisions in the screenplay by Philip Dunne, John Balderston, Paul Perez and Daniel Moore, and shocked by the love interest provided for the great chaste frontier scout, Hawkeye (Randolph Scott). Still, many of the high points of the novel reached the screen, such as the canoe chase over the rapids, the rescue of the two English girls (Binnie Barnes, left and Heather Angel, right) captured by the treacherous Magua (Bruce Cabot), and the massacre at Fort William Henry. Phillip Reed and Robert Barrat played the noble Indians Uncas and Chingachgook, Henry Wilcoxon was Major Heyward, and Ian MacLaren and Olaf Hytton were William Pitt and George II respectively. (RELIANCE)

▽Eddie Cantor's eyes were as big as ever in **Strike Me Pink**, but his box-office appeal was diminishing. This was the last and weakest of the films the diminutive star made for Samuel Goldwyn. The successful formula that had begun six years and six pictures before, was beginning to wear as thin as the screenplay concocted by Frank Butler, Francis Martin and Philip Rapp (story by Clarence Budington Kelland). Cantor (right) played a timid tailor who takes to running an amusement park, unaware that gangsters have the slot machine concession. In a slapstick chase finale, well directed by Norman Taurog, including a mad ride on a roller coaster, he delivers the gangsters to the cops. Pretty Sally Eilers was Eddie's girlfriend and Brian Donlevy, Jack La Rue (left) and Edward Brophy were the heavies. Other support came from William Frawley, Parkyakarkus (Harry Parke), Gordon Jones, Sunny O'Dea, Rita Rio (later Dona Drake) and The Goldwyn Girls. But it was Ethel Merman singing three numbers who really kept the patrons awake. (GOLDWYN)

▽The great French actor Harry Baur was effectively malign in **I Stand Condemned** (GB: **Moscow Nights**), repeating his role in the 1934 French film *Les Nuits De Moscou*. He played the boorish rich contractor Brioukow, betrothed to Natasha (a wooden Penelope Dudley-Ward, illustrated), who has been forced into the marriage by her impoverished aristocratic parents. She really loves a young army captain (a dashing 28-year-old Laurence Olivier, illustrated) who is heavily in debt to Brioukow after losing in a card game. In order to pay his debt, he gets involved unknowingly with a German spy (Athene Seyler) and is charged with treason. Both he and the audience were freed at the end. Although authentic Russian singers and dancers were added, the screenplay by Eric Siepman (from a Pierre Benoit story), and Anthony Asquith's uncertain direction, made it a very un-Russian affair. The rest of the English cast included Robert Cochran, Morton Selten, Walter Hudd, Kate Cutler, Charles Hallard, Edmund Willard and Hay Petrie. (LONDON FILMS)

▽Mary Pickford played him silently and sweetly in 1921, and Ricky Schroder took the role cutely in colour in 1980, but English child actor Freddie Bartholomew (illustrated) as **Little Lord Fauntleroy** was the most memorable of all. As the spoilt child brought up in Brooklyn in the 1880s, who inherits an English title, he was mercifully uncloying. In England, at his family's stately home, he soon wins over his stern grandfather (C. Aubrey Smith) and almost everyone else. Hugh Walpole's adaptation of Frances Hodgson Burnett's snobbish, sugary story, and John Cromwell's direction, kept it warm and humorous. As Dearest, the boy's mother, Dolores Costello (illustrated) made a welcome return to the screen after five years while Mickey Rooney as the bootblack, Henry Stephenson, Guy Kibbee, Eric Alden, Jackie Searl, Jessie Ralph, Una O'Connor, May Beatty and E.E. Clive gave support. It was the first independent production by David O. Selznick, who had left MGM to sign a contract with UA. He was to deliver 12 more pictures, many of them hits as big as this one. (SELZNICK INTERNATIONAL)

▷The title **Modern Times** was a slight misnomer because Charles Chaplin still held out against the use of dialogue. Yet, in an affecting moment towards the end, Charlie's voice is heard for the first time on screen in a song sung in gibberish, thus retaining the universality of his language. The character of the Little Tramp, however, made his last appearance, walking towards the horizon. Charlie (illustrated) played a factory worker literally caught up in the machine age. He loses his job, is sent to jail after being mistaken for a mob leader, sets up home with an orphan girl on the run (Paulette Goddard, Chaplin's third wife), gets work in a department store, is arrested again, and becomes a singing waiter. Any social and political pretensions the picture had were submerged by the welter of brilliant gags interspersed with dollops of sentimentality made palatable by Chaplin's genius. One or two of the stunts were taken from René Clair's *À Nous La Liberté* (1931), but Clair was flattered by the imitation. Henry Bergman, Chester Conklin, Stanley Sanford, Hank Mann, Allan Garcia, Louis Natheux, Lloyd Ingraham (the silent movie director) and Wilfred Lucas did what was asked of them to the letter. The film, written, produced, directed and scored by Chaplin, grossed $1.4 million in the USA alone, proving that he still held the public's affection after all these years. (CHAPLIN)

△The Irish Rebellion of 1921 was the background to **Beloved Enemy**, against which a tragic romance between a rebel leader and the niece of an English governor is enacted. She comes to understand his cause, falls in love with him and helps him negotiate a truce with London. But he is shot and killed by fanatics in his party who feels he has betrayed them. Brian Aherne was suitably noble and heroic, and Merle Oberon (centre) sincere as his 'beloved enemy'. The Irish were represented by Karen Morley, Jerome Cowan, Ra Hould, Granville Bates, P.J. Kelly, Pat O'Malley and Jack Mulhall, while Henry Stephenson (left), David Niven (right), Donald Crisp, Claude King and David Torrence were their English oppressors. Gregg Toland's photography and Richard Day's sets retained the visual standards expected in a Samuel Goldwyn production, and Broadway director H.C. Potter, making his first feature, controlled the sometimes confused action competently. However, the four screenwriters – John Balderston, Rose Franken, David Hart and William Brown Meloney (story by Balderston) – fell too often into the trap of fitting Hollywood romantic notions into historical fact. (GOLDWYN)

△Not one of the highspots of director Rouben Mamoulian's career, **The Gay Desperado** was, nevertheless, a light and entertaining musical spoof for much of the way. Basically a vehicle for Metropolitan opera tenor Nino Martini (right), it was comic Leo Carrillo (left), as a Mexican bandit, who rode off with the picture. He kidnaps Martini because he likes his singing, and also an American heiress played by Ida Lupino, because he hopes to extract a ransom. Harold Huber and Mischa Auer appeared as his sidekicks, and the cast also included James Blakely, Stanley Fields, Adrian Rosely, Paul Hurst, Alan Garcia and Frank Puglia. Wallace Smith's screenplay (story Leo Birinski) attempted some satire on contemporary gangster movies with Carrillo taking off Cagney, Raft and Robinson. But it was mostly high voices and low comedy in this Mary Pickford-Jesse Lasky production. (PICKFORD-LASKY)

▽**The Amateur Gentleman** was the first and best of three pictures starring Douglas Fairbanks Jr for his own English-based company. The screenplay by Clemence Dane, Edward Knoblock and Sergei Nolbanov (from a novel by Jeffrey Farnol) was set in Regency times, the favourite period of British historical-romantic films, and allowed Fairbanks Jr (illustrated) to emulate some of his father's screen heroics. He played an innkeeper's son who poses as a gentleman pugilist in order to prove his father (Frank Pettingell) innocent of a crime for which he is imprisoned. He gains entrance to the court of the Prince Regent (Gilbert Davis), plans his father's escape from Newgate prison, falls in love with Lady Cleone (Elissa Landi, illustrated), and traps her adventurer fiance (Basil Sydney) into admitting the theft for which his father was blamed. Also decked out in Regency dress were Coral Browne, Irene Browne, Margaret Lockwood, Gordon Harker, Athole Stewart, Hugh Williams, Esme Percy and Frank Bertram. Marcel Hellman's production and Thornton Freeland's direction helped make the film as handsome and as lively as its star. (CRITERION)

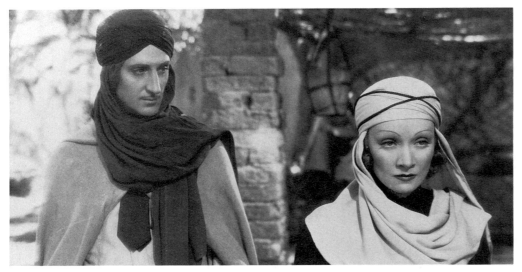

▷Marlene Dietrich (illustrated) and Charles Boyer spread their thick accents over a richly Technicolored desert in **The Garden Of Allah**, an extravagant piece of Hollywood hokum. She was a disenchanted socialite seeking God, he a monk fleeing a Trappist monastery in order to yield to the temptations of the flesh. These two troubled souls meet in Algeria and fall in love, although he keeps his past a secret. Finally, he returns to the monastery, a better man. Others who impinged on their lives were a jealous sheik (Basil Rathbone, illustrated), a sand diviner (John Carradine), a handsome legionnaire (Alan Marshal), a devoted servant (Joseph Schildkraut), an exotic dancing girl (Tilly Losch) and various sanctimonious nuns and priests played by Lucile Watson, C. Aubrey Smith, Helen Jerome Eddy, Charles Waldron and John Bryan. Although philosophically banal, the screenplay by W.P. Lipscomb and Lynn Riggs (from the novel by Robert Hichens), offered a heady mixture of purity and eroticism. But the main quality of David O. Selznick's production was the Oscar-winning colour cinematography by William Howard Greene and Harold Rosson. It was the last completed film to be directed by Richard Boleslawski who died suddenly the following year, aged only 48. (SELZNICK INTERNATIONAL)

▽After three triumphant years in Hollywood, Charles Laughton returned to England to star as **Rembrandt** for Alexander Korda and virtually the same team that made his Oscar-winning *The Private Life Of Henry VIII* (1933). Laughton (illustrated), looking even more like the great 17th-century Dutch painter than he did the English monarch, gave one of his most complex characterizations. The screenwriters, Carl Zuckmayer, Lajos Biro, Arthur Wimperis and June Head, concentrated on the last two decades of the artist's life, his struggles with the Amsterdam burghers, and his relationships with his shrewish wife Geerte (Gertrude Lawrence) and Hendrikje (Elsa Lanchester), the warmer woman who succeeds her. Korda's careful direction was greatly enhanced by his brother Vincent's designs and George Perinal's painterly camerawork. Others in the cast were Edward Chapman, Walter Hudd, Roger Livesey, Allan Jeayes, Sam Livesey, Raymond Huntley, John Clements, Marius Goring and Abraham Sofaer. Unfortunately, despite all its excellence, it was only a modest commercial success. (LONDON FILMS)

▷Alexander Korda had the delightful idea of inviting French director René Clair to make his first English-language film, **The Ghost Goes West**, in England. Although stylistically different from his French films, Clair found in Robert E. Sherwood's screenplay (story by Eric Keown) a vehicle in which he could indulge his taste for comic fantasy. It also gently satirized nouveau riche Americans, personified by the portly Eugene Pallette as a chain-store millionaire persuaded by his spoilt daughter (Jean Parker) to transport a Scottish castle lock, stock and ghost, to Florida. Robert Donat (illustrated) lent his considerable charm to the dual role of the dear, but not completely departed, Murdoch Glourie, killed in his kilt 200 years before, and Donald Glourie, his impoverished descendant. Ralph Bunker, Elsa Lanchester, Everly Gregg, Hay Petrie, Morton Selten, Elliot Mason and Patricia Hilliard also took part in the sometimes over-whimsical shennanigans. Like the ghost, René Clair was to be transplanted to the USA a few years later. (LONDON FILMS)

△H.G. Wells' chilling futuristic novel *The Shape Of Things To Come* was adapted by the author as **Things To Come**. A bleak vision of the next century, it begins in 1940 in Everytown when a world war breaks out. This 30-year debacle is followed by a virtual return to the Stone Age but, gradually, a new civilization develops, and by 2036 all the cities are glass-based and underground, free from poverty but not from bitter conflict. In order to create this Wellsian future, Alexander Korda asked the great Hollywood art director William Cameron Menzies to direct the film and design the sets (with Vincent Korda) at his newly-built Denham studios. Harry Zech and Ned Mann were responsible for the special effects and Arthur Bliss composed the music. However, it was as pretentious as it was portentous. The direction was lacklustre and the characters bloodless. Even the first-rate British-cast, including Ralph Richardson (illustrated lying foreground), Edward Chapman, Raymond Massey (illustrated standing), Margaretta Scott, Cedric Hardwicke, Sophie Stewart, Derrick de Marney and Ann Todd, gave stilted performances. The film's success must be attributed to the impressive art work. Happily, there were many far better things that would come from the Korda studios. (LONDON STUDIOS)

![UNITED ARTISTS]

1937

▽The Union Jack was waved, literally and figuratively, in **Troopship** (GB: **Farewell Again**), a compendium drama made for London Films. Paying tribute to a group of British fighting men whose leave is interrupted after six hours in Southampton, were German producer Erich Pommer and American director Tim Whelan. The cast, however, were true blue British from their stiff upper lips to the toes of their boots. Colonel Leslie Banks has to leave his dying wife Flora Robson, Captain Sebastian Shaw falls for Nurse Patricia Hilliard although he's already engaged, and Sergeant Edward Lexy (right) departs from his wife Marie O'Neill and new-born baby. Various other soldiers, wives, sweethearts and parents were played by Anthony Bushell, Robert Newton, Martita Hunt, John Laurie, Rene Ray and Wally Patch (left). The different stories were cleverly linked by the writers Clemence Dane and Patrick Kirwan, floating in a sea of effective cliches. (PENDENNIS)

△Miraculously, Alexander Korda again persuaded the distinguished author H.G. Wells to write (with Lajos Biro) **The Man Who Could Work Miracles**, his second screenplay after *Things To Come* (1936). Directed by Lothar Mendes, this delightful comic fantasy was as light as the previous film was heavy, without sacrificing the Wellsian philosophy. Wells imagined what would happen if an ordinary little man were given the power to perform miracles and thus change the world. Roland Young (illustrated) was perfect as George McWirter Fotheringay, a draper's clerk, selected by the gods. One night he discovers (aided by Ned Mann's trick photography) that he can turn a lamp upside down, materialize animals, and send a policeman to Hell (later transferring him to San Francisco!). But when he tries to do good, he comes up against human nature. Moral: Humanity is not ready for Utopia just yet. Joan Gardner was the shop girl whose love the miracle worker tries, but fails, to gain for he cannot influence the human mind, and the rest of the supporting cast included Ralph Richardson, Ernest Thesiger, Robert Cochran, Lady Tree, Wallace Lupino, Gertrude Musgrove, Edward Chapman, Sophie Stewart, George Zucco and Wally Patch. (LONDON FILMS)

▷Although **A Star Is Born** was Oscar-nominated for Best Production (David O. Selznick), Best Director (William Wellman), Best Actor (Fredric March), Best Actress (Janet Gaynor) and Best Screenplay (Dorothy Parker, Alan Campbell and Robert Carson), it won awards for Best Colour Cinematography (William Howard Greene) and Best Original Story (Wellman and Carson). Ironically, the latter was not all that original, as it derived greatly from *What Price Hollywood?* (RKO, 1932). It was the abrasive and poignant screenplay that put it among the most vivid studies of Tinseltown, more accurate than its two later Warner Bros. remakes. However, both Judy Garland (1954) and Barbra Streisand (1976) were more convincing in the context as great stars than Janet Gaynor (left). She played a screenstruck farm girl who is discovered by and marries a film star (March, right). As her career grows, his declines, he becomes an alcoholic, and finally drowns himself. The character was partly based on Mary Pickford's first husband Owen Moore (who had a small role in this, his last, film). Giving superb support were Adolphe Menjou, Lionel Stander, Edgar Kennedy, May Robson, Andy Devine and Franklin Pangborn. A future star named Lana Turner, had a walk-on in her first movie. (SELZNICK INTERNATIONAL)

▽The woman was Miriam Hopkins as a go-getting architect, the man was Joel McCrea (both illustrated) as a tight-fisted young millionaire in **Woman Chases Man**, which Samuel Goldwyn entered in the screwball comedy stakes. While not up there with the best, the Dorothy Parker-Alan Campbell-Joe Bigelow screenplay (story by Lynn Root and Frank Fenton) contained enough irreverent humour and eccentric characters to keep lovers of the genre happy. At the centre was a farcical bit of chicanery organized by the architect and the tightwad's father (Charles Winninger) to get the son to invest in a building scheme. To give the impression that dad is rolling in dough, two movie theatre ushers (Ella Logan and Broderick Crawford) pretend to be a maid and butler at a shindig at which two tricksters (Erik Rhodes and Leona Maricle) attend as guests. Charles Halton, Roger Gray, William Jaffrey and George Chandler made up the rest of the cast. If director John G. Blystone had not over-encouraged the slapstick, the film might have been better. (GOLDWYN)

▽Fritz Lang's second American picture, **You Only Live Once**, was an unrelentingly sombre blend of Hollywood romanticism and German expressionism. The German Lang kept a cold eye on the subject of a fugitive couple moving through a shadowy Depression landscape, but the American Lang was gradually forced into religiosity and melodramatics. The Graham Baker-Gene Towne screenplay, the first inspired by the Bonnie and Clyde story, overstressed that young Eddie, a petty crook framed for murder, and his devoted wife, were victims of a cruel society. However, there was a brilliantly directed bank robbery shot from above, some powerful scenes, and poignant performances from Henry Fonda (illustrated) and Sylvia Sidney as the young couple. Barton MacLane, Jean Dixon, William Gargan, Ward Bond, Jerome Cowan, Chic Sale, Margaret Hamilton and Warren Hymer were also cast. It was the first production of a five-year contract with UA by Walter Wanger, who stated 30 years later that 'The picture for which Fritz Lang is given all the credit was completely my idea.' (WANGER)

▷Walter Wanger's **Stand-In** almost did itself an injury straining for laughs at the expense of Hollywood. The screenplay by Gene Towne and Graham Baker (story by Clarence Budington Kelland) lacked the teeth to bite the hand that fed it, ending up as mere burlesque. As Atterbury Dodd, a bookish New York accountant sent to balance the books of Colossal Studios, the usually distinguished Leslie Howard (left) lost his dignity, while Joan Blondell as a humble stand-in, had no dignity to lose as she taught Howard judo, rescued him from the studio vamp (Marla Shelton), and helped him to stand up to unscrupulous director Alan Mowbray and mogul C. Henry Gordon. Humphrey Bogart (right) played an honest producer (sic!), and Jack Carson a not-so-honest PR man. So many shots were aimed at the target by Tay Garnett's hectic direction, that some of them were certain to hit the bull's-eye. (WANGER)

◁Walter Wanger spent $1.4 million on **Vogues Of 1938** (TV: **Vogues**) $600,000 more than anticipated, thus forcing the UA board to keep a firmer hand on his future productions. The money was largely wasted on this frivolous fashion show of a film. Sam and Bella Spewack designed the scanty plot which concerned a leading Fifth Avenue couturier (Warner Baxter, centre left) whose selfish wife (Helen Vinson) wants him to back her in a show. A society girl (Joan Bennett, centre right) really loves him and helps out when the creditors start to become a nuisance. The string of glamorous gowns, designed by top designers and worn by some of America's top models, were very effectively displayed in gorgeous Technicolor. Also on parade, directed by Irving Cummings, were Mischa Auer, Alan Mowbray, Jerome Cowan, Alma Kruger, Marjorie Gateson, Dorothy McNulty and Hedda Hopper. (WANGER)

▷'I've always been known to have stacks of style,' says Barbara Stanwyck as **Stella Dallas** (left) in the remake of the 1926 weepie of feminine sacrifice. Stanwyck's style as an actress is indisputable, but poor Stella grew louder and coarser as the film progressed, almost as a deliberate reaction agains the stiff upper class gentility of her husband (stiff John Boles). Having trapped him into marriage, she proceeds to embarrass him and their teenage daughter (Anne Shirley) by wearing gaudy jewellery and 'Christmas tree' dresses. The husband leaves her for a woman (Barbara O'Neil) of his own class, and Stella marries a boorish bookmaker (Alan Hale). The daughter gains respectability by marrying smug wealthy young Richard Grosvenor (Tim Holt) while her mother, who has bravely renounced her claim to her adored child, watches the ceremony through the tear-stained window. The arguable moral of Victor Heerman and Sara Y. Mason's screenplay (from the Olive Higgins Prouty novel) seems to be that it's better to be boring than vulgar. The Samuel Goldwyn production was neither, under the polished direction of King Vidor. Stanwyck's all-stops-out performance gained her the first of her four Oscar nominations (She never won it!), and Anne Shirley (right) was also nominated for Best Supporting Actress. Marjorie Main, George Walcott, Gertrude Short and Nella Walker completed the cast. Nobody came to Stella Dallas's daughter's birthday party. Everybody went to see the picture. (GOLDWYN)

△Raoul Walsh, who had directed Douglas Fairbanks Sr in *The Thief Of Bagdad* (1924), now directed Fairbanks Jr in **When Thief Meets Thief** (GB: **Jump For Glory**). Further comparisons between that silent classic and this mild comedy-drama would be invidious. Fairbanks (centre) played a man down on his luck in New Orleans who gets involved with Alan Hale as an underworld character. Breaking away from Hale, he skips the country and gets himself to London where he operates as a cat burglar, but the love of a good woman (Valerie Hobson, right) sets him on the right road. The reformed hero then kills his former partner in self-defence and is cleared at the trial in which Basil Radford and Leo Genn played opposing lawyers. Other parts went to Jack Melford, Anthony Ireland, Barbara Everest (left), Edward Rigby and Esme Percy. The none-too-logical screenplay was written by John Meehan and Harold French (from the novel by Gordon MacDonell) for producer Marcel Hellman. (CRITERION)

▽More heat was generated during the shooting of **Fire Over England** by the well-publicized romance between the film's two glamorous stars – Laurence Olivier and Vivien Leigh (both illustrated) – than by this dull Elizabethan epic. (They married in 1940 after divorcing their respective spouses.) Olivier played a dashing soldier in the service of Elizabeth I (Flora Robson in the role she repeated in *The Sea Hawk*, WB, 1940), who enlists as a spy to expose a group of English traitors hired by Philip of Spain (Raymond Massey). Miss Leigh, as a lady-in-waiting waits on the Queen, and also waits for her lover (Olivier) to return. From the public's point of view, the only thing worth waiting for was Robson's speech to the troops, and not the sinking of the Armada which was obviously filmed in a bathtub. The large cast also included Leslie Banks, Tamara Desni, Morton Selten, Henry Oscar, Lawrence Hanray, Roy Russell, Robert Newton, Howard Douglas, Francis De Woolfe and, in a brief appearance, James Mason. American William K. Howard directed sluggishly from a script by Clemence Dane and Sergei Nolbandov (from the A.E.W. Mason novel) for producer Erich Pommer. (PENDENNIS)

▽The Agatha Christie story *Philomel Cottage*, the source of Frank Vosper's play and Frances Marion's script for **Love From A Stranger**, used the familiar theme of a man marrying a woman for money and then trying to do away with her. Ann Harding, in her only British film, played an office girl who wins a French lottery prize. On the boat to France, she meets suave Basil Rathbone (illustrated) who makes such an impression that they are soon married. They buy an isolated cottage in the country where he tricks her into signing her property over to him before trying to murder her. The twist in the tale comes when she claims to have poisoned him, so he dies of a heart attack. Few were thrilled to death by this Max Schach production, ably directed by Rowland V. Lee. Binnie Hale, Bruce Seaton, Jean Cadell, Bryan Powley, Joan Hickson and Donald Calthrop were also in it. It was remade 10 years later in Britain starring Sylvia Sidney and John Hodiak. (TRAFALGAR)

▽The cocktail of comedy and tragedy in **History Is Made At Night** was not too well shaken by director Frank Borzage. It concerned the love affair between Charles Boyer as 'the finest head waiter in all Europe' and wealthy society woman Jean Arthur. Boyer (left), who is wanted for a murder he didn't commit, follows her to New York on a liner and back again. Wanted for murder of the English tongue was Leo Carrillo (right) as super chef The Grand Cesare, who accompanies him. Tragedy occurs when Arthur's jealous shipbuilding husband (Colin Clive) is drowned as a result of his ship hitting an iceberg in thick fog. The fog was no doubt created by Gene Towne and Graham Baker's confusing screenplay. Others in the mediocre Walter Wanger production were Ivan Lebedeff, George Meeker, Lucien Prival, Georges Renavent, George Davis and Adele St Mauer. Gregg Toland's elegant cinematography was one of the film's saving graces. (WANGER)

△David O. Selznick's production of **The Prisoner Of Zenda** was the best and most profitable of the five versions of Anthony Hope's swashbuckling adventure story. This was due, in part, to Ronald Colman's (centre) immaculate double playing of the Englishman in Ruritania forced to impersonate the kidnapped king at his coronation to foil a rebel plot. (Others in the part were James K. Hackett, 1912, Rex Ingram, 1922, Stewart Granger, 1952, and Peter Sellers, 1979.) It also had a fine script by John Balderston, Wells Root and Donald Ogden Stewart, and splendid direction by John Cromwell. A superior cast was made up of Madeleine Carroll as the princess betrothed to the king, Raymond Massey as the usurper, Mary Astor as Massey's mistress and Douglas Fairbanks Jr as the soldier-swordsman Rupert of Hentzau whose confrontation with the hero is the film's climax. C. Aubrey Smith (left) and David Niven (right) were noble supporters of the king. (SELZNICK INTERNATIONAL)

△**Murder On Diamond Row** (GB: **The Squeaker**) was based by scenarists Bryan Wallace and Edward O. Berkman on Edgar Wallace's successful novel and play. Unfortunately, the unsubtle direction of William K. Howard did not make it difficult to spot whodunnit. The murder victim (Robert Newton) is a jewel robber who escapes from prison to get even with the man who betrayed him to the police. Clues lead Detective Barrabal (Edmund Lowe), while on the track of a receiver of stolen goods, to shipping magnate Frank Sutton (Sebastian Shaw, right), who makes a hysterical confession to the murder at the end. Ann Todd played Sutton's fiancee who falls for the sleuth, and other parts were taken by Tamara Desni, Allan Jeayes (left), Alastair Sim, Stewart Rome, Mabel Terry-Lewis and Gordon McLeod. A degree of suspense and humour were the only graces that saved this otherwise undistinguished Alexander Korda production from oblivion. A German version of the story was made in 1965. (LONDON FILMS)

▽The title of Alexander Korda's **Men Are Not Gods** should have served as a warning to the producer of this extremely mediocre comedy-drama. One wonders why Miriam Hopkins bothered to make the trip from Hollywood to London to star in this triangular tale set in a theatrical milieu, written and directed by Walter Reisch. Miss Hopkins played the stage-struck secretary of a drama critic (A.E. Matthews) who fires her for altering his review of *Othello* from negative to positive. She thereupon becomes the mistress of the actor playing the Moor (Sebastian Shaw, right). Later, during a performance of the play, he is about to literally strangle his co-star and wife (Gertrude Lawrence, centre) as Desdemona on stage, when his lover screams from the gallery. Husband and wife are reconciled, and Hopkins starts life anew with an obituary writer (28-year-old Rex Harrison). Laura Smithson, Lawrence Grossmith (left), Winifred Willard, James Harcourt, Noel Howlett, Sybil Grove and Val Gielgud in other roles, did their best to prop up this drivel. (LONDON FILMS)

△The love affair between a French woman spy, played by the very English Vivien Leigh, and her German spy contact, played by the very German Conrad Veidt, both illustrated, in **Dark Journey** (aka **The Anxious Years**) would have been unthinkable on screen a few years hence. Lajos Biro's play (adapted by Arthur Wimperis and Biro) was set in Stockholm where Leigh is the owner of a fashionable dressmaking establishment. On her numerous trips to Paris, she obtains information which she signals to German ships at sea. Veidt is sent from Germany to arrest her when it is discovered that she has been feeding them wrong information. But he is arrested by the Allies and she promises to wait for him until he comes out of prison. Although much of it was unconvincing, the radiant Miss Leigh and the smooth Herr Veidt made a piquant pair. Supporting were Joan Gardner, Anthony Bushell, Ursula Jeans, Margery Pickard, Eliot Markham, Austin Trevor, Sam Livesey, Henry Oscar and Robert Newton. It was atmospherically directed, and produced, by the excellent Victor Saville. (LONDON FILMS)

△Robert Flaherty, 'the father of the documentary film', went to India to do the location work on **Elephant Boy** and, once there, discovered the 11-year-old Sabu, former stable boy to a maharajah, and cast him in the title role. Unfortunately, much of Flaherty's work on the film was scrapped by producer Alexander Korda when the unit returned to England. Korda insisted on extensive changes and further scenes were shot by his director brother Zoltan Korda at Denham studios, including additional elephant sequences composed mainly of gigantic rubber elephant feet. Yet, the often uncomfortable mixture did not dampen the interest the picture aroused. Rudyard Kipling's tale *Toomai Of The Elephants* could be discerned in the screenplay by John Collier, Akos Tolnay and Marcia de Silva, which told of how Toomai (Sabu, illustrated) rides his elephant into the jungle, discovers a huge herd of elephants, rounds them up and brings them back to the white men. Sabu proved to be the most natural and charming of actors, outshining the British players W.E. Holloway, Walter Hudd, Allan Jeayes, Bruce Gordon and Wilfrid Hyde White. (LONDON FILMS)

▽It was while making **Knight Without Armour** in England that Marlene Dietrich was approached by Nazi agents who tried to persuade her to return to the Fatherland to make films. She refused and thereafter her films were banned in Germany. Not that they would have had much to object to in this picaresque thriller which used the Russian Revolution as background. A sort of 'Thirty-nine Steppes', in fact. Marlene (illustrated) as the Countess Alexandria is rescued from execution by British agent Robert Donat, who is posing as a Russian commissar. A white knight and a White Russian flee across Russia together pursued by Red baddies, falling in love in the process. The screenplay by Frances Marion, Lajos Biro and Arthur Wimperis (from James Hilton's novel *Without Armour*), paid scant regard to historical accuracy. Still, this opulent Alexander Korda production was directed with style by the Belgian Jacques Feyder, and the two stars shone brightly. Lesser lights were Irene Vanbrugh, Herbert Lomas, Austin Trevor, Basil Gill, David Tree, John Clements, Raymond Huntley and Miles Malleson. (LONDON FILMS)

▷The opening title of David O. Selznick's **Nothing Sacred** set the tone of screenwriter Ben Hecht's jaundiced satire on the popular press and its credulous readers: 'New York, skyscraper champion of the world, where the slickers and know-it-alls peddle gold bricks to each other, and truth, crushed to earth, rises more phony than a glass eye.' The plot of this Technicolor comedy, directed at a cracking pace by William Wellman, concerned Hazel Flagg, a small town girl who is wrongly diagnosed by the alcoholic local doctor as having fatal radium poisoning. She expresses a last wish to see New York before she dies, a wish granted by a newspaper who brings her to the city with all the attendant ballyhoo. When both she and the paper discover the mistake, they continue to exploit the story. The idea rapidly wore thin despite the welter of wisecracks, and Carole Lombard (left) was far too citified as the hick heroine. Fredric March (right) was good as the reporter she falls for, Walter Connolly (centre) was his irascible editor, and Charles Winninger the imbibing doctor. Also cast were Sig Rumann, Frank Fay, Maxie Rosenbloom, Margaret Hamilton, Hedda Hopper, Monty Woolley, Hattie McDaniel, Olin Howland and John Qualen. A box-office hit, it was remade as *Living It Up* (Paramount 1954), a Dean Martin-Jerry Lewis vehicle with Lewis in the Lombard role. (SELZNICK INTERNATIONAL)

△**Dreaming Lips** was almost an exact replica of the German film *Der Traumende Mund* (1932) with Elisabeth Bergner duplicating every gesture of the earlier performance that had made her famous. Paul Czinner directed his wife once again in the same manner, this time in an English version of Carl Mayer's script by Margaret Kennedy and Lady Cynthia Asquith. The plot, based on Henri Bernstein's faded melodrama, concerned a young girl (Bergner, illustrated) who marries an orchestra conductor (Romney Brent) much older than herself, but falls in love with a famous violinist (Raymond Massey, illustrated). Just as they are about to break the news to the husband, he falls seriously ill, so she nurses him devotedly before throwing herself in the river. Like it or not, the smiling and weeping Miss Bergner was virtually the whole film. Others involved in this Max Schach production were Joyce Bland, Sydney Fairbrother, Felix Aylmer, Fisher White, Bruno Barnabe, Charles Carson, Ronald Shiner and Cyril Raymond. (TRAFALGAR)

▽**52nd Street** was ten streets away from being a good musical. Grover Jones' soppy screenplay was essentially the history of the street from 1912 to 1937, personified by the Rondell family who lost their fortune in the Wall Street Crash and made another from speakeasies. Rufus Rondell (Ian Hunter) keeps his daughter (Pat Paterson, Charles Boyer's wife) in ignorance of his sordid business. Meanwhile, his partner Zamarelli (Leo Carrillo, right) has a son (Kenny Baker), educated in the classics, who wants to be a crooner. ZaSu Pitts and Dorothy Peterson appeared as snobbish aunts, Sid Silvers and Jack White were a couple of hoofers, with Al Shean (left), Marla Shelton, Billy Burrud (seated foreground) and Collette Lyons in other roles. Harold Young's heavy-handed direction was for producer Walter Wanger. (WANGER)

▷If Academy Awards for special effects had been started two years earlier, then James Basevi's work in creating the spectacular climactic storm in **The Hurricane** would certainly have won it. The Oscar the film did win, however, was for Best Sound Recording by Thomas T. Moulton. Other behind-the-scenes boys deserving mention were cameraman Bert Glennon and second unit director Stuart Heisler, who virtually co-directed the picture with John Ford. In front of the cameras were Dorothy Lamour in sarong and Jon Hall in loin cloth (both illustrated) as a happily married couple on a Polynesian island. Their idyll is interrupted when he is imprisoned for striking a white man who has insulted him. The vindictive governor (Raymond Massey) and a sadistic guard (John Carradine) make matters worse for the prisoner, despite the pleas for his liberation from the governor's wife (Mary Astor), a drunken doctor (Thomas Mitchell, Oscar-nominated for Best Supporting Actor), a priest (C. Aubrey Smith) and a sea captain (Jerome Cowan). The screenplay by Dudley Nichols and Oliver H.P. Garrett (from the novel by Charles Nordhof and James Norman Hall) offered a *faux naïf* melodrama with just enough interest to keep audiences patient as they waited for the furious typhoon which wreaks havoc on the island, but spares the lovers. The 1979 remake called *Hurricane* and starring Mia Farrow and Dayton Ka'ne was as much a flop for Paramount as this was a hit for producer Samuel Goldwyn. (GOLDWYN)

◁**Accused** was a backstage whodunnit made by Criterion, Douglas Fairbanks Jr's British company. He and Dolores Del Rio (left) starred as Tony and Gaby, a dancing couple and top liners in a Parisian show put on by Yvette Delange (Florence Desmond), a temperamental singer. She pursues Tony, arousing the jealousy of Gaby. When Yvette is found stabbed, Gaby is accused. At the trial a conviction seems certain until Tony arrives to prove that the nightwatchman did it. Gaby is found innocent, but producer Marcel Hellman, director Thornton Freeland and writers Zoe Akins and George Barraud must be found guilty of making this feeble film. Others involved were Basil Sydney, Athole Stewart, Cecil Humphreys, Esme Percy, Edward Rigby, Moore Marriott, Cyril Raymond, Googie Withers (right) and Roland Culver. (CRITERION)

◁Director William Wyler wanted to shoot **Dead End** on actual locations in New York's Lower East Side, but Samuel Goldwyn insisted on the use of one complex set (by Richard Day) to represent life in the slums. The result was a rather theatrical film based on a theatrical social protest play by Sidney Kingsley. Goldwyn paid $165,000 for the rights of the Broadway hit, and hired Lillian Hellman to write the screenplay. She had to water down much of the street language and soften some of the characters for the screen so that, instead of the inverted cripple of the play, Joel McCrea was a Hollywood hero who returns to the seedy environment after six years away. He aspires to a rich girl (Wendy Barrie) but settles for his old flame (Sylvia Sidney). Also returning to the district is gangster Baby Face Martin (Humphrey Bogart) who is cruel to his ex-girl (Claire Trevor) and – horror of horrors – his own mother (Marjorie Main)! The moralizing tone suggested that the kids of the neighbourhood should emulate good McCrea not bad Bogart. Most of the movie's box office success was due to the kids imported from the stage production, who became known as The Dead End Kids and later, with some changes in personnel, The East Side Kids and The Bowery Boys. They were, illustrated from left to right, Gabriel Dell, Bernard Punsley, Bobby Jordan, Billy Halop, Huntz Hall and Leo Gorcey. The production, the photography (Gregg Toland) the art direction (Richard Day) and Claire Trevor were Oscar-nominated. (GOLDWYN)

▽ The message that sport and discipline develop the masculine virtues and strength of character was already pretty corny before **The Duke Of West Point** trotted it out again. Neither director Alfred E. Green, nor scenarist George Bruce could do much to freshen up this rah-rah college picture. The hero was Louis Hayward, fresh from Cambridge and a wow on the football field at West Point, but considered too cocky by the other (rather old-looking) students. Hayward, however, proves himself by paying the college fees for plebby Richard Carlson, and winning the annual hockey game against a Canadian college. Joan Fontaine (illustrated) was the ingenue who loves the sports champion. Tom Brown, Donald Barry, Alan Curtis (illustrated) and Gaylord Pendleton played other cadets with Charles D. Brown, Jed Prouty, Marjorie Gateson, Emma Dunn, Jonathan Hale and William Bakewell also cast in support. The producer of this routine exercise was Edward Small. (SMALL)

▷ The personalities of Joan Bennett and Henry Fonda redeemed **I Met My Love Again** from being just another small town soaper. David Hertz's screenplay didn't stray far enough from the original woman's magazine serial by Allene Corliss, nor did co-directors Arthur Ripley and Joshua Logan (both making their first picture) discourage this. Bennett and Fonda (both illustrated) played a couple who are engaged until she elopes to Europe with playboy-author Alan Marshal. She returns ten years later, a widow with a daughter (Genee Hall). Fonda, now a college professor, rejects her until a student of his (Louise Pratt, in her screen debut) becomes infatuated with him. He begins to understand that the same kind of infatuation had motivated his ex-fiancee and they marry despite opposition from her daughter, and most of the town's folk, who included Dame May Whitty, Alan Baxter, Tim Holt, Dorothy Stickney and Florence Lake. True love conquered all, though Walter Wanger's production failed to do the same. (WANGER)

▽ **Trade Winds** was the picture in which Joan Bennett (illustrated) changed from blonde to brunette on screen (and stayed that way for the rest of her career). This was at the suggestion of the film's producer Walter Wanger, who was to marry Miss Bennett in 1940. Another reason for the dye-job, was that she was a murder suspect being chased around the world by Fredric March as Detective Sam Wye of the San Francisco police. He catches up with her in the Far East, they fall in love and he proves her innocent. A second romance concerned Ann Sothern as March's dumb blonde sidekick and Ralph Bellamy as dumb Detective Blodgett. Sidney Blackmer, Robert Emmett O'Connor (illustrated), Robert Elliott, Patricia Farr, Phyllis Barry, Dorothy Tree and Walter Byron also had roles in this whirlwind comedy-thriller. Globe-trotting director Tay Garnett had shot several scenes in Japan, India and China a few years before and he managed to work in this material cleverly as back projections. He also wrote the story on which Dorothy Parker, Alan Campbell and Frank R. Adams built the snappy screenplay. Despite a weak dénouement, the movie was a critical and commercial success. (WANGER)

▽ Contributing greatly to the success of **The Divorce Of Lady X**, were four of producer Alexander Korda's pet scriptwriters, Lajos Biro, Arthur Wimperis, Robert E. Sherwood and Ian Dalrymple, excellent Technicolor photography by Harry Stradling, splendid sets by Lazare Meerson and sumptuous costumes by René Hubert. It began at a fancy-dress ball given at a London hotel, where Merle Oberon and Binnie Barnes are wearing identical Empress Eugenie costumes. As a thick fog envelops the hotel and nobody can venture home, Oberon spends the night (innocently) in the room of a young barrister (Laurence Olivier). It so happens that Ralph Richardson thinks he sees his wife (Barnes) leaving the man's suite in the morning. The fact that everyone was slower than the audience in solving the problem mattered little, thanks to the performances of the four leads. (Oberon and Olivier illustrated). Tim Whelan directed and minor roles went to Morton Selten, J.H. Roberts, Gertrude Musgrove and Gus McNaughton. Binnie Barnes had played the Oberon role in a 1933 film entitled *The Counsel's Opinion*, from the Gilbert Wakefield play of the same name. (LONDON FILMS)

△In **Action For Slander**, someone wittily describes the jury system in England as 'the incompetent adjudicating on the incomprehensible!' There was nothing incompetent, however, about the direction of the film by its producer Victor Saville (with Tim Whelan), nor incomprehensible about the script by Miles Malleson and Ian Dalrymple (story by Mary Borden). The law suit of the title is taken by an army major (Clive Brook) against two fellow officers (Arthur Margetson and Anthony Holles) who have accused him of cheating at cards. This slur, false though it may be, has led to his being asked to leave the army and, far worse, his gentleman's club. Supported by his estranged wife (anaemic Ann Todd, illustrated), two army colleagues (Ronald Squire and Percy Marmont), and his cockney batman (Gus McNaughton), he embarks on a fight to clear his name. Margaretta Scott played his mistress, Francis L. Sullivan (illustrated) was the plaintiff's lawyer, and Morton Selten an eccentric judge. It all made for good, gripping entertainment. (LONDON FILMS)

△**The Return Of The Scarlet Pimpernel** was not as welcome to audiences as was his first appearance in 1935 as personified by Leslie Howard. Sir Percy Blakeney, alias the Pimpernel, came back in the shape of Barry K. Barnes (left), making only his second film. While fairly personable, he did not have the star quality of Howard, or that of David Niven in *The Elusive Pimpernel* (British Lion, 1950). Baroness Orczy's famous novel provided screenwriters Lajos Biro, Arthur Wimperis and Adrian Brunel with a plot involving the kidnapping of Lady Blakeney (Sophie Stewart) arranged by Chauvelin (Francis Lister, right), Sir Percy's trip to France to rescue her, and the Pimpernel's part in the downfall of Robespierre (Henry Oscar). Others making up the cast were Margaretta Scott, James Mason, Patrick Barr, David Tree, Allan Jeayes, Esme Percy and Anthony Bushell. Only the guillotine had any edge in this Alexander Korda-Arnold Pressburger production, directed by Hans Schwartz. (LONDON FILMS)

▽After producer Walter Wanger had screened **Blockade**, he said to his press agent, 'What can we do about this picture? All the way down the line it just misses, although the idea is good.' The agent immediately told the newspapers that Generalissimo Franco had banned it in Spain. Needless to say, Franco had neither seen nor heard of the film, but the ploy created some interest in it. Wanger's criticism of this turgid Spanish Civil War drama was correct. The war was artificially depicted, the sets were synthetic, and John Howard Lawson's story and screenplay so bland and vague that nobody knew which side

it was supposed to be on. Director William Dieterle placed picturesque faces in patriotic poses when not concentrating on the love affair between a loyalist peasant (Henry Fonda) and a White Russian (Madeleine Carroll) – both illustrated – whose father (Vladimir Sokoloff) is involved in espionage. Leo Carrillo as Fonda's comic sidekick, John Halliday, Reginald Denny, Robert Warwick, Fred Kohler and Katherine DeMille did their best in support. The picture gets E for Effort for being one of the first Hollywood films of the 30s to deal with contemporary politics. (WANGER)

▷The latest Samuel Goldwyn discovery, Sigrid Gurie, billed as 'The Siren Of The Fjords', was somewhat bizarrely cast as a Chinese princess in her first movie, **The Adventures Of Marco Polo**. All-American Gary Cooper (left) was the Venetian traveller of the title who wins her hand at the palace of her father, the Emperor Kubla Khan (George Barbier) in 13th-century Peking. He also manages to act as marriage counsellor to a warlord (Alan Hale) and his wife (Binnie Barnes), and overcome the Emperor's arch-enemy, the evil Saracen Ahmed (Basil Rathbone, right). Ernest Truex, H.B. Warner, Robert Greig, Ferdinand Gottschalk and Henry Kolker played other roles. Future siren Lana Turner had a bit part as a maid. Robert E. Sherwood's screenplay (based on a story by N.A. Pogson) had its tongue firmly in its cheek, but this flimsy pantomime, directed by Archie Mayo, was greatly in need of Technicolor. (GOLDWYN)

◁Gary Cooper and Merle Oberon were **The Cowboy And The Lady**, brought together under the auspices of Samuel Goldwyn. But this chalk and cheesy combination fell as flat as a thrown bronco rider. The intention of screenwriters S.N. Behrman and Sonya Levien, and the authors of the original story, Leo McCarey and Frank R. Adams, might have been to satirize American politics and high social life, but bite and humour were lacking under H.C. Potter's direction. Cooper (illustrated) was a rodeo rider who meets up with Oberon, the bored daughter of a presidential candidate who swaps places with her maid. They fall in love and elope to Texas, but when he discovers her deception, she leaves to join her father in Palm Springs. This Mr Deeds in a cowboy suit follows her, lectures the stuffed shirts at a dinner party on the simple life, and rescues her from riches. Walter Brennan and Fuzzy Knight (members of the rodeo troupe), Patsy Kelly (the real maid), Henry Kolker (the politician father), Henry Davenport (a jitterbugging uncle), Emma Dunn, Walter Walker, Berton Churchill, Charles Richman and Arthur Hoyt also appeared. (GOLDWYN)

△Storm In A Teacup, made at Alexander Korda's Denham Studios, was the type of comedy that Ealing Studios were to make so successfully in the late 40s. So British was the humour, that it was difficult to believe it derived from a German play by Bruno Falk called *Sturm In Wasserglas* which James Bridie translated as *Storm Over Patsy* for the stage, transporting the action to Scotland. Ian Dalrymple, who co-directed the play with its producer Victor Saville, adapted it further for the screen. The storm of the title is caused when an Irish widow's dog is confiscated by the authorities because its owner can't afford to pay the licence fee. A local reporter (Rex Harrison, left) takes up her cause, inflaming public opinion against the pompous Provost (Cecil Parker) whose own daughter (Vivian Leigh, right) turns against him. The Provost's political career is almost ruined when a dinner he gives for the party leader is invaded by hundreds of dogs. Sara Allgood was the widow and others taking part in this fine comic brew were Ursula Jeans (centre), Gus McNaughton, Edgar Bruce, Robert Hale, Quinton McPherson, Arthur Wontner, Arthur Seaton and, at the centre of it all, Patsy the dog. (SAVILLE)

△Charles Boyer (left) did *not* say 'Come with me to the Casbah' in **Algiers**, but he was stuck with the phrase for most of his life. Still, this epitome of Hollywood exotic romance established him as one of the screen's great continental lovers. And opposite him was ravishing Hedy Lamarr making her American screen debut! He played a fugitive from justice who finds sanctuary among the criminals in the impenetrable maze of the Casbah of Algiers, while the local inspector (Joseph Calleia, right) waits patiently for him to leave. He is tempted out by Lamarr, a visitor from Paris, and betrayed by the jealous half-caste woman (Sigrid Gurie) who loves him. Boyer,

Gene Lockhart, who played a snivelling informer, and cinematographer James Wong Howe, were nominated for Oscars. But despite Walter Wanger's elaborate production and John Cromwell's atmospheric direction, the picture paled beside Julien Duvivier's French film *Pepe Le Moko* (1937) starring Jean Gabin, although John Howard Lawson and James M. Cain kept as close as possible to the original screenplay by Henri Jeanson and Roger D'Ashelbe, based on the latter's novel. It was remade as a musical called *Casbah* (Universal, 1948) with crooner (and inadequate actor) Tony Martin taking the part of Pepe. (WANGER)

△If one could swallow that the Anglo-Saxon cast of **The Gaiety Girls** (GB: **Paradise For Two**) were all supposed to be terribly French, then it was possible to enjoy this bright backstage musical comedy directed by Thornton Freeland. The not overly original screenplay by Arthur MacRae used the familiar mistaken identity angle, with a Parisian chorus girl (American Patricia Ellis, illustrated) pretending to be having an affair with a millionaire banker (jut-jawed Jack Hulbert, illustrated) in order to keep the backers of her show happy. The millionaire, disguised as a reporter, gets to know her, falls for her, ends up backing the show and even co-stars in it. Supporting the reasonably talented leads were Arthur Riscoe, Googie Withers, Sydney Fairbrother, Wylie Watson, David Tree and Roland Culver. (LONDON FILMS)

△Samuel Goldwyn's first all-Technicolor production, **The Goldwyn Follies** was long (two hours), costly ($2 million), and dreadful. In it, a Hollywood producer (Adolphe Menjou) hires an average girl (average Andrea Leeds) to judge the quality of his scripts before they go into production. A pity Goldwyn didn't have a similar girl to turn down the script by Ben Hecht and, legend has it, ten others. The story linked a series of uneven numbers performed by, among others, Vera Zorina in two garish ballets

choreographed by her husband George Balanchine, ventriloquist Edgar Bergen and his dummy Charlie McCarthy, Met singers Helen Jepson and Charles Kullman, dangerously high tenor Kenny Baker, and low comics The Ritz Brothers (illustrated). Also featured were Phil Baker, Ella Logan, Bobby Clark and Jerome Cowan. This mish-mash was directed by George Marshall and H.C. Potter. It contained the last songs written by George Gershwin, who died before its completion. (GOLDWYN)

▽**There Goes My Heart** was the first of 14 features that madcap comedy producer Hal Roach provided for UA between 1938 and 1941. It was a typical Roach product, the parts being greater than the whole. The inconsequential screenplay by Eddie Moran and Jack Jevne (story by Ed Sullivan of TV fame) concerned an heiress (Virginia Bruce, right) who gets a job in her family's department store as a salesgirl, under an assumed name. A tough reporter (Fredric March) gets wind of it, threatens to expose her, but falls for her instead. Somehow, they end up shipwrecked on a desert island where, luckily, a priest (Harry Langdon) turns up to marry them. Punctuating the well-worn story were comic episodes involving the likes of Patsy Kelly (left) and Nancy Carroll (as shop assistants), Alan Mowbray (a correspondence school chiropractor), Eugene Pallette (a dyspeptic newspaper editor), Arthur Lake (a clumsy photographer), Marjorie Main (an irascible shopper), and Claude Gillingwater (the heroine's millionaire grandfather). Former gag writer Norman Z. McLeod directed it with ease. (ROACH)

△To an American audience **South Riding** might have conjured up visions of General Lee's army on the move, but to the English it meant an area in Yorkshire. To readers it also meant a long, realistic novel by Winifred Holt about a small community in the dales where public and private lives impinge on one another. The central figure is the imperious local squire Robert Carne (Ralph Richardson, right), depressed by the mental illness of his wife (Ann Todd), and anxiously watching his daughter (15-year-old Glynis Johns in her screen debut) growing up painfully. He finds solace in the arms of the schoolmistress (Edna Best) who supports his revelations of corruption among the town councillors. Other inhabitants of the well-created town were Edmund Gwenn (left) as a lay preacher, Marie Lohr, the lady of the manor, Milton Rosmer, an alderman, and John Clements, a consumptive socialist. Much of the novel's left-wing views were emasculated in Ian Dalrymple and Donald Bull's meandering screenplay, and London Films producer Victor Saville directed at a slow pace. But it allowed Ralph Richardson time to give one of the best of his early film performances. (LONDON FILMS)

▽**Drums** (GB: **The Drum**) beat a Technicolored tattoo to the glory of British imperialism in India. According to scenarists Lajos Biro, Arthur Wimperis, Patrick Kirwin and Hugh Gray, and the original story by A.E.W. Mason, the English red coats were all gallant, upright and intelligent, while the natives were cowardly, dishonest and cruel. Except, that is, for Prince Azim (Sabu, illustrated) who was educated at an English school. The wicked Prince Ghul (Raymond Massey) has usurped the throne of the young Prince, and plans to revolt against the British. With the help of a little drummer boy (Desmond Tester), Sabu learns to beat out a message that saves the troops from ambush. Roger Livesey and Valerie Hobson as Captain and Mrs Carruthers, David Tree, Francis L. Sullivan, Archibald Batty, Ronald Adam and Edward Lexy played bulwarks of the Empire. Alexander Korda's pleasing production, directed by his brother Zoltan, was full of action and the charm of the smiling Sabu. (LONDON FILMS)

△David O. Selznick's **The Adventures Of Tom Sawyer** was superior to the other versions of Mark Twain's children's classic which starred Jack Pickford (1917), Jackie Coogan (1930), and Johnny Whitaker (1973). In this Technicolor production, Tommy Kelly (left) took the title role with Jackie Moran (Huckleberry Finn, right), Ann Gillis (Becky), May Robson (Aunt Polly), Walter Brennan (Muff Potter), Victor Jory (Injun Joe), Spring Byington (Widow Douglas), David Holt (Sid Sawyer), Victor Kilian, Nana Bryant, Charles Richman, Donald Meek, Margaret Hamilton and Marcia Mae Jones making up a rich gallery of characters. Despite some Hollywoodian sentimentality and slapstick, Norman Taurog's direction kept much of the spirit of the original intact. Most of the favourite episodes such as the whitewashing of the fence, runaways Tom and Huck watching their own funeral, and witnessing the graveyard murder, the courtroom scene when Tom accuses Injun Joe, and Tom and Becky lost in the caves (designed by no less than William Cameron Menzies), remained intact in John V. A. Weaver's screenplay, and audiences were delighted. (SELZNICK INTERNATIONAL)

△A family of confidence tricksters was the promising subject of David O. Selznick's **The Young In Heart**, which also offered a mouthwatering cast. But the languid direction of Richard Wallace, and the screenplay by Paul Osborn and Charles Bennett from the story *The Gay Banditti* by I.R. Wylie, created a gooey allegory posing as a screwball comedy. The family concerned was that of Colonel Anthony 'Sahib' Carleton of the Bengal Lancers (Roland Young, foreground centre) who has never been in the army or even to India, his feather-brained wife Marmy (Billie Burke, foreground centre left), and his golddigging children, George-Anne (Janet Gaynor, foreground centre right) and Richard (Douglas Fairbanks Jr, foreground left). The daughter hopes to snare a Scottish millionaire (Richard Carlson, standing foreground right, an unimpressive debut) to relieve the family's penury. Then they all happen to meet a sweet, rich, old lady called Miss Fortune (Minnie Dupree, lying foreground) whose example and advice makes them see the error of their ways. In the end, the son is even prepared to go to the extreme of taking a job to please the girl he loves (Paulette Goddard, standing foreground left). Others cast were Eily Malyon, Lucile Watson, Henry Stephenson, Irvin S. Cobb and Lawrence Grant. (SELZNICK INTERNATIONAL)

▷'There is that incandescence about Miss Bergman, that spiritual spark which makes us believe that Selznick has found another great lady of the screen,' wrote the *New York Times* critic in October 1939 of 24-year-old Ingrid Bergman's Hollywood debut in **Intermezzo** (GB: **Escape To Happiness**). David O. Selznick had spotted her in the original Swedish version of 1936 and brought her to America for the remake. (He wanted to change her name and glamorize her, but she refused.) George O'Neil adapted the screenplay by Gosta Stevens and Gustave Molander, and Gregory Ratoff directed this sentimental romance diluted with the popular classics. It concerned a brief (69 minutes) encounter between a married Swedish violinist played by the impeccably English Leslie Howard, and a young pianist (Bergman, illustrated). He leaves his wife (Edna Best) and his beloved little daughter (child actress Ann Todd) for a backdrop Mediterranean where the lovers make beautiful music together. But he soon misses his family so Bergman, the sympathetic other woman, gives him up for his own happiness, while the Robert Henning-Heinz Provost love theme underlined every emotion. Others cast: John Halliday (illustrated), Cecil Kellaway, Douglas Scott, Eleanor Wesselhoeft and silent screen star Enid Bennett. It couldn't miss. And didn't. (SELZNICK INTERNATIONAL)

▽Those anything but ordinary stars, James Stewart and Carole Lombard (both illustrated), played the very ordinary couple, John and Jane Mason, in David O. Selznick's **Made For Each Other**. He's a struggling young lawyer, she's a housewife, and they share an unremarkable apartment with his snooty mother (Lucile Watson). Jane gets John to ask his boss (Charles Coburn) for a partnership in the firm, but he returns home drunk, having accepted a 25% cut

in his salary. They have a baby, argue, decide to separate, but are united when the child is seriously ill. This nicely acted, cosy comedy, sensitively directed by John Cromwell from Jo Swerling's screenplay, grew a bit soggy at the end, but was enjoyable along the way. The cast was completed by Eddie Quillan, Alma Kruger, Ruth Weston, Donald Briggs, Harry Davenport, Esther Dale, Russell Hopton, Ward Bond and Louise Beavers. (SELZNICK INTERNATIONAL)

◁Hal Roach produced and directed **Captain Fury**, a rousing comedy-adventure set in 19th-century Australia but shot in 20th-century California. In fact, Grover Jones, Jack Jevne and William De Mille fashioned a screenplay that made Down Under seem more like Down West. Brian Aherne (right) as an Aussie Zorro, escapes from a prison camp, liberates the convicts and organizes a band of outlaws to protect the poor settlers from cruel landowner George Zucco and his gangsters. He wins the support of brutish Victor McLaglen (left) after standing up to him in a fight, and the love of pioneer girl June Lang. John Carradine and Douglass Dumbrille were heavies while Billy Bevan and Claude Allister provided some broad humour. Paul Lukas, Virginia Field, Charles Middleton, Lawrence Grossmith, Lumsden Hare and Mary Gordon completed the cast. (ROACH)

▽Producer Edward Small put his money on **King Of The Turf** and lost. This racetrack melodrama was a non-starter, despite a fine dramatic performance from Adolphe Menjou (left) as a once famous stable owner who has degenerated into a drunken bum. He is persuaded to make a comeback by an honest jockey (Roger Daniel, right), and they buy a colt, train him, and start to win races. But Menjou finds out that the jockey is his son, and deliberately breaks the boy's attachment to him by turning crooked so that he will return to his mother (Dolores Costello) and stepfather (Walter Abel). George Bruce's screenplay was similar to *The Champ* (MGM, 1931), but the direction of Alfred E. Green made this a long stretch. Also rans were Alan Dinehart, William Demarest, Harold Huber, George McKay, Lee M. Moore and, as the little black stableboy, Snowflake. (SMALL)

▷Samuel Goldwyn had acres of heather shipped to the California hills for his favourite production **Wuthering Heights**, but it needed more than heather to reproduce the greatness of Emily Bronte's Gothic novel. Gregg Toland's moody photography and James Basevi's set designs tried to recreate the Yorkshire moors, but William Wyler's direction made the venture into a glossy Hollywood romantic melodrama, covered in Alfred Newman's syrupy music. Yet, Ben Hecht and Charles MacArthur's screenplay, adapted only from the first half of the novel up to Cathy's death, worked surprisingly well as narrative, and the darkly handsome Laurence Olivier (illustrated) scored as Heathcliff. As his immortal love, Cathy, Merle Oberon (illustrated) did her limited best. David Niven as her milk-soppy husband Edgar (a part he loathed), Hugh Williams (her brutish brother Hindley), Cecil Kellaway (her father), Donald Crisp (the doctor), Leo G. Carroll (the servant Joseph) and Miles Mander (Lockwood) gave worthwhile interpretations. Flora Robson (Ellen Dean) and Geraldine Fitzgerald (Isabella) each made effective Hollywood debuts, the latter being Oscar-nominated for Best Supporting Actress. Also up for an Academy Award were Goldwyn, Wyler, and Olivier, but it was Toland who won his — and the film's — only statuette. Gratifyingly large box-office receipts accompanied the many plaudits the film received. Other versions of the novel were made in 1920 and 1970, and by Luis Buñuel as *Abismos De Pasion* (1954), which was made and set in Mexico. (GOLDWYN)

◁The trick photographic joke of ghosts appearing and disappearing, walking through walls, and moving objects about, was beginning to wear a little thin in **Topper Takes A Trip**, the second of three films based on the *Topper* novels of Thorne Smith. Cary Grant appeared briefly in a flashback from *Topper* (MGM, 1937), but as his services had become too pricey for producer Hal Roach, he was replaced by a wire-haired terrier called Mr Atlas. Constance Bennett, as Marion Kerby, the socialite spectre, and Roland Young (left) and Billie Burke as the haunted Mr and Mrs Topper, survived into the sequel written by Eddie Moran, Jack Jevne and Corey Ford, and directed once again by Norman Z. McLeod. The trip the Toppers take is to the Riviera, where Marion spirits Mrs Topper away from a philandering aristo (Alex D'Arcy, right), thus saving the marriage. Verree Teasdale, Alan Mowbray, Franklin Pangborn, Paul Hurst, Eddy Conrad and actor-director Irving Pichel were also in it. The lively box-office returns instigated *Topper Returns* in 1941. (ROACH)

△Constant arguments between producer Hal Roach and comedian Stan Laurel, led Roach to unite Harry Langdon with Oliver Hardy in **Zenobia** (GB: **Elephants Never Forget**). This sole Langdon and Hardy effort was a lumbering comedy about the eponymous elephant owned by Langdon as Professor McCrackle. After having a knot untied from her tail by Doctor Tibbett (Hardy, illustrated), Zenobia thereafter follows him around like a faithful dog. The professor sues the doctor for alienation of affection, and the public could have sued Mr Roach for the same reason. However, screenwriters Walter De Leon, Corey Ford and Arnold Belgard (working from the story *Zenobia's Infidelity* by H.C. Bunner), tried to avoid comparison with the famous Laurel and Hardy comedy partnership by getting Langdon and Hardy to play two separate characters among many. The other inhabitants of a small town in the south in 1870, were the doctor's wife (Billie Burke, illustrated), the town snob (Alice Brady), and black servants Zero and Dehlia (Stepin Fetchit and Hattie McDaniel). Also in it were James Ellison, Jean Parker, June Lang, Olin Howland, Hobart Cavanaugh, Chester Conklin and Tommy Mack. Former *Our Gang* director Gordon Douglas failed to lend any style to his first solo attempt at a feature film. Thankfully, Laurel and Hardy were back together again the following year in *A Chump At Oxford*. (ROACH)

▷Instead of a showdown with guns or custard pies, **The Housekeeper's Daughter** ended with a duel of fireworks. There were plenty of comic fireworks, too, prior to the zany finale of this typically broad and boisterous Hal Roach production, directed by himself. The Rian James – Gordon Douglas scenario (from a novel by Donald Henderson Clarke) contained a hard-drinking reporter (Adolphe Menjou), his photographer sidekick (William Gargan), their apoplectic city editor (Donald Meek), a racketeer who doesn't scare anybody (Marc Lawrence), and a simpleton (George E. Stone) who innocently bumps off people with poisoned coffee. In the title role, tough cookie Joan Bennett (illustrated) helped the sappy hero (John Hubbard, illustrated) a wealthy young professor, to solve the case of a murdered showgirl (Lilian Bond). Peggy Wood played the housekeeper, and Victor Mature made his beefy entrance into the movies as a gangster. (ROACH)

▷The three Korda brothers, Alexander (producer), Zoltan (director) and Vincent (art director) put together **The Four Feathers**, one of the best of British imperialist spectacles. The story by A.E.W. Mason, and the screenplay by R.C. Sheriff, Lajos Biro and Arthur Wimperis, was not only a straightforward yarn of Kitchener's Sudan campaign, but also touched on the nature of heroism. Henry Faversham (John Clements, left) resigns his commission on the eve of the expedition, and is sent white feathers by four of his fellow officers, symbolizing cowardice. To find the courage he has lacked, he goes off to the Middle East, adopts native costume, saves the life of his best friend (Ralph Richardson, right) who has been blinded in the desert, liberates two comrades from prison, and penetrates the lines of the 'Fuzzy Wuzzies' at Khartoum. C. Aubrey Smith was splendid as a military bore, with other roles going to June Duprez (the hero's waiting woman), Allan Jeayes, Jack Allen, Donald Gray, Frederick Culley, Clive Baxter, Henry Oscar and John Laurie. Despite its dubious ideology, the film still holds up as a full-blooded adventure in glorious Technicolor, far more successful than the 1929 Paramount version, the remake *Storm Over The Nile* (Rank, 1956) or the made-for-television version of 1978. (LONDON FILMS)

△**The Man In The Iron Mask** was a rather creaky costume piece, pricked into life by some able swashbuckling. The familiar Alexandre Dumas tale, liberally adapted by George Bruce, told of the twin heirs to the throne of France, one good and one evil (both expertly played by Louis Hayward, right). The baddie imprisons the goodie in a dungeon in the Bastille, becomes Louis XIV with the aid of the wily Fouquet (Joseph Schildkraut), and woos, in his brother's place, Maria Theresa, the Spanish Infanta (Joan Bennett, using her new-found dark hair to good effect). Along come D'Artagnan (Warren William, left) and The Three Musketeers (Alan Hale, Miles Mander and Bert Roach) to the rescue. Albert Dekker was Louis XIII, nightclub singer Marian Martin his mistress, Doris Kenyon was Queen Anne, Montagu Love the Spanish ambassador and Walter Kingsford Colbert. It was directed by a declining James Whale for producer Edward Small, who had hoped to duplicate his success with *The Count Of Monte Cristo* (1934). Memories of Fairbanks Sr in *The Iron Mask* (1929) had not faded. (SMALL)

▽**Slightly Honorable** was a more than slightly confusing comedy-thriller that must have baffled audiences as much as it obviously did its writers Ken Englund, John Hunter Lay and Robert Tallman. The accumulation of suspects and bodies was clearer in the novel, *Send Another Coffin* by F.G. Presnall, from which the plot derived. It didn't really matter, because Walter Wanger's production, directed at a canter by Tay Garnett, had as many wisecracks as red herrings. Basically, it concerned the attempt by a crooked politician (Edward Arnold, illustrated) to frame a lawyer (Pat O'Brien) on a murder rap. But, with the help of his associate (Broderick Crawford), the accused catches the real killer in the end. Ruth Terry (as a dumb nightclub dancer), Claire Dodd, Alan Dinehart, Janet Beecher (illustrated), Phyllis Brooks, Douglass Dumbrille, Eve Arden, Evelyn Keyes, Addison Richards, Douglas Fowley and Willie Best made up the bright and cheerful cast. (WANGER)

▽Walter Wanger's **Eternally Yours**, a comedy about the on-off-on romance between escapologist-magician David Niven (left) and heiress Loretta Young, was escapist but lacked magic. They marry, but she feels neglected for his stunts. So, after a Reno divorce, she weds boring Broderick Crawford on the rebound. Later, of course, she realizes how much she loves Niven when he leaps handcuffed from a plane at New York's World Fair. Director Tay Garnett (who appeared briefly as the airplane pilot) could pull few rabbits out of the hat to rescue Gene Towne and Graham Baker's empty script, despite moving rapidly from location to location. The tedium was relieved intermittently by the delightful supporting cast of Hugh Herbert (right, as the magician's incompetent valet), C. Aubrey Smith (a bishop), Billie Burke, Virginia Field, Raymond Walburn, ZaSu Pitts, Eve Arden, Ralph Graves, Lionel Pape, May Beatty and Herman the rabbit. (WANGER)

▽Samuel Goldwyn paid virtuoso classical violinist Jascha Heifetz $120,000 to star in **They Shall Have Music** (GB: **Melody Of Youth**), a piece of high-class schmaltz with pretensions to culture. Heifetz was no Gable, but his fantastic fiddling was the highlight of the movie. In the script by John Howard Lawson (story by Irmgard Von Cube), he is persuaded by the kids of an East Side school for young musicians to give a fund-raising concert. Gene Reynolds (illustrated – now a TV producer), Terry Kilburn and 12-year-old Dolly Loehr (better known as Diana Lynn from 1941) were among the gifted youngsters on show, Dolly playing Chopin's 'Minute Waltz'. Walter Brennan, as head of the school, Joel McCrea, Porter Hall and the Peter Merembum California Junior Symphony Orchestra lent support, musical and otherwise. Director Archie Mayo went all out to pluck audience's heartstrings, and succeeded. (GOLDWYN)

▽Director Henry Hathaway tried to do for the Americans in **Real Glory** what he had done for the British in *Lives Of A Bengal Lancer* (Paramount, 1935), with the same star, Gary Cooper (centre) once again defeating a whole army of native upstarts almost singlehandedly. Although Jo Swerling and Robert R. Presnell's script (from Charles L. Clifford's novel) was a simplistic justification for the US army presence in the Philippines in 1906 after the Spanish-American war, it was really an excuse for an action-packed adventure in an exotic setting. Army surgeon Cooper, happy-go-lucky David Niven (left), and boneheaded, orchid-loving Broderick Crawford (right) are sent to Manila to help the local constabulary crush the rebel forces of wicked oriental bandit Alipang (Tetsu Komai). The trio triumphs over all odds, and Cooper ends up in the arms of Andrea Leeds, the daughter of the commanding officer. Reginald Owen, Kay Johnson, Russell Hicks, Vladimir Sokoloff, Benny Inocencio, Ruby Robles and Henry Kolker also appeared in this flag-waving Samuel Goldwyn production. (GOLDWYN)

△**Prison Without Bars** was one of several productions in the 30s that were remade in Britain from a European film. In this case, a French picture *Prison Sans Barreaux* (1937), set in a seminary for wayward young women outside Paris. The screenplay by Arthur Wimperis and Margaret Kennedy stuck pretty closely to the Gallic original written by E. and O. Eis, Gina Kaus and Hans Wilhelm, although it had an all-British cast, excepting Corinne Luchaire who repeated her role from the earlier film. She played a delinquent helped by a crusading superintendent to become a nurse to the resident doctor. Edna Best in her last British film before leaving for Hollywood, was the sympathetic reformer, and Barry K. Barnes Miss Best's doctor fiance who goes off with the girl in the end. Other internees were Mary Morris (left), Glynis Johns and Lorraine Clewes (right), with Martita Hunt, Margaret Yarde and Elsie Shelton as their jailors. This rather faded *Mädchen In Uniform*-type picture, which included a rebellion, sadistic treatment and romantic interludes, was directed at a modulated pace by Brian Desmond Hurst for Alexander Korda. (LONDON FILMS)

▷**Stagecoach** was a landmark in the history of Westerns. It raised the genre to artistic status, bringing about a Western revival, stamped John Ford as one of the great Hollywood directors, and rocketed John Wayne from B pictures to stardom. It won two Oscars (Best Supporting Actor for Thomas Mitchell, and Best Music Score based on American folk songs) and was nominated for Best Picture, Best Director, and Best Cinematography (Bert Glennon). Shot in the now familiar Monument Valley, it was Ford's first Western for 13 years. Much of the second unit work was directed by the legendary stuntman Yakima Canutt who also played a Cavalry scout. It is he who falls under the wagon wheels and horse's hoofs and can just be glimpsed getting to his feet at the end of the shot. Dudley Nichols' taut screenplay derived from the Ernest Haycox story *Stage To Lordsburg* which, in turn, was inspired by Guy de Maupassant's *Boule De Suif*. Nine people, each firmly characterized, are making a coach trip through dangerous Indian territory: an outlaw under arrest called The Ringo Kid (Wayne, centre), the marshal accompanying him (George Bancroft, left), Dallas, a shady lady (Claire Trevor), a timid liquor salesman (Donald Meek), a shifty gambler (John Carradine), an embezzling banker (Berton Churchill), an alcoholic doctor (Mitchell), a pregnant woman (Louise Platt, right), and the driver (Andy Devine). En route, loves and hates develop among them, a baby is born, and there are deaths during an attack by Apaches at the exciting climax. Others in the cast were Tim Holt, Francis Ford (the director's brother), Florence Lake, Paul McVey and Chief Big Tree. 20th Century-Fox had the temerity to remake this Walter Wanger production in 1966. (WANGER)

△Budd Schulberg was fired by producer Walter Wanger during the shooting of **Winter Carnival**, after a troubled collaboration on the script with the ailing F. Scott Fitzgerald. Schulberg used his experience on the film as the basis for his 1950 novel *The Disenchanted*. Fitzgerald's name does not appear on the titles, but Schulberg is credited with the original story and screenplay (with Lester Cole and Maurice Rapf). Like Wanger, Schulberg and Fitzgerald were alumni of Dartmouth College, the setting of this thin romantic comedy which took place on the weekend of the famous carnival when former sweethearts Ann Sheridan and Richard Carlson (both illustrated) meet again after some years. He is now a professor at the college and she is a rich divorcee. Her younger sister (Helen Parrish) becomes infatuated with a Count (Morton Lowry), but big sister saves her by playing up to him herself. All's well after the younger sibling is elected carnival queen. 'Oomph Girl' Sheridan was worth watching, but the rest of the movie, directed by Charles F. Reisner, lacked oomph. James Corner, Robert Armstrong, Alan Baldwin, Virginia Gilmore, Marsha Hunt and Joan Brodell (known as Joan Leslie after 1941) took other parts. (WANGER)

▷**Of Mice And Men** was one of the rare serious dramas to be found in comedy producer Hal Roach's filmography. That John Steinbeck's socially conscious novel and play about two migrant workers during the Depression survived the trip to the screen undamaged, was a pleasant surprise for critics and public alike. However, scenarist Eugene Solow was forced to appease the Hays Code by erasing some four-letter words, and not allowing a murderer to go free at the end. It was Burgess Meredith (left) as George who is taken into custody after shooting his big, half-witted friend Lenny, rather than let the authorities commit him to an asylum. Lenny, whose mind isn't too clear 'on accounta he's been kicked in the head by a horse,' doesn't know his own strength, and kills a mouse, a bird, a puppy, and finally Mae (Betty Field), the coquettish wife of the foreman's son (Bob Steele). Meredith and Lon Chaney Jr (right) as Lenny, gave their finest screen performances ever under the graceful direction of Lewis Milestone. Charles Bickford, Roman Bohnen (centre), Noah Beery Jr, Granville Bates and Leigh Whipper played their fellow workers. Adding considerably to the atmosphere and emotion of this Oscar-nominated movie, was the music of Aaron Copland. (HAL ROACH)

△The main difference between the latest **Raffles** and the previous versions of 1917, 1925 and 1930, was the absence of the atmospheric London fog. John Van Druten and Sidney Howard (who died just before the film's release) set the E.W. Hornung story during the contemporary summer, with David Niven (illustrated) proving an admirable successor to John Barrymore and Ronald Colman in the starring role of the charming gentleman thief in love with Gwen (Olivia de Havilland), the sister of his best friend Bunny (Douglas Walton). At a country house party, the latter says he needs £1000 desperately, so Raffles steals a valuable necklace from the hostess Lady Melrose (Dame May Whitty, illustrated), and gives it to Bunny to claim the reward. Dudley Digges played the outwitted Inspector MacKenzie and Lionel Pape was Lord Melrose. Also cast: E.E. Clive, Peter Godfrey, Margaret Seddon, Gilbert Emery and Hilda Plowright. This successful Samuel Goldwyn production was rather less stylish under Sam Wood's direction than the 1930 version, which had also been made by Goldwyn. (GOLDWYN)

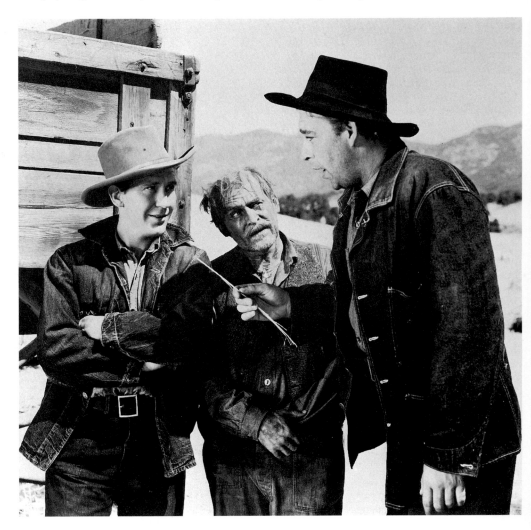

'The incomparable Charles Chaplin is back on the screen in an extraordinary film,' wrote the *New York Herald Tribune* in October 1940. '*The Great Dictator* is a savage comic commentary on a world gone mad. It has a solid fabric of irresistible humour and also blazes with indignation.' Although Chaplin's first sound film with dialogue earned more money than any of his other pictures, he and the world had, indeed, much to be indignant about.

Ironically, the war years were comparatively good times for Hollywood. After peaking in the mid-30s, weekly cinema attendances in America dropped to 55 million in 1941, but were almost doubled by 1944. It was estimated that approximately two thirds of the population went to the movies each week. Motion pictures offered an inexpensive, accessible and relaxing means of escape from long working hours, austerity, and the horrifying news from overseas. Westerns, Technicolor musicals, and screwball and sophisticated comedies were perfect tranquilizers. As a gesture towards topicality, the established genres like the gangster movie and the thriller, substituted a Nazi or a Fifth Columnist for the traditional underworld baddie. Even Sherlock Holmes was recruited to track down Nazis. Between the outbreak of war and Pearl Harbor, notable movies – besides *The Great Dictator*– that extolled the virtues of democracy over the brutality of Fascist regimes included *Confessions Of A Nazi Spy* (Warner Bros., 1939), *The Mortal Storm* (MGM, 1940), *Man Hunt* (20th Century-Fox, 1941), and Alfred Hitchcock's *Foreign Correspondent* (UA, 1940). Later there was the sentimental British homefront film *Mrs Miniver* (MGM, 1942), and its American equivalent *Since You Went Away* (UA, 1944); the romantic *Casablanca* (Warner Bros., 1942), and UA's huge money-making, all-star morale booster, *Stage-Door Canteen* (1943). The best of the battle films were *Bataan* (MGM, 1943), Lewis Milestone's *The Purple Heart* (20th Century-Fox, 1944), *Thirty Seconds Over Tokyo* (MGM, 1944), and UA's realistic and highly praised *The Story Of G.I. Joe* (1945).

It was fortunate for the industry that the domestic market was so healthy, because European and Far East markets were closed to the Hollywood product. However, there was business as usual in Great Britain, where average weekly attendances by wartime audiences had trebled from 1939 to 1945. For UA, Britain represented a vast percentage of their foreign business. J. Arthur Rank, the most powerful man in the British film industry, expressed interest in becoming a UA partner and chairman of a merged Anglo-American distribution company. However, Mary Pickford and David O. Selznick opposed the idea, and Rank's huge theatre circuit in Britain was virtually closed to UA films. Despite this, UA received the distribution rights for six Rank pictures in 1944, making it the leading distributor of British-made films in America.

Meanwhile, Alexander Korda, who had sold his Denham Studios to Rank, had been forced to take his entire organization to Hollywood. Although *The Thief Of Bagdad* (1940), completed in America, grossed over $1 million, production costs on his future pictures exceeded their budgets, and by 1943 he had to sell his UA stock. Previously, UA had taken the unusual step of putting up most of the money for *To Be Or Not To Be* (1942), which Korda and Ernst Lubitsch co-produced. Unfortunately, the release of this anti-Nazi comedy classic coincided with the blackest period of the war, and the death of its star, Carole Lombard. However, it later recovered its production costs. The company also loaned money to Walter

Wanger (who then left for Universal in 1941), and David O. Selznick, who delivered three big hits, *Since You Went Away* (1944), *I'll Be Seeing You* (1945), and Alfred Hitchcock's *Spellbound* (1945). Indeed, it had been Selznick who brought Hitchcock to America in 1940 for *Rebecca*, another prestigious profitable picture for UA. Nevertheless Selznick was forced to leave in 1946, having been sued by UA for breach of contract. (He had given some of his productions to RKO for distribution).

United Artists continued to open its doors to the growing number of independent producers. In 1943, it had 16 of them under contract, one of the most distinguished being Hunt Stromberg, producer of more than 100 MGM features. But apart from the Barbara Stanwyck hit *Lady Of Burlesque* (1943), his record with UA turned out to be disappointing. UA helped James Cagney set up his own company after 12 years as a contract player at Warner Bros. Both his *Johnny Come Lately* (1943) and the anti-Jap *Blood On The Sun* (1945) earned a tidy sum. Yet UA failed to benefit greatly from the fact that the major studios had dropped their output due to shortage of personnel; independent production became more attractive, providing artistic freedom and tax advantages; and there was an increase in public demand for movies, but while the rest of the industry enjoyed a boom during the war years, UA barely managed to eke out an existence. In fact, its net income dropped from $440,000 in 1939 to $409,000 in 1946. This can be put down to bad management, inter-company disputes and, generally, undistinguished product.

The company's problems – along with those of the industry as a whole – were compounded in 1946. With the war over and servicemen returning home, the birth rate soared, and families with babies tended to stay at home and listen to the radio instead of going to the movies. Other leisure activities were opened up, as well as the need to catch up on education. The big studios made fewer pictures, and dropped their low-budget and B-picture quota. As a result, more independents sprang up, but they did not join UA. In 1947, Charles Chaplin had his first outright flop with *Monsieur Verdoux*, and his appearance before the House Un-American Activities Committee alienated him further from the public. The shadow of the HUAC hung over many people's careers. Its investigations into alleged Communist infiltration of the motion picture industry resulted in the imprisonment of 'The Hollywood Ten', the exile of film-makers Edward Dmytryk, Joseph Losey and Carl Foreman, and the pernicious blacklist.

This Right-wing hysteria came at a time when many American films showed a willingness to confront serious issues in the aftermath of the war. Anti-semitism was the theme of Elia Kazan's *Gentleman's Agreement* (20th Century-Fox, 1947), and Dmytryk's *Crossfire* (RKO, 1947), and racial bigotry of *Home Of The Brave* (UA, 1949) and *Intruder In The Dust* (MGM, 1949). These, and other controversial subjects, were to be explored by producers such as Stanley Kramer and Harold Lecht-Burt Lancaster in the new realism of the 50s. But, by the end of the 40s, UA found itself further and further in debt. In 1950, the two remaining founders, Mary Pickford and Charles Chaplin, had to take a back seat when the company was taken over by a syndicate led by Arthur Krim and Robert Benjamin, partners in a law firm accustomed to handling film companies. With one bound, UA escaped again from the ropes of penury, and by the end of 1951, it was out of the red.

UNITED ARTISTS

1940

▽Following his success in *The Hurricane* (1937), Jon Hall continued his career as a male Dorothy Lamour in **South Of Pago Pago**. *Sans* Lamour this time, Hall played the son of a chief of a South Sea island. This paradise is disturbed by a wicked crew of pearl hunters led by Victor McLaglen, with Gene Lockhart, Douglass Dumbrille and barroom queen Frances Farmer. Miss Farmer (illustrated) lures Hall away from his saronged sweetheart (Olympe Bradna), but dies in the end while protecting him from the guns of the intruders. Alfred E. Green directed, George Bruce and Kenneth Gamet wrote the script, and Edward Small produced. Francis Ford, Ben Weldon, Abner Biberman (illustrated), Pedro De Cordoba and Rudy Robles were also in it. (EDWARD SMALL)

▽'We never had no education. We're not illiterate enough', says Stan Laurel (left) to Oliver Hardy (right) in **A Chump At Oxford**, Hal Roach's slapstick answer to MGM's *A Yank At Oxford* (1938). In this case, Stan and Olly were rewarded with an Oxford education by a grateful banker after they have inadvertently captured a bank robber. The screenplay by Charles Rogers, Felix Adler and Harry Langdon moved even further from the realms of the possible with the duo turning up at an unlikely college wearing Eton suits and mortar boards. There, they are remorselessly ragged by the elderly-looking students who included Gerald Fielding, Gerald Rogers, Victor Kendall, Charles Hall and Peter Cushing (his second film). Wilfred Lucas, Forbes Murray, Frank Barker and James Finlayson reacted broadly to the amusing antics of the pair. Alfred Goulding's direction kept things moving at a lively pace. (HAL ROACH)

▽David O. Selznick had the insight to bring Alfred Hitchcock, the British master of suspense, to Hollywood to make **Rebecca**, the film version of Daphne Du Maurier's best-selling mock Gothic novel. The result was a superb blend of romance, comedy, melodrama and psychological mystery story, with Hitchcock creating suspense and atmosphere via the mobility and stylishness of his camera. Robert E. Sherwood and Joan Harrison's screenplay provided scope for strong characterizations from a splendid cast headed by Laurence Olivier as the haunted, moody Max De Winter and Joan Fontaine as the mousy young woman he makes his second wife after meeting her on the Riviera. Florence Bates (the girl's vulgar American employer), George Sanders, Nigel Bruce, Gladys Cooper, Reginald Denny, C. Aubrey Smith, Melville Cooper, Leo G. Carroll and Leonard Carey distinguished themselves, too. But it was the image of Judith Anderson's Mrs Danvers (right), the sinister housekeeper of the sombre Cornish mansion, Manderley, with her maniacal loyalty to the first Mrs De Winter, the Rebecca of the title, that made the most lasting impression. The movie won two Oscars – Best Picture and Best Black and White Cinematography (George Barnes). Olivier, Fontaine (left), Anderson, the director, art director, film editor and the screenwriters were all nominated. The picture added much to producer Selznick's already immense wealth. (SELZNICK)

▽'The man's had a baby instead of the lady,' proclaimed the billboards for **Turnabout**, an oddball gender bender comedy, produced and directed by Hal Roach, and adapted by Mickell Novak, Berne Giler, John McLain and Rian James from the Thorne Smith novel. The ad, however, gave away the punchline of the picture whch concerned a well-heeled couple (John Hubbard and Carole Landis) who have a row about their different roles in life. He works hard all day, while she does nothing but loll around the home. An Oriental idol on the mantelpiece suddenly comes to life and grants them their wish to change places. Next morning, the husband wakes up with a falsetto voice and walks around effeminately, while his wife has a deep voice, dons trousers and goes off to the office. Needless to say, they cause havoc in the home and business, and revert to the roles laid down for them. Their dumbfounded friends and acquaintances were well played by Adolphe Menjou (illustrated), William Gargan, Verree Teasdale, Mary Astor, Polly Ann Young (illustrated), Donald Meek, Joyce Compton, Inez Courtney, Franklin Pangborn, Marjorie Main and Berton Churchill. Georges Renavent was Mr Ram, the idol. Many of the situations, from today's viewpoint, remained unexplored, but it was quite bold at the time. (HAL ROACH)

▽Although **Our Town** received a Best Picture nomination and was not ignored by the public, the essential theatricality of Thornton Wilder's Pulitzer prizewinning play of 1938 translated awkwardly to the screen. Part of the beauty of the play was the simplicity of its homey sentiments, and of the staging, but director Sam Wood made the movie cute and sentimental. Wilder, Harry Chandlee and Frank Craven wrote the screenplay, the latter also playing the druggist (the Stage Manager in the original) who acts as guide to the inhabitants of Grovers Corner, a small New Hampshire town in the decade before World War I. The 'just plain folks' included two families – the doctor (Thomas Mitchell) his wife (Fay Bainter) and their son (22-year-old William Holden in his third screen role, illustrated); and the town's newspaper editor (Guy Kibbee), his wife (Beulah Bondi), and their daughter (Martha Scott, illustrated, repeating her Broadway role in her first screen appearance). The latter is courted and married by the doctor's son before her premature death. Others going about their humdrum lives were Spencer Charters, Stuart Erwin, Doro Merande, Philip Wood, Ruth Toby, and Arthur Allen. The music of Aaron Copland added a further touch of Americana to Sol Lesser's production. (SOL LESSER)

▽The team from *U-Boat 29* (GB: *The Spy In Black*, Columbia, 1939) – Conrad Veidt, Valerie Hobson and director Michael Powell – were reunited for another espionage yarn entitled **Blackout** (GB: **Contraband**). This time Veidt (illustrated) played a neutral Danish sea captain on the trail of two of his mysteriously vanished passengers in a blacked out London. On one busy night's adventure, he gets involved and falls in love with British agent Hobson, and helps to expose the secret headquarters of German Intelligence. Also moving through the darkness were Esmond Knight, a spy for the Admiralty, Hay Petrie as twin Danish spies, Raymond Lovell, Charles Victor, Henry Wolston, Julien Vedey, Leo Genn and Peter Bull. The somewhat tortuous script by Powell, Emeric Pressburger and Brock Williams, didn't help but nor did it detract from the excitement and wit of this John Corfield production. (BRITISH NATIONAL)

△Although it had the same title as Douglas Fairbanks' 1924 silent picture, Alexander Korda's **The Thief Of Bagdad** did not have the same plot. What they did have in common was cinematic magic at the service of witty and exciting Arabian Nights pastiche. However, this version, directed by the trio of Michael Powell, Ludwig Berger and Tim Whelan, had the advantage of sumptuous Technicolor photography (Georges Perinal), outstanding visual and sound effects (Lawrence Butler and Jack Whitney) and spectacular art direction (Vincent Korda), all of which won Oscars. The film was begun at Denham Studios in 1939 but, at the outbreak of war, old Bagdad was reconstructed in the Mojave desert of California. The writers, Miles Malleson (who also played the Sultan) and Lajos Biro, came up with an exotic fantasy concerning the adventures of a deposed Caliph (John Justin in his screen debut), and a thief (Sabu, right) who try to overcome the plans of the evil Grand Vizier (Conrad Veidt). With the help of a flying horse, magic carpets and a titanic black genie (Rex Ingram), the Vizier is overcome and the Caliph marries his princess (June Duprez). Morton Selten (left) and Mary Morris were also cast. The movie grossed over $1 million, more than any other Korda picture earned in the USA. A third film with the same title was made in Italy in 1960 starring Steve Reeves. (KORDA)

◁The fact that dinosaurs had disappeared centuries before humans appeared on this planet didn't seem to bother producer Hal Roach, or the screenwriters Mickell Novak, George Baker and Joseph Frickert of **One Million B.C.** (aka **Cave Man**, GB: **Man And His Mate**). Nor was there concern that the loin cloths seemed to have been woven with modern textiles, and how did Victor Mature (right) shave every morning? No problem in learning his lines though, which consisted merely of grunts, groans and gestures. He of the Rock Tribe meets Carole Landis of the Shell Tribe, and she teaches him table manners. Then he takes her back to his people without pulling her by her peroxide hairdo. Other stone age folk persistently under attack by prehistoric animals were Lon Chaney Jr (left), John Hubbard, Nigel de Brulier, Mamo Clark, Inez Palange and Edgar Edwards, with Conrad Nagel as the narrator. D.W. Griffith was put on the payroll in an advisory capacity, but he later complained that neither of the directors, Roach and his son, Hal Roach Jr, listened to his advice. This enjoyable and profitable nonsense was remade in 1966 by Hammer Pictures as *One Million Years B.C.* (HAL ROACH)

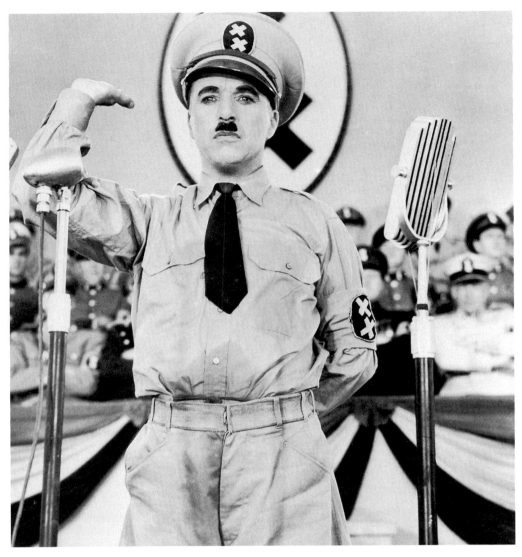

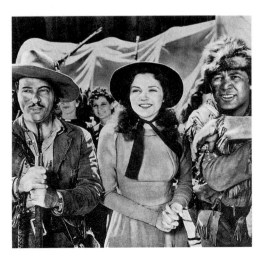

◁In his autobiography, Charles Chaplin wrote that during the shooting of **The Great Dictator**, 'I began receiving alarming messages from United Artists. They had been advised by the Hays Office that I would run into censorship trouble . . . But I was determined to go ahead, for Hitler must be laughed at.' However, he later admitted, that had he known of the mass murder of the Jews, he would not have made the film. Yet, despite the obvious problems of accepting Hitler as a buffoon and therefore lacking in menace, and some obvious crudities, Chaplin's very individual comic vision and humanity made it into one of the screen's masterpieces. Although using sound fully for the first time, many of the best sequences were still those without dialogue – Chaplin as the little barber shaving a customer to Liszt's *Hungarian Rhapsody*, and Chaplin as Adenoid Hynkel (illustrated), the dictator of Tomania, using a globe as a balloon in a solo ballet. He effectively employed gibberish to imitate Hitler's oratory style, and the burlesque scenes between Hynkel and Benzino Napoloni (Jack Oakie) had much in common with the best political cartoons. Chaplin's story told of how a Jewish barber is mistaken for the country's dictator and takes his place. The final embarrassingly naive six-minute oration, using Hitler's rhetoric to preach peace and democracy, is really Chaplin himself speaking and not the character. Other roles were taken by Reginald Gardner (Schultz), Henry Daniell (Garbage), Grace Hayle (Senora Napoloni), Billy Gilbert, Carter De Haven, Maurice Moscovitch, Emma Dunn, Bernard Gorcey, Chester Conklin and Hank Mann. The picture received five Oscar nominations – Best Picture, Best Actor, and Best Original Screenplay, all for Chaplin, Best Supporting Actor for Oakie and Best Original Score. It grossed $5 million, the greatest box-office hit Chaplin ever had. (CHAPLIN)

▽Jon Hall temporarily abandoned the South Sea garb that was fast becoming his trademark, for cowboy gear in the role of **Kit Carson**, the chief scout of western fame. This solid actioner, which was realistically directed by George B. Seitz, and written by George Bruce (story Evelyn Wells), opened with Carson and his two buddies (Ward Bond, right, and Harold Huber, left) being attacked by Indians. They survive the skirmish and get to Fort Bridger where they meet Captain John Fremont (Dana Andrews) who asks them to lead a wagon train to California. On the way, both Carson and Fremont fall for the same pioneer girl (Lynn Bari, centre), and fight off another Indian attack. Others involved for producer Edward Small were Renie Riano, Clayton Moore (later TV's *Lone Ranger*), Rowena Cook, Raymond Hatton, Harry Strang, C. Henry Gordon and Lew Merrill. (EDWARD SMALL)

△Made in 1938, **Over The Moon** was released two years later on the orders of Alexander Korda's creditors. This romantic trifle-cum-travelogue, written by Arthur Wimperis, Anthony Pellissier and Alec Coppel (story by Robert Sherwood and Lajos Biro), concerned Jane Benson (Merle Oberon, illustrated), a country girl who inherits $75 million and then proceeds to squander it. Squandered, too, were the talents of Ursula Jeans, Robert Douglas, Zena Dare and Peter Haddon as various social leeches; Rex Harrison as the young doctor who loves the heiress but doesn't wish to be Mr Jane Benson; David Tree, MacKenzie Ward, Elizabeth Welch, Carle Jaffe and Herbert Lomas (illustrated). The fact that director Thornton Freeland offered Technicolor views of Venice and St Moritz for the first time in a feature film, was small compensation. No-one was over the moon about it, least of all the aforementioned creditors. (LONDON FILMS)

▽**The House Across The Bay** was Alcatraz, so called by the residents of San Francisco. One of them was sultry Joan Bennett (illustrated) who sold her husband George Raft up the river (or across the bay) in order, she claims, to protect him from his racketeer enemies. Meanwhile, she has taken an apartment on Telegraph Hill so she can wave to her hubby while she entertains Lloyd Nolan (illustrated), a shady lawyer, and millionaire Walter Pidgeon. Raft, however, isn't satisfied with being a caged pigeon for ten years, and escapes with predictable results in the Kathryn Scola screenplay (story Myles Connolly). Archie Mayo's direction held much of one's attention, as did Miss Bennett in a series of gowns by Irene. Also around in this Walter Wanger production were Gladys George, June Knight, Peggy Shannon, Edward Fielding and Miki Morita. (WALTER WANGER)

△Although **The Lion Has Wings** was made in ten days at a cost of only $125,000, it turned out to be a polished piece of wartime propaganda. Thanks, in the main, to the supervising editor William Hornbeck, who combined the efforts of three directors – Michael Powell, Brian Desmond Hurst and Adrian Brunel – with much newsreel footage and an excerpt from *Fire Over England* (1937). The documentary side showed Hitler ranting and raving, crosscut with the bleating of sheep, and Chamberlain declaring war. It then set out to prove that the lion (England) had the wings (air power) to repulse any invaders from its shores. The fictional episodes, with their brief glimpses of Merle Oberon and Ralph Richardson (both illustrated), June Duprez, Flora Robson, Robert Douglas, Anthony Bushell, Austin Trevor and Milton Rosmer representing ordinary brave British citizens facing up to war, are slightly risible at this distance in time. The morale-boosting commentary was spoken and written by E.V.H. Emmett for producer Alexander Korda. (LONDON FILMS)

△James Roosevelt, son of the US president, bought John Boulting's British production **Pastor Hall** for distribution in America as further propaganda to shake his countrymen out of their isolation. The picture, directed and edited by Boulting's twin brother, Roy, was a plodding well-meaning story of Nazi brutality, set in a German village and based on the life of Pastor Niemöller. Written by Leslie Arliss, Anna Reiner and Haworth Bromley from an unperformed Ernst Toller play, the screenplay had the good Pastor preaching against the Nazis, conducting a funeral for a man shot by the Storm Troopers, and refusing to give the names of resisters. He is sent to a concentration camp, but is freed when his daughter gives herself to a Nazi major. On release, the pastor continues his anti-Nazi activities and is shot 'while resisting arrest'. Wilfred Lawson (centre left) in the title role, Nova Pilbeam as his daughter, Sir Seymour Hicks and Marius Goring (right) as Nazi officers, Brian Worth, Percy Walsh, Lina Barrie, Eliot Makeham, Raymond Rollett (2nd right), Peter Cotes and Bernard Miles (left) did their British best to be Germans. (CHARTER-ROOSEVELT)

▽Four of Eugene O'Neill's one act sea plays, *The Moon Of The Caribbees, Bound East For Cardiff, In The Zone*, and that of the film's title **The Long Voyage Home**, were skilfully adapted by Dudley Nichols, and updated to include a German plane attack. Although the picture was structurally episodic, it was given a stylistic unity by John Ford's controlling direction. Most of the action took place on a rusty tramp steamer carrying high explosives on a voyage from the West Indies to Britain, but plot was subservient to the series of character studies showing the comradeship of merchant seamen of different nationalities: John Wayne (centre), the big Swede Olson, the only one to get home in the end; Thomas Mitchell, the Irishman lost to another ship; Ian Hunter, the outcast English aristocrat; Wilfred Lawson, the lonely captain; Barry Fitzgerald (left), the bitchy steward; Ward Bond, the American who dies dreaming of land; John Qualen (right), Joseph Sawyer and Arthur Shields as other crew members. Mildred Natwick, Rafaela Ottiano and Carmen Morales appeared only briefly in this tale of men. Despite the bleakness of the subject and the spatial limitations of the setting, this Walter Wanger production was a box-office success. It received three Oscar nominatons – Best Picture, Best Screenplay and Best Black and White Photography (Gregg Toland). (WALTER WANGER)

▽**The Westerner** was the last Samuel Goldwyn production for UA. When he felt he did not have enough power, he tried to release it through Warners and Paramount, but UA threatened to sue him for breach of contract. The picture, made for $1 million plus the cost of delays before showing, turned out to be another solid gold Goldwyn hit. Although Gary Cooper (right) was the nominal star, Walter Brennan (left) won his third Oscar for Best Supporting Actor in five years (an unbroken record), stealing the film from under Coop's nose. Brennan played Judge Roy Bean, the infamous rum-soaked 'hanging judge' of the town of Vinegarroon, Texas, who worships the actress Lily Langtry. In fact, Cooper saves himself from hanging as a horse thief by claiming to know the 'Jersey Lily'. She finally makes an appearance, in the shape of Miss Lillian Bond, and performs alone for the dying judge. The screenplay by Jo Swerling and Niven Busch (story Stuart Lake) was less original when dealing with the feud between homesteaders and cattlemen, and Cooper's romance with homesteader's daughter Doris Davenport (in her only film role), but director William Wyler held the reins with a masterly hand. Fred Stone, Forrest Tucker (debut), Paul Hurst, Chill Wills, Charles Halton, Tom Tyler, Lupita Tovar, Dana Andrews and Julian Rivero gave fine support. Paul Newman played the Brennan role in John Huston's *The Life And Times Of Judge Roy Bean* (First Artists 1972). (GOLDWYN)

▽**Saps At Sea** ended producer Hal Roach's 13-year association with Stan Laurel and Oliver Hardy, a rupture that led to the great comic duo's decline. Although most of the gags in the story and screenplay by Charles Rogers, Felix Adler, Gil Pratt and Harry Langdon had seen better days, as had the two stars, there was a reasonable quota of inspired moments under Gordon Douglas' direction. Half of the 60-minute feature was taken up with Stan (right) and Olly doing their usual saps-on-land routine, including a scene in which their handiwork causes a fridge to play music and a radio to produce ice. Olly works in a horn factory and goes berserk from the constant tooting. After Dr James Finlayson advises a sea voyage, the boys are shanghaied by escaped murderer Dick Cramer. Ben Turpin, Harry Bernard and Eddie Conrad (left) were able stooges. (HAL ROACH)

▽In the year 1812, the good ship *Olive Branch* was under the command of Victor Mature (centre), known as **Captain Caution**. His prudence is mistaken for cowardice by Louise Platt (right), the owner of the ship, but he proves his bravery in a sea battle against the British, and in exposing Bruce Cabot as a traitor conspiring with the enemy to take over the ship. The screenplay by Grover Jones and Norbert Brodine (from the Kenneth Roberts novel) provided plenty of action interrupted by unfunny episodes featuring Leo Carrillo (left), Vivienne Osborne and El Brendel as comic foreigners. Richard Wallace kept it fast-paced enough to prevent the kiddies from growing restless, and Hal Roach produced. The cast also included Robert Barrat, Miles Mander, Roscoe Ates, Andrew Tombes, Aubrey Mather, Pat O'Malley and, in a small role, Alan Ladd. (HAL ROACH)

△Alfred Hitchcock chose a topical subject about a ring of Nazi spies in the Europe of 1938 for his second Hollywood movie, **Foreign Correspondent**. The four writers – Charles Bennett, Joan Harrison, James Hilton and Robert Benchley – based their screenplay on *Personal History*, a non-fiction account by reporter Vincent Sheean. The film, however, squarely inhabited the world of thriller fiction, moving confidently (and wittily) from one brilliant set-piece to another, as an American journalist (Joel McCrea) is sent over to Amsterdam where he witnesses the shooting of a Dutch statesman whose assassin immediately flees. McCrea begins his investigation into the murder with the help of fellow reporters George Sanders and Benchley, as well as pretty Laraine Day, the daughter of a man (Herbert Marshall, left) who stands ostensibly for peace. During his quest, our hero is almost pushed off the top of Westminster Abbey by professional killer Edmund Gwenn, discovers something weird about a windmill whose blades are turning the wrong way, unmasks a fifth columnist, and makes a rousing final speech persuading Americans to enter the war. Other parts went to Eduardo Ciannelli, Harry Davenport and Martin Kosleck in this Walter Wanger production. It received six Oscar nominations – among them, Best Picture, Supporting Actor (Albert Basserman, right, as the presumed dead statesman), Original Screenplay, and Black and White Photography (Rudolph Maté). (WALTER WANGER)

△**My Son, My Son** was a rather heavy-handed film directed by Charles Vidor from Howard Spring's rather hefty best-seller adapted by Lenore Coffee. The family saga, played out in Manchester and London from late Victorian times to World War I, could have been called 'Like Father, Dislike Son'. William Essex (Brian Aherne, left) works his way up from poverty to become a successful and wealthy writer. He wishes to bestow on his son Oliver (child Scotty Beckett, adult Louis Hayward, right) all the benefits of riches and culture he never had. The boy, however, turns out to be a spoiled and vicious person who destroys the daughter (Laraine Day) of his father's best friend (Henry Hull), and even becomes his father's rival for the affections of artist Livia Vaynol (Madeleine Carroll). But the father's faith in the boy is vindicated when the latter dies a hero in Flanders – a more optimistic ending than that of the novel in which he is hanged for murder. Aherne did what he could with the stolid and irritating father, and Hayward was a suitably obnoxious son behind his bland smiles. Others cast were Josephine Hutchinson, Sophie Stewart, Bruce Lester, Brenda Henderson, May Beatty, Stanley Logan and Lionel Belmore, The picture was produced by Edward Small. (EDWARD SMALL)

UNITED ARTISTS

1941

▽Merle Oberon as **Lydia** looked back over half a century to the romances she had experienced with four different men. Michael (Joseph Cotten), a doctor and the son of her wealthy Boston family's butler (John Halliday in his last film); Bob (George Reeves, TV's *Superman* in the 50s), a football hero; Frank (Hans Yaray), a blind pianist and composer; and Richard (Alan Marshal) who went to sea, the only one she really cared for. She has remained true to their love for forty years, but when they meet again at the end, he doesn't remember her. Alexander Korda got Julien Duvivier, the French director of the similarly structured *Un Carnet De Bal* (1937) to make this episodic, sentimental romance in America. Duvivier devised the story with Ladislas Bush-Fekete, and Ben Hecht and Samuel Hoffenstein wrote the bitter-sweet screenplay. The result was tasteful, undemanding and decorative, the most conspicuous feature being the turn-of-the-century gowns worn by the lovely but simpering Miss Oberon (foreground). Others in it were Edna May Oliver, Sara Allgood, Billy Roy (foreground right) and Frank Conlan. (KORDA)

△Hal Roach's successful spooky slapstick series of Topper pictures ended with **Topper Returns**. This time round, the screenplay by Jonathan Latimer and Gordon Douglas, based on 'fictional characters conceived by Thorne Smith', reverted to an 'old dark house' spoof. All the ingredients were there, including wall panels, hidden passages, disappearing bodies, and a bug-eyed nervous Negro (Eddie 'Rochester' Anderson). The film began with the killing of Joan Blondell (illustrated) who then returns in phantom form to solve her own murder. Once again, Roland Young (illustrated) was the bemused Mr Topper who helps her, and Billie Burke his scatter-brained wife. Also around were Carole Landis, Dennis O'Keefe, Patsy Kelly, H.B. Warner, George Zucco, Rafaela Ottiano and Donald MacBride. Roy Del Ruth directed, getting quite a few laughs on the way, but the movie was a ghost of *Topper* (MGM, 1937) and *Topper Takes A Trip* (1939). (HAL ROACH)

△It was no coincidence that George Bruce's screenplay for **The Son Of Monte Cristo** concerned a Balkan country's resistance to a dictator in 1865, while the Nazis were occupying modern Balkan states in 1941. Otherwise, it was a standard swashbuckler with a masked avenger fighting for lady fair against a wicked usurper. The only connection the film had with Alexandre Dumas was that the hero turns out to be the son of Edmond Dantes. Louis Hayward (illustrated) as Dantes Jr, poses as a fop, and insinuates himself into the castle of the Grand Duchess Zona (Joan Bennett, illustrated) who is being held prisoner by crypto-fascist Count Gurko (George Sanders). It ended traditionally with the battle of wits between the two men becoming a battle of blades. Producer Edward Small, while failing to duplicate the triumph of *The Count Of Monte Cristo* (1934), with the same director Rowland V. Lee, gained a reasonable return on the picture. Others in it were Florence Bates, Lionel Royce, Montagu Love, Ian Mac Wolfe, Clayton Moore, Ralph Byrd and Georges Renavent. (EDWARD SMALL)

◁Ernst Lubitsch produced and directed **That Uncertain Feeling** with that uncertain touch. Although it was a remake of *Kiss Me Again* (WB, 1925), one of Lubitsch's best silent pictures, something was lost when sound was added. Based on the French boudoir comedy *Let's Get A Divorce* by Victorien Sardou and Emile de Najac, the screenplay by Donald Ogden Stewart and Walter Reisch crackled wittily for the first quarter of the picture, then became ever sillier and more desperate. Still, Lubitsch was able to ring some clever comic changes out of the eternal triangle theme. After six years of marriage to busy insurance salesman Melvyn Douglas, Merle Oberon (both illustrated) gets recurring hiccoughs. She consults a puerile psychoanalyst (Alan Mowbray) who diagnoses marriage trouble. With another patient (Burgess Meredith), who claims to be the greatest pianist in the world, she finds an outlet for her frustrations. When the husband agrees to a divorce, however, she can't go through with it, and he promises never to neglect her again. Meredith had the best zany moments, insulting everyone in sight. Support came from Olive Blakeney, Harry Davenport, Eve Arden, Sig Rumann, Richard Carle and Mary Currier. (LESSER-LUBITSCH)

▽**Three Cockeyed Sailors** (GB: **Sailors Three**) were cocky cockney Tommy Trinder (centre), asinine Claude Hulbert (right) and jaunty Michael Wilding (left). In a typically lighthearted Ealing Studios manner, the three tars inadvertently find themselves, while on a drunken spree in Buenos Aires, on the German battleship which their own ship has been assigned to hunt down. After a series of incredible but not unamusing incidents, they capture the ship and hand it over to their own captain. Others involved were Carla Lehmann, James Hayter, Jeanne de Casalis, John Laurie and Harold Warrender. This successful British import was written by Angus MacPhail, John Dighton and Austin Melford, and directed by Walter Forde. Producer Edward Small bought it for release in the USA. (EALING-SMALL)

▷Motion pictures set on trains usually move at a rapid pace, and Hal Roach's **Broadway Limited** (GB: **The Baby Vanishes**) was no exception. Rian James must have had Howard Hawks' *Twentieth Century* (Columbia, 1934) in mind when he penned the plot about a movie star (Marjorie Woodworth) on a publicity tour from LA to NYC with her temperamental, despotic director (Leonid Kinsky). The latter insists that she pretend to have a baby to make her seem less frivolous in the public's eyes. Unfortunately, the baby she has found to show her fans at each whistle stop, turns out to be a kidnapped child. As the plot thickened, so the jokes began to thin, and Gordon Douglas' direction became more frantic. Yet, there was some fun to be had from Kinsky's Russian ham portrayal, Victor McLaglen (left) as the engine driver, Patsy Kelly (centre) as the director's secretary, and ZaSu Pitts (right) as a peculiar passenger. Also on board were Dennis O'Keefe as a young doctor who falls for the actress, John Sheehan, George E. Stone, Charles Wilson and baby Gay Ellen Dakin (illustrated). (HAL ROACH)

△'The Church and the Army are the bases of civilization; the Church holds it together and the Army defends it,' preaches Bishop Cedric Hardwicke at the end of **Sundown**. Director Henry Hathaway tried to hold the film together, but not even the Army could defend this implausible adventure about Nazi gun-running in Africa, adapted by Barre Lyndon from his own *Saturday Evening Post* story. District Commissioner Bruce Cabot is disliked by supercilious Major George Sanders because he seems to get on with the wily natives (among whom is a teenage Dorothy Dandridge). Cabot falls for Arab girl Gene Tierney (illustrated) whom Sanders suspects of being a German agent. But the beautiful Miss Tierney turns out to be English after all. Given her performance, it's a wonder anyone was taken in by her. Harry Carey, Joseph Calleia, Carl Esmond and Reginald Gardner were also seen lurking in the bushes of Darkest Hollywood. Walter Wanger produced. (WALTER WANGER)

◁Winston Churchill's favourite picture of the day was said to have been **That Hamilton Woman** (GB: **Lady Hamilton**), perhaps because of its timely warnings to dictators who wished to invade England. Parallels were clearly drawn (in Walter Reisch and R.C. Sheriff's screenplay) between Admiral Horatio Nelson's British fleet fighting to defeat Napoleon's forces, and the war in Europe in 1941. However, producer-director Alexander Korda concentrated more on Nelson the lover than Nelson the naval hero, and his illicit affair with Lady Emma Hamilton, wife of the British ambassador to Naples, whose romance became the talk of the courts and taverns of Europe, and ended when Nelson was fatally wounded at Trafalgar. Another celebrated couple, Vivien Leigh and Laurence Olivier (both illustrated), played the lovers; she radiant and vivacious, he cold and morose. Gladys Cooper and Sara Allgood both overplayed as Lady Nelson, his viperish mother, and Mrs Cadogan-Lyon, her earthy Irish mother. Others cast were Alan Mowbray (Sir William Hamilton), Henry Wilcoxon (Captain Hardy), Heather Angel, Halliwell Hobbes, Gilbert Emery, Miles Mander, Ronald Sinclair, Luis Alberni and Norma Drury. This rather long (128 minutes) and slow film was popular with the public, presumably due to the attractive husband and wife star team. Rudolph Maté was nominated for an Oscar for Best Black and White Cinematography. (KORDA)

▽The news that Franz Schubert was fat and unattractive obviously hadn't reached the makers of **New Wine** (aka **The Great Awakening**), based extremely loosely by Howard Estabrook and Nicholas Jory on the unhappy life of the Austrian composer. Handsome ex-model Alan Curtis gave a colourless portrayal opposite his real-life wife Ilona Massey. As a Hungarian countess, she tries to rescue him from poverty by attempting to prove his genius to the world. She even visits Beethoven (Albert Basserman, illustrated) with the score of The Unfinished Symphony, and he tells her that Schubert should finish it. Intentional comedy was provided by Binnie Barnes and Billy Gilbert. It also featured Sterling Holloway, Richard Carle, John Qualen, Sig Arno, Gilbert Emery, Marion Martin and Forrest Tucker. The director was Reinhold Schunzel, and William Sekely produced. (GLORIA)

△**International Lady** was a mildly amusing spy melodrama, produced by Edward Small and set in London, Lisbon, and New York, but filmed in Hollywood. Howard Estabrook's screenplay (story by E. Lloyd Sheldon and Jack DeWitt) had George Brent (centre) as a G-man posing as a lawyer, Ilona Massey as a German spy posing as a singer, Basil Rathbone (left) as a Scotland Yard detective posing as a music critic, and fifth columnist Gene Lockhart posing as a loyal American. The songs that Miss Massey sings on Lockhart's radio show contain a code giving instructions to enemy saboteurs about the flow of American planes and arms to England. Brent, of course, falls for the melodic Mata Hari but nonetheless arrests her, hoping they will meet again in peacetime. Marjorie Gateson and George Zucco appeared as other Nazi agents. Also cast were Francis Pierlot, Martin Kosleck, Charles D. Brown (right) and Clayton Moore. There was no posing about Tim Whelan's straightforward direction. (EDWARD SMALL)

△**Cheers For Miss Bishop** sentimentally sang the praises of a schoolmistress who devoted 52 years of her life to the teaching profession. As the female Mr Chips, Martha Scott (illustrated), in a grey wig, granny glasses and wrinkled makeup, is guest of honour at a banquet given by many of her former pupils, loved by one and all. But why didn't she ever marry? Well, Sam the grocer (William Gargan), now the town's leading citizen, loved her, but it wasn't reciprocated. She loved two men in her life, but the first (Donald Douglas) was lured into marriage with her cousin (Marsha Hunt), and the second was a married man (Sidney Blackmer, illustrated), whose wife refused to divorce him. So she found solace in her work. Edmund Gwenn, Sterling Holloway, Mary Anderson, Dorothy Peterson, Ralph Bowman and Rosemary DeCamp also appeared in the unfolding of this sad tale. The script by Stephen Vincent Benet, Adelaide Heilbron and Sheridan Gibney, adapted from Bess Streeter Aldrich's novel *Miss Bishop*, perpetuated the myth that career equals spinsterhood. This Richard A. Rowland production was directed by Tay Garnett. (RICHARD A. ROWLAND)

▷Somehow, Hungarian producer Gabriel Pascal persuaded George Bernard Shaw to sell him the film rights of his plays, and **Major Barbara** was the first to be directed by him (although David Lean and Harold French, uncredited, actually made most of it). Shaw himself collaborated with Anatole de Grunwald and Pascal on the screenplay, both telescoping it and contriving to open it up. What it lost in intellectual depth, it gained in entertainment value, being less static and wordy than the 1905 play, without eliminating Shaw's characteristic views on religion, education and politics. The cast was impeccably led by Wendy Hiller as the Salvation Army lass of the title, disillusioned with the 'Army' when they accept money from her millionaire arms manufacturer father. Robert Morley lacked force as Andrew Undershaft, the benevolent capitalist, but Rex Harrison (right) as Adolphus Cusins, the professor of Greek who loves Barbara, Robert Newton (left) as a bully and Emlyn Williams as Snobby Price the parasite were excellent. Good support came from Sybil Thorndike, David Tree, Penelope Dudley-Ward, Marie Lohr, Walter Hudd, Donald Calthrop, Miles Malleson, Stanley Holloway, Kathleen Harrison, Felix Aylmer, and 20-year-old Deborah Kerr making her screen debut as Sergeant Jenny Hill. (PASCAL)

▽As the USA was still officially at peace with Germany, Hitler was never mentioned by name in **So Ends Our Night**, although the screenplay by Talbot Jennings (based on Erich Maria Remarque's novel *Flotsam*) told of the experiences of three people forced to flee from Germany in 1937. The first is an Aryan (Fredric March), opposed to the Nazi regime, the second is a Jewish woman (Margaret Sullavan, right), and the third a young man (Glenn Ford, left), the son of a Jewish mother and Aryan father. They meet in Austria, but are pursued from country to country as the Nazis advance. March risks his life by returning to Germany to visit his wife (Frances Dee) on her deathbed, and the other two fall in love and marry in Switzerland. Also cast were Erich von Stroheim, Anna Sten, Allan Brett, Joseph Cawthorn (centre), Leonid Kinsky, Alexander Granach and Sig Rumann. This long (two hours), often gripping drama, was somewhat over-emphatically directed by John Cromwell. The production, by David L. Loew and Albert Lewin, failed to appeal to the American public who didn't want to feel too involved, but it did better in Britain where the problems depicted were on the country's doorstep. (LOEW-LEWIN)

▽**Pot O' Gold** (GB: **The Golden Hour**) featured radio band Horace Heidt and his Musical Knights, who should have remained heard and not seen. No wonder crusty music-hating health food manufacturer Charles Winninger (centre left) doesn't want to sponsor them on a radio giveaway show. But nephew James Stewart (centre right in doorway), his girlfriend Paulette Goddard, and her landlady mother Mary Gordon get together and put a lot of effort into persuading the old codger to put the band on his show. Frank Melton, Jed Prouty, Dick Hogan and James Burke also appeared in this trivial tale written by Walter De Leon from a story by Andrew Bennison, Monte Brice and Harry Tugend. George Marshall directed in the style of a poor man's Frank Capra for producer James Roosevelt. (ROOSEVELT)

◁With the world going dangerously mad in Europe, even the crazy characters in Hal Roach's **Road Show** must have seemed relatively sane in the 40s. The plot concerned a millionaire, Drogo Gaines (John Hubbard, centre) committed to an asylum by a vindictive gold-digger (Margaret Roach). There he meets Colonel Caraway 'of caraway seeds' (Adolphe Menjou, left) who has invented a camera that doesn't take pictures. They escape from 'Hopedale Club-For The Rest Of Your Life', and join a carnival run by Penguin Moore (Carole Landis), where Drogo becomes a lion tamer. It ends with a slapstick riot as rivals try to take over the show. Other inmates of this picture were Charles Butterworth, Patsy Kelly, George E. Stone, Polly Ann Young, Edward Norris, Marjorie Woodworth, Florence Bates, Willie Best (right) and The Charioteers Singing Quartet. Three directors – Roach, Roach Jr and Gordon Douglas, and three writers – Arnold Belgard, Harry Langdon and Mickell Novak – created this amiable, unsubtle, screwy, escapist comedy. (HAL ROACH)

1942

▽**The Corsican Brothers**, Mario and Lucien, were a pair of Siamese twins miraculously separated at birth, who both grew up to look like Douglas Fairbanks Jr (illustrated). They are brought up apart, but they have a 'physical telepathy', so when one is hurt, the other feels the same pain. Unfortunately, they also both feel the same love for Isabelle (Ruth Warrick, illustrated). Nevertheless, they unite to wreak vengeance on Callona (Akim Tamiroff), the villain who stole their parent's estate and who rules Corsica with an iron hand. There was plenty of action, including swordfighting, knife-throwing, kidnapping and torture in this free adaptation by George Bruce and Howard Estabrook of the Alexandre Dumas novel, the fourth Edward Small production to be inspired by the French author. However, director Gregory Ratoff treated it all too heavily and elaborately, and Fairbanks Jr could have done with more of his father's humour. Tamiroff hammed it up unmercifully, as did much of the rest of the cast which inclued J. Carrol Naish, H.B. Warner, John Emery, Henry Wilcoxon, Gloria Holden, Walter Kingsford, Nana Bryant, Pedro De Cordoba and Veda Ann Borg. (EDWARD SMALL)

△Leslie Howard (illustrated), who had been superb in *The Scarlet Pimpernel* (1934), now played a modern-day Pimpernel in **Mister V** (GB: **Pimpernel Smith**). This time, instead of rescuing victims of the French Revolution, he helped people escape from the Nazis. Pretending to be an absent-minded professor of archaeology digging with some students (David Tomlinson, Philip Friend and Hugh McDermott) in Germany in the summer before the war, he embarks on a dangerous mission to rescue a Polish editor (Peter Gawthorne) and some scientists from prison. In the meantime, he romances the editor's daughter (Mary Morris) and gets to know the Goering-like General Von Graum (Francis L. Sullivan). As he manages the escape over the border, he shouts the warning words, 'We'll be back, we'll be back.' Howard, who also produced and directed, gave one of his most polished performances, aided by the exciting and witty screenplay by Anatole De Grunwald, Roland Pertwee and Ian Dalrymple (story by A.G. MacDonell and Wolfgang Wilheim). Also cast: Raymond Huntley, A.E. Matthews, Roland Pertwee, Allan Jeayes and Suzanne Claire (Howard's real-life girlfriend). (BRITISH NATIONAL)

△There were some good aerial sequences photographed by Roy Kellino on board the British aircraft carrier *Ark Royal* for **Ships With Wings**, but the story definitely ran aground. Written by Patrick Kirwan, Austin Melford, Diana Morgan and the film's director Sergei Nolbandov, it was set on a Greek island controlled by the Germans. John Clements, former Fleet Air Arm pilot, turns up there, followed by cabaret singer Ann Todd who is in love with him. But he loves Jane Baxter, the daughter of Vice-Admiral Leslie Banks (right). When she marries someone else, and his friend, Edward Chapman, is killed by the Nazis, he fatalistically volunteers for a dangerous mission to bomb a German dam. As the dam was so obviously in Toy Town, his heroic death was somewhat diminished in effect. Others doing their patriotic bit in this Michael Balcon production were Basil Sydney (left), Hugh Williams, Frank Pettingell, Michael Wilding (centre), Michael Rennie and Cecil Parker. (EALING)

△Jewel thief and murderer Brian Donlevy (illustrated) was **A Gentleman After Dark**, but his wife Miriam Hopkins was no lady at any time. She carries on with other men, neglects her baby, and tries a spot of blackmail. Donlevy gives himself up to his boyhood friend Preston Foster, now a cop, on condition he brings up his daughter. The years pass, and the 18-year-old girl (Sharon Douglas, her screen debut), thinking Foster is her father, becomes engaged to the son (Bill Henry) of a wealthy family, but Hopkins re-appears on the scene and threatens to tell all unless she gets a large sum of money. Donlevy's paternal love forces him to break out of prison and hunt his wife down. She accidentally falls to her death and the wedding goes on. Harold Huber, Philip Reed, Gloria Holden and Douglass Dumbrille had other roles. Edward L. Marin's direction had a certain emotional impact, despite the false dramatics of George Bruce and Patterson McNutt's screenplay. The story, *A Whiff Of Heliotrope* by Richard Washburn Child, had been filmed as the silent movie *Forgotten Faces* (Paramount 1928) starring Clive Brook and Mary Brian. (EDWARD SMALL)

▷Although **The Jungle Book** was sometimes billed as *Rudyard Kipling's Jungle Book*, the alternative title was misleading. Laurence Stallings took some elements from the Mowgli stories and added many of his own, but only purist children would have failed to respond to this exciting adventure featuring a great fire, a search for buried treasure, and all manner of wild animals (some real, some models) such as Shere Khan, the tiger and Bagheera, the panther. The story had Mowgli (Sabu, illustrated), the lost boy brought up by wolves, returning to his native village when an adolescent. There, he tries to adapt to the human customs of his adopted family, Buldeo (Joseph Calleia) and his young daughter Mahala (Patricia O'Rourke). One day, on a visit to the jungle, Mowgli and Mahala bring back a gold coin which awakens the greed of Buldeo and his cronies (John Qualen and Frank Puglia). They go after the treasure and are killed. Mowgli, disillusioned with bestial humanity returns to the beasts of the jungle. Other bipeds were played by Rosemary DeCamp, Ralph Byrd, John Mather, Faith Brook and Noble Johnson. Zoltan Korda (with good second unit work from Andre de Toth) directed in the USA for his brother Alexander. The breathtaking Technicolor photography of W. Howard Greene was nominated for an Oscar. (KORDA)

▽**Twin Beds** was a fast, furious and often funny bedroom farce with a fine cast. This included George Brent (right) and Joan Bennett (left) as newly-weds who never seem able to be alone together because their apartment keeps being invaded by temperamental Russian musician Mischa Auer and his wife Una Merkel, Bennett's old flame Ernest Truex and his wife Glenda Farrell, plus Margaret Hamilton, Charles Coleman and Charles Arnt. When the three couples decide to move away from each other, they find they've all moved to the same apartment block. The screenplay by Curtis Kenyon, Kenneth Earl and Edwin Moran, referred to the war only obliquely, and the only battle was the battle of the sexes. Tim Whelan directed this Edward Small production. (EDWARD SMALL)

▷With the world living through its darkest days, Ernst Lubitsch came up with one of Hollywood's greatest comedies, **To Be Or Not To Be**. Far from being escapist, it took, of all subjects, the Nazi occupation of Poland as its theme. UA boldly put up the money themselves with Alexander Korda and Lubitsch as producers. Unfortunately, at its release, Pearl Harbor had been attacked, Germany was sweeping across Europe, and the film's star, Carole Lombard, was killed in a plane crash while on a war-bond selling tour. Therefore, neither critics nor public were in the mood to laugh, finding the picture tasteless and callous. Over the years, however, it recovered its production costs and became a classic. Although the Nazis are seen in Edwin Justus Mayer's witty and daring screenplay (story by Lubitsch and Melchior Lengyel) as incompetent clowns, especially Sig Rumann's richly comic Gestapo chief, the situation still comes across as nightmarish, and many of the laughs are bitter ones. As anti-Nazi propaganda, it was probably more effective than more serious attempts. Lombard and Jack Benny (illustrated) played a married couple who head a Polish group of Shakespearan actors. 'What he did to Shakespeare, we're doing to Poland,' laughs a German officer. At the request of a Free Polish pilot (Robert Stack), Benny impersonates both a Nazi professor who has details of the resistance and a Gestapo officer known as 'Concentration Camp Ehrhardt', while other members of the company, one of whom even passes as the Fuhrer, help to outwit the Gestapo. The jokes came thick and fast, and the two leads gave their finest screen performances, ably supported by Stanley Ridges, Felix Bressart, Lionel Atwill, Charles Halton, Tom Dugan, Henry Victor and George Lynn. It was surprisingly well remade in 1983 starring Mel Brooks and Anne Bancroft. (KORDA-LUBITSCH)

▽Produced, directed and written by Michael Powell and Emeric Pressburger, **One Of Our Aircraft Is Missing** was a stirring, exciting and beautifully photographed (by future director Ronald Neame) tale set in occupied Holland, into which six British airmen are forced to parachute. They are Godfrey Tearle, Eric Portman (right), Hugh Burden, Hugh Williams, Bernard Miles (left) and Emrys Jones, representing the usual cross-section of British society, but well characterized. The film traced their attempts to get back to England via a Channel port without getting caught by the Nazis. They are helped by heroic Hollanders including Pamela Brown, Googie Withers, Joyce Redman, Alec Clunes and Peter Ustinov. Hay Petrie and Selma Vaz Dias were a suspicious burgomaster and wife, and ballet dancer-actor Robert Helpmann (in his first film) was suitably wormlike as a quisling. The picture was a success in Britain and America, and was nominated for a Best Original Screenplay Oscar. (BRITISH NATIONAL)

△The **Friendly Enemies** in this Edward Small production were two German-born American millionaires who emigrated to America 40 years before the outbreak of World War I. Karl Pfeiffer has remained very German in character and outlook, while Heinrich Block has become more integrated. When Pfeiffer's son Bill joins up, he is appalled that the boy will be fighting against his relatives. But when his son's ship is sunk, he joins the secret service and, with Block, captures a German spy. Bill, who survives the sinking, marries Block's daughter in the end. Charles Winninger (left) and Charles Ruggles (right) were entertaining as the pair of quibbling Krauts, but less so as patriotic Yanks. James Craig and Nancy Kelly (as the chip off the old Block), were pleasant as the young lovers. Others in it were Otto Kruger, Ilka Grunig, Greta Meyer, Addison Richards, Charles Lane and Ruth Holly. Scenarist Adelaide Heilbron did not update the 1918 Samuel Shipman-Aaron Hoffman play, but Allan Dwan's direction made contemporary allusions. (EDWARD SMALL)

▷Ageing 14-year-old Shirley Temple received her first screen kiss from another former child star, Dickie Moore, in **Miss Annie Rooney**, but the picture failed to give Shirley's career the kiss of life it needed. She played the motherless daughter of an impecunious inventor (William Gargan), while Moore was the son of a rubber tycoon (Jonathan Hale). Being from the wrong side of the tracks, Shirley (illustrated) is greeted snootily by the boy's parents and friends at his birthday party, but she wins them over by displaying her jitterbugging talents. The party is ruined when her father bursts in to demonstrate his new invention to the tycoon but – surprise, surprise – the invention is a success. Shirley's father gets a job in the rubber company, and boy gets girl. This unambitious movie was produced by Edward Small, directed by Edwin L. Marin and written by George Bruce. In supporting roles were Guy Kibbee, Peggy Ryan, Roland Dupree (illustrated), Gloria Holden, Mary Field and Selma Jackson. (EDWARD SMALL)

▷**The Shanghai Gesture** was a throwback to Josef von Sternberg's golden days at Paramount and a return to the stylized Orient of *Shanghai Express* (1932), but seriously lacking the erotic presence of Marlene Dietrich. Although the bordello of John Colton's play had to be changed into a gambling den by the writers (Geza Herczeg, Karl Vollmoeller, Jules Furthman and Sternberg), the film still reeked of depravity. Most of it took place in the clandestine casino run by Madame Gin Sling (Ona Munson, right, looking like Spider Woman), a spectacular set imaginatively used by the director. Drawn into her web is Poppy (Gene Tierney, left), the daughter of Sir Guy Charteris (Walter Huston) who wants to close the casino down with the aid of the police commissioner (Albert Basserman). Other habitues of the den were Victor Mature in a fez as Gin Sling's philosophical Arab lover, Phyllis Brooks, Maria Ouspenskaya, Eric Blore, Ivan Lebedeff and Mike Mazurki. The camp proceedings ended in a melodramatic manner with Gin Sling shooting Poppy on discovering she is her own daughter by Sir Guy! Arnold Pressburger handled the production which seemed to come at the wrong moment for both critics and public. (ARNOLD PRESSBURGER)

![UNITED ARTISTS 1943]

▷Printed in the programme for the first showing of **The Moon And Sixpence** was 'For the first time nude figures will appear on screen in the paintings'. After the Hays Office saw the part they played in the picture, they passed the paintings with only one request – that the backside of one figure have a leaf or flower over it.' Artist Paul Gauguin, whose life inspired Somerset Maugham's novel, never had to contend with the Hays Office as did Albert Lewin, the director, screenwriter and producer (with David L. Loew) of the picture. Shot in 32 days at a cost of $401,000, this slow-paced, rather wordy piece, used black and white for the Paris sequences, sepia for the South Seas, and colour for a brief moment for the murals in the painter's hut. Herbert Marshall (illustrated) played the Maugham-like narrator who tells of how English stockbroker Charles Strickland (George Sanders) leaves his wife (Heather Thatcher) and goes off to Paris to paint. There, he has an affair with Blanche (Doris Dudley), the wife of a Dutch artist (Steve Geray). He then journeys to the South Seas, marries a Tahitian woman (Elene Verdugo), paints, and dies of leprosy. Support came from Eric Blore, Molly Lamont, Albert Basserman, Florence Bates (illustrated) and Robert Greig. (LOEW-LEWIN)

△**Somewhere In France** (GB: **The Foreman Went To France**) continued the British cinema's preoccupation with the Occupation. Five screenwriters (John Dighton, Angus MacPhail, Leslie Arliss, Roger MacDougall and Diana Morgan) adapted the J.B. Priestley story, based on a true incident, about the secret mission to France of a Welsh factory foreman (Clifford Evans, foreground left) to save special machines from getting into the hands of the Nazis. He succeeds with the help of an American girl (Constance Cummings, foreground right), a cockney Tommy (Tommy Trinder, behind left) and a young Scots soldier (19-year-old Gordon Jackson, behind right, making an impressive film debut), despite a fifth columnist (a hammy Robert Morley), dive bombers, lack of food and other hardships. Alberto Cavalcanti produced this morale booster, and director Charles Frend kept a nice balance between comedy, drama and thrills. Most of the other parts were taken convincingly by members of the Free French forces and refugees in England. (EALING)

▽Noel Coward won a special Oscar for the 'outstanding production achievement' on **In Which We Serve**, which he also wrote, scored and co-directed. David Lean, who edited the film, was given his first chance to direct. Coward himself gave a characteristically clipped, and somewhat expressionless, performance as Captain Kinross, skipper of the *HMS Torrin*, a proud destroyer defending the coasts of Britain against German war ships. Eventually, his vessel is sunk off Crete in May 1941, and this 'story of a ship' is told in flashback by survivors as they cling to a life raft. The captain recalls his wife (Celia Johnson) saying that to every naval woman there's 'one undefeated rival – her husband's ship.' Chief Petty Officer Hardy (Bernard Miles) remembers his wife (Joyce Carey) killed in the

◁**Stage Door Canteen**, named after the New York club where servicemen dined and were entertained by stars of stage and screen, was a huge benefit show, 86½% of the vast profits going to the American Theater Wing to establish similar canteens across the country. The producer Sol Lesser took the remaining percentage of the $4.5 million in order to cover overheads. The enormous army of stars that UA rounded up, worked for nothing, some doing turns, others making brief appearances handing out coffee and doughnuts. Among the many were (in alphabetical order) Judith Anderson, Tallulah Bankhead, Count Basie, Ralph Bellamy, Ray Bolger, Katherine Cornell, Xavier Cugat, Gracie Fields, Lynn Fontanne, Benny Goodman, Helen Hayes, Hugh Herbert, Jean Hersholt, George Jessel, Kay Kyser, Gertrude Lawrence, Peggy Lee, Gypsy Rose Lee, Guy Lombardo, Alfred Lunt, Harpo Marx, Elsa Maxwell, Ethel Merman, Yehudi Menuhin, Paul Muni, Merle Oberon, Franklin Pangborn (left), George Raft, Ethel Waters, Johnny Weissmuller (right) and Ed Wynn. Squeezed in between the celebrity appearances was a slight story, written by Delmer Daves, about the meetings, love affairs and separations of a number of young couples. These 'ordinary' people were played by William Terry, Cheryl Walker, Lon McCallister, Marjorie Riordan, Michael Harrison and Margaret Early. Although most of the action took place in the canteen over four nights, director Frank Borzage shot half the film in New York and half in Los Angeles to accommodate actors who were in Broadway stage successes. (SOL LESSER)

Blitz, and Ordinary Seaman Shorty Blake (John Mills) thinks back on his marriage to Hardy's niece (Kay Walsh). There are also memories of Dunkirk, and the loss of comrades. Permeating the film is a deep love for the ship which symbolizes the nation, without too many false heroics or flagwaving. Others in the cast were Derek Elphinstone, Robert Sansom, Frederick Piper, Geoffrey Hibbert, Philip Friend, Michael Wilding, Hubert Gregg, James Donald, Walter Fitzgerald, Kathleen Harrison, nine-year-old Daniel Massey (Raymond's son), and 19-year-old Richard Attenborough making his film debut as a coward for Coward. The picture made over $1.5 million. Illustrated clockwise, left to right: Elphinstone, Piper, Miles, Hibbert, Sansom, Mills, Coward. (TWO CITIES)

▽Fresh from his Oscar-winning triumph in *Yankee Doodle Dandy* (Warner Bros., 1942), James Cagney (centre) left the studio and set up his own company with his brother William as producer. They kicked off with **Johnny Come Lately** (GB: **Johnny Vagabond**), which grossed $2.4 million. Cagney himself played an ex-reporter on the skids who is arrested for vagrancy in a small western town in 1906. His fine is paid by the elderly crusading lady owner of the local newspaper (stage actress Grace George, right, in her only screen appearance), who then hires him to help her fight the corrupt political boss (Ed

McNamara) who runs the town. After re-establishing democracy, Cagney goes on his way, leaving a lot of grateful folksy people behind him. The star, cleverly combining pugnacity with warmth, received good support from Marjorie Main, Hattie McDaniel, Margaret Hamilton, George Cleveland (left), Marjorie Lord, Bill Henry, Robert Barrat, Arthur Hunnicutt, Lucien Littlefield and Tom Dugan. This amiable, small scale, small town picture, adapted by John Van Druten from *McLeod's Folly* by Louis Bromfield, was capably directed by William K. Howard. (JAMES AND WILLIAM CAGNEY)

△Silent screen vamp Pola Negri (right), aged 51, returned to Hollywood after an 11-year absence for **Hi Diddle Diddle** (aka **Try And Find It**, aka **Diamonds And Crime**), her penultimate picture. In this fast-paced screwball comedy, produced and directed by Andrew Stone, she played Genya Smetana, temperamental wife to Adolphe Menjou's Colonel Phyffe (centre). Their sailor boy son (Dennis O'Keefe) is about to marry his sweetheart (Martha Scott, left) when they learn that her mother (Billie Burke) has been swindled out of all her money. The Colonel proceeds to get back the money on the stock exchange and by gambling. The complicated scenario, by Edmund Hartman, was finally unravelled when the mother admits it was all a clever ruse to prove that the boy was not marrying her daughter just for the money. The leads got good support from June Havoc (centre left), Walter Kingsford, George Metaxa, Bert Roach and Paul Porcasi. (ANDREW STONE)

◁The John Robert Powers modelling agency in New York was the background to **The Powers Girl** (GB: **Hello Beautiful**), an undernourished musical full of pulchritudinous girls. Principally, Anne Shirley and Carole Landis (illustrated) as sisters both in love with fast-talking photographer George Murphy (illustrated). He makes a renowned model out of Landis, but falls for Shirley. Other roles went to Alan Mowbray (as Powers), Mary Treen, Jean Ames and Raphael Storm. The threadbare screenplay by Edwin Moran and Harry Segall (story William A. Pierce and Malvin Ward), was interrupted by numbers from Dennis Day, and Benny Goodman and his orchestra, and a beauty parade featuring Powers American Beauties. Norman Z. McLeod, living up to his middle initial, directed for producer Charles R. Rogers. (CHARLES R. ROGERS)

▽'Take it off the G-string, Lay it on the E-String,' sang Barbara Stanwyck in **Lady Of Burlesque** (GB: **Striptease Lady**), a picture with far more tease than strip. Barbara was Dixie Daisy who gets her big break in a burlesque show where, backstage, two showgirls are murdered, strangled with their own G-strings. Needless to say, the murderer is revealed in the end while attempting to kill Dixie in the same way. Miss Stanwyck (illustrated) displayed her talent and her legs to advantage, while Iris Adrian, Gloria Dickson and Marion Martin were suitably hard-boiled as her three colleagues. Michael O'Shea (in his film debut) was the show's comic, and J. Edward Bromberg, Stephanie Bachelor, Charles Dingle, Eddie Gordon and Frank Fenton played other roles. James Gunn's racy script was based on ex-stripper Gypsy Rose Lee's novel *The G-String Murders*, and director William Wellman caught the tawdry atmosphere of a tatty Broadway show. This first production for UA by former MGM producer Hunt Stromberg grossed over $2 million. (HUNT STROMBERG)

△Whereas Chaplin in *The Great Dictator* (1940) and Lubitsch in *To Be Or Not To Be* (1942) treated the Nazis as buffoons, Fritz Lang and his screenwriter John Wexley (from an original story by Lang and Bertold Brecht), in **Hangmen Also Die** portrayed them as vicious and dangerous. In fact, they were played without nuance as heavies who actually say things like 'Ve haf vays of making you talk.' Yet, despite an uninspiring cast and a disconcerting mixture of accents, an atmosphere of terror was created and the tension mounted with true Langian skill. Dull Brian Donlevy (right) got top billing as a doctor

working for the resistance in Prague who assassinates the notorious Gestapo head, Heydrich (Hans von Twardowski). Wounded and on the run, he is given refuge by a history professor (Walter Brennan) and his daughter (Anna Lee). A Nazi collaborator (Gene Lockhart) gets the professor and 400 others taken as hostages to be shot unless the killer comes forward. Dennis O'Keefe, Alexander Granach, Margaret Wycherly, Jonathan Hale, Nana Bryant and Lionel Stander gave support. This Arnold Pressburger production concluded with the title, 'Not The End'. (ARNOLD PRESSBURGER)

UNITED ARTISTS

1944

▷A film of atmosphere and mood, conversation and character, **Summer Storm** was an admirable attempt by Hollywood to create something European in essence. The intelligent screenplay by Rowland V. Lee, Robert Thoeren and Douglas Sirk (the latter directing elegantly) was adapted from Anton Chekhov's story *The Shooting Party*. It takes place on the country estate of Count Volsky (Edward Everett Horton) where Olga (Linda Darnell illustrated), the wife of the Count's overseer (Hugo Haas), casts an eye on Petroff (George Sanders), a provincial judge. He becomes enraptured by her, and kills her in a fit of passion, allowing the guileless husband to be sentenced for the crime. He dies a decade later, after the Revolution, and the Count becomes a down-and-out. Sanders exuded decadence with ease, but Darnell, although alluring, was less comfortable as a Russian peasant girl. Horton (illustrated) made the most of the comic elements in one of his most rewarding roles. Others cast were Anna Lee, Lori Lahner, John Philliber, Sig Rumann, André Charlot, Mary Servoss, John Abbott and Robert Greig. Seymour Nebenzal produced. (ANGELUS)

△Helen Walker was the broad in the punny title of the broad farce, **Abroad With Two Yanks**, the two being William Bendix and Dennis O'Keefe (centre) and abroad being Australia. The two US marines, who arrive Down Under on leave, both fall for the same dame, and each uses every ruse to gain advantage over the other. Among the many slapstick situations dreamed up by writers Charles Rogers, Wilkie Mahoney and Ted Sills (story by Fred Guiol), were an escape from the guardhouse in drag, and a ten-minute mad chase. Eventually, Miss Walker (right) turns them both down and settles for the home-grown product (John Loder). Other inhabitants of an Australia where nobody sported an Aussie accent were George Cleveland, Bill Lee (left), Janet Lambert, James Flavin, Arthur Hunnicutt, Herbert Evans, William Forrest and John Abbott. Director Allan Dwan, one of Hollywood's most experienced hands at the job, managed to wring as many laughs as possible from this popular Edward Small production. (EDWARD SMALL)

▽One of the weepiest, longest (172 minutes), and biggest hits about the home front during World War II, was David O. Selznick's **Since You Went Away**. Selznick himself wrote the morale-boosting script, from the novel by Margaret Buell Wilder, about the lives of indomitable American middle-class women coping while their menfolk are at war. Claudette Colbert (Oscar nominated) was the noble mother, and Jennifer Jones (Best Supporting Actress nomination) and Shirley Temple (right) her daughters, helping rufugees, making soldiers on leave feel at home, and doing war work. The girls also find time for romances with GIs Robert Walker (then married in real life to Jennifer Jones) and Guy Madison (debut). Mama, too, is tempted for a short while by Joseph Cotten. The maid, Hattie McDaniel (left), works on for them cheerfully without pay. In fact, everyone is full of love and good will except local gossip Agnes Moorehead who doesn't play her part in the war effort. Others in the large cast were Monty Woolley (Best Supporting Actor nomination), Lionel Barrymore, Craig Stevens, Keenan Wynn, Albert Basserman, Lloyd Corrigan, and Nazimova in her final film. This idealized evocation of an American family was directed smoothly by John Cromwell. Other nominations were for Best Picture and Black and White Cinematography (Stanley Cortez and Lee Garmes), but it was Max Steiner who won the only Oscar for the Best Musical Score. (SELZNICK INTERNATIONAL)

▽**The Bridge Of San Luis Rey** was the second screen version of Thornton Wilder's Pulitzer prize-winning novel, although it bore scant resemblance to its source in the scenario of Howard Estabrook and Herman Weissman. Rowland V. Lee's ponderous direction failed to shed light on the investigation into the lives of the five people who were killed when a Peruvian rope bridge collapsed in the mid-18th century. Some of the performances, too, were as shaky as the bridge, among them Lynn Bari (illustrated) as the singer who rises to become the viceroy's favorite; Akim Tamiroff (illustrated), her gossipy uncle; Louis Calhern, the suave Viceroy; Francis Lederer as rival twin brothers; Nazimova the jealous Marquesa; Donald Woods as Brother Juniper. All tried hard, but with a marked lack of success, to bring the ill-conceived characters to life. Others involved were Blanche Yurka, Emma Dunn, Barton Hepburn, Joan Lorring and Abner Biberman. This Benedict Bogeaus production was inferior to MGM's 1929 silent screen treatment starring Lili Damita and Ernest Torrence. (BENEDICT BOGEAUS)

▽The attack on Pearl Harbor, which had shaken America to its very core, even coloured the attitudes in the biopic of **Jack London** (aka **Adventures Of Jack London**) the turn-of-the-century traveller, reporter and adventure story writer. As embodied by the underpowered Michael O'Shea (left), the eponymous hero spent much of the time warning the world of the Japanese menace after covering the Russo-Japanese war. Other incidents dealt with in Ernest Pascal's episodic screenplay, based on a biography written by the author's wife Charmian London (played in the film by Susan Hayward), were London's experiences on a sailing ship, oyster pirating, and gold prospecting in the Klondyke. His peripatetic existence is hard on his wife, but she nobly refuses to stand in his way. Albert Santell's direction tried not to stand too much in the way of action either in this debut Samuel Bronston production. Also in the cast were Osa Massen, Harry Davenport, Frank Craven, Ralph Morgan, Louise Beavers, Jonathan Hale, Paul Hurst and newly graduated Goldwyn Girl Virginia Mayo, who was to marry O'Shea in 1947. (SAMUEL BRONSTON)

▽The main fascination of Lester Cowan's production of **Tomorrow The World**, lay in the performance of 14-year-old Skip Homeier (illustrated) in his screen debut as the odious Hitler youth foisted on middle America, the role he played in James Gow and Arnaud D'Usseau's Broadway play. This little monster is the orphaned child of an anti-Nazi German father who died in a concentration camp, and an American mother. The boy is sent to stay with his university professor uncle (Fredric March) in the USA. Having been indoctrinated back home in Germany, he considers his father a traitor to the Reich, turns against his uncle's Jewish fiancee (Betty Field), fights with his young cousin (Joan Carroll, illustrated), and alienates his schoolmates. Only when he is threatened with prison, nearly strangled by March, and beaten up, does he begin to see the benefits of democracy. The sincerity of Ring Lardner Jr and Leopold Atlas' screenplay, and Leslie Fenton's direction, was undermined by the naivety of the message and story, symbolizing the current anti-Nazification of Germany by the Allies. Other parts were taken by Agnes Moorehead, Edith Angold, Rudy Wissler, Boots Brown, Marvin Davis, Patsy Ann Thompson and Tom Fadden. (LESTER COWAN)

▷An ancient bedroom farce of the 20s by Otto Harbach and Wilson Collison provided the creaky plot for **Up In Mabel's Room**, briskly directed by veteran Allan Dwan. But even the expert comic playing of Mischa Auer (right), Charlotte Greenwood, John Hubbard and Binnie Barnes in supporting roles could not disguise the fact that it was virtually one 76-minute joke in Tom Reed's adaptation. It might have been funnier with better leads than Dennis O'Keefe (dim-witted husband, left), Marjorie Reynolds (jealous wife) and Gail Patrick (the other woman of the title). You see, hubby gave Mabel a piece of lingerie embroidered with a loving message before his marriage. Now he must retrieve it from her bedroom without getting caught. Naturally, he keeps finding himself in compromising situations. ... Janet Lambert, Fred Kohler, Lee Bowman and Harry Hayden also took part in this Edward Small production. (EDWARD SMALL)

▷William Bendix (left), the dumb ox of dozens of pictures, had his finest role as Hank Smith, **The Hairy Ape**, the proud and hulking stoker of Eugene O'Neill's raw and powerful play of the 20s. As usual, Hollywood softened up the original material, added an irrelevant romance, and changed the ending. The culprits were Jules Levey (producer), Alfred Santell (director), and Robert D. Andrews and Decla Dunning (screenwriters). Despite this, much of O'Neill's proletarian theme remained intact in this updated version. Hank Smith's life comes into question after a visit to the boiler room of his ship by rich bitch Mildred Douglas (Susan Hayward, centre). He begins to lust after her, but she reviles him and uses him as a pawn. He nearly kills her, but comes to see that she is no different from the girls he has met in dock cafes around the world. Miss Hayward injected the right dose of vileness into her role as Mildred, John Loder (right) and Dorothy Comingore played upper-deck lovers, and other passengers and crew were played by Roman Bohnen, Tom Fadden, Alan Napier, Charles Cane, Raphael Storm and Charles La Torre. (JULES LEVEY)

△Most of the blame (and some praise) for **Voice In The Wind** must be laid at the door of Arthur Ripley, since he produced (with Rudolph Monter), directed and wrote the original story. Praise was due for his valiant attempt to make a symbolic mood piece as well as an anti-Nazi tract, blame for the gap between ambition and fulfilment. Frederick Torberg's script was untidy and, although there were moments of strange beauty, much unintentional laughter was provoked by the inadequate performances in the serious passages. And serious it was ... On the island of Guadeloupe a crazed pianist plays in a waterfront saloon. A flashback tells us that he was once a great Czech virtuoso who was tortured by the Nazis and lost his memory. His sweetheart, who thought she would never see him again, is lying ill on the same island. She hears him play, goes to him, he is stabbed in a fight, and they die in each other's arms. Francis Lederer (right) and Sigrid Gurie were the tragic lovers, and J. Carrol Naish and Alexander Granach (left) were heavies. In other supporting roles were: J. Edward Bromberg, David Cota, Olga Fabian, Hans Schumm, Luis Alberni and George Sorel. (RIPLEY-MONTER)

▽The quicksand into which Elisha Cook Jr disappears while trying to murder Merle Oberon in **Dark Waters**, was the only thing quick about this Benedict Bogeaus production. The screenplay by Joan Harrison and Marian Cockrell, derived from the *Saturday Evening Post* serial by Frank and Marian Cockrell, had Miss Oberon suffering from the effects of being torpedoed and staring wildly everytime anyone mentions water. She is staying on the Louisiana plantation of her uncle and aunt (John Qualen, centre, and Fay Bainter, right), where Cook Jr is the overseer and Thomas Mitchell (left) a mysterious guest. They all turn out to be phonies who have done away with her real relatives and are hoping, similarly, to dispose of her, but local doctor Franchot Tone saves her from the baddies' machinations in the nick of time. Others involved in the murky proceedings were Rex Ingram, Odette Myrtil, Eugene Borden, Eileen Coghlan, Nina Mae McKinney and Alan Napier. Andre de Toth's direction was as emphatic as the Miklos Rosza score was repetitious. (BENEDICT BOGEAUS)

▽One of the few films about Russo-American friendship during the war, **Three Russian Girls** (GB: **She Who Dares**) did little for the cause or for cinema in general. The slight script, written by Aben Kandel and Dan James, told of the heroic work of a group of Russian volunteer nurses at the front, led by Natasha (Anna Sten). An American pilot (Kent Smith, illustrated), testing a Russian plane, has been brought down, and Natasha nurses him to recovery. They fall in love, but he has to return to the USA, and she must remain to help her people. They hope to meet again in happier circumstances after the war, in the now ironic ending. Mimy Forsaythe (illustrated) and Cathy Frye were other nurses, and Alexander Granach, Paul Guilfoyle, Kane Richmond, Jack Gardner and Marcia Lenack took other roles. The Gregor Rabinovitch production was directed sluggishly by Sten's Russian emigré husband Fedor Ozep (with Henry Kesler), and was uncomfortably interrupted by footage of the training of nurses and some stirring patriotic Soviet songs. (GREGOR RABINOVITCH)

▽A reporter who can foretell the news 24 hours before it occurs was the intriguing idea behind the script of **It Happened Tomorrow**, written by Rene Clair and Dudley Nichols. But Clair's direction missed many opportunities offered for comedy-fantasy. Perhaps a lighter touch in the performances of Dick Powell as the reporter and Linda Darnell as his girlfriend (both illustrated), was needed, while Jackie Oakie as a bogus clairvoyant, Edgar Kennedy as a police inspector,

Ed Brophy, George Cleveland and Sig Rumann were merely stock farce characters. John Philliber played a mysterious old man who has the power to show Powell the next day's newspaper, allowing him to get scoops and predict racetrack winners. All goes well until he reads of his own death. A clever twist at the end showed how he survives. Producer Arnold Pressburger correctly foresaw that this would be one of the box-office hits of the year. (ARNOLD PRESSBURGER)

▽The only song that survived from the original 1938 Broadway musical flop, **Knickerbocker Holiday**, by Maxwell Anderson and Kurt Weill, was the evergreen 'September Song'. Charles Coburn (illustrated) as Peter Stuyvesant, the one-legged tyrannical Dutch governor of New Amsterdam, sings it when he realizes he has made a fool of himself by falling in love with a much younger girl. Constance Dowling (illustrated) played the girl, herself in love with crusading newspaperman Nelson Eddy. Others cast were Ernest Cossart, Shelley Winters (billed as Winter), Glen Strange, Otto Kruger, Percy Kilbride, Chester Conklin and Fritz Feld. Although much of the political content of the stage version was lost in the screenplay by David Boehm, Harold Goldman and Roland Leigh, obvious parallels were drawn between Stuyvesant's regime and the book-burning Nazis. Throughout it all the heavy hand of producer and director Harry Joe Brown lay over the picture. (PRODUCERS' CORPORATION OF AMERICA)

▽**Sensations Of 1945** was as good an excuse as any for putting together a number of acts, including W.C. Fields, Sophie Tucker and the bands of Cab Calloway and Woody Herman. It also displayed the dancing dexterity of Eleanor Powell (illustrated) who, in one number, tapped on a giant pinball machine. Pity that producer and director Andrew Stone, with Dorothy Bennett, bothered to concoct a silly screenplay from a story by Frederick Jackson, in order to link the enjoyable routines. For what it's worth, it concerned the attempts of Powell's agent, Dennis O'Keefe (illustrated), to find stunts to keep her in the public eye. O'Keefe's stuffy father C. Aubrey Smith, head of the publicity firm, objects to these crude gimmicks, particularly as one of them lands her in jail. Eugene Pallette, Lyle Talbot and Dorothy Donegan had other roles. It was Miss Powell's last film before retiring to become Mrs Glenn Ford. (She returned only once, six years later, for a speciality spot in *The Duchess Of Idaho*, MGM). (ANDREW STONE)

◁**Song Of The Open Road** was only notable for the screen debut of petite 15-year-old radio singing star Jane Powell. Charles R. Rogers' production was virtually a showcase for her vocal talent which soon led to an MGM contract and blonde hair. The Albert Mannheimer screenplay (story by Irving Phillips and Edward Verdier) was one of those well-worn juvenile let's-put-on-a-show yarns. Powell (illustrated) runs away from home to join her friends at a youth farm where every other youngster happens to have some musical gift. The show they put on to inspire farm chores, managed to include guest stars W.C. Fields, The Condos Brothers, and Edgar Bergen and Charlie McCarthy. Also participating were Bonita Granville, Jack Moran, Peggy O'Neill, Bill Christy, Reginald Denny, Regis Toomey, Rose Hobart and Sig Arno (illustrated). A merry romp, but Sylvan Simon's direction could have done with some of Miss Powell's freshness. (CHARLES R. ROGERS)

UNITED ARTISTS
1945

▷The great French director Jean Renoir was given advice by American novelist William Faulkner on the script of **The Southerner**, adapted from George Sessions Perry's novel *Hold Autumn In Your Hand*. The result was probably Renoir's finest American film, the only one to be well-received critically and to break even at the box-office. 'What attracted me in the story was precisely the fact that there was really no story, nothing but a series of strong impressions – the vast landscape, the simple aspiration of the hero, the heat and the hunger,' wrote Renoir. In order to achieve pictorial splendour and realism, he shot the film almost entirely on location on a cotton field in California's San Joaquin valley, (standing in for the Texas of the novel), with his own cameraman Lucien Andriot and designer Eugene Lourie, and the encouragement of producers David Loew and Robert Hakim. It told of one year in the life of a farm hand, tired of working for others, who decides to go it alone. With his wife, old mother and small son, he finds a patch of waste land and builds a shack on it. There he has to fight a malicious neighbour, the elements, and malnutrition, but he does not give in. When Joel McCrea refused the lead, Zachary Scott (left) was cast against type. He, Betty Field (the wife), Beulah Bondi (the grandmother), J. Carrol Naish (the neighbour, right), Percy Kilbride, Blanche Yurka, Norman Lloyd, and Estelle Taylor all gave excellent performances. (LOEW-HAKIM)

◁Veteran character actor Felix Aylmer (left) had one of his rare leading roles in **Mr Emmanuel**, the first of a six-picture package given to UA for distribution in the States by British producer J. Arthur Rank. Aylmer was seldom off the screen as the Jew who goes from England to Germany in 1936 to find the mother of a half-Jewish refugee boy (Peter Mullins). Made a scapegoat for a political murder, he is interrogated and beaten by the Gestapo, but is released through the intervention of a cabaret singer (Greta Gynt) who helps him find the boy's mother. The background and atmosphere was well conveyed in Harold French's direction, but the screenplay by Gordon Wellesley and Louis Golding (from the latter's novel) was a trifle stilted. Walter Rilla, Ursula Jeans, Frederick Richter, Elspeth March, Frederick Schiller, Guy Dezhy (right), Maria Berger, Charles Goldner, Irene Handl and a teenage Jean Simmons (in her second film) gave competent support. Unfortunately the picture came five years too late to elicit an enthusiastic response from the public. (RANK)

◁Whatever the negative aspects of **Guest Wife**, a positive one was Claudette Colbert (illustrated) at her sophisticated comic best. Of the male leads, Dick Foran overdid it as her jovial, bumbling banker husband, and Don Ameche looked strained as the man whose wife she pretends to be. As well he might! In the Bruce Manning – John Klorer screenplay, Ameche (illustrated) was cast as a foreign correspondent who has to pose as a married man for the benefit of his boss (Charles Dingle) in order to keep his job. The motivations were clumsy, with the farcical situation growing extremely complicated when Colbert is accused of living with a married man (actually her own husband), and Foran becomes more and more jealous as Ameche takes advantage of the situation. Jack H. Skirball's production was an attempt at a sort of *Design For Living* (Paramount 1933), but instead of Ernst Lubitsch, it had Sam Wood directing. Also in the cast were Grant Mitchell, Wilma Francis, Chester Clute, Irving Bacon, Hal K. Dawson and Edward Fielding. (JACK H. SKIRBALL)

△Journalist Ernie Pyle, on whose book and experiences **The Story Of G.I. Joe** (aka **G.I. Joe**, aka **War Correspondent**) was based, died just before the picture was released. He was among a group of experienced war reporters who acted as technical consultants on the film, and who approved the screenplay by Leopold Atlas, Guy Endore and Philip Stevenson. Unlike the usual war saga, it concentrated on the fatigue, discomfort and anxiety that the common soldier must suffer. A small group from the 18th Infantry are followed by Pyle (Burgess Meredith) from North Africa to Italy. The group included an understanding captain (Robert Mitchum, illustrated foreground, in his first substantial role), a tough sergeant (Freddie Steele) who carries a phonograph record of his child's voice around with him, and a Brooklyn Romeo (Wally Cassell). Also taking part were Jimmy Lloyd, Jack Reilly, Bill Murphy and actual veterans of the Italian campaign. Director William Wellman, himself an active participant in World War I, used a now slightly dated semi-documentary style, but there was no denying the attempt to tell it how it was. Lester Cowan produced the well-received picture which gained four Oscar nominations: Best Supporting Actor (Mitchum), Screenplay and Music – song and scoring. (LESTER COWAN)

▽Although Jay Dratler and Alma Reville (Mrs Alfred Hitchcock) based their script for **It's In The Bag** (GB: **The Fifth Chair**) on Elie Ilf and Eugene Petrov's story *The Twelve Chairs*, the plot was soon abandoned to give radio star Fred Allen (left) full reign for his wacky comedy routines. The baggy-eyed, dyspeptic comedian played Fred Floogle, a flea circus owner, who inherits money sewn into the seat of one of five antique chairs. With his wife (Binnie Barnes) he goes on a quest for the right chair, encountering on the way tightwad Jack Benny (right), crazy psychiatrist Jerry Colonna, menacing gangster William Bendix, scheming John Carradine, detective Sidney Toler, and Minerva Pious as Mrs Nussbaum from his radio show. He also joins Rudy Vallee, Don Ameche and Victor Moore in a barbershop quartet at a Gay Nineties cafe. The money is found, so his daughter Gloria Pope can marry William Terry, son of mousetrap inventor Robert Benchley. Richard Wallace directed this rib-tickling ragbag for producer Jack H. Skirball. The story was filmed less amusingly as *Keep Your Seats Please* (1936) starring British comic George Formby, and more faithfully later by Mel Brooks as *The Twelve Chairs* (1970). (JACK H. SKIRBALL)

◁The team of producer Edward Small, director Allan Dwan, and star Dennis O'Keefe of the bedroom farce *Up In Mabel's Room* (1944), were again upstairs and downstairs and in a lady's chamber in **Getting Gertie's Garter**. This time round, instead of the piece of lingerie given to Mabel, the silly goose of a husband (O'Keefe, illustrated), has to retrieve a $500 engraved jewelled garter given to Gertie (Marie 'The Body' McDonald, illustrated) before she shows it to his jealous wife (Sheila Ryan). The misunderstandings were even less amusing than in the previous picture, and the cast, apart from Binnie Barnes, was less attractive. It included Barry Sullivan, J. Carrol Naish, Jerome Cowan, Vera Marshe, Donald T. Beddoe and Frank Fenton. Dwan and Karen de Wolf's script was adapted from the stage play by Wilson Collison and Avery Hopwood, filmed once before in 1927 with Charles Ray. (EDWARD SMALL)

◁The haunting title song by Irving Kahal and Sammy Fain of **I'll Be Seeing You**, underscored the sentimental mood of this wartime romance produced by David O. Selznick. The money-making picture was saved from tumbling into schmaltz by the overall sensitivity of Dore Schary's first production, and the restrained and affecting performances of Ginger Rogers and Joseph Cotten (both illustrated) in the main roles. She played a prisoner on parole at Christmas, he an ex-soldier recovering from shellshock. They meet on a train, and she invites him to stay with her uncle and aunt (Tom Tully and Spring Byington) over the holiday period. In the cosy atmosphere of the small town American home, they fall in love. A crisis is reached, however, when the teenage daughter of the family (Shirley Temple) blurts out that her cousin is a jailbird. However, an overwrought flashback shows her innocent of the crime of killing her amorous boss. Love cures the soldier's neurosis, and he prepares to wait for her to complete her sentence. The story by Charles Martin and the screenplay by Marion Parsonnet contained inconsistencies but, on the whole, director William Dieterle handled it in a simple, straightforward manner. Also cast were Chill Wills, Kenny Bowers and 18-year-old John Derek in a bit part. (SELZNICK INTERNATIONAL)

△Producers William and James Cagney satisfied the public's need to hate the Japs with **Blood On the Sun**, which grossed $3.4 million. Director Frank Lloyd treated the rather simplistic script by Lester Cole (from a story by Garrett Fort) as an action adventure, unhampered by propaganda. Cagney (Jimmy) played a spunky reporter in Tokyo in 1931, who gets hold of Premier Tanaka's written plans for world conquest. Wallace Ford, a journalist who first got the information, is killed, and pressure is put on Cagney to drop it. He meets Sylvia Sidney as a Eurasian pro-Chinese agent pretending to work for the Japanese and, after certain violent incidents, Cagney (right) and the girl (centre) escape to America with the information. John Emery as Tanaka and Robert Armstrong as General Tojo were two of the yellow heavies, with other roles going to Rosemary DeCamp, Leonard Strong, Frank Puglia, Jack Halloran, Hugh Ho, Philip Ahn, Joseph Kim, Rhys Williams (left) and Porter Hall. Wiard Ihnen and A. Roland Fields won an Oscar for Best Art Direction and Interior Decoration for their recreation of Japanese settings. (JAMES AND WILLIAM CAGNEY)

▽Anne Baxter was a viper in the nest in **Guest In The House**, a typical 40s Hollywood melodrama with a scheming woman at its centre. She is invited to the house on the cliff of artist Ralph Bellamy (illustrated) and his wife Ruth Warrick, and rewards their hospitality by driving the artist's model (Marie McDonald, illustrated) away, setting his daughter (Connie Laird) against him, exploiting the love of his brother (Jerome Cowan), and making a play for the artist himself.

Only aunt Aline MacMahon sees through her and, playing on her phobia about birds, drives her to suicide. Like the manner of Miss Baxter's death, John Brahm's direction was sometimes over the top in his handling of the unconvincing situations in Ketti Frings' screenplay based on *Dear Evelyn*, a play by Hagar Wilde and Dale M. Eunson. Percy Kilbride, Margaret Hamilton and Scott McKay also appeared in Hunt Stromberg's profitable production. (HUNT STROMBERG)

▽Charles Laughton (centre) descended from Captain Bligh in *Mutiny On The Bounty* (MGM, 1935) to playing **Captain Kidd** in a low-budget Benedict Bogeaus production. Director Rowland V. Lee allowed Laughton, complete with stage cockney accent, to ham it up as the bloodthirsty pirate who deceives King William III (Henry Daniell) into empowering him to protect a treasure ship from buccaneers. With his crew of cut-throats (among them John Carradine and Gilbert Roland) is Adam Mercy (Randolph Scott, right) who rescues the Kidd-napped Lady Anne (Barbara Britton) from the Captain's clutches. Kidd is later hanged for his crimes. The screenplay by Norman Reilly Raine (story by Robert N. Lee), containing the usual piratical ingredients, was as creaky as Kidd's ship. Also aboard were Reginald Owen, John Qualen, Sheldon Leonard (left), Abner Biberman, Ian Keith, William Farnum and Miles Mander. Laughton reprised the role even more hammily in *Abbott And Costello Meet Captain Kidd* (Warner Bros., 1952). (BENEDICT BOGEAUS)

△With the world at war crying out for more and more doctors, jokes about women medics in **Bedside Manner** (TV: **Her Favorite Patient**) went down like castor oil. The lady doctor in question was Ruth Hussey (illustrated), who stops on her way to Chicago to help out her overworked uncle Dr Charles Ruggles in his small town surgery. She is quite remarkable at curing any problem, physical or psychological, but she can't see through test pilot John Carroll (illustrated) who is faking a head injury just to be near her. Frederick Jackson and Malcolm Stuart Boylan (story by Robert Carson) wrote the fatuous screenplay, and Andrew Stone was responsible for both the production and direction. Other casualties of the movie were Ann Rutherford, Claudia Drake, Renee Godfrey, Esther Dale, Grant Mitchell, Joel McGuinness and John James. (ANDREW STONE)

△The last picture made by popular British singing comedienne Gracie Fields before she retired to Capri, was **Paris Underground** (GB: **Madame Pimpernel**). Not the highest note on which to leave the film industry! It was hard to believe that Boris Ingster and Gertrude Purcell's hackneyed script was based on the true story by Etta Shiber, who helped Allied aviators escape the Nazis into Free France. 'Our Gracie' (left) played an Englishwoman in Paris who joins up with American Constance Bennett (right – who was also given the credit as producer) to smuggle 259 pilots out of Occupied France. After killing a Gestapo agent, the two brave gals are arrested and tortured, but the Liberation saves them. Gregory Ratoff's direction made little distinction between the farcical and tragic episodes, and many of the characterizations were inadequate. Also featured were George Rigaud, Kurt Kreuger, Charles Andre, Leslie Vincent, Eily Malyon, Gregory Gaye, Vladimir Sokoloff and future director Andrew McLaglen (Victor's son). According to the record, Carley Harriman functioned as 'executive assistant producer to Miss Bennett', which is probably a way of saying that *he* did the work! (CONSTANCE BENNETT)

△**Delightfully Dangerous** was neither delightful nor dangerous, but it did offer winsome young soprano Jane Powell (left) her second screen role. When she sang, the tedium of the Walter De Leon-Arthur Phillips script (story by Irving Phillips, Edward Verdier and Frank Tashlin) abated. She played a sedate music student who believes her sister (Constance Moore) to be a Broadway star instead of the stripper she is. But little Miss Powell, armed with a bundle of clichés, manages to marry her off to a big musical producer (Ralph Bellamy), and gets him to put them both in one of his shows. Other participants were Arthur Treacher and Louise Beavers as a butler and maid (what else?), Ruth Tobey (right), Ruth Robinson, André Charlot, Shirley Hunter Williams and Morton Gould and his orchestra. Arthur Lubin directed this insipid Charles R. Rogers production. (CHARLES R. ROGERS)

▷The psychology of Alfred Hitchcock's **Spellbound**, as in *Psycho* (Paramount, 1960) and *Marnie* (Universal, 1964), was extremely half-baked and facile. Psychoanalysis was coming into vogue in the mid-40s when producer David O. Selznick got Ben Hecht and Angus MacPhail to adapt Francis Beeding's Freudian murder mystery *The House Of Dr. Edwardes* as a subject for the Master of Suspense. What mattered, however was not the content so much as the way Hitchcock displayed his virtuosity and his ability to involve an audience. The brilliant black-and-white photography by George Barnes (Oscar-nominated), the romantic score by Miklos Rosza (winning his first Oscar), plus a thrilling flashback, and a memorable dream sequence (somewhat artily designed by Salvador Dali), puts it among Hitchcock's best films of the decade. Effective, too, in the atmosphere of insanity, was the casting of handsome, uncomplicated Gregory Peck (illustrated) as the amnesiac imposter who becomes head of a mental institution, and fresh, normal Ingrid Bergman (illustrated) as the doctor who helps cure him. He subconsciously believes himself to be a murderer, but her analysis expunges his guilt and points to the real culprit. She also explains why he goes loony everytime he sees dark lines against a white background. Giving good support were Michael Chekhov (nominated as Best Supporting Actor), Rhonda Fleming, John Emery, Leo G. Carroll, Norman Lloyd, Wallace Ford and Regis Toomey. Other Oscar nominations were for Best Picture and Director. (SELZNICK INTERNATIONAL)

△**The Great John L** (GB: **A Man Called Sullivan**) told of the rise and fall of turn-of-the-century world heavyweight boxing champion John L. Sullivan (Greg McClure) known as 'The Boston Strong Boy'. In between fighting and drinking, John L. marries a musical comedy star (alluring Linda Darnell, centre) who leaves him when the going gets tough. After he loses his title to James Corbett (the subject of *Gentleman Jim* WB, 1942, starring Errol Flynn, and a far superior biopic), the boxer becomes a drunk and the film tottered. It ended with him walking off a Temperance platform into the arms of his first love (wooden Barbara Britton). McClure (right), starring in his first picture, did not have the personality to carry the film, and later ended up playing Joe Palooka in a programmer. Others in the cast were Otto Kruger, Wallace Ford (left), George Matthews, Robert Barrat, J.M. Kerrigan and Rory Calhoun. The screenplay by James Edward Grant situated the action in London, Paris and New York. This Bing Crosby production was good on period atmosphere, but Frank Tuttle's direction was strictly in the flyweight division. (BING AND HARRY CROSBY)

△The imaginative producing, directing and screenwriting partnership of Michael Powell and Emeric Pressburger continued to go against the British realist tradition with **Colonel Blimp** (GB: **The Life And Death Of Colonel Blimp**). At a time when the war was being portrayed in black and white terms, and most Germans as monsters, they provided a subtle story of Anglo-German relations from the Boer War to World War II, reflected in the friendship of a German officer and a British soldier. In the course of the tale, Anton Walbrook (illustrated) moved from being an arrogant German challenging British Roger Livesey to a duel, to becoming a pathetic prisoner-of-war, and later a refugee in England. Livesey changes from a young officer to a red-faced old windbag, out of touch with modern warfare. Because of the satire on sensitive issues, and the sympathetic German character, the film was badly cut on release from its original 163 minutes. The two excellent leads were given support by Deborah Kerr (illustrated) as three images of English womanhood in three eras, as well as by Roland Culver, James McKechnie, Albert Lieven, Arthur Wontner, A.E. Matthews, John Laurie, Felix Aylmer and Ursula Jeans (Roger Livesey's real-life wife). The extravagant sets by Alfred Junge were filmed in sensuous Technicolor by Jack Cardiff. (RANK)

▽The housing shortage in the USA provided the farcical basis for **Three Is A Family**. However, there was more of a shortage of good jokes in the script by Harry Chandlee and Marjorie L. Pfaelzer, derived from Henry and Phoebe Ephron's stage play. It concerned the intrusion into a four-room apartment of a middle-aged couple (Charles Ruggles, illustrated, and Fay Bainter) by their daughter (Marjorie Reynolds) and her twin babies (Donna, left, and Elissa Lambertson), and their son (Arthur Lake) and pregnant daughter-in-law (Jeff Don-nell). Also sharing the apartment is a maiden aunt (Helen Broderick, illustrated), and, finally, another pregnant woman. John Philliber (in his last role) played the half-blind family doctor trying to deliver the babies, while Hattie McDaniel as the maid spent her time laughing at the chaos, which was more than audiences managed to do. Edward Ludwig directed this infantile (in two senses) Sol Lesser production. Also around, giving what little support they could muster were Walter Catlett, Clarence Kolb and Cheryl Walker. (SOL LESSER)

◁Edward Small's production of **Brewster's Millions**, pacily directed by Allan Dwan, provided more laughs than the 1914, 1921, 1935, 1961 and 1984 versions of the Winchell Smith-Brian Ongley play (from George Barr McCutcheon's novel). The screenplay by Siegfried Herzig, Charles Rogers and Wilkie Mahoney stuck, more or less, to the original plot in which Monty Brewster (Dennis O'Keefe, right) is told on the day of his wedding, that he is his rich uncle's sole heir. However, in the terms of the will, he must spend $1 million in two months or forfeit a further $7 million. His prodigality at the race track and stock exchange only brings him more money. Finally a flop musical helps him get rid of the million before the appointed time. Eddie 'Rochester' Anderson was his factotum; Helen Walker (left), June Havoc and Gail Patrick, the women in his life. Others cast included Mischa Auer (centre), Joe Sawyer, Nana Bryant, John Litel and Thurston Hall. (EDWARD SMALL)

UNITED ARTISTS

1946

▽**Whistle Stop** outstayed its welcome, but Ava Gardner (illustrated) arrived as a star. She played a small town gal whose tastes have become expensive after two years in the big city. On returning home, she hesitates between two admirers – George Raft (illustrated), the local bum and drunkard, whom she really loves, and smooth Tom Conway, owner of a thriving gambling joint. She succumbs to the latter, but when he is murdered Raft is implicated. Naturally, the real killer is revealed at the last moment. Raft gets a job, and Ava settles for love. The happy ending to Philip Yordan's scenario, adapted from Maritta M. Wolff's novel, was as false as everything that preceded it. Raft remained gloomily impassive throughout opposite the extraordinarily attractive Miss Gardner. Victor McLaglen, Florence Bates, Charles Drake, Charles Judels, Carmel Myers and Jimmy Conlin also tried to prop up this Seymour Nebenzal production. It was the last of three Hollywood films directed by Russian emigré Leonide Moguy, before his return to France. (NERO)

△In answer to Warner Bros'. ludicrous objections to the title of the Marx Brothers picture **A Night In Casablanca**, Groucho wrote, 'You claim you own Casablanca ... What about Warner Brothers? ... You probably have the right to use the name Warner, but what about Brothers? Professionally, we were brothers long before you were.' No-one could have confused this last authentic Marx Brothers burlesque with *Casablanca* (WB, 1942), although it was ostensibly set in the same city. Groucho as Ronald Kornblow is the manager of the post-war Hotel Casablanca, appointed as a last resort after a series of managers have been bumped off, Chico was his self-appointed bodyguard and owner of the Yellow Camel Taxi service, and Harpo the mute servant of Sig Rumann's Count Pfefferman, an escaped Nazi. Lisette Verea ('I'm Beatrice Reiner. I stop at the hotel.' 'I'm Ronald Kornblow. I stop at nothing.') vamps the manager (see illustration) while the Nazis try to escape with loot hidden in the hotel. Charles Drake and Lois Collier were the obligatory young lovers helped by the trio, and Dan Seymour, Lewis Russell, Harro Mellor and Frederick Gierman were also cast. Although neither Archie Mayo's direction, nor the script by Joseph Fields, Roland Kibbee and Frank Tashlin were vintage Marxism, this David Loew-Albert Lewin production was still a welcome return of the inimitable brothers after a five year absence from the screen. (LOEW-LEWIN)

▽'Beautiful women and politics do not mix,' says pokerfaced George Raft (illustrated) as **Mr Ace**, crooked boss of a political machine. The particular woman he has in mind is Sylvia Sidney (illustrated) as a senator determined to become governor of Illinois. Using her feminine charms to hide her tough tactics, she outwits Raft, wins the election without resorting to corruption, and makes him an honest man. Miss Sidney tried hard to convince in an impossible role, but was not helped by Edwin L. Marin's conventional direction or Fred Finklehoffe's far-fetched script. Supporting were Stanley Ridges, Sara Haden, Jerome Cowan, Sid Silvers, Alan Edwards and Roman Bohnen. This political fable, produced by Benedict Bogeaus, failed to get many people's votes. (BENEDICT BOGEAUS)

◁Although **Abie's Irish Rose** was updated by Anne Nichols, the author of this record-breaking Broadway play of the 20s, the ethnic low comedy was still as corny as ever. The story concerned the shocked reactions of two racially stereotyped families when Abie Levy (Richard Norris) marries Rosemary Murphy (Joanne Dru, illustrated, her screen debut). To satisfy their parents, the couple are first married by a Protestant minister (Bruce Merritt), then a rabbi (Art Baker), then a Catholic priest (Emory Parnell). But the fathers, Solomon Levy (Michael Chekhov, illustrated) and Patrick Murphy (J.M. Kerrigan), are only reconciled when the twins born are named after each of them. Also involved were George E. Stone, Vera Gordon and Eric Blore. Edward Sutherland directed this indigestible mix of spuds and matzo balls for producer Bing Crosby. It was previously filmed by Paramount in 1928 when the exaggerated Yiddish and Irish accents were thankfully silent. (BING AND HARRY CROSBY)

▽Laurence Olivier (illustrated) received a special Oscar 'for his outstanding achievement as actor, producer and director in bringing **Henry V** to the screen.' He also received nominations for Best Picture and Best Actor. The film, distributed on a roadshow basis in the USA, proved conclusively that William Shakespeare *could* be box-office by grossing over $2 million. Made on the eve of the Allied invasion of Normandy, a clear parallel was drawn between the historical King's conquest of France, and the coming defeat of contemporary Germany. Olivier and Alan Dent's screen adaptation caught the patriotic mood of the times and, with Robert Krasker's superb Technicolor photography and William Walton's stirring music, Olivier's first film as director was Shakespeare in the cinema at its most imaginative. Symmetrical in structure, it began with a brilliant reconstruc-

tion of a performance at the Globe Theatre in 1603, and when the Chorus (Leslie Banks) invites us to take 'imagined wing', the film shifts to France. The range of stylized sets by Paul Sheriff, derived from medieval paintings, gives way to the cleverly orchestrated Battle Of Agincourt, shot on location in Ireland, inspired by Uccello, and by Sergei Eisenstein's Battle On The Ice From *Alexander Nevsky* (Mosfilm 1938). Supporting Olivier's virile performance in this 137-minute, million dollar production was a distinguished cast including Robert Newton (Pistol), Esmond Knight (Fluellen), Renee Asherson (Katherine), George Robey (Falstaff), Harcourt Williams (Charles VI), Max Adrian (The Dauphin), Felix Aylmer (The Archbishop), Ralph Truman (Mountjoy), Leo Genn, Ernest Thesiger, Ivy St Helier, Valentine Dyall, John Laurie and Robert Helpmann. (RANK)

△Any Western was as safe as a frontier town, in this case **Abilene Town**, when Randolph Scott was marshal. Until he arrived, the villainous cattlemen, using murder and arson, were preventing law-abiding homesteaders from settling near the town. Along comes Scott and, with the help of local tradesmen, gets rid of the baddies. Edwin L. Marin directed competently, following the simple, strong storyline in Harold Shumate's screenplay derived from the novel *Trail Town* by Ernest Haycox. In between the plentiful action, Scott found himself torn between gold-hearted saloon singer Ann Dvorak (illustrated), and pretty grocer's daughter Rhonda Fleming, but settled respectably for the latter in this Jules Levey production. Other parts were taken by Edgar Buchanan, Lloyd Bridges, Howard Freeman, Richard Hale, Helen Boice, Jack Lambert and Hank Patterson. (JULES LEVEY)

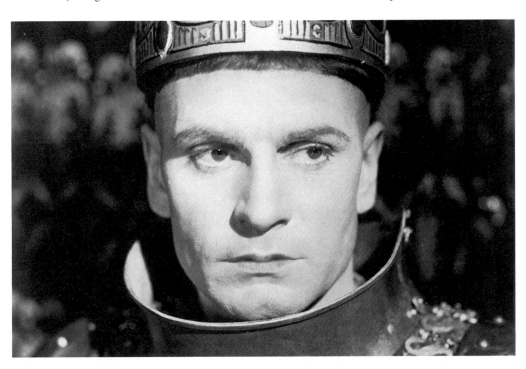

△*Here Comes Mr Jordan* (Columbia, 1941) inspired a number of inferior movies such as **Angel On My Shoulder**, in which dead characters are sent back to Earth for a while. In this case, Paul Muni, as a murdered criminal, is dispatched by urbane devil Claude Rains from Hell to America, in order to stop a do-gooder judge from doing good. Muni (illustrated) takes the form of the judge but, instead of blackening the judge's character as instructed, he inadvertently makes him into a hero. The devil then loses power over the ex-con when the latter's love for Anne Baxter (illustrated) reforms him. As Muni's morals improved, so the film, directed by Archie Mayo, deteriorated, and mawkishness crept in. The otherwise lively script was by Harry Segall and Roland Kibbee, and others appearing in the parable produced by Charles R. Rogers included Onslow Stevens, George Cleveland, Hardie Albright, James Flavin, Erskine Sanford and Marion Martin. (CHARLES R. ROGERS)

△**Young Widow** was the first chance for the public at large to see Jane Russell (left), because *The Outlaw* was yet to be nationally released. She drifted decoratively and weepily through this plodding sudser, playing a woman trying to forget her husband killed in the war. But wherever she goes something reminds her of him – the farmhouse where they lived, a dance tune, and even her job as a journalist. Glumly following her around is soldier Louis Hayward, who finally persuades her that he's the man to take her husband's place. The wordy screenplay was by Richard Macaulay and Margaret Buell Wilder (from the novel by Clarissa Fairchild Cushman), and the picture was directed by Edwin L. Marin. Also in this Hunt Stromberg production were Faith Domergue (another Howard Hughes protegee), Kent Taylor, Marie Wilson, Connie Gilchrist (right), Penny Singleton, Norman Lloyd, Cora Witherspoon (centre) and Steve Brodie. (HUNT STROMBERG)

△Most of the witty and brittle dialogue from Noel Coward's play was preserved in **Blithe Spirit** by adaptors David Lean, Ronald Neame and Anthony Havelock-Allan. But the latter's production, Lean's direction, Neame's pastel colour camerawork, and the Oscar-winning special effects by Thomas Howard, could not really transport the essentially theatrical conversation piece into the realms of cinema. Nevertheless, there was much pleasure to be had from the elegant playing of Rex Harrison as novelist Charles Condomine, Constance Cummings as his second wife Ruth, and Kay Hammond as Elvira, Charles' first wife who returns from the dead with purple lips to form a ghastly, ghostly *menage á trois*. This situation is brought about by an eccentric bicycle-riding medium called Madame Arcati, who conjured Elvira up at a seance, and doesn't know how to send her back. The medium was one of marvellous Margaret Rutherford's most memorable creations (illustrated). Completing the cast were Joyce Carey and Hugh Wakefield as sceptical friends, and Jacqueline Clarke as a maid rushing about the country house setting. (RANK)

1947

▷The **Macomber Affair** was as faithful to Ernest Hemingway's story *The Short Happy Life Of Francis Macomber* as Hollywood allowed. At least, it was more faithful than Mrs Macomber (Joan Bennett, illustrated), who makes a play for a manly white hunter (Gregory Peck) whom she compares with her cowardly husband (Robert Preston, illustrated). The Macombers arrive in Kenya on a hunting expedition as a last attempt at reconciliation. After showing a yellow streak during a lion hunt (some good location work by director Zoltan Korda), Macomber tries to prove himself in a wild buffalo hunt. But his wife shoots him dead while attempting to save him from a stampeding buffalo. Was she a good shot or a bad one? Hemingway suggests murder, screenwriters Casey Robinson and Seymour Bennett implied an accident. The movie ended with her trial but with no verdict revealed. A clue to the result, perhaps, was the last thing to be seen on the screen – 'Released by United Artists.' Others cast in this Benedict Bogeaus-Casey Robinson production were Reginald Denny, Earl Smith, Jean Gillie, Carl Harbord and Frederick Worlock. (BENEDICT BOGEAUS)

▽Imagine tough and smouldering Barbara Stanwyck as a concert pianist dying of tuberculosis in **The Other Love**, while Miklos Rosza's music swells, and you have a fair idea of this soppy soap opera, directed without conviction by Andre de Toth. Miss Stanwyck (left), according to the script by Harry Brown and Ladislas Fodor (from the novel *Beyond* by Erich Maria Remarque), is 'living on a policy of smashing the face of the clock.' Ignoring the advice of her doting doctor David Niven, she leaves her Swiss sanatorium to run around the Riviera with racing car driver Richard Conte and croupier Gilbert Roland. Coughing on cue, she returns to the mountain top, marries Niven, and dies. Also seen in the light of Stanwyck's flickering flame were Maria Palmer (right), Joan Lorring, Richard Hale, Edward Ashley and Natalie Schafer. David Lewis produced. (ENTERPRISE)

▷Straight and solid Joel McCrea (right) was **Ramrod**, in a straight and solid Western adapted from Luke Short's *Saturday Evening Post* story by Jack Moffit, Graham Baker and Cecile Kramer. He was a cowhand who helps tough lady Veronica Lake avenge herself on Preston Foster, strong man of the area, for driving her weakling fiancé Ian McDonald away. McCrea wants to keep within the law as represented by Sherriff Donald Crisp, but Miss Lake ruthlessly pursues her ends. After McCrea and Foster have a showdown and our hero wins, he rejects Veronica for Arleen Whelan, a sweet milliner. Charles Ruggles, Don DeFore, Lloyd Bridges (left), Rose Higgins and Chic York added sharp characterizations. Director André de Toth (Veronica Lake's husband) demonstrated that he had an eye for powerful action stuff in this David Loew-Charles Einfeld production. (ENTERPRISE)

△Although most of the numbers were truncated in **New Orleans**, it was good to see and hear such great jazz artists as Louis Armstrong (right), Billie Holiday (centre), Meade Lux Lewis, Barney Bigard, Kid Ory, Charlie Beal (left), and Woody Herman and his orchestra. But the hot music only made the corny script by Elliot Paul and Dick Irving Hyland (story by Paul, and Herbert J. Biberman) appear luke warm. A wealthy young soprano (Dorothy Patrick) is seduced by jazz as much as by Basin Street nightclub owner Nick Du Kane (a bored Arturo de Cordova). Other young ladies from high society frequent the dive, as does a classical musician (Richard Hageman). It ends with the soprano outraging many of the audience at a concert by singing 'Do You Know What It Means To Miss New Orleans' as an encore. The film, indifferently directed by Arthur Lubin, neither outraged nor excited anyone. Also in the Jules Levey production were Irene Rich, John Alexander, Marjorie Lord and, with one line to speak Shelley Winters. (JULES LEVEY)

▽**Carnegie Hall** was an indigestible musical feast whose only interest lay in seeing (as well as hearing) snatches of 'long-haired' performances by Artur Rubenstein (illustrated), Jascha Heifetz, Bruno Walter, Leopold Stokowski, Lili Pons, Risë Stevens, Ezio Pinza, Jan Peerce and others. For hepcats there were the bands of Harry James and Vaughn Monroe. Karl Kamb's screenplay (story by Seena Owen) purported to be the history of the famous Manhattan concert venue as seen through the eyes of an immigrant cleaning woman (Marsha Hunt). She rises to become concert organizer, and uses her position to further the career of her pianist son (William Prince). Other non-musical performers were Frank McHugh, Hans Yaray, Joseph Buloff, Emile Boreo, and Alfonso D'Artega who took the part of Tchaikowsky. B-film director Edgar Ulmer was given the biggest project of his career to date by producers Boris Morros and William Le Baron. (MORROS-LE BARON)

▽'There's no price tag on my principles' says former smuggler-turned-hero George Raft in **Intrigue**. The star, beginning to show his age (52), ambled expressionlessly through the film, confronting a lot of heavies in post-war Shanghai. When he realizes that the gang of black marketeers he works for is fixing the price of food, thus adversely affecting Chinese orphans, tough cookie Raft (illustrated) crumbles. He tracks down the head of the ring, and gives the food to the starving population. The boss of the 'importing business' happens to be a Madame Baranoff, played by June Havoc (illustrated) as a blonde tiger lady dressed in diamonds. The script was mined for cliches by Barry Trivers and George Slavin (story by Slavin), and Edwin L. Marin was responsible for the stilted direction. Also in this Sam Bischoff production were Helena Carter, Tom Tully, Marvin Miller, Dan Seymour, Philip Ahn, Jay C. Flippen, Charles Lane and Edna Holland. (STAR)

▽**Lured** (GB: **Personal Column**) was the last of three stylish atmospheric period pieces directed by Douglas Sirk and starring elegant George Sanders (illustrated). (The others were *Summer Storm*, 1944, and *Scandal In Paris*, 1946). Screenwriter Leo Rosten changed the locale of Robert Siodmak's 1939 French film *Pièges* from Paris to Victorian London where eight beautiful young girls have disappeared after answering an advertisement in a newspaper. Lucille Ball (illustrated), an American girl working in a nightclub, is persuaded by Scotland Yard detective Charles Coburn to act as bait for the killer. Is it Sanders, Joseph Calleia, Alan Mowbray, Sir Cedric Hardwicke, George Zucco or Boris Karloff? Suffice to say that Miss Ball survived to tell the tale in this James Nasser production. (HUNT STROMBERG)

▽'Chaplin Changes! Can You!' was the challenging slogan for **Monsieur Verdoux**. It was more than six years since the unprecedented success of *The Great Dictator* (1941), so Charles Chaplin's return was eagerly awaited. However, both critics and public were generally hostile to this 'comedy of murders', and it was his first financial failure. The Little Tramp had become the dapper Bluebeard Henri Verdoux, alias Varnay, Bonheur and Floray, marrying women for money and then disposing of them. When he is found guilty and sentenced to death, he claims to be no worse than the politicians and businessmen. 'If war is the logical extension of diplomacy, then the logical extension of business is murder', he claims. It was a hard pill for audiences to swallow, especially as it came at the end of a film that was not particularly funny. Of course, there were wonderful Chaplinesque moments such as the aborted attempt to murder Martha Raye (illustrated), and Chaplin's performance was an elegant masterpiece. But his direction had not evolved very far from the 30s and, despite the hard surface of the picture, it had the usual soft centre containing a waifish girl (Marilyn Nash) Verdoux gives money to, and the crippled legal wife (Mady Correll) whom he really loves. Chaplin (illustrated) produced, scored, wrote and directed (assisted by Robert Florey and Wheeler Dryden). The two-hour movie also featured Isobel Elsom, Margaret Hoffman, Ada-May, Irving Bacon, Almira Sessions, William Frawley, and Edna Purviance, Chaplin's leading lady of the past, as an extra. The film was Oscar nominated for Best Original Screenplay. (CHAPLIN)

▷Screams in the night from an abandoned house in a dark forest formed the eerie core of **The Red House**. Director and screenwriter Delmer Daves recreated the sombre mood of George Agnew Chamberlain's novel in which two inquisitive teenagers (Lon McCallister and Allene Roberts) find out the horrible secret hidden for years in the house. It involved a dour one-legged farmer (Edward G. Robinson, illustrated) his spinster sister (Judith Anderson), and a case of parricide. Julie London, Rory Calhoun, Ona Munson, Harry Shannon, Arthur Space and Walter Sande played other characters affected by events in the house. Sol Lesser's production often had 'full house' signs outside theatres. (SOL LESSER)

△Director Alfred E. Green tried to follow up the biopic bonanza of *The Jolson Story* (Columbia, 1946) with **The Fabulous Dorseys**, a tepid but tuneful account of bandleader brothers Tommy (on trombone, left) and Jimmy (on saxophone, right), played by themselves. According to screenwriters Richard English, Art Arthur and Curtis Kenyon, they spent their lives bickering. Even when friends use ruses to get them to play together for the sake of their parents (Sara Allgood and Arthur Fields), they refuse, and only the death of their father reunites them. The Dorseys played better than they acted, and the galaxy of musical guest stars included Bob Eberly, Charlie Barnet, Ziggy Elman, Art Tatum, Paul Whiteman and Helen O'Connell. Others in the cast were Janet Blair (centre), William Lundigan, James Flavin, William Bakewell and, playing the brothers as children, Bobby Ward and Buz Buckley. Charles R. Rogers produced. (CHARLES R. ROGERS)

▷Demanding a certain suspension of disbelief, **Fun On A Weekend** provided 92 minutes of enjoyment. It set out to prove the theory that if one has enough cheek, one can bluff one's way into society and gain wealth. Putting it to the test were Eddie Bracken (left) and Priscilla Lane (centre), both broke and hungry on a Florida beach. With the acquisition of some smart beach clothes (sold to them by Joe Devlin, right), they pass themselves off as Mr and Mrs Peter Porterhouse III of Wall Street, and mingle with the millionaire set, although Bracken nearly gives the game away when he suspects Priscilla of falling for playboy Tom Conway. But she really loves Eddie, and the get-rich-quick fable ended with his being offered the presidency of a department store by one of the gullible moguls. Also to be found among the upper crust were Allen Jenkins, Arthur Treacher, Clarence Kolb, Alma Kruger, Russell Hicks, Fritz Feld, Richard Hageman and Lester Allen. This wishful-thinking tale was produced, directed and written by Andrew Stone. (ANDREW STONE)

▽A low point in the careers of Groucho Marx and Carmen Miranda (both illustrated) was **Copacabana**, cheaply and dismally directed by Alfred E. Green in a couple of nightclub sets. The script by Laslo Vadnay, Allen Boretz and Howard Harris (story Vadnay) required the two stars to do a lot of frantic running around, motivated by the fact that Carmen is agent Groucho's only client, and he has negotiated a deal with nightclub owner Steve Cochran for a pair of entertainers. So Miss Miranda has to pose as a blonde, veiled French chanteuse, as well as her usual Brazilian Bombshell self. Other numbers were performed by fading ex-child star Gloria Jean, and insipid crooner Andy Russell. Also appearing in this Sam Coslow production were Ralph Sanford, Andrew Tombes and newspaper columnists Louis Sobol, Earl Wilson and Abel Green. (SAM COSLOW)

△**Christmas Eve** (aka **Sinners' Holiday**) was basically three unlikely tales wrapped together in one sentimental package by producer Benedict Bogeaus, and sloppily directed by Edwin L. Marin. Laurence Stallings' script (from stories by himself and Richard H. Landau) had Ann Harding as a rich, eccentric old woman who wishes to see her three absent foster sons at Christmas. Three extended flashbacks fill in the histories of the sons: George Raft is in a South American country unable to return to the USA because the FBI is after him; Randolph Scott is a broken-down rodeo rider mixed up in a black-market baby racket; George Brent (illustrated) has been passing rubber cheques. But they all turn up for Christmas, Raft having caught a Nazi war criminal, Scott having broken the baby racket, and Brent having exposed the villainies of the old lady's nephew, Reginald Denny. The three girls in the boys' lives were Joan Blondell (illustrated), Virginia Field and Dolores Moran, with Clarence Kolb, John Litel and Douglass Dumbrille in other roles. (BENEDICT BOGEAUS)

▽**Dishonoured Lady**, the story of a woman with a hidden past, should have remained hidden from audiences. Based on Margaret Ayer Barnes and Edward Sheldon's play, Edmund H. North's scenario couldn't be taken seriously on any level. Ravishing Hedy Lamarr (left), playing an art editor who has derived little satisfaction from her many affairs, drives her car into a wall in a suicide attempt. It happens to be the wall of a psychiatrist (Morris Carnovsky) who advises her to 'grow a new soul'. She gives up her job, her wealthy boyfriend (her real-life third husband John Loder), and rents an attic in a boarding house where she meets a nice young doctor (Dennis O'Keefe). But her dark past catches up with her when her former beau is murdered and she is accused of the crime. The real killer is, of course, revealed and, after further platitudes from the shrink, she marries the doctor. Also cast were Natalie Schafer (right), William Lundigan, Paul Cavanagh, Douglass Dumbrille, Nicholas Joy and Margaret Hamilton. Robert Stevenson was responsible for the limp direction of this Hunt Stromberg flop, which went $1.2 million over budget. (HUNT STROMBERG)

△**Heaven Only Knows** (aka **Montana Mike**) was a feeble attempt by producer Seymour Nebenzal, director Albert S. Rogell, and writers Art Arthur and Rowland V. Lee (story Aubrey Wisberg) to introduce religious fantasy into the Western genre. Only Robert Cummings' tongue-in-cheek archangel Michael (left), came out of it with any credit. The angel is sent to Glacier, Montana to save the soul of saloon owner and ruthless killer Brian Donlevy. He encourages the villain to fall for minister's daughter Jorja Curtright rather than dance-hall girl Marjorie Reynolds, and uses heavenly light to blind an adversary in a gunfight. In the end, Donlevy (right) proves that he has a soul by rescuing the angel from a lynching. Others cast were Bill Goodwin, John Litel, Stuart Erwin, Gerald Mohr, Edgar Kennedy, Lurene Tuttle and Peter Miles. Although neither fish nor fowl, the picture was a turkey. (SEYMOUR NEBENZAL)

▽Money was the *leitmotif* of **Body And Soul**, in which John Garfield (bare-chested, centre) is 'not just a kid who can fight. He's money.' Director Robert Rossen and screenwriter Abraham Polonsky (Oscar nominated) saw boxing as the perfect metaphor for dog-eat-dog society. Soon after the film's release Rossen, Polonsky and Garfield were brought before the House UnAmerican Activities Committee marking them for life. There is nothing more American than the tale of an unemployed Jewish lad (Garfield) from New York's East Side who finds he can make a lot of dough from the fight game and save his widowed mother (Anne Revere) from poverty. He meets an artist (Lilli Palmer), but loses her when he gets involved with a crooked promoter (Lloyd Goff) and a showgirl (Hazel Brooks). However, when he has the chance to make big money if he takes a dive, he wins both the fight and the good girl, and his new morality brings him strength to withstand the gangsters. A great deal of the picture was powerful, despite the over-insistent direction and script, and a happy ending that dodged the issues raised. Its main quality lay in John Garfield's expressive, bullish, Oscar-nominated performance, and James Wong Howe's expert *film noir* camerawork. Francis Lyon and Robert Parrish won an Oscar for their editing. Other roles went to Joseph Pevney, William Conrad, Canada Lee, James Burke, Virginia Gregg and Joe Devlin. (ENTERPRISE)

▽After tackling Somerset Maugham (*The Moon And Sixpence*, 1942) and Oscar Wilde (*The Portrait Of Dorian Gray*, MGM 1945), producer, director and writer Albert Lewin turned his aesthete's eye on **The Private Affairs Of Bel Ami**, Guy de Maupassant's late 19th-century novel. Like the previous two films, it starred George Sanders (right), whose perverse sophistication suited Lewin's own rococo tastes. Tossing off sub-Wildean epigrams like 'Love and marriage are entirely different subjects,' Sanders rises in the world of Parisian journalism and politics by using various women as rungs on the ladder, before coming to a bad end in a duel. The women included Marie Wilson, Angela Lansbury (left), Ann Dvorak, Frances Dee, Katherine Emery, Susan Douglas and little Karolyn Grimes (centre). The other men in the cast were John Carradine, Hugo Haas, Albert Basserman, Warren William and Richard Fraser. As in the two other films, Lewin inserted a scene in colour, this time the anachronistic Max Ernst painting of 'The Temptation Of St Anthony'. It was well photographed by Russell Metty, and the score was by Darius Milhaud, but this 'history of a scoundrel' was more arty than artistic, and unfortunately it proved to be too refined for the general public. (LOEW-LEWIN)

UNITED ARTISTS

1948

▷**So This Is New York**, Stanley Kramer's first independent production, was not the type of solemn 'message' movie with which he was soon to be associated, but was an unusual and amusing comedy based on Ring Lardner's novel *The Big Town*. Screenwriters Carl Foreman and Herbert Baker changed some of the Lardner prose to suit the acid-tongued, deadpan talents of radio comedian Henry Morgan (right), making his screen debut. He played a hick who goes off to the New York of the early 20s, with his wife (Virginia Grey) and daughter (Dona Drake), in search of a wealthy husband for his offspring. Five suitors materialize: a gambler (Jerome Cowan), a jockey (Leo Gorcey, left), an antique dealer (Hugh Herbert), a comedian (Bill Goodwin), and a Texas ranch owner (Rudy Vallee). None of them prove suitable, and they return to South Bend, Indiana, where the girl marries her first love. Most of the gags worked well under Richard Fleischer's direction. Others in the cast were Dave Willock, Frank Orth, Arnold Stang and William Bakewell. (ENTERPRISE)

▽**My Dear Secretary** was pretty slender, which does not merely refer to Laraine Day (right) in the title role, but to the writing and direction of this popgun battle of the sexes comedy by Charles Martin. Kirk Douglas (centre) was cast as a best-selling novelist who chases his secretaries around his desk between paragraphs. He meets his match in Miss Day, however and marries her, whereupon she writes a best-seller.

There followed a series of unfunny role reversal situations in which nobody told granite-jawed Douglas he was supposed to be playing comedy, while Keenan Wynn (left), as his sarcastic friend, had slapstick problems doing housework. Others working for producer Leo C. Popkin were Helen Walker, Rudy Vallee, Florence Bates, Alan Mowbray, Grady Sutton, Irene Ryan, Gale Robbins and Virginia Hewitt. (HARRY M. POPKIN)

◁In **Four Faces West** (GB: **They Passed This Way**), taciturn cowboy Joel McCrea, urgently in need of money, asks the bank for a loan, and when they refuse, he holds it up, leaving an IOU. The rest of this taut Western, directed by Alfred E. Green, detailed the long pursuit of McCrea by sherriff Charles Bickford (right). On the way, the cowboy meets nurse Frances Dee (McCrea's real-life wife), and Joseph Calleia, a gambler who becomes his friend. Fleeing through the desert lands of New Mexico, he stops to help a Mexican family dying of diphtheria, and the sheriff catches up with him, giving an assurance that the court will be lenient. Unusually, not a single shot was fired in this David Loewe-Charles Einfield production written by Graham Baker and Teddie Sherman (from Eugene Manlove Rhodes' novel *Paso Por Aqui*). Supporting were William Conrad, Martin Garralaga (left), Raymond Largay, John Parrish and Dan White. (ENTERPRISE)

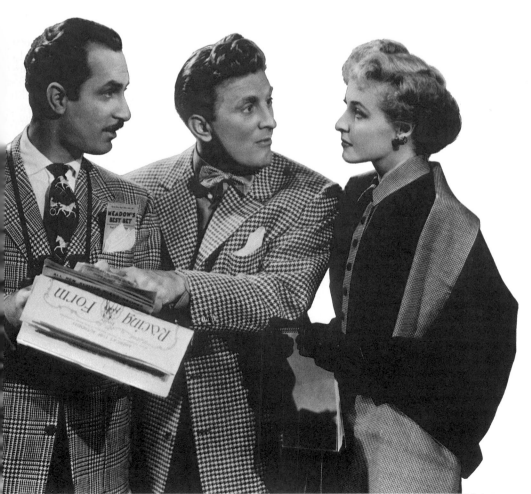

△Former high tenor Dick Powell (left) continued to exploit his glum, craggy 40s persona in low key, low budget pictures like **Pitfall**. Director Andre de Toth created a heavy *film noir* atmosphere out of the screenplay by Karl Kamb (derived from Jay Dratler's novel), in which Powell played an ordinary, happily married insurance man who gets caught in the tentacles of a fashion model (Lizabeth Scott, right). Told in flashback by the man to his wife (Jane Wyatt), it explains how the model's private eye boyfriend (Raymond Burr, background) menaces him, and how he is accused of murder. John Litel, Byron Barr, Timmy Hunt, Ann Doran, Selmer Jackson, Margaret Wells and Dick Wassel had other roles in this efficient Sam Bischoff production. (REGAL)

1948

△ **The Vicious Circle** (GB: **Woman In Brown**) can be submitted in evidence against those who say that courtroom dramas can't miss. Drearily produced and directed by W. Lee Wilder, it recounted an actual trial held in Hungary in 1882 in which a landed aristocrat (Reinhold Schunzel) accuses five Jewish farmers of the murder of a 14-year-old servant girl. It turns out, thanks to the brilliance of the defence attorney (Conrad Nagel, left), that the girl killed herself, and the evil aristo has faked evidence in order to frame the Jews. The ostensibly interesting theme of racial intolerance was helped neither by the uninspired performances, nor the stiff dialogue by Guy Endore and Heinz Herald from the play *The Burning Bush* by Herald and Geza Herczeg. Lyle Talbot (prosecutor), Edwin Maxwell (judge), Philip Van Zandt, Eddie Leroy, Frank Ferguson, Fritz Kortner (right) and David Alexander were also cast. (MERIT)

△ Edward Peskay's production of **The Angry God** was unsatisfactory both as a travelogue and as a fictional feature. Shot entirely in Mexico in Full Color by the American Museum of Natural History, Emma-Lindsay Squier's simple script (from her *Good Housekeeping* magazine story) concerned the legend of a god who sought the love of an Indian girl and nearly brought destruction on her people when she spurned him. The expression of his wrath came in some spectacular scenes of an erupting volcano. Otherwise, the lengthy narration, endless shots of local dances and costumes, the badly dubbed English dialogue delivered like a speak-your-weight machine, and the equally unlively direction by Van Campen Heilner, was enough to anger the box-office gods. The all-native cast was headed by Alicia Parla, Casimiro Ortega and Mario Forastieri. 'And so we say farewell ...' (PESKAY)

▽No longer the favourite South Seas heroine of the armed forces, Dorothy Lamour (right) found her popularity declining as was the quality of her pictures. **The Girl From Manhattan**, produced by Benedict Bogeaus, was no exception. In it, she returns to her home town from New York to find her uncle's boarding house is to be pulled down to make room for a new church. Enlisting the aid of the new young minister (George Montgomery, centre), they expose the shady dealings of an unscrupulous financier (Howard Freeman) who wants the old church property for himself. Neither Howard Estabrook's story and screenplay nor Alfred E. Green's direction made much effort to impart freshness to this stale small town fable. Only magical Charles Laughton in a cameo role as a bishop, Ernest Truex (left) as the uncle, and Hugh Herbert, Constance Collier and William Frawley as his non-paying boarders, gave any pleasure. Others cast were Sara Allgood, Frank Orth, Raymond Largay and George Chandler. (BENEDICT BOGEAUS)

▽David Loewe and Charles Einfeld's $5 million production of **Arch Of Triumph** was far from a triumph, being one of the biggest flops for many a decade. Lewis Milestone's direction plodded gloomily for two hours in an old-fashioned manner through a studio-bound pre-war Paris. Ironically, that most Gallic of stars, Charles Boyer (illustrated), played a foreign surgeon from a Nazi-occupied Middle European country, finding refuge in France. He meets Ingrid Bergman (illustrated), a girl of the streets, and helps get her a singing job at a nightclub where his Russian friend Louis Calhern is the doorman. Meanwhile, Boyer makes the aquaintance of Charles Laughton, the Nazi inquisitor from his own country, and clubs him to death on a quiet road. The film ends tragically when a jealous admirer of Bergman shoots her and she dies in Boyer's arms. The picture, written by Milestone and Harry Brown (adapted from Erich Maria Remarque's novel), also featured Ruth Warrick, Roman Bohnen, Stephen Bekassy, Curt Bois, J. Edward Bromberg, William Conrad and Michael Romanoff. (ENTERPRISE)

UNITED ARTISTS

1949

▽Not much impact was made by **Impact**, its star Brian Donlevy, or the direction of Arthur Lubin who took nearly two hours to tell a mediocre tale. The screenplay by Dorothy Reid started out with an unfaithful wife (Helen Walker, illustrated) and her lover (Tony Barrett) planning to kill her rich industrialist husband (Donlevy) in a car crash. Their plot (and the film's) goes awry when the lover is killed instead. The husband, meanwhile, having escaped in the crash, disappears, changes his name and starts a new life working at a garage run by a woman (Ella Raines) who loves him for himself. However, he is tracked down by a slow detective (Charles Coburn) and accused of his rival's death. All was cleared up at the end of Leo C. Popkin's production. Also in it were Anna May Wong in her first film for seven years, Mae Marsh, William Wright, Art Barker (illustrated), and Robert Warwick. (HARRY M. POPKIN)

▽Returning from the army suffering from amnesia, John Payne (left) in **The Crooked Way** found himself caught up in a brutal and dark world of Los Angeles gangsters, forcefully created by director Robert Florey. He finds that both mob leader Sonny Tufts and police inspector Rhys Williams have something against him, and his wife Ellen Drew is not mad about him either. But, according to Richard Landau's screen adaptation of Robert Monroe's radio play *No Blade Too Sharp*, the head injury Payne received in the war, has completely changed him from villain to hero. He wins his wife back and captures the crooks. Others in Benedict Bogeaus' production were Percy Helton (right), John Doucette, Charles Evans, Greta Granstedt and Harry Bronson. (BENEDICT BOGEAUS)

▽As harness race horses go, **The Great Dan Patch** went faster than most at the turn of the century. This quadruped biopic, shot in sepia tones by Joseph M. Newman, had a warm, nostalgic feel to it when the screenplay by John Taintor Foote (who also produced) was concerned with the horses, the riders and the trainers in Indiana, rather than the boring biped domestic problems of Dan Patch's owner (Dennis O'Keefe). He is a chemist who's mad about racing, but his socialite wife (Ruth Warrick) is more interested in good breeding among people. He leaves her to marry a horse-loving girl (Gail Russell, illustrated) whose father (John Hoyt) is a trainer. More human interest was supplied by Henry Hull, Charlotte Greenwood, Arthur Hunnicutt, Clarence Muse and Harry Lauter. (W.R. FRANK)

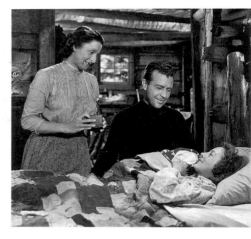

△Dick Powell (centre) played Sergeant Mike Flannigan, a Canadian mountie who got his woman in **Mrs Mike**. Evelyn Keyes (right) in the title role was a Boston girl who gives up everything to go off and face the hardships and loneliness of life in the frozen North in 1907. There was a certain charm in her attempts to adapt to rural life, but when their child dies during a diphtheria epidemic, the film tumbled into predictable sentimentality, ending on a note of rugged optimism. To have done justice to this picturization of Benedict and Nancy Freedman's popular novel, it needed a better eye than director Louis King's, and a better ear than that of screenwriters Alfred Lewis Levitt and DeWitt Bodeen. Nevertheless, there was enough humour and adventure to make the movie, produced by Edward Gross, appealing. Among the scanty population of the picture were J.M. Kerrigan, John Miljan, Frances Morris, Angela Clarke (left), Nan Boardman, Will Wright and Chief Yowlatchie. (NASSOUR-HARTFORD)

△So complicated and implausible was the plot of **The Lucky Stiff** that Brian Donlevy, as a criminal lawyer, attempted to explain it for the audience's benefit at the end. At least the director Lewis Foster must have understood the screenplay, as he himself adapted it from a novel by Craig Rice. In broad terms, it concerned nightclub singer Dorothy Lamour convicted of the murder of her boss, but reprieved while on her way to the electric chair. However, Donlevy (illustrated) circulates the news of her execution to the press so that she can impersonate her own ghost to scare racketeers into confessing their crimes. This uneasy mixture of slapstick, sophisticated comedy, and drama was unlucky for 'tightwad' Jack Benny who produced. Also appearing in support were Claire Trevor (illustrated), Irene Hervey, Marjorie Rambeau, Robert Armstrong, Billy Vine, Warner Anderson and Virginia Patton. (AMUSEMENT)

▽Although much of **Outpost In Morocco** was shot on location, it was about as authentic as a rainstorm in the Sahara, but not as welcome. Directed by Robert Florey, with the assistance of the Foreign Legion and hundreds of Moroccan cavalrymen, the picture was a cardboard French colonial adventure starring a stiff George Raft (illustrated) as a legionnaire holding out in a garrison against thirst and attacks by a rebel Emir (Eduard Franz), whose daughter (an inadequate Marie Wilson, illustrated) he loves. She is killed when Raft attacks her father's headquarters. Akim Tamiroff almost out-acted the camels as his second-in-command. The cast also included John Litel, Erno Verebes, Carane Whitley and Damian O'Flynn. The producer, Joseph H. Ermolieff, wrote the story from which the screenplay by Charles Grayson and Paul de Sainte-Claude was taken. (MOROCCAN)

▽The *Champion* team of Stanley Kramer (producer), Mark Robson (director) and Carl Foreman (screenwriter) courageously took on the subject of racial prejudice in the US army in **Home Of The Brave**, using a virtually unknown all-male cast. The gamble paid off. Mind you, the movie did have the reputation of Arthur Laurents' successful play behind it, although the main character was changed from a Jew to a Negro for the film. Being one of the first pictures to deal with the topic, and framed by a fashionable but sincere use of psychoanalysis, it had an impact at the time which has now somewhat diminished. The black soldier (James Edwards, left) has returned in a state of shock from a mission on a Japanese-held island in the South Pacific. Through analysis, conducted by a sympathetic shrink (Jeff Corey), the story of what happened comes to light. The GI, who had been the butt of constant racial abuse by one of the platoon (Steve Brodie), cracked because his only buddy (Lloyd Bridges, centre) was killed during an attack. Douglas Dick as the young Major, and Frank Lovejoy (right) made up the rest of the group, with Cliff Clark as the colonel back at base. Whatever its failings, the picture nonetheless prepared the way for other explorations of racial bigotry which, in their turn, led to its virtual elimination from Hollywood itself. (STANLEY KRAMER)

▽Little Mickey Rooney played a racing driver in **The Big Wheel**, which could easily have been entitled The Big Noise. More than 20 minutes of the picture was taken up with cars tearing round the track at full throttle. Rooney (left) was his usual high-octane self as Billy Coy (coy, he isn't!) who rises from garage mechanic to champion driver, losing friends on the way. His mother (Spring Byington) sits terrified in the stands, watching her son go round and round until, on one occasion, he gets drunk and kills a colleague in a race. In the end, however, he redeems himself by showing guts in the Indianapolis 500, gains the respect of his rival (Michael O'Shea), and wins the girl (Mary Hatcher, right). Thomas Mitchell, Lina Romay, Steve Brodie, Allen Jenkins and Richard Lane also appeared in this poorly directed (Edward Ludwig) and ineptly scripted (Robert Smith) production by Samuel H. Stiefel. (POPKIN-STIEFEL-DEMPSEY)

◁John Garfield, Henry Fonda, Burgess Meredith, Marlene Dietrich and Marsha Hunt made unbilled guest appearances in **Jigsaw** (aka **Gun Moll**), presumably because they supported the picture's anti-racist theme. Basically though, it was a standard gangster movie with pretentions to social significance, flashily directed by Fletcher Markle (who also made an appearance). There were too many pieces of the jigsaw missing in the screenplay by Markle and Vincent O'Connor (story John Roeburt) concerning the efforts of a New York Assistant DA (Franchot Tone, right) to track down a mob of fascist racketeers. After a journalist (Myron McCormick) is murdered for exposing their activities, the DA uses a society woman (Winifred Lenihan) to penetrate their ranks. In a showdown in an art gallery, she is revealed as the gang's leader. Other roles were taken by Jean Wallace (then married to Franchot Tone), Marc Lawrence, Betty Harper, Hedley Rainie (left), Walter Vaughn and George Breen. It was produced by American brothers Edward and Harry Danziger, who were soon to settle in England and make a string of second features. (TOWER)

The most perceptible changes in the motion picture industry took place in the 50s, and UA mirrored many of them. The main cause for the shake-up was laid at the door of television, the one-eyed monster that was proliferating throughout the USA in the early years of the decade. The presence of this competitor in the entertainment stakes produced both good and bad effects in Hollywood. Desperate to entice people away from the little black and white screen in their living rooms, a series of complex devices and gimmicks were offered to the public. UA had the dubious distinction of launching the first feature in 3D, *Bwana Devil* (1953), whose commercial success derived from the novelty of putting 'a lion in the lap' of audiences. This led other studios to experiment with the process for about another year, until eye-weary patrons and critics called a halt. At the same period 20th Century-Fox introduced CinemaScope with *The Robe* (1953), followed by Paramount's VistaVision, used for the first time in *White Christmas* (1954). Although *Oklahoma!* (20th Century-Fox, 1955) was the first movie made in Todd-AO, most theatres were only equipped to project it in CinemaScope. A far greater number of cinemas were able to show the UA release of *Around The World In Eighty Days* (1956) in Todd-AO, one of the most glitteringly star-studded and top money-making movies of all time.

However, the need to fill every inch of the wide screen with spectacle proved an expensive business, and only a small percentage of the big films recouped their costs. In contrast, a cheaper, and often a more qualitative way to get people back into the cinemas was to offer controversial and adult subjects deemed unsuitable by TV's commercial sponsors for family viewing at home. So if one wanted to hear words like 'virgin' and 'seduce', one would have to go out and see Otto Preminger's *The Moon Is Blue* (UA, 1953) which was released without the Production Code's Seal of Approval, thus proving that the Seal was no pre-requisite for commercial success. The picture helped wrest Hollywood from the puritan values that had gripped it for so long.

Despite being rattled by the second series of hearings of the House Un-American Activities Committee begun in 1951, Hollywood continued to explore liberal themes. The Red Indian was more sympathetically treated than ever before in Westerns such as *Broken Arrow* (20th Century-Fox, 1950) and *Apache* (UA, 1954). Joseph Mankiewicz's *No Way Out* (20th Century-Fox, 1950) prepared the way for a more thorough examination of racial bigotry in Stanley Kramer's *The Defiant Ones* (UA, 1958). Preminger's *The Man With The Golden Arm* (UA, 1955) tackled the subject of drug addiction with a frankness hitherto unknown, which led to other powerful studies of the problem in *Monkey On My Back* (UA, 1957) and *A Hatful Of Rain* (20th Century-Fox, 1957). With both the Korean War and Senator McCarthy now bitter memories, Stanley Kubrick was able to make *Paths Of Glory* (UA, 1958), one of the screen's most forceful anti-militaristic statements. Ironically, Television, the arch-enemy, provided Hollywood with some of the best screenplays of the era. *Marty* (UA, 1955), based on a Paddy Chayefsky teleplay, was the 'sleeper' of the decade. As a result, other intimist, realistic television dramas such as *The Bachelor Party* (UA, 1957), *Twelve Angry Men* (UA, 1957) and *The Middle Of The Night* (Columbia, 1959), were adapted for the big screen.

The shot in the arm the industry received was mainly due to the growing number of independent producers who gradually broke the stranglehold of the major studios. In fact, by 1958, 65% of Hollywood movies were being made by independents. This was all to UA's benefit. Previously handicapped by the lack of its own studio, UA was spared the impossibly high overheads that burdened other companies when location shooting became more prevalent. By the end of the decade, UA had about 50 independents on its books, including actors turned producers John Wayne, Frank Sinatra, Gregory Peck, Bob Hope, Robert Mitchum and Kirk Douglas' Bryna Productions, and product units such as Hecht-Hill-Lancaster and The Mirisch Corporation, the latter boosted by *Some Like It Hot* (1959), one of UA's biggest hits. Stanley Kramer, who was at Columbia, still had one picture to deliver on his UA contract. Columbia suggested he give UA 'the Western without action'. It was *High Noon* (1952), which grossed $12 million worldwide. Kramer went on to supply UA with bonanzas like *The Pride And The Passion* (1957) and *On The Beach* (1959). By the mid-50s, UA's earnings were up $45 million from 1950.

How did this vast turnaround in the company's fortunes come about? When a syndicate, headed by Arthur Krim from Eagle Lion and Robert Benjamin from the Rank Organisation, took over at the beginning of 1951, UA was losing around $100,000 a week, and the receiver was at the door. Krim and Benjamin rescued the business by borrowing $3 million from Chicago financier Walter E. Heller, and $500,000 from Spyros P. Skouras at Fox. Although head of a rival organization, Skouras felt it would be harmful to the industry if UA went under. At the end of the syndicate's first year, due to a combination of these loans, judicious management, and two big box-office hits, *The African Queen* (1951) and *High Noon*, UA was showing a profit of $313,000.

But Krim and his colleagues owned only half the company shares. They immediately began separate discussions for the purchase of the remaining stock held by Mary Pickford and Charles Chaplin, both of whom held out for some years. In February 1955, Chaplin telephoned Krim from Switzerland asking for $1.1 million in cash within five days for his 25%. The deal was closed, and he received his money within the week. Chaplin, who had been summoned to appear before the HUAC, had settled in Europe after the American immigration authorities refused to grant him a re-entry visa. *Limelight* (UA, 1952), his last US film, was picketed by the American Legion, forcing its withdrawal from major theatres in New York and the West Coast. In 1956, Pickford received $3 million for her remaining share. But the syndicate only held full ownership of UA for about a year. In early 1957, the company went public, offering $17 million in stocks and debentures for sale.

UA's relative economic stability allowed them greater flexibility on the production side. The company and producers came to a decision on the story, the cast, the director and the budget together, after which the producer was given complete freedom to make the picture. Since the producers also owned a share in their movies' profits, they sometimes appointed their own sales representatives to help the distribution. As Otto Preminger said 'Only UA has a system of true independent production. They recognize that the independent has his own personality.' The effect of this system was to provide higher quality pictures which, in turn, resulted in bigger returns. Thus UA, from being the pariah of the industry in the 40s, became the paradigm for the majors to emulate in the 50s. In a sense, then, United Artists was once more living up to its name.

1950

▽A cute pup, owned by a not-so-cute Hollywood child actress called Gayle Reed, played the title role in **Johnny One-Eye**. In it, girl and dog strike up a friendship with gangster Pat O'Brien (illustrated), hiding out from the law in a derelict house. The pug and the thug were both outcasts in Richard H. Landau's schmaltzy adaptation from the Damon Runyon story. Wayne Morris took the role of the brat's father, a DA with political ambitions who has raked up O'Brien's past, while other semi-Runyonesque characters in this Benedict Bogeaus production were played by Dolores Moran, Lawrence Cregar, Jack Averman and Raymond Largay. It was the last film directed by Robert Florey before his retirement. In the same year, the French government decorated him with the *Legion d'Honneur* for his contribution to the art of film. They must have missed seeing this one. (BENEDICT BOGEAUS)

△'Some men are following me,' says Marilyn Monroe to private eye Groucho Marx in **Love Happy**. 'Really, I can't understand why,' he replies. La Monroe only appeared briefly, and Groucho for no longer than ten precious minutes, while Chico popped up occasionally, once on piano in a virtuoso duet with a gypsy violinist. But this Lester Cowan production was really a Marx Brother picture, the story being conceived by Harpo as a vehicle for his own marvellous miming. Frank Tashlin and Mac Benoff developed it into an uninspired screenplay, unevenly directed by David Miller. It not only made the mistake of unbalancing the great three-man act, but it tried to force Harpo into Chaplinesque sentimentality. He played a shop-lifting tramp who keeps a troupe of struggling actors from starving as they rehearse a Broadway revue. By accident, he steals a tin of sardines that contains a Romanoff necklace hidden there by wicked vamp Ilona Massey and her cohorts Raymond Burr and Melville Cooper. The whole thing ended with an imaginative rooftop chase among neon signs. Dancer Vera-Ellen, miscast in a Sadie Thompson-style number (illustrated) was the object of Harpo's affections. Also appearing were Paul Valentine, Marion Hutton (Betty's sister), Eric Blore, Leon Belasco and Bruce Gordon. (LESTER COWAN-MARY PICKFORD)

▽Cagney was a blonde *femme fatale* in **Quicksand**. No, not James, but his sister Jeanne (centre), leading poor little Mickey Rooney (left) astray. He was a clean-living garage mechanic loved by sweet Barbara Bates, until the two-timing gold-digger gets him to 'borrow' $20 from the cash register, then commit a hold-up so he can buy her a mink coat. In the end, he is cornered by the cops and tries to shoot it out before giving himself up. Rooney put a great deal of conviction into his role in this unoriginal Mort Briskin production of a Robert Smith screenplay which suggested that petty crime has a tendency to snowball — and, sadly, director Irving Pichel followed it earnestly downhill. The supporting cast included Peter Lorre (right), Taylor Holmes, Art Smith, Wally Cassell, John Gallaudet and Minerva Urecal. (SAMUEL H. STIEFEL)

◁The startling opening of **D.O.A.** showed Edmond O'Brien reporting a murder at a police station. 'Whose?' asks the cop. 'My own,' replies O'Brien. In Russell Rouse and Clarence Greene's clever story and screenplay, O'Brien (illustrated) is a businessman slowly being poisoned by a substance for which there is no antidote, and has only a short amount of time in which to discover his own murderer. His quest takes him through the streets and dives of San Francisco and LA until he finds his man. After his story is told, the police mark his file as D.O.A. (Dead On Arrival). Pamela Britton, as the dying man's secretary and fiancée; Neville Brand, in his debut as a psychotic killer; Luther Adler, Beverly Campbell (later Beverly Garland), Lynne Baggett, William Ching, Henry Hart, Laurette Luez (illustrated), Virginia Lee and Jess Kirkland gave fine support to O'Brien who was hardly ever off the screen. Director Rudolph Maté shot most of the Leo Popkin production on location. The picture was remade as *Colour Me Dead* (1970) in Australia starring one-time screen cowboy Tom Tryon. (HARRY M. POPKIN)

△**Champagne For Caesar** sparkled only intermittently in its efforts to satirize radio game shows. The story and screenplay, by Hans Jacoby and Fred Brady, had the idea of opposing a mild man of great intellect against a wealthy, neurotic soap manufacturer who is the sponsor of a $20 million quiz show. Both Ronald Colman's urbanity as Beauregard Bottomly, the genius, and Vincent Price's hamming as Burnbridge Water, the sponsor, wore thin long before the end under Richard Whorf's direction. The former successfully answered the most difficult questions on the show until, in the double or nothing finale, he fails to remember his social security number. Celeste Holm played Flame O'Neil, sent by Burnbridge to distract Beauregard (both illustrated), and Barbara Britton was the egghead's sister who falls incomprehensibly for the show's emcee, Happy Hogan, played by TV's Art Linkletter. Also included in the George Moskov production were Byron Foulger, Ellye Marshall, Vici Raaf, Douglas Evans and Lyle Talbot. It was Colman's last film role, apart from two further guest appearances. (HARRY M. POPKIN)

▽'You're rotten,' says June Havoc (illustrated) to Cesar Romero in **Once A Thief**, a phrase that could equally be applied to this tawdry little melo. Richard S. Conway's screenplay (story by Max Colpet and Hans Wilhelm) told the tepid tale of shoplifter Havoc falling for handsome cad Romero. After relieving her of all her savings, he then gives her away to the police. When she comes out of jail, Havoc creates havoc, and Romeo Romero is accidentally killed. Marie McDonald, Iris Adrian, Lon Chaney Jr, Jack Daly, Marta Mitrovich, Ann Tyrell, Kathleen Freeman, Dana Wilson, Bill Baldwin and Michael Mark were also in it. Although the film made an attempt at realism, it so lacked style that there was no danger of producer-director W. Lee Wilder being confused with his younger brother Billy. (W. LEE WILDER)

▽**Three Husbands** (aka **A Letter To Three Husbands**) was a rather faded copy of *A Letter To Three Wives* (20th Century-Fox, 1948). The screenplay by Edward Eliscu and Vera Caspary (story by Caspary) tried to show the male side of the coin first flipped so brilliantly by Joseph Mankiewicz in the previous film. The few bright moments in this one were due to the playing of three wives by Eve Arden, Ruth Warrick (illustrated) and Vanessa Brown, and by Billie Burke as a mother-in-law. Howard da Silva, Sheppard Strudwick (illustrated) and Robert Karnes in the title roles were less interesting as characters who are shattered when they each receive a posthumous letter from a recently dead bachelor friend claiming that he had had an affair with their respective wives. In multiple flashbacks, they begin to view previously innocent episodes with suspicion. It all turns out to be a joke played on the three couples by their rakish friend. Emlyn Williams, making his Hollywood debut and not sufficiently seductive to be convincing, Louise Erickson and Jonathan Hale took other roles in this I.G. Goldsmith production, under the direction of Irving Reis. (GLORIA)

△The latter half of the title **So Young, So Bad**, was also applicable to the latter half of this Edward and Harry Danziger production. Actually, the Bernard Vorhaus-Jean Rouverol story and screenplay was about young and bad(?) girls in an authoritarian reform school. All the cliches of a women-behind-bars tale were on display, including the cold, calculating director of the institute (Cecil Clovelly), the sadistic matron (Grace Coppin), the suicide of a sensitive girl (Enid Pulver), and a rebellion by the inmates. Along comes kindly psychiatrist Paul Henreid (illustrated) who, assisted by Catherine McLeod, carries out a crusade to improve conditions for the girls, using love and understanding as weapons, rather than the cane. Anne Jackson (her debut), Anne Francis (illustrated) and Rosita (later Rita) Moreno were contrasting delinquents. It was rather ineptly directed by Bernard Vorhaus. (DANZIGER BROTHERS)

△'The actor who would make Hollywood revise its standards of performance,' claimed the publicists about Marlon Brando, making his first screen appearance in Stanley Kramer's **The Men** (aka **Battle Stripe**). And for once they were right! It is no exaggeration to say that a new era of film acting began with Brando (left). This most physical and virile of actors brought a poignant suppressed power to his role of an ex-GI paralysed from the waist down who feels he is 'only half a man.' Brando's portrayal was no doubt helped by spending several weeks among paraplegics (some of whom appeared as themselves in the picture), as well as by Fred Zinnemann's sensitive direction. Carl Foreman's Oscar-nominated screenplay underlined the psychological and sexual problems, as well as the physical, facing the character. In the hospital (where most of the action was confined), he at first withdraws self-pityingly into himself and breaks off his engagement to his understanding fiancee (Teresa Wright). Gradually, however, aided by the cruel-to-be-kind doctor (Everett Sloane, right) and the girl, he agrees to lead as normal as life as possible. This brave, uncompromising movie, marred occasionally by sentimentality, proved that the public would pay to see something other than escapist fare. Jack Webb, Howard St John and Richard Erdman played other patients. (STANLEY KRAMER)

△First-rate B-movie director Joseph H. Lewis made **Gun Crazy** (aka **Deadly Is The Female**), a stylish *film noir* inspired by the Bonnie and Clyde story. The screenplay by Millard Kaufman and MacKinlay Kantor, based on Kantor's *Saturday Evening Post* story, attempted to provide a psychological explanation for the behavior of the character of reluctant hoodlum Bart Tare (John Dall, right) by flashing back to his childhood and his love of guns. He grows up a great marksman and meets the deadly female Laurie Starr (Peggy Cummins) at a carnival shooting gallery. After they marry, she starts lusting after luxuries his honest job cannot provide, and persuades him to join her in a series of robberies. When she shoots two people during a hold-up, they flee from the law, ending up on a misty mountain top. As they are about to be arrested, Laurie prepares to shoot the sheriff, but Bart kills her before she can. It is the first time he has shot anybody. The casting of clean-cut young performers Dall and Cummins was effective in so violent a tale of doom and passion. This cultish Frank and Maurice King production also cast Barry Kroeger (left), Annabel Shaw, Harry Lewis, Morris Carnovsky, Stanley Praeger, Nedrick Young, Don Beddoe and Rusty (later Russ) Tamblyn as Bart as a child. (KING BROTHERS)

◁Wanda Hendrix played the title role in **The Admiral Was A Lady**, although the character was really an unpretentious ex-Wave. This strained comedy, produced and directed by Albert S. Rogell, didn't have too many pretensions either. There were few laughs in Sidney Salkow and John O'Dea's story and screenplay about a gang of four ex-airmen (Edmond O'Brien, centre, Johnny Sands, right, Steve Brodie, centre left, and Richard Erdman, left) whose aim is to avoid work. They join up with Hendrix (centre right) who is engaged to jukebox king Rudy Vallee. She ends up with O'Brien, and Vallee returns to his ex-wife (Hillary Brooke). Also in it were Richard Lane, Garry Owen and Fred Essler. (ROXBURY)

▽George Montgomery (illustrated) as **Davy Crockett, Indian Scout**, and Philip Reed as Red Hawk, his Indian assistant, helped to get a wagon train through dangerous territory in this old-fashioned, action-filled Western. When they weren't shootin' rebel Red-skins, they were wooin' Ellen Drew (illustrated), as a part-Injun school marm who betrays them to her father's people, but later redeems herself. Told partly in flashback, Richard Schayer's screenplay (story Ford Beebe) blithely ignored logic and historical accuracy for the sake of a good yarn, which director Lew Landers allowed to unfold simply enough for kids to follow. The Edward Small production also featured Noah Beery Jr, Robert Barrat, Paul Guilfoyle, Addison Richards, Erik Rolf, William Wilkerson, John Hamilton, Vera Marshe, Chief Thundercloud and Ray Teal. Among others who have played the famous trapper and scout were Fess Parker in *Davy Crockett* (Walt Disney 1955) and John Wayne in *The Alamo* (1960). (EDWARD SMALL)

▽James Fenimore Cooper's *Leather Stocking Tales* provided the basis for **The Iroquois Trail** (GB: **The Tomahawk Trail**), although scriptwriter Richard Schayer was a far cry from the great 19-century adventure novelist. Under Phil Karlson's direction, it turned out to be just another shallow action movie of the 50s. Set in 1775, it had trapper Hawkeye (stolid George Montgomery, right) becoming a scout for the British to avenge his brother who was killed by the French. Aided by his trusty Indian friend Sagamore (Monte Blue), he breaks up a spy ring, rescues a Colonel's daughter (Brenda Marshall, centre, in her last film), and kills Indian chief Ogana (Sheldon Leonard) in a knife fight. Glen Langan (left), Reginald Denny, Paul Cavanagh and Dan O'Herlihy played British officers for producer Bernard Small. (EDWARD SMALL)

▽**Johnny Holiday** was one of those sincere, sentimental semi-documentaries, in the tradition of *Boys' Town* (MGM, 1938), about a model reform school. Roland Alcorn's production was actually shot by director Willis Goldbeck at the Indiana Boys' School, situated in acres of unenclosed land. Goldbeck, Jack Andrews and Frederick Stephens devised a well-meaning tale of a 12-year-old wayward lad (Allen Martin Jr, right) who comes under the bad influence of an older delinquent (Stanley Clements). The latter shoots

and wounds the tough but warmhearted supervisor (William Bendix, left) while trying to run away. But both the boys' confidence is won, and they are rehabilitated. Other actors mingling with the staff and boys of the school were Donald Gallagher, Jack Hagen, Greta Granstedt, Leo Cleary and Alma Platt. Even Hoagy Carmichael managed to pop up at one stage to sing the boys a Christmas song, and the real Governor of Indiana also put in an appearance as himself. It was that kind of movie. (ALCORN)

△**The Underworld Story** (aka **The Whipped**) was an over-involved story (by Craig Rice) which provided a forceful and unflattering account of the world of journalism. It showed reporter Dan Duryea helping gangster Howard da Silva by his articles in his city paper. Thrown out of his job, Duryea is provided with racketeers' money and buys a partnership in a provincial paper. The big story in the town is the murder of the daughter-in-law of the local magnate (Herbert Marshall, right), of which a negro servant is wrongly accused. Duryea smells a rat who turns out to be the bigwig's son. The director Cyril (later Cy) Endfield made the most of the nasty aspects including three murders and various beatings, although Henry Blankfort's script was a little short on character motivation. Hal E. Chester's production also included Gale Storm, Michael O'Shea, Mary Anderson, Gar Moore (left) and Melville Cooper. (FILM CRAFT)

▽There was nothing great about **The Great Plane Robbery**, set mostly aboard a transcontinental plane on which a robbery and murders take place. Screenwriters Richard G. Hubler and producer Sam Baerwitz (story by Russell Rouse and Clarence Greene) had no qualms in padding out the 63 minutes with episodes which seldom advanced the plot, and cheapo director Edward L. Cahn did not avoid the contrived and ludicrous aspects of the tale. Tom Conway (right) was the brave pilot who, with the help of homely, eccentric passenger Margaret Hamilton (left), foils the heavies, Steve Brodie and Marcel Journet. Also in it were Lynne Roberts, David Bruce, Gilbert Frye, Ralph Dunn and Lucille Barkley. Two characters plummeted to their deaths due to faulty parachutes. The public exited less dangerously, but as quickly. (BELSAM)

1951

▷**The African Queen** was not only the rusty river steamer which took scruffy, profane, unshaven, gin-drinking captain Humphrey Bogart, and prim, scrawny spinster missionary Katharine Hepburn (both illustrated) down the Congo river in 1914, but was also a vehicle that carried the stars to new success in what were essentially character parts. In fact, the role of Charlie Allnut won Bogie his first and only Oscar. Director John Huston, who co-wrote the screenplay with James Agee (adapted from C.S. Forester's novel), wisely concentrated on the two ripe performances, showing the characters' gradual change from animosity to love for each other. The unlikely pair are thrown together after Hepburn's brother (Robert Morley) is killed by German soldiers, and Bogart persuades her to escape with him. Negotiating rapids, shallows and storms, they succeed in blowing up a German gunboat. The small cast was completed by Peter Bull, Theodore Bikel, Walter Gotell, Peter Swanwick and Richard Marner. Produced by Sam Spiegel (billed as S.P. Eagle until 1954), the big-earning picture, shot in Africa, was the first Technicolor feature for Huston, Bogart and Hepburn. (ROMULUS-HORIZON)

▽John Garfield (illustrated), aged 39, died of a heart attack a year after completing **He Ran All The Way**, his last movie. In it, as in many previous pictures, he played an outsider and outlaw. Garfield's petty hoodlum, who shoots a policeman after a holdup, is explained in Guy Endore and Hugo Butler's screenplay (from the Sam Ross novel) by the lack of love he suffered from his drunken mother (Gladys George). On the run, he holes up at the apartment of a factory girl (Shelley Winters, illustrated), keeping her, her parents (Wallace Ford and Selena Royle) and kid brother (Bobby Hyatt) hostages until it is

safe to leave. The Bob Roberts-produced picture mainly concerned the relationship and tensions between the family and their tormentor. Director John Berry, after an excellently filmed opening hold-up, allowed the situation to deteriorate into over-melodramatic postures. The ending was reasonably poignant, with the gangster dying in the gutter just as his escape car arrives. It was widely conjectured that Garfield's own death was hastened by the Un-American Activities hearings. Berry, too, was blacklisted by the Committee, and left the USA for France, returning to Hollywood only in 1974. (ROBERTS)

◁Jean Renoir, after seven restrictive years in Hollywood, was given complete creative freedom by producer Kenneth McEldowney on **The River**, shot entirely in India. He was also given the use of Technicolor for the first time, an opportunity superbly capitalized upon by his cinematographer nephew, Claude Renoir. The country, and the river that flowed through the film, lent themselves to the colour camera along with the bazaars, ceremonial dances, saris and snake charmers, although this tended to give much of the picture the air of a prolonged travelogue. The slight story, adapted by Renoir and Rumer Godden from the latter's novel, dealt lyrically with the adolescent joys and pains of three girls in India: sophisticated Adrienne Corri, sensitive Patricia Walters, and the half-breed Radha (illustrated), all part of the British community. The main object of their attention was a bitter young American army officer who had lost a leg in the war, something that had actually befallen Thomas E. Breen (illustrated) who played the role. Nora Swinburne and Esmond Knight brought much-needed professionalism to a film that relied too heavily on amateur players. (ORIENTAL INTERNATIONAL)

△**Fort Defiance** was standard Western fare injected with a few interesting characterizations in Louis Lantz's screenplay. Top-billed Dane Clark (left) played a bitter deserter from the Civil War who is worshipped as a hero by his blind brother Peter Graves (centre). In fact, Clark caused the death of Ben Johnson's brother by a cowardly action. Johnson, intending to avenge his brother, finds himself fighting a local gang and a tribe of Navajo Indians at Clark's side, and the latter redeems himself by attacking the Indians bravely before being shot. Tracey Roberts (right), George Cleveland, Ralph Sanford, Iron Eyes Cody, Craig Woods, Dick Elliott and Kit Guard took other roles in Frank Melford's production. The direction by John Rawlins was as erratic as the Cinecolor. (VENTURA)

△**Pardon My French** was a feeble excuse for a comedy. Roland Kibbee's story and screenplay involved the clash between a prim Bostonian schoolteacher (Merle Oberon, illustrated) and a group of squatters in her inherited French chateau. Naturally, she is furious when she arrives at the sumptuous residence to find it teeming with impoverished French families but, before she can evict them, she is won over by the Gallic charm of the head squatter (Paul Henreid, illustrated), the father of five motherless brats. They marry, and the supposedly lovable squatters are permitted to stay. The Peter Cusick-Andre Sarrut Franco-American co-production, filmed on location in France, was ploddingly directed by Bernard Vorhaus; this turned out to be his last movie before he became a victim of blacklisting. The cast also included Paul Bonifas, Maximilienne, Jim Gerald, Alexander Rignault, Martial Rebe, Dora Doll, Lauria Daryl and Lucien Callamand. (SAGITTA AND JUPITUR)

△**The Sound Of Fury** (aka **Try And Get Me**) bore some resemblance to Fritz Lang's first American film *Fury* (MGM, 1936). Both dealt with a lynching and the psychology of mob violence, although the later movie, directed by Cyril (later Cy) Endfield, was even more downbeat and realistic. Based by Joe Pagano on his novel *The Condemned*, it showed how San Jose, California, an otherwise normal American town is whipped up into a frenzy of retribution in 1933. As a result, two men were hanged in the town square. Frank Lovejoy (right) and Lloyd Bridges (left) were the victims of the mob, the former an unemployed veteran inveigled into the kidnapping of the son of a wealthy family by the brutish Bridges. When Bridges kills the boy in cold blood, Lovejoy confesses to the kidnapping. Hatred against the men is whipped up by local journalist Richard Carlson, who is then shocked by the fury he unleashes. Kathleen Ryan (as Lovejoy's wife), Katherine Locke and Adele Jergens (as good-time girls), Cliff Clark (the sheriff), Art Smith, Irene Vernon, Carl Kent and Donald Smelick gave good support. A flaw in Robert Stillman's harrowing production was the introduction of an Italian doctor (Renzo Cesana) who utters platitudes about violence, making points that are already gratuitous clearly evident in the situations. (ROBERT STILLMAN)

▽**The Prowler** was a tense, glum, low-budget *film noir* directed by Joseph Losey for producer S.P. Eagle (later Sam Spiegel). Van Heflin (illustrated) gave one of his best characterizations as a bitter, materialist cop who meets a lonely woman (Evelyn Keyes, illustrated) during a routine check on a prowler. They begin a furtive affair at nights while her husband (Emerson Treacy), a middle-aged, sterile disc jockey, is on the air. Fans of *The Postman Always Rings Twice* might have guessed that passion and greed lead them to murder the husband, making it look like

suicide. When she becomes pregnant, suspicions are aroused, so they hide out in a ghost town. Eventually, she betrays him to the police. The screenplay by Hugo Butler (story Robert Thoeren and Hans Wilhelm) created shallow but explicable middle-American characters. As Heflin explains in the end, 'I did it for $62,000, but I love you, you gotta give me credit for that.' Also credited were John Maxwell, Katherine Warren, Madge Blake, Wheaton Chambers, Robert Osterloh, Sherry Hall and Louise Lorimer. (HORIZON)

▽If Bing Crosby could don priest's garb in *Going My Way* (Paramount, 1944) then, thought somebody, surely fading crooner Dick Haymes could do the same. He did – in **St Benny The Dip** (GB: **Escape Me If You Can**) – but to far less effect. Although he sang 'I Believe', it was hard to believe in John Roeburt's script (story by George Auerbach) about three conmen on the run from the law (Haymes, left, Roland Young, right and Lionel Stander, centre) who disguise themselves as priests. They are soon running a mission in the Bowery and naturally become as saintly as people think them. Haymes settles down to marriage, Young continues as a missionary, and Stander goes back to the wife and kids he had deserted. Nina Foch was Haymes' girl, and former child star Freddie Bartholomew (aged 27), in his final film, appeared as a priggish clergyman. Also in Edward and Harry Danziger's production were Oscar Karlweis, Dort Clark, Will Lee and Verne Colette. This Edgar Ulmer-directed picture needed the patience of a saint to sit through. (DANZIGER BROTHERS)

▽**The Lady Says No**, and so did most of the critics and public. Joan Caulfield (illustrated) was the negative lady of the title who writes a best-seller warning women against the opposite sex. Along comes charming sexually-opposite photographer David Niven (illustrated) to interview her. He tries to prove her ideas nonsense, while she sets out to prove the superiority of women. In a dream sequence, she discovers she loves him and, after a mad chase finale, she succumbs to male domination. Miss Caulfield, who tiresomely couldn't make up her mind whether to marry Niven or not, was actually married to the film's director Frank Ross. Ross also produced (with John Stillman Jr), and Robert Russell wrote the unfunny screenplay. Seemingly unembarrassed by it all were James Robertson Justice, Lenore Lonergan, Frances Bavier, Peggy Maley, Henry Jones, Jeff York and George Davis. (STILLMAN)

1951

△Nothing much new about **New Mexico**, a reasonably exciting Cavalry vs Injuns movie in Ansco Color. Max Trell's story and screenplay had Lew Ayres (right) as a captain in the US 15th Cavalry, who sympathises with the grievances of the Indians of the territory. On his way to sign a peace treaty with the Chief (Ted de Corsia, 2nd right), he rescues saloon entertainer Marilyn Maxwell (left) when her stagecoach is attacked. When they reach a fortress, an Indian boy, who turns out to be one of the chief's sons, is shot and killed. A bloody battle rages in which there are few survivors. Miss Maxwell got to sing a few numbers, Andy Devine provided some dumb comedy, and Raymond Burr looked daggers. Other roles went to Robert Hutton, Jeff Corey, Lloyd Corrigan, Verna Felton, John Hoyt, Donald Buka, Robert Osterloh and Ian MacDonald. Irving Reis directed for producer Irving Allen. (IRVING ALLEN)

△Writers Clarence Greene and Russell Rouse based the well-meaning **The Well** on an actual incident. Leo C. Popkin, who co-produced with Greene, and co-directed with Rouse, believed in it as a comment on racial disharmony, but opted for a low-budget, small-town melodrama with an unknown cast. The result was rather superficial as social comment, and over-emotional as drama. It concerned the disappearance of a five-year-old black girl (Gwendolyn Laster) whose classmates tell the sheriff (Richard Rober, left) that she was last seen with a white man. He is found to be the nephew (Henry Morgan, right) of the town's wealthiest citizen (Barry Kelley, centre). The parents (Ernest Anderson and Maidie Norman), and the black community at large, feel that justice is not being done, and riots break out until the girl is discovered to have fallen down an abandoned well. There is a sudden reconciliation between blacks and whites as they rescue the child together. Margaret Wells, Dick Simmons (2nd left), Tom Powers and George Hamilton were also cast. (HARRY M. POPKIN)

▽Although Stanley Kramer's production of **Cyrano De Bergerac** was rather underfunded and undercast, it did provide an effective showcase for Jose Ferrer's bravura Oscar-winning performance as the famous 17th-century Gascon swordsman-poet with the tremendously long nose. Fresh from playing the role on Broadway, Ferrer imparted the necessary wit, pathos and agility to the character. Despite the uninspired direction by Michael Gordon, Ferrer (illustrated) was allowed full rein in Brian Hooker's workmanlike screen adaptation of Edmond Rostand's 1897 verse comedy. Because of his proboscis, Cyrano dares not tell his cousin Roxanne (Mala Powers, illustrated) that he loves her. He therefore woos her in the darkness under her balcony, and writes love letters for Christian (William Prince), a doltish fellow-officer. Only years later, just before Cyrano dies, does Roxanne realise that she had fallen in love with him through his words. Even in the blank verse translation from the French, the words wooed enough audiences to make this cultural enterprise worthwhile. Others in the cast were Morris Carnovsky, Ralph Clanton, Virginia Farmer, Edgar Barrier, Elena Verdugo and Lloyd Corrigan. Ferrer repeated the role in Abel Gance's *Cyrano Et D'Artagnan* in 1964. (STANLEY KRAMER)

▽Religion reared its haloed head again in **The First Legion**, produced, and directed with his customary stylishness, by Douglas Sirk. It was a cut above most sacred soaps, except for the mushy ending. The often absorbing, well-acted drama was set in a small-town Jesuit seminary suddenly startled by an apparent miracle. An old priest (H.B. Warner), paralysed for years, gets up and walks. Many afflicted people flock to the seminary for a cure. The agnostic doctor (Lyle Bettger, right) explains to a sceptical priest (Charles Boyer, left) that the 'miracle' was merely the result of shock treatment. A crippled girl (Barbara Rush, centre) refuses to believe the doctor, and manages to walk. Screenwriter Emmet Lavery decided to change the cripple character from the young boy, in his 1934 Broadway play, to a girl to add some feminine interest to the picture. Among the Fathers were William Demarest, Leo G. Carroll, Walter Hampden, Wesley Addy, Taylor Holmes, George Zucco and John McGuire. Lay characters were played by Clifford Brooke, Dorothy Adams, Molly Lamont and Queenie Smith. (SEDIF)

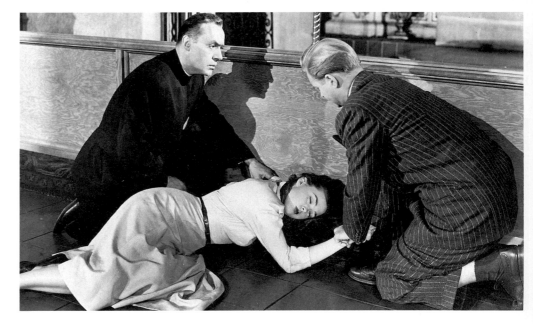

136

▽The old *döppelganger* plot was exploited again in the thriller, **The Man With My Face**. Unfortunately, the interesting script by Samuel W. Taylor (from his novel), T.J. McGowan, Vincent Bogert and Edward J. Montaigne, needed a stronger cast and more distinguished direction (from Montaigne) to carry it off. Much of Edward F. Gardner's production was shot on location in Puerto Rico, which provided an exotic background to the nightmarish story of an American accountant (Barry Nelson, illustrated) who returns home one evening to find a man who is his double with his wife (Lynn Ainley, illustrated) and business partner (John Harvey). They, of course, treat him as the imposter. In desperation, he persuades his former sweetheart (Carole Mathews) and her brother (Jack Warden) to help him prove his identity and expose the other man. He has to evade the police who suspect him of bank robbery, and a sinister gangster (Jim Boles) with a vicious doberman. Finally, the dog attacks and kills his double, who falls from a castle parapet. Also cast were Henry Lascoe and Johnny Kane. (EDWARD F. GARDNER)

▽A crazy homicidal psychiatrist, a philosophical turkey farmer, a singing waitress called Cash and Carry Connie, and an escaped lunatic were the main characters in **The Scarf**, a screwball drama. John Ireland (illustrated) was the so-called nut who escapes from the asylum where he was committed for having strangled his fiancee with a scarf, although he doesn't remember doing it. He is given refuge at the farm of a loquacious farmer (James Barton) who rambles on about fate, freedom and responsibility. When Ireland meets Connie (Mercedes McCambridge, illustrated), the scarf she is wearing brings back memories of the murder. He goes to his psychiatrist friend (Emlyn Williams) who convinces him he's guilty. But from the way the shrink plays with a feather, it's obvious who the real murderer is. E.A. Dupont, directing his first film for 12 years, went for a tricksy, arty style to cover up his own unbelievable script (story by the producer I.G. Goldsmith, and E.A. Rolfe). Also in it were Lloyd Gough, Basil Ruysdael, David Wolfe, Harry Shannon, Celia Lovsky, Dave McMahon and Chubby Johnson. (GLORIA)

◁Betsy Drake (then Mrs Cary Grant in real life) brought succour to mentally disturbed Robert Young in **The Second Woman** (GB: **Ellen**). The first woman, in Robert Smith's screenplay, was Young's fiancee, whose accidental death he blames himself for. The problem is that the whole California coast community, including ladykiller John Sutton, tycoon Henry O'Neill, Florence Bates, Maurice Carnovsky, Jean Rogers, Steven Geray (illustrated) and Jason Robards Sr seem to point the finger at him as well. But gutsy Miss Drake (illustrated) sticks by him despite his gloom, his dimly lit house, and his telling her to get lost. Director James V. Kern provided the usual atmospheric trappings of a psychological suspense drama without making any claims to being Hitchcock. Mort Briskin produced. (HARRY M. POPKIN)

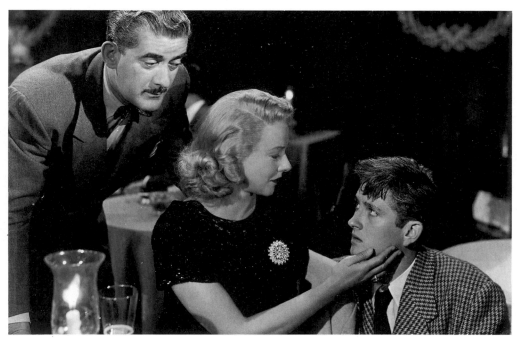

△John Barrymore Jr, the 19-year-old son of John Barrymore and Dolores Costello, took the lead in **The Big Night**, a grim little drama directed rather showily by Joseph Losey. Young Barrymore (right), having to carry most of the picture on his inexperienced shoulders, played a youth who spends one long night tracking down a sports columnist (Howard St John) who, for no apparent reason, beat up his father (Preston Foster). The widower father, an ex-boxer, doesn't resist when the man lays into him with a cane. The boy's quest leads him through a sleazy world of cheap hotels, bars and nightclubs before he finds the man, who proceeds to reveal his father's true black character. The contrived screenplay was written by Losey and Stanley Ellin, adapted from Ellin's novel *Dreadful Summit*. Other denizens of the night were Howard Chamberlain, Philip Bourneuf (left), Joan Lorring and Dorothy Comingore (centre, her last film) in Philip A. Waxman's production. Barrymore Jr, whose career was interrupted by many brushes with the law, was billed as John Drew Barrymore from 1958. (PHILIP A. WAXMAN)

1951 OTHER RELEASES

Four In A Jeep
An American soldier helps a Viennese housewife whose husband has escaped from a Russian prisoner-of-war camp. Viveca Lindfors, Ralph Meeker, Yoseph Yadin, Michael Medwin, Dinan, Hans Putz. *Dir* Leopold Lindtberg. *Pro* Lazar Wechsler. (Switzerland) PRAESENS

The Hoodlum
A pathological criminal ruins the lives of his brother and mother, before being caught by the cops. Lawrence Tierney, Allene Roberts, Edward Tierney, Lisa Golm, Marjorie Riordan, *Dir* Max Nosseck. *Pro* Maurice Kosloff. JACK SCHWARZ

The Man From Planet X
A visitor from outer space enslaves a scientist, his daughter and several of the population on a Scottish island by means of a mesmeric ray. Robert Clarke, Margaret Field, Raymond Burr, William Schallert, Roy Engel. *Dir* Edgar Ulmer. *Pro* Aubrey Wisberg, Jack Pollexfen. SHERILL CORWIN/MID-CENTURY

Queen For A Day (aka *Horsie*)
Three separate stories related to the popular radio programme, about three worthy women. Phyllis Avery, Darren McGavin, Rudy Lee, Frances E. Williams, Joan Winfield, Lonny Burr. *Dir* Arthur Lubin. *Pro* Robert Stillman. STILLMAN

Three Steps North
An American con returns to Italy after a stretch in jail to dig up some blackmail money he had stashed away there during the war. Lloyd Bridges, Lea Padovani, Aldo Fabrizi, William C. Tubbs, Dino Galvani. *Dir* & *Pro* W. Lee Wilder (Italy/USA) WILDER

Two Gals And A Guy
The female partner of a married TV star team, leaves the show to adopt and take care of twins. Robert Alda, Janis Paige, James Gleason, Lionel Stander, Arnold Stang, Linda Preston. *Dir* Alfred E. Green. *Pro* John W. Arent. WEISNER BROS.

UNITED ARTISTS

1952

▽**One Big Affair** was one big bore. Peter Godfrey shot the Francis Swann-Leo Townsend script (story George Bricker) on location in Mexico at the pace of a sleepy *burro*, although the Benedict Bogeaus production was meant to be a lively comedy. Evelyn Keyes (left) starred as a kooky American schoolteacher on a sightseeing trip by bus from Mexico City to Acapulco. When she is accidentally left behind in a small town, her travelling companions, Mary Anderson and Connie Gilchrist, think she has been kidnapped and report it to the police. Actually, she has met and become romantically involved with American lawyer Dennis O'Keefe (right). They make their way to Acapulco despite the law and their well-meaning friends. Support came from Thurston Hall, Andrew Velajquez, Gus Schilling and Jose Torvay. (BENEDICT BOGEAUS)

△Most of the 75 doleful minutes of **Chicago Calling** concerned the attempts of alcoholic photographer Dan Duryea (right) to get money to pay his $50 phone bill before his phone is cut off. The urgency is due to the fact that his wife (Mary Anderson, left) has gone home to mother in Chicago with his small daughter (Melinda Plowman, centre). The girl has been badly hurt in an accident, and his wife will phone the result of the child's operation. In vain does he go to his old drinking buddies, charitable organizations, and a finance company. Only a broke good-hearted waitress (Marsha Jones) and an orphan boy (Gordon Gebert) befriend him. The telephone engineer (Ross Elliot) lets him have one final call. After being told his daughter has died, he is saved from suicide by the orphan, and finds 'the lost faith' in himself. Director John Reinhardt, shooting entirely on location, created a realistic background against which to set the artificial story and screenplay written by himself and producer Peter Berneis. Other roles in this drab saga went to Roy Engle, Judy Brubaker, Jean Harvey, Bob Fallon, Mark Lowell and Bob Stork. (ARROWHEAD-JOSEPH JUSTMAN)

▽Unlike Mel Brooks' *Silent Movie* (20th Century-Fox, 1976), **The Thief**, a film without spoken dialogue, was meant in earnest. This suicidally crazy idea was thought up by the writing team of Clarence Greene (producer) and Russell Rouse (director). The story of a nuclear physicist (Ray Milland, illustrated) who passes secret information to foreign agents lent itself to a wordless narrative, as he pursued his lonely and dangerous mission. But the gimmick didn't pay off and became predictably, if gradually, tedious—a deterioration which was underlined by a weighty musical score. Suspected by the FBI, the spy hides out in a shabby tenement house where he has a brief and silent affair with a temptress (Rita Gam – her film debut). He kills a G-man (Harry Bronson) on his trail but, after being racked with guilt and obviously dying to talk, he gives himself up. Martin Gabel, Rita Vale and Rex O'Malley played sinister foreign agents. Also silent were John McKutcheon and Joe Conlin. Sam Leavitt's Washington and New York location photography was the most eloquent part of the picture. (HARRY M. POPKIN)

◁Nothing in **Moulin Rouge** quite lived up to the flamboyant 20-minute opening sequence, although it was a superior biopic. With its kaleidoscopic colour (Oswald Morris' superb camerawork), imaginative cutting, and evocative sets and costumes (Oscar winners Paul Sheriff and Marcel Vertes), producer-director John Huston recreated the celebrated gay 90s cabaret of the title as seen through the eyes of French artist Henri Toulouse-Lautrec. In a series of *tableaux vivantes*, the Can Can, singer Jane Avril (Zsa Zsa Gabor), and other entertainers burst onto the screen. Huston and Anthony Veiller based their screenplay on Pierre La Mure's fictional life of the dwarfish painter, dealing with his hopeless affair with a whore (Colette Marchand, illustrated), his platonic relationship with his model (Suzanne Flon), his descent into alcoholism, and (only incidentally) his development as an artist. The pain of having to walk around on his knees probably helped José Ferrer (illustrated) to express suffering. (He also played Lautrec's domineering father.) Katherine Kath, Claude Nollier, Muriel Smith, Eric Pohlmann, Christopher Lee and Michael Balfour made up the cast. The memorable theme song was composed by Georges Auric. The movie earned over $5 million, more than Lautrec made from all his paintings in his lifetime. (ROMULUS/HUSTON)

▽When Charles Chaplin and his fourth and final wife Oona were on their way to England for the premier of **Limelight**, news came that the US Attorney General had denied Chaplin re-entry to his adopted country, a far from comic custard pie in the face of one of the world's most beloved figures. Although his last American-made movie was verbose (once Chaplin started speaking on screen, he never stopped), overly sentimental, self-indulgent, and often clumsily filmed, the material of Chaplin the producer, director and writer was transcended by Chaplin the supreme performer. Realizing he had lost his mass audience, he courageously played an old-fashioned comic who no longer makes people laugh. In the England of 1914, Calvero (Chaplin, illustrated), once the most famous music hall comedian, is now a drunken has-been living in a tenement building. One day, he smells gas and rescues Terry (Claire Bloom, illustrated), a young dancer, from a suicide attempt. Through their friendship, they regain confidence in themselves. She soon gets a leading role in a ballet written by a young man (Sydney Chaplin, Charles' son in his film debut) with whom she falls in love. Calvero tries to make a comeback but flops. Years later, he is persuaded by an impresario (Nigel Bruce) to do an act at a benefit with another oldtimer (Buster Keaton). In this hilarious sequence, Chaplin and Keaton, appearing for the only time together, attempt to give a violin-piano recital. After her poignant interaction with Chaplin, the 21-year-old Claire Bloom became an international name. Other parts in this 150-minute film were given to Norman Lloyd, Marjorie Bennett, Wheeler Dryden, Snub Pollard, Stapleton Kent and Leonard Mudie. Three of Chaplin's other children, Geraldine, Michael and Josephine, as well as his leading lady of silent days Edna Purviance, appeared as extras. Charles Chaplin Jr, another offspring, danced in the ballet with André Eglevsky and Melissa Hayden. Because the picture was not shown in Los Angeles on its release, it received an Oscar retroactively in 1972 for Best Original Dramatic Score (Chaplin, Raymond Rasch and Larry Russell), which produced the great hit, 'Eternally'. (CHAPLIN)

◁Newspaper editor John Forsythe (illustrated) tells the story of **The Captive City** into a tape recorder while on his way to Washington to testify before Senator Estes Kefauver's Crime Investigating Committee. (The senator himself appears in an epilogue). What is revealed (in flashback) is a tale of widespread corruption in the small town where Forsythe lives with his wife (Joan Camden, illustrated) and runs his paper. Police chief Ray Teal is controlled by racketeer Victor Sutherland, who is himself under orders from a huge crime syndicate. This forceful, often over earnest, thriller was based by screenwriters Karl Kamb and Alvin Josephy Jr on the latter's actual experiences as a reporter on *Time Magazine*. Robert Wise's direction kept up the tension by showing many of the top gangsters only in long shot, or heard as voices on a telephone. Photographer Lee Garmes also made effective use of the Hoge deep focus lens. Other parts were played by Harold J. Kennedy, Marjorie Crossland, Martin Milner, Geraldine Hall, Hal K. Dawson and Ian Wolfe. Theron Warth produced for a new company formed by Wise and Mark Robson. (ASPEN)

△Prolific writer Ben Hecht produced, directed and adapted two of his short stories under the generic title **Actors And Sin**. The first, *Actor's Blood*, was a gloomy affair which starred Edward G. Robinson (kneeling) as a retired actor who makes the suicide of his neurotic failed actress daughter (Marsha Hunt, on bed) look like murder so she will gain some posthumous attention. Dan O'Herlihy (centre), Rudolph Anders (right) and Alice Kaye (left) had other roles. It was almost worth suffering through it for the second story, *Woman Of Sin*, a Hec(h)tic farce set in Hollywood. In this one, energetic agent Eddie Albert receives a sexy scenario from an author who turns out to be a nasty nine-year-old girl, well played by Ben's daughter, Jenny Hecht. The rest of the plot concerned the agent's attempts to hide the identity of his client. Alan Reed, Tracey Roberts and Jody Gilbert added to the fun. (SID KULLER)

△**Babes In Bagdad**, a dismal take-off of Arabian Nights movies, was fortunate to run more than one night, never mind 1001. Tamely directed by Edgar G. Ulmer, it was filmed on location in Spain in Exotic Color, a process as faded as its stars. The scantily-clad 'babes' of the title were Paulette Goddard (in her early 40s, right) and Gypsy Rose Lee (in her late 30s, centre) as members of the harem of rich Caliph John Boles (57-year-old romantic lead of yesteryear in his last role, left.) Goddard, however, demands equal rights for women, and is supported in her views by Richard Ney, the Caliph's godson, who falls for her. After various unintriguing intrigues, they marry, and the Caliph settles for a monogamous life with Gypsy Rose. Others clowning painfully were Thomas Gallagher, Sebastian Cabot, MacDonald Parke, Natalie Benesh, Hugh Dempster and Peter Bathurst. The screenplay by Felix Feist and Joe Anson (additional dialogue by Reuben Levy and John Roeburt) was as witless as it was pointless. Edward and Harry Danziger produced; they should have known better. (DANZIGER BROTHERS)

△**Park Row**, a tough low-budget movie about true-life characters and newspaper rivalry in the New York of 1886, was close to the heart of producer, director and writer Samuel Fuller, who once worked in tabloid journalism. It traced the rise of Phineas Mitchell (Gene Evans, centre) who sets up *The New York Globe* in opposition to *The Star*, run by Charity Hackett (Mary Welch). He scoops her paper with a report of the famous leap by Steve Brodie (George O'Hanlon) from Brooklyn Bridge, and instigates a modern layout with the help of Ottmar Mergenthaler (Bela Kovacs, right), who perfected the linotype machine. While the circulation war ranges, Mitchell manages to romance his rival, even kissing her between cigar chewing. The rest of the less-than-inspiring cast were Herbert Heyes, Tina Rome, J.M. Kerrigan, Forrest Taylor, Don Orlando, Neyle Morrow and Dick Elliott. As usual, Fuller's tracking shots went a long way towards liberating the often meandering and pompous script. (SAMUEL FULLER)

1952 OTHER RELEASES

Buffalo Bill In Tomahawk Territory
Western hero Buffalo Bill protects Indians from evil palefaces trying to get their hands on gold on Indian land. Clayton Moore, Slim Andrews, Rod Redwing, Chief Yowlachie, Chief Thundercloud, Charlie Hughes. *Dir* B. B. Ray. *Pro* Edward Finney, B. B. Ray. JACK SCHWARZ

Confidence Girl
A confidence trickster couple pose as detective and clairvoyant. Tom Conway, Hillary Brooke, Eddie Marr, Dan Riss, Jack Kruschen, John Gallaudet. *Dir* & *Pro* Andrew Stone. WILLIAM SHAPIRO

The Fighter
A Mexican boxer takes on a first-rate contender on a winner-takes-all basis in order to make enough money to buy guns for the 1910 Mexican Revolution. Richard Conte, Lee J. Cobb, Vanessa Brown, Frank Silvera, Martin Garralaga. *Dir* Herbert Kline. *Pro* Alex Gottlieb. GH PRODUCTIONS

Gold Raiders (GB: The Three Stooges Go West)
A gun-toting insurance agent joins up with The Three Stooges to rid the West of raiders hijacking mine shipments. George O'Brien, The Three Stooges (Moe Howard, Shemp Howard, Larry Fine), Sheilah Ryan, Clem Bevans, Monte Blue. *Dir* Edward Bernds. *Pro* Bernard Glasser. JACK SCHWARZ

Monsoon
In a remote village of India, a man falls for his fiancee's sister with tragic consequences. Ursula Thiess, Diana Douglas, George Nader, Ellen Corby, Philip Stainton, Eric Pohlman. *Dir* Rodney Amateau. *Pro* Forrest Judd. Technicolor FILM GROUP JUDD

Red Planet Mars
A high-powered radio, establishing contact with Mars, learns that the planet has developed atomic weapons. Peter Graves, Andrea King, Orley Lindgren, Bayard Veiller, Walter Sande. *Dir* Harry Horner. *Pro* Anthony Veiller. HYDE/VEILLER

The Ring
A young Mexican, the son of a poor family, becomes a boxer to earn money and respect for his people. Gerald Mohr, Rita Moreno, Lalo Rios, Jack Elam, Robert Osterloh, Robert Arthur. *Dir* Kurt Neumann. *Pro* Maurice, Frank and Herman King. KING BROS.

Untamed Women
A United States bomber is forced down at sea and the crew is washed ashore on an island inhabited by beautiful women who capture them. Mikel Conrad, Doris Merrick, Richard Monahan, Mark Lowell, Morgan Jones. *Dir* W. Merle Connell. *Pro* Richard Kay. JEWELL

Without Warning
A killer likes to plunge garden shears into blondes, because his blonde wife left him for another man. Adam Williams, Meg Randall, Edward Binns, Harlan Warde, John Maxwell. *Dir* Arnold Laven. *Pro* Arthur Gardner, Jules Levy. SOL LESSER

UNITED ARTISTS
1953

▽Charles Bennett, the writer of some of Hitchcock's better picaresque pursuit thrillers, made a vain attempt to recapture their spirit in his screenplay for **No Escape** (aka **City On A Hunt**), but as a director he lacked the Master's touch. Both Lew Ayres (left) as an alcoholic song writer, and Marjorie Steele (centre) as an ordinary working girl, think they have murdered artist-playboy James Griffith in his apartment. They run away together, and fall in love, while her cop fiance Sonny Tufts (right) pursues them. It turns out that Tufts himself is the murderer. Some of the San Francisco backgrounds were well used, but the contrived happenings and unconvincing performances in the foreground were the problem. Other roles in this Hugh Mackenzie-Matt Freed production went to Lewis Martin, Charles Cane, Gertrude Michael, Jess Kirkpatrick, Robert Watson, Robert Bailey, Leon Burbank and Renny McEvoy. (MATTHUGH)

△When the prissy and antiquated Production Code refused to give **The Moon Is Blue** a seal of approval, the picture's producer-director Otto Preminger released it nonetheless, finding enough willing outlets in the country and proving that the Code's approval was not necessary for commercial success. In fact, the ban gave the film a million dollars worth of free publicity. The fuss was caused by such shocking words as 'virgin', 'seduce' and 'mistress'. The nothing about which there was so much ado, was a tame, little moral comedy about a determined virgin (sorry!) who refuses to be seduced (oops!) or become the mistress (tsk! tsk!) of a playboy architect who picks her up one night on top of The Empire State Building, and takes her back to his bachelor apartment. Most of F. Hugh Herbert's screenplay thereafter stuck drearily to his 1951 Broadway stage hit, in which the girl finally gets the playboy on her own terms i.e. marriage. Maggie McNamara (seated), in the first of her four films (she committed suicide in 1978), brought some charm to the irritating character, but both William Holden (standing) as the architect, and David Niven (seated) as a middle-aged roué who intrudes, seemed world weary. The cast was completed by Tom Tully, Dawn Addams (standing), Fortunio Bonanova and Gregory Ratoff. (OTTO PREMINGER)

▽The endurance shown by the characters in **Shark River** when faced with snakes, swamps and Seminole Indians, was nothing compared to the endurance needed by audiences. Shot in something called Vivid Color by producer-director John Rawlins, the picture was punctuated with stock shots of the flora and fauna of the Florida swamps where most of Joseph Carpenter and Lewis Meltzer's sprawling screenplay took place. Struggling through the treacherous territory on their way to Cuba, were Steve Cochran (left), Warren Stevens as his brother wanted for murder, and Robert Cunningham, a badly-wounded friend. The latter dies of a snake bite but the brothers, surviving on alligator sandwiches, come across a clearing where young widow Carole Mathews (right) lives with her small son Spencer Fox (centre) and mother-in-law Ruth Foreman. In an Indian attack, the bad brother and the mother-in-law are conveniently killed, leaving Cochran, the widow, and her son encumbered, to escape to the Mexican Gulf. So much for that. (JOHN RAWLINS)

◁Blood, sweat and sand were elements in **The Steel Lady** (GB: **Treasure Of Kalifa**), although most of the desert wastes were painted on studio backcloths. Equally unconvincing was the contrived screenplay by Richard Schayer (story Aubrey Wisberg), and the slap-dash direction by E.A. Dupont. The all-male cast, except for dancing girl Carmen d'Antonio who popped up at an oasis stopover, was led by dour Rod Cameron (standing), the pilot of a plane forced down in the Sahara. The rest of the crew consisted of Tab Hunter (left), the radio man, Richard Erdman (right), the comic mechanic, and John Dehner (2nd left), a drunken troublemaker. The sirocco uncovers an Afrika Korps tank, in which jewels have been hidden. Dehner and evil sheik John Abbott want the jewels for themselves. They, and rampaging Arabs come to a sticky end, along with the movie. Also in the Grant Whytock production were Frank Puglio, Anthony Caruso, Christopher Dark, Dick Rich and Charles Victor. (WORLD-EDWARD SMALL)

▽The Jolly Roger was hoisted again in **Raiders Of The Seven Seas**, a jolly Technicolored piratical romp. The buccaneers in this yarn were a virtuous lot led by Barbarossa (John Payne, left) who captures a Spanish galleon single-handed, and a Spanish countess (Donna Reed). She is engaged to a cowardly and deceitful officer (Gerald Mohr, centre), but Barbarossa, instead of holding her to ransom, decides to keep her for himself. The lively finale showed the pirates'

victorious attack on the Spanish garrison at Havana. Pity the leads were less exciting than the events in which they participated. Others involved were Lon Chaney Jr (right), Anthony Caruso, Henry Brandon, Skip Torgerson, Frank DeKova, William Tannen, Christopher Dark and Howard Freeman. A very industrious Sidney Salkow both produced and directed, and also concocted the far-fetched story and screenplay (with John O'Dea). (GLOBAL)

▽Mike Hammer, Mickey Spillane's sadistic private eye hero, made the first of several film appearances in **I, The Jury**. As interpreted by the ineffectual Biff Elliot (illustrated), he should have remained between soft covers. The direction and screenplay by Harry Essex, adapted from Spillane's pulp novel of the same name, also lacked the punch of the unpleasant original. Shot in 3D but released in 'flat', the Victor Saville production concerned the efforts of the charmless detective to avenge the murder of a friend (Robert Swanger). The possible suspects include an effete art dealer (Alan Reed) and a psychiatrist (Peggie Castle) with whom Hammer falls in love. Preston Foster as a police captain, Margaret Sheridan, Frances Osborne, Robert Cunningham, Elisha Cook Jr, Paul Dubov, John Qualen, Mary Anderson, and Tani and Dran Seitz, as amorous twins, made up the cast. No prizes for guessing that the lady shrink 'dunnit', and Hammer kills her in self defence. 'Love 'em and leave 'em' was his motto. (PARKLANE)

◁**War Paint**, shot entirely on location in California's dramatic Death Valley in Pathécolor, was an exciting Western littered with Indian and Cavalrymen's corpses. In it, Lieutenant Robert Stack is given nine days to deliver a peace treaty to an Indian chief to prevent his people going on the war path. Stack and his troops are attacked by rebellious Indians, fall out among themselves, and go crazy with thirst for drink and gold. Finally, Stack (illustrated) staggers into the camp on deadline, just in time to stop the uprising. Today, a telegram or a telephone call would probably have saved all the lives lost but, equally, would have spoiled the screenplay by Richard Alan Simmons and Martin Berkeley (story Fred Friedberger and William Tunberg), and the taut direction by Lesley Selander. Supporting roles in Howard W. Koch's production were taken by Joan Taylor (as the Indian chief's daughter, illustrated), Charles McGraw, Peter Graves, Keith Larsen, William Pullen, Richard Cutting and Douglas Kennedy. (K-B)

▷**Melba** was an example of the fiction-is-sillier-than-truth school of biopics. American soprano Patrice Munsel (illustrated) as the famous Australian-born prima donna, managed admirably to sing snatches of arias from a range of hideously-produced operas, as well as warbling 'Comin' Through The Rye' to Queen Victoria (Sybil Thorndike), and a 1950s-type ballad called 'Dreamtime'. As an actress, however, Miss Munsel proved to have no personality at all – not that director Lewis Milestone gave her much to do between songs. The vapid Harry Kurnitz screenplay followed the star from her father's cattle farm to Paris where she studies with Madame Marchesi (Martita Hunt) who tells her, 'You must change your name. Nelly Mitchell sounds like a music hall artist.' Melba soon becomes the toast of Europe and the USA, pursued everywhere by two suitors (John Justin and Alec Clunes), although she marries her beau (John McCallum) from back home. The latter leaves her after getting tired of waiting around for her outside the opera houses of the world, come rain or shine. Among the facts proffered in the lavish British-made Technicolor S.P. Eagle (Sam Spiegel) production was that, after a mishap in a restaurant kitchen, the chef says 'Serve it and call it Peach Melba.' Also cast were Robert Morley (illustrated), Joseph Tomelty, Beatrice Varley and Theodore Bikel. (HORIZON)

▷After filming the US-Italian co-production **Stranger On The Prowl** in Italy in 1951, Joseph Losey returned to the States only to find he had been blacklisted. When the picture was released two years later, the direction and screenplay were credited to one Andrea Forzano. Losey might have done better to remain hidden behind the pseudonym as maker of this trite and murky attempt at Italian neo-realism in English. However, it did bring Paul Muni (illustrated) back to the screen after six years, and was well-photographed in authentic settings by Henri Alekan. The story (originated by producer Noel Calef) told of how Muni (pretentiously known only as The Man) joins up with a street urchin (Vittorio Mazzunchelli, illustrated) to survive without money. The Man is wanted for murder, and The Boy has run away from home. After being given refuge by a maid (Joan Lorring), they have to flee again when she gives them away after hearing of a reward for their capture. They escape over a roof, but The Boy falls to his death and The Man is shot. Also in this cheerless little piece were Luisa Rossi, Aldo Silvani, Arnold Foa, Alfred Varelli, Elena Manson and Fausta Mazzunchelli. (C.P.C.T.)

▷Mark Robson shot the whole of **Return To Paradise** on the islands of Western Samoa in Technicolor, using many of the islanders in roles or as extras, and thus gaining authenticity. However, both the playing, and the script by Charles Kaufman (adapted from James A. Michener's novel), was curiously uneven. Basically, it told of the clash between a happy-go-lucky beachcomber known as Mr Morgan (Gary Cooper, illustrated), and a puritanical missionary (Barry Jones). Morgan has a love affair with a native girl (Roberta Haynes, illustrated), but when she dies after giving birth to their child, he leaves the island. During World War II, he returns with supplies and meets his grown-up daughter (Polynesian-born Moira MacDonald), and is persuaded to stay by the now less fanatical pastor. The father-daughter episodes were inferior to the earlier father-mother drama, although Cooper managed the shift in emphasis quite well. Other roles were taken by John Hudson, Vala, Hans Kruse, Mamea Mataummua, La'ili and Ezra Williams. The leisurely production was by Theron Warth. (ASPEN)

◁Mexico stood in for 19th-century southern France in the Howard Dimsdale production of **Captain Scarlett**, filmed in rather indifferent Technicolor. Not only was the French background dubious, but the mainly Mexican cast, led by Englishman Richard Greene (illustrated) in the title role of the swashbuckling hero, made unlikely Frenchmen. Most of Dimsdale's story and screenplay seemed to be intended for an undiscerning kiddie audience who would respond to the conventional Robin Hoodish adventure. Plotwise, this had Green returning from the Napoleonic wars to find his province ruled by a villainous duke (Manolo Fabregas). He forms a group of highwaymen to fight the oppressor and, as is customary in tales of this nature, he also rescues a princess (Leonora Amar, illustrated) from an unwanted marriage to a decadent count (Eduardo Norriega). Greene added the dash missing from Thomas H. Carr's direction. Also cast were Nedrick Young, Isobel del Puerto and Carlos Musquiz. (CRAFTSMAN)

▽There were more jets of tears from the eyes of pilots' wives than there were jets in the sky in **Sabre Jet**, an over-emotional drama filmed in greenish Cinécolor. Newspaper woman Coleen Gray joins her husband Robert Stack (both illustrated) at an airbase in Japan to write a feature about the wives of pilots who fly over Korea. She finds herself comforting Julie Bishop, whose husband Richard Arlen has failed to return from a mission. When her own husband leads a flight of jets on a dangerous bombing raid, she realizes, in the film's anti-feminist ideology, that it is more important to be a wife than a 'career woman'. Producer Carl Krueger wrote the story which Dale Eunson and Katherine Albert turned into a routine screenplay. Whether on the ground or in the air, Louis King's direction never took off. Other officers and their wives were played by Leon Ames, Amanda Blake, Reed Sherman, Michael Moore, Lucille Koch, Tom Irish, Kathleen Crowley, Jerry Paris and Jan Shepard. (KRUEGER)

▽**Overland Pacific** needed four writers – J. Robert Bren, Gladys Atwater, Martin Goldsmith (screenplay) and Frederic Louis Fox (story) to come up with a formula Western. Although there was not much new in this Injuns v Railroad men tale, shot in colour by Color Corp. of America by director Fred F. Sears, it had its exciting moments. Jack (later Jock) Mahoney is sent by a railroad company to investigate Comanche attacks on the laying of the tracks through their territory. He discovers they are being encouraged by saloon owner William Bishop and sheriff Chubby Johnson, who stand to lose a fortune unless the railway is diverted through their town. Mahoney (left) solves the problem by dynamiting the Indians and killing Bishop (right) in self-defence. The gals were Peggie Castle (centre) and Adele Jergens. Other roles went to Walter Sande, Pat Hogan, Chris Alcaide, Phil Chambers, George Eldredge, Dick Rich and House Peters Jr. No producer credit was given, though Edward Small had a hand in it. (RELIANCE)

▽**Return To Treasure Island**, an updated sequel to Robert Louis Stevenson's classic adventure novel, was the unbright idea of producers-screenwriters, Aubrey Wisberg and Jack Pollexfen. They came up with a plot wherein Jamesina Hawkins (Dawn Addams, right), direct descendant of Jim Hawkins, comes into possession of a map of the whereabouts of treasure buried by Captain Flint 200 years before. On the island, she becomes victim of two rival treasure-seeking gangs, one led by a phony archaeologist (Porter Hall, centre), and the other by a blind man (James Seay, left). But she meets and falls in love with an archaeological student (Tab Hunter). Together they outwit the crooks and uncover the treasure. At least E.A. Dupont directed this badly-acted nonsense with some pace and in pleasant Pathécolor. Others in it were Harry Lauter, William Cottrell, Lane Chandler, Harry Rowland, Dayton Lummis and Robert Long. (WORLD)

△A bright publicist came up with the slogan 'The World's Most Exciting Animal' to describe Ava Gardner in **The Barefoot Contessa**. Not even a zoologist could disagree when La Gardner, as the girl from the Madrid slums turned Hollywood star, kicked off her shoes, lifted her skirt and danced with gypsies. But there wasn't much more to get excited about in Forrest E. Johnson's 128-minute Technicolor production, although crowds paid to see Ava's physical attributes in spite of her limited acting range. The story began at the star's funeral in the rain. Beside the grave is Humphrey Bogart (centre), the director who discovered her some years before. The flashback tells of her rise to fame, her love affairs, and her marriage to aristocrat Rossano Brazzi (bride and groom illustrated left) who turns out to be impotent. Despite the surface cynicism and the sophisticated European settings, Joseph L. Mankiewicz's story, screenplay and direction was standard soap. However, he was Oscar-nominated for his writing, and Edmond O'Brien earned himself a Best Supporting Actor Oscar as a sweating, ruthless press agent. Others cast were Marius Goring, Valentina Cortese (centre right), Elizabeth Sellers, Warren Stevens, Franco Interlenghi, Mari Aldon, Enzo Staiola and Bill Fraser. (FIGARO)

△**The Lone Gun** didn't disappoint fans of the traditional Western. The story and screenplay, by Don Martin and Richard Schayer, contained a taciturn ex-marshal (George Montgomery, centre) riding alone into a lawless Texas town, out to get three nasty cattle-rustling brothers (Neville Brand, Douglas Kennedy and Robert Wilke) who have moved in on the cattle ranch of a brother and sister (Skip Homeier and Dorothy Malone, left). At the happy ending, the hero shoots two of them, captures the third, wins the hand of the attractive sister, and becomes the new marshal. Also cast were Frank Faylen (right), Fay Roope and Douglas Fowley. Ray Nazarro shot it in colour by Color Corp. of America for producer Edward Small. (WORLD)

△A film in which an actor is alone on screen for 60 of the 90 minutes running time would seem a foolhardy venture, but director Luis Buñuel's **The Adventures Of Robinson Crusoe** overcame most of the difficulties. In fact, the beauty of the Pathécolor photography, the expert editing, and Dan O'Herlihy's Oscar-nominated, well-shaded performance (right) never allowed the famous Daniel Defoe story of the 17th-century castaway to pall. Only later, with the entrance of Friday (James Fernandez, left), and of the cannibals and mutinous sailors, did it become less absorbing, despite the attempt in Phillip Roll and Buñuel's screenplay to subvert the Christian message of the novel by showing Crusoe wavering in his faith. The few other spoken roles were taken by Felipe De Alba, Chel Lopez, Jose Chavez and Emilio Garibay. Oscar Dancigers and Henry Ehrlich's production was shot in Mexico where the director was in exile from his native Spain. (TEPEYAC)

∇Barbara Stanwyck (illustrated) was the **Witness To Murder**, but nobody believed her, poor girl. One stormy night, she wakes up to see George Sanders strangling a girl in the apartment across the street. But Sanders gets rid of the body and any clues, so that police detective Gary Merrill thinks interior decorator Barbara is dotty. Ex-Nazi and killer Sanders encourages the hallucination theory. Roy Rowland's direction provided suspense up to the contrived, literally cliff-hanging, climax. This powerful female star gave rather more than producer Chester Erskine's screenplay was worth, and good support came from Jesse White, Harry Shannon, Claire Carleton, Lewis Martin, Dick Elliott, Harry Tyler and Juanita Moore. (CHESTER ERSKINE)

△There were more blondes than you could shake a stick at in **The Long Wait**, adapted from Mickey Spillane's hard-boiled novel. Four of them were Peggie Castle (illustrated), Mary Ellen Kay, Shawn Smith and Dolores Donlon, one of whom framed Anthony Quinn (illustrated) for a murder rap. But Quinn has lost his memory and fingerprints in a car crash, so the cops can't nail him. Quinn's pursuit of the girl leads him to racketeer Gene Evans, bank president Charles Coburn, and the treacherous dame. Other roles went to John Damler, Barry Kelley, James Millican, Bruno Ve Sota, Jay Adler and Frank Marlowe. The involved script was by producer Lesser Samuels, and Alan Green. British director Victor Saville was unsuited for this tough and crass thriller, which only came to life at the climax in a deserted warehouse where Quinn is about to be liquidated. (PARKLANE)

1954 OTHER RELEASES

The Diamond Wizard (GB: The Diamond)
An American agent in London investigating a million dollar treasury robbery, uncovers a synthetic diamond-manufacturing ring. Dennis O'Keefe, Margaret Sheridan, Philip Friend, Alan Wheatley, Francis de Wolff. *Dir* Montgomery Tully. *Pro* Stephen Pallos. (USA/GB) GIBRALTAR

Jesse James' Women
The romantic conquests by the famed outlaw of a banker's daughter, a saloon singer, and the saloon owner. Don Barry, Jack Beutel, Peggie Castle, Lita Baron, Joyce Rhed, Betty Brueck, Laura Lee. *Dir* Donald Barry. *Pro* Lloyd Royal, T. V. Garraway. Technicolor. PANORAMA

The Lawless Rider
A marshal poses as a gunman to catch cattle thieves. Johnny Carpenter, Rose Bascom, Frankie Darro, Douglas Dumbrille, Frank 'Red' Carpenter. *Dir* Yakima Canutt. *Pro* Johnny Carpenter. ROYAL WEST

Operation Manhunt
A Russian clerk employed in the Soviet Embassy in Ottawa gives information to the West. Harry Townes, Irja Jensen, Jacques Aubuchon, Robert Goudier, Albert Miller, Caren Shaffer. *Dir* Jack Alexander. *Pro* Fred Feldkamp. MPTV

The Scarlet Spear
A district officer and a girl reporter persuade an African chief to refrain from dipping his spear into a rival chief as is the custom to prove himself to his tribe. John Bentley, Martha Hyer, Morasi. *Dir* George Breakston, Ray Stahl. *Pro* Charles Reynolds. Technicolor. (GB) PRESENT DAY

The Snow Creature
A botanist captures the legendary snow creature in the Himalayas and brings him back to the USA, where the beast escapes and terrifies the populace. *Dir* & *Pro* W. Lee Wilder. WILDER

The Steel Cage
Three separate stories of prisoners in San Quentin. John Ireland, Walter Slezak, Lawrence Tierney, Paul Kelly. *Dir* Walter Doniger. *Pro* Berman Swartz, Walter Doniger. PHOENIX

Wicked Woman
A sultry blonde arrives in a small California town and takes a bar owner away from his alcoholic wife. Beverly Michaels, Richard Egan, Evelyn Scott, Percy Helton, Robert Osterloh. *Dir* Russell Rouse. *Pro* Clarence Greene. EDWARD SMALL

▷Kirk Douglas launched his own new production company with **The Indian Fighter**, making sure that Frank Davis and Ben Hecht's screenplay (story by Ben Kadish) provided a whopping great part for himself. In the title role, the buckskinned, dynamic Douglas was barely off the screen as he fought his way through Indian territory while protecting a wagon train. And magnificent territory it was, filmed in CinemaScope and Technicolor on location in the mountain country of Oregon. Most of the trouble en route was caused by unscrupulous Walter Matthau and Lon Chaney Jr, who exchange whisky for gold with the Indians. Douglas (left) ends their dirty deals, signs a peace treaty with Chief Eduard Franz, and marries his daughter Elsa Martinelli. The latter, in her first Hollywood movie, impressed with few words but meaningful glances. Walter Abel (right), Diana Douglas, Alan Hale Jr, Elisha Cook Jr, Michael Winkelman, Harry Landers, William Phipps (centre), Buzz Henry and Ray Teal took other roles. Director Andre de Toth sustained the action well for producer William Schorr. (BRYNA)

◁Noble Foreign Legionnaires and dastardly Arabs were at each other's throats again in **Desert Sands**. Among the former were Ralph Meeker (right), John Smith, Ron Randall, J. Carrol Naish, Otto Waldis and Terence De Marney. The Arab side was led by evil Sheik John Carradine and Keith Larsen, whose father was killed by Carradine's cronies disguised as Legionnaires. Larsen's sister, Marla English, falls for legionnaire Meeker, and brings about her brother's defeat. Lesley Selander staged the battles well in Technicolor and SuperScope, but could do nothing with the stereotyped characters and events in the screenplay by George W. George, George F. Slavin and Danny Arnold from a John Robb novel. Others in Howard W. Koch's production were Jarl Victor, Lita Milan, Nico Minardos and Mort Mills. (BEL-AIR)

▽**The Big Knife** was plunged right between Hollywood's shoulder blades by producer-director Robert Aldrich, just as Clifford Odets had done seven years previously in his play of the same name. Faithfully adapted by James Poe for the screen, the combination of Odets' rambling rhetoric and Aldrich's bludgeoning style made for an overheated, overwordy, but hardhitting occasion. In a single set Aldrich, using a variety of emotional camera angles, attempted to reveal the movie business and its protagonists as vulgar, greedy and ruthless. At the moral centre, Jack Palance (illustrated) was rather miscast as the big star (reputedly modelled on John Garfield) who wants to break his contract with venomous producer Rod Steiger, and Ida Lupino was the wife who believes that her husband is worthy of better pictures. Others preying on the star were Wendell Corey as a toadying public relations man and Jean Hagen his drunken cheating wife, Shelley Winters (illustrated) as a blackmailing Hollywood floozie, Ilka Chase a bitchy gossip columnist and Everett Sloane a corrupt agent. Also around were Wesley Addy, Paul Langton, Nick Dennis, Bill Walker, Mike Winkelman and Mel Wells. For two hours they went at each other tooth and claw. No wonder the actor takes his own life in the end. Hollywood, however, survived the attack, and continued as glib and ruthless as ever. (ROBERT ALDRICH)

△Most of the action of **Big House, USA**, took place in the impressive Colorado National Park, and not in jail, as the title suggests. However, in a cell at Cascabel Island Prison are Rollo Lamar (Broderick Crawford), Alamo Smith (Lon Chaney Jr, right), Benny Kelly (Charles Bronson, left), Machine-Gun Mason (William Talman, 2nd left) and small-time hood Jerry Barker (Ralph Meeker, 2nd right). The latter has buried the ransom money he received from the father of a boy he kidnapped. The unlovely crew break out of jail and make for the Park where the money is hidden, and the Rangers are waiting for them. A gun battle ensues, and it's back to the big house for those that survive. Aubrey Schenck's production was effective because John C. Higgins' screenplay employed a minimum of dialogue, while Howard W. Koch's direction provided maximum action. Reed Hadley, Randy Farr, Roy Roberts and Peter Votrian, as the ill-fated boy, made up the cast. (BEL-AIR)

▽Burt Lancaster directed and starred in **The Kentuckian**, a spirited recreation (in Technicolor and CinemaScope) of pioneer life in Kentucky during the 1820s. Lancaster (left), in buckskins throughout, brought humour, virility and pathos to his role of a widower heading for the new land of Texas with his young son, Donald MacDonald (lying down). On the way, they spend their savings on buying the freedom of bondslave Dianne Foster (right). In the town of Humility, the freedom-loving woodsman is forced to stay with his brother John McIntire and

sister-in-law Una Merkel, who try to make him settle down with local schoolmarm Diana Lynn. But Burt, his son, and the ex-slave take off for Texas after getting involved in a family feud, and having got the better of nasty, whip-toting saloon keeper Walter Matthau. It was Diana Lynn's final film, and Matthau's first. Among others cast were John Carradine, John Litel, Rhys Williams, Edward Norris, Clem Bevans, Douglas Spencer and Paul Wexler. A.B. Guthrie Jr adapted Felix Holt's novel *The Gabriel Horn* for producer Harold Hecht. (HECHT-LANCASTER)

▽There was not a woman to be seen in **Battle Taxi**, but there were plenty of battle axes or 'choppers'. Malvin Wald's screenplay, from the slim story by himself and Art Arthur, added up to little more than one operation after another by the Helicopter Air Rescue Service during the Korean War. Sterling Hayden (right) was the captain in charge who has problems with former jet pilot Arthur Franz. The latter resents his non-combative duties at first, but after some hazardous missions, he becomes a valued member of the unit at the flag-waving finale. Also in uniform were Marshall Thompson (left), Leo Needham, Jay Barney, John Goddard, Robert Sherman, Joel Marston, John Dennis, Dale Hutchinson and Andy Andrews. The Ivan Tors-Art Arthur production contained much thrilling aerial material, but director Herbert L. Strock had trouble keeping it interesting on the ground. (IVAN TORS)

▽In **Summertime** (GB: **Summer Madness**), suave Latin Lover Rossano Brazzi tells American spinster Katharine Hepburn, 'You Americans think too much about sex instead of doing something about it,' just before she succumbs to his kiss. Hepburn (illustrated), overdoing her scrawny, tearful spinster bit, comes to Venice eager to take in all the sights and hoping to find a 'magic explosion', an expression hardly applicable to David Lean's tame direction. Lean's screenplay (co-written with H.E. Bates), based on the stage play *The Time Of The Cuckoo* by Arthur Laurents, concerned the brief encounter between married antique dealer and unmarried

antique mid-western schoolteacher Hepburn, which ends when she breaks it off on moral grounds. Having had her illicit cake, she leaves Venice clutching her crumbs of comfort. Also in the cast were Isa Miranda, Darren McGavin, Mari Aldon, André Morell, Jeremy Spencer, Gaetano Audiero (an appealing waif, illustrated), and Jane Rose and MacDonald Parke (as caricatured but amusing American tourists). However, upstaging everyone in the successful Ilya Lopert production, was *La Serenissima*, the city of Venice (well-photographed by Jack Hildyard), which should have been nominated for the Best Actress Oscar rather than Miss Hepburn. (LOPERT-KORDA)

▽What separated **Canyon Crossroads** from the usual Western, was that it was set in the contemporary 1950s, had uranium in 'them thar hills' instead of gold, and had the hero, Richard Basehart (illustrated), pursued by a helicopter instead of a horse at the climax. Otherwise the story and screenplay by Emmett Murphy and Leonard Heideman resorted to stock characters and situations. Basehart, a uranium prospector, accompanied by Alan Wells, his Red Indian friend, and Phyllis Kirk (illustrated), a geology professor's daughter, goes on an expedition in Colorado. Rival prospector Stephen Elliott hires a heavy, Charles Wagenheim, to trail them. When they find uranium, Wagenheim traps them in a cave, but Basehart escapes to get help from Kirk's father, Russell Collins, and Richard Hale, the Indian's brother. The William Joyce production provided both a promising opening, and an exciting ending, but not much in between, apart from some good location work by director Alfred Werker. (M.P.T.)

▷Charles Laughton's only film as director was the eerily beautiful parable of good and evil, **Night Of The Hunter**. Its visual style derived from German Expressionism and American Primitive paintings. The use of irises and other silent screen techniques, as well as the presence of Lillian Gish, also echoed the rural dramas of D.W. Griffith. The screenplay, brilliantly adapted by James Agee from Davis Grubb's novel, concerned a psychopathic woman-hating preacher who obtains money for 'the Lord's work' by marrying and murdering rich widows. The two children of his latest victim flee from him with money stashed away in the little girl's doll. They take a boat down the river and finally find refuge with an old woman who protects them with a rifle. Evil is destroyed by the forces of good and innocence as represented by the old lady, the children, nature and animals, all atmospherically photographed by Stanley Cortez. The Paul Gregory production failed to attract audiences on its first release, but people have since recognised that the extraordinary Robert Mitchum (centre) pursuing the children (Billy Chapin, right, Sally Jane Bruce, left) through a nocturnal landscape, Lillian Gish guarding a brood of orphans like a mother hen, and the murdered Shelley Winters' hair streaming out under water, are some of the cinema's most haunting images. Don Beddoe, Evelyn Varden, Peter Graves and James Gleason had other roles. (PAUL GREGORY)

△Unlike his *Macbeth* (Republic, 1948), shot in one set over three weeks, Orson Welles' **Othello** (illustrated) took three years in several countries to complete. Although it won the Cannes Film Festival award in 1952, it was another three years before it was released. Indeed, the problems of the jealous Moor were as nothing compared to the suffering of the producer-director in getting the picture made. The constant stops and starts in filming were due to the continual exhaustion of funds, and a scene begun on one continent was finished a year or so later on another. No wonder that the finished product was guilty of erratic editing and sound, unexplained gaps, and inconsistent performances. Making a virtue of necessity when the costumes failed to turn up on one occasion, Welles filmed the killing of Roderigo and Cassio in a Turkish bath in Morocco! For the rest, Michael MacLiammoir was too much the blatant villain as Iago, Suzanne Cloutier lacked spirit as Desdemona, and there were weaknesses in the other performances from Robert Coote (Roderigo), Michael Lawrence (Cassio), Fay Compton (Emilia), Doris Dowling (Bianca) and Hilton Edwards (Brabantio). Nonetheless, Welles' overriding genius was felt behind every frame, and in his tragic stature in the title role. (MERCURY)

▷Strong, silent outlaw George Montgomery rode into Junta Junction – and into trouble – at the start of **Robbers' Roost**. He finds a job on a ranch run by crippled Bruce Bennett (left) and, when Sylvia Findley (centre), Bennett's sister, is kidnapped by rustler Richard Boone who joins forces with Peter Graves' rival gang, Montgomery rides to the rescue. But the two leaders save him the trouble by falling out and killing each other. Guitar-strumming cowboy Tony Romano, Warren Stevens, William Hopper (Hedda's son, right), Leo Gordon, Stanley Clements, Joe Bassett, Leonard Geer, Al Wyatt and Boyd 'Red' Morgan made up the cast of the Robert Goldstein production. Zane Grey's novel provided plenty of action for the screenplay by John O'Dea, Maurice Geraghty and Sidney Salkow, the latter directing in washed-out De Luxe Colour. (LEONARD GOLDSTEIN)

△Adapted from Morton Thompson's thick best-seller on the medical profession, **Not As A Stranger** was a long (135 minutes) and slow drama with an all-star cast. Robert Mitchum (centre), acting as if under an anaesthetic, played the poor but ambitious medical student who marries Head Nurse Olivia de Havilland (right, and Svedish-accented) in order to pay his tuition fees. Later, when he becomes the assistant to gruff small town physician Charles Bickford, he leaves his long-suffering wife for bored and wealthy Gloria Grahame. His old friend from medical school, Frank Sinatra (left), now a big city doctor, tries to patch up the marriage, but Mitchum only returns to his wife after he has botched an operation on the unfortunate Bickford. The cast also included Broderick Crawford, Myron McCormick, Lon Chaney Jr, Jesse White, Harry Morgan, Lee Marvin, Viriginia Christine, Whit Bissell, Jack Raine and old-timer Mae Clarke. Screenwriters Edna and Edward Anhalt kept most of the novel's plot and some of the clinical details, but if producer Stanley Kramer, directing his first feature, had used more of his scalpel on the film, it might have been less laboured. (STANLEY KRAMER)

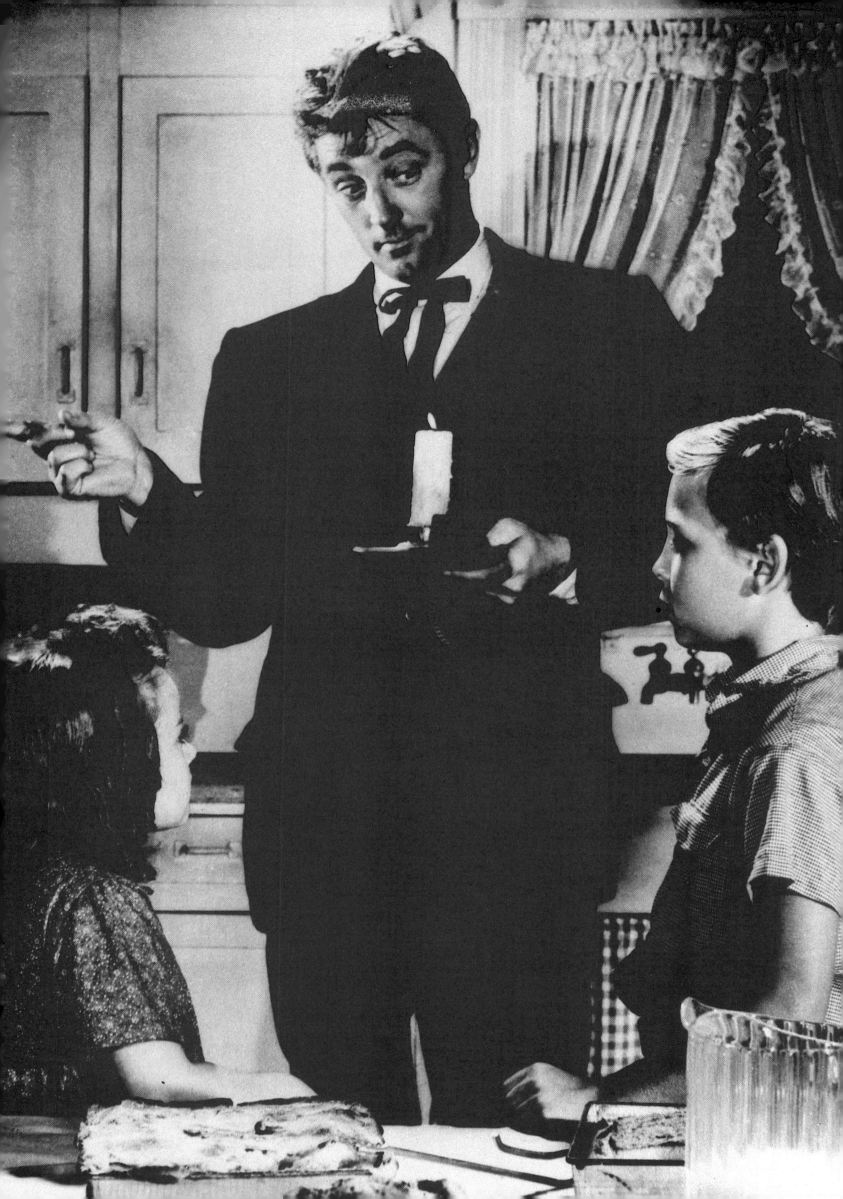

▷**Marty** was one of the first films in the mid-50s to bring new naturalism, new talent and new life to Hollywood from television. This gentle, intimate study of the mundane, marred only by a certain sentimentality, began a vogue for small scale, cheaply made dramas about ordinary people. Both director Delbert Mann and writer Paddy Chayefsky entered the movies at producer Harold Hecht's instigation to transfer Chayefsky's teleplay (directed by Mann) to the big screen. Although the picture had no stars, and was about uncomely characters, it kept the box-offices busy and won four Oscars – Best Director, Best Screenplay, Best Film, and Best Actor. The latter was awarded to movie heavy Ernest Borgnine (illustrated – in the role created by Rod Steiger on TV), whose untypical casting as an ugly 34-year-old butcher from the Bronx, made him world-renowned. In the simple love story, plain Marty meets a plain schoolteacher at a Saturday night dance. She has been stood up, and they are drawn together by their own fears of rejection and loneliness. The only problem arises when his mother (Esther Minciotti) objects to the girl not being Italian. Betsy Blair (illustrated – then Gene Kelly's wife) was nominated for an Oscar as the schoolteacher; so was Joe Mantell as Marty's friend, and the cinematographer Joseph LaShelle, for his recreation of the drab milieu. Others giving excellent performances were Karen Steele, Jerry Paris, Joe de Santis and Augusta Ciolli. (HECHT-LANCASTER)

▽**Kiss Me Deadly**, produced and directed by Robert Aldrich, was a multi-layered, often pretentious *film noir* that used a Mickey Spillane pulp novel as the basis for a gripping allegory of America in the 1950s. Its use of an amoral hero, real locations and low-key photography (by Ernest Laszlo) made it an influence on the French New Wave, and a candidate for cult status. Each scene, peppered with self-conscious art work and references to poetry, opera and paintings contrasts vividly with the violent world the film inhabits. The cryptic script by A.I. Bezzerides involved tough private eye Mike Hammer (Ralph Meeker, illustrated) in a search for a mysterious black box, sought after by an unnamed foreign power and a group of racketeers. Through a series of nasty incidents with a woman escapee from a mental home (Cloris Leachman in her film debut), a wealthy and ruthless gangster (Paul Stewart), a strange doctor (Albert Dekker), and assorted idiosyncratic characters, Hammer discovers the box contains radio-activity. A two-timing dame (Marion Carr) opens the box at a beach house, and everything goes up in flames. Mike and his secretary (Maxine Cooper) escape although, in some versions, the picture ends with a conflagration in which there are no survivors. Excellent support came from the rest of the cast: Nick Dennis (crushed under a car), Percy Helton (fingers crushed in a drawer), Fortunio Bonanova (vintage Caruso records broken), Juano Hernandez, Wesley Addy, Gaby Rodgers, Jack Lambert, Jack Elam, and Nat 'King' Cole. (PARKLANE)

△Two of the cinema's most notorious gangsters, Edward G. Robinson (right) and George Raft (left), were brought face to face in **A Bullet For Joey**. Robinson this time was on the side of the law as a plainclothes inspector with the Royal Canadian Police, while Raft gave his well-worn interpretation of a tough racketeer. Both stars, now past their best, were given little help by the routine direction of Lewis Allen, and the confused and confusing screenplay by Geoffrey Homes and A.I. Bezzerides (story James Benson Nablo). Raft is sent to Montreal by Peter Van Eyck, the leader of a spy ring, to kidnap nuclear scientist George Dolenz. With the help of his ex-girlfriend (Audrey Totter in a familiar role), who has to vamp the boffin, Raft manages to get him on board a ship. Robinson, on their trail, is captured and held prisoner until he is rescued by the harbour police. The only thing unfamiliar about the Samuel Bischoff-David Diamond production, was the Canadian setting. Also involved were Peter Hanson, Karen Verne, Henri Letondal, Ralph Smiley, John Cliff and Joseph Vitale. (BISCHOFF-DIAMOND)

▷The tried and tested Cavalry vs Indians formula worked yet again in **Fort Yuma**, with a soupçon of a 1950s racial tolerance theme thrown in. Danny Arnold's story and screenplay placed anti-Indian lieutenant Peter Graves at loggerheads with his pro-Indian scout John Hudson (left). Joan Vohs (centre), an attractive missionary, tries to reconcile the two men. Only when the Apaches attack them and Joan Taylor (right), Hudson's sister whom Graves loved, is killed, do they bury the tomahawk. All liberal sentiments are forgotten in the final carnage when the Indians are routed. Abel Fernandez, James Lilburn, Bill Phillips, Stanley Clements and Addison Richards supported in Howard W. Koch's Technicolor production. Director Lesley Selander kept things lively. (BEL-AIR)

▽No heights were reached in **Top Of The World**, a lugubrious drama set in a weather observation unit in North Alaska. In John D. Klorer and N. Richard Nash's artificial script, senior jet pilot Dale Robertson (left) is naturally piqued when transferred from Honolulu to the frozen Arctic. Yet, who should he meet there, but his ex-wife Evelyn Keyes (2nd left), now owner of the Klondyke Club. However, she intends to marry Major Frank Lovejoy (right) who commands the post. After Robertson and his men are rescued by Lovejoy from a floating island of ice, the pilot is reunited with his wife, and the major has to settle for PR officer Nancy Gates (2nd right). Others receiving cold comfort were Paul Fix, Robert Arthur, Peter Hansen, Nick Dennis, Russel Conway, William Schallert, Peter Bourne and David McMahon. Some eye-catching aerial photography helped to enliven Lewis R. Foster's direction, but producers Michael Baird and Foster could only hope for a heat wave to encourage business. (LANDMARK)

△When the Motion Picture Association of America refused to give a Code Seal to **The Man With The Golden Arm**, UA resigned from the MPAA and submitted the picture to local state censors, most of whom gave it a certificate. Producer-director Otto Preminger had again taken on the censors after *The Moon Is Blue* controversy two years before, and won. Adult audiences paid over $4 million to see Hollywood's first attempt at tackling the subject of drug addiction, and were suitably shocked. Today, its rather hysterical approach is outdated, but the cold turkey scenes, the seedy atmos-phere, Elmer Bernstein's jazz score, and Frank Sinatra's pained Oscar-nominated performance, still pack a certain punch. Sinatra (right) played a professional gambler in Chicago married to a beautiful, bitter cripple (Eleanor Parker). He gets hooked on narcotics, and is helped to kick the habit by the lovely and lonely Kim Novak. Darren McGavin (the pusher, left), Arnold Strang, Robert Strauss, John Conte, Doro Merande, George E. Stone and George Mathews were also cast. Walter Newman and Lewis Meltzer's screenplay lacked the edge of Nelson Algren's novel. (OTTO PREMINGER)

▽Robert Mitchum (left) was the **Man With The Gun** (GB: **The Trouble Shooter**) who rides into Sheridan City to restore law 'n order. But the citizens, led by Emile Meyer, begin to regret hiring him because of his brutal methods. Also agin him are the Marshal, Henry Hull, young farmer John Lupton (right), and heavy Ted de Corsia. But Mitchum proves himself a good guy in the end by deciding to retire from gunfighting and settling down with his estranged wife, Jan Sterling, who runs a troupe of dancing girls at the saloon. Karen Sharpe (centre), Barbara Lawrence, Leo Gordon, James Westerfield, Florenz Amez, Robert Osterloh, Jay Adler and Angie Dickinson (in her second small part) completed the gallery of interesting characters. Director Richard Wilson, who wrote the screenplay with N.B. Stone Jr, built up the tension slowly and effectively, helped by Lee Garmes' moodily atmospheric photography. The picture also marked the debut of producer Sam Goldwyn Jr. (FORMOSA)

△Mainly financed by Bronx chemist Morris Bousel with $40,000, **Killer's Kiss** failed to recover its costs. However, it brought Bousel's co-producer, who also directed the film, to the attention of the movie industry, although not yet to the public at large. This gentleman also photographed, edited, wrote the story, and co-wrote the screenplay with Howard O. Sackler. His name was Stanley Kubrick, and even his then wife, Ruth Sobotka, had a small role as a dancer. The only thing that wasn't Kubrick's was the imposed happy ending. The nightmarish atmosphere of the film suggested the inevitable doom of the young lovers, a nightclub dancer (Irene Kane) and a boxer (Jamie Smith), who rushes to her aid one night when he sees the club owner (Frank Silvera) trying to rape her. In revenge, the owner sets his strong-arm boys onto the young man, while he holds the girl prisoner in a warehouse. The couple (illustrated) escape together, after the villain is killed. All this in 67 minutes! The cast, principally recruited from TV, included Jerry Jarret, Mike Dana, Felice Orlandi, Ralph Roberts, Phil Stevenson and Julius Adelman. Kubrick's camera was eloquent, especially at the exciting climax in the warehouse where shop-window mannequins are violently dismembered. (MINOTAUR)

▽The only novelty that **The Naked Street** could boast was that, instead of the usual Italian racketeer, the principal hoodlum in this gangland drama was of Slavic origin. The origin of Maxwell Shane and Leo Katcher's screenplay (story by Katcher), however, was many a gangster movie before it, especially *Scarface* (1932). Notorious racketeer Phil Regal (née Regalzyk), played in a vociferous manner by Anthony Quinn (illustrated), is inordinately fond of his mother and sister (Else Neft, and Anne Bancroft, illustrated, in conventional roles). When the latter gets pregnant by a small-time crook (Farley Granger), Regal makes him marry his sister and go straight. But when he finds his no-good brother-in-law becoming his brother outlaw and neglecting his sister, he frames him for murder. However, after his own rackets have been exposed by a reporter (Peter Graves), Regal is killed in a fall during a rooftop chase. Director Maxwell Shane exposed much of the plot's implausibility by adopting a semi-documentary approach. Others in the Edward Small production were Jerry Paris, Frank Sully, John Dennis, Angela Stevens, Joy Ferry and G. Pat Collins. (WORLD)

▽Edward G. Robinson (left) was still knocking (and shooting) them dead in **Black Tuesday**, a gripping throwback to the gangster movies of the 1930s. In Sydney Boehm's story and screenplay, the star was a killer and racketeer awaiting execution in New Jersey State Penitentiary. With fellow inmate Peter Graves (right), he arranges the kidnapping of a prison guard's daughter in order to break out. Using the chaplain (Milburn Stone) as a shield, they escape and join the rest of the gang, including Robinson's girlfriend (Jean Parker), in a disused warehouse. The police trace their whereabouts, and the film ends in a bloody shoot-out. Hugo Fregonese directed in a cool, semi-documentary style with an effective use of silence. Also in the Robert Goldstein production were Warren Stevens, Jack Kelly, Sylvia Findley, James Bell, Victor Perrin, Hal Baylor and Harry Bartell. (LEONARD GOLDSTEIN)

△**Gentlemen Marry Brunettes** made one understand why gentlemen prefer blondes. Despite the gorgeous costumes by Travilla and Christian Dior, the Technicolor and CinemaScope, the chic Parisian settings, and some good songs, it was a feeble farrago. The uninspired screenplay was by Mary Loos and Richard Sale, the niece and husband of Anita Loos, the creator of the better blonde version. Sale was also responsible for the jaded direction, and the production (with Robert Waterfield). Jeanne Crain (right) and Jane Russell (left) both played dual roles as the brunette Jones sisters in the Paris of 1955, and their blonde mother and aunt, Mimi and Mitzi, the toast of the Paris of 1926. In the past, they are courted by Rudy Vallee and Guy Middleton, while their contemporary beaus were an agent (Scott Brady) and an odd job man (Alan Young) who turns out to be a millionaire. Also participating were Eric Pohlmann, Ferdy Mayne, Leonard Sachs, Guido Lorraine and Derek Sydney. (VOYAGER)

△**Top Gun** was a run-of-the-range Western, good enough to satisfy fans of the genre. A gunman (Sterling Hayden, left) rides into town to find his mother's murderer. He suspects a ranch owner (William Bishop, centre) engaged to his own former girlfriend (Karin Booth, right). When the marshal is killed, the hero takes his place, defeats a gang of raiders, finds his mother's killer, and rides off with the girl. James Millican, Regis Toomey, Hugh Sanders, John Dehner, Rod Taylor, Denver Pyle, Bill Phillips and Dick Reeves filled other roles. No producer credit was given, but there was certainly no reason for director Ray Nazarro, or screenwriters Richard Schayer and Steve Fisher (story Fisher) to feel any shame for putting their names to the picture. (FAME)

▽**Stranger On Horseback** galloped by in 66 minutes under Jacques Tourneur's taut direction. Although the script by Herb Meadows and Don Martin (story Louis L'Amour) was the familiar one-man-against-hostile-town tale, it avoided many Western stereotypes. Joel McCrea was the judge who arrives in the town of Bannerman, feudal domain of the Bannerman family, to arrest the scion of the family for murder. A corrupt attorney (John Carradine), under the control of Bannerman Sr (John McIntire), is appointed prosecutor. The daughter of the family (Miroslava, illustrated) falls for McCrea, and helps him get her brother Tom (Kevin McCarthy, illustrated) a fair trial in a neighbouring town. Nancy Gates, Emile Meyer, Robert Cornthwaite, Walter Baldwin and Jaclynne Greene were also in the Robert Goldstein Ansco Color production. (LEONARD GOLDSTEIN)

1955 OTHER RELEASES

The Big Bluff
A handsome cad marries a girl for her money, knowing she has only a year to live, but when she starts to recover, he plans to murder her. John Bromfield, Martha Vickers, Robert Hutton, Rosemarie Bowe, Eve Miller. *Dir* & *Pro* W. Lee Wilder. WILDER

Sabaka
A young Indian boy avenges his family's death by fire at the hands of followers of Sabaka, the Fire Demon. Boris Karloff, Nino Marcel, June Foray, Lou Krugman, Victor Jory. *Dir* & *Pro* Frank Ferrin. Eastmancolor. FERRIN

The White Orchid
Two explorers in the jungles of Mexico rescue a woman about to be sacrificed by an ancient tribe. William Lundigan, Peggie Castle, Armand Silvestre, Jorge Trevino. *Dir* & *Pro* Reginald Le Borg. Eastmancolor. COSMOS

UNITED ARTISTS

1956

▽Crooner Tony Martin (right) abandoned his tuxedo and gave his singing voice a rest in **Quincannon, Frontier Scout** (GB: **Frontier Scout**). John C. Higgins and Don Martin's screenplay allowed Martin, in the title role, no time for songs as he undertook a mission to investigate the theft of repeating rifles by Indians. Accompanied by two soldiers (John Bromfield and John Smith), and Maylene (Peggie Castle), searching for her missing brother, Quincannon runs down his former friend and army captain (Ron Randell) as the man secretly selling guns to the Redskins. Also in Howard W. Koch's production were Peter Mamakos, Ed Hashim (left) and Morris Ankrum. Director Lesley Selander, who shot the picture in the Utah desert in De Luxe Color, made it into a fairly entertaining horse-opera despite its uncomfortable star. (BEL-AIR)

△Paris, seen in CinemaScope and Technicolor, was the setting for **The Ambassador's Daughter**, a fluffy piece of nonsense produced and directed by Norman Krasna. Olivia de Havilland (centre, who had moved to Paris in 1955 when she married the editor of *Paris Match*), now a trifle mature, played the title role. She sets out to prove to visiting senator Adolphe Menjou (centre right), investigating the conduct of American soldiers in the city, that they are all perfect gentlemen. She does this by allowing herself to be picked up by GI John Forsythe who thinks she's a Dior model, thus permitting the inclusion of a couple of fashion parades in the movie. Also justifying the on-location shooting, was a tourist's eye view of Paris as the couple gad about, falling in love at the same time. The thin Krasna screenplay was given most weight by the performances of oldtimers Edward Arnold (in his last film, centre left) as the ambassador, Francis Lederer as a white Russian aristocrat, Menjou and, especially, Myrna Loy (right) as his elegant and dryly humorous wife. Tommy Noonan was Forsythe's buddy, and Minor Watson (left) an American general. (NORMAN KRASNA)

▽The action of **Rebel In Town** was sparked off when a young boy (Bobby Clark) fires a toy pistol at the back of Wesley Mason (John Smith), a member of a family of bankrobbers. The man fires back instinctively and kills the boy. Wesley and his brothers (Ben Cooper, Ben Johnson and Sterling Franck) flee town until their father (J. Carrol Naish) forces his other sons to hand over Wesley for trial. However, the guilty man escapes and is killed by the dead boy's father (John Payne, illustrated) who had vowed revenge despite the pleas of his wife (Ruth Roman, illustrated). Good characterizations, a sensitive script by Danny Arnold, and solid direction from Alfred Werker, raised this Howard W. Koch production above the usual level of low-budget Westerns. The cast also included James Griffith, Mimi Gibson and Joel Ashley. (BEL-AIR)

◁CinemaScope and De Luxe Color dissipated some of the tension in **A Kiss Before Dying**, a thriller that cried out for a black and white *film noir* approach, although it didn't harm the box-office unduly. Laurence Roman's screenplay also lacked the bite of the original Ira Levin novel in which the killer is unknown until the end, but Gerd Oswald, in his first directorial assignment, did well to maintain intrigue. In the film, Robert Wagner (illustrated), effectively cast against type, is seen pushing his pregnant girlfriend (Joanne Woodward in her second movie) off a rooftop, and faking her suicide note. Virginia Leith (illustrated), the girl's sister, suspects murder, and persuades college lecturer Jeffrey Hunter to help investigate. When Wagner becomes engaged to the unsuspecting sister, he tries to push her off a precipice, but goes over himself. Mary Astor, in her first picture for seven years, made a brief but effective appearance as the psychopath's mother. George Macready, Robert Quarry, Howard Petrie, Bill Walker, Molly McCart and Marlene Felton made up the cast of the Robert L. Jacks production. (CROWN)

▽Robert Mitchum (left), in panama hat and white suit, had his tongue firmly in his cheek, and a gun in his hand in **Bandido**. As an American adventurer in the Mexico of 1916, he is caught up in the civil war, reluctantly helping rebel leader Gilbert Roland (right). Earl Felton's complicated screenplay had Mitchum getting the better of cunning American gun-runner Zachary Scott, and stealing Scott's attractive but cold wife, Ursula Thiess (Robert Taylor's German wife in her last Hollywood movie). Director Richard Fleischer continually filled the CinemaScope screen with noisy action, shot in garish De Luxe Color on location in Mexico for producer Robert L. Jacks. Henry Brandon, Douglas Fowley, and Mexican actors Rudolfo Acosta, Victor Junco and Alfonso Sanches Tello took supporting roles. (ROBERT L. JACKS)

▽Sibling rivalry was the over-familiar theme of **Gun Brothers**, but it served well enough for screenwriters Richard Schayer and Gerald Drayson Adams (story by Adams). Brothers Chad (Buster Crabbe, illustrated) and Jubal (Neville Brand) are on opposite sides of the law. When an Indian girl (Lita Milan, illustrated), jealous of trapper Chad's liking for a saloon singer (Ann Robinson), tells Jubal that his brother has informed on him, the two men face each other. Just as Chad convinces Jubal of his loyalty, outlaws attack them and, after a skirmish, Jubal dies in his brother's arms. The two leads acted with vigour in this fairly credible Western directed by Sidney Salkow. Others in it were James Seay, Michael Ansara, Walter Sande, Roy Barcroft, Slim Pickens and Dorothy Ford. No producer was credited. (GRAND)

▽Flamboyant showman-producer Michael Todd's **Around The World In 80 Days** took almost three hours to wend its star-studded but unscintillating way towards the best part of the picture, the witty end credit titles by Saul Bass. Among the 44 stars making cameo appearances were (in alphabetical order) Charles Boyer, Joe E. Brown, Martine Carol, John Carradine, Charles Coburn, Ronald Colman, Noel Coward, Andy Devine, Marlene Dietrich (2nd right), Fernandel, John Gielgud, Hermione Gingold, Jose Greco, Cedric Hardwicke, Trevor Howard, Glynis Johns, Buster Keaton, Bea Lillie, Peter Lorre, John Mills, Robert Morley, Jack Oakie, George Raft, Gilbert Roland, Cesar Romero, Frank Sinatra (right) and Red Skelton. Like the Jules Verne novel on which it was based, James Poe, John Farrow and S.J. Perelman's screenplay concerned the attempt of Victorian gentleman Phileas Fogg (an impeccable David Niven, 2nd left) to win a bet with the members of his club that he can do what the title suggests. Travelling with his valet Passepartout (Cantinflas, Mexico's favourite comedian, left), he is followed by a suspicious Inspector Fix (Robert Newton in his last role), and takes along Indian Princess Aouda (Shirley MacLaine) after rescuing her from a pyre. Some of the incessant shots of boats and trains were shot around the world in 70 mm Todd-AO and Eastman Color, while others were filmed on a variety of Hollywood backlots. Michael Anderson (Oscar-nominated) directed this multimillion dollar box-ofice blockbuster which won five Academy awards. (MICHAEL TODD)

▷**The Killer Is Loose** provided a nail-biting time. The plot featured a psychopath (Wendell Corey) whose wife was accidentally killed when detective Joseph Cotten (centre) captured him. Now, he has broken out of jail with the intention of bumping off Cotten's wife (Rhonda Fleming, right). A dragnet is put out. Will they get to Corey before he gets to the lovely Rhonda? Director Budd Boetticher kept up the tension despite the familiar ingredients and predictable outcome of Harold Medford's screenplay (story by John and Ward Hawkins). Alan Hale Jr, Michael Pate, Virginia Christine, John Larch, John Beradino and Paul Bryar took other roles in Robert L. Jacks' production. (CROWN)

△The caveat at the start of **Foreign Intrigue** – 'This is a story of today, that began yesterday and will end tomorrow' – was meant metaphorically, but the 100 minutes of the picture seemed literally as long. Despite the attractive European locations, shot in Eastman Color, and the Pierre Balmain costumes, Sheldon Reynolds' production turned out to be a third-rate *Third Man*. Reynolds' conventional direction and screenplay (story by himself, Harold Jack Bloom and Gene Levitt) followed a soporific Robert Mitchum (left) from the Riviera, to Stockholm and Vienna, in an attempt to uncover the past of a millionaire client of his press agency, who has mysteriously died. Along the way Mitchum gets romantically entangled with Swedish blonde Ingrid Thulin (billed as Tulean for her first American film), and French brunette Genevieve Page (also making her US film debut). Others in the cast of mixed nationality and quality were Frederick O'Brady (on bed), Eugene Deckers, Inge Tidblad, John Padovano, Frederick Shrecker, Lauritz Falk and Peter Copley. (SHELDON REYNOLDS)

▽'We'll never make it,' says Jane Greer as she stumbles through a steamy Mexican jungle in **Run For The Sun**. 'We've got to make it,' replies Richard Widmark, pulling her along. Pity producer Harry Tatelman and director Roy Boulting felt the same need to remake *The Most Dangerous Game* (GB: *The Hounds Of Zaroff*, RKO, 1932) and *Game Of Death* (RKO, 1946). This time round, in Technicolor and Super-Scope, screenwriters Boulting and Dudley Nichols updated the Richard Connell short story by making the heavy, Trevor Howard (left), a British traitor hiding out in the jungle with Nazi war criminals Peter Van Eyck (right) and Carlos Henning. Widmark (centre) and Greer accidentally come across their hideout when their plane is forced to land due to lack of fuel. After regaling his guests with anecdotes of the war, and serving a good meal, Howard inhospitably sets the dogs on them when they try to escape. Location-shooting in the heat of Mexico might have been the cause for the sluggish manner in which the film moved. (RUSS-FIELD)

△A man finds himself being strangled in a mirrored room at the start of **Nightmare**. He then kills his assailant with a sharp tool, stuffs the body in a closet and locks it. When he awakens in his hotel room, he finds marks around his throat, and a coat button and key in his hands. The key to this intriguing mystery was only found towards the end of the Howard Pine-William Thomas production. Director Maxwell Shane, who adapted the screenplay from Cornell Woolrich's novel, kept the movie strangely compelling, despite the interruption of some inadequate big band numbers, and a rather preposterous denouement. Kevin McCarthy (right) was the jazz musician suffering the all-too-realistic nightmare, and riveting Edward G. Robinson (left) played his sceptical detective brother-in-law. Connie Russell, Virginia Christine, Gage Clarke, Rhys Williams, Marian Carr, Barry Atwater, Meade 'Lux' Lewis and Billy May and his orchestra, completed the cast. The movie was a remake of *Fear In The Night* (1947), which had also been directed and written by Maxwell Shane. (PINE-THOMAS-SHANE)

▷Hollywood's short-lived infatuation with re-making television plays that began with *Marty* (1955), continued with **Patterns** (GB: **Patterns Of Power**). Apart from Van Heflin (illustrated) in the lead, the film had virtually the same cast, the same director, Fielder Cook, the same writer, Rod Serling, and the same wallop that it packed on the small screen. Basically, it was a tense big business drama about the conflicts among executives in a corporation run by Everett Sloane, the ruthless president. Ed Begley gave a bravura performance as the man replaced by Heflin and driven to his death by Sloane. Beatrice Straight, Elizabeth Wilson (illustrated), Joanna Roos, Elene Kiamos, Shirley Stanlee, Ronnie Welsh Jr, Sally Gracie and Adrienne Moore all brought sterling support to Michael Myerberg's production. (MICHAEL MYERBERG-JED HARRIS)

△Rory Calhoun (illustrated), the peripatetic hero of **Flight To Hong Kong**, popped up in Tangiers, Macao, Honolulu and San Francisco, in the course of working for an international crime syndicate based in Hong Kong where he deals in stolen goods. Girlfriend Dolores Donlon wants him to go straight, but novelist Barbara Rush (illustrated) likes him just the crooked way he is. You see, she's using him as copy for a book she is writing. Finally, he double-crosses his bosses, and returns to good girl Donlon. Being a cheapie, most of the exotic locales were seen in stock shots or back projection, but producer-director Joseph M. Newman didn't linger anywhere long enough for audiences to question the inconsistencies of the Leo Townsend-Edward G. O'Callaghan script (story by Newman, O'Callaghan and Gustave Field). The supporting cast included Soo Yong, Pat Conway, Mel Welles, Werner Klemperer, Paul Picerni and Rhodes Reason. (SABRE)

▷Sharks were the real stars of **The Sharkfighters**, a pre-*Jaws* adventure, shot in Technicolor and CinemaScope. Laurence Roman and John Robinson's screenplay (story Jo and Art Napoleon) set the action off the coast of Cuba during World War II, where Victor Mature (illustrated) leads a group of Navy scientists researching a shark repellent to save the lives of flyers forced into the sea. The creatures have already gobbled up an expendable native assistant (Rafael Campos) when Mature offers himself as shark bait, covered in a new formula derived from octopus ink. Naturally, they find Mature pretty repellent, displaying better taste than is usually attributed to sharks. James Olson, Philip Coolidge, Claude Akins, George Neise and Nathan Yates were other helpers, while Karen Steele, as Mature's wife, paced up and down in Havana. Jerry Hopper's flabby direction picked up whenever the man-eaters entered the Sam Goldwyn Jr Production. (FORMOSA)

◁Hugh O'Brian (illustrated), star of the long-running *Wyatt Earp* TV series (1955–1961), was the impassive hero of **The Brass Legend**, an engrossing oater with director Gerd Oswald firmly in the saddle. A moral dilemma faced Sheriff O'Brian at the centre of Don Martin's screenplay (story by George Zuckerman and Jess Arnold): When the young brother (Donald MacDonald) of his fiancee (Nancy Gates, illustrated) reports that he has seen a dangerous wanted man (Raymond Burr), the sheriff arrests the villain, keeping quiet about the boy's part in the capture in order to protect him from retribution. However, O'Brian is accused of not wanting to share the glory or the reward with the boy, and the story is spread in the local paper. As a result, the boy is shot at and wounded. In a climactic duel, the sheriff overcomes four gunmen. Reba Tassell, Bob Burton, Eddie Firestone, Willard Sage, Stacy Harris and Norman Leavitt had other roles in Herman Cohen's production. (BOB GOLDSTEIN)

▽The life of **Alexander The Great** was a relatively short one, but Robert Rossen's dour epic took 141 minutes to recount it. Shot on location in Spain in CinemaScope and Technicolor, the picture had Richard Burton (right), in a blonde wig and Grecian battle dress, making long speeches and throwing himself into battle after battle until he becomes conqueror of the known world. But the all-powerful Rossen, who wrote, produced and directed, plainly wanted to have his beefcake and eat it, too. At one moment the screen was filled with spectacular fighting, and the next, the characters stood around reflecting on the nature of glory. Alexander's parents, Philip of Macedonia and Olympias, were played by Fredric March (centre) and Danielle Darrieux; Claire Bloom languished as the warrior's wife, and Barry Jones philosophized as Aristotle. Drawn from the top rank of British actors, Harry Andrews (Darius), Michael Horden (Demosthenes), Peter Cushing, Stanley Baker and Niall MacGinnis (left) hid behind beards. Unlike the film's hero, it failed to conquer. (ROBERT ROSSEN)

△As star and producer of **Johnny Concho**, Frank Sinatra (illustrated) continued to display his versatility by stepping directly from *High Society* (MGM, 1956) into *High Noon* territory. He played a skinny, cowardly bully protected by his notorious gunman brother. But his easy life in Cripple Creek comes to an end when two outlaws, William Conrad and Christopher Dark, arrive, inform him they have killed his brother, and take over the town. Sinatra flees with barroom gal Phyllis Kirk but, realizing he can never live with himself, returns to face the gunmen. He is wounded, but the townspeople, led by pistol-packin' parson Keenan Wynn, finish the baddies off. Wallace Ford, Dorothy Adams, Howard Petrie, Harry Bartell, Dan Russ, Robert Osterloh and John Qualen were others celebrating the triumph of good over evil. Alas, Don McGuire's lumbering direction and David P. Harmon's pseudo-psychological story and screenplay were both triumphs of mediocrity over good. (KENT)

▽Bud Abbott and Lou Costello, the vastly popular comedy duo of the 40s and early 50s, finally split up after **Dance With Me Henry**, proving that all bad things must come to an end. This dismal comedy, directed by Charles Barton, contained hoary cracks like, 'You're forcing me to be frank.' – 'I'm not forcing you to be anybody.' Devery Freeman's script (story William Kozlenko and Leslie Kardos) started in a naively sentimental manner with social worker Mary Wickes threatening to take a group of orphaned children away from Lou (centre) who, with Bud, runs an amusement park called Kiddieland for the kids' pleasure. The picture then reverted to unfunny slapstick routines when gangster Ted de Corsia and his henchmen try to recover money hidden in the park and are set upon by hordes of children. Bob Goldstein's Kiddyland production also cast Gigi Perreau (left), Rusty Hamer (right), Ron Hargrave, Sherry Alberoni, Frank Wilcox and Richard Reeves. (ABBOTT AND COSTELLO)

△**Timetable** was tense and terse for most of the time, before deteriorating into a routine cops 'n' robbers yarn. But Mark Stevens (illustrated), the picture's producer, director and star, did a competent job on Aben Kandel's script (story Robert Angus) about a meticulously timed $500,000 train theft. Naturally, the plan, organized by insurance investigator Stevens, misfires. When he tries to double-cross his partners in crime, he is shot down by his chief accomplice, railway policeman King Calder. Wife Marianne Stewart and mistress Felicia Farr (Jack Lemmon's wife making her film debut) were the women in Stevens' life. Wesley Addy, Alan Reed, Rudolfo Hoyos Jr, John Marley and Jack Klugman took other roles. (MARK STEVENS)

▽John Payne (left) almost obliterated the memory of his glamorous and dashing song 'n dance days at Fox in the 40s, by his portrayal of **The Boss**, a ruthless and corrupt politician. Payne, who co-produced with Frank N. Seltzer, and co-wrote with Ben Perry, played a small town politician who, after World War I, ascends to having virtually complete control over a mid-western state with the help of a crooked lawyer (William Bishop, right) and a gangster (Robin Morse). Meanwhile, his private life has become a fiasco. Rejected by a suitably attractive nice girl (Doe Avedon, centre), he marries a pathetic and plain one (Gloria McGhee) on the rebound. Neither the marriage, nor crime succeeds in the end. Byron Haskin's efficient direction allowed Payne to give an impressive performance. Good support came from Roy Roberts, Rhys Williams, Gil Lamb, Joe Flynn, Bill Phipps, Bob Morgan and Alex Fraser. (FRANK N. SELTZER)

△The scenery in **Storm Fear** might have been mountainous, but Cornel Wilde's direction and Horton Foote's script (from the Clinton Seeley novel) was pretty flat. Wilde (left), who also produced, starred as one of three fugitives from justice who find refuge in the mountain home of his ex-girlfriend Jean Wallace (the real-life Mrs Wilde), now unhappily married to his brother, sneaky Dan Duryea. Wilde's two companions are Steven Hill (right), a psychopathic killer, and Lee Grant, a gangster's moll. Wallace's young son (David Stollery) agrees to guide them onto an escape route. Duryea dies in a snowdrift while trying to contact the police, Grant falls over a cliff, Hill is shot by Wilde, and Wilde is shot by hired hand Dennis Weaver. Some good performances and location shooting prevented the picture from sinking completely. (THEODORA)

▽Because of the promise shown by Stanley Kubrick with *Killer's Kiss* (1955), UA itself agreed to invest $200,000 in **The Killing**, with a proviso that a well-known actor was cast, and that they would have a final say on the screenplay. Sterling Hayden (illustrated) was given the lead, and the script by Kubrick and Jim Thompson, based on the novel *Clean Break* by Lionel White, was given the okay. The first class thriller which emerged, earning more than its money back, justified UA's confidence in Kubrick. Cleverly structured to recount the same day from the viewpoint of various characters, the picture told of a $2 million racetrack heist meticulously organized by ex-con Hayden. Those involved are the racetrack cashier Elisha Cook Jr, crooked cop Ted de Corsia, former alcoholic Jay C. Flippen, hired gunman Timothy Carey, barman Joe Sawyer, and wrestler Kola Kwarian. Everything goes like clockwork, but the gang failed to reckon on Cook Jr's sexy wife, Marie Windsor, spilling the beans to her gangster lover Vince Edwards, who steps in after the robbery. The use of realistic locales, the punchy script, the performances, especially those of Windsor and Cook Jr in a sado-masochistic relationship, demonstrated that a new director of quality had arrived. James B. Harris produced, and Colleen Gray (illustrated), Jay Adler, Joe Turkel and James Edwards were also cast. (HARRIS-KUBRICK)

△Bravely keeping alive the swashbuckling tradition of Douglas Fairbanks and Errol Flynn, Cornel Wilde duelled admirably through **Star Of India**, an entertaining and thoroughly unoriginal Technicolor Raymond Stross production. No need for anything new when director Arthur Lubin provided plenty of swordplay, gorgeous costumes, and a background of castles, manors and landscape filmed on location in Europe. Herbert Dalmas delivered a screenplay set in 17th-century France and concerning the theft of a famed Indian jewel from a Dutch collection which has been spirited to France. On its trail is beautiful blonde Dutch agent Jean Wallace (Mrs Cornel Wilde, illustrated), who is led to the court of King Louis XIV (Basil Sydney) and his mistress Madame de Montespan (Yvonne Sanson). The villain of the piece was evil French count Herbert Lom who purloined the jewel, but he is outwitted and killed by French nobleman Wilde (illustrated) in the end. John Slater, Walter Rilla and Arnold Bell were also cast. (RAYMOND STROSS)

△**The Broken Star** was a workmanlike oater which neatly had Bill Williams' (right) investigation of the robbery and murder of a Mexican, leading to his best friend, fellow deputy Howard Duff (left). Attempting to escape, Duff is shot dead by his buddy. Curly-haired Williams is helped in his quest for the truth by dancehall singer Lita Baron, and marshal Addison Richards. Also involved were Henry Calvin, Douglas Fowley, Joel Ashley, John Pickard, William Phillips and Dorothy Adams. John C. Higgins' screenplay gave director Lesley Selander opportunities for action and suspense, if only on a modest scale, in Howard W. Koch's production. (BEL-AIR)

△**The Black Sleep** (aka **Dr Cadman's Secret**) was a last-gasp example of the type of horror movie popular in the 30s and 40s. Basil Rathbone (centre), an old hand at this type of grisly material, played a brain surgeon in foggy Victorian England. In order to find a way of curing his dying wife's brain tumour, he carries out experiments on human guinea pigs in a deserted abbey. As a result his cellars are full of gibbering mutants, ruled over by an eye-rolling John Carradine. Also in his employ are horrifying hunk Lon Chaney Jr, Bela Lugosi (who died in the year of the film's release) as a mute butler, and Akim Tamiroff, who supplies the mad doctor with victims. When Rathbone's former student, Herbert Rudley (right), finds out the truth, he rescues Nurse Patricia Blake (left), and the monsters turn on their master. Reginald Le Borg directed John C. Higgins' script with a straight face, but audiences found it rib-tickling. Also in the Howard W. Koch production were Phyllis Stanley (on bed), Tor Johnson, Sally Yarnell and Claire Carleton. (BEL-AIR)

▷Subtitles might have helped non-jive audiences at **The Wild Party** in which most of the characters spoke in hepcat slang. 'When you think back, you think black,' was one of the more intelligible lines in John McPartland's screenplay, punctuated by a loud Buddy Bregman jazz score. The accompanying crime melo plot concerned a group of layabouts who kidnap a naval officer and his fiancee to extort money from the man by threatening the girl. The gang consisted of Anthony Quinn (illustrated), a bitter ex-football player, Nehemiah Persoff, an unemployed pianist, Jay Robinson, a sadistic petty hoodlum, and Kathryn Grant (soon to be Mrs Bing Crosby, illustrated), a lonely girl. Their victims were Arthur Franz and Carol Ohmart. Paul Stewart was also in the Sidney Harmon production. Director Harry Horner's attempt to give the movie a dreamlike atmosphere didn't pay off and only made it more confusing. Other pictures with the same title, but completely different plots were made by Paramount in 1929, and James Ivory in 1975. (SECURITY)

◁According to the opening of **Comanche**, 'the facts and characters actually portray history.' True or false, producer Carl Krueger's screenplay, and George Sherman's direction seemed to stick fairly closely to the fiction formula of many a Hollywood Western. All the elements were there: a frontier scout (Dana Andrews, right) who wants the Indians to get a square deal and the bigoted white soldier (John Litel) who wants to wipe them out; the Indian chief (Kent Smith, left) who wants peace and his troublesome aide (Henry Brandon) who wants war; the hero's comic sidekick (Nestor Paiva) and a beautiful Mexican lady (Linda Cristal) to provide the love interest. At the end, to quote Oscar Wilde, 'the good end happily and the bad unhappily. That's what fiction means.' Other roles in this attractive CinemaScope-De Luxe Color picture went to Reed Sherman, Stacy Harris, Lowell Gilmore and Mike Mazurki. (CARL KRUEGER)

△Gina Lollobrigida, in a spangled costume, was the lovely bone of contention between circus performers Burt Lancaster (right) and Tony Curtis (left), on the ground and in the air, in **Trapeze**, a sawdust and tinsel epic shot almost entirely in the Cirque d'Hiver in Paris. Director Carol Reed caught its atmosphere in CinemaScope and De Luxe Color, and there was some exciting aerial camerawork by Robert Krasker. Not so high-flying was the musty script and story by James R. Webb and Liam O'Brien, with which even the talented trio of stars could do little. Curtis was the daring young man who learns the perilous triple somersault from Lancaster, the once brilliant, now crippled aerial artist. The climax comes when Lancaster plays 'catcher' to his love rival Curtis, who is about to do the triple without a safety net. Katy Jurado, Thomas Gomez, Johnny Puleo, Minor Watson, Gerard Landry, Sidney James and a variety of colourful and entertaining circus acts made up the cast. The James Hill production pulled in vast crowds. (HECHT-LANCASTER)

◁Regiscope was a new animation process introduced in **The Beast Of Hollow Mountain** to create, it was claimed, a prehistoric monster more convincingly than hitherto. Whether the Tyrannosaurus Rex depicted was an authentic reconstruction is debatable, but its arrival in a present-day farming community in Mexico caused havoc among the natives, and was fun for audiences. The fact that Robert Hill adapted his screenplay from a story by Willis O'Brien, the special effects expert on *King Kong* (RKO, 1933), would lead one to expect that something gigantic is making rancher Guy Madison's cattle disappear. One day, he finds his girlfriend (Patricia Medina) being threatened by Mr T. Rex. Madison (left) lures the monster to a swamp and it drowns in the quicksand. Edward Nassour and Ismael Rodriguez directed the picture in CinemaScope and De Luxe Color, on location in Mexico. Eduardo Noriega (right), Carlos Rivas, Mario Navarro and Julio Villareal also appeared in William and Edward Nassour's production. (NASSOUR-PILICULAS RODRIGUEZ)

◁Clark Gable, known as 'The King', traded on his past glory in **The King And Four Queens**, a Western as jaded as its star. Yet he still added much-needed charm to the cynical screenplay by Margaret Fitts and Richard Allan Simmons (story by the former), and had enough sex-appeal left to make credible the attraction the four 'queens' of the title feel for him. Mind you, there was no other man for miles around. Gable (illustrated) comes across the girls when he rides into a ghost town on the trail of gold hidden somewhere on the ranch of sharpshooting Jo Van Fleet, who lives with her four daughters-in-law: cool schemer Eleanor Parker (illustrated), big and brassy chorus girl Barbara Nichols, sexy, unscrupulous Jean Willes, and naive Sara Shane. Gable finds the loot and rides away with Parker. Roy Roberts, Jay C. Flippen and Arthur Shields completed the cast of David Hempstead's production, shot in CinemaScope and De Luxe Color. It was the second, and weakest, of three movies in a row that Gable made with director Raoul Walsh. (The other two were *The Tall Men*, 20th Century-Fox, 1955, and *Band Of Angels*, WB, 1957). (RUSS-FIELD-GABCO)

△But for the fact that Stirling Silliphant is such a singular name, it was difficult to believe that the screenwriter of **Huk** and the Oscar-winning writer of *In The Heat Of The Night* (1967) were one and the same man. This early effort, based on his own novel, had a fair share of the clichéd dialogue and situations found in Hollywood adventures of this type. It told of George Montgomery's effort to defend his rice and sugar plantation in the Philippines from attacks by the Huks, a guerrilla army led by the vicious Kalak (Ramio Barri). The blood-and-thunder climax featured a battle in which Montgomery (illustrated foreground), his friend (John Baer) and others save a boatload of women and children from the Huks, with Baer getting killed in the process. After victory, the hero goes back to his farm with Baer's widow (Mona Freeman, illustrated). James Bell, Teddy Benavedes and Ben Perez had other roles in Collier Young's production. John Barnwell directed this hokum, shot on location in Eastman Color. (COLLIER YOUNG)

△No wonder the US Defence Department declined to co-operate on Robert Aldrich's production **Attack!**. Few punches were pulled in the director's bleak depiction of the attitude of certain officers during World War II. The main targets of scorn in James Poe's screenplay (from the play *Fragile Fox* by Norman Brooks) were Eddie Albert's cowardly captain, and Lee Marvin's conniving colonel. Due to Albert's craven behaviour, a small platoon, diligently led by Lieutenant Jack Palance (illustrated), has to fight its way back from the frontline where it has been stranded without cover, resulting in the loss of many men. Marvin, who hopes for favours from the captain's father back home, refuses to condemn Albert. Palance returns to get Albert, who dies from the bullets of his own company. The all-male cast was completed by Robert Strauss, Richard Jaeckel, Buddy Ebsen, William Smithers, Jon Shepodd, Jimmy Goodwin, Steve Geray, Peter Van Eyck and Strother Martin. Although a bold film to make in the Eisenhower era, Aldrich overplayed his hand by resorting to frenzied melodrama when Eddie Albert has a mental breakdown, and Jack Palance becomes an avenging monster. (ASSOCIATES AND ALDRICH)

△Big burly Anthony Quinn (illustrated) gave one of his 'noble savage' performances in **Man From Del Rio**, a Western with the usual dose of barroom brawls, drinking, and gun fighting. Harry Horner's direction and Richard Carr's story and screenplay promised more originality at the start than they delivered. Quinn, a Mexican hobo, is asked by Peter Whitney, a villainous saloon keeper, to help him control the town. But Quinn, relying mostly on bluff, becomes sheriff and eventually rids the place of Whitney, as well as three outlaws that threaten it. Opposite the fervent Quinn was the fiery Katy Jurado, far too spicy a combination to swallow. Producer Robert L. Jacks also utilized the services of Douglas Fowley, John Larch, Whit Bissell, Douglas Spencer, Guinn 'Big Boy' Williams and Marc Hamilton. (ROBERT L. JACKS)

1956 OTHER RELEASES

Crime Against Joe
A young, unsuccessful artist goes on a binge, only to wake up next morning to find he is being accused of murdering a girl he met the night before. John Bromfield, Julie London, Henry Calvin, Patricia Blake, Joel Ashley, John Pickard. *Dir* Lee Sholem. *Pro* Howard W. Koch. BEL-AIR

Emergency Hospital
Various cases dealt with in one night at a hospital. Margaret Lindsay, Walter Reed, Byron Palmer, Rita Johnson, John Archer, Jim Stapleton. *Dir* Lee Sholem. *Pro* Howard W. Koch. BEL-AIR

Ghost Town
A party of stage coach passengers are forced to spend the night in a ghost town after being attacked by Cheyenne indians. Kent Taylor, John Smith, Marian Carr, John Doucette, Serena Sande, William Phillips. *Dir* Allen Miner. *Pro* Howard W. Koch. BEL-AIR

Gun The Man Down (aka **Arizona Mission**)
An outlaw seeks revenge on his old associates and his former sweetheart who abandoned him when he was wounded after a bank robbery. James Arness, Angie Dickinson, Robert Wilde, Emile Meyer, Don Megowan. *Dir* Andrew V. McLaglen. *Pro* Robert E. Morrison. BATJAC

Hot Cars
An unwitting car salesman is tricked into joining a gang operating a stolen car racket. John Bromfield, Joi Lansing, Mark Dana, Carol Shannon, Ralph Clanton, Robert Osterloh. *Dir* Donald McDougall. *Pro* Howard W. Koch. BEL-AIR

Manfish (GB: **Calypso**)
Three men in pursuit of buried treasure in the West Indies, start to argue among themselves. John Bromfield, Lon Chaney Jr, Victor Jory, Barbara Nicholson, Tessa Prendergast, Eric Coverly. *Dir* & *Pro* W. Lee Wilder. De Luxe Color. WILDER

The Peacemaker
A gunfighter turned preacher brings peace to a community where the farmers and ranchers are warring. James Mitchell, Rosemarie Bowe, Jan Merlin, Jess Barker, Hugh Sanders. *Dir* Ted Post. *Pro* Hal. R. Makelim. HAL R. MAKELIM

Running Target
A hunt takes place for escaped convicts, on the run in the scenic Colorado Rockies. Arthur Franz, Doris Dowling, Richard Reeves, Myron Healy, James Parnell. *Dir* Marvin R. Weinstein. *Pro* Jack C. Couffer. De Luxe Color. COUFFER

Three Bad Sisters
A pilot gets involved with the daughters of a multi-millionaire, one of them wanting to get rid of her sisters so she can inherit the entire fortune. John Bromfield, Marla English, Kathleen Hughes, Sara Shane, Jess Barker, Madge Kennedy. *Dir* Gilbert L. Kay. *Pro* Howard W. Koch. BEL-AIR

▷Almost the whole of **Twelve Angry Men** took place in a jury room where the jury are considering whether a slum kid was guilty of knifing his father. It is a hot day, and the bored men are all ready to convict and go home, except for one of their number, who has a reasonable doubt. Henry Fonda (foreground left) was the only good man and true, who gradually persuades his fellow jurors, one by one, to return a verdict of not guilty. Playing the other eleven were Lee J. Cobb (foreground, centre right), E.G. Marshall (seated left), Jack Warden (background in hat), Ed Begley (standing right of centre), Martin Balsam (seated right), John Fiedler (standing centre), Jack Klugman (seated left behind Marshall), George Voskovec (standing right), Robert Webber, Edward Binns (standing, background left) and Joseph Sweeney. Much pleasure was derived from watching each showy actor do his turn, with Fonda an excellent representative of the liberal conscience at the film's centre. Few changes were made for the cinema by Reginald Rose from his own expertly contrived TV play, or by Sidney Lumet, who had directed it. Lumet, making his first cinema feature, shot it in 20 days, creating an intimate claustrophobic atmosphere. Today, it is only dated by the all-white, all-male jury. Fonda and Rose produced this unexpected hit movie, nominated for three Oscars – Best Picture, Best Director and Best Screenplay. (ORION-NOVA)

▷**Bailout At 43,000** landed with a dull thud. Producers Howard Pine and William Thomas obviously thought it enough to show pilots continually jumping out of planes in between a hackneyed story. John Payne (right) looking worried throughout, joins a team testing an ejection seat for jet bombers. When his colleague, Eddie Firestone, breaks his neck testing it, Payne loses his nerve. Karen Steele, his wife, goes to Paul Kelly (left), the fatherly colonel, and tells him her husband is not fit to jump. But Payne has to prove he's a hero in the eyes of his son, Richard Eyer. Paul Monash's script resolved it in the most predictable way, and director Francis D. Lyon depended heavily on the aerial photography to lift the picture. Also in the cast were Constance Ford, Gregory Gaye, Adam Kennedy, Steven Ritch and Richard Crane. (PINE-THOMAS-SHANE)

◁**The Monte Carlo Story** was a vain attempt to recapture the charm of romantic comedies of the 30s, such as Ernst Lubitsch's *Monte Carlo* (Paramount, 1930). Gorgeous Riviera locations shot in Technirama and Technicolor, and the attractive (though ageing) Marlene Dietrich and Vittorio de Sica in the leads (both illustrated), could not bring enough glitter to Samuel Taylor's dull direction and script (from a story by the producer Marcello Girosi, and Dino Risi). Marlene, as the Marquise Maria de Crevecouer, and Vittorio, as Count Dino della Fiaba, are both penniless gamblers who confer mutual favours, each believing the other possesses a fortune. When they discover the truth, they pose as brother and sister, turning their attention on wealthy American tourist Arthur O'Connell. But the two con artists end up together at the roulette tables. Natalie Trundy, Jane Rose, Clelia Matania, Mischa Auer, Carlo Rizzo and Truman Smith were among the cast of the US-Italian coproduction which lost its gamble. (TITANUS)

▷After a huge amount of ballyhoo, producer-director Otto Preminger's choice for his **Saint Joan**, from thousands of applicants all over the world, fell on Jean Seberg, a 17-year-old school-girl from Iowa who had never acted pro-fessionally in her life. 'I wanted to win. I had to win. Wasn't I Saint Joan's age; didn't I come from a small farming town – and I didn't want to marry the boy next door either!' The result was disastrous, both critically and financially. Al-though Seberg (illustrated) did not have the spiritual and emotional range necessary for the role of George Bernard Shaw's heroine, she did achieve some innocence and pathos. However, the critics burnt her at the stake. More to blame was Preminger's static direction and Graham Greene's uncinematic adaptation of the play, which even placed Shaw's epilogue at the begin-ning to enable a flashback, thus losing much of Shaw's irony. Even the distinguished cast of mainly British actors could not save it. They included Richard Todd (Dunois), Richard Wid-mark (The Dauphin, illustrated), Anton Wal-brook (Bishop of Beauvais), John Gielgud (Earl of Warwick), Felix Aylmer (The Inquisitor), Harry Andrews, Barry Jones, Finlay Currie, Bernard Miles, Patrick Barr, Kenneth Haigh, Archie Duncan, Margot Grahame, Francis De Wolff, Victor Maddern and David Oxley. Other famous Maids on screen both before and after this one, included opera star Geraldine Farrar (1916), Falconetti (1928), Ingrid Bergman (1948) and, in French, Michele Morgan (1954) and Florence Delay (1962). (PREMINGER)

△Ebullient blonde Betty Hutton (illustrated) returned to the screen after five years away, noticeably more subdued than her raucous usual self, for what turned out to be her last role in **Spring Reunion**. The title refers to the Carson High School Class of '41, coming together fifteen years later. Spinster Betty, who works in her father's business, meets Dana Andrews (illustrated) again, once 'the boy most likely to succeed', but who has become a drifter. Encour-aged by her mother, Laura La Plante (the former well-known silent screen star also in her final film), Betty leaves her possessive father, Robert Simon, and goes off with the attractive Andrews to start a new life. Robert Pirosh's direction and screenplay (story by Alan Arthur) was given a lift in the earlier scenes by other visiting alumni Jean Hagen, Gordon Jones and Sara Berner, but then fell into routine romantic fare. James Gleason, Irene Ryan, Richard Shannon, Ken Curtis and Herbert Anderson also appeared in the Jerry Bresler production. (BRYNA)

▽In **Valerie**, tall, voluptuous, Swedish sex-symbol Anita Ekberg (illustrated) found herself in a curious romantic melodrama with a Western setting and a flashback technique, skilfully em-ployed by director Gerd Oswald, in which the contradicting points of view of each of the principal witnesses at a trial are seen. It was, in fact, virtually the only interest in Leonard Heiderman and Emmett Murphy's screenplay. On trial was Sterling Hayden, a respected rancher and Civil War hero, charged with the murder of his parents-in-law (John Wengraf and Iphigenie Castiglioni), and with wounding his wife (Ekberg). Through the various testimonies, among them that of the defendant's brother (Peter Walker), and the minister (Anthony Steel, Ekberg's real-life husband, illustrated), a Jekyll and Hyde picture is built up of a man and his accomplice (Jerry Barclay). At the contrived climax, Hayden was shot down while trying to escape. Producer Hal R. Makelim's endeavours escaped most people's notice. (HAL R. MAKELIM)

▷The team of producer Harold Hecht, director Delbert Mann, and writer Paddy Chayefsky, followed up *Marty* (1955) with **The Bachelor Party**, also based on a Chayefsky TV play. Although the returns were not as good as the previous picture, it was as good a film. Set in a cheerless New York at night (fine camerawork by Joseph LaShelle), it followed the attempts of five office workers to enjoy the last night of bachelorhood of one of their number. They do a round of tatty bars and nightclubs, gatecrash a Greenwich Village party, and watch a blue movie (which we don't see). But instead of having a good time, their problems become highlighted. Don Murray (left) learns that his wife is going to have a baby he can ill afford to support; E.G. Marshall has bad asthma and will die unless he leaves the city; Larry Blyden (right) has ruined his marriage by his adulteries; Philip Abbott, the groom-to-be, is a virgin and terrified of sex; and Jack Warden (centre) is unmarried but ends up lonelier and sadder than the others. The somewhat heavily underlined message was that marriage is depressing, but it is better than being miserable alone. Each of the men gave impressive performances, as did the women: Patricia Smith, the pregnant wife, Nancy Marchand, Karen Norris, Barbara Ames, Norma Arden Campbell, and Carolyn Jones – Oscar-nominated for her supporting role as a love-starved, garrulous kook. (HECHT-HILL-LANCASTER)

▽Screenwriters George W. George and George F. Slavin seemed to have derived their heavy script for the Western **The Halliday Brand**, more from the reading of Freud than Zane Grey. But director Joseph H. Lewis made it into a gripping family drama with strong performances from a good cast. The head of the dynastic Hallidays is Big Dan (Ward Bond, centre), wealthy rancher and sheriff of a small community. Prejudiced against Indians, he deliberately allows a crowd to lynch the half-breed Jivaro (Christopher Dark) who is in love with his daughter Martha (Betsy Blair). This causes a rift between him and his elder son Daniel (Joseph Cotten, right), who comforts Jivaro's white father (Jay C. Flippen, on ground) and sister (Viveca Lindfors). In the final father-son confrontation, Big Dan collapses and dies while his younger son (Bill Williams, left) watches. Collier Young produced. (COLLIER YOUNG ASSOCIATES)

▷**Five Steps To Danger** was one step from disaster. Betraying its origins as a serial in *The Saturday Evening Post* by Donald Hamilton, producer Henry S. Kesler's screenplay (story by Hamilton, and Turnley Walker) was as muddled as it was mundane. Caught up in the mysterious goings-on were Ruth Roman (left), who has a secret code engraved on a mirror passed on to her by her murdered scientist brother in East Berlin; Sterling Hayden (centre), an engineer whom Roman picks up on the highway; and Werner Klemperer (conductor Otto's son), a spy pretending to be a scientist working for the Allies. The latter commits Miss Roman to a mental institution to prevent her delivering the code to the FBI, but she escapes with the help of Hayden, and exposes the Cold War villain. Other spies, intelligence experts and cops were played by Richard Gaines (right), Charles Davis, Jeanne Cooper, Peter Hansen, Carl Lindt and John Merrick. Henry S. Kesler's direction failed to clarify the proceedings. (GRAND)

▽Former Tarzan Lex Barker (left) bared his chest again as an Apache chief in **War Drums**, proving once more that he had an abundance of muscle but little talent. However, Howard W. Koch's production in De Luxe Color, survived the performances of Barker and Joan Taylor (centre) as the Mexican girl he marries. Due to the unusually feminist and pro-Indian screenplay by Gerald Drayson Adams, and the firm direction by Reginald Le Borg, it was a better-than-average Western in which a chief marries outside his tribe and has to prove himself in a combat to the death. After the marriage, the bride refuses to be just another squaw. He, therefore, trains her to be a warrior and ride by his side in the fight against white oppression. Also in it were Ben Johnson (right), Larry Chance, Richard Cutting, James Parnell, John Pickard, John Colicos, Tom Monroe and Stuart Whitman. (BEL-AIR)

△$5 million was spent on Stanley Kramer's production of **The Pride And The Passion**, a few cents of which could have been spent on a pair of scissors and a red pencil. The sprawling 130-minute epic, flatly directed by the producer, contained empty rhetorical dialogue by Edna and Edward Anhalt, mouthed unhappily by a miscast trio of stars – Cary Grant (right), Frank Sinatra (left) and Sophia Loren (2nd right). Grant was Captain Anthony Trumbull, a British naval officer sent to Spain in 1810 to retrieve a huge cannon abandoned by the Spanish army, for use by the British against Napoleon's army. Sinatra, sporting dark curls and speaking broken English, played Miguel, a guerilla leader who wants the gun to attack the French garrison at Avila. Loren came along to provide a triangular romance as they trundle the cannon endlessly across Spain and attack the city. Others noticeable in the cast of thousands were Theodore Bikel, John Wengraf, Jay Novello, Jose Nieto, Carlos Narranaga and Philip Van Zandt. The cannon, which provided the title of C.S. Forester's novel *The Gun* on which the film was based, was far more interesting than any of the cliched characters. The spectacle, which earned more than its money back, was enhanced by Technicolor and VistaVision. (STANLEY KRAMER)

△**The Ride Back** was a low-cost Western of the long trek variety, which explored the relationship between the hunter and the hunted. The latter was Anthony Quinn, wanted for murder and tracked down by law enforcement officer William Conrad to a small Mexican village. On the way back to base, they come across a little girl speechless since Indians killed her family. The three of them continue en route, until Conrad is wounded by Apaches. Quinn (illustrated) leaves him and the girl, returns with help, and is guaranteed leniency at his trial. Screenwriter Anthony Ellis was guilty of verbosity, and director Allen H. Miner of lethargy, but Quinn and Conrad (who also produced) brought insight into their characters. Ellen Hope Monroe (the little girl), George Trevino, Lita Milan (illustrated), Victor Millan and Joe Dominguez also appeared. Eddie Albert sang the narrative ballad on the soundtrack. (ALDRICH AND ASSOCIATES)

▷In order to protect **The Outlaw's Son** from his father's bad influence, his aunt pins a crime on the outlaw to keep him out of the way. Ten years later, the 22-year-old son learns of his aunt's action and starts robbing stage coaches with his father's former associates. The father returns to save his son from a life of crime, but dies in the process. Thus the uninspiring content of the Richard Allan Simmons screenplay (from the novel *Gambling Man* by Clinton Adams), directed with smooth efficiency by Lesley Selander for producer Howard W. Koch. Dane Clark (left, in his last movie for 13 years) was appropriately dour as the father, Ellen Drew (in her final film, centre) was good as the protective aunt, and Joseph Stafford (right, aged 12) and Ben Cooper (aged 22) played the title role touchingly. Charles Watts, Lori Nelson, Cecile Rogers, Eddie Foy III, John Pickard, Robert Knapp and Les Mitchell took secondary roles in this no more than secondary movie. (BEL-AIR)

▽American-born British director Alexander MacKendrick's first film in the country of his birth, **Sweet Smell Of Success**, was a brilliant, vitriolic view of the New York publicity world. It was also a biting duet played by Burt Lancaster (left) and Tony Curtis (right), the latter a whining clarinet to Lancaster's sombre bassoon, played against the jazzy dazzle of James Wong Howe's black and white images of the city by night. Lancaster as the megalomaniac J.J. Hunsecker, a Walter Winchell-type gossip columnist with steely eyes glinting behind his glasses, had one of his greatest roles playing one of his rare villains. Curtis as Sidney Falco, the cringing, loathsome press agent, gave a compelling per-formance, proving that he wasn't just a pretty face with a pretty awful accent. The screenplay by Clifford Odets and Ernest Lehman (from Lehman's short story), revealed the machina-tions of the columnist, helped by the toadying press agent, particularly his attempts to break up the affair of his sister (Susan Harrison) with a jazz musician (Martin Milner), leading to suicide and murder. Barbara Nichols, Emile Meyer, Jeff Donnell, Edith Atwater and Sam Levene took other parts. Harold Hecht's production proved too uncompromising for the general public on first release, but the picture has deservedly gained in reputation and, over the years, has earned a profit. (HECHT-HILL-LANCASTER)

△Shot on location in Copenhagen, **Hidden Fear** made one wonder if the trip was really necessary. In Andre de Toth and John Ward Hawkins' muddled screenplay, American cop John Payne (right) goes to Denmark in order to help his sister (Natalie Norwick) who is being held for the murder of her partner in a vaudeville act. He makes contact with the dead man's girlfriend (Anne Neyland, centre) and her new elderly American lover (Conrad Nagel, left). These contacts lead to a gang of counterfeiters headed by an ex-German naval officer (Alexander Knox). The dull Danish denouement has Payne catching up with the villain on his yacht, struggling with him in the water, and seeing him drown. Suffering a similar fate at the box-office was the Robert St Aubrey-Howard E. Kohn II production, directed in a sub-Hitchcockian manner by De Toth. Others appearing in it were Elsie Albiin, Paul Erling, Mogens Brandt and Buster Larsen. (ST AUBREY-KOHN)

▽Bulbous-nosed actor Karl Malden's only di-rectorial effort, **Time Limit**, contained many of the pros and cons of his own acting style – powerfully intense but over-emphatic. Apart from three forceful flashbacks, the action in Henry Denker's adaptation from his and Ralph Berkey's stage play, was confined to a military court and headquarters. It concerned the court-martial of a major charged with collaboration with the enemy while a POW in a North Korean prison camp. He admits his guilt, and the testimonies of 14 of his fellow-prisoners seem to confirm it. But the more the investigating colonel probes into the case, the more inconsistencies he discovers. Finally, he proves that the major collaborated to save his men from being shot, after one of their number had given away their escape plans under torture. Richard Widmark (right, who also co-produced with William Rey-nolds) and Richard Basehart as the investigator and defendant respectively, gave gripping per-formances. Others cast included Carl Benton Reid, Dolores Michaels (centre), June Lockhart, Martin Balsam (left) and Rip Torn. (HEATH)

△At first, **The Monster That Challenged The World** seemed rather an innocuous little mol-lusc, but it grew into frightening enough pro-portions to please sci-fi fans. According to Pat Fielder's screenplay (story David Duncan), the creature began life in the Salton Sea, California, where it drained the blood from three men attached to the naval research station there. Tim Holt, an intelligence officer, Hans Conried, head of the lab, and Audrey Dalton (illustrated), the secretary, attempt to stop the monster from laying eggs that could get into the waterways of the earth. Arnold Laven's direction was not world shattering, but it was effective enough to put one off seafood for life. Also looking anxious in the Jules Levey-Arthur Gardner production were Harlan Warde, Casey Adams, Mimi Gibson and Gordon Jones. (GRAMARCY)

△Ageing but baby-faced Mickey Rooney (left) made an explosive **Baby Face Nelson**, alias Lester Gillis, notorious 30s hoodlum, in a tough, low-budget thriller directed by Don Siegel. Screenwriters Irving Shulman and Daniel Mainwaring traced Nelson's rise and fall in gangsterdom from his apprenticeship as gunman for Rocca (Ted de Corsia), his meeting with Dillinger (Leo Gordon, right), his escape from prison aided by his girlfriend (Carolyn Jones), his achieving the position of Public Enemy No 1, and his demise from FBI bullets. The screenplay, however, left audiences uninformed as to his motivations or the Prohibition era. Good support was provided by Cedric Hardwicke, Christopher Dark, Emile Meyer, Anthony Caruso, Jack Elam, John Hoyt, Dan Terranova, Robert Osterloh and Elisha Cook Jr in Al Zimbalist's production. (FRYMAN-ZS)

◁**The Girl In Black Stockings** was an entertaining little whodunnit, efficiently directed by Howard W. Koch, in which the murder victims, who included Mamie Van Doren, were all females. Among the array of suspects to choose from at a chic Utah resort were young lawyer Lex Barker (illustrated); Anne Bancroft (illustrated), the receptionist whom he loves; Ron Randell, the bitter, crippled hotel owner; his devoted sister, Marie Windsor; and has-been actor John Holland. Others in the guest house were Richard Cutting, Gene O'Donnell, Larry Chance, Gerald Frank and Stuart Whitman. John Dehner, the local sheriff, investigated the murders. Caught redhanded, the killer turns out to be ... Clue: Anne Bancroft fled to Broadway after this Aubrey Schenck production. The screenplay by Richard Landau, was adapted from *Wanton Murder* by Peter Godfrey. (BEL-AIR)

◁**Chicago Confidential** was very much of a second-rate thriller although set in America's interesting and impressive second city. The familiar script by Raymond T. Marcus (based on the Jack Lait and Lee Mortimer best-seller) delved into the activities of a crooked gambling syndicate which contrives to have a union chief (Dick Foran) framed for murder because he has refused to co-operate with them. Enter State Attorney Brian Keith (illustrated) who manages to break the syndicate's power as well as proving Foran's innocence. Good location shooting by director Sidney Salkow, helped to give Robert E. Kent's production an authentic look and feel. Beverly Garland (illustrated), Beverly Tyler, Elisha Cook Jr, Paul Langton, Anthony George, Douglas Kennedy, Gavin Gordon and Buddy Lewis were also in it. (PEERLESS)

△**Monkey On My Back**, far from being another *Tarzan* movie, was in the vein of drug addiction pictures opened by *The Man With The Golden Arm* (1955). The screenplay (by Crane Wilbur, Anthony Veiller and Paul Dudley) purported to be the true story (drawn from biographical material supplied by Ivan Bunny) of Barney Ross, world welterweight boxing champ in the 30s, and war hero at Guadalcanal. After being wounded and contracting malaria, Ross was given morphine, and gradually became dependent on drugs. His degradation in civilian life until he was cured, was luridly detailed by director Andre de Toth, although a brief scene showing Ross injecting himself, was later cut in order to obtain a Code Seal from the MPAA. Cameron Mitchell (illustrated) did well to suggest the different aspects of Ross's character, and Diane Foster (illustrated) was pleasing as his understanding wife. Also in it were Paul Richards, Jack Albertson, Barry Kelley, Lisa Golm and Dayton Lummis. Ross, who acted as advisor on the picture, sued UA and producer Edward Small, for damages to his reputation. Ross lost, the box-office gained. (IMPERIAL)

▷**The Big Caper** was a small film set in a small town where a gang plans to rob the bank. The gang consisted of James Gregory (left), the sadistic leader, his moll Mary Costa (right), Robert Harris, a senile arsonist, Corey Allen, a strong-arm man, and Rory Calhoun (centre) a young hood. Calhoun and Costa pose as a married couple running a gas station, who then really fall in love. Gradually, the friendliness of the townsfolk gets to them, so when Gregory plans to blow up the local school to create a diversion, Calhoun stops him in a vicious fight, after which the cops are called. Robert Stevens direction was slow to start and overdramatic to end, but Martin Berkeley's script (story Lionel White) kept it interesting in between. Also employed in the Howard Pine-William Thomas production were Paul Picerni, Louise Arthur, Roxanne Arlen, Pat McVey, James Nolan, Florenz Ames and Roscoe Ates. (PINE-THOMAS)

▽A Western starring Joel McCrea, and containing a secret piano-playing villain called Velvet Clark, couldn't be all bad, although **Gunsight Ridge** came pretty close. McCrea (left) was a Wells Fargo agent who rides the well-worn trail to track down those responsible for the constant stagecoach hold-ups. When the sheriff (Addison Richards) is killed by the masked leader of the bandits, our middle-aged hero finds the aforementioned Velvet (Mark Stevens, right) and shoots him in a traditional showdown. He rides back into town, becomes marshal, and marries the sheriff's daughter (Joan Weldon, centre). Francis D. Lyon's direction brought little life to the scrappy script by Talbot and Elizabeth Jennings. Others in Robert Bassler's production were Darlene Fields, Robert Griffin, Slim Pickens and Carolyn Craig. (LIBRA)

▽Sturdy performances from veteran stars Joel McCrea (left) and Barbara Stanwyck (right), and a miscegenation theme, made **Trooper Hook** more than just another horse opera. Yet, Sol Baer Fielding's production contained many standard ingredients such as an Indian vs Cavalry clash, and a stage coach ambushed by Apaches. On the coach were McCrea, escorting Stanwyck and her small half-breed son (Terry Lawrence, centre) to join her rancher husband (John Dehner). The boy is the son of an Indian chief (Rudolfo Acosta) who had captured Stanwyck and forced her to marry him. When they arrive at the ranch, the husband refuses to accept the child, but his death allows McCrea to ride off with mother and son whom he has come to love. Supporting were Earl Holliman, Edward Andrews, Susan Kohner, Royal Dano, Celia Lovsky, Stanley Adams and Pat O'Moore. The screenplay was by Charles Marquis Warren – who directed – David Vistor and Herbert Little Jr (story Jack Schaefer). (SOL BAER FIELDING)

▽Child actor Dean Stockwell, last seen in 1951 aged 14, returned to the screen six years later to play a teenager in **The Careless Years**. This pedestrian pubescent love story, produced and written by Edward Lewis, had Stockwell and Natalie Trundy (both illustrated) unwilling to wait until they finish school before they marry. Off they go to Mexico, but the boy's father, John Larch, finds them and brings them back. They return to school, older and wiser, realizing that marriage will come in time. Barbara Billingsly and John Stephenson were the girl's anxious parents, and others involved were Maureen Cassidy, Alan Dinehart III, Virginia Christine, Bobby Hyatt, Hugh Sanders and Claire Carleton. It was the first feature of director Arthur Hiller, who would make *Love Story* for Paramount, 13 years later. (BRYNA)

▽**Men In War**, directed realistically by Anthony Mann, heavily restated the oft-repeated, but seldom heeded, 'War is Hell' message. The script, by Philip Yordan from the novel *Combat* by Van Van Praag, did not avoid the stereotyping of soldiers in an infantry platoon in Korea, but the unshaven characters gradually emerged as tragic figures in a bloody landscape. Lieutenant Robert Ryan was the leader of a brave band, cut off from battalion headquarters and trying to combat mines, snipers and enemy machine-gun nests. In the midst of battle, Sergeant Aldo Ray is struggling to get his shell-shocked Colonel, Robert Keith, to the safety of a hospital behind the front lines. Few survived from the all-male cast of Philip Pine, Vic Morrow, Nehemiah Persoff (illustrated), James Edwards, L.Q. Jones, Adam Kennedy, Scott Marlowe, Walter Kelley, Race Gentry and Anthony Ray. Sidney Harmon was the producer. (SECURITY)

▽Sad to see a worse-for-wear Errol Flynn, swashbuckling hero of the 30s and 40s, losing a duel in **The Big Boodle** (GB: **Night In Havana**) against incompetent direction by Richard Wilson, and an incomprehensible script by Jo Eisinger (from Robert Sylvester's novel). Flynn (illustrated) played a dealer in an Havana casino, suspected by police chief Pedro Armendariz of forging pesos. In search of the real culprits, Flynn gets involved with Sandro Giglio, principal banker in Cuba, and his two lovely daughters, Rossana Rory and Gia Scala (illustrated). The latter is revealed as being part of a counterfeit racket organized by Jacques Aubuchon, a trusted official in the bank. While Flynn struggled to keep alive, many of the other characters struggled with basic English. Carlos Rivas and Charles Todd also appeared in this cheap Lewis Blumberg production. (LEWIS BLUMBERG)

▷Initially, **Witness For The Prosecution**, based on Agatha Christie's hit play, did not seem promising material for the celebrated sweet-and-sour comedy of director Billy Wilder. But, with Harry Kurnitz, he added sharper dialogue, and played it for more laughs. It also gave Charles Laughton (illustrated right) room to upstage and outact everyone else on screen outrageously, in a cast that included Marlene Dietrich (illustrated), Tyrone Power, John Williams (left), Henry Daniell, Ian Wolfe, Una O'Connor (in her last film), and his wife Elsa Lanchester. In one of his last great film performances, Laughton richly hammed his way through the whodunnit, as a convalescent London barrister defending a caddish American (Power) accused of the murder of a rich old woman. The only person who can provide an alibi is Power's German wife (Dietrich). Trial scenes seldom miss, and the public paid nearly $4 million to see Arthur Hornblow Jr's production with its triple twist ending. Oscar nominatons went to Laughton, Lanchester (supporting) and the picture. (THEME)

◁Even without Barbara Stanwyck (right), **Crime Of Passion** would have been a superbly paced *film noir*. With her, it couldn't miss. Smouldering magnificently as the wife of nice cop Sterling Hayden (centre), she despises the small-minded wives of her husband's colleagues and is determined that he should be seen to succeed in his career. To this end, she sleeps with police captain Raymond Burr, who is being forced to retire because of his wife's bad health. Her hopes that Burr will name her husband as his successor are dashed when the younger, better qualified Royal Dano (left) is given the job. Hell hath no fury like Stanwyck scorned, and she shoots Burr. Hangdog Hayden, investigating the murder, gradually has to move in on his wife. Jo Eisinger's story and screenplay created a little masterpiece of suspense, skilfully directed by Gerd Oswald. Fay Wray and Virginia Grey were incisive as the wives of Burr and Dano respectively, and other roles went to Robert Griffin, Dennis Cross, Malcolm Atterbury, John S. Launer and Stuart Whitman for producer Herman Cohen. (BOB GOLDSTEIN)

△John Derek was a complex cowboy in **Fury At Showdown**, a straightforward, small-scale Western directed with punch by Gerd Oswald. The Jason James screenplay (from a Lucas Todd novel) had Derek (centre) trying to live down his reputation as a gunfighter by trying to run a cattle ranch with his younger brother (Nick Adams). But a crooked lawyer (Gage Clarke) and his hired bodyguard (John Smith) try to pressure him into selling his property. When his brother is killed, Derek shows his fury at a showdown, shoots the triggerman, gets the lawyer arrested, and marries his girl (Carolyn Craig). John Beck's production also cast Robert E. Griffin, Malcolm Atterbury, Rusty Lane, Sydney Smith, Frances Morris and Tyler McDuff. (BOB GOLDSTEIN)

△**Drango** was no mere good guys vs bad guys Western, but a sombre attempt to demonstrate the necessity for reconciliation after conflict. Jeff Chandler (left), as a major in the Union army, is entrusted to help rebuild a small Georgian community after the Civil War. He is faced with hostility from some of the defeated population, particularly Ronald Howard (Leslie Howard's son in his first US film), son of the local judge (Donald Crisp). After a bit of lynching and arson, Howard prepares to shoot an unarmed Chan-dler, but Crisp shoots his son instead. Joanne Dru (centre) and Julie London provided interesting portrayals of contrasting women. There were also good vignettes from John Lupton, Morris Ankrum, Helen Wallace, Milburn Stone (right), Walter Sande, Parley Baer, Amzie Strickland and Charles Horvath. However, the wooden Jeff Chandler looked as if he could have bored the community into submission. The picture was produced, written and directed (with Jules Bricken) by Hall Bartlett. (EARLMAR)

▽Jane Russell (illustrated) needed seven years to recover from **The Fuzzy Pink Nightgown** before she appeared on the screen again. In this stale and vulgar farce, written by Richard Allan Simmons from a novel by Sylvia Tate, she played a blonde movie star who is kidnapped on the opening night of her latest picture, *The Kidnapped Bride*. Her captors, Ralph Meeker (illustrated) and Keenan Wynn, keep her imprisoned in an isolated beach house until her studio coughs up the ransom. Naturally, she falls for Meeker and, when the crooks are caught, the star tells the police it was an elaborate publicity stunt. Adolphe Menjou, a film producer, Fred Clark, a detective, and Una Merkel succeeded in bringing a little wit to the proceedings, directed by Norman Taurog. Also in the Robert Waterfield production were Benny Venuta, Robert Harris, Bob Kelley, John Truex and Milton Frome. (RUSS-FIELD)

△If producer-director Henry Hathaway's aim in **Legend Of The Lost** was to show how tedious, slow, and energy-sapping a trip across the Sahara could be, then he succeeded all too well. For almost two hours, John Wayne, Sophia Loren (both illustrated) and Rossano Brazzi battled against sandstorms, tarantulas, and thirst on their way to the ruins of Timgad. Brazzi flees with the treasure they discover, leaving the other two members of the glamorous trio to survive on no more than a tin of peaches, which they clearly do, for they manage to catch up with their betrayer who promptly attacks the macho Wayne, but is himself shot by Miss Loren. Luckily, a Timbuktu-bound caravan happens to be passing, and they hitch a ride. Jack Cardiff's Technicolor photography in Technirama of the North African desert added a dimension to the arid and protracted screenplay by Robert Presnell Jr and Ben Hecht. Kurt Kasznar, Sonia Moser, Angela Portaluri and Ibrahim El Hadish had other roles. (BATJAC-ROBERT HAGGIAG-DEAR)

1957 OTHER RELEASES

Bayou (aka **Poor White Trash**)
A Cajun girl falls in love with an architect newly arrived in the swamp country of Louisiana, despite opposition from her father and one of the jealous local youths. Peter Graves, Lita Milan, Douglas Fowley, Tim Carey, Jonathan Haze. *Dir* Harold Daniels. *Pro* M. A. Ripps. M. A. RIPPS

Bop Girl
A college student who is writing a thesis on Rock 'n' Roll persuades a nightclub singer to sing in a calypso beat, thus creating a new musical style. Judy Tyler, Bobby Troup, Margo Woode, Lucien Littlefield, George O'Hanlon. *Dir* Howard W. Koch. *Pro* Aubrey Schenck. BEL-AIR

The Buckskin Lady
A young doctor in the Wild West attracts the attentions of the girlfriend of a bank robber. Patricia Medina, Richard Denning, Gerald Mohr, Henry Hull, Hank Warden. *Dir & Pro* Carl K. Hittleman. BISHOP/HITTLEMAN

The Dalton Girls
After the Dalton boys are brought to justice and executed, their sisters decide to follow in their footsteps and become outlaws too. Merry Anders, Lisa Davis, Penny Edwards, Sue George, John Russell, Ed Hinton. *Dir* Reginald Le Borg. *Pro* Howard W. Koch. BEL-AIR

The Delinquents
The criminal exploits of a gang of youths who smash windows, go on drinking sprees and rob cash from a filling station. Tom Laughlin, Peter Miller, Richard Bakelyn, Rosemary Howard, Helen Hawley. *Dir & Pro* Robert Altman. IMPERIAL

Four Boys And A Gun
Four teenagers organize a holdup at a fight arena and are wrongly accused of killing a cop. Frank Sutton, Terry Green, James Franciscus, William Hinant, Otto Hulett, Robert Dryden. *Dir & Pro* William Berke. SECURITY

Gun Duel In Durango
An outlaw decides to go straight, marry, and adopt an orphan boy, but his old gang kidnap the boy and force him to rob a bank with them. George Montgomery, Ann Robinson, Steve Brodie, Bobby Clark, Frank Ferguson, Donald Barry. *Dir* Sidney Salkow. *Pro* Robert E. Kent. PEERLESS

Hell Bound
A master criminal organizes a robbery of a $2 million shipment of wartime surplus narcotics in Los Angeles harbour. John Russell, June Blair, Stuart Whitman, Margo Woods, George Mather. *Dir* William J. Hole Jr. *Dir* Howard W. Koch. BEL-AIR

Hit And Run
A prosperous junk-car dealer sees his twin brother murdered and assumes his identity to trap the killers. Cleo Moore, Hugo Haas, Vince Edwards, Julie Mitchum, Dolores Reed. *Dir & Pro* Hugo Haas. HAAS

The Iron Sheriff
A sheriff proves that his teenage son is innocent of the crime of robbing a stage and killing the driver. Sterling Hayden, Constance Ford, John Dehner, Kent Taylor, Darryl Hickman, Walter Sande. *Dir* Sidney Salkow. *Pro* Jerome C. Robinson. GRAND

Jungle Heat
Pre-Pearl Harbor fifth columnists create havoc in the industries and plantations of Hawaii, until an American doctor helps defeat them. Lex Barker, Mari Blanchard, Glenn Langan, James Westerfield, Rhodes Reason. *Dir* Howard W. Koch. *Pro* Aubrey Schenck. BEL-AIR

Lady Of Vengeance
An American publisher in London hires a master criminal to plot the death of the man who drove his young ward to suicide. Dennis O'Keefe, Ann Sears, Anton Diffring, Patrick Barr, Vernon Greeves. *Dir* Burt Balaban. *Pro* Bernard Donnenfield, Burt Balaban. (GB) RICH AND RICH

My Gun Is Quick
Mickey Spillane's rough and tough private-eye hero, Mike Hammer, solves a murder and jewel robbery despite opposition from two rival gangs. Robert Bray, Whitney Blake, Pat Donahue, Donald Randolph, Pamela Duncan. *Dir & Pro* George A. White, Phil Victor. VICTOR SAVILLE

Pharoah's Curse
Archaeological expedition in the Valley of the Kings meets trouble by desecrating a sacred tomb. Mark Dana, Ziva Shapir, Diane Brewster, George Neise. *Dir* Lee Sholem. *Pro* Howard W. Koch. BEL-AIR

Revolt At Fort Laramie
Union soldiers rescue Confederate soldiers from attacks by the Sioux Indians. John Dehner, Gregg Palmer, Frances Helm, Don Gordon, Robert Keys. *Dir* Lesley Selander. *Pro* Howard W. Koch. De Luxe Color. BEL-AIR

So Lovely, So Deadly
Private eye hired by rich widow to escort stepdaughter, uncovers mystery of her father's death. Henry Beckman, Robert Middleton, Lou Prentiss, Natalie Priest. *Dir & Pro* Will Kohler. MONARCH/BRITISH LION

Street Of Sinners
Rookie New York cop has to deal with juvenile delinquents, his superiors, and blame for the suicide of a woman who jumped to her death while he was in her apartment. George Montgomery, Geraldine Brooks, Nehemiah Persoff, Marilee Earle, William Harrigan. *Dir & Pro* William Berke. SECURITY

Tomahawk Trail (GB: **Mark Of The Apache**)
An inexperienced West Point Academy-trained martinet and an old-timer sergeant battle with each other and massacre Apaches at the same time. Chuck Connors, John Smith, Susan Cummings, Lisa Montell, George Neise. *Dir* Lesley Selander. *Pro* Howard W. Koch. BEL-AIR

The Vampire (TV: **The Mark Of The Vampire**)
A medic swallows experimental tablets that turn him into a vampire who attacks his colleagues and nurse. John Beal, Coleen Gray, Kenneth Tobey, Lydia Reed, Dabbs Greer. *Dir* Paul Landres. *Pro* Jules V. Levy, Arthur Gardner. GARDNER/LEVY

Voodoo Island (aka **Silent Death**)
A group of people go to a Pacific island where they have problems with carnivorous plants and voodoo doings. Boris Karloff, Beverly Tyler, Murvyn Vye, Elisha Cook Jr, Rhodes Reason. *Dir* Reginald Le Borg. *Pro* Howard W. Koch. BEL-AIR

▷The anti-militarist stance of **Paths Of Glory** was so powerful that the film was banned in parts of Europe and in US military movie theatres for some years. It came opportunely in the aftermath of the Korean war and after Senator McCarthy's fall, although the action of the screenplay by Stanley Kubrick, Calder Willingham and Jim Thompson was set in France in 1916. Its inspiration came from Humphrey Cobb's novel based on an actual incident when a general ordered a captain to fire on his own troops because some of them refused to obey an order to go over the top. The captain defied orders, three men were chosen at random and executed after a court martial, and the affair was hushed up by the French authorities of the time. In the film, the scheming generals were impeccably played by Adolphe Menjou and George Macready, safely and comfortably installed in a chateau away from the trenches. Kirk Douglas (right), all controlled passion, was the colonel defending the men – Timothy Carey, Joseph Turkel and Ralph Meeker (left) – shot at dawn despite his efforts. Others cast were Wayne Morris, Richard Anderson, Peter Capell, Suzanne Christian (Kubrick's third wife), Emile Meyer, Ken Dibbs, John Stein and Bert Freed. The James B. Harris production, established Kubrick as an important figure in American cinema. Much of the graphic depiction of trench warfare must be attributed to the camerawork of George Krause, but the ironic cross-cutting, the savage view of the officers, and the harsh awareness of death were all the director's. It is perhaps significant that this outspoken movie never won a major award. (BRYNA)

▽The earthiness of **God's Little Acre** caused some censorship problems, although Philip Yordan's screenplay was a diluted version of Erskine Caldwell's 1930s novel about a family of 'white trash' farmers in the Georgia of the Depression. Despite a miscast Robert Ryan (centre) as Ty Ty Walden, the *paterfamilias*, and some overdone rustic knockabout comedy, Anthony Mann's direction retained much of the book's evocation of place and period, and quite a bit of the passion. Most of the latter was provided by Tina Louise (screen debut, left) and Aldo Ray as Griselda and Bill, making adulterous love in a cotton mill. Ty Ty spends his days digging for gold on his farm, instead of ploughing his fields, once using an albino (Michael Landon) to divine its whereabouts. The only gold the picture produced was at the box-office. Playing Ty Ty's offspring were Jack Lord (Buck, right), Helen Westcott (Rosamund), Vic Morrow (Shaw), Lance Fuller (Jim) and Fay Spain (Darlin' Jill). The cast of Sidney Harmon's production was completed by Buddy Hackett (Darlin' Jill's suitor, Plato) and Rex Ingram (Uncle Felix). (SECURITY)

△The good guy in **Ride Out For Revenge** was law enforcement officer Rory Calhoun (illustrated), a friend of the Cheyennes. The bad guy was cavalry officer Lloyd Bridges who tries to remove the Indians from their land in order to get their gold. Gloria Grahame (illustrated) loves Calhoun, but hates Redskins, so she loses him to Pretty Willow (Joanne Gilbert), sister of the young Chief Little Wolf (Vince Edwards). Bridges kills the chief, but Calhoun catches up with him in the end, and the Indians move off to their reservations. There were reservations, too, about the flat direction by Bernard Girard, and the over-familiar script by Norman Retchin. Others in Vic Orsatti's production were Frank De Kova, Michael Winkelman, Richard Shannon and John Merrick. (BRYNA)

▽**The Gun Runners** was the third and weakest film version of Ernest Hemingway's novel *To Have And Have Not*. Warner Bros. gave us Howard Hawks' with the same title as the book, but an altered plot, and Michael Curtiz's more faithful *The Breaking Point*. Director Don Siegel's plodding picture suffered in comparison, and Audie Murphy (right) and Patricia Owens were no match for Humphrey Bogart and Lauren Bacall in 1944, and John Garfield and Patricia Neal in 1950. The updated screenplay (by Daniel Mainwaring and Paul Monash) also lacked conviction, despite a vain attempt to imitate Hemingway's sparse style of dialogue. The glum-faced Murphy, who rents his motor boat to fishermen off Key West, Florida, is asked by a grinning Eddie Albert (left) to take him, his girlfriend, Gita Hall, and three cronies to Havana. Albert turns out to be supplying arms to Cuban rebels, so Murphy alters course, kills the baddies, and heads home to his wife, Owens. Everett Sloane, Richard Jaeckel, Paul Birch, Jack Elam, Freddie Roberto, John Harding, Edward Colmans and John Qualen were also in Clarence Greene's production. (SEVEN ARTS)

△**Separate Tables** started life on the London stage as two inter-connected one-act plays by Terence Rattigan. John Gay and Rattigan combined the plays into one screenplay cast with Hollywood stars of magnitude and thus diminishing many of the subtle merits of the original stage opus. Among the guests at a genteel English seaside guest house were left-wing journalist Burt Lancaster (standing right), his glamorous ex-wife Rita Hayworth who wants him back, his mistress, Wendy Hiller, who is the proprietress of the establishment, bogus English major David Niven, plain spinster Deborah Kerr (left) with her domineering mother Gladys

Cooper (2nd left), young honeymoon couple Rod Taylor and Audrey Dalton, and old gossips Cathleen Nesbitt (seated right) and May Hallatt. Lancaster and Hayworth were totally unconvincing in underwritten parts, but the rest of the cast compensated for the pedestrian direction of Delbert Mann. The scene when Niven admits he is not only a fraud, but a man who molests women in cinemas, was enough to win him his Best Actor Oscar. Wendy Hiller was Best Supporting Actress, and nominations went to Deborah Kerr, the screenplay, and Charles Lang Jr's photography. Harold Hecht's production reaped a good $2½ million. (HECHT-HILL-LANCASTER)

△Robert Mitchum (right) and his 19-year-old son Jim (left), following father's footsteps and making his screen debut, played hillbilly brothers in **Thunder Road**, which was based on a story by Mitchum Sr. James Atlee Phillips and Walter Wise's screenplay had the pair of them and their father (Trevor Bardette) operating one of the largest moonshine whiskey stills in Harlan County, Kentucky. Unfortunately, their illicit idyll is disturbed when a big-city mobster (Jac-

ques Aubuchon) tries to intimidate them into selling their entire output to him. After defying the gangsters, the elder brother is killed while being pursued by Treasury men. Keely Smith, Sandra Knight, Betsy Holt, Francis Koon, Randy Sparks and Mitch Ryan were also cast in supporting roles. The blend of whiskey, guitar music, cops 'n robbers, and mountain folklore was efficiently held together by director Arthur Ripley for an uncredited producer. (DRM)

△**The Horse's Mouth** provided Alec Guinness with the plum role of Gully Jimson, an archetypal portrait of the artist as non-conformist. With rasping voice, tipsy gait and roguish eyes, Guinness (illustrated) – who wrote the screenplay himself from Joyce Cary's novel – gave a brilliant larger-than-life performance, swindling, pestering and exploiting everyone for the sake of his paintings. The main targets of his behaviour were his ex-wife (Renee Houston), and a stuffy art collector (Ernest Thesiger). Gully paints a huge mural on the walls of a house while the millionaire owner (Robert Coote) is away, and depicts 'The Last Judgement' in a building due for demolition. Good support came from Kay Walsh as his barmaid ally, Mike Morgan, Arthur Macrae, Veronica Turleigh, Michael Gough and Reginald Beckwith. A vital contribution were the paintings by John Bratby (standing in for Jimson's) which were appropriately visionary in Technicolor. However, the British-made John Bryan production, was directed with a light comedy style by Ronald Neame which reduced the original study of the creative force to mere eccentricity. (KNIGHTSBRIDGE)

▽**The Vikings** conquered the box-office, getting away with a booty of around $7 million. On the Technirama screen, in Technicolor, the Northern hordes invaded England taking back gold and captives to Scandinavia. One of the latter was Welsh Princess Janet Leigh, brought as a bride for Kirk Douglas (illustrated), son of barbaric Chief Ernest Borgnine. With her is English slave Tony Curtis, the chief's bastard son, in love with the princess. The end sees the two half-brothers facing each other in mortal combat, not knowing of their blood tie until too late. In between there were splendidly staged battles involving impressive long ships. The screenplay by Calder Willingham, from Edison Marshall's novel *The Viking*, contained the usual anachronistic and risible dialogue, but director Richard Fleischer gave it an epic grandeur, boosted by Jack Cardiff's location photography in Norway. Also cast: Frank Thring, James Donald, Maxine Audley, Alexander Knox, and Orson Welles narrating. However, Douglas stood out in Jerry Bresler's production as the brutish prince whose looks were ruined when a falcon plucked one of his eyes out. (KD)

▽The most memorable image in **Terror In A Texas Town** was that of Sterling Hayden, armed with a whaling harpoon and facing gunfighters in an unusual variation on the traditional showdown. It was the climax of a stylish Western by the cultish director Joseph H. Lewis, and also the climax of his film career. How Hayden came to be using the harpoon was recounted in Ben L. Perry's well-conceived screenplay. Portly plutocrat Sebastian Cabot has the Texas town in his pocket, including the Sheriff (Tyler McVey). When a Swedish farmer (Ted Stanhope) opposes Cabot, he is shot down by the latter's triggerman (Ned Young). The farmer's seaman son (Hayden, illustrated), arrives, rallies the townsfolk against Cabot and his henchmen, and overcomes the cowboys with a weapon he understands. Others in the Frank N. Seltzer production were Carol Kelly (illustrated), Eugene Martin, Victor Millan, Ann Varela, Sheb Wooley and Gil Lamb. (SELTZER)

▽**The Lone Ranger And The Lost City Of Gold** was a spin-off from the popular *Lone Ranger* TV series with the same two small-screen stars – Clayton Moore (illustrated) as the masked cowboy hero and Jay Silverheels as Tonto, his faithful Indian friend – riding out once more to eradicate evil. Charles Watts, Lisa Montell, Ralph Moody and Norman Frederic were also in the reasonably entertaining Sherman A. Harris production, shot in Eastman Color, and directed firmly by old Western hand Lesley Selander. Robert Schaefer and Eric Freiwald's serviceable screenplay involved five silver medallions which, when placed together would show the location of the lost city. The owners of three of the pieces have been killed, but the intrepid duo manage to get to the other two men before the baddies (Douglas Kennedy and Noreen Nash) can bump them off. The Lone Ranger and Tonto ride off towards the horizon shouting, 'Heigh Ho, Silver!', a cry that was not echoed at the box-office. (JACK WRATHER)

◁**Run Silent, Run Deep** was neither very silent nor particularly deep, but it did contain a compulsive profile-to-profile confrontation between two major stars – Clark Gable and Burt Lancaster – on a submarine. Commander Gable (centre) thinks only of avenging himself on the Jap ship that once sank him, and second-in-command Lancaster (left) (in a crew-cut) is worried about his superior officer's screwy behavior. Gable spends his time reliving his past humiliation by playing with toy ships on his desk, if not in his bath. But, Ahab-like, he pursues his quarry and, after a lot of models get shaken up in an artificial pool, Gable redeems himself. The John Gay script, based on a novel by Commander Edward L. Beach, offered little insight into the characters, but director Robert Wise sustained the claustrophobic underwater tensions in the sub. Other members of the crew in Harold Hecht's production were Jack Warden, Brad Dexter, Don Rickles (right), Nick Cravat, Joe Maross and Eddie Foy III. Mary LaRoche played Gable's onshore wife. (HECHT-HILL-LANCASTER)

△**The Big Country**, a 166-minute Western in Technicolor and Technirama, had both sweep and substance. William Wyler's fluent direction mitigated some of the more pretentious elements in the screenplay by James R. Webb, Sy Bartlett and Robert Wilder (based on Donald Hamilton's novel) which attempted a pacifist message. Basically, it was a film of contrasts. Opposition held sway between Eastern gentleman Gregory Peck (right) and brutish ranch foreman Charlton Heston; between the spoiled selfishness of Carroll Baker, Peck's fiancée and the simple integrity of schoolmarm Jean Simmons (centre right); between the stiffness and wealth of Baker's father, Charles Bickford, and the roughness and poverty of Burl Ives (winner of the Best Supporting Actor Oscar, centre left). The feud between these last two stubborn old men ends only when they kill each other. Notable among some outstanding set pieces were Peck's brave efforts to master a wild stallion, a fist fight between Peck and Heston by the light of the moon, and the climactic battle in a canyon. The vigorous score by Jerome Moross gave a boost to the $5 million grossing William Wyler-Gregory Peck production. The cast also included Alfonso Bedoya, Chuck Connors (left), Chuck Hayward, Buff Brady and Jim Burk. (ANTHONY-WORLDWIDE)

△Producer Dore Schary not only truncated the title of Nathanael West's remarkable 1933 novel *Miss Lonelyhearts* to **Lonelyhearts**, but his screenplay changed the tone of the book completely by adding liberal platitudes on tolerance and the atom bomb, and an artificial happy ending. Vincent J. Donahue's lifeless direction also failed to come to terms with the book. At least Montgomery Clift (illustrated) and Robert Ryan were well cast as the tortured agony columnist, Adam White, and his cynical editor, William Shrike, respectively. Taunted by the editor's challenge that people who write letters for advice to the papers are 'phonies', Adam contacts one of his unhappy correspondents. Out of pity, he allows himself to be seduced by the aging, sexually frustrated woman (Oscar-nominated Maureen Stapleton in her film debut, illustrated), before he is almost killed (he dies violently in the novel) by her crippled husband (Frank Maxwell). Myrna Loy looked elegant and worried as Mrs Shrike (nasty in the book), and Dolores Hart (who became a nun in 1970) was merely pretty as Adam's fiancée. Also in it were Jackie Coogan, Mike Kellin, Frank Overton and Onslow Stevens. (SCHARY)

▷Producer-director Stanley Kramer's **The Defiant Ones** was an advance on Hollywood's usual treatment of racial themes, and contained some good performances, but the screenplay by Nathan E. Douglas and Harold Jacob Smith was too message-laden, and the direction too single-minded and naively optimistic to really work. A chain was the clanking symbol which bound racist Tony Curtis to negro Sidney Poitier (both illustrated), both of them cons on the run, after the truck in which they are travelling to jail, is involved in an accident. Curtis, who begins by calling Poitier, 'nigger' and 'boy', gets to see his companion as a suffering human being like himself as they try to survive together. In a town, the inhabitants want to lynch them, but they are freed by Lon Chaney Jr who shows some human decency. Later, they are given shelter by widow Cara Williams (John Barrymore Jr's wife) who falls for Curtis and directs Poitier to the quicksands. Although the chain has been severed, they are now linked by an iron friendship, and Curtis leaves the woman to save his friend. Poitier, in turn, refuses to make his escape alone, when Curtis fails to jump on a train. Finally, the humanitarian sheriff, Theodore Bikel, catches up with them in each other's arms. The cast also included Charles McGraw, King Donovan, Claude Akins, Lawrence Dobkin, Whit Bissell and former *Our Gang* star, Carl 'Alfalfa' Switzer in his last film, before being shot dead in 1959, aged 32. The picture won five nominations and two Oscars, and good messages were sent from the box-office. (STANLEY KRAMER)

△**Man Of The West** was a strongly allegorical Western, directed with intensity by Anthony Mann, and starring Gary Cooper (left) at his most anguished. As a man of peace who gave up the life of a bank robber 20 years earlier, Cooper is faced with the need to use violence once more. The train on which he is travelling is ambushed and he, a card sharp (Arthur O'Connell, right) and a dancehall singer (Julie London, centre) are stranded in the wilderness after being robbed. They come across the hideout of the gang of which Cooper was once a member. It is now led by a half-crazed outlaw (a hammy performance from Lee J. Cobb) who encourages his depraved crew in their sadism. Gradually, by talk and action, the hero overcomes them all, and rides off with the girl. Although filmed in CinemaScope and De Luxe Color, much of Reginald Rose's taut screenplay (from the novel by Will C. Brown) was confined to the small space of the hideout where the characters interact. Jack Lord, John Dehner, Royal Dano, Robert Wilke and Jack Williams were other members of the gang. The Walter M. Mirisch production, generally dismissed on its first release, has since gained in reputation, and certainly offered Cooper his last great role. (ASHTON)

▽**Anna Lucasta** was first an all-black Broadway play by Philip Yordan, then an all-white movie (Columbia, 1949) starring Paulette Goddard, and finally an all-black picture with Eartha Kitt (centre right) in the title role. She was nervously energetic as the prostitute on the San Diego waterfront who attempts to start a new life. Anna falls in love with a studious college boy (Henry Scott) who, unaware of her shady past, asks her to marry him. The marriage celebrations are interrupted by the appearance of one her previous sailor lovers (Sammy Davis Jr, seated centre). Distraught, she goes off with him on a drunken spree, but returns to find her father (Rex Ingram, left) on his death bed. Both he and her husband forgive her, and she is redeemed. Not much redeemed the Sidney Harmon production, stagily directed by Arnold Laven, which Yordan himself adapted. Apart from Miss Kitt, many of the performances were too melodramatic even for such an emotional story. Others in the cast were Frederick O'Neal, George Burke, James Edwards, Rosetta Lenoire, Isabelle Cooley, Alvin Childress (right), Charles Swain (at back) and John Proctor. (LONGRIDGE)

△The combined talents of Frank Sinatra (left) and Tony Curtis (right) breathed a modicum of life into **Kings Go Forth**, a stodgy wartime drama directed by Delmer Daves. But, despite a few sharp lines in Merle Miller's script (based on the Joe David Brown novel), delivered with the right edge by the two stars, the situations remained implausible. The Frank Ross production was set in 1944 in Southern France, where hardbitten Lieutenant Sinatra takes on devil-may-care radio operator Curtis. Their personalities clash, but the main cause for dispute comes from their shared attachment to a French girl, played rather tamely by the 20-year-old Natalie Wood. Sinatra is shocked for a while when he hears that her dead father was black, but he overcomes the prejudice which Curtis does not share. On a dangerous mission, Curtis is killed by the Germans, and Sinatra is wounded but survives with the loss of an arm. In the soapy finale after D-Day, he finds the girl again, teaching war orphans. Leora Dana, Karl Swenson, Anne Codee and Jackie Berthe were also in the cast. (ROSS-ELTON)

▽Joseph L. Mankiewicz, producer-director-writer of **The Quiet American**, followed the Graham Greene novel fairly faithfully for about half of the 120 minutes of the film. He then threw the book away, changed the ending, and altered the anti-American viewpoint to an anti-Communist one. Whatever the political pros and cons of the change, it became a standard murder yarn weighed down with more talk than action. It told of a naive young man (Audie Murphy, right), known only as The American, who comes to Saigon on an economic trade mission. He makes the acquaintance of Fowler, a cynical journalist (Michael Redgrave, left), who is living with an Indo-Chinese girl (Giorgia Moll, centre). He falls in love with her, offering marriage, something that Fowler never did. In the end, the journalist betrays The American to the Communist rebels by telling them he was exporting explosives for use against them. The cast also included Claude Dauphin, Kerima, Bruce Cabot, Fred Sadoff, Richard Loo, Peter Trent, Clinton Andersen and Yoko Tani, but only Redgrave brought the picture close to Greeneland. It was shot on location in Indo-China and at Cinecitta studios in Rome. (FIGARO)

△The Mirisch Corporation hoping 'to become pre-eminent as *the* quality independent filmmaker', launched **Fort Massacre** as its first production. Although a solid, rugged Western of merit, shot in CinemaScope and De Luxe Color, it did not quite fulfil that hope. The pro-Indian sentiments in Martin N. Goldsmith's screenplay were commonplace by the mid-50s, but director Joseph M. Newman handled the action with his customary skill, and Joel McCrea (right) was at his reliable best. This time McCrea as a sergeant who commands a detachment of US cavalry in Apache country, was not a real goodie. His all-consuming hatred of Indians, because his wife and children were killed by them, makes him reckless, and he imperils the lives of his men. In the end, he is shot by fellow soldier John Russell (left) as he is about to kill a harmless old Indian. Others in the Walter M. Mirisch production were Susan Cabot (as an Indian girl, centre), Forrest Tucker, Anthony Caruso, Robert Osterloh, Denver Pyle, Guy Prescott, Larry Chance, Irving Bacon and Claire Carleton. (MIRISCH)

▽After being nominated four times previously for a Best Actress Oscar, Susan Hayward (illustrated) finally won the award for her portrayal of Barbara Graham in **I Want To Live!**, a harrowing drama based on fact. The LA Police Department and many people in the film industry tried to dissuade producer Walter Wanger from tackling the subject of a woman executed in the gas chamber, and containing an anti-capital punishment message. Wanger was vindicated by the industry, if not the police, when the picture won praise and made over $3 million. Graham, a cardsharp, thief and prostitute, was sentenced to death for murder, despite some doubt about her guilt. Among those fighting to save her were a psychologist (Theodore Bikel) and a journalist Ed Montgomery (Simon Oakland) from whose articles the script by Nelson Gidding and Don Mankiewicz was derived. The main wallop packed by Robert Wise's clinically realistic direction was the long final sequence as Graham prepares for death, and the scene in the gas chamber. Much of the film's force also depended on the gritty performance by Hayward, who showed the vulnerability but also the toughness of the woman. Virginia Vincent, Wesley Lau and Philip Coolidge had other roles. The director, the screenwriters, the cinematographer (Lionel Lindon) and the film editor (William Hornbeck) received Oscar nominations. (FIGARO)

△Frank Borzage, who had been forced out of work in 1948 by the McCarthyite blacklist, returned to direct **China Doll**. Borzage's forte in the 30s had been for bitter-sweet romances about lovers fighting against adversity. As his own producer, decades later, he attempted to serve up a similar sentimental dish, using a screenplay by Kitty Buhler, based on a story by James Benson Nablo and Thomas F. Kelly, but times and audiences had changed. Set in China in 1943, it concerned an American officer (Victor Mature, illustrated) who marries his Chinese housekeeper (Li Li Hua, illustrated), later killed by Japanese bombers when she follows him to the front with their child. He hides the baby in a safe place, and goes out on a mission from which he fails to return. Years later, in the USA, the now grown-up daughter is welcomed in a tear-stained ceremony by the members of her father's old air crew. A lovable chess-playing cleric (Ward Bond), as well as a group of saxophone-playing nuns were also thrown in. Others piping the eye were Bob Mathias (famous Olympic athlete), Stuart Whitman, Johnny Desmond, Ken Perry, Tiger Andrews, Steve Mitchell, Don Barry and Elaine Curtis. It was the director's penultimate picture. (ROMINA-BATJAC)

1958

▽The ski-nosed American Bob Hope and the horse-faced Frenchman Fernandel made a funny peculiar (rather than a funny 'ha ha') combination in **Paris Holiday**. Neither comedian produced many laughs despite strenuous efforts from each – Hope wisecracking, Fernandel miming, Hope in the clutches of Anita Ekberg, Fernandel in drag, and both in a slapstick helicopter finale over the French capital. Not that Edmund Beloin and Dean Riesner's screenplay (story by Hope) was quite sure how to use the Franco-American farcical mixture. Bob (centre) played an American comedian in France to buy the script of a French author, not knowing that it contains the secrets and names of a real gang of counterfeiters. The crooks kill the author and pursue Hope using Ekberg as a weapon. But the Swedish siren falls for Bob and, for his own protection, has him committed to an asylum from which he is rescued by Fernandel (right). Also involved in the Bob Hope production were Martha Hyer (left), Andre Morell, Jean Murat, Irene Tunc, Maurice Teynac and Roger Treville. The director, Gerd Oswald, made good use of the Paris locations in Technicolor and Technirama, but the brief uncredited appearance of Preston Sturges was a reminder of a better director and superior comedies. (TOLDA)

△**The Fearmakers** were less the Communists in the film who doctor public opinion polls to further their own interests in the USA, than the makers of this crude anti-Red scaremongering picture, directed by Jacques Tourneur. The speechifying and implausible screenplay by Elliot West and Chris Appley (from Darwin Teilhet's novel) related how war veteran Dana Andrews (centre) returns to Washington D.C., after two years of captivity and brainwashing in North Korea, to find his public relations firm has been taken over by Dick Foran. With the help of Foran's secretary, Marilee Earle (left), he gains access to confidential files, and discovers a conspiracy to undermine the state. After some platitudes delivered by paternal Senator Roy Gordon, a representative of true patriotism, Andrews captures the villains near the Lincoln Memorial. Other roles went to Mel Torme (right), Kelly Thorsden and Veda Ann Borg in Martin H. Lancer's production. Few people were brainwashed into seeing it. (PACEMAKER)

1958 OTHER RELEASES

Cop Hater
A man kills three policeman in order to confuse the detectives, as only the third murder had a real motive. Robert Loggia, Gerald O'Loughlin, Ellen Parker, Shirley Ballard, Russell Hardie. *Dir* & *Pro* William Berke. BARBIZON

Curse Of The Faceless Man
An excavator at Pompeii unearths a man of stone who comes to life and begins searching for his 2000 year-old lost love. Richard Anderson, Elaine Richards, Adele Mara, Luis Van Rooten, Gar Moore. *Dir* Edward L. Cahn. *Pro* Robert E. Kent. VOGUE

Edge Of Fury
A young man who is befriended by a woman and her two daughters, turns out to be a psychopath. Michael Higgins, Lois Holmes, Jean Allison, Doris Fesette, Malcolm Beggs. *Dir* Robert Gurney Jr, Irving Lerner. *Pro* Robert Gurney Jr. WISTERIA

Flame Barrier (aka **It Fell From The Flame Barrier**)
An earth satellite lands in the Mexican jungle and exudes a jelly-like creature which doubles its form every day. Arthur Franz, Kathleen Crowley, Robert Brown, Vincent Padula. *Dir* Paul Landres. *Pro* Arthur Gardner, Jules V. Levy. GRAMERCY

Fort Bowie
The Cavalry massacre Indians, the Indians massacre the Cavalry, the Cavalry massacre the Indians defending Fort Bowie. Ben Johnson, Jan Harrison, Kent Taylor, Jana Davi, Larry Chance. *Dir* Howard K. Koch. *Pro* Aubrey Schenck. BEL-AIR

Gun Fever
Two brothers set out to avenge the massacre of their parents by a band of Indians who were led by a white renegade. Mark Stevens, John Lupton, Larry Storch, Jani Davi, Aaron Saxon. *Dir* Mark Stevens. *Pro* Harry Jackson. JACKSON-WESTON

Hong Kong Confidential
An American agent posing as a nightclub singer, investigates the kidnapping of the son of a Middle East potentate by the Russians. Gene Barry, Beverly Tyler, Allison Hayes, Noel Drayton, Ed Kemmer. *Dir* Edward L. Cahn. *Pro* Robert E. Kent. VOGUE

I Bury The Living
A man finds he has the macabre power to take people's lives by placing pins on a map of the cemetery where they have reserved their future resting places. Richard Boone, Theodore Bikel, Peggy Maurer, Herb Anderson, Howard Smith. *Dir* Albert Band. *Pro* Louis Garfinkle, Albert Band. MAXIM

Island Women
A rich American girl falls for the captain of a charter sailing boat in the West Indies, although her aunt does her best to break up the affair as she is angling to have the man for herself. Marie Windsor, Vince Edwards, Marilee Earle, Leslie Scott. *Dir* & *Pro* William Berke. SECURITY

It! The Terror From Beyond Space
A monstrous ape-like being from Mars enters an American space ship through one of the air ducts. Marshall Thompson, Shawn Smith, Kim Spalding, Ann Doran, Dabbs Greer. *Dir* Edward L. Cahn. *Pro* Robert E. Kent. VOGUE

The Lost Lagoon
An unhappily married middle-aged businessman is presumed drowned, but is washed up on a Caribbean island where he falls in love with a lonely girl with whom he sets up a hotel. Jeffrey Lynn, Lelia Barry, Peter Donat, Don Gibson, Roger Clark. *Dir* & *Pro* John Rawlins. BERMUDA

The Lost Missile
A mysterious unguided missile travelling at 4,000 miles an hour wipes out Ottawa, but New York is saved from destruction at the last minute by the intervention of a rocket. Robert Loggia, Ellen Parker, Philip Pine, Marilee Earle, Larry Kerr. *Dir* Lester William Berke. *Pro* William Berke. BERKE

Man On The Prowl
A psychopath insinuates himself into a woman's home and then threatens to kill her two children unless she surrenders herself to him. Mala Powers, James Best, Ted De Corsia, Jerry Paris, Vivi Jannis, Josh and Jeff Freeman. *Dir* Art Napoleon. *Pro* Jo and Art Napoleon. JANA

The Mugger
A police psychiatrist attempts to find a mugger obsessed with the need to seek out lonely women and slash their faces. Kent Smith, Nan Martin, James Franciscus, Stefan Schnabel, Connie Vaness. *Dir* & *Pro* William Berke. BARBIZON/HELPRIN-CROWN

Return Of Dracula (aka **The Curse Of Dracula**, GB: **The Fantastic Disappearing Man**)
A vampire escapes to America and settles in a small town where he sets about his evil work. Francis Lederer, Norma Eberhardt, Ray Stricklyn, Jimmie Baird, Greta Granstedt. *Dir* Paul Landres. *Pro* Jules V. Levy, Arthur Gardner. GRAMERCY

Ten Days To Tulara
A barnstorming American pilot operating a one-man airline in Central America is forced to join a gang of desperados. Sterling Hayden, Grace Raynor, Rudolfo Hoyos, Carlos Muzquiz, Tony Caravajal. *Dir* George Sherman. *Pro* Clarence Eurist, George Sherman. GEORGE SHERMAN

Toughest Gun In Tombstone
A leader of the Arizona Rangers poses as an outlaw in order to get in with a gang and arrest them. George Montgomery, Beverly Tyler, Don Beddoe, Jim Davis, Scotty Morrow. *Dir* Earl Bellamy *Pro* Robert E. Kent. PEERLESS

Wink Of An Eye
A henpecked perfumier plans to murder his wife with the help of his secretary. Jonathan Kidd, Doris Dowling, Barbara Turner, Irene Seidner, Jaclynne Green, Wally Brown. *Dir* Winston Jones. *Pro* Fernando Carrerre. IVAR

▷Although **The Horse Soldiers** was not a vintage John Ford Western, it was still recognizably Fordian in its mythic view of America's past, characters and landscape. There were plenty of masterly panoramas of riders on the march, the soldiers being those of General Grant (Stan Jones), with the imposing figure of John Wayne (foreground centre) at their head, raiding the South in 1863. But the rather meandering screenplay by producers John Lee Mahin and Martin Rackin (from the novel by Harold Sinclair) had a tendency to favour the Confederate side – especially in a splendid scene where a group of teenage cadets from a Southern military academy take on the enemy who scorn to fight them and retreat while the boys cheer. A romance develops between Wayne and Southern belle Constance Towers, whom he is forced to take along after she overhears the Union plans to destroy a railway depot. There is also a bitter personality clash between Wayne and surgeon William Holden, although the mutual animosity turns to respect in the end. Both male stars deserved the $750,000 plus 20% of the profits they each received on the big-earning De Luxe Color picture. Others cast were Wimbledon tennis champion Althea Gibson, veteran cowboy star Hoot Gibson in his last film, Judson Pratt, Ken Curtis, Bing Russell, Willis Bouchey, Carleton Young, Basil Ruysdael, O.Z. Whitehead, Denver Pyle and Strother Martin. (MIRISCH)

△**The Hound Of The Baskervilles** was given the Hammer horror treatment by producer Anthony Hinds and director Terence Fisher. Screenwriter Peter Bryan added blood and sex to the celebrated Arthur Conan Doyle tale, as well as some love interest – thankfully not involving Peter Cushing's stiff Sherlock Holmes (right) or Andre Morell's unappealing Dr Watson (2nd left). The basic plot of Holmes being asked by Sir Henry Baskerville (Christopher Lee, seated) to solve the mystery of the ghastly hound that brings death to each succeeding head of the family, remained unaltered. Ewen Solon played the suspicious farmer, and Marla Landi his treacherous daughter, with other parts going to Francis De Wolff (left), Miles Malleson, John Le Mesurier and David Oxley. Despite the eerie atmosphere, and Technicolor, this British-made picture was no match for the 1939 20th Century-Fox version with Basil Rathbone as the master detective. (HAMMER)

▽Approaching the end of long movie career, which had been spent largely in the saddle, Joel McCrea (right) took the role of the legendary Bat Masterson with supreme ease in **The Gunfight At Dodge City**. This entertaining Western, shot in CinemaScope and De Luxe Color by director Joseph M. Newman, had an ironic script by Daniel B. Ullman and Martin M. Goldsmith (story by the former) in which Masterson is faced with one headache after another. After killing a man in self-defence, he joins his brother (Harry Lauter) in Dodge City, and buys a half interest in a saloon run by a pretty widow (Nancy Gates). When his brother is killed by a gunfighter (Richard Anderson), he becomes sheriff and is immediately threatened by a troublemaker (Don Haggerty, left), a half-wit killer (Wright King), and the widow, who grows jealous of his friendship with the minister's daughter (Julie Adams). Others going through their paces in the Walter M. Mirisch production were John McIntyre, Jim Westerfield and Walter Coy. (MIRISCH)

▷The only moments of genius in **The Naked Maja** were the few glimpses given of the work of Francisco Goya, the great 18th-century Spanish painter on whose life this US-Italian co-production claimed to be based. Four screenwriters, Giorgio Prosperi, Norman Corwin, Albert Lewin and Oscar Saul (story by Talbot Jennings) opted to ignore the fascinating facts and came up with conventional fiction instead; director Henry Koster did little to enliven it. The story told of the love affair between Goya (Anthony Franciosa, confusing histrionics for intensity) and the Duchess of Alba (lovely Ava Gardner, illustrated), threatened by the Inquisition and vindictive Queen Maria Luisa (Lea Padovani). Goya is arrested after painting the picture of the title, but released following Alba's intercession with King Charles IV (Gino Cervi). It ends with a prolonged deathbed scene in which the Duchess, poisoned by an evil aristocrat (Amedeo Nazzari), forecasts a great future for her lover. There wasn't much future in the Goffredo Lombardo Technirama-Technicolor production. Also in the Hispanic hokum were Massimo Serato, Carlo Rizzo and Renzo Cesana. TITANUS

△Producer Robert Wise's **Odds Against Tomorrow** was a hard-hitting heist movie that overreached itself. No complaint about the build-up to the bank robbery, or the black and white location shooting of an unfriendly New York. But Wise's direction got too emphatic, and the John O. Killens-Nelson Gidding screenplay (from the novel by William McGivern) tried to support a rather pat socially significant theme. The plot had former cop Ed Begley devising a robbery plan with the help of ex-con Robert Ryan (illustrated) and nightclub singer Harry Belafonte, but Ryan's racial prejudice against his black colleague leads to the bungling of the getaway. Begley is shot by the police, and the other two are burnt alive in an exploding gas tank, their blackened corpses becoming indistinguishable from each other. On the female side, Shelley Winters (illustrated) and Gloria Grahame provided a few lively moments. Others in it were Will Kuluva, Kim Hamilton, Mae Barnes and Richard Bright. (HARBEL)

△ 60-year-old James Cagney, still as pugnacious as ever, led a cast of mainly English and Irish actors in **Shake Hands With The Devil**, a shot-in-Ireland story of The Troubles. He played a college professor in the Dublin of 1921, who is also a secret IRA leader. Don Murray, a young Irish-American medical student is wrongfully arrested and brutally beaten up by a Black and Tan officer. Cagney (right) organizes his escape, and kidnaps Dana Wynter, daughter of an English official. As romance blossomed between Murray and Wynter, so the screenplay by Ivan

Goff, Ben Roberts and Marion Thompson (from Rearden Conner's novel) began to wither. At the melodramatic ending, Cagney, echoing his gangster mannerisms of the past, was shot and killed. The romantic Irish landscape made up for some of the shortcomings of producer Michael Anderson's direction. Good support was given by Glynis Johns (background), Michael Redgrave, Sybil Thorndike, Cyril Cusack (2nd left), Lewis Casson, Harry Corbett, Allan Cuthbertson, Donal Donnelly (left), Richard Harris and John Le Mesurier. (TROY)

◁ Although **The Wonderful Country** was set in both Mexico and the USA, the title naturally referred to the latter in Chester Erskine's Hollywood production. Both countries, however, formed splendid Technicolor backgrounds to the tangled tale of Robert Mitchum (right), to-ing and fro-ing from one side of the border to the other, first as gunrunner for provincial Mexican dictator Pedro Armendariz, then as a Texas Ranger under Major Gary Merrill, then back again to Pedro, then to Texas to win Merrill's wife Julie London, after her husband has been got rid of by Apaches. Other roles were taken by Jack Oakie, Albert Dekker, Charles McGraw, John Banner, Jay Novello, Mike Kellin, and Tom Lea (left) who wrote the novel on which Robert Ardrey's screenplay was based. The unresolved points in the story were disguised by the fast action direction of Robert Parrish. (DRM)

▷ **Escort West** was about a long trek, but it wasn't a long haul for audiences. In fact, the Robert E. Morrison-Nate H. Edwards production, under Francis D. Lyon's brisk direction, reached its destination in 76 minutes. Going west were widower Victor Mature (illustrated) and his 10-year-old daughter Reba Waters; two sisters, Elaine Stewart and Faith Domergue, and their elderly black servant, Rex Ingram, seriously wounded during an Indian attack. Mature helps to escort the party, delivering Miss Stewart to William Ching, her soldier fiance. But after Mature rescues Ching's troops from Indians, she is given up to him. Also cast were Noah Beery Jr, Leo Gordon, John Hubbard, Harry Carey Jr, Slim Pickens, Roy Barcroft and Ken Curtis. The straightforward screenplay was by Lee Gordon and Fred Hartsook (story Steven Hayes). It was one of the few Hollywood movies of the time made in black and white, although shot in CinemaScope. (ROMINA-BATJAC)

▷ **Some Like It Hot** was a high-water mark in American post-war comedy. Producer-director Billy Wilder created an amalgam of parody, slapstick, romance, farce and sophistication; modern in its liberated sexual approach, nostalgic in its tribute to screwball comedies and gangster movies of the 30s. The snappy script (suggested by a story by R. Thoeren and M. Logan), fashioned by Wilder and I.A.L. Diamond (the second of more than a dozen collaborations) began in Chicago in the 20s. Joe (Tony Curtis) and Jerry (Jack Lemmon, right), two jazz musicians on the run from gangsters, disguise themselves as 'Josephine' and 'Daphne' and join an all-girl band on its way to Florida. On the train, they become friends with Sugar Kane (Marilyn Monroe, left), the band's singer, with whom Joe falls in love. In Miami, Jerry gets the unwanted attention of millionaire Osgood Fielding (Joe E. Brown), while Joe – when out of petticoats – adopts the guise of a millionaire and uses Osgood's yacht to woo Sugar. After Jerry becomes engaged to Osgood, he finally admits that he's a man. Osgood replies, in one of the most memorable punchlines in the cinema, 'Well, nobody's perfect,' and whisks his fiance(e) away in his speedboat. Wilder's equally speedy comic style was given performances equal to it. Curtis and Lemmon gave Hollywood's best drag portrayals, unparalleled until Dustin Hoffman's *Tootsie* (Columbia, 1982). Curtis, in fact, offered a triple treat as his wiseguy self, as a woman in a dark wig, high-pitched voice and alluring made-up eyes, and – as the 'millionaire' – impersonating Cary Grant. Lemmon, in high-heeled shoes, flapper's frock and blonde wig, was hilarious as he identified more and more with his female persona. Monroe, the genuine feminine article, brought sensitivity to the proceedings, and sang two zippy 20s numbers, 'Runnin' Wild' (with ukelele) and 'I Wanna Be Loved By You'. Immaculate support came from George Raft (spinning a coin), Pat O'Brien, Nehemiah Persoff, Joan Shawlee, Billy Gray, George E. Stone, Edward G. Robinson Jr and Mike Mazurki. The picture was a hot property, grossing $7 million in its first year, and remains a durable favourite to this day, Amazingly, although nominated for Best Director, Best Actor (Lemmon), Best Screenplay, and Best Photography (Charles Lang Jr), only costumer designer Orry-Kelly won an Oscar. (MIRISCH-ASHTON)

△ Steve McQueen (right) was top-billed in the B movie **The Great St Louis Bank Robbery**, although stardom was still two years away from him. Richard Heffron's script, based on an actual incident, told of a mother-fixated cracksman (Crahan Denton, left) who attempts a caper with two accomplices (David Clarke and James Dukas), while ex-football ace McQueen agrees to drive the getaway car. Their plans go awry, however, when the sister (Molly McCarthy) of one of the gang betrays them. Bungled too, was the direction of this heist movie by the producer Charles Guggenheim and John Stix, although the good location photography gave it a certain gritty reality. (GUGGENHEIM AND ASSOCIATES)

△When David Niven angrily put his foot through a TV set in **Happy Anniversary**, he was reflecting the desire of everyone involved in the movie industry. TV was the great enemy of the cinema in the 50s, and when the taboo subject was mentioned in pictures, it was always satirically or negatively. Mind you, Ralph Fields' production did little to convince audiences that films were much better as entertainment. Mechanically adapted by Joseph Fields and Jerome Chodorov from their hit Broadway play *Anniversary Waltz*, it was a strained comedy on the disruptive force of a TV set on the marriage of Niven and Mitzi Gaynor (both illustrated on the couch), celebrating their 13th wedding anniversary. Their daughter (Patty Duke) goes on a programme and spills the beans about her father's youthful indiscretions, thus prompting the aforementioned violent reaction. Director David Miller merely sat back and allowed the likeable cast, including Carl Reiner, Loring Smith, Phyllis Povah, Monique Van Vooren, Elizabeth Wilson and Kevin Coughlin (on floor) to do their best with it. (FIELDS)

▽Lewis Milestone, the director of the anti-war classic *All Quiet On The Western Front* (Universal, 1930), failed to avoid the guts 'n' glory cliches of the genre in **Pork Chop Hill**. Unlike the pacifist sentiments and sympathy for the 'other side' expressed in the earlier film, the Korean enemy was seen crudely caricatured as a bunch of evil Orientals holding up a peace conference or hectoring US troops through powerful loudspeakers. A small American unit, led by an inscrutable Lieutenant, Gregory Peck (left), attacks a Chinese-held hill at great cost to lives and ammunition. The 25 survivors out of a company of 135 hold the fort until reinforcements arrive. Among the usual cross-section of soldiers in Sy Bartlett's production were Harry Guardino, George Shibata (right), Woody Strode, Rip Torn, Barry Atwater, George Peppard, Robert Blake, Biff Elliot, Carl Benton Reid and Martin Landau. Although James R. Webb's screenplay, based on the writings of ex-military man S.L.A. Marshall, showed America's 'police action' in Korea as no picnic, it also extolled the necessity for the war and heroism. (MELVILLE)

△Tyrone Power died of a heart attack during the shooting of **Solomon And Sheba** in Spain, so Yul Brynner (illustrated) was quickly given a wig and despatched to take over the male lead in this Super 70-Technicolor production. Some scenes had to be reshot by director King Vidor (making his last film), pushing the budget over the $2 million mark, but the movie more than doubled this in earnings despite the negative critical reaction. The dialogue in the Anthony Veiller-Paul Dudley-George Bruce script for this Biblical Western, veered uneasily between ancient and modern. But spectacle rather than speech was the film's strong point, plus the voluptuousness of Gina Lollobrigida (illustrated) displayed in a succession of scanty gowns. As the Queen, she seduced King Sol, in order that the armies of the Pharoah (David Farrar) can overrun Israel. However, they and the troops of Solomon's resentful brother Adonijah (George Sanders) are defeated when they are blinded by the sun flashing on the shields of the Jewish forces. Also involved in Ted Richmond's production were Marisa Pavan, John Crawford, Laurence Naismith, Alejandro Ray, Harry Andrews, Jose Nieto, William Devlin and Jean Anderson. (EDWARD SMALL)

△Five children (Barbara Beaird, Susan Gordon, Charles Herbert, Mike McGreevy and Steven Perry) gathered the few bouquets thrown at **The Man In The Net**. Brickbats were thrown mainly at the verbose and often predictable script by Reginald Rose (from the novel by Patrick Quentin), the patchy direction by 70-year-old Michael Curtiz, and the stolid playing by Alan Ladd (illustrated) in the lead. Ladd was unconvincing as an artist in a small Connecticut town, married to alcoholic adulteress Carolyn Jones, among whose lovers are Charles McGraw, a tough cop, John Lupton, the son of local industrialist John Alexander, and Tom Helmore, a wealthy playboy. When her body is discovered under the floor of a barn, Ladd is suspected of murder and takes to the woods where a group of children hide him in a cave. With the kids as messengers and spies, Ladd is able to solve the case. Also in the Walter M. Mirisch production were Diane Brewster, Betty Lou Holland, Kathryn Givney and Edward Binns. (MIRISCH-JAGUAR)

△The Oscar-winning Sammy Cahn-Jimmy Van Heusen song 'High Hopes', one of Frank Sinatra's biggest hits, reflected the feelings of 60-year-old producer-director Frank Capra embarking on **A Hole In The Head**, his first picture after eight years in retirement. The hopes were fulfilled at the box-office, and the critics, on the whole, welcomed him back warmly. The episodic script, adapted by Arnold Schulman from his own play (changing the characters from Jewish to Italian), concerned the financial problems of widower Sinatra (illustrated), owner of a Miami Beach hotel threatened with foreclosure. In order to raise money from his successful New York businessman brother, Edward G. Robinson, he pretends that his 11-year-old son, Eddie Hodges, is ill. Robinson and his wife, Thelma Ritter arrive to find the boy well, so the loan is refused. Meanwhile, they try to marry Sinatra off to wealthy widow Eleanor Parker. At the tearful happy ending, the hotel is saved, a marriage is in the offing, and the freckle-faced motherless boy is in his father's arms. Apart from a number of good jokes, Capra's flabby direction was saved by Robinson who, as usual, stole most of the film. Carolyn Jones (illustrated) was irritating as a kooky, surf-boarding, bongo-drumming, hula-hooping girl, but good support came from Keenan Wynn, Joi Lansing, Connie Sawyer, George DeWitt, Jimmy Komack, Dub Taylor, Benny Rubin and Ruby Dandridge. It was shot in CinemaScope and De Luxe Color. (SINCAP)

△**Timbuktu** was obviously shot in the California desert, and so should all of those involved in it have been, including director Jacques Tourneur, and screenwriters Anthony Veiller and Paul Dudley. Producer Edward Small had the sense to drop his name from the credits. It was the tired old story of French colonialists vs wily Arabs. In 1942, Victor Mature (illustrated left), a renegade American, is smuggling guns to Arabs in North Africa, but changes sides when he meets Yvonne de Carlo (illustrated), wife of Colonel George Dolenz (lying on ground), the new commander at Timbuktu. Mature gains the confidence of Emir John Dehner, in order to betray him to the French. Fortunately for Mature, the colonel is killed in a final skirmish, leaving the way clear for the hero to ride out of the desert with Miss de Carlo. Also stumbling through it were Marcia Henderson, James Fox, Leonard Mudie, Paul Wexler, Robert Clarke, Willard Sage and Mark Dana. (IMPERIAL)

△Bob Hope had gone West far more humorously in the past than he did in **Alias Jesse James**. The initial story dreamed up by Robert St Aubrey and Bert Lawrence and turned into a screenplay by William Bowers and Daniel D. Beauchamp, promised more hilarity than it delivered under Norman Z. McLeod's direction. The idea was that Hope (centre), a bumbling insurance agent from the East coast, sells a policy to notorious outlaw Jesse James (Wendell Corey), and then has to protect his client. Along the way he gets entangled (literally) with Jesse's girlfriend and beneficiary (Rhonda Fleming), redheaded singer at The Dirty Dog Saloon. The Jack Hope Technicolor production spoofed most of the Western cliches in a mildly amusing manner, the climax parading almost every current TV and Hollywood cowboy star – including James Arness, James Garner, Hugh O'Brian and Gene Autry – there to come to Hope's assistance. More support was given by Jim Davis (as Frank James), Mickey Finn (left), Will Wright, Mike Mazurki (right), Gloria Talbott and Mary Young. (HOPE ENTERPRISES)

▽The billboards for producer-director Stanley Kramer's **On The Beach** claimed it to be 'The Biggest Story Of Our Time'. Although the picture earned over $5 million, it didn't live up to its claim, or to its theme – nuclear annihilation. Not that Neville Shute's best-seller on which John Paxton and James Lee Barrett based their screenplay had managed much better, but at least the reader was spared 'Waltzing Matilda' blaring forth from the soundtrack at regular intervals as a reminder that the location was Australia. The scene was Melbourne in 1964 after an atomic war in the northern hemisphere. Five people's lives are spotlighted among the population waiting for the radio active drift to reach them: American submarine captain Gregory Peck (centre – busily moving his eyebrows), nervous, hard-drinking Ava Gardner (doing what she could with a non-existent character), conscience-stricken nuclear physicist Fred Astaire (right – in his first non-musical, putting over corny speeches in a wavering English accent), and young couple Anthony Perkins (left) and Donna Anderson with the responsibility of a baby to look after. Aside from a slight sense of urgency from the latter couple, most of the characters behaved as if the war was little more than an irksome interruption to a cocktail party. Others awaiting their doom were John Tate, Lola Brooks, Lou Vernon and Ken Wayne. The message was that nuclear war was bad for the health but good for the box-office. (LOMITAS)

▽George Bernard Shaw's **The Devil's Disciple** was not one of his most profound plays, but it had more interesting ideas in it than John Dighton and Roland Kibbee's script suggested. Nor did the ironic comedy of British colonialism lend itself to the realistic action approach of director Guy Hamilton, balanced slightly by puppet interludes. The setting was Springtown, New Hampshire in 1777 (Harold Hecht's production was shot entirely in England) where a citizen has been hanged by King George's army as a warning to the American rebels. The dead man's son, Dick Dudgeon (Kirk Douglas), cuts the body down, but is arrested after seeking refuge in the house of Pastor Anthony Anderson (Burt Lancaster, illustrated) and his wife (Janette Scott). The Pastor rides off to join the colonists, intercepts a message from the British General Burgoyne (Laurence Olivier), and saves Dudgeon from the gallows in the nick of time. Douglas, in the flashier role, was more at ease than Lancaster, but Olivier made the most impact in his few brief scenes. Also cast were Eva Le Gallienne, Harry Andrews, Basil Sydney, George Rose, Neil McCallum, David Horne, Mervyn Johns, Erik Chitty and Jenny Jones. (HECHT-HILL-LANCASTER/BRYNA)

△**The Last Mile**, the term given to the walk from the death cell to the electric chair, was also the title of a 1930 play by John Wexley through which Spencer Tracy (on Broadway) and Clark Gable (in LA) won Hollywood contracts. Preston Foster, in the 1932 film version, also gained recognition in the leading role of 'Killer' John Mears. In contrast, Mickey Rooney's reputation had long been established when he took on the part of the vicious character who organizes a prison riot with seven other condemned men. They manage to seize weapons and systematically begin killing the captured guards, until Rooney (left) himself is mowed down by machine guns. The cast of mainly stage actors included Harry Millard, Clifford Davis, John McCurry, Ford Rainey, John Seven and Michael Constantine as convicts and, as the guards, Donald Barry, Leon Janney, Clifton James, Milton Selzer and Frank Conroy, with Frank Overton as the chaplain (centre) and Alan Bunce (right) the prison warden. Screenwriters Milton Subotsky and Seton I. Miller kept the film to the period of the play in order to be able to claim in the prologue that such things no longer happen in US prisons. The claim was as artificial as Howard W. Koch's melodramatic direction. Subotsky and Max J. Rosenberg were the producers. (VANGUARD)

1959

▽Ernest Borgnine in *Marty* (1955) was in at the start of the short period of intimate realist films derived from TV plays, and in at the end in **The Rabbit Trap**. The short (76 minutes) and simple story, written by J.P. Miller from his own TV drama, had Borgnine (illustrated) as a hardworking draughtsman who finds little time for his wife (Bethel Leslie) or his young son (Kevin Corcoran, illustrated). They finally leave for a vacation for the first time in years, but Borgnine's boss (David Brian) calls him back for some work. At the risk of being fired, he decides to continue the vacation to be with his family. Philp Leacock directed economically and approached the subject gently for producer Harry Kleiner. June Blair, Jeanette Nolan and Don Rickles completed the cast. (CANON)

▽**Cast A Long Shadow** cast a short Audie Murphy (illustrated) as a no-good gambling drifter who never knew who his father was. When a cattle baron dies and leaves Murphy his estate, everyone believes him to be the dead man's son. The new wealth and power goes to his head, he loses his girlfriend, Terry Moore, and makes a few enemies. After the foreman, John Dehner, saves his life in a cattle stampede, the foreman reveals himself as Murphy's real father. Martin H. Goldsmith and John McGreevey's screenplay (from a novel by Wayne D. Overholser) failed to reveal why Murphy became heir to the ranch and why the foreman had been concealing his paternity. Not that anybody really cared by the time this Thomas Carr-directed horse opera plodded to its climax. Other parts in Walter M. Mirisch's production went to James Best, Rita Lynn (illustrated), Denver Pyle, Ann Doran, Stacy B. Harris and Robert Foulk. (MIRISCH)

◁Robert Aldrich's direction of **Ten Seconds To Hell** was a blend of slow and boring, and fast and boring, like the picture's two stars. Jeff Chandler (left) was dull and wooden, Jack Palance (right), nervy and hollow. In the feeble script by Aldrich and Teddi Sherman (from *The Phoenix*, a novel by Lawrence P. Bachmann), Chandler and Palance were members of a group of six German soldiers who form a bomb disposal unit in post-war Britain. There is tension between the two men over Martine Carol, the French widow of a German officer. A climax is reached when they have to help each other defuse a 1000 lb bomb. The malicious Chandler tries to kill Palance by activating a fuse, but is blown up himself. The biggest bomb, however, was the Michael Carreras Anglo-American production. Also appearing were Robert Cornthwaite, Dave Willock, Wesley Addy, Jimmy Goodwin, Virginia Baker and Richard Wattis. (HAMMER-SEVEN ARTS)

▽**Day Of The Outlaw** was a bleak and powerful Western set against a wintry Wyoming landscape. Director Andre de Toth constructed a tense and moody allegory of good and evil from Philip Yordan's screenplay (based on the Lee Wells novel). It began with a showdown between ruthless cattleman Robert Ryan (left) and small rancher Alan Marshal, whose wife, Tina Louise (centre), is having an affair with Ryan. They are interrupted by the arrival of six outlaws led by Burl Ives. They hold the isolated community in terror for two days while Ives has a bullet removed from his lung. Ryan, the bully bullied, leads them out to the snow-covered mountains to a non-existent path to freedom. Only he, and the youngest outlaw, David Nelson, survive to return. The Sidney Harmon production, also included Nehemiah Persoff, Venetia Stevenson, Jack Lambert (2nd left), Frank de Kova (right), DeForest Kelley (2nd right), Helen Westcott and Elisha Cook Jr. (SECURITY)

1959 OTHER RELEASES

Counterplot
An American on the run from a murder rap seeks refuge in Puerto Rico, until he discovers that the man he slugged in New York was actually murdered by the victim's business partner. Forrest Tucker, Allison Hayes, Gerald Milton, Edmundo Rivera Alvarez. *Dir & Pro* Kurt Neumann. KURT NEUMANN

Cry Tough
A young Puerto Rican released after a year in prison finds that his old gang won't allow him to go straight, and he commits suicide. John Saxon, Linda Cristal, Joseph Calleia, Arthur Batanides, Paul Clarke. *Dir* Paul Stanley. *Pro* Harry Kleiner. CANON

A Dog's Best Friend
A boy cares for a wounded German Shepherd dog trained by a murderer to hide a gun used to kill an old hermit. Bill Williams, Marcia Henderson, Roger Mobley, Charles Cooper, Dean Stanton. *Dir* Edward L. Cahn. *Pro* Robert E. Kent. PREMIUM

The Four Skulls Of Jonathan Drake
An anthropologist specializing in the practice of head shrinking and voodoo, has his own head grafted onto the body of a dead Ecuadorian medicine man. Eduard Franz, Valerie French, Henry Daniell, Grant Richards, Paul Cavanagh. *Dir* Richard L. Cahn. *Pro* Robert E. Kent. VOGUE

Guns, Girls and Gangsters
A nightclub singer and two hoodlums contrive an elaborate scheme to rob an armoured truck carrying money from the saloons of Las Vegas to Los Angeles. Mamie Van Doren, Gerald Mohr, Lee Van Cleef, Grant Richards, *Dir* Edward L. Cahn. *Pro* Robert E. Kent. IMPERIAL

Inside The Mafia
A gang leader holds people hostage at an airport in a plot to seize control of a Mafia syndicate. Cameron Mitchell, Elaine Edwards, Robert Strauss, Jim L. Brown, Ted De Corsia. *Dir* Edward L. Cahn. *Pro* Robert E. Kent. PREMIUM

Invisible Invaders
An invisible army of spacemen cause world-wide chaos until it is discovered that they cannot stand hi-frequency sound. John Agar, Jean Byron, Robert Hutton, Philip Tonge, John Carradine. *Dir* Edward L. Cahn. *Pro* Robert E. Kent. PREMIUM

Machete
The cousin of a wealthy plantation owner in Puerto Rico plants seeds of jealousy in the man's mind concerning his new wife and the handsome foreman. Mari Blanchard, Albert Decker, Juano Hernandez, Carlos Rivas, Lee Van Cleef. *Dir & Pro* Kurt Neumann. J. HAROLD ODELL

Mustang
A rodeo star forced to earn his living as a cowhand, saves a wild mare from destruction. Jack Beutel, Madalyn Trahey, Steve Keyes. *Dir* Peter Stephens. *Pro* Robert Arnell. ARNELL

Pier 5 Havana
A man arriving in Havana to investigate the disappearance of his friend during the Cuban revolution, discovers he is being held by Batista sympathisers who have forced him to prepare bombs for a counter-revolution. Cameron Mitchell, Allison Hayes, Eduardo Noriego, Michael Granger, Logan Field. *Dir* Edward L. Cahn. *Pro* Robert E. Kent. PREMIUM

Riot In Juvenile Prison
A psychiatrist is appointed supervisor of a reformatory and sets about turning it into a rehabilitation centre despite initial opposition. Jerome Thor, Scott Marlowe, John Hoyt, Marcia Henderson, Dick Tyler, Dorothy Provine. *Dir* Edward L. Cahn. *Pro* Robert E. Kent. VOGUE

At the 1960 Oscar ceremonies, UA swept the boards, winning 11 awards in all, including Best Picture for *The Apartment*. *West Side Story* gained the accolade for UA the following year, *Tom Jones* in 1963, *In The Heat Of The Night* in 1967 and *Midnight Cowboy* in 1969. In fact, in the history of the Academy, UA has won more Best Picture awards than any other studio. In addition, the prestige gained by the many Oscars was not inconsistent with the financial health of the company.

The studio was less affected than most by the strike on 15 January 1960 by the screen section of the Writers' Guild of America which was holding out for more equitable contracts and a share of the profits from films sold to TV. In March the same year, the Screen Actors' Guild of America demanded a raise in minimum salaries and a share in TV residuals. Both the writers and the actors won their cases, victories that became a contributory factor in pushing Hollywood to the brink of economic disaster. A rope was thrown to Paramount by Gulf and Western Oil, Warner Bros. merged with Seven Arts Ltd., a TV company, and MGM shifted its interests to real estate. The studios became administrative centres organizing finance and distribution. Following UA's lead, the independent producer became the rule rather than the exception in the 60s. They would come to the studio with a package consisting of director, literary property or script, writers, and marketable stars. Although some risks were taken, most of the pictures followed the genre pattern initiated by the studios in their heyday.

UA, without huge overheads and star salaries, continued to attract many leading independent producers and directors. Stanley Kramer continued his happy association with the company by delivering *Judgement At Nuremberg* (1961) and his greatest ever success *It's A Mad, Mad, Mad, Mad World* (1963), a $10 million earner. Through a contract with the Mirisch brothers, UA also acquired directors like Billy Wilder, Norman Jewison, John Sturges, Robert Wise and Blake Edwards. Walter Mirisch's connection with the film business began at 17 as a management trainee at a motion picture theatre. After World War II, he joined Monogram as a producer of low-budget films. In 1957, with his brother Marvin and half-brother Harold, he formed the Mirisch Company Inc. which gained a reputation for careful budgeting, quality of production, and the complete creative autonomy they gave to film-makers. In 1963, a stock transfer gave ownership of Mirisch to UA, although their *modus operandi* changed little.

It was while working under the UA logo that Billy Wilder produced his finest and most mature comedies starting with *Some Like It Hot* (1959) and following up with *The Apartment* (1960), *One, Two, Three* (1961), *Irma La Douce* (1963), *Kiss Me, Stupid* (1964) and *The Fortune Cookie* (1966), all of them earning from three to nine million dollars. Norman Jewison provided bonanzas such as *The Russians Are Coming, The Russians Are Coming* (1966) and *The Thomas Crown Affair* (1968). John Sturges hit the jackpot with *The Magnificent Seven* (1960), which earned a magnificent $7 million, and *The Great Escape* (1963). Robert Wise's *West Side Story* (1961) grossed $11 million, and Blake Edwards' *The Pink Panther* (1964) began a slapstick series starring Peter Sellers that continued even after the star's death in 1980.

However, the longest running series, and the most durable of all in the history of the cinema, was the string of Agent 007 James Bond movies, still going strong after almost a quarter of a century.

The first, *Dr No* (1963), was made for less than $1 million, but they got progressively more expensive as they took more at the box office. *Thunderball* (1965), the fourth in the series, became the sixth highest earning movie of the decade from any source, pulling in nearly $26 million. The Bond picture producers with the gold fingers were Albert R. 'Cubby' Broccoli, an American agronomist, and Canadian-born Harry Saltzman. Together they formed Eon Productions situated in England from where all the Bonds have originated, although their locations ranged far and wide.

As movie going had ceased to be a habit, each film had to attract its own audience, and extravagant advertising campaigns accompanied the many million-dollar spectacles that bludgeoned their way onto the screens, among them *Exodus* (UA, 1960), *King Of Kings* (MGM, 1961), *Lawrence Of Arabia* (Columbia, 1962), *The Fall Of The Roman Empire* (Paramount, 1964), *The Greatest Story Ever Told* (UA, 1965) and *Doctor Zhivago* (MGM, 1965). Twentieth Century-Fox came unstuck by disastrously investing over $40 million in the infamous *Cleopatra* (1963), regained a fortune with *The Sound Of Music* (1965), and then lost it all again with *Doctor Dolittle* (1967) and *Star* (1968).

At the same time, Hollywood found itself with a new audience drawn mainly from the 16–24 age bracket with different tastes from their elders. This younger generation expressed a growing aversion to traditional values, and political and social processes, which culminated in the anti-Vietnam war movement in 1968. It was films like *The Graduate* (Avco-Embassy, 1967) and *Easy Rider* (Columbia, 1969) that spoke directly to this generation. Furthermore, with the demise of the old Production Code, the limits of language, topics, and behaviour were considerably widened, almost sufficiently to satisfy young audiences craving for sex and violence. This appetite was amply catered for by films like *The Magnificent Seven* (UA, 1960), *Bonnie And Clyde* (Warner Bros., 1967), *The Dirty Dozen* (MGM, 1967), *The Wild Bunch* (Warner Bros., 1969), and particularly the James Bond movies and 'Spaghetti Westerns'. The last two vast money-spinners demonstrated the shift from Hollywood as a production centre, and vindicated UA's policy of increased investment in overseas productions. Curiously enough, it was an adaptation of a classic English 18th-century novel, Fielding's *Tom Jones* (1963) directed by Tony Richardson, that triggered off the vogue for 'Swinging London' pictures many of them backed and distributed by UA. These included three British-made Richard Lester films – the Beatles extravaganzas, *A Hard Day's Night* (1964) and *Help!* (1965), each earning a healthy $4 million, and *The Knack ... And How To Get It* (1965). It seemed in the sixties that UA had the knack of finding the right properties.

In 1968, UA reached a new high when it generated over $20 million in profits after tax. Its impressive record attracted the interest of the Transamerica Corporation of San Francisco, a diversified organization known largely as a major insurance company. It purchased 98% of UA's stock and made it a subsidiary. Little interfered with the formula developed by Arthur Krim and Robert Benjamin who remained as president and chairman of the board of directors respectively. But in 1969, David Picker took over from Krim, and his brother Arnold became chairman of the board. This prompted a characteristically alliterative *Variety* headline – 'Pickers Pluck Plum UA Posts.' They might with good reason have added, 'From Pickford To Picker, UA Knows How To Pick 'Em'.

▽Melina Mercouri (illustrated) used her ouzo-soaked voice to croak passionately to good effect as the life-enhancing whore in **Never On Sunday**. The Greek-made picture, in which Miss Mercouri plied her trade on the colourful waterfront at Piraeus, was produced, directed and written by her husband, Jules Dassin. The latter also played (ineffectually) a pedantic American writer who tries to educate the prostitute to higher things. Needless to say, his attempt to be Pygmalion fails when faced with her exuberant hedonism. The meeting between the rationalist American and the sensualist Greek and, by extension, uptight America and easy-going Greece, was extremely naive and contrived. But it was one of the rare portrayals in the cinema of an unrepentant happy hooker. The Oscar-winning bouzouki music by Manos Hadjidakis and the star's ebullient performance were the two most noteworthy features that helped to make the $100,000 picture a tremendous box-office hit. Also taking part in supporting roles were native Greek actors Georges Foundas, Tito Vandis, Mitsos Liguisos and Despo Diamantidou. (MELINA FILMS)

△There was no better demonstration of the art of producer-director Billy Wilder than **The Apartment**, with its meticulously structured plot and dialogue (by Wilder and I.A.L. Diamond), a perfect blend of sweet and sour, tender and heartless, and the masterful comic timing. Audiences appreciated being treated as mature adults and paid over $5 million to see it. The crummy but convenient apartment of the title belonged to C.C. Baxter (Jack Lemmon, illustrated), a nebbish clerk in a mammoth New York insurance company. Exchanging his key for promotion, he allows his premises to be used as a meeting place for his married superiors and their girlfriends. One night, Baxter finds Fran Kubelik (Shirley MacLaine, illustrated), the company's elevator girl whom he fancies, unconscious in his apartment, following a suicide attempt because her lover, Head of Personnel J.D. Sheldrake (Fred MacMurray), refuses to divorce his wife. C.C. nurses Fran to recovery, finally resigns from his job in disgust, and wins the girl's hand and heart. Although the film was a mordant satire on business and private ethics, it examined human frailties with humour and understanding. Lemmon and MacLaine, as the schnook and the kook, worked stylishly together, she touching and vulnerable, he pathetic and amusing, as in the memorable moment when he strains spaghetti through a tennis racket. Excellent support came from Ray Walston, David Lewis, Jack Kruschen, Joan Shawlee and Edie Adams (screen debut). The picture gained ten nominations and won five Academy Awards including Best Picture – significantly, the last black-and-white film to do so – Screenplay and Director. (MIRISCH)

△**The Facts Of Life** professed to be a satire on American middle-class marriage, but the facts of box-office life turned it into a fluffy romantic comedy which came out heartily in favour of its so-called target. What else could be expected from a Bob Hope-Lucille Ball movie catering for the family entertainment market? With the two pros amiably wise-cracking and slapsticking, it succeeded on its own conventional level. The Norman Panama-Melvin Frank script had Hope and Ball (both illustrated) as suburbanites taken for granted by their respective spouses (Ruth Hussey and Don DeFore) and children. So they embark on an affair that remains unconsummated due to abortive meetings at motels, rained-out weekends, and the disconcerting trust of their families. The roving couple finally decide to end the relationship because of the problems and heartbreak divorce would cause. Also in it were Louis Nye, Philip Ober, Marianne Stewart, Peter Leeds, Hollis Irving, Louise Beavers and Mike Mazurki. Panama produced and Frank directed, keeping Bob and Lucy faithful to their fans. (H.L.P./PANAMA-FRANK)

▷A dust storm hung over the barren plains of the Texas Panhandle at the impressive beginning of **The Unforgiven**. Although the film did not lose its pictorial felicities (photography by Franz Planer in Panavision and Technicolor), it never lived up to the initial brooding atmosphere created by directed John Huston. The screenplay by Ben Maddow (from Alan Le May's novel) took up themes but failed to develop them, and the characters remained skin-deep despite a promising cast. Burt Lancaster (centre left) was sturdy and serious as the man who runs a ranch with his two younger brothers (Audie Murphy, right, Doug McClure, behind centre) and his partner (Charles Bickford). Also on the property were Lillian Gish (centre right), the mother of the boys, John Saxon as a half-breed hired hand, and Audrey Hepburn (left), an Indian girl adopted as a baby by the family and passed off as white. When the secret of her birth is revealed by saddle tramp Joseph Wiseman, the Kiowas want to reclaim her and the white community want her out. The problem was resolved in time-honoured Western fashion by a massacre of attacking Indians, and no pity was spared for the warrior who cried 'sister' as Hepburn shot him. Albert Salmi, June Walker, Kipp Hamilton, Arnold Merritt and Carlos Rivas had other roles. (JAMES/HECHT-HILL-LANCASTER)

▷Tennessee Williams' youthful play *Battle Of Angels* (1939) re-emerged on Broadway as *Orpheus Descending* in the 50s, and then on film under the title **The Fugitive Kind**. It starred Marlon Brando, who was paid a salary of over $1 million, the first star ever to receive such a sum. As Val Xavier, an itinerant guitarist, Brando, giving a mumbling, soporific performance, seemed to do as little as possible to earn his money. Director Sidney Lumet left the star (illustrated) to his own devices, and seemed to spend most of his time trying to help female leads Anna Magnani (illustrated) and Joanne Woodward in their unconvincing roles. It all took place in the small, steamy town of Two Rivers, Mississippi, which could well have been named Williams, Tennessee. Val arrives in town, carries on with Lady Torrance (Magnani), married to bed-ridden Jabe (Victor Jory), and Carol Cutrere (Woodward), a wealthy, sexually voracious dipso. That is, until he is run out of town by the brutal sheriff (R.G. Armstrong), leaving only his snakeskin jacket, one of the many symbols that cluttered the script by Meade Roberts and Williams. The Martin Jurow-Richard A. Shepherd production also cast Maureen Stapleton (as a visionary artist), Emory Richardson, Madame Spivy, Sally Gracie and Lucille Benson. (JUROW-SHEPHERD-PENNEBAKER)

◁In the fight for racial harmony, **Take A Giant Step** took a small step in the right direction. Singer Johnny Nash (illustrated) played a black youth lifted out of a slum environment by his parents (Frederick O'Neal and Beah Richards) and educated in a middle class New England town. Apart from the usual adolescent problems, he has to face racism from his white schoolmates. He leaves home and finds consolation with his ailing grandmother (Estelle Hemsley, illustrated) and sexual gratification with a housemaid (Ruby Dee), both of whom help his advance towards maturity. Philip Leacock's tentative direction sometimes managed to touch the emotions, but the awkward script by the producer Julius J. Epstein and Louis S. Peterson (from the latter's play) now seems a shade patronising. Other parts were taken by Ellen Holly, Pauline Meyers, Royce Wallace, Frances Foster and Dell Erickson. (SHEILA/HECHT-HILL-LANCASTER)

△The role of **Elmer Gantry**, the whoring, drinking, silver-tongued con man who turned his talents to making evangelism into big business, seemed made to measure for Burt Lancaster (illustrated). His efforts won him the Academy Award, although his grinning, enunciating and gesticulating mannerisms grew tiresome over 146 minutes. The Academy also erred by giving Shirley Jones the supporting actress Oscar for her unexceptional interpretation of Lulu Bains, the blowsy hooker, presumably because she had become identified with virginal roles. A third Oscar went to Richard Brooks' screenplay based on Sinclair Lewis' cynical 1927 novel on show biz-style evangelism, although Brooks softened the story and used only the first half of the book.

In his other capacity as director, Brooks managed to evoke much of the Midwestern atmosphere of the novel (aided by John Alton's Eastmancolor photography), as the revivalist group moved from place to place watched by sceptical newspaper-man Jim Lefferts (Arthur Kennedy). The cast also included Dean Jagger, Edward Andrews (George Babbitt), Patti Page, John McIntire, Joe Maross, Hugh Marlowe, Philip Ober and Rex Ingram. As Sister Sharon Falconer, Jean Simmons (the director's wife) gave the most subtle performance, leaving audiences wondering whether she believed in her vocation or not. No doubt about the faith of the public who paid over $3½ million to see the Bernard Smith production. (ELMER GANTRY PRODUCTIONS)

▷It was perfectly logical that **The Magnificent Seven** should have been adapted from Akira Kurosawa's *The Seven Samurai* (Toho, 1954), given that the Japanese director himself has acknowledged his debt to the Hollywood Western. A further link with the earlier film was made by casting the oriental-looking Yul Brynner as the leader of a gang of mercenaries hired to protect a Mexican mountain village from marauding bandits. William Roberts' screenplay ingeniously transposed the traditional Japanese samurai genre to the traditional Hollywood genre, but lost the social background of the characters on the way. As producer-director John Sturges was more interested in showing their lethal skills, the development of their self-sacrificial idealism seemed contrived. However, it was the action and the charisma of the stars that had the public clamouring to see it. Apart from Brynner (left), the other heroes – illustrated from left to right – were Steve McQueen, Horst Buchholz (US screen debut), Charles Bronson, Robert Vaughn, Brad Dexter and James Coburn facing up to grinning, sadistic Eli Wallach and his cronies. The movie, in De Luxe Color and Panavision, boosted the careers of McQueen, Coburn and Bronson, and led Wallach to be cast as the heavy in Spaghetti Westerns a few years later. Three far from magnificent sequels followed – *The Return Of The Seven* (1966), *Guns Of The Magnificent Seven* (1969) and *The Magnificent Seven Ride* (1972). (MIRISCH-ALPHA)

▽A war movie without a single battle scene and only a few exteriors sounds interesting, even experimental, but **The Gallant Hours** was merely dull and conventional. Ex-movie star Robert Montgomery (he retired from the screen in 1950) produced and directed this obviously sincere tribute to Admiral 'Bull' Halsey, the commander of the South Pacific area during World War II. James Cagney (illustrated) did his best to make this paragon (as written by Beirne Lay Jr and Frank D. Gilroy) into a believable human being, but the heavenly choir on the soundtrack sabotaged his efforts. Halsey directs his operations in Guadalcanal, and despite the loss of US men and ships, the battles paved the way for final victory over the Japanese. This hagiopic was disguised as reality by a narration and the documentary approach of the director (who made an unbilled cameo appearance). Also in uniform were Dennis Weaver, Ward Costello, Richard Jaeckel, Les Tremayne, Robert Burton, Carl Benton Reid, Walter Sande, Raymond Bailey and Karl Swenson. (CAGNEY-MONTGOMERY)

△If drama is conflict, then **Tunes Of Glory** was drama *par excellence* – up to a point. The conflict existed between stoical disciplinarian Colonel John Mills, ex-Eton and Oxford, and wild, hard-drinking red-haired Colonel Alec Guinness, a man who has risen from the ranks. The former has arrived in Scotland to replace Guinness as commander of a Highland regiment. The stark character contrast was well drawn in James Kennaway's screenplay (from his own novel), and by the two riveting actors, particularly Mills in the less showy part. Director Ronald Neame effectively caught the tensions, intrigues and jealousies in the confined officer's quarters

where the drama comes to a head after Guinness (standing foreground) strikes soldier John Fraser in a pub because he objects to the young man seeing his daughter (Susannah York, making her film debut). Mills, faced with the task of court-martialling the popular Guinness, is despised by his fellow officers, and ends up taking his own life. Guinness, filled with remorse, starts seeing ghosts and the picture lost its grip. The supporting cast featured Dennis Price (front left), Gordon Jackson (front right), Kay Walsh, Duncan Macrae and Alan Cuthbertson, playing to type. The production by Colin Lesslie was filmed in Technicolor. (KNIGHTSBRIDGE)

◁John Wayne (centre) said he produced and directed **The Alamo** 'to remind people, not only in America but elsewhere, that there were once men and women who had the guts to stand up for the things they believed.' Large audiences had the guts to sit through 193 minutes of this long-winded saga, in Todd-AO and Technicolor, paying nearly $7½ million to see an amalgam of every Wayne movie ever made. James Edward Grant's screenplay recounted the tale of the gallant 180 Texans who stood up against the 3000 men of the Mexican army in March 1836. Among the defenders of Fort Alamo were frontiersmen Davy Crockett (Wayne), legendary scout Jim Bowie (Richard Widmark) and the commander of the post, Colonel William Travis (Laurence Harvey). Everyone at the fort is annihilated, but their sacrifice gives General Sam Houston (Richard Boone) time to train an army to defeat the enemy and gain independence for Texas. On its rambling way towards the spectacular climactic massacre, there were the usual personality clashes, barroom brawls, homespun philosophy, flirtations and ballads (sung anachronistically by 60s pop star Frankie Avalon, left). Also cast: Linda Cristal, Chill Wills (right), Patrick and Aissa Wayne (two of Big John's offspring), Joseph Calleia, Carlos Arruza, Joan O'Brien and Ken Curtis. (BATJAC/ALAMO)

▽Jewish comedian Mort Sahl, invited by producer-director Otto Preminger to the preview of the 220 minute epic **Exodus**, stood up after three hours and said, 'Otto, let my people go!' Audiences who paid over $7 million to see it, seemed to enjoy the length and never mind the quality. Dalton Trumbo's simplistic all-things-to-all-men script, based on Leon Uris' 600 page best-seller about the birth of Israel, was filmed by Preminger in Technicolor and Super Panavision, but with little passion, depth or sweep. What it had were stereotypes, sanctimony and schmaltz. And plenty of stars. Paul Newman (illustrated) was Ali Ben Canaan, an idealistic Zionist freedom fighter (or terrorist), Eva Marie Saint a non-Jewish nurse who falls for Newman's blue eyes and his cause; Ralph Richardson and Peter Lawford were British officers trying to frustrate that cause, Sal Mineo a fanatic who blows up the King David Hotel, David Opatoshu a chess-playing terrorist, and Jill Haworth (an ineffectual Preminger discovery) a young German Jewish girl killed during a raid and buried with John Derek, a passive and therefore good Arab. Also around were Lee J. Cobb, Hugh Griffith, Gregory Ratoff, Felix Aylmer, Alexandra Stewart, Martin Benson, Martin Miller and Marius Goring. The Oscar-winning Ernest Gold score tried to give the picture an uplift it otherwise lacked. (CARLYLE/ALPHA)

△Robert Mitchum gave a fair imitation of an Irish accent in **Night Fighters** (GB: **A Terrible Beauty**), as he would do ten years later in *Ryan's Daughter* (MGM). His hood-eyed underplaying came as a relief from the brawlin', drinkin' and singin' 'Oirish' types around him, played by genuine native actors. The plot had Mitchum (kneeling, centre), risking the disapproval of his fiancee Anne Heywood and friend Cyril Cusack, is persuaded by hothead Richard Harris to join the IRA. He soon becomes disillusioned with their fanatical club-footed leader, Dan O'Herlihy (right), and turns informer. Captured by his former colleagues, the dubious hero is rescued and escapes to England. Most of Robert Wright Campbell's screenplay (from the Arthur Roth novel) trod familiar ground, the wordy and specious considerations of IRA motives bogging down some brisk action. Veteran Hollywood director Tay Garnett shot the picture for producer Raymond Stross in and around the Ardmore Studio in Dublin. Others in it were T.P. McKenna (left), Marianne Benet, Niall Macginnis, Harry Brogan, Eileen Crowe and Hilton Edwards. (RAYMOND STROSS/DRM)

△James T. Farrell objected strongly to **Studs Lonigan**, the filmization of his famous trilogy of novels written in the 30s. Most critics and audiences felt the same way. Philip Yordan (who also produced) tried to compress the 700 pages of the books into a screenplay of 103 minutes, and tacked on a happy ending. It was helped neither by Irving Lerner's arty direction, nor the limited capabilities of newcomer Christopher Knight (right) in the title role. Studs, the teenage Irish-American 'pool room bum', against the wishes of his parents (Dick Foran and Katherine Squire), hangs around with his pals, Kenny Killarney (Frank Gorshin), Paulie (Robert Casper) and Weary Reilly (Jack Nicholson unremarked in his fourth movie). Unlike the novel, which ends with the hero's death, he marries the girl (Carolyn Craig) he got pregnant, after a sermon from lovable Father Gilhooey (Jay C. Flippen, left). Other characters were played by Helen Westcott, Venetia Stevenson, Kathy Johnson, Jack Kruschen, Madame Spivy and Suzi Carnell. A redeeming feature was Jack Poplin's art direction which captured the look of Chicago in the 20s. (LONGRIDGE)

▽The subject of producer Stanley Kramer's **Inherit The Wind** was the famous 'Monkey Trial' which took place in 1925 in Dayton, Tennessee in which school-teacher John T. Scopes was accused of breaking the State law by teaching Darwin's theory of evolution. In Nathan E. Douglas and Harold Jacob Smith's screenplay (based on the play by Jerome Lawrence and Robert E. Lee), the name of the town was changed to Hillboro, the teacher to Bertram Cates (Dick York), and Clarence Darrow, defence counsel, William Jennings Bryan, the prosecutor, and H.L. Mencken, the newspaper reporter were thinly disguised as Henry Drummond (Spencer Tracy, illustrated), Matthew Harrison Brady (Fredric March) and E.K. Hornbeck (Gene Kelly). The battle that takes place in the stifling courtroom came down to a battle between Tracy and March for the top acting honours. Tracy's Oscar-nominated eloquent underplaying won over March's febrile overplaying, just as the latter's character lost the edge in the trial. Effective support came from Florence Eldridge (Mrs March playing Mrs Brady), Donna Anderson, Claude Akins, Elliott Reid, Harry Morgan, Philip Coolidge, Noah Beery Jr, Renee Godfrey and Ray Teal (behind Tracy). Kramer's rather commonplace direction was enhanced by Ernest Laszlo's camerawork (another of the Oscar nominations) and Ernest Gold's score which contained a vigorous rendering of 'Old Time Religion'. (LOMITAS)

The Boy And The Pirates
A contemporary youngster is transported back through time by means of a genie to Blackbeard's pirate vessel. Charles Herbert, Susan Gordon, Murvyn Vye, Paul Guilfoyle, Joseph Turkel. *Dir & Pro* Bert I. Gordon Eastmancolor. BERT I. GORDON

Cage of Evil
A crooked cop and his blonde accomplice organize the jewel robbery which he is then later assigned to investigate. Ronald Foster, Pat Blair, Harp McGuire, John Maxwell, Preston Hanson. *Dir* Edward L. Cahn. *Pro* Robert E. Kent. ZENITH

The Chaplin Revue
An omnibus version of *A Dog's Life* (1918), *Shoulder Arms* (1918) and *The Pilgrim* (1922), each introduced in a few words by their star and director, Charles Chaplin. *Dir & Pro* Charles Chaplin. CHAPLIN

Gunfighters Of Abilene
A gunslinger avenges the murder of his brother in a final showdown with a megalomaniac landowner. Buster Crabbe, Barton MacLane, Judith Ames, Russell Thorson, Lee Farr. *Dir* Edward L. Cahn. *Pro* Robert E. Kent. VOGUE

Macumba Love
A writer visits a South American island to unmask murderous practitioners of voodoo, only to find he is marked down as a voodoo victim. Walter Reed, Ziva Rodann, William Wellman Jr, June Wilkinson, Ruth de Souza. *Dir & Pro* Douglas Fowley. Eastmancolor. (USA/Brazil). ALLIED ENTERPRISES

A Matter Of Morals
An American bank official in Stockholm gets romantically involved with a client's sister-in-law, which leads to his moral decline. Patrick O'Neal, Mogens Wieth, Maj-Britt Nilsson, Eva Dahlbeck, Class Thelander. *Dir* John Cromwell, *Pro* Steven G. Hopkins, John D. Hess. (Sweden/USA) FORTRESS

The Music Box Kid
A gang leader's religious wife is persuaded by a priest to inform on him. Ronald Foster, Luana Patten, Grant Richards, Johnny Seven, Carl Milletaire. *Dir* Edward L. Cahn. *Pro* Robert E. Kent. PREMIUM

Noose For A Gunman
A gunslinger is asked by a town to become marshal and save it from a notorious outlaw bent on robbery. Jim Davis, Lyn Thomas, Ted de Corsia, Walter Sande, Barton MacLane. *Dir* Edward L. Cahn. *Pro* Robert E. Kent. PREMIUM

Oklahoma Territory
A villainous railroad agent frames a Cherokee Indian chief for murder in order to stir up the Indians to war. Bill Williams, Gloria Talbott, Ted de Corsia, Grant Richards, Walter Sande. *Dir* Edward L. Cahn. *Pro* Robert E. Kent. PREMIUM

Police Dog Story
A rookie policeman is sent to the Police Dog Training School with a half-wild German Shepherd. They become a successful team and later capture an arson gang together. Jim L. Brown, Merry Anders, Barry Kelley, Milton Frome, Vinton Hayworth. *Dir* Edward L. Cahn. *Pro* Robert E. Kent. ZENITH

The Pusher
Two police officers who are investigating the murder of a young narcotics addict, discover the murderer through the daughter of one of the officers, the connection being that she herself is an addict. Kathy Carlyle, Felice Orlandi, Douglas F. Rodgers, Sloan Simpson, Robert Lansing. *Dir* Gene Milford. *Pro* Gene Milford, Sidney Katz. MILFORD/CARLYLE

Three Came To Kill
Three hoodlums accept an assignment to assassinate a mid-Eastern politician who is on a visit to Los Angeles. Cameron Mitchell, John Lupton, Steve Brodie, Lyn Thomas, Paul Langton, *Dir* Edward L. Cahn. *Pro* Robert E. Kent. PREMIUM

Vice Raid
A cop framed by racketeers and dismissed from the force, gets himself reinstated by cornering the mob himself with the help of a blonde model. Mamie Van Doren, Richard Coogan, Brad Dexter, Barry Atwater, Carol Nugent. *Dir* Edward L. Cahn. *Pro* Robert E. Kent. IMPERIAL

The Walking Target
An ex-con sets out to find money hidden after a payroll robbery, but is persuaded to turn it over to the police by the widow of his former accomplice. Joan Evans, Ronald Foster, Merry Anders, Harp McGuire, Robert Christopher, *Dir* Edward L. Cahn. *Pro* Robert E. Kent. ZENITH

UNITED ARTISTS

1961

▷Producer-director Billy Wilder's **One, Two, Three** was a splendidly sustained quick tempo comedy in which James Cagney (before retiring from films for 20 years) gave a virtuoso verbal machine-gun performance. The satiric screenplay by Wilder and I.A.L. Diamond (derived partly from a Ferenc Molnar one-act play) spared nothing and nobody. Sexually repressed sober-suited Russians, heel-clicking greedy West Germans, vulgar Americans, Southern belles, dumb blondes, communists, capitalists, and even Coca Cola were mowed down. Cagney (illustrated) was C.R. MacNamara, an American executive in West Berlin trying to sell Coke to the Russians. He and his wife (Arlene Francis) are chaperones to his boss's empty-headed daughter Scarlett Hazeltine (Pamela Tiffin) who has got herself married to Otto Piffl (Horst Buchholz), an East German communist. How he is converted rapidly into an aristocrat and a capitalist before her parents (Howard St John and Lois Bolton) arrive, was the main thrust of the wild action. Despite the national stereotypes, the now-dated topical jokes, and occasional crassness, much of the film was nonetheless outrageously funny. Also in the delightful cast were Hans Lothar, Lilo Pulver, Leon Askin, Red Buttons, and Hubert von Meyerinck as the wonderfully named Count von Droste-Schattenburg, a lavatory attendant. (MIRISCH/PYRAMID)

▷Although **Paris Blues** was shot in France with a French crew by director Martin Ritt, who showed some influence of the French New Wave on his style, it was fairly familiar Hollywood material, albeit with a thin skein of social consciousness running through it. Jack Sher, Irene Kamp and Walter Bernstein's tame script (from the Harold Flender novel) dealt with four Americans in Paris. Paul Newman (standing) and Sidney Poitier (seated) were the expatriate jazz musicians who play every night in a Left Bank club, and who pair off with tourists Joanne Woodward and Diahann Carroll respectively. After much talk in cafes and during frequent strolls around the city, Newman and the two women decide to return to the States, while Poitier promises to follow soon in order to help them break down racial barriers back home. The undernourished tale was beefed up by the moody Duke Ellington score, and jam sessions in smoky cellars, some of them featuring Louis Armstrong. Also cast for producer Sam Shaw were Serge Reggiani, Barbara Laage, Andre Luguet, Roger Blin, Marie Versini and Moustache. (PENNEBAKER/DIANE/JASON/MONICA/MONMOUTH)

◁**Goodbye Again** was a movie described by *Variety* as having 'strong appeal for a middle-aged distaff audience'. In other words, a 'woman's picture', a discredited genre (sometimes unfairly so) that can offer far more apt examples than this superficially sophisticated soap produced and directed by Anatole Litvak. The 'middle-aged distaff audience' might have enjoyed seeing wealthy Ingrid Bergman, dressed by Dior, falling for wealthy younger man Anthony Perkins while her lover of five years, wealthy businessman Yves Montand, is abroad. When Montand returns, he gives up his cherished freedom and makes an honest woman of her as she tearfully gives up Perkins. It was all enacted in an elegantly photographed Paris of dinners at Maxim's, smart hotels, chic apartments and fast sports cars. Miss Bergman (illustrated) brought some reality into the spurious screenplay by Samuel Taylor (based on Francoise Sagan's threadbare novel *Aimez-Vous Brahms?*), while Montand and Perkins (illustrated) did their man-of-the-world and boyish bits respectively. Support came from Jessie Royce Landis, Pierre Dux, Peter Bull, Uta Taeger, Lee Patrick, Diahann Carroll and Alison Leggatt. (MERCURY/LITVAK/ARGUS)

▽Despite a veneer of social responsibility, **Town Without Pity** was an exploitation picture with an oft-repeated rock 'n' roll title song (sung by Gene Pitney), and a salacious interest in rape, torn bikinis and Peeping Toms. Basically a straightforward courtroom drama, the script by Silvia Reinhardt, Georg Hurdalek and Jan Lustig (from Manfred Gregor's novel *The Verdict*) concerned the trial of four GI's (Robert Blake, Richard Jaeckel, Frank Sutton and Mal Sondock) accused of raping a local teenage girl (Christine Kaufmann, illustrated) in the small German town where they are stationed. Major Kirk Douglas (illustrated), the appointed defence attorney, begins his investigation by probing into the girl's life. He breaks her down in the witness box, proving that she is not as pure as she makes out. The GI's are found guilty, but are saved from the death penalty. Soon after the trial, the girl kills herself, and Douglas leaves the town in hollow triumph. Hollow too were the heavy expressionistic techniques used by the producer-director Gottfried Reinhardt. Others in the picture, shot in Germany, were Barbara Rutting, Hans Nielsen, Karin Hardt, Ingrid van Bergen and Gerhart Lippert. (MIRISCH/GLORIA)

▽The genuine Aussies in **Season Of Passion** (GB: **Summer Of The Seventeenth Doll**) – Vincent Ball, Ethel Gabriel, Janette Craig, Deryck Barnes, Tom Lurich and Al Thomas – all took minor roles and, although shot in Australia, not much else was genuine in this stagey comedy-drama produced and directed by Leslie Norman. Adapted by John Dighton from Ray Lawler's hit play, the movie was less raunchy and gritty than the original, as it told of the five months annual layoff of canecutters who return to their women after seven months work. In this 17th summer, Roo (Ernest Borgnine, illustrated) returns to find his girl Olive (Anne Baxter, illustrated) wanting more from him than the dolls he brings her as a token each year, and Barney (John Mills) finds his sweetheart has got married and left Pearl (Angela Lansbury) as a substitute. Mills and Lansbury made the more plausible couple, but audiences would have to wait over a decade for the real Australian cinema to come into its own. (HECHT-HILL-LANCASTER)

▽After tackling the subject of nuclear annihilation in *On The Beach* (1959), producer-director Stanley Kramer, nothing if not ambitious, made **Judgement At Nuremberg**. Abby Mann's long-winded, heavily polemical (Oscar-winning) script, vastly expanded from his 1959 teleplay, dealt with the trial in 1948 of four German judges (Burt Lancaster (seated, centre), Werner Klemperer, Martin Brandt and Torben Meyer) accused of crimes against humanity. Among the 'star' witnesses were an emotional Judy Garland as a dumpy *hausfrau* persecuted by the Nazis for having had relations with a Jew, an overwrought and mannered Montgomery Clift as a victim of sterilization, and an irrelevant but elegant Marlene Dietrich as the aristocratic widow of a Nazi general. For 190 minutes the arguments were shouted around the court, calmly presided over by Spencer Tracy, who had the last, self-righteous, word in the matter. Richard Widmark's belligerent prosecutor (left) was curiously less sympathetic than Maximilian Schell's defence attorney (seated, right). Despite Kramer's elementary direction, the film must be commended for attempting to analyse one of the great issues of the century and it was presumably informative to some of the public who paid over $3½ million to see it. Also in it were John Wengraf, Ray Teal, Alan Baxter, Virginia Christine and William Shatner. (ROXLOM)

▽**The Young Doctors** was full of the usual operating theatre theatricals, the staple diet of TV medical soaps over the years. Joseph Hayes' script (from Arthur Hailey's novel *The Final Diagnosis*) contained a Dr Kildare/Dr Gillespie type personality clash, romantic involvements between medics and nurses, a baby's life saved, and a leg amputated. Ben Gazzara (standing, left) was the new young pathologist who arrives at Three Counties Hospital as assistant to the ageing Dr Fredric March (seated, left), and they're soon at loggerheads over two cases, the first concerning the treatment of Phyllis Love, the pregnant wife of intern Dick Clark (centre), and the other about the possible cancer of student nurse Ina Balin, Gazzara's girlfriend. Naturally, they end up respecting one another. Phil Karlson's direction, however, had little respect for structure or coherence. Old doctors March, Eddie Albert (right) and Aline MacMahon had better written roles than their younger colleagues. Others in white coats or otherwise were Edward Andrews, Arthur Hill, Rosemary Murphy, Bernard Hughes, Joseph Bova, Matt Crowley and George Segal (his screen debut). Producers Stuart Miller and Lawrence Turman found the right prescription for a healthy box-office. (DREXEL/MILLER-TURMAN)

△Juvenile delinquency was the fashionable theme of **The Young Savages**, although producer Pat Duggan threw in many more themes for the price of one – political corruption, newspaper ethics, bad housing and racial intolerance. There was also a courtroom drama and the romantic problems of an assistant DA (Burt Lancaster, left) with his socialite wife (Dina Merrill) and old flame (Shelley Winters), the whole ending with a big, banal message rammed home by director John Frankenheimer. The screenplay (by Edward Anhalt and J.P. Miller from Evan Hunter's novel *A Matter Of Convic-*

tion) had Lancaster prosecuting three teenagers (John Davis Chandler, Neil Nephew, Stanley Kristien) for fatally stabbing a blind Puerto Rican boy. A product of the same slums as the accused, Lancaster decides to throw away his political ambitions and produces vital evidence to exonerate one of the boys. Overloaded as it was, this East Side Story benefited from sincere playing by the younger members of the cast, and Lionel Lindon's graphic photography. Jody Fair, Pilar Seurat, Vivien Nathan, Edward Andrews, Larry Gates, Chris Robinson and Telly Savalas (as a cop) had supporting roles. (CONTEMPORARY)

▽After Yuri Gagarin became the first man in space, the Americans came back with their first man-piloted rocket ship called, unimaginatively, **X-15**, and celebrated by this semi-documentary in Panavision and Technicolor. Narrator James Stewart tried to explain the technical details of the flight to a lay audience, while Charles Bronson (right), James Gregory, David McLean, Ralph Taeger, Brad Dexter (left), Kenneth Tobey and Phil Dean went through the motions of pretending to be assorted astronauts and boffins. The hackneyed James Warner Bellah script added the usual quota of waiting wives and girlfriends, among them Mary Tyler Moore (her first film), Patricia Owens and Lisabeth Hush. The direction of TV recruit Richard Donner, making his first feature, never got off the ground. (He did far better 17 years later with *Superman*, WB). Tony Lazzarino, who co-produced with Henry Sanicola, wrote the story. (ESSEX)

▽Despite its mildly provocative title, **The Hoodlum Priest** was mostly a routine crime melo which would have starred Pat O'Brien in the 30s. Now, it fell to Don Murray (right) to play the Reverend Charles Dismas Clark, an actual Jesuit priest known for his work with ex-cons in St Louis. The rather formless screenplay by Joseph Landon and Don Deer (really Don Murray) concentrated on the priest's attempts to keep young Billy (Keir Dullea, seated left, in an impressive film debut) out of trouble. On release from prison, the boy is given a job and finds a steady girl (Cindi Wood). Unfortunately, Billy is unfairly sacked and attempts to rob the firm's safe and kills a man when interrupted. Panic-stricken, he takes refuge in a derelict building from which Father Clark persuades him to come out. Despite the pleas for mercy, the boy is sent to the gas chamber. Although Irvin Kershner's direction tried a restrained documentary approach, Murray's movie-star good looks and dollops of do-good philosophy made it less effective than it might have been. Don Joslyn, Larry Gates, Logan Ramsey, Sam Capuano, Lou Martini, Al Mack and Vince O'Brien had other parts in the Don Murray-Walter Wood production. (MURRAY-WOOD)

△**West Side Story** opened with a now famous helicopter shot of Manhattan, the camera zooming in on the finger-snapping American-born youths of The Jets, sworn enemies to The Sharks, a Puerto Rican gang. However, the filming on location on West 64th Street, only emphasized the unreality of a gang dancing balletically down the streets. The 1959 landmark Broadway hit, an essentially theatrical mixture of opera, ballet, musical and social drama, had worked better on stage. The Panavision 70-Technicolor close-ups also revealed that the teenage gang members were played by cleancut dancers aged between 22 and 30. The dubbing of the voices of Natalie Wood and Richard Beymer (both illustrated) as Maria and Tony, the doomed lovers from opposing factions, made for a certain artificiality, and the toothy Beymer in

particular was vapid and uneasy in his mawkish role. But Leonard Bernstein's music remained as tuneful and dynamic as ever, and Stephen Sondheim's lyrics came over brilliantly in the two humorous numbers, 'Gee, Officer Krupke' and 'America', the latter danced and sung with panache by Rita Moreno, George Chakiris and chorus. As in the theatre, it was the choreography of Jerome Robbins, who received co-director's credit with producer Robert Wise, and the vigorous dancing that dominated the Oscar-winning (ten of them) movie. One of them went to screenwriter Ernest Lehman, who adapted the Arthur Laurents book, inspired by Shakespeare's *Romeo And Juliet*. The $11 million grosser also cast Russ Tamblyn, Jose de Vega, Tucker Smith, Tony Mordente, David Winters and Simon Oakland. (MIRISCH/SEVEN ARTS)

▷**The Misfits** had the smell of doom about it. It was the final film of two Hollywood legends, Clark Gable and Marilyn Monroe. Gable, whose death was said to have been hastened by the strenuous roping of stallions demanded by the role, died a few weeks after the picture was completed, and Monroe's suicide followed less than a year later. Her husband, Arthur Miller, wrote the original screenplay for her, but their marriage was disintegrating during the fraught filming of the picture, and they were divorced a week after the premiere. Miller's heavily symbolic and self-pitying parable told of three failed men who come together in the Nevada desert to catch wild mustangs to be slaughtered for dog food. They are an ageing cowboy (Gable, left), a broken bronco-buster (Montgomery Clift), and a former wartime pilot (Eli Wallach, centre). Their values are put into perspective by the tender-hearted young divorcee (Monroe, right) who is repelled by their job. John Huston's direction only underlined the script's pretentious solemnities, despite some superbly shot visual set pieces such as the final roundup, backed by Alex North's rousing music. However, the valedictory performances of Gable and Monroe were among the best things they ever did. Completing the cast were Thelma Ritter, James Barton (his last picture too), Estelle Winwood and Kevin McCarthy. The Frank E. Taylor production grossed nearly $4 million. (SEVEN ARTS)

▽**A Cold Wind In August** was a refreshing new look at the older woman-younger man theme, told with more sensuousness than was customary at the time. It began with the 17-year-old janitor's son (Scott Marlowe, illustrated) being sent to the apartment of a thrice-married stripper (Lola Albright, illustrated) to mend her air-conditioner during a sweltering New York summer. She gets the hots for him and, without the boy knowing of her past or profession, a genuine relationship develops between them, only disturbed by his father (Joe De Santis), her recent industrialist lover (Herschel Bernardi), and her last husband (Clark Gordon) who gets her to make an appearance at a burlesque hall. Some of her young lover's friends find out, and take him to the show where his illusions about her are cruelly shattered. Bernard Wohl's screenplay (from his own novel) functioned well, thanks to the truthful performances of the two leads and the perceptive direction by Alexander Singer, making his first feature. Also in this Phillip Hazelton low-budget production were Janet Brandt, Skip Young, Ann Atmar and Jana Taylor. Despite the favourable critical and public response, the careers of Albright (Hollywood supporting actress of long standing), Marlowe (ex-Actors' Studio) and Singer (ex-assistant to Stanley Kubrick) went nowhere. (TROY)

△Gary Cooper, aged 60, died of cancer a month before **The Naked Edge** was released, thus sparing him the justified lambasting the picture received. Josef Stafano, who had scripted *Psycho* (Paramount, 1960), wrote the corny screenplay (based on Max Ehrlich's novel *First Train To Babylon*) which only Hitchcock could have made work. As it was, director Michael Anderson pulled out a collection of outworn thriller tricks such as close-ups of eyes and sweat, tilted camerawork, overworked eerie music, and a hysterical heroine trapped alone in her palatial home with an unseen killer. Deborah Kerr (2nd left) was the lady convinced that her businessman husband (Cooper, left) is a murderer, since she found out that he is being blackmailed by shady Eric Portman, who claims to have seen him kill a man. Poor Gary Cooper moved through the unsurprising London settings looking distinctly disquieted. And who could blame him! Thankfully, there were some amusing smaller roles: Hermione Gingold was the dotty patroness of effeminate playwright Sandor Eles, and Wilfred Lawson a porno book collector. The Walter Seltzer-George Glass production also got good support from Michael Wilding, Diane Cilento (2nd right), Ray McAnally (right), Peter Cushing, Ronald Howard, Helen Cherry, Joyce Carey and Diane Clare. (PENNEBAKER/GLASS-SELTZER/BARODA/JASON/MONICA/MONMOUTH/BENTLEY)

▽Lana Turner continued her reign as mature queen of glossy prurient soap operas in **By Love Possessed**, suffering glamorously in an array of stunning gowns. The score (by Elmer Bernstein) and the settings were further lush accompaniments to the trashy goings-on directed with uncertainty by John Sturges. The screenplay by John Dennis (from James Gould Cozzens' novel) had Lana (illustrated) married to impotent Jason Robards Jr. She seeks solace in drink, horse-riding and moonlight trysts with her husband's law partner, Efrem Zimbalist Jr (illustrated). 'I don't want this night to end,' says Lana stroking her lover's head. It does, however, because Efrem has to face his son George Hamilton ('Dad, we sort of talk at each other. We don't communicate.') whose fiancee Susan Kohner has killed herself by drinking cleaning fluid, and who is charged with raping the town trollop, Yvonne Craig. On top of which, Efrem's father-in-law, Thomas Mitchell, is guilty of embezzlement. Surrounded by this mayhem of immorality and neurosis, only Barbara Bel Geddes as Efrem's estranged wife brought some calm into the fraught proceedings. Also cast in the Walter Mirisch production (filmed in De Luxe Color and Panavision) were Everett Sloane, Jean Willes, Frank Maxwell, Gilbert Green and Carroll O'Connor. (MIRISCH/SEVEN ARTS)

▽Frank Capra's farewell film, **Pocketful Of Miracles**, was an inglorious attempt to remake his earlier success *Lady For A Day* (Columbia, 1933) in Panavision and Technicolor, and this time pitching it into the 'swinging sixties'. Not only was the fairytale world of warm-hearted gangsters and lovable socialites a faded one, but Capra's direction was heavy-handed and sadly short on invention. The spirit of the original Damon Runyon story, *Madama La Gimp*, which had served admirably for Robert Riskin's screenplay for the earlier film, was coarsened and oversentimentalized in Hal Kanter and Harry Tugend's reworking of it. It told of how Apple Annie (Bette Davis, left), a hawker round Broadway, makes her daughter (Ann-Margret in her screen debut) in Spain believe she's a high society lady. When the girl writes home to mother to say she is bringing her fiance (Peter Mann) and his father Count Romero (Arthur O'Connell) to New York, Annie is desperate. But thanks to bootlegger Dave the Dude (Glenn Ford, right), his girl Queenie (Hope Lange, centre), the Governor (David Brian) and the Mayor (Jerome Cowan), Annie is dramatically transformed into a dowager with her own penthouse. The picture was given something of a perk by a fine array of supporting players such as Peter Falk, Thomas Mitchell, Edward Everett Horton, Sheldon Leonard, Barton MacLane, Fritz Feld, Jack Elam, Benny Rubin and Snub Pollard. In his autobiography, Capra petulantly blamed Glenn Ford's performance for his production's failure. (FRANTON)

△Robert Mitchum's career has been a series of highs and lows, and **The Last Time I Saw Archie** was plainly in the latter category. However, his performance was a masterpiece of subtlety amidst the overplaying of those around him including Martha Hyer, Louis Nye, James Lydon, Del Moore, Joe Flynn, Don Knotts, Robert Strauss, Harvey Lembeck and his own son, Jim Mitchum (right). The broad service comedy had Mitchum and co-star Jack Webb (who also produced and directed) enlisted in an army-air force unit for over-age civilian pilots during World War II. A slick con man, Mitchum has the entire outfit believing he's really a general in disguise on the trail of a Japanese girl spy (France Nuyen) who is, in fact, the ward of the colonel (Richard Arlen). After the war, Mitchum (centre) becomes head of a film studio, and Webb (left) a Hollywood scriptwriter – hopefully a better one than William Bowers, who scripted this offering. Webb's direction was on a dismal par with his acting – flat and pointless. (MARK VII/MANZANITA/TALBOT)

OTHER RELEASES

Boy Who Caught A Crook
A boy, a tramp and a puppy track down a gangster, after the boy has found a briefcase stuffed with loot. Wanda Hendrix, Roger Mobley, Don Beddoe, Richard Crane, Johnny Seven. *Dir* Edward L. Cahn. *Pro* Robert E. Kent. HARVARD

The Cat Burglar
A burglar steals a briefcase containing a secret formula which the owner had planned to sell to a foreign power. Jack Hogan, June Kenney, John Baer, Gregg Palmer, Will White. *Dir* William N. Witney. *Pro* Gene Corman. HARVARD

The Clown And The Kid
When a clown dies, his small son forms a circus act with an escaped convict. The latter falls in love with the amusement park owner. John Lupton, Mike Mc-Greevey, Don Keefer, Mary Webster, Mary Adams. *Dir* Edward L. Cahn. *Pro* Robert E. Kent. HARVARD

The Explosive Generation
Three high school students get their teacher reinstated after he's been suspended for introducing sex education into the class. William Shatner, Patty McCormack, Lee Kinsolving, Billy Gray, Steve Dunne. *Dir* Buzz Kulik. *Pro* Stanley Colbert. VEGA

Five Guns To Tombstone
A reformed gunman is framed by his escaped convict brother, and thus finds himself pushed into renewed lawlessness. James Brown, John Wilder, Walter Coy, Robert Karnes, Joe Haworth. *Dir* Edward L. Cahn. *Pro* Robert E. Kent. ZENITH

The Flight That Disappeared
Three nuclear scientists on a plane suddenly find themselves on trial by people of the future who will remain unborn if the earth is destroyed by the scientists' work. Craig Hill, Paula Raymond, Dayton Lummis, Gregory Morton, John Bryant. *Dir* Reginald Le Borg. *Pro* Robert E. Kent. HARVARD

Frontier Uprising
Two trappers join a wagon train headed for California, which is attacked by Indians armed by the Mexicans. James Davis, Nancy Hadley, Ken Mayer, Nestor Paiva, Don O'Kelly. *Dir* Edward L. Cahn. *Pro* Robert E. Kent. ZENITH

The Gambler Wore A Gun
Ironic tale of a gambler who buys a ranch, only to find that rustlers are using it as a cover for their activities. James Davis, Merry Anders, Mark Allen, Addison Richards, Don Dorrell. *Dir* Edward L. Cahn. *Pro* Robert E. Kent. ZENITH

Gun Fight
Two brothers, one good, one bad, clash until the latter reforms and dies nobly and the former finds himself a wife. James Brown, Joan Staley, Gregg Palmer, Ron Soble, Ken Mayer. *Dir* Edward L. Cahn. *Pro* Robert E. Kent. ZENITH

Gun Street
A sheriff goes in pursuit of a gunman who finally dies from gunshot wounds obtained while making his escape. James Brown, Jean Willes, John Clarke, Med Flory, John Pickard. *Dir* Edward L. Cahn. *Pro* Robert E. Kent. HARVARD

The Minotaur (GB: **Warlord Of Crete**, orig **Teseo Contro Il Minotauro**)
Theseus frees Crete from the Minotaur and from the evil domination of Princess Phaedra. Bob Mathias, Rosanna Schiaffino, Alberto Lupo, Rik Battaglia. *Dir* Silvio Amadio. *Pro* Giorgio Agliani. Technicolor. (Italy) AGLIANI-MORDINI/ILLIRIA

Operation Bottleneck
A seven-man paratroop team, aided by girl guerillas, carries out a mission in Burma against the Japanese at the cost of all but one of their number. Ronald Foster, Miiko Taka, Norman Alden, John Clarke, Ben Wright, Dale Ishimoto. *Dir* Edward L. Cahn. *Pro* Robert E. Kent. ZENITH

The Revolt Of The Slaves (orig: **La Rivolta Degli Sciavi**)
In Ancient Rome, a slave and the beautiful daughter of a rich patrician fall in love, become Christians, and manage to escape death in the arena. Rhonda Fleming, Lang Jeffries, Ettore Manni, Dario Moreno, Wandisa Guida. *Dir* Nunzio Malasomma. *Pro* Paolo Moffa. Eastmancolor. (Italy/Spain/W. Germany) AMBROSIANA/C.B./ULTRA

Secret Of Deep Harbor
Remake of *I Cover The Waterfront* (1933) about a reporter exposing the drug smuggling of his girlfriend's father. Ronald Foster, Barry Kelley, Merry Anders, Norman Alden, James Seay. *Dir* Edward L. Cahn. *Pro* Robert E. Kent. HARVARD

Teenage Millionaire
A lad who has inherited a million dollars decides he wants to be a Rock 'n' Roll singer much to the displeasure of his aunt. Jimmy Clanton, Rocky Graziano, ZaSu Pitts, Diane Jergens, Joan Tabor. *Dir* Lawrence F. Doheny. *Pro* Howard B. Kreitsek. Musicolor. LUDLOW

When The Clock Strikes
Several people who had been connected with an executed murderer all arrive at a deserted motel on a quest for money believed hidden by the dead man. James Brown, Merry Anders, Henry Corden, Roy Barcroft, Peggy Stewart. *Dir* Edward L. Cahn. *Pro* Robert E. Kent. HARVARD

You Have To Run Fast (aka **Man Missing**)
A doctor becomes unwittingly involved with gangsters, but eventually escapes from them into the backwoods. Craig Hill, Elaine Edwards, Grant Richards, Willis Bouchey, Ric Marlow, John Apone. *Dir* Edward L. Cahn. *Pro* Robert E. Kent. HARVARD

UNITED ARTISTS

1962

▷**War Hunt** was an interesting off-beat little picture that seemed to bode well for the future of the Saunders brothers, Terry (producer) and Dennis (director), whose second feature this was. The hint of promise was never fulfilled. However, the film contained the first appearance of an actor who was soon to make it big – Robert Redford (right). Also making his debut as a performer was Sydney Pollack, future director of a number of Redford's movies. They played members of a platoon in Korea which includes schizo John Saxon (left), who goes out on lone missions and kills the enemy with a stiletto. He is hero-worshipped by an eight-year-old orphan boy (Tommy Matsuda) whom Redford wants to wrest from Saxon's bad influence. The theme equating war with mental illness was rather perfunctory in Stanford Whitmore's screenplay but the picture, shot in 15 days, established an atmosphere of menace by the use of landscape and natural sounds. Charles Aidman, Gavin MacLeod and Tom Skerritt were also in it. (T-D)

▽In **Follow That Dream**, Elvis Presley played a member of a roving family of hillbillies claiming squatters rights on an abandoned house in Florida. But whatever the locale, studio or role Elvis found himself in, he was the same un-spoiled singin' and guitar playin' Tennessee country boy. The cutesy screenplay by Charles Lederer (from the novel *Pioneer Go Home* by Richard Powell) told of how Elvis (left), his pa (Arthur O'Connell, at wheel) and three unof-

ficially adopted kids (Pam Ogles and twins Gavin and Robert Koon, all illustrated) face eviction by a couple of gangsters (Jack Kruschen and Simon Oakland) and the State Welfare superintendent (Joanna Moore). The rock star sang five instantly forgettable songs to the delight of his girlfriend (Anne Helm, centre) and his fans. The David Weisbart production in Panavision and De Luxe Color, directed by Gordon Douglas, was equally unmemorable. (MIRISCH)

△Former UA publicist Richard Condon's first novel, *The Oldest Confession*, was an entertaining yarn which turned into **The Happy Thieves**, an unentertaining yawn. The cause lay in the fatigued direction of George Marshall, and the full-of-holes script by John Gay. Nor were matters helped by the uneasy star pairing of Rex Harrison and Rita Hayworth (both illustrated) as two art thieves attempting to steal a priceless Goya from the Prado Museum in Madrid by substituting a fake during a commotion provoked in a nearby bullring. Needless to say, the robbery, like the movie, failed to come off. The cast also included Joseph Wiseman, Gregoire Aslan, Alida Valli, Virgilio Texeira, Peter Illing and Brita Ekman. The picture, shot in Spain, was produced by James Hill and Rita Hayworth, nearing the end of their marriage. (HILLWORTH)

△**Something Wild** was a tame psychodramatic vehicle for the blonde eroticism of Carroll Baker. Jack Garfein, her husband from 1955–1969, directed, co-produced (with George Justin) and co-wrote (with Alex Karmel) from the latter's novel *Mary Ann*. He also gathered around him distinguished collaborators such as photographer Eugene Schufftan, title designer Saul Bass, art director Richard Day and composer Aaron Copland (his first film score for 12 years). Despite this exalted company, the movie was ill-judged and predictable. Virtually a monotonous, 'Method'-acting two-hander for Baker (illustrated) and Ralph Meeker, it concerned the curious relationship between a couple of misfits cooped up together in a basement apartment. She is still suffering the after-effects of rape, he is a possessive, lonely garage mechanic who saved her from suicide. The small cast was completed by Mildred Dunnock, Charles Watts, Jean Stapleton and Martin Koslek. The bleak New York City location photography gave the picture a slight lift, but not enough to save it from falling flat. (PROMETHEUS)

△Vincent Price graduated to the lead in **Tower Of London**, after having played Clarence to Basil Rathbone's Richard III in Universal's 1939 version of the same title. Although both pictures were equally lurid, this Gene Corman production was far cheaper than its predecessor, and Roger Corman's direction less stylish. Price (right) was his usual hammy self as Crookback, murdering his way to the throne of England, and then suffering ghostly visions of his victims. Screenwriters Leo V. Gordon, Amos Powell and James B. Gordon probably were inspired more by their bank managers than by Shakespeare. Future director Francis Ford Coppola was credited as dialogue director. He should have directed it to the nearest trash can. Also in it were Michael Pate (left), Joan Freeman, Robert Brown, Justice Watson, Richard McCauley and Sara Selby. (ADMIRAL)

▽'Why do you always have to look as if your head were about to come to a point?' asks Angela Lansbury of her brainwashed son Laurence Harvey (right) in **The Manchurian Candidate**. She is the wife of ultra-right wing senator James Gregory, both of whom are using Harvey, programmed by Reds during the Korean war to carry out a series of assassinations in the USA, for their own devious purposes. At the exciting climax which took place in the setting of a convention in Madison Square Garden, Harvey's buddy Frank Sinatra (left) prevents him killing a major liberal politician at the very last moment. Harvey was perfectly cast as the stiff, zombie-like assassin, and Lansbury gave one of the best performances of her career as his monster mama (in reality only three years older than her screen son). Sinatra and Janet Leigh did what they could with less flashy roles. Also cast: Henry Silva, John McGiver, Leslie Parrish, James Edwards and Barry Kelley. George Axelrod's screenplay (from Richard Condon's bestseller) successfully managed to incorporate social and political satire into the rather insane thriller plot. The enjoyable Howard W. Koch production, which was directed in an often too febrile manner by John Frankenheimer, gained the overwhelming vote of the public. (MC)

▽**The Valiant**, the name of a battleship in Alexandria Harbour during World War II, could have equally applied to its stiff upperlip British crew which included John Mills, Robert Shaw, Liam Redmond, Ralph Michael, Colin Douglas, Dinsdale Landen, John Meillon, Patrick Barr and Moray Watson. They have captured two Italian frogmen (Ettore Manni and Roberto Risso), who have laid a time-fuse mine beneath the ship. The Willis Hall-Keith Waterhouse script (based on Robert Mallet's play *L'Equipage Au Complet*) was preoccupied with the attempts of stalwart Captain Mills (illustrated) to find out where it is planted before it goes off. Nothing explosive, alas, about Roy Baker's direction which used outworn techniques in a vain attempt to build tension. Ironically, the ship was played by an Italian cruiser that had been saved from the scrapyard, a fate not shared by Jon Penington's production. (BHP/EURO-INTERNATIONAL)

▷**Geronimo**, to nobody's surprise, was about the famous Apache chief. Equally unsurprising was the screenplay by Pat Fielder, which trod the well-worn war path of uncontroversial pro-Indian Westerns. The eponymous hero, played with little charm by rugged, blue-eyed Chuck Connors (centre), is betrayed by a US cavalry captain, a hypocritical government agent and a cattleman who grab the land promised to him for his people. With his squaw (Kamala Devi) and his men, the chief flees to Mexico where they live as bandits. The falsely uplifting ending had a Washington Senator signing a new treaty with the Apaches, showing what a good deal the Redskins got from the Palefaces. Filmed in Mexico in Panavision and Technicolor, the picture's sweeping action scenes maintained some interest. Arnold Laven produced, directed and co-wrote the story (with Fielder). Pat Conway, John Anderson, Joe Higgins and Denver Pyle were featured, with Ross Martin, Adam West (future TV *Batman*), Enid Jaynes, Lawrence Dobkin and Eduardo Noriega also cast. (LAVEN/GARDNER/LEVY/BEDFORD)

◁**Sergeants Three** was the second of four movies featuring close friends Frank Sinatra, Dean Martin, Sammy Davis Jr, Peter Lawford and Joey Bishop, a teaming that was collectively known in Hollywood as the Rat Pack. The other self-indulgent romps, all released by Warner Bros. and all with numbers in the titles were *Ocean's Eleven* (1960), *Four For Texas* (1963) and *Robin And The Seven Hoods* (1964). John Sturges, the director of this somewhat exhausting spoof, let the stars play at expensive home movies while he concentrated his main efforts on the vigorous action and stunts. W.R. Burnett's script, which attempted to transfer *Gunga Din* (RKO, 1939) to a Western setting, had three brawling cavalry officers (Sinatra, centre, Martin, left, and Lawford, right) fighting marauding Indians. A faithful ex-slave (Davis Jr) comes to the rescue and saves the day by blowing his bugle to warn them of an ambush. Support came from three of Bing Crosby's sons (Phillip, Dennis and Lindsay), Henry Silva, Ruta Lee and Buddy Lester. Sinatra himself produced the Panavision-Technicolor picture. (ESSEX-CLAUDE)

▷Although **The Children's Hour** (GB: **The Loudest Whisper**) updated the Lillian Hellman play of the early 30s, it retained the original's overt reference to lesbianism (which producer-director William Wyler had been unable to do in his previous version, *These Three*, 1936), but it remained an old-fashioned melodrama. The adaptation by Hellman and John Michael Hayes drew attention to the fact by setting it in the more permissive 60s, thus making the tale of two schoolmistresses, who run a private girls' school, suspected of an 'unnatural relationship', less plausible. A rumour is started by a spoilt brat who tells her grandmother. Horrified, she removes the child from the school and advises other parents to do the same. It ends with the suicide of the elder teacher when she realises there was some truth to the allegation. The latter was played by Shirley MacLaine (right – touching), and the other teacher by Audrey Hepburn (left – adrift). James Garner (uncomfortable) was Hepburn's fiance, and Karen Balkin (less memorable than Bonita Granville in the earlier film) was the little gossip. The best performances came from Fay Bainter (the grandmother) and Miriam Hopkins (MacLaine's silly Aunt Lilly), neither of whom had made a movie for nine years. Hopkins, who played the MacLaine role in the 1936 version, was a reminder that it was the better film, despite bowdlerization. (MIRISCH)

▷Producer-director Jean Negulesco offered an even more synthetic Hollywood view of Europe in **Jessica** than he had in *Three Coins In The Fountain* (20th Century-Fox) eight years earlier. This quaint treatment of Sicilian life, derived from the novel *The Midwife Of Pont Clery* by Flora Sandstrom, was written by Edith Sommer and dealt with the effects on the inhabitants of a small village of the arrival of sexy American midwife Angie Dickinson (centre). In protest, the jealous wives go on to Lysistrata-like strike, deciding that if there were no more babies, the woman would have to leave. Among the villagers were Maurice Chevalier, spreading his charm too thickly as a priest, Agnes Moorehead, Noel-Noel, Gabriele Ferzetti, Sylva Koscina, Marcel Dalio and Kerima. The slow-moving picture provided a few ditties, as well as postcard views in Panavision and Technicolor. (ARIANE/DEAR)

△**The Road To Hong Kong** marked the end of the road for the popular series which had taken Bing Crosby, Bob Hope and Dorothy Lamour to *Singapore* (1940), *Zanzibar* (1941), *Morocco* (1942), *Utopia* (1946), *Rio* (1948) and *Bali* (1953), although they hardly ever strayed from the Paramount backlot. This low-budget effort, filmed in England, had Hope (right) and Crosby (centre) still wise-cracking as rival buddies getting in and out of scrapes, but Lamour was ungallantly replaced by Joan Collins (left). As compensation, Dotty was given a cameo appearance, which put the lovely Joan to shame. The screenplay, by producer Melvin Frank and director Norman Panama, was an unhilarious hodge-podge concerning master criminal Robert Morley's attempts to obtain a secret rocket fuel formula which has somehow become planted in Hope's mind. The formula of the movie, in which the trio meet various guest stars (Peter Sellers, David Niven, Frank Sinatra, Dean Martin, Jerry Colonna), was stale. Others cast: Walter Gotell, Roger Delgado, Felix Aylmer, Alan Gifford and Robert Ayres. (MELNOR)

▽**Hero's Island** was the second of two movies written, produced, and directed by Leslie Stevens (the first being *Private Property*, 1960), both starring his wife Kate Manx (illustrated), who later committed suicide. In this awkward brew of soap opera and pirate picture, she played a gutsy widow and mother of two children whose island home is attacked by three wicked fishermen (Rip Torn, Robert Sampson and Dean Stanton). To her rescue comes none other than James Mason (illustrated standing) as Major Stede Bonnet, alias Blackbeard the Pirate. Mason gave over-much and Manx overlittle in their roles, which the patchy direction and rhetorical script did nothing to alleviate. Ted McCord's Technicolor photography in Panavision, made the most of the seascapes and location shots, unfortunately interspersed with cardboard studio sets. Others in it were Neville Brand, Warren Oates (on ground), Brandon Dillon, Morgan Mason and Darby Hinton. (DAYSTAR/PORTLAND)

◁'I love you, and when I say I love you I mean I'm in love with you,' was one of the classic lines uttered in **Phaedra**, producer-director Jules Dassin's updating of Euripides, written by him (and Margarita Liberaki) for his wife Melina Mercouri (illustrated). Set among the rich in modern-day Greece, it had Mercouri as the second wife of shipping magnate Raf Vallone, falling passionately in love with her stepson Anthony Perkins (illustrated). Of course, being based on an ancient tragedy, Perkins drives his sports car over a cliff, Mercouri kills herself, and the *SS Phaedra* sinks, perhaps symbolic of the whole enterprise. The overwrought performances were observed by a chorus of bemused women in black. Others cast were Elizabeth Ercy, Olympia Papadouka, George Sarris and Dassin himself as an old Greek. (MELINAFILM)

△Most of **Birdman Of Alcatraz** took place in a prison cell, but the intensity of John Frankenheimer's direction and Burt Lancaster's mesmeric performance sustained the Stuart Miller-Guy Trosper production for two-and-a-half hours. The meticulous study of the development of a man and the inhumanity of the penal system, was no less dramatic for having only one big action scene – a climactic jail break. In 1962, Robert Stroud, the subject of Thomas E. Gaddis' biography (adapted by Guy Trosper), was a 73-year-old lifer who had been incarcerated for 53 years, most of them in solitary confinement. As Stroud, Lancaster (illustrated), brilliantly ageing from his teens to middle age, showed the change from the bitter young double murderer to one of the world's greatest experts on bird diseases. The jailbird, who first finds companionship in a fledgling that flies through his bars, attracts more birds to his cell, and when his feathered friends die, he seeks the cause of their illness. Good support was given by Thelma Ritter (his mother), Betty Field (his wife), Karl Malden (prison warder), Neville Brand (the tough guard who learns to respect him), Hugh Marlowe, Telly Savalas, James Westerfield and Whit Bissell. (NORMA/HECHT-HILL-LANCASTER)

▽At 27, Elvis Presley already appeared too paunchy to be a successful welterweight boxer in **Kid Galahad**, a loose remake of the 1937 Warner Bros. movie of the same name. Writer William Fay refashioned the story (originally based on a novel by Francis Wallace) to suit Elvis' screen persona. Just out of the army and broke, he is offered a job as sparring partner at a training camp owned by Gig Young (2nd left). Young fancies him as a boxer, and Lola Albright and Joan Blackman fancy him for other reasons. Following a series of quick wins, Elvis (2nd right) wants to give up boxing and marry Miss Blackman. Young, in trouble with gangster David Lewis, offers Elvis one more fight. After being punched in close-up for five rounds, Elvis suddenly and passionlessly lands a KO blow. 'And you sing too,' someone remarks. He did. About seven songs between bouts. Fans were obviously delighted and flocked to the David Weisbart production, directed by Phil Karlson in Panavision and Technicolor. Also in it were Charles Bronson (left), Ned Glass, Robert Emhardt, Michael Dante and Judson Pratt. (MIRISCH)

◁The Argentinian Pampas stood in credibly for the Russian Steppes in **Taras Bulba**, but most of the multi-national cast were less believable as assorted Poles and Cossacks. Andrei Bulba (Brooklynese Tony Curtis, foreground left), the son of Taras (virile Yul Brynner, foreground right), chief of the Cossacks, falls in love with Polish Natalia Dubrov (Christine Kaufmann, Curtis' wife from 1963-1967). When the army of Taras besieges the Polish town of Dubno, Andrei tries to rescue Natalia, but is shot by his own father as a traitor. Little of the power and sweep of Nikolai Gogol's novel survived in Waldo Salt and Karl Tunberg's screenplay, or in J. Lee Thompson's prosaic direction, despite a number of epic cavalry charges and sword fights shot in Panavision and Technicolor. The two-hour Harold Hecht production was considerably slowed down by the central soft-focus love affair. Others involved were George Macready, Sam Wanamaker, Guy Rolfe, Brad Dexter, Perry Lopez and Vladimir Sokoloff who died soon after filming. (HAROLD HECHT/AVALA)

▽**The Magic Sword** (GB: **St George And The Seven Curses**) had many of the fairytale ingredients that keep young audiences happy. A handsome knight (Gary Lockwood, illustrated), a damsel in distress (Anne Helm), an evil sorcerer (Basil Rathbone) and plenty of special effects filmed in Eastmancolor. Bernard Schoenfeld's screenplay allowed the hero to rescue the kidnapped princess from the clutches of the villain by means of a magic sword, a bewitched horse, and seven of the most famous knights of the time. Obstacles in their way included a 25-foot high ogre and a two-headed dragon. Bert I. Gordon produced, directed and wrote the story for the moderately successful picture which also cast Estelle Winwood, Liam Sullivan, John Mauldin and Jacques Gallo. (GORDON)

▷**The Miracle Worker** offered a vivid record of the performances of Anne Bancroft and Patty Duke for those who were not privileged to see them on stage. In the theatre, Arthur Penn's direction and William Gibson's play, altered slightly by the author for the screen, had a greater impact, especially the eight-minute skirmish between Annie Sullivan (Bancroft, right), the partially blind teacher of the blind, deaf and mute Helen Keller (Duke, left). After a tremendous fight in the dining room, as part of the teacher's attempts to turn her pupil from an animal into a 'civilized' human being, Annie claims, 'The room's a wreck, but her napkin's folded.' Yet, the fascinating and moving study of the young dedicated Boston teacher's efforts to 'disinter the soul' of the child, gradually giving her the ability to communicate, still came across strongly under Penn's direction. Bancroft, back after five years away from Hollywood, revealed the character's complexity and own psychological needs in her Oscar-winning performance. The supporting actress award was given to Patty Duke for her physically demanding portrayal, making her deservedly (at 15) the youngest recipient ever. The other rather sketchy characters were played by Victor Jory and Inga Swenson (too stern and too sweet respectively as Helen's parents), Andrew Prine, Beah Richards, Kathleen Comegys, Jack Hollander and Michael Darden. The Fred Coe production ended with an unnecessarily sentimental 'I Love You' signalled from pupil to teacher, a phrase echoed by the public in general to the picture. (PLAYFILMS)

▷Although director Robert Wise treated **Two For The Seesaw** as cinematically as he could, and Isobel Lennart's screenplay added some new characters to William Gibson's Broadway two-hander, it remained stubbornly theatrical. The rather glib conversation piece between a lonely businessman about to get a divorce and a lonely Greenwich Village kook had its moments of wit and pathos, although neither Robert Mitchum nor Shirley MacLaine (both illustrated) were at their best. Their affair ends with the man going back to his wife, and the woman bravely facing the future without him. Also in the Walter Mirisch production were Edmon Ryan, Elizabeth Fraser, Eddie Firestone and Billy Gray. (SEESAW/MIRISCH/ARGYLE/TALBOT/SEVEN ARTS)

△The moot point made in **Pressure Point** was that Fascism is a curable mental illness. Proposing this theory were director Hubert Cornfield, who also wrote the screenplay with S. Lee Pogostin (based on Dr Robert Lindner's book *The 50 Minute Hour*), and producer Stanley Kramer. Interpreting the heavily slanted message were wise and wonderful psychiatrist Sidney Poitier (standing) and hallucinating nasty young Nazi Bobby Darin (on couch), who naturally doesn't take to having a black man treat him. The latter's neurosis is expunged after his unhappy childhood, seen in a number of confusing flashbacks, is analysed. Also in this well-meaning collection of platitudes were Peter Falk, Carl Benton Reid, Mary Munday, Barry Gordon, Howard Caine and Anne Barton. (LARCUS)

1962 OTHER RELEASES

Beauty And The Beast
An Italian duke is the victim of a curse that turns him nightly into a beast, until the love of a beautiful lady frees him. Joyce Taylor, Mark Damon, Eduard Franz, Michael Pate, Merry Anders. *Dir* Edward L. Cahn. *Pro* Robert E. Kent. HARVARD

Dead To The World
A government official falsely accused of Communist sympathies, gets mixed up in sabotage and murder. Reedy Tarlton, Jana Pierce, Ford Rainey, John McLiam, Casey Peyson. *Dir* Nicolas Webster. *Pro* F. William Hart. NATIONAL FILM

Deadly Duo
A wicked woman poses as her good twin sister in order to get the money that is coming to the latter. Craig Hill, Marcia Henderson, Robert Lowery, Dayton Lummis, Carlos Romero. *Dir* Reginald Le Borg. *Pro* Robert E. Kent. HARVARD

Incident In An Alley
A policeman shoots a juvenile delinquent after the robbery of a music shop, and after having it weighing on his conscience, gradually satisfies himself, his wife and his friends that his act was justified. Chris Warfield, Erin O'Donnell, Harp McGuire, Virginia Christine, Michael Vandever. *Dir* Edward L. Cahn. *Pro* Robert E. Kent. HARVARD

Jack The Giant Killer (aka **The Giant Killer**)
Jack saves a princess from the clutches of an evil magician, fighting two giants and monsters on the way. Kerwin Mathews, Judi Meredith, Torin Thatcher, Walter Burke, Roger Mobley. *Dir* Nathan Jurow. *Pro* Edward Small. Eastmancolor ZENITH

The Manster (GB: **The Split**)
An American reporter in Japan unwittingly becomes the subject of a scientist who turns him into a two-headed monster. Peter Dyneley, Jane Hylton, Satoshi Nakamura, Terri Zimmern, Toyoko Takechi. *Dir* George Breakston, Kenneth G. Crane. *Pro* George Breakston. (Japan/USA) UA JAPAN/BREAKSTON

The Nun And The Sergeant
A platoon of Marines enrolled from the brig for a dangerous mission in Korea, prove to be heroes due to the influence of a nun and a group of Korean schoolgirls they are forced to take along. Robert Webber, Anna Sten, Leo Gordon, Hari Rhodes, Robert Easton. *Dir* Franklin Adreon. *Pro* Eugene Frenke. SPRINGFIELD/EASTERN

The Proper Time
A UCLA student stammers badly except when he is with girls, but gets cured when he goes to a clinic. Tom Laughlin, Nyra Monsour, Norman Quine. *Dir* & *Pro* Tom Laughlin. BUSINESS ADMINISTRATION

Saintly Sinners
A kindly old priest, through a mixture of naivete and simple faith, reforms a collection of lovable felons in his humble parish. Don Beddoe, Paul Bryar, Stanley Clements, Ellen Corby, Ron Hagerthy. *Dir* Jean Yarbrough. *Pro* Robert E. Kent. HARVARD

Third Of A Man
A man has to organize a posse to hunt down his own brother, who has escaped from the local insane asylum. James Drury, Jan Shepard, Whit Bissell, Jimmy Gaines, Simon Oakland. *Dir* Robert Lewin. *Pro* None credited. PHOENIX

▽Vincent Price was up to his evil tricks again in **Diary Of A Madman**, a hackneyed Technicolor picture that could only have frightened the investors in the production. Producer Robert E. Kent's screenplay was an artless adaptation from stories by Guy de Maupassant, in particular the ghost tale *The Horla*. The latter is a malignant spirit that possesses people, getting them to do its bidding. The Horla has got hold of Price (illustrated), a sculptor who is soon strangling his pet canary, and then kills one of his models (Nancy Kovack). After his attempt to get rid of another girl (Elaine Devry) is foiled by the light of a crucifix, he sets fire to himself and his house, leaving only the diary of his deeds behind. Most of the techniques used by director Reginald Le Borg were pulled out of an old hat, except for one scene in which a trail of blood leads to a severed head. Other roles went to Chris Warfield, Stephen Roberts, Lewis Martin and Ian Wolfe. (ADMIRAL)

▷Bette Davis went blind just before dying radiantly in *Dark Victory* (WB, 1939), and Susan Hayward did the same in an even more cloying manner in **Stolen Hours**. All but the most hardy fans of soap opera must have been sorely tested by Daniel Petrie's flat direction of this made-in-Britain remake in De Luxe Color. Jessamyn West's limp screenplay, adapted from the drama by George Emerson Brewer Jr and Bertram Bloch, had Susan (illustrated) as a wealthy American divorcee in London suffering from recurrent loss of vision and headaches and discovering she has only a year to live. Death is seen as an enobling agent, as the heroine gives up her racing-driver lover (Edward Judd) and marries a nice doctor (Michael Craig, illustrated). Luckily, she is rich enough to make her last days comfortable in an idyllic Cornish village. Even Miss Hayward, facing death with majestic fortitude, failed to jerk many tears. Also in Dennis Holt's production were Diane Baker, Paul Rogers, Robert Bacon, Paul Stassino and Jerry Desmonde. (MIRISCH/BARBICAN)

△**It's A Mad, Mad, Mad, Mad World** was producer-director Stanley Kramer's gigantic homage to slapstick comedy, filmed in Ultra Panavision 70 (a form of Cinerama), stereo-honic sound and Technicolor. Unfortunately, there were more laughs in a Mack Sennett black-and-white silent short than in all three hours of this mammoth maniacal movie. Yet it impressed cumulatively with its sheer size, the number of pratfalls and spectacular stunts. The William and Tania Rose script found room for a vast roster of comedians, past and present, including Milton Berle, Sid Caesar, Ethel Merman, Buddy Hackett (left), Mickey Rooney (right), Dick Shawn, Phil Silvers, Terry-Thomas, Jonathan Winters, Edie Adams, Dorothy Provine, Eddie 'Rochester' Anderson, Jim Backus, William Demarest, Peter Falk, Paul Ford, Leo Gorcey, Ben Blue, Edward Everett Horton, Buster Keaton, Joe E. Brown, Carl Reiner, The Three Stooges, ZaSu Pitts, Stirling Holloway, Jack Benny and Jerry Lewis. They are all led by greed on the trail of buried loot after Jimmy Durante gives a clue to its whereabouts just before he dies, literally kicking a bucket. Following the mad mob in various vehicles across America to California, is Spencer Tracy, a cop about to retire from the force who tries to make off with the treasure himself. The often vulgar, cynical and cruel movie made off with over $10 million. (KRAMER)

△Tony Richardson, the producer and director of **Tom Jones**, had great difficulty in getting the costly project financed. UA backed and distributed what was one of the most expensive British productions to date at over $1 million. The risk paid off handsomely at the box-office, and the 135-minute Eastmancolor picture became the first entirely British-made Oscar winner since *Hamlet* (1948). It was also the only film ever to boast three supporting actress nominees in the cast, Edith Evans (Miss Weston), Diane Cilento and Joyce Redman, the latter seducing Tom (Albert Finney, right) while suggestively eating a large tavern meal. John Osborne's freewheeling adaptation of Henry Fielding's 18th-century picaresque novel, followed the mainly amorous adventures of young Tom, the illegitimate son of a servant girl. Fostered by Squire Weston (Hugh Griffith, centre), he finally marries the squire's daughter Sophia (Susannah York, left). Others in the cast were Joan Greenwood (Lady Bellaston), David Warner (Blifil), George Devine, David Tomlinson, Peter Bull, Wilfred Lawson, Rachel Kempson and her youngest daughter, Lynn Redgrave, in her screen debut. The popular appeal of the movie might have been due to the ribaldry and the irreverent approach to an English classic, but Richardson's ragbag of cinematic tricks turned the great novel into a simpleminded bawdy romp. (WOODFALL)

▽Three of Nathaniel Hawthorne's most vivid horror stories were reduced to a cheap and garish vehicle for Vincent Price (left) under the generic title of **Twice Told Tales**. *Dr Heidegger's Experiment* told of how Sebastian Cabot and his false friend Price, discover an elixir of youth and are able to bring back to life the former's fiancee (Mari Blanchard), who died on their wedding night. In *Rappaccini's Daughter*, Price played the over-possessive father who injects his daughter (Joyce Taylor, right) with a poison powerful enough to kill anyone who touches her. When she falls for a young student (Brett Halsey), the inoculation proves fatal to him. *The House Of The Seven Gables* (filmed in 1940 by Universal, also with Price) told of Gerald Pyncheon bringing his bride (Beverly Garland) to his haunted ancestral home, and meeting his death in a secret vault where treasure is meant to be hidden. As Gerald, Vincent Price hammed it up in the same manner as in the other two tales. Abraham Sofaer, Edith Evanson, Richard Denning and Jacqueline de Wit also appeared for producer-writer Robert E. Kent and director Sidney Salkow. (ADMIRAL)

◁John Cassavetes claimed that producer Stanley Kramer did extensive re-editing and interfered with his direction of **A Child Is Waiting**. Despite the director's displeasure with the finished product, the movie served well the didactic purpose of Abby Mann's contrived but touching script (based on his TV play), which attempted to see retarded children as personalities in their own right. Helping this aim were Burt Lancaster as a radically-minded head of a special school, and Judy Garland (illustrated), a teacher who learns that merely loving the children is not enough to give them a sense of independence. She gets overly involved in the case of one boy (child actor Bruce Ritchey fitting in well with real handicapped kids), and approaches his divorced parents (Steven Hill and Gena Rowlands, Mrs Cassavetes) despite Lancaster's warnings. Judy kept many of her emotional mannerisms under control, while Lancaster underplayed. The cast also included Gloria McGehee, Paul Stewart, Lawrence Tierney, Elizabeth Wilson and Barbara Pepper. (LARCUS)

▷John Wayne, his family, and his friends dominated **McLintock**. Eldest son Michael Wayne produced, Patrick and Aissa, two other Wayne offspring, had roles, and Maureen O'Hara, his co-star in four previous pictures including *The Quiet Man* (Republic, 1952) from which James Edward Grant (Wayne's friend and favourite screenwriter) derived some of the plot, played a shrewish wife tamed by Big John. The star (right) portrayed a powerful cattle baron whose wife has returned after two years away attempting to obtain a divorce and custody of their 17-year-old daughter (Stephanie Powers, left). Meanwhile, he has taken on an attractive widow (Yvonne de Carlo) as housekeeper, which arouses his wife's jealousy. After sorting out his daughter's suitors (Patrick Wayne, centre, and Jerry Van Dyke), and some Comanches, he chases his wife, in her underwear, down the streets and gives her a good spanking, the perfect answer to a happy marriage. This derivative 126-minute comedy-Western filmed in Panavision and Technicolor, which included plenty of fist fights and much falling in the mud, was directed by Andrew McLaglen, son of actor Victor. Other supporting roles went to Edgar Buchanan, Bruce Cabot, Perry Lopez, Michael Pate, Strother Martin, Leo Gordon, Chill Wills, Jack Kruschen and Mari Blanchard. (BATJAC)

▷**The Great Escape** was the longest (173 minutes), most expensive and biggest money-making POW picture of all. Not that it was all that much better than many others in the barbed-wired-tunnel-digging genre, but producer-director John Sturges handled it with a certain gusto, and the screenplay by James Clavell and W.R. Burnett (from the non-fiction book by Paul Brickhill) offered some ingenious variations on the familiar theme. Filmed in Germany in Panavision and De Luxe Color, the picture started light-heartedly, and ended in a tragic but uplifting manner. A massive escape from a camp is planned through three tunnels. Although one tunnel is discovered and some escapees caught, 76 men get away, and the film then follows their attempts to get out of Germany (with an Elmer Bernstein musical motif for each man or group). Richard Attenborough, James Donald, James Garner, Charles Bronson, Donald Pleasence, David McCallum, Gordon Jackson, John Leyton and Nigel Stock played the usual Stalag stereotypes. It was loner Steve McQueen (illustrated), commandeering a Nazi motorbike and teaching it to jump fences, who perhaps contributed as much as anyone to the film's vast appeal. (MIRISCH/ALPHA)

◁The sight of a silver-haired Joan Crawford in a skin-tight black judo outfit as senior nurse Lucretia Terry in **The Caretakers** (GB: **Borderlines**), offered one of the few pleasures to be had from this loony picture about a mental hospital. The script by Henry F. Greenberg (from Dariel Telfer's novel) had Miss Crawford opposed to the humane methods of Dr Robert Stack (right), who believes in letting the patients express themselves freely. His views are vindicated when Polly Bergen (left), an inmate with homicidal tendencies, prevents fellow patient Barbara Barrie from burning down the hospital. Herbert Marshall, the head of the establishment, wearily watched the hysterical proceedings which included an attempted rape and electric shock treatment. Producer-director Hall Bartlett's shock tactics precluded any serious approach to the subject. Others acting their wigs off were Janis Paige, Diane McBain, Constance Ford (centre), Sharon Hugueny, Ann St Clair, Robert Vaughn and Susan Oliver. (HALL BARTLETT)

▷Melodramas don't come much sillier than **Five Miles To Midnight**, courtesy of screenwriters Peter Viertel and Hugh Wheeler (from an idea by Andre Versini). The plot so far ... Anthony Perkins, husband of Sophia Loren (both illustrated), is the only survivor of a plane crash between Paris and Casablanca. He returns to his wife's apartment, a little worse for wear, and tells her to hide him while she collects the life insurance. She gets the money and drives him to the Belgian frontier where she runs him over with her car, and dumps the body in a river. While telling her tale to lover Gig Young, she gradually goes insane. Producer-director Anatole Litvak merely added to the moronic mechanics of the movie by approaching it in an hysterical manner. Loren registered anxiety in close-up, while Perkins gave another rather stereotyped portrayal of arrested development. Others in it were Jean-Pierre Aumont, Yolande Turner, Tommy Norden, Guy Laroche, Bill Kearns and Regine. (FILMSONOR/DEAR)

△Some critics hailed **Johnny Cool** as a return to the golden age of gangster movies, but in general it gained more modest praise. The picture lacked a Cagney or Robinson, and the Joseph Landon script (from the novel *The Kingdom Of Johnny Cool* by John McPartland) was too knowing. Set in the present day, it followed Henry Silva (right) as a Sicilian mobster despatched to the USA to rub out several successful and apparently respectable men who once betrayed his boss, Marc Lawrence. Among the victims were Brad Dexter, Jim Backus, Mort Sahl and Telly Savalas, before the 'delivery boy of death' met his own end. Others contributing vignettes were Elizabeth Montgomery, Sammy Davis Jr (left), Wanda Hendrix, Richard Anderson, Joey Bishop, Elisha Cook Jr, Robert Armstrong and Douglass Dumbrille. As director William Asher, who also produced, went on to make *Beach Party* movies, this must be considered his masterpiece. (CHRISLAW)

◁The ancient Mayan civilization was the potentially fascinating subject of **Kings Of The Sun**, shot entirely in Mexico in Panavision and De Luxe Color, amidst real and recreated Mayan architecture. But director J. Lee Thompson's treatment of it was slow and synthetic, and most of the performances were decidedly ancient Hollywood. It was difficult to accept the under-powered George Chakiris as King Balam leading his people to a new land to avoid barbarian invaders, and Elliott Arnold and James R. Webb's screenplay (story by Arnold) contained lines like 'And some day we will watch our babies lead buffaloes around by the noses.' Only Yul Brynner, in a loincloth, as Indian Chief Black Eagle (illustrated) whose tribe saves the Mayans from their pursuers, had any presence. The Lewis J. Rachmil production also cast Shirley Ann Field, Richard Basehart, Brad Dexter, Barry Morse, Leo Gordon and Armando Silvestre in support. (MIRISCH)

▷Twenty-four years after Hattie McDaniel in *Gone With The Wind* (MGM, 1939), Sidney Poitier became only the second black performer to win an Oscar – for his role as the cheerful footloose workman in **Lilies Of The Field**. Poitier's charm and way with comedy just saved the low-budget picture from falling into all the sentimental traps set in James Poe's script (from the William E. Barrett novel). The themes of Christian unity, racial harmony and simple faith were self-consciously expounded in a tale of how Poitier (illustrated) teaches English to a group of five East European nuns (Lilia Skala, Lisa Mann, Iso Crino, Francesca Jarvis and Pamela Branch), and helps them build a chapel in the Arizona desert. The cast was completed by Stanley Adams, Dan Frazer and Ralph Nelson, the film's producer-director. The unsophisticated formula held instant appeal to audiences, who rushed to see it, and it gained four other Oscar nominations as well as Poitier's. (RAINBOW)

1963

▷Although incest, infidelity and imbecility were retained from Lillian Hellman's stage play, screenwriter James Poe's adaptation of **Toys In The Attic** was not even moderately shocking. Many aspects of the original were toned down, and it was given an upbeat ending, while director George Roy Hill's obligatory opening out (into the streets of New Orleans) of this claustrophobic study of two ageing sisters in their shabby mansion, diminished the atmosphere. The spinsters (Geraldine Page, left, and Wendy Hiller, right) give everything they have to their adored younger brother (Dean Martin, centre), but trouble brews when he returns from Chicago with his childlike bride (Yvette Mimieux). They realise that their love for their brother borders on the unnatural, and painfully release their hold on him. Whatever the deficiencies of the talkative Walter Mirisch production in Panavision, it offered two choice performances by Misses Page and Hiller. Others cast were Gene Tierney, Larry Gates, Frank Silvera, Nan Martin and Charles Lampkin. (CLAUDE/MIRISCH)

△Judy Garland (illustrated) stood on the stage of the London Palladium in her valedictory film role, defiantly belting out **I Could Go On Singing**. *The Lonely Stage* was the less optimistic, but more appropriate original title of Mayo Simon's trite script (story by Robert Dozier), almost a parody of the star's own public and private life. The plump and rather ravaged Judy played an American singer in London renewing her relationship with the Harley Street doctor (Dirk Bogarde) by whom she had a son some 12 years before. The boy has always lived with his father, but when mother and child meet, they take to each other, and she decides she wants to keep him. The father asks the boy to make a choice. After the son, for an unexplained reason, phones his mother to say he cannot see her again, Judy goes on a drunken spree before deciding to give her love to the public. The cast of the Lawrence Turman Panavision-Eastmancolor production also included Jack Klugman, Aline MacMahon, Pauline Jameson, Gerald Sim, Russell Waters and Gregory Phillips (as the son). Bogarde offered a range of two expressions, approving and disapproving. It was only Judy's powerhouse talent that carried the movie, especially when singing four numbers, or waiting in the wings nervously winding herself up to go on. Although much of Ronald Neame's direction was mediocre, the film came nearer than any other of her films in capturing the feel of her stage performances. (BARBICAN)

▽Producers Harry Saltzman and Albert R. Broccoli were so confident that the first James Bond movie, **Dr No**, would be a hit that the final credit reads 'James Bond will be back in *From Russia With Love*.' And he *was* back – again and again and again, in a series of unstoppable box-office attractions for the next 20 years and beyond. Although they became more and more packed with technical wizardry, and there have been some changes in personnel, Sean Connery (Bond), Terence Young (director), Ken Adam (designer) and Richard Maibaum, Johanna Harwood and Berkeley Mather (screenwriters) immediately established the successful recipe of sex, violence and campy humour which has remained virtually unchanged. The ingredients were exotic Technicolored locales, a bevy of (mostly treacherous) beautiful females whom Bond beds, an evil genius who wishes to control the world, and spectacular stunts. This first example of the genre had Bond sent to Jamaica to investigate the death of a fellow British secret agent, and becoming a prisoner on the island of the megalomaniac Eurasian Dr No (Joseph Wiseman), who has an elaborate plan to launch American nuclear rockets towards their own soil. The hero (illustrated) survives a tarantula in his bed, car crashes and radio-active contamination, to thwart the plan at the last moment without working up too much sweat. Most of the time, he is accompanied by the voluptuous Honey Rider (Ursula Andress, illustrated), first seen rising from the sea in a bikini with a knife at her waist. Others in the cast were Bernard Lee (as 'M', Bond's boss), Lois Maxwell (Miss Moneypenny), Jack Lord, John Kitzmiller, Zena Marshall, Eunice Gayson, Anthony Dawson and Lester Prendergast. Ian Fleming, author of the original novels, saw David Niven in the Bond role, but the virtually unknown, Scots-accented, tough Connery was chosen, giving a more modern image to 007, licensed to kill. (EON)

△**Love Is A Ball** (GB: **All This And Money Too**) was a frothy Panavision and Techicolor picture, set amidst the sumptuousness of the French Riviera and trying desperately to be satiric about The Rich. The particular plutocrats in the screenplay by the director David Swift and Tom and Frank Waldman (based on the novel *The Grand Duke And Mr Pimm* by Lindsay Hardy) were a gauche aristocrat (Ricardo Montalban) and the wild American millionairess (Hope Lange, illustrated) he wishes to marry. To that end, a debonair matchmaker to top people (Charles Boyer, illustrated) has insinuated a racing driver (Glenn Ford) into the girl's household as chauffeur in order to drive her into his client's arms. Of course, she falls for the chauffeur, and the duke marries the girl's secretary (Ulla Jacobsson). Minor amusement was to be had from the vulgarity of the American parvenu family's house with its erotic statues, but Swift's direction did not have enough wit to sustain it over 112 minutes. Also doing their bit in Martin H. Poll's production were Telly Savalas, Ruth McDevitt, Georgette Anys, Andre Luguet and John Wood. (OXFORD/GOLD MEDAL)

△The reunion of the successful team from *The Apartment* (1960), Shirley MacLaine, Jack Lemmon (both illustrated) and producer-director Billy Wilder, proved in **Irma La Douce** that excellent ingredients do not necessarily make a dish palatable. The main error made by Wilder and his co-writer I.A.L. Diamond was to have expunged the 16 songs which contributed so much to the charm of the original small-scale Marguerite Monnot-Alexandre Breffort stage musical, over-extending the frivolous farce into a 147-minute Panavision-Technicolor picture. Alexander Trauner's large studio-built set of the Rue Casanova, though clever, contributed to the artificial air of the raucously unfunny proceedings. Irma (MacLaine), a Parisian prostitute, is loved by former gendarme Nestor (Lemmon), who becomes her pimp. But he soon hates her going with other men, so he visits her disguised as an English Lord and becomes her sole client. The complications of his double life lead to Nestor's doing away with the Lord by throwing his clothes into the Seine. After being acquitted of the murder of the non-existent aristocrat, he marries the pregnant Irma. The two stars, working hard for the few laughs in the essentially theatrical material, were supported by Lou Jacobi, Bruce Yarnell, Herschel Bernardi, Joan Shawlee, Hope Holiday and Cliff Osmond. The big names and the 'naughty' subject obviously helped the film to gross $9 million at the box-office. (PHALANX/MIRISCH/EDWARD L. ALPERSON)

◁**The Mouse On The Moon** was a pipsqueak sequel to the mildly risible Peter Sellers' comedy, *The Mouse That Roared* (Columbia, 1959), with only David Kossoff's Professor Kokintz retained from the earlier film. Once again, the setting for this lightweight romp was The Duchy of Grand Fenwick, an English Ruritania situated somewhere on the Continent. Ruled over by the Grand Duchess Gloriana (Margaret Rutherford), it is badly run down, until they discover that their locally produced wine can be used as rocket fuel. The hereditary Prime Minister Mountjoy (Ron Moody, left) sends his gormless son (Bernard Cribbins, right) up in a rocket ship which successfully reaches the moon before the Americans and Russians. Others in a cast from which Sellers was sorely missing were Terry-Thomas, June Ritchie, Roddy McMillan, John Le Mesurier, John Phillips, Hugh Lloyd, Clive Dunn and Frankie Howerd. Unlike the explosive wine, the jokes were flat in the Michael Pertwee script (based on Leonard Wibberley's novel) and fared badly under the direction of Richard Lester, making his second feature. Walter Shenson produced the film in Technicolor. (WALTER SHENSON)

1963 OTHER RELEASES

Amazons Of Rome (aka **Warrior Women** orig: **Le Vergini Di Roma**)
Three hundred Roman girl hostages rout the Etruscans on horseback before returning to their own country. Sylvia Syms, Louis Jourdan, Nicole Courcel, Ettore Manni. *Dir* Vittorio Cattafavi, Carlo Ludovico Bragaglia. *Pro* Carlo Ludovico Bragaglia. Eastmancolor. (Italy/France/Yugoslavia) REGINA/CRITERION/CINE ITALIA/UFUS

Call Me Bwana
A phony expert on Africa is drafted by the Pentagon to recover a nosecone of a moon missile, while the Russians send a beautiful blonde anthropologist on the same mission. Bob Hope, Anita Ekberg, Edie Adams, Lionel Jeffries, Arnold Palmer. *Dir* Gordon Douglas. *Pro* Albert R. Broccoli. (GB) EON

Sons Of Thunder (orig: **Arrivano I Titani**)
Crios, one of the Titans, brings about the downfall of the tyrannical King Cadmus, outwits both the Gorgon and the Cyclops, and rescues Cadmus' daughter from her father's evil clutches. Pedro Armendariz, Giuliano Gemma, Antonella Lualdi, Jacqueline Sassard, Gerard Sety. *Dir* Duccio Tessari. *Pro* Franco Cristaldi. Technicolor. (Italy/France) VIDES/ARIANE/FILMSONOR

▷**The Pink Panther** began one of the most commercially successful cycle of comedies in the history of the cinema. This was due to the original creation by Peter Sellers (left) of the extraordinarily maladroit Inspector Clouseau, whose constant falling about had audiences doing the same thing. Not only was he unable to cross a room without breaking something, but his singular French accent ('fern' for phone, and 'mirt' for moth) caused problems in communication. With his broad-belted trench coat, tweed hat, small moustache and large magnifying glass, the character fitted in well with the animated credit titles. Otherwise, director Blake Edwards' attempts at a light comedy-thriller in the *Raffles* mode, were rather laboured. According to the script (by Edwards and Maurice Richlin), the film's title referred to the priceless diamond owned by an Indian princess (Claudia Cardinale) vacationing at a Swiss ski resort. It is no coincidence that an international gentleman jewel thief (David Niven, right) alias 'The Phantom', and his rascally nephew (Robert Wagner) also happen to be there. Clouseau, investigating the diamond's disappearance, is unaware that his wife (Capucine) is in league with 'The Phantom'. Martin Jurow's production, which had Technicolor-Technirama views of Switzerland, Paris and Rome, also cast Brenda de Banzie, Colin Gordon, Burt Kwouk, Fran Jeffries and John Le Mesurier. Five further Sellers *Pink Panther* pictures followed this, besides the ill-fated Alan Arkin effort, *Inspector Clouseau* (1968). (MIRISCH)

◁'It did Adlai Stevenson great harm not having a wife and trying to be funny all at the same time,' says Ann Sothern, an influential party delegate in **The Best Man**. She could well have been speaking of Gore Vidal, who adapted his witty play about personal and public morality in political life. The clever, often contrived, plot happened during a convention to nominate a presidential candidate. Up for selection are Henry Fonda (centre), the intellectual liberal candidate, and Cliff Robertson (left), the young unscrupulous right-winger. Between them is the dying ex-President (Lee Tracy in his last screen role, and his first for 17 years) whose endorsement each of them wants. Both candidates have damaging information on the other, Robertson on Fonda's previous nervous breakdown, and Fonda on the other man's homosexuality in the army. Good support was given by Margaret Leighton (right, as Fonda's estranged wife), Edie Adams (as Robertson's dumb wife), Kevin McCarthy, Gene Raymond, Richard Arlen (behind), Penny Singleton and Mahalia Jackson (as herself). Only comedian Shelley Berman gave an unfortunately jarring, over-the-top performance. It was forcefully directed by Franklin Schaffner in a convincing, semi-documentary style for producers Stuart Miller and Lawrence Turman. (MILLER-TURMAN)

◁**Girl With Green Eyes** got neither the critical nor public reaction it deserved. It was a gently humorous and refreshing first feature from director Desmond Davis, who had been the camera operator on three of Tony Richardson's British 'New Wave' films. Shot in Ireland, it dealt with the contrast between country and city life, but Edna O'Brien's firm screenplay, adapted from her novel *The Lonely Girl*, concentrated on a *jolie laide* couple of young girls, delightfully played by Rita Tushingham (illustrated) and Lynn Redgrave, sharing digs in Dublin and enjoying their first taste of liberty away from home. A chance meeting with middle-aged married author Peter Finch (illustrated) fulfils Tushingham's dreams of romance. When the affair turns sour, she decides to go off to England with her friend and start a new life. Oscar Lewenstein's production had fine support from Lislott Goettinger, Marie Kean, Eileen Crowe, Harry Brogan, Julian Glover, T.P. McKenna and Yolande Turner (Peter Finch's blonde and pretty, real-life wife). (WOODFALL)

▷Billy Wilder's brash sex comedy **Kiss Me, Stupid** came in for a lot of flak from the Puritan lobby who were outraged by its searing attack on American marriage, small-town life, Tin Pan Alley and TV fame. But underneath the bitter satire and smutty humour was a brittle, sensitive, ironic fable of love, fidelity and jealousy. The screenplay by Wilder and I.A.L. Diamond (suggested by the play *L'Ora Della Fantasia* by Anna Bonacci) set the action in the town of Climax, where famous crooner Dino (Dean Martin, left, entertainingly self-parodic) stops for gas on his way to Hollywood from Las Vegas. He is delayed there by the garage attendant, Barney Millsap (Cliff Osmond), and piano teacher Orville J. Spooner (Ray Walston, right taking over from the stricken Peter Sellers), in the hope that he will use one of their unsuccessful songs (actually minor George and Ira Gershwin numbers). Knowing of the randy singer's reputation for 'action' every night, the jealous Orville sends his wife Zelda (Felicia Farr) out of the house, and employs Polly The Pistol (Kim Novak, centre, in a role crying out for the late Marilyn Monroe), hostess at The Belly Button, to take her place. A double adultery was the sting at the end of the naughty but nice tale. Barbara Pepper, Doro Morande, Howard McNear, Henry Gibson, Alan Dexter, Alice Pearce and Mel Blanc had other roles. (MIRISCH/PHALANX)

△English restraint prevented **Woman Of Straw** from being as full-blooded as it needed to be if audiences were to relish its Gothic melodramatics. Basil Dearden's direction lacked the style necessary to counteract the absurdities of plot and dialogue in the screenplay by producer Michael Relph, Robert Muller and Stanley Mann (from a Catherine Arley novel). It told of a plot to murder a wealthy, crippled despot (Ralph Richardson, centre) hatched by the Italian nurse (Gina Lollobrigida, right) and his nephew (Sean Connery, left) who gets her to marry the invalid to see that he changes his will. The uncle dies mysteriously at sea, and the wife is blamed. However, the nephew is later revealed as the killer, just before he topples accidentally down the staircase of his uncle's mansion. La Lollo was uncomfortable in her role, but comfortable in a range of Dior outfits, while Connery seemed to have his mind on the next Bond movie. As ever, Richardson outacted everyone else, even when a corpse. Other roles were taken by Johnny Sekka, Laurence Hardy, Alexander Knox, Edward Underdown, Andre Morell and Peter Madden. The Eastmancolor shots of Majorca and the English countryside, and Mozart and Beethoven on the soundtrack gave the film a superficial air of sophistication (NOVUS)

▽The Japanese Daiei Studio's technical department deserved what little credit could be given to **Flight From Ashiya**, the star of which was a red helicopter struggling to save a group of survivors from a shipwreck off the coast of Japan during a typhoon. On board were pilot Richard Widmark (right), co-pilot George Chakiris (left), and Polish-Japanese parachute expert Yul Brynner (centre). While they attempted the rescue, each of them was given a prolonged flashback, unimaginatively directed by Michael Anderson and tritely written by Waldo Salt and Elliott Arnold (from the latter's novel). These involved Widmark's wartime romance with magazine photographer Shirley Knight who died in a Japanese internment camp, Chakiris having to abandon a group of people to die in an avalanche caused by his helicopter, and Brynner's love affair in Manila with Algerian girl Daniele Gaubert. Others appearing were Suzy Parker, Eiko Taki, Joe de Reda and Andrew Hughes. The Harold Hecht production, in Panavision and Technicolor, was a dubious tribute to the Air Rescue Service. (HECHT/DAIEI)

◁Although a rather tired-looking Peter Sellers took the title role in **The World Of Henry Orient**, the Nora and Nunnally Johnson script (based on the former's novel) centred on the adolescent antics of two 14-year-old schoolgirls, played by Tippy Walker (2nd right) and Merrie Spaeth (right). One day in Central Park, they come across Sellers (left), a mediocre concert pianist, making love to married Paula Prentiss. The girls weave an elaborate fantasy around him, until they become disillusioned when he makes a pass at one of their mothers. Director George Roy Hill was unable to strike a balance between the broad comedy of Sellers and Prentiss, and the whimsicality of the youngsters, often resorting to speeded up and slow motion when at a loss. Much better was the more satiric middle ground of the world of parents and their friends played by Angela Lansbury, Tom Bosely, Phyllis Thaxter, Bibi Osterwald, Peter Duchin, John Fielder, Al Lewis and Fred Stewart. The Park Avenue background was well caught in Panavision and De Luxe Color. (PAN ARTS)

▷**Topkapi** was a mixture of the realistic heist movie *Rififi* (France, 1955) and the light romp *Never On Sunday* (Greece, 1960), two previous Jules Dassin-directed pictures, although it had neither the excitement of the first nor the exuberance of the second. It did, however, have agreeable Technicolor travelogue photography by Henri Alekan, a lively score by Manos Hadjidakis, and a diverting screenplay by Monja Danischewsky (adapted from Eric Ambler's novel *The Light Of Day*). The plot revolved around a plan to steal a priceless emerald-encrusted dagger from the Topkapi Museum in Istanbul. The gang of thieves consisted of Melina Mercouri (Dassin's wife, illustrated), her Swiss lover Maximilian Schell (left), eccentric English inventor Robert Morley (right), athletic mute Gilles Segal (standing centre), and a German strong man, Jess Hahn (seated background). They are all in hiding at a villa where the drunken cook, Akim Tamiroff, believes them to be Russian spies. Due to a serious hitch, the robbery fails and the only thing that ended up being stolen was the movie – by Peter Ustinov (on couch), winning the Best Supporting Actor Oscar as a shabby con-man used by the police to spy on the gang. Also taking part in the box-office hit were Titos Vandis, Ege Erhart and Joseph Dassin (the producer-director's son by his first marriage). (FILMWAYS)

▽**Invitation To A Gunfighter** was a routine Western made interesting by Yul Brynner's strange presence as Jules Gaspard d'Estaing, a dandyish Creole who is expert at poker, playing the spinet, quoting poetry and shooting people dead. Brynner (right) is hired by the people of Pecos to kill George Segal, who has shot a man and barricaded himself in a house. Half way through the muddled screenplay by Elizabeth and Richard Wilson (from a story by Hal Goodman and Larry Klein), the gunfighter changes sides and helps Segal face the town's boss (Pat Hingle, left). Director Richard Wilson shot most of the Stanley Kramer production on the Universal backlot, using Hitchcock's *Psycho* house for Hingle's home. Also in it were Janice Rule, Brad Dexter, Alfred Ryder, Mike Kellin, Clifford David and Bert Freed. (KRAMER)

△A bumper crop of adventure movie cliches was to be found in **The Seventh Dawn**, set in the Malaya of 1945. Karl Tunberg's screenplay (from the novel *The Durian Tree* by Michael Keon) had two pals, William Holden and Tetsuro Tamba, who fought the Japs together during the war, now on opposing sides – Holden (centre), an Imperialist rubber plantation owner, and Tamba (left), a Communist guerrilla. Between machine gun fights in the jungle, parachute landings, betrayals and counter betrayals, Holden finds time for a three-cornered romance with Capucine, as a Eurasian, and Susannah York (right), a newly arrived English girl. Despite the well-publicized off-screen romance between Holden and Capucine, their on-screen amour lacked fire. Lewis Gilbert directed, in Technicolor, as if oblivious to the predictable mechanics of the plot. Michael Goodliffe, Allan Cuthbertson, Maurice Denham and Sidney Tafler played a collection of dreary British colonialists, and Charles K. Feldman was responsible for the production. (HOLDEAN)

▽'Give me ten men like Clouseau and I could destroy the world,' said a twitching Herbert Lom as the bumbling French Inspector's superior in **A Shot In The Dark**, producer-director Blake Edwards' first encore of the Peter Sellers character (illustrated) introduced so successfully in *The Pink Panther*. This time Edwards, and fellow screenwriter William Peter Blatty, slotted Clouseau into the framework of Harry Kurnitz's Broadway play, in turn adapted from the French comedy, *L'Idiote* by Marcel Achard. It concerned the investigation by Clouseau into the case of a parlourmaid (Elke Sommer) accused of shooting her lover in the mansion of her employer (George Sanders). While trying to prove her innocence, Clouseau leaves a trail of murders in his wake, finds himself in a nudist camp, and constantly falls out of a window. Other roles went to Tracy Reed, Graham Stark, André Maranne, Martin Benson and Burt Kwouk. It was filmed in Panavision and De Luxe Color, shot in Paris, and pleased Clouseau fans. (MIRISCH/GEOFFREY)

▷Bondmania began to spread with **From Russia With Love**, which consolidated the success of *Dr No* (1963). Producers Harry Saltzman and Albert Broccoli chose the same director (Terence Young) and two of the same writers (Richard Maibaum and Johanna Harwood) of the previous picture to bring Ian Fleming's novel to the screen. Less dependent on extravagant sets than many other James Bond movies, it had Istanbul and Venice as the main backdrops to the tongue-in-the-cheek action. As 007, Sean Connery (left – even more at ease in the role) had to face the forces of SPECTRE-Special Executive for Counter-Intelligence, Terrorism, Revenge and Extortion – who are trying to kill him and steal a top secret Russian coding machine. His principal adversaries are Red Grant (a stony-faced Robert Shaw, right) and Rosa Kleb (Lotte Lenya) whose boots are equipped with poisoned spikes. When the former, pretending to be a British agent on the Orient Express, makes the social blunder of ordering red wine with fish, he is unmasked by Bond and an exciting two-minute fight ensues. Others in the Technicolor production were Pedro Armendariz (in his last role), Daniela Bianchi (illustrated), Bernard Lee ('M'), Lois Maxwell (Miss Moneypenny), Eunice Gayson, Walter Gotell, Francis de Wolff, Nadja Regin, Vladek Sheybal and Peter Bayliss. (EON)

△Spectacular aerial photography in Panavision and Technicolor, bombs exploding and ear-splitting martial music (by Ron Goodwin) were not enough to make **633 Squadron** more than a standard war movie. No matter how stirring some of the flying action was under Walter E. Grauman's direction, the script by James Clavell and Howard W. Koch (from the novel by Frederick E. Smith) never allowed the actors to be more than stereotyped heroes. Top-billed American Cliff Robertson had no problem playing a Canadian (left), but George Chakiris' attempt at a Norwegian resistance leader (right) was as doomed as the character he portrayed, killed by Allied bombs before giving away a plan under Nazi torture. The plan was for Robertson and eleven other pilots to fly light Mosquito aircraft to bomb a German fuel factory on a Norwegian fjord. Only the star survived to tell the tale. Only just surviving in Cecil F. Ford's production were Maria Perschy (centre), Harry Andrews, Donald Houston, Michael Goodliffe, John Meillon and Scot Finch. (MIRISCH)

▽Made at the height of Beatlemania, **A Hard Day's Night** brought the pop group to an even wider public. The frantic pace of Walter Shenson's production and Alun Owen's plotless script suited the anarchic personalities of The Beatles (illustrated left to right: Paul McCartney, George Harrison, Ringo Starr and John Lennon) who played themselves. The madcap so-called plot had the Fab Four hotly pursued by fans, boarding a train for London where they are to do a TV show. They are accompanied by their harassed manager (Norman Rossington) and Paul's awkward grandad (Wilfred Brambell). In London, they keep disappearing during rehearsals much to the annoyance of a fussy TV director (Victor Spinetti), but all's well that ends with the show. Also in it were John Junkin, Kenneth Haigh, Anna Quayle, Deryck Guyler and Richard Vernon. The group sang many of their biggest hits, including the title song and 'Can't Buy Me Love', during which they were seen cavorting in a field forming patterns caught by a helicopter shot. Director Richard Lester started the fashion for placing pop stars in various unlikely settings, using jump cuts and slow and speeded up motion. The millions the picture made at the box-office not only reflected the Beatles' popularity, but the film's as well. (PROSCENIUM)

△**Goldfinger**, the third James Bond movie, had the Midas touch, earning around $20 million. It also cost UA and producers Harry Saltzman and Albert R. Broccoli more money than both the previous Bond pictures together. The main expense was due to the remarkable Ken Adam designs, in particular the full scale replica of Fort Knox built at Pinewood studios. Basically, the screenplay by Paul Dehn and Richard Maibaum followed the already tried-and-tested witty, male heterosexual fantasy formula, tenuously derived from Ian Fleming's novels, but Guy Hamilton's direction added even more extravagant touches. This time, Sean Connery's 007 was attempting to prevent the international gold smuggler of the title (German actor Gert Frobe, illustrated standing, with Connery) from detonating a nuclear device inside Fort Knox to contaminate US gold reserves. His bodyguard, a massive Korean called Odd Job (Harold Sakata), likes to behead people by throwing his steel bowler at them like a lethal frisbee, while more opposition to Bond came in the shape of glamorous pilot and Judo expert Pussy Galore (Honor Blackman). Others cast in the Technicolor picture were Shirley Eaton (dying exquisitively, covered in gold paint), Bernard Lee ('M'), Lois Maxwell (Miss Moneypenny), Desmond Llewellyn, Martin Benson, Tania Mallett, Nadja Regin and Bill Nagy. John Barry's title song, rendered with her characteristic sense of drama by Shirley Bassey, became a perennial best-seller. (EON)

▷What could be vaguely made out on screen through the obscure lighting, was that **The Ceremony** was a pretentious crime thriller set (and shot) in Spain, starring Laurence Harvey (right) as a bank robber jailed for the murder of a guard. His girlfriend (Sarah Miles) and younger brother (Robert Walker Jr, left) carry out a successful escape plan. But, after a series of complications that only Ben Barzman, who adapted the script from a novel by Frederic Grendel, could explain, one brother is accidentally executed in place of the other. 'This is my brother. My brother died for me,' says Harvey arranging the dead Walker Jr into a crucifix position. The real martyr was Laurence Harvey, who had to bear the slings and arrows of the critics as he produced and directed the picture. Also discernible were John Ireland, Ross Martin, Lee Patterson, Jack MacGowran, Murray Melvin, Fernando Rey and Noel Purcell. (MAGLA)

▽Director Roger Corman interrupted his cycle of horror movies to look at the horror of war in **The Secret Invasion**. The script by R. Wright Campbell, pre-dating *The Dirty Dozen* (MGM) by three years, told of how a British major (Stewart Granger, left) assembles a team of five convicts to rescue an Italian general (Enzo Fiermonte, right) held hostage in the Nazi fortress at Dubrovnik during World War II. The special squad consists of a sharpshooter (Henry Silva, centre left), an ex-gang leader (Raf Vallone, centre right), a dynamite expert (Mickey Rooney, 2nd right), a forger (Edd Byrnes) and an art faker (William Campbell). Aided by two partisans (Peter Coe, and Mia Massini, 2nd left), they effect the general's escape only to discover they have rescued his double. The Gene Corman production ended tragically, with only one survivor from the group. Despite some stilted playing and dialogue, the picture, shot in Yugoslavia in Panavision and De Luxe Color, made for exciting entertainment. (SAN CARLOS)

1964 OTHER RELEASES

For Those Who Think Young
A group of college kids find time between their endless beach parties to save a club from being closed down by a business tycoon. James Darren, Pamela Tiffen, Woody Woodbury, Robert Middleton, Paul Lynde, Tina Louise, Nancy Sinatra. *Dir* Leslie H. Martinson. *Pro* High Benson. Technicolor AUBREY SCHENCK/HOWARD W. KOCH

Ladybug, Ladybug
A community has to deal with the effects of a falsely triggered alert of a nuclear attack on a small rural American school. Jane Connell, William Daniels, James Frawley, Richard Hamilton, Kathryn Hays. *Dir & Pro* Frank Perry. PERRY

One Man's Way
A religio-biopic of the Reverend Norman Vincent Peale which tells of his spiritual awakening, his years at the seminary, his marriage and his belief in the power of prayer. Don Murray, Diana Hyland, William Windom, Virginia Christine. *Dir* Dennis Sanders, *Pro* Frank Ross. FRANK ROSS

1965

▷**The Train** began with a dedication 'to those French railway men, living and dead, whose magnificent spirit and whose courage inspired this story.' Admirable as producer Jules Bricken's intentions were, the picture seemed more of a tribute to the athletic prowess of Burt Lancaster (illustrated) as an American-accented French railway engineer in German-occupied France. His only concession to Frenchness was to stick a Gaulois in the side of his mouth while he leapt over walls and on and off trains. Even after being shot in the leg, he moved faster than any of the genuine French cast which included Jeanne Moreau, Michel Simon, Suzanne Flon, Albert Remy, Charles Millot and Jacques Marin. Lancaster's mission was to stop a trainload of art treasures from being transported to Germany. As the art-obsessed German colonel, Paul Scofield looked sour as he concentrated on getting his nasal German accent right. The screenplay by Franklin Coen, Frank Davis and Walter Bernstein (based on *Le Front De L'Art* by Rose Valland) contained some embarrassing lines about the paintings being part of French national heritage (Picasso!), and there was an unintentional Ealing-comedy like denouement. But the action was well-handled by director John Frankenheimer, replacing Arthur Penn after several days shooting. (ARIANE/DEAR)

▷**Billie** was a tomboyish teenager who could run faster, jump higher and throw further than any of the boys on the High school athletic team, thus embarrassing her father, who is running for mayor on a 'male supremacy' platform. Her boyfriend, whom she beats into second place in all the events, asks her to leave the team. She (and the movie) resists for a while, but finally gives in to the male browbeating. Producer-director Don Weis brought a lightness of touch to the unpromising script by Ronald Alexander, who pruned his 50s play *Time Out For Ginger* for the screen, allowing room for track meets and a few numbers. Patty Duke (illustrated left), in the title role, sang a song with perfume in one hand and running shoes in the other, the message being that one must choose between femininity and sport. Jim Backus played Billie's hen-pecked father, Jane Greer her mother, and Warren Berlinger her boyfriend. Also in the Techniscope-Technicolor picture were Billy de Wolfe, Charles Lane, Dick Sargent, Susan Seaforth and Richard Deacon. (CHRISLAW)

▽**Help!** was an Eastmancolor package for The Beatles (left to right: George Harrison, John Lennon, Ringo Starr and Paul McCartney), who spent much of the time being pursued by villains across 'Swinging' London, to Stonehenge, the Alps and the Bahamas. Also relentlessly pursuing them with his box of visual tricks was director Richard Lester, filming the boys through colour filters, out of focus, sideways, and upside down. Some of the group's personality survived Lester's technique, which worked best in the surreal staging of the numbers. The silly screenplay by Marc Behm and Charles Wood had Ringo somehow getting a sacrificial ring stuck on his finger causing High Priest Clang (Leo McKern), his priestess Ahme (Eleanor Bron), mad scientist Foot (Victor Spinetti) and his fat assistant Algernon (Roy Kinnear) to try and retrieve it. Protected by the Army and Police, the group manage to give a concert on Salisbury Plain. Other parts went to Patrick Cargill, John Bluthal, Alfie Bass and Warren Mitchell. Walter Shenson's production made almost as much money as *A Hard Day's Night* (1964), the first of the two fictional films in which the popular quartet appeared. (WALTER SHENSON/SUBAFILMS)

▽The first half of **Return From The Ashes** concerned the marriage of Jewish radiologist Ingrid Thulin (seated) to obsessively chess-playing Pole, Maximilian Schell (standing right) in Paris in 1938. When the Nazis enter the city, she is arrested and taken to Dachau. In the ludicrous second half the war is over and Schnell, believing his wife dead, is now living with Samantha Eggar. But Thulin returns, having had plastic surgery on her disfigured face, and Max drowns Samantha in her bath before attempting to kill Ingrid for money. The police nab him in time. Someone should have nabbed producer-director J. Lee Thompson before he committed himself to this muddy melodrama. The three leads managed to inject some life into Julius J. Epstein's script (from the novel by Hubert Monteilhet), with support coming from Herbert Lom (standing left), Talitha Pol, Vladek Sheybal, Jacques Brunius, André Maranne and Yvonne André. (MIRISCH)

△*Harvard Lampoon* got it right when they gave **The Greatest Story Ever Told** the Please-Don't-Put-Us-Through-DeMille-Again award to the movie 'which best embodies the pretentions, extravagance and blundering ineffectiveness of the traditional screen spectacular.' George Stevens, the producer, director and (with James Lee Barrett) co-writer seemed more inspired by the Gospel according to Hallmark than Saint Mark, and the 225-minute epic (later cut down to 141 minutes after it flopped), in Ultra-Panavision 70 and Technicolor, contained dreary cameos from a horde of Hollywood stars. These included Dorothy McGuire (The Virgin Mary), Charlton Heston (John The Baptist, illustrated), Telly Savalas (Pontius Pilate), Claude Rains (Herod), Pat Boone, Shelley Winters, John Wayne, Van Heflin, Sidney Poitier, Carroll Baker, Ed Wynn, Jose Ferrer, Donald Pleasence, Richard Conte, Roddy McDowell, David McCallum, Sal Mineo, Angela Lansbury, Gary Raymond, Victor Buono and Nehemiah Persoff. Max Von Sydow played Jesus Christ Superbore. (GEORGE STEVENS)

△The likes of a Barbara Stanwyck or a Susan Hayward might have brought flamboyance and passion to the rescue of **A Rage To Live**, despite the ineptitude of Walter Grauman's direction. Unfortunately, Suzanne Pleshette (illustrated) was nowhere near that magnitude in the role of sex-hungry Grace Caldwell, whose promiscuity only leads to loneliness and despair. At least the John O'Hara bestseller had attempted more of an analysis of her character than John T. Kelley's script did. Wealthy Grace has an affair with her brother's friend (Mark Goddard), and goes off with a bellhop in the hotel where her mother (Carmen Mathews) is having a heart attack. In guilt, she decides to marry a businessman (Bradford Dillman) but, after three years of happy marriage, she succumbs to a contractor (Ben Gazzara, illustrated). However, she does at least turn down her husband's married friend (Peter Graves). At the end, the husband walks out for good, something the audience was tempted to do rather sooner. Lewis J. Rachmil's Panavision production also cast James Gregory, Ruth White and Virginia Christine. (MIRISCH)

▽Not only was **Mister Moses** fairly offensive to black Africans, but it displayed general contempt for the intellect of audiences. The implausible screenplay by Charles Beaumont and Monja Danischewsky (from Max Catto's novel) told of how diamond smuggler Joe Moses (Robert Mitchum, illustrated) leads the people of an African village about to be flooded by a new dam, on a long trek across harsh terrain to the promised land. With him is a missionary's daughter (Carroll Baker), her priggish District Commissioner fiance (Ian Bannen), and a troublemaking witchdoctor's son (Raymond St Jacques). By the time they reach the new territory, the bad black man has been killed, the girl has naturally fallen for the smuggler, and an elephant has stolen the picture. Lest the Biblical parallels escaped notice, director Ronald Neame hit them home with a sledgehammer. Alexander Knox, Orlando Martins and Reginald Beckwith were the other professional actors in the cast. Frank Ross' production, shot in East Africa, did contain some Technicolored visual splendour on the Panavision screen. (FRANK ROSS/TALBOT)

▽So overwhelmingly popular were the James Bond movies, that the budget of over $4 million allotted by UA to producer Kevin McClory on **Thunderball**, was no risk at all. The film earned a mammoth $26 million in the USA alone. With more gadgets than ever, the human element in the screenplay by Richard Maibaum and John Hopkins (based on an original treatment by McClory, Jack Whittingham and Ian Fleming) was less important. This time, the main setting was the Bahamas, warmly evoked in Panavision and Technicolor, where Bond (Sean Connery, left) has been sent by 'M' (Bernard Lee, as usual) to find the underwater headquarters of SPECTRE. The evil organization has hijacked a NATO plane with two nuclear bombs on board, and is holding the Western world to ransom. Before saving the West from destruction at the last thrilling moment in Ken Adam's vast underwater set, Bond faces arch-villain Largo (Adolfo Celi in an eye-patch, right), and beds his usual quota of beauties. It was all efficiently orchestrated by director Terence Young, with the help of John Stears' Oscar-winning special effects. Also cast were glamorous trio Luciana Paluzzi, Claudine Auger (centre) and Martine Beswick, Guy Doleman, Desmond Llewellyn ('Q'), Lois Maxwell (Miss Moneypenny), Roland Culver, Earl Cameron, Philip Locke, George Pravda and Edward Underdown. (EON)

△**The Glory Guys** stood out from dozens of other competent Westerns because the Indians, not the Cavalry, won the climactic battle. Sam Peckinpah's script, based on the novel *The Dice Of God* by Hoffman Birney, tried to put the Indians' point of view, but as they were rarely seen until the massacre of a troop of inexperienced recruits, the point was lost. Arnold Laven's uneven direction concentrated mainly on the rivalry between Captain Tom Tryon (illustrated) and scout Harve Presnell over pretty Senta Berger. The two men have a semi-comic fight on a staircase, finally learning to respect one another. The often exciting action was further held up by the 'puppy love' affair between Michael Anderson Jr and Laurel Goodwin. Others cast were Andrew Duggan, James Caan, Slim Pickens, Peter Breck, Jeanne Cooper and Wayne Rogers. Produced by Laven, Arthur Gardner and Jules Levy, the picture contained the familiar but impressive sight of cavalry on the march in Panavision and De Luxe Color. (BRISTOL)

△**The Satan Bug** referred to a deadly virus developed for US defence in a secret research lab in the desert. One night, the flasks containing the bacteria are stolen. Onto the case comes George Maharis (illustrated) who with the help of General Dana Andrews' daughter, Anne Francis (illustrated), tracks down the man responsible. 'Mr Big' is none other than Dr Richard Basehart, one of the scientists who developed the virus. Fancy that! There were few surprises in the James Clavell-Edward Anhalt script (from the novel by Ian Stuart alias Alistair MacLean). The wooden cast of the Panavision-De Luxe Color picture also included Edward Asner, Frank Sutton, John Larkin, John Anderson, Simon Oakland and Richard Bull. The movie ends with a fight in a helicopter while the lethal flasks are rolling around. Maharis takes over the controls saying, 'I may be a bit rusty at this.' Producer-director John Sturges could have said the same thing. (MIRISCH/KAPPA)

▽Director Richard Lester turned his attention from The Beatles to another quartet of young people in **The Knack**, again pulling out a plethora of modish New Wave tricks to tell the tale. The characters were Colin (Michael Crawford, right), a sex-starved young teacher who owns a house in London, and his lodgers Tolen (Ray Brooks, left), who has such a knack with women he has to hold a reunion of his ex-girlfriends in the Albert Hall, Tom (Donal Donnelly), an easygoing Irish lad, and Nancy (Rita Tushingham), a wide-eyed innocent newly arrived from the North. Tolen tries his seduction technique on Nancy, but Colin gets her in the end. Screenwriter Charles Wood rid Ann Jellicoe's stage play of its more serious implications, and the Oscar Lewenstein production had a youthful larkiness that overcame some of the heavy 'generation gap' satire, such as street interviews with 'square' older people. Also appearing were John Bluthal, Wensley Pithey, William Dexter, Peter Copley, Dandy Nichols and, making her film debut in a bit part as a water skier, Charlotte Rampling. (WOODFALL)

▽Approached more modestly, **The Hallelujah Trail** might have made passable entertainment, but at nearly three hours, the comedy-Western, in Ultra-Panavision and Technicolor, strained to breaking point. Producer-director John Sturges decked it out with a fatuous narration (spoken by John Dehner), attempting to satirize everyone while at the same time trying to keep the characters convincing. John Gay's anachronistic script (from the novel by Bill Gulick) told of how a shipment of 40 wagon-loads of whisky tries to reach Denver, Colorado, before winter sets in, faced with a group of temperance women, comic Indians, and a sandstorm (impressively photographed by Robert Surtees). In the end, the last wagon is sunk in quicksand. Luckily, the likeable and highly professional cast kept the film from sinking entirely: Burt Lancaster (illustrated, as a put-upon Colonel escorting the ladies), Lee Remick (illustrated, as the head teetotaller), Jim Hutton (young captain in love with Pamela Tiffin, the colonel's daughter), Donald Pleasence (clairvoyant when plied with drink) and Brian Keith (the whisky transporter). Other roles went to John Anderson, Tom Stern, Robert J. Wilke and Jerry Gatlin. (MIRISCH/KAPPA)

△'We're both too old for this sort of thing,' says baddie Jack Hawkins (illustrated) to ambiguous hero Cliff Robertson after they have traded blows in **Masquerade**. There was no truer line in producer Michael Relph and William Goldman's script (based on the Victor Canning novel *Castle Minerva*). The two leads come to this conclusion after being dragged through a complicated plot in which Robertson is employed by the F.O. to kidnap the 14-year-old future king (Christopher Witty) of an oil-rich Arab state, to protect him, until his coronation, from the anti-British Regent (Roger Delgado) who might kill the boy. Also taking part were Marisa Mell, Bill Fraser, Michel Piccoli, Tutte Lemkow, Charles Gray, John Le Mesurier and Felix Aylmer. Director Basil Dearden managed to make something of a couple of set pieces, one in a circus where Robertson is abducted by four clowns, and the finale on a collapsing suspension bridge. The Eastmancolor picture, shot in Spain, tried to overlay the idiotic plot with the cynical message than crime *does* pay. The box-office didn't reflect the message. (NOVUS)

△**I'll Take Sweden** was one of a series of feeble sex comedies offering sad evidence of Bob Hope's decline on screen. The three screenwriters, Nat Perrin, Bob Fisher and Arthur Marx (story by Perrin) managed to squeeze out a few vintage wisecracks for the comedian at the start when he puts down the friends of his teenage daughter, Tuesday Weld. But the widower is soon behaving even more moronically than they in his attempts to stop his daughter marrying guitar-playing Frankie Avalon. He whisks her off to Sweden where they both succumb to the temptations of Swedish sexual permissiveness (or nearly). Bob (left) and Dina Merrill (right), and Tuesday and Jeremy Slate, coincidentally land up at the same hotel for their 'trial honeymoons'. Crudely directed by Frederick de Cordova, Edward Small's Technicolor production represented Sweden by a few stock shots of Stockholm. Others involved were Rosemarie Frankland (Miss World of 1961), Walter Sande, John Qualen, Peter Bourne and the stripper Beverley Hills. (EDWARD SMALL)

▽The answer to the question **What's New, Pussycat?** was nothing much, except that Woody Allen (left) was making his film debut as actor and screenwriter. Neither of his talents were given much chance in the welter of flatfooted slapstick imposed on the picture by director Clive Donner, detrimentally influenced by Richard Lester's Beatles movies. After the wittily designed credits by Richard Williams and the Burt Bacharach title song, put over punchily by Tom Jones, it was downhill all the way. The meagre plot revolved around playboy fashion editor Peter O'Toole (right) who is unable to settle down with his fiancee, Romy Schneider, because he is constantly distracted by all the leggy models around him, including Capucine, Paula Prentiss and Ursula Andress. On the advice of his friend Victor Shakapopolis (Allen), he consults crazy psychiatrist Fritz Fassbender (Peter Sellers in a Richard III wig and large glasses), who is having trouble with his Wagnerian wife (Edra Gale). Charles K. Feldman's Technicolor production ended with the entire cast desperately trying to get laughs from a go-kart race. Though panned by the critics, the public loved it. (FAMOUS ARTISTS)

▽Box-offices were besieged by audiences wanting to know **How To Murder Your Wife**. Producer-screenwriter George Axelrod and director Richard Quine illustrated the ostensibly macabre lesson with the aid of Jack Lemmon (illustrated), who wishes to dispose of his wife, blonde Italian beauty Virna Lisi (illustrated), whom the confirmed bachelor married while in a state of severe intoxication. Lemmon, the strip cartoonist of 'Brash Brannigan, Secret Agent', works out the feasibility of each of his hero's exploits with the assistance of his valet, Terry-Thomas. His wife changes the strip to 'The Brannigans', the mis-adventures of a henpecked husband. When Lemmon tries out her murder using a dummy, he is arrested after her disappearance. (She's gone back to Italy.) In a ludicrous court scene, he is acquitted by the all-male jury after making a plea for the Amrican man to free himself from female tyranny. Not only was Lemmon happier before Signora Lisi entered his life, but so was the Technicolor picture, which drooped considerably after the first lively hour. Support was given by Eddie Mayehoff, Claire Trevor, Sidney Blackmer, Max Showalter, Jack Albertson and Mary Wickes. (MURDER INC.)

△Four of the cast of six in **A Thousand Clowns** were reprising the roles they had played on stage in this Herb Gardner 1962 Broadway hit comedy. They were Jason Robards Jr (right), the hack TV gag writer, Barry Gordon, his precocious 12-year-old nephew who shares his one-room apartment, William Daniels, the Child Welfare Offficer ('I am not one of the warm people'), and Gene Saks, TV's 'Chuckles the Chipmunk' whom children loathe and vice versa. Also excellent were Barbara Harris in her screen debut as Daniels' assistant who also moves into the apartment, and the ever dependable Martin Balsam (left, winner of the Best Supporting Actor Oscar) as Robards' go-getting agent brother. Producer-director Fred Coe tried some mandatory opening up of the one-set play, but it detracted rather than added to the piece. Gardner retained most of the witty lines in his screenplay, and the creeping whimsy, indicated in the title, was kept to a minimum. (HARRELL)

UNITED ARTISTS

1966

▷Mary McCarthy's best-selling novel, **The Group**, did not lend itself easily to a screen adaptation. Structurally, the book followed the lives of eight graduates of the Class of 1933 at Vassar (not named in the film) for the next 20 years, dealing almost equally with all of them. Producer Sidney Buchman manfully tried to cram as much as he could into his unwieldy screenplay, but many of McCarthy's political and social views were lost, and some of the characters became mere sketches, even in its 150 minutes. Worst casualty was top-billed Candice Bergen (standing right, daughter of ventriloquist Edgar Bergen) as Lakey, the lovely lesbian (coyly referred to as 'Sapphic'), who, nevertheless, made an impact in her screen debut. The other girls were Dottie (Joan Hackett, 2nd right front, debut), Priss (Elizabeth Hartman, left front), Polly (Shirley Knight, right front), Kay (Joanna Pettet, standing left, debut), Pokey (Mary-Robin Redd, standing 2nd right), Libby (Jessica Walter, standing 2nd left) and Helena (Kathleen Widdoes, 2nd left front, debut). The various men in their lives (most of them weak) were played by James Broderick, James Congdon, Larry Hagman, Hal Holbrook, Richard Mulligan and Robert Emhardt. Sidney Lumet's direction tottered uncertainly between satire and soap opera, but the period backgrounds were captured with appeal in De Luxe Color by Boris Kaufman's camera, and the picture introduced several bright new actresses. (FAMOUS ARTISTS)

▷An unfunny thing happened on the way to the screen of **A Funny Thing Happened On The Way To The Forum** under Richard Lester's flashy direction. Jump cuts, rapid editing, speeded up and slow motion, fine for the Beatles movies, was fatal to the enjoyably old-fashioned burlesque Broadway musical by Burt Shevelove, Larry Gelbart and Stephen Sondheim. Yet, so strong were the personalities of the cast, that they managed to break through the style. The script, by Melvin Frank and Michael Pertwee, retained the basic plot of the bawdy Roman farce which involved the slaves Pseudolus (Zero Mostel, left, repeating his stage triumph) and Hysterium (Jack Gilford), a brothel owner (Phil Silvers, right), a lascivious senator (Michael Hordern), his dragon wife (Patricia Jessel), a conquering hero (Leon Greene), naive young lovers (Michael Crawford and Annette Andre) and wealthy patrician Erronius (Buster Keaton, tragically wasted in his last film). Melvin Frank's production, filmed in an old movie set in De Luxe Color, was given a sort of seedy grandeur by the old-time comics, but this didn't help. (QUADRANGLE)

◁British director Basil Dearden was given **Khartoum**, the biggest budget picture of his career, by producer Julian Blaustein, who probably hoped to emulate the commercial success of *Lawrence Of Arabia* (Columbia, 1962). He didn't. Despite some good battle scenes and splendid location photograpy in Ultra-Panavision and Technicolor, shot on the banks of the Nile, the attempt to combine a dull history lesson with the conventions of the action spectacle made the 134 minutes rather heavy going. Robert Ardrey's problematic screenplay, while avoiding the imperialist line, tried to work up sympathy for the action of General 'Chinese' Gordon in holding out against the Mahdi instead of evacuating the British from the Sudan, as instructed by Prime Minister Gladstone (Ralph Richardson). Charlton Heston as Gordon (foreground centre) gave his familiar 'great man' performance, missing the complexities of the character, although he was better than the somewhat caricatured playing by Laurence Olivier as the Mahdi in turban and tan make-up. Also in the cast were Richard Johnson (left), Hugh Williams, Alexander Knox, Johnny Sekka, Nigel Green, Michael Hordern and Zia Moyheddin. (BLAUSTEIN)

△In the old saloon song from which **Frankie And Johnny** derived its title, Johnny is shot dead by Frankie for cheating on her, an end that would not have done for Elvis Presley. In this innocuous Technicolor musical, Elvis (illustrated) was to be found on a Mississippi showboat as a singing gambler who temporarily strays from Dona Douglas to Nancy Kovack, whom he hopes will bring him better luck at the roulette table. Any attempt in the screenplay by Alex Gottlieb (from Nat Perrin's story) to pastiche riverboat dramas was subordinated to the need to include a dozen songs for the once shocking but now bland star. Other roles were given to Sue Ane Langdon, Harry Morgan, Audrey Christie, Jerome Cowan and Robert Strauss. It was director Frederick de Cordova's last movie. Edward Small's production had the same title as a 1935 RKO movie which did end, traditionally, in a death. (FRANKIE AND JOHNNY PRODUCTIONS)

△**Boy, Did I Get A Wrong Number!** was an apt expression to be used by everyone involved in this no-no comedy. Bob Hope (illustrated), at 63, should have known better than to get involved in this strained bedroom farce or with lightly-clad blonde Elke Sommer whom he is trying to hide from his wife Marjorie Lord, while staying at a weekend cottage. When the girl's car is found at the bottom of the lake, he is accused of murder but, after an escape and chase, all is explained at the happy ending when Elke turns up alive. Not so alive was the script by Burt Styler, Albert E. Lewin and George Kennett (story George Beck), and the who-cares direction from septuagenarian George Marshall. Comedienne Phyllis Diller, in the first of three Hope movies, provided a few chuckles as Bob's wild-haired maid. Others in it were Cesare Danova, Kelly Thorsdon, Benny Baker and Harry Von Zell. The producer of the De Luxe Color picture was Edward Small. Boy, did he (EDWARD SMALL)

▽Directing on screen for the first time, George Axelrod also produced and co-wrote (with Larry H. Johnson) **Lord Love A Duck**, a wicked and witty satire on American mores, based on the Al Hines novel. Unhappily, it flopped due to its multitude of targets, its attitude to sacred cows, and its often slapdash style. The central figure, Alan 'Mollymauk' Musgrave, a high school senior with a tremendous I.Q. (Roddy McDowell, centre, pushing 40), helps fellow student, dumb blonde Barbara Ann (a delicious Tuesday Weld, right) fulfil all her dreams. These include getting twelve cashmere sweaters from her father (Max Showalter), marrying a handsome undergraduate Bob (Martin West), and becoming star of a beach party movie called 'Bikini Widow'. When she wants to get rid of her husband, Alan obliges by crushing him beneath a bulldozer. Other characters were a lustful film producer (Martin Gabel), a prostitute wishing to be known as a 'cocktail waitress' (Lola Albright), a snobbish Freudian (Ruth Gordon, left), an inane school principal (Harvey Korman) and a minister (Donald Murphy) who holds sex seminars and runs a drive-in church. Only in America ... (CHARLESTON)

▽Although the nine marines landing on a Japanese-held island in **Ambush Bay** were doing it for the first time, audiences had been there many times before. Hal Klein's production, shot in De Luxe Color in the Philippines, had hardboiled Sergeant Hugh O'Brian taking over a platoon which included Mickey Rooney (illustrated), James Mitchum, Peter Masterson, Harry Lauter, Greg Amsterdam, Jim Anauo, Tony Smith and Clem Stadler. They make contact with woman spy Tisa Chang, who tells them that the bay is full of mines which must be detonated before the anticipated invasion by General MacArthur. The brave soldiers fulfil their mission, but only Mitchum, the inexperienced radio man, survives. The episodic script by Marve Feinberg and Ib Melchior served Ron Winston well enough in his direction of the standard heroics. (COURAGEOUS)

△In response to the question **What Did You Do In The War, Daddy?**, producer-director Blake Edwards gave a satiric, anti-heroic and somewhat prolonged answer. Lieutenant James Coburn (right) and his war-weary company, led by Captain Dick Shawn (left), are ordered to capture the town of Valerno during the Italian campaign in 1943. When they arrive, they find the town is only too willing to surrender, but only after the inhabitants have finished their soccer game and wine festival. The GIs happily join the lovable, comic, cowardly, vino-drinking Italians, pretending to HQ that they have met unexpected resistance. More resistible was some of the overplaying, especially by Shawn, and the gradual thinning out of good jokes in William Peter Blatty's script (story by Edwards and Maurice Richlin). The Panavision-De Luxe Color picture also used the services of Sergio Fantoni, Giovanna Ralli, Aldo Ray, Harry Morgan, Carroll O'Connor, Leon Askin, Jay Novello and Johnny Seven. (MIRISCH/GEOFFREY)

△Producer-director Melville Shavelson wrote a book called *How To Make A Jewish Movie* about his problems while filming the 144-minute Panavision-De Luxe Color **Cast A Giant Shadow** in Israel. One thing he didn't do was make a good Jewish movie. Based on Ted Berkman's biography of Colonel David 'Mickey' Marcus, Shavelson's simplistic screenplay told of how Marcus (Kirk Douglas, right) helped build the Israeli army from scratch in 1947. In between killing villainous Arabs with his bronzed heroic troops, he jumps into bed with a glamorous Israeli freedom fighter (Senta Berger). After seeing the state of Israel established, he prepares to return to his wife (Angie Dickinson) in New York, but is accidentally shot dead by one of his sentries. John Wayne (left) and Yul Brynner made guest appearances; so did Frank Sinatra, playing the part of a pilot who bombs Egyptians with soda syphons. Others cast were Luther Adler, Stathis Giallelis, James Donald, Gordon Jackson, Topol (billed as Haym Topol), Ruth White, Michael Hordern, Gary Merrill and Jeremy Kemp. (MIRISCH/LLENROC/BATJAC)

▽**The Russians Are Coming, The Russians Are Coming** was often as repetitious as its title and, like the Russian seamen who accidentally land in a small resort in Nantucket, it overstayed its welcome. Producer-director Norman Jewison slowed up the 120-minute Panavision-De Luxe Color movie by dwelling on the soppy love affair between a Russian boy (John Phillip Law, centre left) and an American girl (Andrea Dromm). Yet, the screenplay by William Rose (based on Nathaniel Benchley's novel *The Off-Islanders*) was made to work by the amiable cast enacting characters caught in comic panic. They were

Carl Reiner (right) and Eva Marie Saint (left) as a New York writer and his wife on vacation, suddenly finding Russians knocking on their door, Brian Keith, the amused police chief, Paul Ford, the hot-head who wants to repel the invaders with a sword, Tessie O'Shea, the gossiping telephone operator, and Ben Blue, the town drunk. Jonathan Winters, Theodore Bikel, Sheldon Golomb (left foreground) and Cindy Putnam (2nd left) took other roles. But it was Alan Arkin's Oscar-nominated screen debut as a confused Russian lieutenant (centre), that got the most laughs in this big earner. (MIRISCH)

▽**Return Of The Seven** was actually the return of the one. Namely, Yul Brynner (centre behind), the only survivor from the cast of *The Magnificent Seven* (1960) of which this was a poor retread. Gunfighter Yul is asked by the inhabitants of a small Mexican village to rescue them from bandits, who have rounded up all the males for use as slave labour. With the help of (left to right) Robert Fuller, Julian Mateos, Claude Akins, Virgilio Teixeira, Jordan Christopher and Warren Oates, he routs the 100-strong enemy and brings peace to the village. Emilio Fernandez, Rudolfo Acosta, Elisa Montes and Fernando Rey had other roles. At the fadeout, the heroes rode away, only to return in different bodies but in the same plot in *Guns Of The Magnificent Seven* (1969) and *The Magnificent Seven Ride* (1972). The action sequences, under Burt Kennedy's predictable direction, were interrupted by the characters giving biographical accounts of themselves, a vain attempt by screenwriter Larry Cohen to make them more human. The Panavision-Technicolor picture was produced by Ted Richmond. (MIRISCH/C.B.)

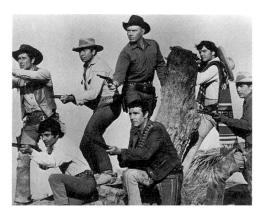

▽Walter Mirisch's production of **Hawaii** never began to earn back the $15 million spent on it, nor was it worth the seven years it took to make. $600,000 was paid for the film rights of James A. Michener's tome, which embraced centuries of Hawaiian history. The screenplay by Dalton Trumbo and Daniel Taradash only dealt with the period from 1820 to 1841 when the island began to be corrupted by Western ways. The endless (186 minutes) tale told of how Reverend Abner Hale (Max Von Sydow) goes out to Hawaii with his bride Jerusha (Julie Andrews). He is an unbending and arrogant man who makes no effort to understand the islanders, but manages to convert local chieftain Queen Malama, the plump and amusing Oscar-nomi-

nated Hawaiian actress Jocelyn La Garde (centre, holding Andrews). His wife renews her acquaintanceship with her former lover, whaler Rafer Hoxworth (Richard Harris), but pluckily remains with her husband until her death. He lives on in loneliness, finally learning to love the people. It was not easy to love cold Von Sydow, but Andrews supplied warmth and Harris fire. Also cast were Carroll O'Connor, Elizabeth Cole, Diane Sherry, Torin Thatcher, Gene Hackman, Heather Menzies and George Rose. Some of the more spectacular sequences – storms at sea, typhoons, pagan ceremonies – were impressive in Panavision and De Luxe Color, directed by George Roy Hill, who replaced Fred Zinnemann. (MIRISCH)

▽In one scene in **Mademoiselle**, Jeanne Moreau (illustrated) gets down on her knees, bays like a dog, and licks the muddy boots of her Italian workman lover (Ettore Manni). Aside from having a fetish for feet (or boots or mud?), Mademoiselle Moreau, the teacher in a small French village, goes off at night, smartly dressed in gloves and high heels, and sets fire to barns, opens the lock gates to flood the town, and poisons the water of the livestock. Then she makes sure the villagers blame her lover for these crimes and claims he tried to rape her. Why she did all this was not explained in Jean Genet's screenplay (translated into English by Bernard Frechtman) or in Tony Richardson's sub-Buñuelesque direction. Not that anyone cared by the time Oscar Lewenstein's production came to its ludicrous conclusion. Also in it were Keith Skinner, Umberto Orsini, Jane Berretta, Mony Reh and Georges Douking. (WOODFALL/PROCINEX)

1966

△**Duel At Diablo** was a traditional Western, right down to the timely arrival of the cavalry at the climax to save the hero and heroine from a Red Indian attack. However, the more violent nature of the deaths, and the fact that a black man (Sidney Poitier) played a leading role, made the Ralph Nelson-directed picture a typical product of the mid-60s. Screenwriters Michel M. Grilikhes and Marvin H. Albert (adapting the latter's novel *Apache Rising*) had scout James Garner rescuing Bibi Andersson (the Swedish actress in her US debut, illustrated) from marauding Indians, and taking her back to the fort where her husband, nasty Dennis Weaver, is waiting. Garner, Bibi and horse-breaker Poitier survive further Indian attacks, but Weaver meets a painful death. Bill Travers, William Redfield, John Hoyt, John Crawford, John Hubbard and Kevin Coughlin took other conventional roles. The Ralph Nelson-Fred Engel production was shot in the Utah hills in De Luxe Color. (NELSON/ENGEL/CHEROKEE/RAINBOW/BRIEN)

▽The time was **10.30 P.M. Summer**. The place was Spain. The result was an illogical and ill-conceived melodrama which Jules Dassin produced (with Anatole Litvak), wrote (with Marguerite Duras, adapting the latter's novel) and directed, starring his wife Melina Mercouri. The earthy Greek actress (illustrated) was part of a tedious triangle consisting of her husband, Peter Finch (illustrated), and her best friend, Romy Schneider, on holiday together. Melina has erotic dreams (or is it reality?) about Peter and Romy making love. It is not clear which of them she fancies most. On one of her nightly jaunts, Melina meets a young Spaniard (a wordless Julian Mateos) on the run after killing his wife and lover. She helps him escape, but he shoots himself. Had he turned his gun on Miss Mercouri, audiences might have cheered instead of jeered. Isabel Maria Perez and Beatriz Savon took other roles. (JORILL/ARGOS)

△Although Peter Sellers (illustrated foreground) had always admired Vittorio De Sica, the formerly great Italian neo-realist director, he tried to get him replaced during the shooting of **After The Fox**. Surprising, as Sellers was allowed to indulge himself outrageously in a variety of unfunny costumes and accents. Not that there was much De Sica (who also took a cameo role) could have done with the witless material cooked up by screenwriters Cesare Zavattini and Neil Simon. It told of how Sellers and his gang steal 300 bars of gold bullion in Cairo, and get it unloaded from a ship into an Italian coastal village by pretending they are making a heist movie. To give the con authenticity, Sellers hires an ageing American star (Victor Mature) to play opposite his sister (Britt Ekland, the real-life Mrs Sellers, in a dark wig). All goes wrong when one of the gang (Akim Tamiroff) tries to doublecross his boss. Also in it were Lidia Brazzi, Paolo Stoppa, Martin Balsam and Mac Ronay. The one bright spot in John Bryan's Panavision-Technicolor production was Mature, in trench coat and slouch hat from the 40s, sending himself up in a tragi-comic manner. (COMPAGNIA CINEMATOGRAFICO/NANCY)

△Producer-director Billy Wilder's **The Fortune Cookie** (GB: **Meet Whiplash Willie**) was a wickedly funny moral tale in 15 chapters enlivened by Walter Matthau's Oscar-winning brilliant caricature of a shyster lawyer. Wilder and I.A.L. Diamond's finely wrought script told of how TV cameraman Jack Lemmon (centre) is bowled over on the sidelines at a football match by Cleveland Brown's wide receiver, Ron Rich (left). He is taken to hospital, but there's nothing wrong with him that a hot bath won't cure. Enter Matthau (right), his lawyer brother-in-law, who is 'so full of twists that when he starts to describe a doughnut, it comes out a pretzel.' He gets Lemmon to pretend he's paralyzed from the neck down in order to sue the National Football

League and everyone else in sight. Lemmon's mercenary wife, Judi West, returns to him, and the contrite football player waits on the 'cripple' hand and foot. Just when he has won his case, Lemmon's conscience pricks him to stand up (literally) for his principles. Lemmon was excellent in a difficult role, as were West, Cliff Osmond, Lurene Tuttle, Harry Holcomb, Les Tremayne, Marge Redmond and Sig Rumann. However, under the film's steely surface was a soft centre, namely the goodhearted, simple black sportsman whose relationship with Lemmon, although important to the plot, was unsubtle. But the sugar was counteracted by the delicious acrimony of Matthau's whiplash tongue. (MIRISCH/PHALANX/JALEM)

1966 OTHER RELEASES

Don't Worry We'll Think Of A Title
A bumbling incompetent is believed by a secret organization to be a defected cosmonaut hiding in a small American college town. Moray Amsterdam, Rose Marie, Richard Deacon, Tim Herbert, Jackie Heller. *Dir* Harmon Jones. *Pro* Moray Amsterdam, Aubrey Schenck. COURAGEOUS/KAM

Namu, The Killer Whale
A 25-foot killer whale is captured in a British Columbia cove and transferred to Seattle where it becomes a number one attraction at a Marine Park. Robert Lansing, John Anderson, Lee Meriweather, Richard Erdman, Robin Mattso. *Dir* & *Pro* Laszlo Benedek. De Luxe Color. IVAN TORS

Renegade Gunfighter (aka **For A Thousand Dollars A Day**, orig: **Per Mille Dollari Al Giorno**)
A man learns to become the best shot in New Mexico in order to rid his home town of the gang who killed his parents which, of course, he does. Anna Maria Pierangeli, Zachary Hatcher, Dick Palmer, Pepe Calvo, Mirko Ellis. *Dir* Silvio Amadio. *Pro* Uncredited. Technicolor. (Italy/Spain) TIRSO FILM/PETRUKA FILM

1967

▽Bob Hope continued his fruitless search for laughs in **Eight On The Lam** (GB: **Eight On The Run**), an empty-headed farce which exercised the brains of no fewer than four writers, Albert E. Lewin, Burt Styler, Bob Fisher and Arthur Marx (story by Fisher and Marx). The eight of the title were widowed bank teller Hope and his seven kids (Kevin Brody, Stacey Maxwell, Glenn Gilger, Debi Storm, Michael Freeman, and the star's grandchildren Robert and Avis Hope). They are on the lam because Bob (illustrated) is suspected of having stolen money from the bank but, at a dude ranch, disguised as a wealthy Texan, he unmasks the real criminal (Austin Willis). In the end, he marries Shirley Eaton, and his crazy babysitter Phyllis Diller marries detective Jonathan Winters. Jill St John (illustrated) made an attractive addition to the cast. The De Luxe Color movie was misdirected by George Marshall for a producer who wisely preferred to remain unknown. (HOPE ENTERPRISES)

▷**The Way West** took 122 minutes and as many cliches to tell the tale of how a wagon train of pioneers crossed the hazardous Oregon Trail from Missouri to what they saw as the promised land. Not so promising was the cluttered screenplay by Ben Maddow and Mitch Lindemann (from the A.B. Guthrie Jr novel), and the listless direction by Andrew V. McLaglen. Along for the ride were Kirk Douglas (left) as the ruthless senator who leads them, Robert Mitchum (centre), the half-blind guide(!), Richard Widmark (right), his wife, Lola Albright, and son, Michael McGreevey, Michael Whitney, who gets himself hanged after accidentally killing an Indian boy, Roy Glenn, the Negro slave who whips Douglas at the latter's request to prove his mortification at the death of his son, flirt Sally Field (her screen debut), Katherine Justice, Stubby Kaye, Jack Elam, Connie Sawyer, Harry Carey Jr, Elisabeth Fraser and William Lundigan. Harold Hecht's production contained some handsome long shots of the wagon train against rock formations, filmed in Panavision and De Luxe Color. (HAROLD HECHT)

△It took three years before the Italian-made Western **A Fistful Of Dollars** was picked up for distribution in the USA, although it had been an enormous hit in Italy. Most critics ignored it at first, while others jeered at the idea of foreigners attempting the sacrosanct American genre, despite the makers attempts to disguise themselves behind anglicized names:- producers Harry Columbo and George Papi (Arrigo Columbo and Giorgio Papi), director Bob Robertson (Sergio Leone), composer Dan Savio (Ennio Morricone), cinematographer Jack Dalmas (Massimo Dallamano) and co-star John Welles (Gian Maria Volonte). No need for Clint Eastwood (right), playing The Man With No Name, to change his. After small parts in ten movies, and seven years in TV's *Rawhide* series, Eastwood found himself an international superstar at 37. Leone's leisurely, self-conscious direction and screenplay (written with Duccio Tessari) helped form the character of the impassive, laconic, poncho-clad loner, constantly smoking a cheroot, who became part of the mythology of what was soon dubbed the 'Spaghetti Western.' The plot, taken from Akira Kurosawa's *Yojimbo* (Toho, 1961), was a typically violent brew with Clint playing off two rival gangs against each other, and then facing five gunmen alone in the final protracted shootout. Also cast were Marianne Koch, Pepe Calvo (left), Wolfgang Lukschy, Sieghardt Rupp, Margherita Lozano and Daniel Martin. The Techniscope-Technicolor picture made fistfuls of dollars worldwide and spawned several 'sequels'. (JOLLY/CONSTANTIN/OCEAN)

▽**For A Few Dollars More** (made in 1965) followed hard on the heels of *A Fistful Of Dollars* (made in 1964), and matched its tremendous success. Sergio Leone's direction was even more ritualistic than in the previous movie – snarling faces under sombreros in large, silent close-ups, circular tracking shots, and meaningful pauses between spurts of violent action, underscored by Ennio Morricone's emotive music. The screenplay by Leone and Luciano Vincenzoni (story by Leone and Fulvio Marzella) offered no psychology, but merely moved from one life-is-cheap episode to another as taciturn hero-villains shot one another for dollars or revenge. The main characters were two bounty hunters (Clint Eastwood, illustrated) and Lee Van Cleef, and their bank robber quarry (Gian Maria Volonte). Cheroot-smoking, unsmiling Eastwood and pipe-smoking, sadistically-smiling Van Cleef, made an awesome pair, the latter gaining stardom after fourteen years as a supporting heavy. Alberto Grimaldi's 130-minute Techniscope-Technicolor production also cast Klaus Kinski (maniacally staring and twitching), Mara Krup, Joseph Egger, Mario Brega and Rosemary Dexter. (P.E.A./ARTURO GONZALES/CONSTANTIN)

△Sadistic sergeant Rip Torn says in **Beach Red**, 'That's what we're here for, to kill – and the rest is all crap.' He said it! Three writers, Clint Johnston, Donald A. Peters and Jefferson Pascal derived the banal screenplay from Peter Bowman's 1945 novel, which concentrated on a small group of American marines out to take a Japanese-held island in the Pacific. Each of the characters was a mere cipher for a different point of view:- the war lover (Torn), the Southerner (Burr DeBenning, left) who finds comradeship in the army, the 18-year-old minister's son (Patrick Wolfe) who remembers his girl back home, and the cruel-to-be-kind captain (expressionless Cornel Wilde, right) who hates war and loves his wife (Jean Wallace, Mrs Cornel Wilde, dragged in). Others cast were Jaime Sanchez, Genki Koyama, Norman Pak and Dewey Stringer. Wilde also produced and directed the De Luxe Color picture in which a gratuitous variety of severed limbs made the point that war is hell. (THEODORA)

▽In **Clambake** Elvis Presley (right) played a rich boy whose aim in life seems to be to get girls to love him for himself and not for his money. Therefore, in Arthur Browne Jr's script and story, he changes places with water-ski instructor Will Hutchings (left). At a studio-bound Miami beach, he sings songs like 'Who Needs Money?' and 'Hey, Hey, Hey', and instructs gold-digger Shelley Fabares in water-skiing. Elvis also helps build a speed boat, using a miraculous protective coating called Goop, before beating playboy Bill Bixby in the speed boat race. James Gregory, Amanda Harley, Suzie Kaye, Angelique Pettyjohn and Gary Merrill took other roles in the Jules Levy-Arthur Gardner-Arnold Laven Techniscope-Technicolor production. The movie, directed by Arthur H. Nadel, was Goop from start to finish. (RHODES)

△The *grande dame* of the British theatre, Edith Evans (illustrated), did well to suggest an old, lonely, working-class woman in **The Whisperers**, although her technique was a mite too theatrical to be utterly convincing. Yet, the film was at its best when Bryan Forbes' direction and screenplay (based on the novel by Robert Nicolson) concentrated on her alone, leading a sordid, solitary existence in a slum apartment, where she is convinced she's being spied upon, and hears voices emanating from the pipes and walls. But the various digressions dealing with her estranged con-man husband (Eric Portman), her wayward son (Ronald Fraser), the evil woman (Avis Bunnage) who steals from her, and other excessively seedy characters, revealed British 'New Realism' at its worst. Also in Michael S. Laughlin and Ronald Shedlo's production were Nanette Newman and Sarah Forbes (the director's wife and daughter), Gerald Sim, Leonard Rossiter, Kenneth Griffith, Harry Baird, Margaret Tyzack and Robin Bailey. (SEVEN PINES)

▽**Fitzwilly** (GB: *Fitzwilly Strikes Back*) was a refreshing throwback to a 30s-type comedy, only lacking stars like William Powell and Claudette Colbert, and more stylish direction than Delbert Mann could muster. Nevertheless, Walter Mirisch's production had an amiable cast and some good lines in Isobel Lennart's screenplay (based on *A Garden Of Cucumbers*, a novel by Poyntz Tyler). The overly whimsical but amusing plot concerned the efforts of gentlewoman's gentleman Fitzwilliam (Dick Van Dyke, centre), to keep his philanthropic employer (Edith Evans, left) from knowing that she has been penniless for years. He does this by organizing a crime syndicate which includes the footman (John McGiver), the chauffeur (Sam Waterston in his film debut), and the maids (Anne Seymour and Helen Kleeb). Despite the intrusion of a suspicious secretary (Barbara Feldon, right) who helps the old lady compile a dictionary for people who can't spell, the gang robs Gimbels store of $190,000 on Christmas Eve. The money is returned when the dictionary becomes a best-seller. Unfortunately, the Panavision-De Luxe Color movie could not claim as much. Others in it were Harry Townes, John Fielder, Norman Fell and Cecil Kellaway. (MIRISCH/DRAMATIC)

▽At one stage, Ian Bannen, the glum hero of **The Sailor From Gibraltar**, says 'It's just like a movie.' Yes, and a very bad one at that. The Oscar Lewenstein-Neil Hartley production, based on the subtle, poetic novel by Marguerite Duras, degenerated into romantic claptrap in the unsubtle, prosaic hands of director Tony Richardson. He, Christopher Isherwood and Don Magner wrote the screenplay which told of the love of a young Englishman (Bannen, illustrated), on vacation in Italy, for a mysterious Frenchwoman (Jeanne Moreau, illustrated) who sails the seas in her yacht in search of the sailor of the title. They sail together endlessly to Greece, Alexandria and Ethiopia, meeting Orson Welles in a fez, Hugh Griffith as a white hunter, Zia Moyheddin, Umberto Orsini, John Hurt and Eleanor Bron along the way. Vanessa Redgrave, then the director's wife, played Bannen's excessively irritating girlfriend whom he ditches for Moreau. In the same year, Miss Redgrave divorced Richardson citing Mlle Moreau as co-respondent. She could have effectively cited the film as well. (WOODFALL)

▽The song 'I Believe In You' from **How To Succeed In Business Without Really Trying**, seemed to have inspired producer-director David Swift's attitude in faithfully adapting the hit Broadway musical to the screen. His screenplay kept the mordant and amusing satire of the show's book (derived from Shepherd Mead's novel) by Abe Burrows, Jack Weinstock and Willie Gilbert, paralleled in the music and lyrics by Frank Loesser, whose numbers were imaginatively choreographed by Dale Moreda (based on Bob Fosse's stage routines). The simple morality tale told of how a window cleaner

△**Kill A Dragon** wasn't even good enough to kill time. This Hong Kong hokum starred Jack Palance as a soldier of fortune who is asked by some Chinese villagers to help them get rid of racketeer Fernando Lamas and his cronies, who have blockaded their island. One of Lamas' cargo junks carrying high explosives has been wrecked on the island, and he doesn't want anyone to touch it. Palance (left), two karate experts (Don Knight and Hans Lee), and a tough tourist guide (Aldo Ray), penetrate the blockade, eliminate the gangster's men with fists, karate chops, guns and explosives, take Lamas (right) hostage, and sail the boat to Hong Kong. Alizia Gur, Kam Tong and Judy Dan made up the cast of Hal Klein's Technicolor shoe-string production. Director Michael Moore could not hide the fact that the sailing vessel in the movie was not the only junk around. (AUBREY SCHENCK)

rises to an executive post in a large Madison Avenue company in a matter of hours. One of his ruses is to get round the big boss (Rudy Vallee happily recreating his stage role), by claiming to have gone to the same college ('Grand Old Ivy'), and pushing aside the man's crawling nephew (Anthony Teague). Others in the offices were Michele Lee (as the young man's girl), Maureen Arthur, Murray Matheson, Kay Reynolds and Sammy Smith. Robert Morse as the climber (illustrated), reprising his Broadway role, failed to tone down his performance for the Panavision-De Luxe Color picture. (MIRISCH)

▽**How I Won The War** was a real loser, succeeding neither as anti-war satire nor as plain slapstick comedy. On paper, Charles Wood's script (based on a novel by Patrick Ryan) must have looked promising, but on Eastmancolored celluloid it was killed by producer-director Richard Lester's gimmicky approach. It told of the platoon of Lieutenant Goodbody (Michael Crawford) in North Africa during World War II, being ordered to penetrate behind enemy lines and set up a cricket pitch to impress a visiting VIP when the battle is over. Members of the troop, of which only two survive, were a former member of the British Nazi Party (John Lennon in specs, right), a cynical sergeant (Lee Montague), a coward (Jack Hedley), a red-nosed clown (Jack MacGowran), a fat and worried soldier (Roy Kinnear, left) and three others (Ronald Lacey, James Cossins and Ewan Hooper). Each of their staged gory deaths were intercut with actual newsreel footage. Various other military types were played by Michael Hordern, Karl Michael Vogler, Alexander Knox, Robert Hardy and Paul Daneman. (PETERSHAM)

◁Ken Russell's overkill directorial style in **Billion Dollar Brain** put an end to the series of pictures starring Michael Caine as the reluctant, bespectacled, cockney spy Harry Palmer, which had also included *The Ipcress File* (Rank, 1965) and *Funeral In Berlin* (Paramount, 1966). Caine (right), as deadpan as ever, moved through the meaningless *mélange* of John McGrath's script (based on Len Deighton's novel) without even simulating comprehension. It all had something to do with mad anti-Red General Midwinter (blustering Ed Begley), who attempts to get eggs containing a deadly virus into Russia. Other characters were Leo Newbegin (Karl Malden, left), who handles a network of fictional spies and pockets their salaries, Russian Colonel Stok (Oscar Homolka), Palmer's friendly enemy, and alluring Russian agent Anya (Francoise Dorléac, tragically killed in a car smash some months after filming). Others in it were Guy Doleman, Vladek Sheybal, Milo Sperber and Mark Elwes. At least the snowy landscapes in Panavision and Technicolor in Harry Saltzman's production, were worth looking at. (LOWNDES)

▽'When you have to shoot, don't talk, shoot,' seemed to be the philosophy behind **The Good, The Bad And The Ugly**. Despite the title, none of the characters were good, but all were monosyllabic, bad and ugly, except Clint 'Golden-haired Angel' Eastwood (right), who was monosyllabic, bad and handsome. He and Eli Wallach (left, grimacing madly in close-up) operated a racket whereby Clint captures Eli, gets a reward, and then rescues him from the rope at the last moment. But they keep double-crossing each other in the dangerous game. Along comes cold-blooded Lee 'Angel Eyes' Van Cleef, who thinks nothing of shooting a man's face through a pillow. He's after a box containing $200,000 of stolen money. This leads the three of them to a cemetery where it's buried. In a showdown to end all showdowns, the director Sergio Leone swung the camera around 180 degrees as they faced each other with long, lingering looks, with Ennio Morricone's music adding to the drama. It was worth waiting 181 minutes for this gripping climax. The script by Age-Scarpelli, Luciano Vincenzoni and Leone (English adaptation by Mickey Knox) allowed for a certain amoral mythic grandeur along its bloody way. Aldo Giuffre, Mario Brega, Luigi Pistilli, Rada Rassimov and Enzo Petito had other roles in Alberto Grimaldi's Technirama-Technicolor huge money-making production. (PRODUZIONI EUROPEE)

▷Most of the plot is contained in the title of **The Persecution And Assasination Of Jean-Marie Marat As Performed By The Inmates Of The Asylum Of Charenton Under The Direction Of the Marquis De Sade**. Known for convenience as **The Marat/Sade**, and made for only $500,000, the film was a valuable record, in De Luxe Color of the Peter Weiss play (adapted by Adrian Mitchell and translated by him and Geoffrey Skelton) performed by the inmates of the Royal Shakespeare Company under the direction of Peter Brook. Brook's transposition of his own staging, though still powerful, was too theatrical an experience to work comfortably on screen, and the play-within-a-play format was more effective than the play within a film. Nor was the long central debate between Marat (Ian Richardson, right), the revolutionary, and Sade (Patrick Magee, left), the pragmatist, as absorbing as on stage. However, the closed set created a claustrophobic atmosphere, and some of the close-ups of the insane, who eventually go berserk and take over the asylum, were effectively gruesome. Other members of the RSC in leading roles were Glenda Jackson (making her screen debut as Charlotte Corday), Michael Williams, Robert Lloyd, Clifford Rose, Freddie Jones, John Steiner and Susan Williamson. The producer was Michael Birkett. (MARAT-SADE)

▷The run-of-the-mill whodunnit plot of **In The Heat Of The Night** merely formed the framework for an entertaining exposé of racial bigotry in a small Mississippi town. The butt of the prejudice is Philadelphia's number one detective Virgil Tibbs (played with dignity and passion by Sidney Poitier, left) who finds himself helping Gillespie (Rod Steiger, right), a thick redneck police chief, in an enquiry into the murder of 'the most important white man in town'. The crux of Stirling Silliphant's measured and telling screenplay (based on the novel by John Ball) was the dominance game played by the white bigot and the black homicide expert, from which the latter emerges victorious by solving the case. Oscar-winning Steiger, behind yellow sunglasses and incessantly chewing gum, managed to find many nuances in the role, so that his final capitulation to respect and tolerance of Tibbs rang true. Good support was given by Warren Oates, Quentin Dean, William Schallert, Lee Grant, Larry Gates, Scott Wilson, Beah Richards and Anthony James. Director Norman Jewison created a realistic background against which the duet was played, a steamy ignorant burg whose inhabitants consisted of a weird owner of a fly-infested diner, lunk-head cops, thuggish young men who beat up 'niggers', and a girl who cools herself by standing nude at her window. Walter Mirisch's De Luxe Color production won an Oscar for Best Picture, and did well at the box-office. Poitier went on to play the same character in *They Call Me* Mister *Tibbs!* (1970) and *The Organization* (1971). (MIRISCH)

▽Japan was the exotic setting for **You Only Live Twice**, the fifth blockbusting James Bond movie. This time the budget leaped to $5½ million, the half million going on one Ken Adam set – the interior of a volcano where the organization SPECTRE has its huge rocket launching pad. Director Lewis Gilbert made sure every cent was worth it in the Panavision-Technicolor picture. Again Bond (Sean Connery, illustrated) saved the Western world from destruction at the eleventh hour. Before he is sent to the Far East, Miss Moneypenny (Lois Maxwell) gives him a book called *Instant Japanese*. 'You forget,' he tells her, 'I got a First in Oriental languages at Cambridge.' He also proves better than the Japanese at martial arts, and cleverly avoids being thrown into a pool of piranha fish. The latter is a

trap set for him by Ernst Stavro Blofeld (Donald Pleasence with a dreadful scar through his eye and cheek), the head of SPECTRE, only seen as a pair of hands stroking a cat in previous Bond films. 'So, we meet at last, Mr Bond!' Also appearing were Akiko Wakabayashi, Tetsuro Tamba, Mie Hama, Karin Dor, Desmond Llewellyn ('Q'), Bernard Lee ('M'), Charles Gray, Alexander Knox, Robert Hutton, Tsai Chin and Burt Kwouk. Roald Dahl, the screenwriter, carried out his instructions that he could make Bond kill as many people as he liked, so long as he didn't do it sadistically. After shooting, Sean Connery told producers Harry Saltzman and Albert R. Broccoli that he was giving up Bond for good. He was back four years later in *Diamonds Are Forever*. (EON-DANJAQ)

▽Exactly ten years after making *Gunfight At The OK Corral* (Paramount), producer-director John Sturges took up the story in **Hour Of The Gun**. The sequel was slower, bitter and more violent. Whereas the morality in the earlier film was more straightforward, here James Garner's Wyatt Earp (right) was a cold-blooded killer, chastised by an ever more whisky-sodden Doc Holliday (Jason Robards Jr, centre right), who ends up in a sanatorium with TB. In the screenplay by Edward Anhalt (who appeared briefly as a medic), based on Douglas D. Martin's *Tombstone's Epitaph*, Ike Clanton (Robert Ryan) swears vengeance on the Earp brothers for the murder of his sons at the OK Corral. When Virgil Earp (Frank Converse, centre left) is wounded, and Morgan Earp (Sam Melville, left) is killed by Clanton's henchmen, Wyatt tracks Ike down to a Mexican village and shoots him. Others in the all-male Panavision-De Luxe Color picture were Steve Ihnat, Michael Tolan, Bill Fletcher, Monte Markham, and Jon Voight making his screen debut. (MIRISCH/KAPPA)

▽**The Honey Pot** was an uneasy mixture of farce, satire, comedy and whodunnit, with insufficient of any of the ingredients to justify its 150 minutes. The screenplay by director Joseph L. Mankiewicz (who also co-produced with Charles K. Feldman) was based on the play *Mr Fox Of Venice* by Frederick Knott, derived in turn from the novel *The Evil Of The Day* by Thomas Sterling, itself an updated version of *Volpone* by Ben Jonson (obviously giddy in his grave). The 20th century fox was Rex Harrison (illustrated) as Cecil Fox, a millionaire living in isolation in a palazzo in Venice. With the help of an actor, William McFly (Cliff Robertson), he plans to

trick three former mistresses by pretending he is on his death bed. They are a fading film star (Edie Adams), a princess (Capucine, illustrated) and a wealthy hypochondriac (Susan Hayward). The latter is murdered, and her secretary (Maggie Smith) unmasks Fox's plot and the killer. Other roles went to Adolfo Celi, Herschel Bernardi and Hugh Manning. Occasionally, amidst the tedium, a vintage Mankiewicz line would flash by, but it was the Technicolor photography of Venice by the great cinematographer Gianni De Venanzo that made the original title of the picture, *Anyone For Venice?*, seem more appropriate. (FAMOUS ARTISTS)

▽**Paper Lion** was the screen version of the best-seller in which intrepid journalist George Plimpton recounted his experiences of playing pro football in a pre-season tryout game with the Detroit Lions. The book was not only a personal document, but also an intricate study of the game. Much of the spirit of the original survived in Lawrence Roman's screenplay, although it made some concessions by adding female interest (Lauren Hutton in her film debut) and some rather corny sight gags. Although Alan Alda (illustrated) had the right combination of physical ineptitude and witty objectivity, it was a pity that Plimpton himself could not have been filmed trying to do his own thing, rather than getting an actor to fake it. The documentary side, observing the Lions in their dressing room and on the field, was revealing, but as actors they made great football players. David Doyle, Ann Turkel, Roy Scheider (in a bit) and, as themselves, Sugar Ray Robinson, Frank Gifford, Vince Lombardi and Alex Karras also appeared. Producer Stuart Miller took over the Technicolor picture after firing Alex March, who was credited as sole director even so. (STUART MILLER)

△Family planning had a different meaning in **Yours, Mine And Ours**, a comedy in which widower Henry Fonda, father of ten, marries widow Lucille Ball (both illustrated), mother of eight. The main thrust of the screenplay by director Melville Shavelson and Mort Lachman (story by Madelyn Davis and Bob Carroll), based on a true story, was how the two families managed to find a *modus vivendi*. Despite ex-sea captain Fonda's efforts to run the household like a battleship, organization breaks down because the children of each family resent one another. It is only when Lucy has her 9th child (at 57? That's Hollywood!), and Fonda's eldest boy goes off proudly to Vietnam, that all the kids begin to merge into one big happy family. The Technicolor movie which began in high comedy fashion, gradually degenerated into farce, wrapped in cuteness and sentimentality. Adult support came from Van Johnson, Tom Bosely and Louise Troy, while the minor cast of 18 included Jennifer Leak, Timothy Matthieson, Kevin Burchett, Gilbert Rogers, Kimberley Beck, Nancy Roth, Mitchell Vogel and Gary Goetzman. Robert F. Blumofe's production raked in $11 million in the USA. (DESILU/WALDEN)

▷Like the soldiers at the battle of Balaclava, **The Charge Of The Light Brigade** died the death. It had everything going for it. A no-expense-spared production by Neil Hartley, in Panavision and De Luxe Color, clever titles and animated interludes by Richard Williams, authentically researched decor and costumes, Cecil Woodham Smith's excellent book *The Reason Why* as inspiration, and a distinguished cast that included Trevor Howard (Lord Cardigan), John Gielgud (Lord Raglan, left), Harry Andrews (Lord Lucan), Vanessa Redgrave, Jill Bennett, David Hemmings (right), Peter Bowles, Mark Burns, Howard Marion Crawford, Mark Dignam, Alan Dobie, Michael Miller (centre), Corin Redgrave, Rachel Kempson, Helen Cherry and Donald Wolfit. The reason why the picture, shot in Turkey, turned out a turkey, was that neither Charles Wood's quasi-satirical script, nor Tony Richardson's convoluted direction allowed the characters to be anything more than cardboard figures in a pretty Victorian landscape. Even the charge itself failed to generate much excitement. Wildly fictional as the Warner Bros.-Errol Flynn movie of 1936 was, it at least knew how to entertain. (WOODFALL)

▽**Danger Route** was another film of the period to jump on the Bond wagon. Richard Johnson (right) played a secret service agent who is a licensed-to-kill karate expert and who, for some obscure reason, has to bump off a Czech scientist (Reg Lye) being held by Americans in a house in Dorset. Among the people the hero encounters are a man from the ministry who disappears (Harry Andrews), a double agent (Gordon Jackson, left), and four women (Carol Lynley, Barbara Bouchet, Sylvia Syms and Diana Dors) all unaccountably attracted to him. Also around in the nasty, flashy Max J. Rosenberg-Milton Subotsky De Luxe Color production were Maurice Denham, Sam Wanamaker, David Bauer and Robin Bailey. Meade Roberts' screenplay (from the novel *The Eliminator* by Andrew York) had as many twists as a pretzel but was not as nourishing. It was the last completed film directed by Seth Holt, who died of alcoholism in 1971, aged 48. (AMICUS)

▽Hrundi V. Bakshi was never as famous as Inspector Clouseau, but he was an equally blundering character as portrayed by Peter Sellers in **The Party**, filmed in Panavision and De Luxe Color. Sellers (illustrated) in dark make-up and the 'Goodness-gracious-me' Indian accent he had used in *The Millionairess* (20th Century-Fox 1961), played an actor brought to Hollywood to star in *Son Of Gunga Din*, but who is fired when he accidentally blows up an expensive set. In error, he is invited to a lavish party given by the head of the studio (J. Edward McKinley), and causes chaos there. Some laughs were to be had from the series of slapstick situations, but every gag was milked dry (such as a 12-minute sequence in a bathroom). Many of the best moments came from Steve Franken as a waiter getting progressively drunker. Claudine Longet (illustrated), Marge Champion, Fay McKenzie, Gavin MacLeod, Denny Miller and Sharron Kimberley were other guests. The cleverly designed split level set by Fernando Carrere was the background to producer Blake Edwards' attempt to create a plotless comedy in the style of French master Jacques Tati, but neither his direction, nor his story or script (co-written by Tom and Frank Waldman) were inventive enough. (MIRISCH/GEOFFREY)

▽**The Thomas Crown Affair** was the cinema's equivalent to a pleasantly entertaining and well illustrated story in a chic magazine, a glossy Panavision-De Luxe Color package for Steve McQueen and Faye Dunaway, both looking (and acting) like fashion plates. When not driving sleek cars or flying gliders, they got down to play a sexy chess game (modelled on the well known eating scene in *Tom Jones*, 1963), the phallic game mirroring the wider intellectual game they're engaged in playing. McQueen (left), a Boston tycoon, successfully organizes a bank raid, and Dunaway (right) is the insurance investigator on his trail. Getting romantically involved with him naturally causes a conflict of interests, resolved at the twist ending. Director Norman Jewison (who also produced) covered the quite ingenious screenplay by Alan R. Trustman with cutesy multiple-images, split screens and zooms, backed by the lushly romantic Oscar-winning song 'The Windmills Of Your Mind' by Michel Legrand, sung by Noel (son of Rex) Harrison. Also effectively cast in the $6 million grossing picture were Paul Burke, Jack Weston, Yaphet Kotto, Biff McGuire, Astrid Heeren and Carol Corbett. (MIRISCH/SIMKOE/SOLAR)

△**The Night They Raided Minsky's** (GB: **The Night They Invented Striptease**) evoked some of the seedy charm of New York's Lower East Side in the 20s, and of the famous titillating Minsky's Burlesque, in De Luxe Color and sepia-tinted inserts. However, 28-year-old director William Friedkin was not content to recreate the comic acts and musical numbers of the period, but went into a St Vitus dance routine himself, jumping from one character and situation to another so that nobody and nothing was allowed to develop. The script by producer Norman Lear, Arnold Schulman and Sidney Michaels (based on Rowland Barber's book) was promising, but neither the director nor cast delivered. It was hard to accept lugubrious Jason

Robards Jr (left) as part of a comedy duo (the other half was British comedian Norman Wisdom (right) in his first and last Hollywood movie), or Britt Ekland (centre) as a naive virgin from the backwoods offering to dance scenes from the Bible. Billy Minsky, played by Elliott Gould in his screen debut, hires her in order to assuage Denholm Elliott's Society for the Suppression of Vice, which wants to close down his theatre. When the girl's Quaker father, Harry Andrews, arrives in the big city, he tears his daughter's dress while trying to get her off stage. And so, we are asked to believe, striptease was born! Others cast were Forrest Tucker, Joseph Wiseman, Jack Burns and veteran Bert Lahr, who died during filming. (TANDEM)

△Although based on fact (as recorded in the book by Robert H. Aldeman and Colonel George Walton), **The Devil's Brigade** (as written by William Roberts) seemed another poor imitation of *The Dirty Dozen* (MGM, 1967). William Holden (left) was the lieutenant colonel assigned the task of making a group of thugs and misfits into a disciplined army unit for action in Italy during World War II. Rivalry exists between them and a crack Canadian outfit under the command of Cliff Robertson (2nd left), allowing the film to indulge in one of those free-for-all brawls director Andrew V. McLaglen liked to introduce into his Westerns. Of course, the two platoons later gain mutual respect as they fight Germans in the mountains, suffering heavy losses. Audiences suffered battle fatigue by the end of the 128-minute David L. Wolper Panavision-De Luxe Color production. Also in uniform were Vince Edwards (3rd left), Andrew Prine, Claude Akins, Carroll O'Connor (right), Richard Jaeckel, Jack Watson, Harry Carey Jr, Dana Andrews, Michael Rennie and Patric Knowles (as Lord Mountbatten). Gretchen Wyler was billed as 'a lady of joy'. (WOLPER)

△Middle-aged direction (by producer Melvin Frank) of a menopausal cast said 'Arrivederci' to the initial bright comedy idea behind **Buona Sera, Mrs Campbell**. Denis Norden and Sheldon Keller's script had Gina Lollobrigida living luxuriously off three American men, each of whom believes himself to be the father of her 20-year-old daughter (Janet Margolin). However, the mother, who took her married name from a can of soup, is distressed to learn that the men, who were all stationed in the Italian village during the war, are returning for an American

Air Force reunion. The three putative fathers (Phil Silvers, left, Peter Lawford, centre, and Telly Savalas, right) arrive to see their daughter, unbeknown to their respective wives (Shelley Winters, Marian Moses and Lee Grant). After much running in and out of doors, an unfunny chase sequence, and a few tears shed, the lie was preserved and the non-existent Captain Campbell honoured by the visiting Americans and the locals (Philippe Leroy, Giovanna Galletti and Renzo Palmer). The Technicolor locations brought some relief to the eye. (CONNAUGHT)

△**Inspector Clouseau** was as maladroit as the title character in its attempt to put Alan Arkin into Peter Sellers' clumsy boots. Not that Arkin (right) was bad, he was nearer a character than a caricature, but the public could not accept a replacement for the man who had almost copyrighted the role after *The Pink Panther* (1963) and *A Shot In The Dark* (1964). Besides, Arkin was ill-served by Tom and Frank Waldman's screenplay and the unfunny direction by Bud Yorkin. In another Bond pastiche, Clouseau found himself on the trail of the money from the Great Train Robbery. After various misadventures, he tracks the robbers down to a barge on which money is being loaded wrapped up as chocolate bars. He accidentally sinks the vessel and the gang is captured. Others in Lewis J. Rachmil's Panavision and Eastmancolor production were Delia Boccardo, Frank Finlay (left), Patrick Cargill, Beryl Reid, Barry Foster and Clive Francis. (MIRISCH)

▷What had the James Bond movies and the children's musical fantasy **Chitty Chitty Bang Bang** in common? Producer Albert R. Broccoli, designer Ken Adam, screenwriters Roald Dahl and Richard Maibaum, and the heavy, Gert Frobe (ex-Goldfinger), had all been connected with Bond pictures previously. And the film was based on a collection of children's stories by Bond author Ian Fleming. It also relied heavily on gadgetry and special effects. At this point, 007 and the Edwardian flying amphibious car of the onomatopaeic title, parted company as the auto's inventor, Caractacus Potts (Dick Van Dyke, illustrated), flies off in it with his fiancee Truly Scrumptious (Sally Ann Howes, illustrated) and his two children Jemima and Jeremy (Heather Ripley and Adrian Hall, both illustrated) to the land of Vulgaria to rescue Grandpa Potts (Lionel Jeffries) from the clutches of Baron and Baroness Bombust (Frobe and Anna Quayle). Other parts were played by Benny Hill, James Robertson Justice, Robert Helpmann, Barbara Windsor, Desmond Llewellyn and Richard Wattis. Some of the sets and machines were amusing but, under the direction of Ken Hughes (who also co-wrote), the movie was 145 minutes of badly-acted, sugar-coated whimsy, punctuated by dreadful songs and shoddy special effects. Nonetheless, the $10 million Super Panavision 70-Technicolor venture earned back $7.5 million in the USA alone. (WARFIELD/D.F.I.)

▽If *In The Heat Of The Night* (1967) subverted the movie stereotype of the inferior black man in terms of a thriller, **The Scalphunters** did it in Western form. In the uneasy partnership of white fur-trapper Burt Lancaster and runaway slave Ossie Davis, it was the slave who had all the brains. Together, they're on the trail of a gang that stole Burt's furs. The gang's brutal leader (Telly Savalas, illustrated) hires Ossie to wait on him and his floozie girlfriend (Shelley Winters, illustrated) on their way to Mexico. In the end, the slave kills Savalas to save Lancaster's life, but the friends brawl over the furs. The two men becoming indistinguishable after fighting in the mud was an obvious point made in William Norton's screenplay. The leads, who gave good value, were well supported by Armando Silvestre, Dan Vadis, Dabney Coleman, Paul Picerni and Nick Cravat. The generally entertaining if overstretched Jules Levy-Arthur Gardner-Arnold Laven production (in Panavision and De Luxe Color) never gelled into a satisfying whole, because director Sydney Pollack tried to ride off in too many directions at once – modern and traditional Western, didactic drama and slapstick comedy. (BRISTOL/NORLAN)

△It might have been better if **The Private Navy Of Sgt O'Farrell** had been lost at sea. Frank Tashlin's screenplay (story by John L. Greene and Robert M. Fresco) set Bob Hope (illustrated) adrift in a crude World War II comedy in which he played an officer on a South Sea island, worried about the morale of his troops. His frantic attempts to import nurses end with the arrival of daffy-looking Phyllis Diller. However, who should pop up on a raft but his old flame Gina Lollobrigida (illustrated) and her niece, attractive blonde, Mylene Demongeot. Lieutenant Jeffrey Hunter captures Mylene's heart, and Bob captures a Japanese submarine. Producer John Beck also employed John Myhers, Mako, Henry Wilcoxon, Dick Sargent, Christopher Dark and William Wellman Jr in other roles. The Technicolor picture was the last to be directed by Tashlin. (NAHO)

▷**Hostile Witness** was the most conventional of the five films directed by actor Ray Milland. In fact, it was hardly a film at all, but a starchy celluloid version of a hoary courtroom drama by Jack Roffey (adapted by him) which Milland had played in on the London stage. Looking mainly anxious in close-up, the director-star portrayed a barrister whose daughter is killed by a hit-and-run driver. When his neighbour is found stabbed, Milland (right) is arrested for murder. After dismissing his lawyer, Sylvia Syms, halfway through the case, he defends himself, and exposes the murderer who was also the driver of the fatal car. Others cast were Felix Aylmer, Raymond Huntley, Geoffrey Lumsden (left), Norman Barrs, Richard Hurndall and Percy Marmont. Both critics and public were hostile witnesses to David E. Rose's lifeless De Luxe Color production. (CARALAN/DADOR)

▷There was not much of a leap for The Beatles to make from the comic strip figures they cut in *Help!* (1965) to becoming drawings in **Yellow Submarine**, the first British cartoon feature for 14 years. Only at the fade-out did John Lennon, Paul McCartney, George Harrison and Ringo Starr appear in person. The screenplay by the producer Al Brodax, Jack Mendelsohn, Erich ('Love Story') Segal and Lee Minoff (who also wrote the story) was based on the title song by Lennon and McCartney. Once upon a time, the happy kingdom of Pepperland was suddenly attacked by Blue Meanies. Fred, the conductor of Sgt. Pepper's Lonely Hearts Club Band, manages to escape in a yellow submarine, which surfaces in the streets of Liverpool. There, he meets The Beatles, who set off with him through the Seas of Green Time, Monsters, and the Land of Holes, until they arrive to repulse the enemy from Pepperland, bringing back music and colour. The principal designer, Heinz Edelman, and director George Dunning created a fascinating compendium of all the art and fashion fads of the day – Art Nouveau, Surrealism, Pop Art, Op Art, Psychedelia, kinky boots, mini skirts and a dozen or so Beatles' hits – so that the De Luxe Color movie came nearer than most live-action films in explaining the phenomenon of the 60s. Other voices were supplied by Dick Emery, Lance Percival, Paul Angelus, Geoffrey Hughes and John Clive. (KING/APPLE/SUBA)

△**Hang 'Em High** was a slick, sick American imitation of an Italian Western imitating an American one. The second hand feeling was marked by the presence of Clint Eastwood (illustrated) making his first Hollywood movie since his Italian triumph in 'Spaghetti Westerns'. In the meandering script by producer Leonard Freeman and Mel Goldberg, hangdog Clint is made deputy by Judge Pat Hingle, who has saved him from a lynching, but Eastwood is determined to take revenge on the nine men who left an ugly scar on his neck. He eliminates them one by one, aided by widow Inger Stevens (illustrated), leaving their leader Ed Begley to hang himself. Other roles went to Arlene Golonka, James MacArthur, Charles McGraw, L.Q. Jones, Jack Ging, Alan Hale Jr, Dennis Hopper, Bruce Dern, and cowboy from the 20s Bob Steele. The episodic nature of Ted Post's direction showed that nine years in TV had rubbed off on him, though it was an episodic plot. The De Luxe Color picture, however, was lapped up by the public. (LEONARD FREEMAN/MALPASO)

▽**Salt And Pepper** was a pseudo-Bond pseudo-comedy starring Sammy Davis Jr (as Charles Salt, left) and Peter Lawford (as Christopher Pepper, right), owners of a nightclub in a studio-built Soho in the midst of the then mandatory 'Swinging London'. As both stars were executive producers (Milton Ebbins was the producer), they obviously knew what they were getting into, and even seemed to be enjoying themselves. In Michael Pertwee's screenplay they were kidnapped by the British Secret Service, who ask them to help find the murderer of a woman agent killed in their club. The emetic heroes uncover a plot by a power-crazed soldier (John Le Mesurier) to hijack a nuclear submarine and take over the country. Richard Donner directed the De Luxe Color picture in which Michael Bates, Ernest Clark, Ilona Rogers, Graham Stark, Jeanne Roland and Robertson Hare had other roles. The largely indifferent public were offered a sequel called *One More Time* (1970). (CHISLAW/TRACE-MARK)

◁**Here We Go Round The Mulberry Bush** was a perfect example of the detrimental effect the 'Swinging London' image had on British films of the period. This trendy Technicolor picture, produced and directed by Clive Donner, had it all: incessant pop songs, girls in mini skirts, psychedelia, garish decor and vacuous characters. The protagonist of the screenplay by Larry Kramer and Hunter Davis (from the latter's novel) was a schoolboy (23-year-old Barry Evans, centre) who is still a virgin, despite having girls of all types offering themselves to him. His Walter Mitty-ish fantasies revolve around a seemingly unapproachable blonde (Judy Geeson, back, centre right). When he finally attains her, he's disillusioned and goes off to University fancying someone else. The 'dolly birds' were played by Sheila White (left), Adrienne Posta (back, centre left), Angela Scoular (front, centre left), Diane Keen (front centre right) and Vanessa Howard (right). The caricatured adults were Moyra Fraser, Michael Bates, Maxine Audley and Denholm Elliott. (GIANT)

1968 OTHER RELEASES

Attack On The Iron Coast
An American major leads a British commando on a suicide mission to attack a vital German stronghold on the French coast. Lloyd Bridges, Andrew Keir, Sue Lloyd, Mark Eden, Maurice Denham, Glyn Owen. *Dir* Paul Wendkos. *Pro* John C. Champion. (GB/USA) MIRISCH

Massacre Harbour
A four-man commando group is assigned the task of rescuing 5000 Allied prisoners being held by the Germans in a North African port. Christopher George, Gary Raymond, Larry Casey, Justin Tarr, Claudine Longet. *Dir* John Peyser. *Pro* Fred Lemoine. De Luxe Color. MIRISCH/RICH TV

The Ugly Ones (GB: The Bounty Killers)
A misunderstood bounty killer is despised by everyone except his girlfriend. Richard Tyler, Tomas Milian, Ella Karin, Hugo Blanco. *Dir* Eugenio Martin. *Pro* Jose Maesso. Eastmancolor. (Italy/Spain) DISCOBOLO FILM/TECISA

The Wicked Dreams Of Paula Schultz
An East German woman athlete is helped by an American to defect to the West. Elke Sommer, Bob Crane, Werner Klemperer, Joey Forman, John Banner. *Dir* George Marshall. *Pro* Edward Small. De Luxe Color. EDWARD SMALL

▽The first problem with Neil Hartley's De Luxe Color production of **Laughter In The Dark** was the ungainly transference by playwright Edward Bond of Vladimir Nabokov's scintillating 1933 novel from pre-war Germany to Swinging London. The second was Tony Richardson's gimmicky and over-emphatic direction which turned Nabokov's harsh parable of blindness, physical and otherwise, into a tedious *menage á trois* thriller. The third problem was the casting of a too-young, whining Nicol Williamson (illustrated) as the wealthy art dealer Sir Edward More, and the attractive but blank pair of Anna Karina (illustrated) as Margot the usherette, the object of Sir Edward's passion, and Jean-Claude Drouot as Hervé, her lover. The latter, pretending to be gay to avert jealousy, becomes the art dealer's chauffeur to be near Margot and help her relieve her patron of his fortune. When Sir Edward is blinded in a car crash, he (and the audience) are tormented by his mistress and her boyfriend. Other parts went to Peter Bowles, Sian Phillips, Sebastian Breaks, Edward Gardner, Helen Booth, Sheila Burrell and Kate O'Toole. (WOODFALL/WINKAST)

△Drugs, Country and Western music, protest songs, anti-Vietnam war sentiments and the hippy philosophy of all-embracing love were served up in **Alice's Restaurant**. Arlo Guthrie (right), son of the renowned folk singer Woody Guthrie, wrote a 20-minute talking blues, 'Alice's Restaurant Massacree', celebrating the flower children who frequented the actual deconsecrated church in Vermont. Director Arthur Penn expanded it into a screenplay (helped by Venable Herndon) and got Arlo to play himself. Pat Quinn (as Alice), James Broderick, Michael McClanathan, Geoff Outlaw and Tina Chen gave support. The judge and arresting officer who had had Arlo jailed as a litterbug, blithely re-enacted their real-life roles in the affair. The film reflected the free-flowing lifestyle of the characters, mixing fact and fiction, satire, whimsy, social comment and ballads, obviously appealing to those who could identify with the hippie haven. The scene depicting a long-haired Arlo being momentarily inducted into the American army, was one of the first to express the growing draft-dodging feeling among the young. Hillard Elkins and Joe Manduke produced the Technicolor picture. (FLORIN)

▽To shave or not to shave was the grave concern of Dick Van Dyke in **Some Kind Of A Nut**, although cutting his throat might have put audiences out of their misery sooner. Director Garson Kanin's script purported to be an anti-Establishment comedy in which bank teller Van Dyke (centre), stung on his chin by a bee and unable to shave, grows a beard and refuses to get rid of it. In fact, the beard becomes the droopy symbol of his rebellion. After making a tour of the hippy nightspots with flower child Zohra Lampert, and being rescued from an asylum by his estranged wife Angie Dickinson, he finds new strength of character and shaves the thing off. The unfunny Walter Mirisch De Luxe Color production also cast Rosemary Forsyth, Elliott Reid, Steve Roland, Dennis King, Pippa Scott and Robert Ito. (MIRISCH/DFI/TFT)

◁The title of **Play Dirty** was also the cynical message of the Harry Saltzman production, another war movie to cash in on the success of *The Dirty Dozen* (MGM, 1967). Lotte Colin and Melvyn Bragg's screenplay (from a story by George Marton) stated rather crudely that only the insane or criminals make good soldiers. Playing dirty (and acting well) were Michael Caine (front) and Nigel Davenport (behind) as antagonistic officers in command of a unit made up entirely of ex-cons. They are ordered by Colonel Nigel Green to destroy a German oil dump on the North African coast. Ironically, the only survivors are Caine and Davenport, who escape in German uniforms, but are shot down by the British. Other roles went to Harry Andrews, Bernard Archard, Daniel Pilon, Vivien Pickles, Aly Ben Ayed, Takis Emmanouel, Scott Miller, Patrick Jordan and Enrique Avila. The Panavision-Technicolor picture was the last directed by Andre de Toth. (LOWNDES)

▽Knocking more nails into the coffin of the serious Western, **Support Your Local Sheriff** was an amusing spoof on the cliches of the genre. William Bowers' screenplay included a stranger riding into town (James Garner) who is appointed sheriff, a drunken deputy (Jack Elam), an ineffectual mayor (Harry Morgan), his pretty daughter (Joan Hackett, illustrated foreground with Garner), and a mean pa (Walter Brennan) with three unruly cretinous sons (Bruce Dern, Dick Peabody and Gene Evans). However, the sheriff, who plans to emigrate to Australia where the real pioneers are, uses his brains more than his gun. After taming the town, he stays on and marries the mayor's accident-prone daughter. Burt Kennedy directed with a fairly light hand, and Garner had fun sending up his TV *Maverick*-image. Henry Jones, Walter Burke and Willis Bouchey had other roles. Bill Finnegan's Technicolor production was so well supported that a sequel, *Support Your Local Gunfighter* (1971) soon followed. (CHEROKEE)

▽'Someday you'll find that corn is very sustaining' remarked Anne Francis (illustrated) in **Impasse**. Not so sustaining was the corn of this adventure yarn in which she sets off to seek gold in the Philippines, hidden there by her father prior to the Japanese invasion. To this end she hires muscular Burt Reynolds (illustrated), bigoted Lyle Bettger, drunken Vic Diaz and obese Rudolfo Acosta to help her. Complications arise, in John C. Higgins' screenplay, when gangster Jeff Corey also gets into the act. Much of the action under Richard Benedict's direction was standard fare, although a chase by Reynolds of a thug (Eddie Nicart) across Manila, had some sweep. Also in Hal Klein's De Luxe Color production were Clarke Gordon, Miko Mayama, and Joanne Dalsass as a hippy who seemed smitten with Miss Francis. (AUBREY SCHENCK)

▽The twelve million dollars spent on **Battle Of Britain** was nearly as much as the cost of the actual battle, and neither was much fun. As usual, the special effects boys and stunt flyers got the best of it in spectacular aerial ballets, seen to advantage in Panavision and Technicolor. However, it was rather extravagant to pay for so many famous faces, when they were indistinguishable behind pilot's masks. On the ground, a veritable 'Who Was Who' of British films could be glimpsed – Robert Shaw, Michael Caine, Kenneth More, Trevor Howard, Ralph Richardson, Patrick Wymark, Ian McShane, Harry Andrews, Michael Redgrave, Nigel Patrick, Edward Fox, Michael Bates, Robert Flemyng and Barry Foster. Curt Jurgens did his 'good' German bit, and Christopher Plummer and Susannah York delayed the action with their marital problems. The screenplay by James Kennaway and Wilfred Greatorex, based partly on the book *The Narrow Margin* by Derek Wood and Derek Dempster, told of how the invasion of England by German was repulsed by brave British bombers/fighter pilots in 1940. While Laurence Olivier, playing Sir Hugh Dowding, directed operations, Guy Hamilton directed the familiar 131-minute material competently for producers Harry Saltzman and S. Benjamin Fisz. (SPITFIRE)

▽Director John Huston, a long-time resident of Ireland, shot **Sinful Davey**, in Panavision and Eastmancolor, entirely in his adoptive country, using many Irish actors in supporting roles. The fact that James R. Webb's screenplay, based on the early 19th-century memoirs of David Haggart, was set in Scotland, didn't seem to worry him or his producer William N. Graf. Worse than the inauthentic landscape and accents, was the leaden direction and dull playing in this feeble assay at a bawdy romp à la *Tom Jones* (1963). John Hurt (aged 28) played the title role of the teenage highwayman (centre) who links up with a pickpocket (Ronald Fraser, right), poses as a gentleman to rob an aristocrat (Robert Morley) during a ball, and is saved from the hangman at the last moment by his 'lassie' (Pamela Franklin). Also cast were Nigel Davenport, Maxine Audley, Noel Purcell, Fionnuala Flanagan, Fidelma Murphy (left), Francis de Wolff, Donal McCann and Eddie Byrne. (MIRISCH/WEBB)

△The fact that Ralph Richardson played the title role (!) in **The Bed Sitting Room** indicates the nature of the surreal humour contained in this post-nuclear war satire. In John Antrobus and Charles Wood's script (based on the 1964 play by Antrobus and Spike Milligan), a small group of people lead a precarious existence in a desolate Britain, three years after the bomb has dropped. Among them are a family consisting of father (Arthur Lowe), mother (Mona Washbourne), and daughter (Rita Tushingham) who live on the Circle Line tube train; a fire guard (Milligan, left); head of regional government (Harry Secombe); a male nurse in drag (Marty Feldman); two policemen (Peter Cook and Dudley Moore) suspended in a balloon, and Mrs Ethel Shroake (Dandy Nichols) who becomes Queen of England, being closest in line to the throne. Other survivors were Michael Hordern (right), Richard Warwick, Roy Kinnear, Frank Thornton, Ronald Fraser and Jimmy Edwards. Producer-director Richard Lester, shooting in sepia, created an eerie comic nightmare, and one of his best films. However, it bombed at the box office, and Lester had to wait five years before he worked again. (OSCAR LEWENSTEIN)

▽George Kennedy took over Yul Brynner's role as Chris, the legendary gunman, in **Guns Of The Magnificent Seven**, the second sequel to *The Magnificent Seven* (1960). Herman Hoffman's screenplay and Paul Wendkos' direction offered more of the same viz a group of seven men gathered for a mission against impossible odds, plenty of gunshots, explosions and violent deaths, interspersed with pretentious dialogue in which the characters assess their lives. Apart from Kennedy (left), the others were James Whitmore (knife expert), Monte Markham (horse thief), Bernie Casey (black), Joe Don Baker (one-armed), Scott Thomas (tubercular) and Reni Santoni (Mexican rebel, right). Their job is to free revolutionary Mexican hero Fernando Rey from a prison where he is being held by villainous commandant Michael Ansara. Frank Silvera, Wende Wagner and Tony Davis (as Emilio Zapata as a child) made up the cast. Vincent M. Fennelly produced the Panavision-De Luxe Color picture. (MIRISCH)

▽**If It's Tuesday, This Must Be Belgium** was as superficial and as soporific as the kind of whirlwind tour of Europe it seemed to be parodying. David Shaw's story and screenplay focused on a party of American tourists visiting seven countries in 18 days. Among the group were Murray Hamilton, wife Peggy Cass and teenage daughter Hillary Thompson; Norman Fell (left) and wife Reva Rose; spinsters Mildred Natwick and Pamela Britton; ex-GI Michael Constantine (right); camera fiend Marty Ingels; and attractive department store buyer Suzanne Pleshette. They were escorted by handsome English guide Ian McShane, who only has an eye for the 'birds'. Teenage daughter gets involved with hippy Luke Halpin, and one woman gets on the wrong coach and spends the entire vacation with a group of Japanese. There were also brief and insignificant appearances by Vittorio De Sica, Anita Ekberg, Elsa Martinelli, Catherine Spaak, Robert Vaughn, John Cassavetes, Ben Gazzara, Senta Berger, Joan Collins and Virna Lisi. Director Mel Stuart guided them all through the De Luxe Color postcard views for producer Stan Margulies. (WOLPER)

△Hollywood was over 40 years old before it began to face up squarely to sex. The three boys in **The First Time** (GB: **You Don't Need Pyjamas At Rosie's**) on the other hand, took only 16 years to confront the same topic. One of them (Wes Stern, illustrated) while on vacation in Buffalo, writes to his buddies (Rick Kelman and Wink Roberts) describing his activities at Rosie's, an imaginary brothel. When his friends arrive, he tells them it was closed down by the police. But they pick up an English girl (Jacqueline Bissett, illustrated) about whom they invent stories for each other about having made love to her. This light and amiable adolescent comedy, directed by James Nielson, was well played by the youngsters, backed up by Gerard Parkes, Sharon Acker, Cosette Lee, Vincent Marino and Eric Lane. Shots of Niagara Falls in De Luxe Color filled out the screenplay by Joe Heims and Roger Smith (who co-produced with Allan Carr), from a story by Bernard Bassey, unnaturally expletive-free. (MIRISCH/ROGALLAN)

▽Although **On Her Majesty's Secret Service** earned over $9 million, it was less than half of what the other James Bond movies had brought in. This seemed to support producers Harry Saltzman and Albert R. Broccoli's claim that Sean Connery was an essential part of the film's appeal. When it seemed that Connery was serious about not doing another Bond, a frantic search was begun for his successor. After screen-testing 20 unknown applicants, 30-year-old Australian George Lazenby (illustrated) was chosen. The inexperienced Lazenby carried the can for the picture's comparative failure, but in fact the handsome ex-model was perfectly competent in carrying out the usual manoeuvres concocted by Richard Maibaum from Ian Fleming's novel, although the real stars were the skiing and sledding stuntmen. In this one, Bond penetrated the Alpine retreat of Blofeld (Telly Savalas without earlobes), who is threatening the Western world with bacteriological destruction. Blofeld's aerie is a Hugh Hefner-type castle filled with beautiful girls, one of them being Diana Rigg, whom Bond rescues and marries (!!). At the wedding are 'M' (Bernard Lee), 'Q' (Desmond Llewellyn) and a tearful Miss Moneypenny (Lois Maxwell). But before the honeymoon, the bride is killed by machine gun fire from a passing car. Most convenient. Others cast were Ilse Steppat, Gabriele Ferzetti, Angela Scoular, Joanna Lumley and Julie Ege. Peter Hunt, editor on previous Bonds, directed the Panavision-Technicolor picture. (EON-DANJAQ)

△For his role of the unattractive bum, Ratso Rizzo, in **Midnight Cowboy**, Dustin Hoffman (left) earned ten times more than he had in *The Graduate* (1967). With greasy hair, pallid complexion, bad teeth and gammy leg, he presented a man who merged easily into the excessively seedy and sordid atmosphere of the New York conjured up by British John Schlesinger, directing his first American movie. Opposite Dustin, as would-be stud Joe Buck, Jon Voight (right) shot to instant stardom. The relationship between the big, blond, likeable dimwit and the small down-and-outer, formed the centre piece of Waldo Salt's screenplay, based on the James Leo Herlihy novel. Hick Joe arrives in the rotten Big Apple in leather cowboy gear, hoping to make a living by servicing wealthy Park Avenue ladies. However, he is reduced to sleazy encounters with both men and women in 42nd Street grindhouses and hotels. His only friend is the tubercular Ratso, who dreams of getting to the sunshine of Florida one day. Joe steals two bus tickets to Miami, but Ratso dies just as they reach the place of his dreams. The huge success of Jerome Hellman's De Luxe Color production was due largely to the two Oscar-nominated lead performances, and hit rock songs on the soundtrack. Other roles went to Brenda Vaccaro, Sylvia Miles, John McGiver, Barnard Hughes and Ruth White. (PAN ARTS)

◁'You're so dumb,' says prostitute Margot Kidder to Beau Bridges in **Gaily, Gaily** (GB: **Chicago, Chicago**), an adjective equally applicable to the De Luxe Color picture. Abram S. Ginnes' screenplay not only changed the hero's name from Ben Hecht to Ben Harvey, but changed Hecht's autobiographical tales into a silly period romp which producer Norman Jewison's broad direction did little to mitigate. It garishly evoked the Chicago at the turn of the century where young Ben (Bridges, illustrated) arrives to seek his fortune. He is taken in (literally and figuratively) by Queen Lil (Melina Mercouri), celebrated Madam of a plush brothel, although he takes some time to realize the nature of his lodgings. As a cub reporter, he manages to get hold of a book containing a list of all the bordello's clients, putting politicians George Kennedy, Hume Cronyn and Wilfrid Hyde-White in an awkward position. Brian Keith, as an unscrupulous, sentimental Irish newsman, stood out among the strained goings on. Melodie Johnson, John Huntington and John Randolph took other roles. (MIRISCH/CARTIER)

▽In **The Happy Ending**, while watching *Casablanca* on TV, bored middle-class housewife Jean Simmons (illustrated) says of Bogie and Co, 'They're more alive than we are.' There was no truer line in Richard Brooks' glossy, laboured attempt to satirize suburban marriage, despite a sprinkling of sharp epigrams and performances. Simmons (real-life wife of producer, director and writer Brooks) leaves her boring commuter hubbie (John Forsythe) and flies off to the Bahamas in search of excitement. It comes in the shape of a gigolo, played phonily by Robert (yes, Bobby) Darin (illustrated), but she returns home and enrols in night classes. So what ... Other roles in the Technicolor-Panavision picture were taken by Shirley Jones, Lloyd Bridges, Teresa Wright, Dick Shawn, Nanette Fabray, Tina Louise, Karin Steele and Kathy Fields. (PAX)

▽**The File Of The Golden Goose** laid an egg. The first of a few films directed by the otherwise intelligent American actor-stage producer Sam Wanamaker, resident in England, it was a conventional thriller with 'Swinging London' trimmings. Plodding through the John C. Higgins-James B. Gordon script (story by Higgins) was an unsmiling Yul Brynner (right) as an American agent in Britain on the trail of a ruthless gang of counterfeiters. With the unwanted help of Scotland Yard detective Edward Woodward, he gets involved with perverted hedonist crook Charles Gray (left), who leads him to 'Mr Big'. On the way, the David E. Rose Eastmancolor production stopped to take in some tourist views of London. John Barrie, Bernard Archard, Ivor Dean, Anthony Jacobs, Adrienne Corri, Karel Stepanek, Graham Crowden and Walter Gotell were also to be seen. (CARALAN-DADOR)

▽**Popi** was a Puerto Rican living in the slums of Spanish Harlem and despairing for the future of his two small sons. He has the clever idea (supplied by screenwriters Tina and Lester Pine) of setting the boys adrift in a small fishing boat off Miami Beach, in the hope that they will be picked up and adopted by a wealthy family if they claim to be Cuban refugees. They are indeed rescued, and gain nationwide publicity, but when the hoax is discovered, the boys return joyously to New York. Director Arthur Hiller managed to extract some bitterly funny ethnic comedy from the first half, but poured too much syrup over the second. However, Herbert B. Leonard's De Luxe Color production was redeemed by Alan Arkin (illustrated) as the nervously disenchanted father. Other roles went to Rita Moreno, cute kids Miguel Alejandro (back right) and Ruben Figuero (front), John Harkins, Joan Tompkins, Anthony Holland and Arny Freeman. (LEONARD)

▽Caesar's Palace, the lush Las Vegas gambling joint, was **Where It's At**, according to director-screenwriter Garson Kanin. Actually shot in front of and behind the scenes, the famous casino was the real star of this uneven comedy-drama. Against the glitzy background, captured in De Luxe Color, a father-son clash takes place between David Janssen (illustrated), owner of the Palace, and Robert Drivas, fresh from Princeton. The son's ideals do not include gambling or loose women, but he learns his father's 'me-first' philosophy and gains control of the business at the end. Exactly how he does this was not made too clear, yet there were good performances from the two male leads, as well as from Rosemary Forsyth, Brenda Vaccaro, Warrene Ott, Edy Williams, Don Rickles and Vince Howard. Frank Ross produced. (FRANK ROSS/T.F.T.)

▽As **Sam Whiskey**, Burt Reynolds revealed some of the devil-may-care tongue-in-cheek macho personality that was to become his trademark. However, a painfully joky screenplay by William W. Norton, and mediocre direction by Arnold Laven, failed to give him much help on his road to superstardom. He played an itinerant gambler hired by Angie Dickinson to retrieve a large amount of gold lying in a sunken ship at the bottom of a river in Colorado. It was stolen by her late husband from the Denver Mint, and she wants it returned there pronto before they find it's missing. With the help of black blacksmith Ossie Davis (left) and inventor Clint Walker, Burt (right) foils a pair of gangsters (Rick Davis and Del Reeves), recovers the gold and returns it to its rightful owners. Also in the Jules Levy-Arthur Gardner-Arnold Laven De Luxe Color production were William Schallert, Woodrow Parfrey and Anthony James. The picture was strictly for those who found that Burt Reynolds, in long-johns using a coal scuttle on his head as a driving helmet, conformed to their idea of humour. (BRIGHTON)

△After Oliver Reed as **Hannibal Brooks** blows up a German convoy, he says, 'What's it all for?' He might well ask. On paper, the screenplay by Dick Clement and Ian La Frenais, based on a story by Tom Wright and producer-director Michael Winner, must have seemed a hoot. A British POW (Reed, illustrated) in Germany helps out at the local zoo where he becomes deeply attached to Lucy the elephant, and vice versa. When the Allies start bombing, he is instructed to evacuate Lucy by taking her, under guard, across the Alps to Innsbruck Zoo. En route they meet an escaped American prisoner (Michael J. Pollard) who leads a private guerrilla army. With Lucy's assistance and some explosives, they all make it to freedom in Switzerland. Also in the De Luxe Color picture, filmed on location in Bavaria, were Wolfgang Preiss, Helmut Lohner, Karin Baal, John Alderton and James Donald. It had some of the ingredients but, neither funny enough for comedy, nor exciting enough for a war movie, it fell between two stools. Elephant ones at that! (SCIMITAR)

▷Robert Mitchum sang the title song and starred in **Young Billy Young**, although the 52-year-old actor could hardly have taken the title role. That dubious distinction went to 29-year-old Robert Walker Jr who played a hired gunman in partnership with David Carradine. They fall out, and Walker joins up with Mitchum, who becomes marshal. In a final, tepid showdown, Mitchum and Walker overcome Carradine and John Anderson, as his vicious father. Many of the relationships were contrived in Burt Kennedy's screenplay (based on the novel *Who Rides With Wyatt* by Will Henry), but Max Youngstein's De Luxe Color production was a fair diversion. Pity, though, that Burt Kennedy's direction wasn't as tight as dancehall singer Angie Dickinson's black stockings. (Mitchum and Dickinson illustrated). Also in it were Paul Fix, Willis Bouchey, Parley Baer and Rudolfo Acosta. (TALBOT-YOUNGSTEIN)

△Charlton Heston (illustrated), as veteran quarterback of the New Orleans Saints in **Number One**, is told sagely 'You can't beat the clock.' When he injures his knee in a pre-season game, rumours circulate that he's through, but at 40 (Heston was 45), he's afraid to start a new life. His wife (Jessica Walter), who used to watch all his games, now pays more attention to dress designing. So, dreadfully dour Heston takes to drink, has a brief affair with another woman (Diana Muldaur), and generally feels sorry for himself. David Moessinger's potentially interesting screenplay about the problems facing an ageing sports star, became lost in soap operatics, and Tom Gries' direction revealed less about pro football than viewers could get any Saturday afternoon on TV. Others in Walter Seltzer's De Luxe Color production were Bruce Dern, John Randolph, Mike Henry and the New Orleans Saints. (WALTER SELTZER)

▷**The Bridge At Remagen** was the last bridge standing over the Rhine in 1945, which both German and American forces fought to control. The screenplay by Richard Yates and William Roberts (story Roger Hirson) gave as much time to both sides (of the bridge and the war) showing GIs and Germans suffering under fire. Tough American platoon leader George Segal was under the command of General E.G. Marshall, and German Major Robert Vaughan (centre) had to take orders from General Peter Van Eyck, but neither man on the spot seemed too clear about his superior's military thinking. Audiences were no wiser, but there was plenty of explosive action, well photographed by Stanley Cortez in De Luxe Color. Among the US soldiers were Ben Gazzara, Bradford Dillman, Matt Clark and Fritz Ford, and on the other side Hans Christian Blech (behind) and Vit Olmer (foreground). Director John Guillermin shot much of the David L. Wolper production in Czechoslovakia, but had to complete it in Italy when Russian troops moved in. (WOLPER)

△The secret of **The Secret Of Santa Vittoria** was that one million bottles of wine were concealed underground by the Italian villagers from the occupying German army in 1945. Nothing else was kept quiet in director Stanley Kramer's long (140 minutes) and loud (it starred Anthony Quinn, illustrated, and Anna Magnani) Panavision-Technicolor production. The basically amusing screenplay by William Rose and Ben Maddow (from Robert Crighton's novel) was pumped up with unnecessary subplots and a heavy Ernest Gold score. Only the big set piece when the bottles are passed from hand to hand as the Germans advance on the town, carried some impact. Quinn was the clownish mayor who becomes a hero, Magnani, his shrewish wife, and Virna Lisi a local contessa who has an affair with army deserter Sergio Franchi. Hardy Kruger as the German Captain brought a lightness of touch missing from the other characterizations. Renato Rascel, Giancarlo Giannini, Patrizia Valturri, Valentina Cortese and Leopoldo Trieste had other roles. (STANLEY KRAMER)

▷If **Crossplot** had been Roger Moore's screen test for the part of James Bond, he would never have got the job. Moore (left), in his first ever British film after making little impression in Hollywood, was charmlessly arch as an advertising executive who is unwillingly caught up in a plot to kill a visiting African statesman in England. Leigh Vance's story and screenplay dealt with how the plotters use a Peace organization as a cover, and how Moore, by solving a crossword puzzle clue, prevents them from carrying out the assassination during a birthday salute in Hyde Park. Alvin Rakoff's direction moved ineptly through the dregs of 'Swinging London', taking in a psychedelic disco, a vintage car race and a helicopter chase. Also in Robert S. Baker's Eastmancolor production were Martha Hyer, Claudine Lange, Alexis Kanner (foreground centre), Francis Matthews, Bernard Lee, Derek Francis and Ursula Howells. (TRIBUNE)

▽**More Dead Than Alive** aptly described cowboy Clint Walker's performance in this leaden Western directed by Robert Sparr. In George Schenck's script, Walker (left) was a gunman released after 18 years in prison. He gets a job in a Wild West show, but his attempts to go straight and settle down with a pretty widow (Anne Francis) are thwarted by a trigger-happy kid (Paul Hampton), and an old enemy (Mike Henry) who guns him down. Others in Hal Klein's De Luxe Color production were Craig Littler, Beverly Powers, Clarke Gordon, William Woodson and Harry Lauter. Only surprise in it was Vincent Price (right) as the kind-hearted impresario of the show. (AUBREY SCHENCK)

1969 OTHER RELEASES

Death Rides A Horse (orig: **Da Uomo A Uomo**)
A young man who has grown up nurturing a dream of revenge on the bandits who killed his parents joins up with an ageing outlaw also out to get them for having him put in prison. John Phillip Law, Lee Van Cleef, Luigi Pistilli, Anthony Dawson (Antonio Margheriti), Jose Torres. *Dir* Giulio Petroni. *Pro* Alfonso Sansone, Henry Chroscicki. Technicolor. (Italy) PEC

Out Of It
Two high school students are contrasted, one an intellectual but socially unsuccessful, the other a stupid football hero and ladykiller. Barry Gordon, Jon Voight, Lada Edmund Jr, Gretchen Corbett, Peter Grad. *Dir* Paul Williams. *Pro* Edward Pressman, Paul Williams. PRESSMAN/WILLIAMS

Submarine X-1
A naval group is trained on the north coast of Scotland for an attack on a German battleship sheltering in a Norwegian fjord, by means of three new midget submarines. James Caan, Norman Bowler, David Sumner, Brian Grellis, Paul Young. *Dir* William Graham. *Pro* John C. Champion. Eastmancolor. (GB/USA) MIRISCH

The Thousand Plane Raid
A massive daytime bombing raid on an aircraft factory situated deep in Germany, is carried out successfully. Christopher George, Laraine Stephens, J.D. Cannon, Gary Marshall, Michael Evan. *Dir* Boris Sagal. *Pro* Lewis J. Rachmil. De Luxe Color. OAKMONT

Three
Two young men on a motoring holiday in Italy and France meet an English girl, and make a fragile pact to keep sex out of their relationship. Charlotte Rampling, Robie Porter, Sam Waterston, Pascale Roberts, Edina Ronay. *Dir* James Salter. *Pro* Bruce Becker. Eastmancolor. OBELISK

An estimated 43.5 million Americans visited cinemas each week in 1960, compared with only 15 million ten years later. But when there was a picture that the public really wanted to see in the 70s, then more of them went to see it than in previous periods. The result was that certain films grossed a fortune while too many others barely recouped their costs. Escalating production expenses made film-making a far greater financial risk than ever.

In 1970, despite such box-office hits as *Butch Cassidy And The Sundance Kid* (1969) and *M*A*S*H* (1970), 20th Century-Fox showed a $77 million loss. In 1968, UA's income had reached an awesome $250 million, generating $20 million in profits after tax. However, two years later profits plunged unaccountably to $35 million pretax losses. Transamerica chairman John Beckett tackled the problem by appointing Eric Pleskow as president, Arthur Krim chairman and Robert Benjamin vice-chairman of UA, cutting overheads drastically, and firing almost a sixth of the company's workforce worldwide. In 1973, UA acquired the domestic theatrical and syndicated distribution rights of all MGM pictures for ten years, and also purchased MGM's music publishing companies. MGM, which had been deteriorating progressively over the last few years, decided to get out of the distribution business, cut down on production (they would make an average of a mere four movies a year), and spend $120 million on the 2,084-room MGM Grand Hotel in Las Vegas.

In the first four years of the decade, UA lost its lead in the Oscar stakes, although it still enjoyed smash-hits like Norman Jewison's *Fiddler On The Roof* (1971) and the perennial James Bond movies (despite 007 changing from Sean Connery to Roger Moore via George Lazenby). But most of the studio's properties at this period could not hope to compete with blockbusters such as Paramount's *Love Story* (1970), *The Godfather* (1972) and *The Godfather Part II* (1974), 20th Century-Fox's *Patton* (1970) and *The French Connection* (1971), Warner's *Dirty Harry* (1971) and *Deliverance* (1972), and Universal's *The Sting* (1973). Neither did UA cash in on the 'disaster movie' trend represented by *Airport* (Universal, 1970) and its sequels, *The Poseidon Adventure* (20th Century-Fox, 1972) and *The Towering Inferno* (20th Century-Fox/Warner Bros., 1974). Nor did they jump onto the youth bandwagon along with *Easy Rider* (Columbia, 1969), *Five Easy Pieces* (Columbia, 1970), *Woodstock* (Warner Bros., 1970) and *American Graffiti* (Universal, 1974). But, foreshadowing the career of the screen's most popular boxer (and one of UAs greatest assets), the company made a spectacular comeback in the mid-70s by winning three Best Picture Academy Awards in a row.

The first, *One Flew Over The Cuckoo's Nest* (1975), based on a cult novel of the 60s, became the first movie in 41 years to fly off with all five major Oscars, and earned itself $56½ million. This sum was almost equalled by the following year's winner. Producer Irwin Winkler recalled, 'In comes this big lug who weighed 220 lbs, didn't talk well, and acted slightly punchdrunk. He said he had an idea for a boxing script and wanted to star in it. The 'lug' was Sylvester Stallone, Winkler and Robert Chartoff took a chance, and the fabulous success of *Rocky* (1976) is well known. UA's third Best Picture winner was another surprise package, *Annie Hall* (1977), Woody Allen's sixth film as director. Previously Allen stated, 'I have a nice gentleman's agreement with United Artists. I've traded the idea of making millions in return for artistic control. My films have

a very modest audience – they don't make anything like a Streisand or Redford picture. But I make them very cheaply and they produce a small profit. As long as that goes on, UA is happy. They leave me alone and I deliver them a finished movie.' *Annie Hall* reached rentals of almost $20 million.

Thanks to pictures like *Annie Hall*, three *Pink Panther* movies starring Peter Sellers, and the costly ($19 million) but profitable James Bond epic *The Spy Who Loved Me* (1977), UA was riding high. Arthur Krim wished to separate from the parent company of Transamerica, allowing them to retain a controlling interest. Beckett refused and Krim was quoted in *Fortune* magazine as saying, 'You will not find any top officer here who feels that Transamerica has contributed anything to UA.' Beckett retorted, 'If the people at UA don't like it they can quit and go off on their own.' They did. Krim, Benjamin, Pleskow, Bill Bernstein (head of business affairs) and Mike Medavoy (head of production) resigned to form a new company called Orion. They also took filmmakers, principally Woody Allen, with them. Orion's first hit was Blake Edwards' *10* (1979), which had been rejected by UA.

On January 24, 1978, an open letter addressed to John Beckett and signed by 63 producers and directors appeared in *Variety* and *The Hollywood Reporter*. It read,

'Dear Mr Beckett,
We, the undersigned, have made films in association with Arthur Krim, Eric Pleskow, Bob Benjamin, Bill Bernstein and Mike Medavoy. The success of United Artists throughout the years has been based upon the personal relationships of these executive officers of United Artists with us, the film makers. We seriously question the wisdom of Transamerica Corporation in losing the talents of these men who have proven their creative and financial leadership in the film industry for many years. The loss of this leadership will not only be felt by United Artists but by all of us.'

Arthur Krim had been the dominant figure at UA from 1951 to 1978, and was known by many as 'The Great White Father.' One producer commented, 'Arthur Krim is the smartest single individual ever to work in the motion picture industry,' and Steven Bach in his book *Final Cut* wrote, 'the day Arthur Krim walked out of 729 Seventh Avenue was the day UA died.' Not many weeks previously, Charles Chaplin had died on Christmas Day 1977. The last surviving founder of UA, Mary Pickford, died just over a year later.

James Harvey, Transamerica's executive vice-president became chairman of the UA board. Andy Albeck, UA's senior vice-president became president to run things from New York. The virtually unknown Albeck had been with the film company for almost 30 years, and a trusted assistant to Krim. During the management crisis, UA struck a distribution deal with the powerful TV company, Lorimar, who supplied them with around a dozen movies until 1981. It left roughly $100 million a year for their own pictures. UA invested over $7.5 million in *Apocalypse Now* (1979), and lent Francis Coppola a few million more to complete the Vietnam war movie. Despite the mounting cost of *Apocalypse Now*, and the major management upheaval, the summer of 1979 saw UA enjoying the most successful box-office period in its history. This was mainly due to *Manhattan, Moonraker, Rocky II, The Black Stallion* and the French/Italian import *La Cage Aux Folles*. Nonetheless, the company was to be virtually wiped out in a few more years.

UNITED ARTISTS
1970

▽'All that keeps our men together is the need for violence and money,' says Kerwin Mathews, sidekick to Warren Oates' black-garbed bandido in **Barquero**. Presumably, the same two needs motivated producer Hal Klein and director Gordon Douglas to make this brutish Western. Most of the action in George Schenck and William Marks' screenplay took place on two opposite banks of a river between which bald and grizzled Lee Van Cleef (illustrated) plies his rope-hauled ferry. When Oates and his unprepossessing bunch arrive, Van Cleef, who apparently has the only craft in the area, refuses to carry them and their booty across the river. Much blood is spilt while tosh is talked about the Old West, and Oates hallucinates on 'grass'. Forrest Tucker (as a very basic backwoodsman who eats ants and slits people's throats), Mariette Hartley, Maria Gomez, Brad Weston, Armando Silvestre, John Davis Chandler and Craig Littler were also in it. (AUBREY SCHENCK)

△**Where's Poppa?** was an over-extended but funny Jewish momma joke. Ruth Gordon's senile momma (centre) chews gum, pops her fingers, pours Coke over her cereal, and watches television all day. Her presence scares off her lawyer son's girlfriends. The son (a frantic George Segal, left) tries to give her a heart attack by dressing in a gorilla suit and jumping onto her bed. 'You almost scared me to death,' she cries. 'Almost is not good enough', he replies. Robert Klane's script from his own novel also dealt with Segal's brother (Ron Liebman in his screen debut) who rapes a male policeman in drag, and a fraternity of muggers and mugged in Central Park. Carl Reiner directed in the worst possible taste, amusing and outraging in equal measure. Others in the Jerry Tokofsky–Marvin Worth production were Trish Van Devere (right), Rae Allen, Vincent Gardenia, Joe Keyes Jr, Tom Atkins and Paul Sorvino. (TOKOFSKY-WORTH)

▷Rock Hudson (illustrated) lived up to his first name in **Hornet's Nest**, both in strength and impassivity. He played a US army captain assigned to blow up an important Italian dam during World War II. Injured when parachuting into enemy territory, he is helped by a group of Italian orphans whose parents were shot by the Germans. The screenplay by S.S. Schweitzer (from a story by Schweitzer and Stanley Colbert) literally dragged in a German doctor (Sylva Koscina, illustrated) to tend to Hudson, and provide feminine appeal. She is forced (unconvincingly) to go along with them to the dam, which she later helps blow up. The theme of war's corruption of innocence was lost on the way, and the children were not well directed by Phil Karlson, although Stanley S. Canter's production certainly ended with a bang. Other roles went to Mark Colleano, Serge Fantoni, Jacques Sernas, Rossi Stuart, Mauro Gravina and John Fordyce. (TRIANGLE)

▷By casting rebellious pop star Mick Jagger as Australia's notorious 19th-century Irish outlaw **Ned Kelly**, producer Neil Hartley and director Tony Richardson were obviously going for contemporary relevance. However, the diminutive Jagger (left), shorn of his mane and deprived of The Rolling Stones, delivered his lines as if in a stupor, fighting a losing battle with an Irish accent. Apart from the disastrous central performance, it was a sprawling, artsy Aussie Western, peppered with incessant folk songs, and lines like, 'Fearless, free and bold, that's how we'll live,' in the banal script by Richardson and Ian Jones. The plot told of how young Ned formed the Kelly gang because of social injustice towards the Irish Catholics by the corrupt Protestant colonists, and how he ended his days on the gallows. Others cast were Allen Bickford, Geoff Gilmour (right), Mark McManus, Serge Lazareff, Peter Sumner, Ken Shorter, Jane Wesley and James Elliott. (WOODFALL)

▽An air of desperation hung over **Pussycat, Pussycat, I Love You**, a silly semi-sequel to *What's New Pussycat?* (1965), filmed at Cinecitta in Rome. In common with the previous film (a masterpiece by comparison), the screenplay by the director Rod Amateau called for a bevy of beautiful girls, a man with sexual problems and a crazy psychiatrist. Ian McShane (illustrated) played the poor guy unhappily married to Anna Calder-Marshall, and having affairs with Beba Loncar, Madeline Smith, Veronica Carlson and Katia Christina, while his wife takes Marino Mase and John Gavin as lovers. The shrink was Severn Darden, in a red fright wig, having problems with his own wife, Joyce Van Patten. It seemed natural that Jerry Bresler's production should end with a sex-mad gorilla chasing everyone. (THREE PICTURES CORP.)

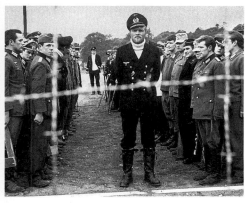

△An interesting new slant was given to the usual World War II POW escapist dramas by **The McKenzie Break**. Arnold Gardner and Jules Levy's production was set in a camp in Scotland (actually filmed in Ireland) which held a group of German officers and men, including a crack U-boat corps. When a young Luftwaffe pilot (Horst Janson) is murdered, the major in charge of the camp (Ian Hendry) gets a captain and ex-crime reporter (Brian Keith) to investigate. He discovers that the killing was connected with an ingenious escape plan. Helmet Griem (illustrated centre) was effective as the German commander under whose leadership the camp is turned into a microcosm of Nazi society, with its drills, martial singing, anti-Jewish and anti-homosexual attitudes. Other Brits and 'Jerries' were Jack Watson, Patrick O'Connell, Alexander Allerson, John Abineri, Constantin de Goguel and Tom Kempinski. Both Lamont Johnson's direction and William Norton's intelligent script (from a Sidney Shelley novel) kept the picture satisfactorily absorbing right to the suspenseful end. (BRIGHTON/GARDNER-LEVY-LAVEN)

△Although director Ken Russell restrained some of his more vulgar excesses in **Women In Love**, D.H. Lawrence's polemical novel on the nature of sex and love became trivialized and prettified. In fact, the picture fell somewhere between Russell's irreverent extravaganzas and more academic TV adaptations of classics. Neither producer Larry Kramer's screenplay, nor the direction, were able to make the two tempestuous love affairs convincing, despite the well-chosen casting of Glenda Jackson (foreground left, Best Actress Oscar-winner) and Jennie Linden (centre right) as the emancipated Brangwen sisters, Gudrun and Ursula, Oliver Reed (left) as the wealthy and brutal Gerald Crich, and Alan Bates (centre) as school inspector Rudolph Birkin, the girls' respective lovers. The first affair ends tragically when the jealous Gerald walks out into the snow to die in Switzerland, while the second couple try to find a way to go beyond the conventions of marriage. Many of the other roles were caricatured, especially Eleanor Bron's dilettante Hermione Roddice (right), and Vladek Sheybal's camp German sculptor. Also cast were Michael Gough, Alan Webb, Catherine Wilmer, Christopher Gable and Sarah Nicholls. The evocation of a Midland colliery town in the early 20s, and the handsomely shot Zermatt sequences were the best features of the film, although the crude, nude wrestling scene between Reed and Bates is mainly remembered. (BRANDYWINE)

△**The Private Life Of Sherlock Holmes** was a mildly amusing attempt by producer-director Billy Wilder, and his co-writer I.A.L. Diamond to debunk the legend of Sir Arthur Conan Doyle's famous sleuth. Holmes (played sardonically by Robert Stephens, centre) complains that he only wears the deerstalker and cape, and smokes a pipe, because the public have come to expect it of him. Happier with his cocaine and violin than solving mysteries, he finds that almost every one of his conclusions is inaccurate. In the first of two unrelated plots (there were to have been four), Holmes cites his relationship with Dr Watson (Colin Blakely, left) as proof of his dislike for women in order to get out of marriage to a Russian ballet dancer (Tamara Toumanova). In the film's best moment, Watson, enjoying himself dancing with ballerinas backstage, suddenly finds himself surrounded by male dancers. The other tale concerned a beautiful German spy (Genevieve Page), 'submersible' warships in Loch Ness, trappist monks, midgets, Queen Victoria (Molly Maureen) and Sherlock's elder brother Mycroft (Christopher Lee). Filmed in an uncharacteristically leisurely manner by Wilder, it had some good period detail and pleasant Scottish scenery. Other roles went to Irene Handl (Mrs Hudson, right), Clive Revill, Catherine Lacey, Stanley Holloway and Peter Madden. (PHALANX/MIRISCH/SIR NIGEL)

△TV director Paul Bogart's first feature **Halls Of Anger**, was as well-meaning and safe as many a teleplay, although the premise of Al Ramrus and John Shaner's screenplay offered interesting elements of social parable. Because of the national integration plan, 60 white students are sent to an all-black blackboard jungle where they suffer the kind of racism that affects blacks in a white-dominated society. One of the whites (19-year-old Jeff Bridges in his screen debut) is a particular target of a tough gangleader (James Watson), while a white girl (Patricia Stich) is humiliated by black girls in the locker room. But a black teacher (Calvin Lockhart, illustrated) solves all the school's problems by his caring approach. It seems that in order to get kids to read you give them a sexy paperback, and to bring the undisciplined to heel you get them to paint a mural. Janet MacLachlan, Bob Reiner, Dewayne Jesse, Roy Jenseon, John McLiam and TV's Lou Grant, Edward Asner, also appeared in Herbert Hirschman's De Luxe Color production. (MIRISCH)

△Director Jan Kadár's *The Shop On Main Street* (1965), starring Ida Kaminska, was the first Czech film ever to win an Oscar, but Kádar's first American picture, **The Angel Levine**, gained little approval. The underlying sentimentality of the previous movie poured out unrestrained in this adaptation by Bill Gunn and Ronald Ribman of a Bernard Malamud short story in which an elderly Jewish tailor (Zero Mostel, left) receives a visit from a black angel called Levine (Harry Belafonte, right, returning to the screen after ten years). The heavenly messenger descends at the right moment for the tailor whose backaches are impeding his work, and whose wife (Kaminska) is seriously ill. The angel works miracles, something the good cast failed to do with the material. Support came from Milo O'Shea, Gloria Foster, Barbara Ann Teer, and husband and wife team, Eli Wallach and Anne Jackson, in cameos. The producer of this schmaltz was Ciz Schultz. (BELAFONTE)

△**Leo The Last** was a flabby allegory starring a lethargic Marcello Mastroianni (right) in the title role. Director John Boorman, who also wrote the script with William Stair, asked him to play a dethroned European monarch whose town house happens to be plumb in the middle of an unrealistic slum area of London. From his window, he observes the behavior of birds and the (mostly black) slumdwellers through his telescope. The ex-king gets involved in the people's problems, particularly those of an ill-treated prostitute (Glenna Forster Jones). In the end, the aristo joins them to burn down his mansion, and gives all his property in the street to the poor. The well-meaning but badly conceived and acted picture, based on George Tabori's play *The Prince*, was produced by Irwin Winkler and Robert Chartoff. Also in the cast were Billie Whitelaw, Calvin Lockhart (foreground left), Graham Crowden, Gwen Ffrangcon-Davies, David De Keyser and Vladek Sheybal. (CHARTOFF-WINKLER-BOORMAN)

▽Jon Voight (left), fresh from his triumph in *Midnight Cowboy* (1969), adopted rimless spectacles, a shabby raincoat, baggy trousers and flapping boots for his role as **The Revolutionary**. Paul Williams, who directed Voight in another low budget drama, *Out Of It* (1969), and Hans Koningsberger, adapting his own novel, created an engrossing portrait of a middle-class student who becomes a left-wing political activist. Among the characters who influence Voight, known only as A, are militant factory worker Robert Duvall, anarchist Seymour Cassell (right), fellow Radical Party member Collin Wilcox-Horne (that's a she), and bourgeois student Jennifer Salt. Others in Edward Rambach Pressman's production were Lionel Murton, Reed de Rouen, Warren Stanhope and Mary Barclay. Although shot in London, the carefully chosen locations avoided identification with any particular place or time. The film, in spite of its leading man, failed to awaken much fervour in the public. (PRESSMAN-WILLIAMS)

▽**Cotton Comes To Harlem** was one of the very first black – as distinct from *noir* – thrillers, and part of the new wave of what were called Blaxploitation movies. Actor Ossie Davis, directing for the first time, wrote the script (with Arnold Perl) which featured Chester Himes' Harlem detectives Grave Digger Jones (Godfrey Cambridge, right) and Coffin Ed Johnson (Raymond St Jacques, left) finding out what happened to $87,000 stashed away in a bale of cotton. The money was conned from the 'good folks' by swindler-cum-preacher, the Reverend Deke O'Malley (Calvin Lockhart) for his phony 'Back To Africa' movement. Others cast were Judy Pact, Redd Foxx, John Anderson, Emily Yancy, J.D. Cannon, Mabel Robinson, Cleavon Little and Dick Sabol. The lively Harlem location shooting, the energetic playing, the funny foul-mouthed dialogue made Samuel Goldwyn Jr's production, despite its occasional rough edges, a refreshing change from the more usual 'honkie' movie. (SAMUEL GOLDWYN JR)

▽When redneck sheriff Rod Steiger mockingly asks black detective Sidney Poitier in *In The Heat Of The Night* (1967) if other policeman call him Virgil, Poitier replies, **They Call Me *Mister* Tibbs!** The only thing in favour of this lukewarm follow-up movie, was that race was not mentioned once by a totally integrated cast. The routine screenplay, written by James R. Webb and Alan R. Trustman (story by the latter), had Poitier (right), reprising his earlier role, helping to solve the case of a murdered prostitute found in a Nob Hill apartment in San Francisco. Among the suspects are a Reverend (Martin Landau, left), a drug pusher who owns the building (Anthony Zerbe), the janitor (Juano Hernandez), and a real-estate agent (Edward Asner). The plot was unnecessarily interrupted by scenes from the home life of the detective with his wife (Barbara McNair) and kids (George and Wanda Spell). Others in Herbert Hirschman's production were Jeff Corey, David Sheiner, Norma Crane, Ted Gehring and Beverly Todd. Apparently the star took over the director's reins from Gordon Douglas on occasions, but it was difficult to see where as there was little noticeable improvement. Poitier came back once more as the character Virgil Tibbs in *The Organization* (1971). (MIRISCH)

△Another chunk of James A. Michener's hefty novel *Hawaii*, which had already provided material for the 1966 film of the same name, was served up as **The Hawaiians** (GB: **Master Of The Islands**), in particular the section covering the years 1870 to 1900. Presumably, had Walter Mirisch's production been more successful, the book could have been used for many more pictures. James R. Webb's rambling screenplay followed the fortunes of two families over two generations. The Hoxworths (Charlton Heston, left, and Geraldine Chaplin) and their son Noel (John Phillip Law) run a prosperous pineapple plantation; Mun Ki (Mako, centre), his wife Nuyk Tsin (Tina Chen, right) and their daughter (Virginia Ann Lee) are a family of Chinese farmers. After 132 slowish minutes, the two dynasties are united by the marriage of the children. In the acting department, the orientals beat the occidentals hands down. Also cast were Alec McCowen, Don Knight, Miko Mayama, Naomi Stevens, Keye Luke and James Gregory. Despite plague, revolution and typhoons, there was less action under Tom Gries' direction than in the previous film, nor were the beauties of Hawaii used to the best effect. (MIRISCH)

▽Miraculously, **One More Time**, sequel to *Salt And Pepper* (1968), managed to be even less funny than its predecessor. Again, Sammy Davis Jr (left) and Peter Lawford (right) played London nightclub owners Charles Salt and Chris Pepper, who get mixed up in dirty doings concocted for them by screenwriter Michael Pertwee. As if one Peter Lawford were not enough, he also portrayed his wealthy and supercilious twin brother, Lord Sydney Pepper, who is murdered by diamond smugglers. The Milton Ebbins production ended with the mandatory hectic chase before the baddies got their just desserts. Also in it were Maggie Wright, Leslie Sands, John Wood, Sydney Arnold, Edward Evans, Percy Herbert, Bill Maynard and Dudley Sutton. There was small comfort in the fact that it was the only picture directed by Jerry Lewis in which he did not appear. (CHRISLAW/TRACE-MARK)

▽Hal Ashby, Oscar-winning editor of *In The Heat Of The Night* (1967), made his directing debut with **The Landlord**, which also dealt with race relations. However, the style and content of the two films could not have been more different. Whereas Norman Jewison (here producing) went for a cool, naturalistic treatment in the previous movie, Ashby approached this protracted satire in a flashy, caricatural manner. As a result, much of Bill Gunn's amusing script (based on a novel by Kristin Hunter) lost much of its incisiveness, although some good points were scored. Beau Bridges (left) played the well-meaning owner of a tenement in Brooklyn's black ghetto. 'Didn't we all go together to see *Guess Who's Coming To Dinner*? Believe me, dear, not all negroes are like that,' says Lee Grant (right) camping it up as Beau's mother in an effort to dissuade him from marrying black art student Marki Bey (centre). Walter Brooke and Susan Anspach played his WASPish father and sister. The landlord's other tenants included Pearl Bailey, Diana Sands, Louis Gossett, Douglas Grant and Melvin Stewart. (MIRISCH/CARTIER)

▷**Pieces Of Dreams**, a sudsy story about love between a young Catholic priest (Robert Forster, illustrated) and an attractive, well-dressed, divorced social worker (Lauren Hutton, illustrated), hardly raised an eyebrow, nor did Robert F. Blumofe's production raise much at the box office. The lovers meet over the case of a Mexican boy shot while attempting a robbery. They're soon hitting the sack together, and prancing in soft-focus to the tune of Michel Legrand's sugary title number, sung by no less than Peggy Lee. Besides grappling with Miss Hutton, Father Forster grapples with his conscience, which forces him to leave the embrace of the church and become an ambulance driver. Roger O'Hirson's script (adapted from William E. Barrett's novel *The Wine And The Music*) touched on the subjects of abortion, the pill, drugs and juvenile delinquency, but Daniel Haller's pious platitudinous direction denuded it of any contemporary urgency. Other roles went to Will Geer, Ivor Francis, Richard O'Brien, Edith Atwater, Mitzi Hoag, Rudy Diaz, Gail Bonney and Helen Westcott. (RFB)

▽The Mexican Revolution provided the background to **Cannon For Cordoba**, although historical accuracy was not its strong point. The strength of Paul Wendkos' direction lay in the pace of the action in which a US army captain (George Peppard, right) and his friends attempt to destroy six cannons before either the Mexican army or rebel leader Cordoba (Raf Vallone) can use them. Giovanna Ralli, playing a girl once raped by Cordoba and now bent on revenge, managed to change costumes in the heat of battle. Stephen Kandel's script gave some opportunity for the leading actors to create a web of tensions, while the extras died like flies. Pete Duel, Don Gordon (left), John Russell, Francine York and Gabriele Tinti had other roles in Vincent M. Fennelly's production. (MIRISCH)

The Bridge In The Jungle
A young crocodile hunter comes across an old American man living with the Indians at a remote trading post in the jungles of Mexico. John Huston, Charles Robinson, Katy Jurado, Carmelita Elizabeth Guadalupe Chauvet, Jose Angel Espinoza. *Dir & Pro* Pancho Kohner. (USA/Mexico) CAPRICORN

The Christine Jorgensen Story
The true story of the first sex change operation which changed George into Christine in Denmark. John Hansen, Joan Tompkins, Quinn Redeker, John W. Himes, Ellen Clark. *Dir* Irving Rapper. *Pro* Edward Small. EDPROD

Hell Boats
An American with the Royal Navy in Malta in 1942 devises a way of destroying a strategically sited German arsenal in Sicily, and has an affair with his superior's wife at the same time. James Franciscus, Elizabeth Shepherd, Ronald Allen, Reuven Bar-Yotam. *Dir* Paul Wendkos. *Pro* Lewis J. Rachmil. (GB/USA) OAKMONT

The Last Escape
A group of American officers, with a mission to bring various British military personnel, German scientists and other refugees out of enemy territory, are suspensefuly pursued by the SS and a Russian tank. Stuart Whitman, John Collin, Martin Jarvis, Pinkas Braun, Gunther Neutze, Margit Saad. *Dir* Walter Grauman. *Pro* Irving Temaner. (GB/USA) OAKMONT

The Mercenary (aka **A Professional Gun**, orig: **Il Mercenario**)
Miners take over a mine during the Mexican Revolution and hire a mercenary to help them rout the government soldiers. Franco Nero, Tony Musante, Jack Palance, Giovanna Ralli, Eduardo Fajardo. *Dir* Sergio Corbucci. *Pro* Alberto Grimaldi. Technicolor. (Italy/Spain) PEA/DELPHOS

Mosquito Squadron
A British squadron uses a new bounce bomb to destroy a chateau in Occupied France where V3 rockets are being developed, although the chateau contains hundreds of RAF prisoners of war. David McCallum, Suzanne Neve, David Buck, David Dundas, Dinsdale Landen, Charles Gray. *Dir* Boris Sagal. *Pro* Lewis J. Rachmil. (GB/USA) OAKMONT

Pound
Actors take the part of dogs and cats in a pound in order to act out an allegory of human existence. Lawrence Wolf, Stan Gottlieb, Charles Dierkop, Elsie Downey, Carolyn Groves. *Dir* Robert Downey. *Pro* Floyd L. Peterson. FLOYD L. PETERSON

Sabata
An expert gunslinger and a troubadour who carries his gun hidden inside a banjo, find themselves as rivals for a reward out for bandits. Lee Van Cleef, William Berger, Franco Ressel, Linda Veras, Pedro Sanchez. *Dir* Frank Kramer (Gianfranco Parolini). *Pro* Alberto Grimaldi. (Italy) PEA/DELPHOS

Underground
An American officer, tortured into naming members of his espionage ring, attempts to redeem himself by joining the Maquis and helping to kidnap a German general. Robert Goulet, Daniele Gaubert, Lawrence Dobkin, Carl Duering, Joachim Hansen. *Dir* Arthur H. Nadel. *Pro* Jules Levy, Arthur Gardner, Arnold Laven. BRIGHTON

The Way We Live Now
A Madison Avenue executive is unhappily married, but finds that he is even more miserable during a trial separation. Nicholas Pryor, Linda Simon, Joanna Miles, Patricia McAneny, Rebecca Darke. *Dir & Pro* Barry Brown. SAUL LAPIDUS

UNITED ARTISTS

1971

▽It was sad to see Rosalind Russell's admirable 37-year screen career coming to an end with the execrable espionage spoof **Mrs Pollifax-Spy**. The screenplay, written by Russell herself under the name of C.A. McKnight (adapted from Dorothy Gilman's novel *The Unexpected Mrs Pollifax*), had the initially amusing notion of a respectable American matron offering her secret services to the CIA. Leslie Martinson's direction soon turned smiles to yawns as the indomitable lady (illustrated), on the track of a microfilm, was kidnapped with another agent (Darren McGavin, illustrated), taken to a mountain fortress in Albania, and escaped, while simultaneously throwing in wodges of propaganda for the American Way of Life. Other roles went to Nehemiah Persoff, Harold Gould, Albert Paulsen, John Beck and Dana Elcar. Frederick Brisson, the star's husband, produced. (METEOR)

▽**Valdez Is Coming** was the message sent by Burt Lancaster to a powerful group of men who have humiliated him. Burt wants a mere $100 for the pregnant widow of the man he was forced to kill in their defence. When one of them, a wealthy ranch owner (Jon Cypher), refuses, Lancaster (left) kidnaps his woman (Susan Clark) and heads for the mountains. Roland Kibbee and David Rayfiel's screenplay (from the novel by Elmore Leonard) brought about the inevitable showdown between hero and heavy after some ponderous proceedings directed by theatre man Edwin Sherrin. Also cast: Barton Heyman, Richard Jordan, Frank Silvera (right, final film), Hector Elizondo, Juanita Penaloza and Roberta Haynes. Ira Steiner's production was shot in Spain. (NORLAN/IRA STEINER)

▽So desperate were producers Harry Saltzman and Albert R. Broccoli to have Sean Connery (illustrated) back as James Bond in **Diamonds Are Forever** after the relative failure of *On Her Majesty's Secret Service* (1969), they gave him $1 million straight fee (which he donated to the Scottish International Education Trust) plus a weekly salary of $10,000, and a promise from UA to finance two films of his choice. As the seventh Bond movie raked in over $21 million, the concessions were worth it. Four years away from the role had not altered Connery's droll style or sexual magnetism, although there was some change in his girth. Differing greatly from Ian Fleming's book, the script by Richard Maibaum and Tom Mankiewicz had 007 bound-

◁Publicity for **The Hunting Party** claimed that 'the film shows the men of Texas ... not as folklore makes them out to be, but as they really were ...' It's a wonder that producer Lou Morheim and director Don Medford were not hunted down and shot by Texans for defaming their ancestors. Representing 19th-century Texas manhood, in the screenplay by Morheim, Gilbert Alexander and William Norton (story by former two), was cattle baron Gene Hackman, who goes on a hunting trip on a bordello-equipped train with four friends toting high-precision rifles. Meanwhile, outlaw Oliver Reed has kidnapped Hackman's wife Candice Bergen, so the husband turns his attention from animals to the shooting of Reed and his gang. While they were being picked off from a safe distance, one by one, the captor and captive fall in love. It ends with the lovers (illustrated) being killed in the desert by Hackman, who then dies of thirst and exposure. Simon Oakland, Mitchell Ryan, L.Q. Jones, G.D. Spradlin, William Watson, Ronald Howard and Rayford Barnes were also in this gory and repellent made-in-Spain picture. (BRIGHTON/LEVY-GARDNER-LAVEN)

ing from London to Amsterdam, LA to Las Vegas on the trail of a huge diamond smuggling operation behind which lurks his old arch enemy Blofeld (now Charles Gray). Bond has a good fight in a small elevator, is pestered by two vicious gays (Putter Smith and Bruce Glover), and attracted by two beauties named Tiffany Case (Jill St John) and Plenty O'Toole (Lana Wood, Natalie's sister). The cast also included Jimmy Dean, Bruce Cabot, Norman Burton and regulars Bernard Lee, Desmond Llewelyn and Lois Maxwell as 'M', 'Q' and Miss Moneypenny. Guy Hamilton directed the familiar extravagances with more camp than previously, and Ken Adam's futuristic sets again deserved most of the applause. (EON-DANJAQ)

△After packing them in on Broadway for years, the Jerry Bock-Sheldon Harnick musical **Fiddler On The Roof**, transposed to the Panavision 70 screen by producer-director Norman Jewison, earned over $25 million at the box-office. During the 180 minutes, the public got most of the songs, including 'If I Were A Rich Man' and 'Matchmaker, Matchmaker', the involving tragicomic tale (faithfully adapted by Joseph Stein from his stage play) of Tevye, the Jewish milkman trying to marry off his five daughters in the Ukraine in 1905, and having to emigrate to America because of the pogroms, and a virile, well-sung and charm-laden performance from Israeli actor Topol (illustrated). What they missed was the richer humour and deeper pathos of Zero Mostel's stage performance, the vitality of Jerome Robbins' choreography (ruined here by insensitive cutting), and the splendid Chagall-inspired settings. The opening out into real locations (shot in Yugoslavia) also reduced its impact, and the Oscar-winning photography by Oswald Morris was inappropriately glossy for the subject, distancing the film even further from the original short story, *Tevye And His Daughters*, by Sholom Aleichem. Others cast were Norma Crane (Tevye's wife Golde), Molly Picon (Yente, the matchmaker), Leonard Frey (Motel, the Tailor), Barry Dennen, Paul Mann, Rosalind Harris, Michele Marsh, Neva Small, Michael Glaser, Patience Collier, and Tutte Lemkow in the title role (dubbed by Isaac Stern). (MIRISCH)

△Erich Segal, the writer of *Love Story* (Paramount, 1970), and Noel Black, the director of the promising matricidal drama *Pretty Poison* (20th Century-Fox, 1968), made a pretty poisonous combination on **Jennifer On My Mind**. This draggy drug story, based on a novel by Roger L. Simon, told of how an aimless Jewish youth (Michael Brandon) meets a bored WASP girl (Tippy Walker, illustrated with Brandon), in Venice, where they smoke pot and walk hand in hand in slow motion. Back in the USA, they smoke pot and walk hand in hand in slow motion. He buys her Moroccan hash for her birthday, the effects of which make her jump off a roof unharmed. Later, in response to her pleas, he injects her with heroin and she dies. Bernard Schwartz's production also cast Lou Gilbert, Steve Vinovich, Peter Boberz, Renee Taylor, Chuck McCann, Bruce Kornbluth and Robert De Niro. (BERNARD SCHWARTZ)

▷Producer-director Frank Perry's **Doc** was another attempt, in a cynical age, to debunk a Western myth – in this case, the legendary characters who took part in the oft-filmed gunfight at the OK Corral. But his technique was so self-conscious and solemn, and *New York Post* columnist Peter Hamill's script was so deliberate, that one longed for the traditional hero-worshipping Western of yesteryear. Stacy Keach (illustrated) stared gloomily into a whisky glass and coughed up blood as Doc Holliday, Faye Dunaway (illustrated), still with an aura of Park Avenue allure, was Katie Elder, the prostitute Doc won in a poker game, and Harris Yulin played Wyatt Earp as a petty opportunist. The gunfight itself took about ten seconds; the film, alas, took 122 minutes. Others cast were Mike Whitney (as Ike Clanton), Denver John Collins, Dan Greenberg, Penelope Allen, Hedy Sontag, Bruce M. Fischer and James Green. (FRANK PERRY)

▽**What's The Matter With Helen?** was directly descended from films like *What Ever Happened To Baby Jane?* (Warner Bros., 1962) in which aging Hollywood first ladies could camp it up in Grand Guignol fashion. The matter with Helen (Shelley Winters, right) was the matter with Curtis Harrington's direction. Neither knew how far to go too far. Nothing much was the matter with the first half which wittily established the place and period – Hollywood in the early 30s – where dance teachers Helen and Adelle (Debbie Reynolds, left, in her last screen role to date) set up a school for budding Shirley Temples. An out-of-work actor (Michael MacLiammoir) joins them as elocution teacher, and they mount a lavish Kiddystar Revue. But when blood replaced greasepaint in the screenplay by Henry Farrell (who wrote the story of *Baby Jane*), the George Edwards-James C. Pratt production faltered slightly. Helen starts to hallucinate, kills pet rabbits, an intruder and, finally, Adelle. Dennis Weaver, Agnes Moorehead, Sammee Lee Jones, Robbi Morgan, Helene Winston and Molly Dodd had other roles. (FILMWAYS/RAYMAX)

△'Where do you train your nurses? Dachau?' asks a patient in **The Hospital**, a far cry from cosy TV medic soaps like *Dr Kildare*. In this crazy institution imagined by screenwriter Paddy Chayevsky, someone is going around killing doctors, an intern is delighted when a patient dies as he can use the empty bed for his amorous adventures, and an African witch-doctor tries out his methods. At the centre of Howard Gottfried's production, and keeping Arthur Hiller's direction from going over the top, was George C. Scott's brilliant Oscar-winning performance as the chief doctor, stooped, boozy, gruff and glum, with an anarchist son and a drug-pushing daughter. Although he is cured of his impotence by Diana Rigg (illustrated), daughter of a religious homicidal maniac (Barnard Hughes), Scott (illustrated) reaches the fatalistic conclusion that 'we cure nothing.' Others taking part in this successful black comedy were Richard A. Dysart, Stephen Elliott, Andrew Duncan and Nancy Marchand. (SIMCHA)

▷Producer-director Ken Russell stated that he was 'fed up with the reverential treatment of musical heroes', and **The Music Lovers**, a biopic of Peter Tchaikowsky, was an example of his own irreverent approach. A bushy-bearded Richard Chamberlain (left) played the great romantic Russian composer, who seemed to do little else other than romp with his boyfriends, and break a fortune's worth of champagne glasses. In one of the many grotesque and philistine visualisations of the music, he imagines cannons shooting off the heads of his enemies during the 1812 overture. There was also room for a homosexual-marries-nymphomaniac scene in which Tchaikowsky, on his wedding night on a train, grows more and more repulsed by his bride's body as she undresses. She (Glenda Jackson) ends up in an asylum being groped by madmen. Who knows what Melvyn Bragg's script (based on Catherine Drinker Bowen and Barbara Von Meck's book *Beloved Friend*) was like before the 44-year-old *enfant terrible* of the British cinema got his hands on it. Max Adrian (Nicholas Rubinstein), Izabella Telezynska (Madame Von Meck, Tchaikowsky's patroness), Christopher Gable, Kenneth Colley (foreground right), Sabina Maydelle, Maureen Pryor, Bruce Robinson and four Russell children were also cast. For the record, André Previn conducted the London Symphony Orchestra. (RUSSFILMS)

△So successful was the parody Western *Support Your Local Sheriff* (1969) that the same team of producer Bill Finnegan, director Burt Kennedy and star James Garner (left) got together again for **Support Your Local Gunfighter**. But less support was given to the gunfighter than to the sheriff by the public who had got the joke the first time round. Nevertheless, it was an amiable and mildly amusing affair, with an old screenplay credited to James Edward Grant who died in 1966. Also old was the gag of a man mistaken for a notorious gunslinger. Con man and gambler Garner is thought by the inhabitants of Purgatory to be killer Chuck Connors. When the bald Connors arrives and faces the reluctant hero, he shoots himself in the foot. 'I'm slow,' says Garner, 'but you're slower.' Good support came from Suzanne Pleshette (tomboyish), Jack Elam (dim-witted, right), Joan Blondell (the local Madam), Harry Morgan, Marie Windsor, Henry Jones, John Dehner, Dub Taylor and Kathleen Freeman. (CHEROKEE/BRIGADE)

▽British producer-director Michael Winner brought his debatable talents to America to make **Lawman**, a familiar Western dish smothered in tomato ketchup. Using a hash of styles but excessively favouring the zoom, Winner misused an excellent cast, including Burt Lancaster (illustrated) as a taciturn, inflexible and disliked marshal, Robert Ryan, a weak and corrupt sheriff, Lee J. Cobb, the vicious town boss, Sheree North, a golden-hearted tart, Joseph Wiseman, a crippled brothel keeper, John McGiver, an anxious mayor, and Richard Jordan, a trigger-happy kid. Other roles went to Robert Duvall, Albert Salmi, J.D. Cannon and John Beck. Gerald Wilson's screenplay had Lancaster, the unpopular and unwelcome outsider with the whole town agin' him, having to arrest some local men who killed an old man while on a drunken spree. (SCIMITAR)

◁Roger Corman gave up directing to concentrate on producing after **Von Richthofen And Brown** (GB: **The Red Baron**) nose dived at the box office. The trouble was that neither the direction, nor the screenplay by John and Joyce Corrington, nor the performances could make the characters anything but cardboard figures. However, the dog fights, actually filmed in the air, gave the flying sequences an authenticity. Basically, the action, set in 1916, shifted uneasily between the German and British airbases, until the final confrontation between the two flying aces, Baron Manfred von Richthofen (a phony-accented John Phillip Law) and Roy Brown (a wooden Don Stroud). Also in Gene Corman's production were Barry Primus as Herman Goering, Karen Huston, Corin Redgrave, Hurd Hatfield, Peter Masterson, Robert La Tourneaux and George Armitage. (CORMAN)

▷**Sunday Bloody Sunday** offered a triangular love affair for the 70s in which Jewish Harley Street doctor Peter Finch (left), and wealthy, lonely divorcee Glenda Jackson (right) moon around (with Mozart on the sound track), because they're both in love with the same vapid boy, Murray Head (centre). The latter, a sculptor with no apparent talent, leaves both his lovers to console each other in the end. Although Jackson and Finch brought some real emotion to the self-pitying characters, Finch was defeated by the embarrassing closing monologue. The cast in Joseph Janni's production included Peggy Ashcroft, Maurice Denham, Vivien Pickles, Frank Windsor, Thomas Baptiste, Tony Britton and Harold Goldblatt as boring victims of Penelope Gilliatt's feebly satiric script on the affluent English middle-classes. Director John Schlesinger observed the goings-on with stiff elegance, only letting rip in an amusing Barmitzvah set piece. (VECTIA)

▽Producer Norman Lear bravely invited an easy put-down by entitling his first (and only) film as director, **Cold Turkey**. In fact, the obvious comment was allayed because it (mysteriously) made about $5 million at the box office. Lear's script (story by himself and William Price Fox Jr) focussed on a small Iowa town trying to win a prize of $25 million offered by an eccentric tobacco manufacturer (a wordless Edward Everett Horton in his last role) if no-one smokes for 30 days. The inhabitants consist of an ambitious parson (Dick Van Dyke, illustrated), his long-suffering wife (Pippa Scott, illustrated), a playboy (Tom Poston), the mayor (Vincent Gardenia), his gluttonous wife (Jean Stapleton), a fanatical doctor (Barnard Hughes), a banker (Sudie Bond) and a Red-baiter (Graham Jarvis). Bob Newhart was the phony PR getting worried when the town looks like winning. TV impersonators Bob Elliott and Ray Goulding commented amusingly on the proceedings, but the forced satire on greed was enough to make anyone take up cigarettes. (TANDEM-DFI)

▽**Bananas**, Woody Allen's second film as director, was an undisciplined series of sketches bunched around a central theme. Allen's gag-a-minute script (written with Mickey Rose) provided about 40 minutes of laughter out of 80. In it, Woody (illustrated) played a timid product tester for a New York corporation who accidentally gets involved in a Cuba-type revolution in Latin America. Best scenes: Woody attempting to buy a porno mag discreetly; Woody being threatened by young hoodlums in the subway (one of them an unbilled first appearance by Sylvester Stallone); Woody in a cafe ordering food for his rebel friends in the hills ('1000 grilled cheese sandwiches, 300 tuna fish, 700 coffees, 500 Cokes and 1000 Seven-Ups to go'); and TV sports commentator Howard Cosell giving a blow-by-blow description of Woody's honeymoon with Louise Lasser (then Mrs Woody Allen, illustrated). Others in Jack Grossberg's production were Carlos Montalban, Natividad Abascal, Jacobo Morales, Miguel Suarez and David Ortiz. (ROLLINS-JOFFE)

◁Czech director Ivan Passer in **Born To Win**, his first American film, brought his gentle humour to bear on the harsh world of New York junkies, without actually finding the right blend of European and American sensibilities. However, George Segal (left) as an ex-hairdresser needing $100 a day for his heroin habit, Jay Fletcher (right), his buddy who helps him rip off a Broadway eatery, and Karen Black, a kooky hanger-on, somehow overcame the monotony of incident and lack of character analysis in David Scott Milton's screenplay. Also appearing in Jerry Tokofsky's production were Hector Elizondo, Marcia Jean Kurtz, Sylvia Syms, Paula Prentiss (appearing only briefly despite prominent billing) and an emergent Robert De Niro. (TOKOFSKY-PHILIP LANGNER)

△**The Organization** saw the last of Sidney Poitier's black super-sleuth Virgil Tibbs, who first appeared in *In The Heat Of The Night* (1967), then in the disappointing follow-up, *They Call Me Mister Tibbs!* (1970). A further decline was evident in this plodding police melo, written by James R. Webb and directed by Don Medford, in which the incorruptible cop becomes reluctantly involved with a group of young San Francisco vigilantes who have stolen a load of heroin from a drug syndicate to force the police to take some action against the gangsters. Tibbs' investigations lead him to the ringleaders and their connection with some of his colleagues in the narcotics department. Giving support to the cool and often bored-looking Poitier (centre) were Gerald S. O'Loughlin, Barbara McNair, Sheree North, Raul Julia, Ron O'Neal, Lani Miyazaki, Allen Garfield and Bernie Hamilton. Walter Mirisch produced. (MIRISCH)

1971 OTHER RELEASES

Adios Sabata (aka The Bounty Hunters)
A soldier of fortune teams up with an American gambler, a Mexican guerilla leader and his two right hand men to steal a shipment of gold from a military outpost to buy guns for the Mexican Revolution. Yul Brynner, Dean Reed, Pedro Sanchez, Sal Borgese. *Dir* Frank Kramer (Gianfranco Parolini). *Pro* Alberto Grimaldi. (Italy) PEA

200 Motels
No plot as such, but a series of surrealistic sequences inspired by the experiences of a rock group on the road. The Mothers Of Invention, Ringo Starr, Theodore Bikel, Janet Ferguson, Lucy Offerall, Pamela Miller. *Dir* Frank Žappa, Tony Palmer. *Pro* Jerry Good, Herb Cohen. (GB/USA) MURAKAMI WOLF/BIZARRE

Winged Devils (orig: Forza G)
A young pilot joins The Tricolor Darts, an Italian acrobatic flying team and helps them defeat Britain's Red Arrows at a Venice air display. Riccardo Salvino, Pino Colizzi, Mico Cundari, Giancarlo Prete, Ernesto Colli, Barbara Bouchet. *Dir* Duccio Tessari. *Pro* Franco Cristaldi. (Italy) VIDES

UNITED ARTISTS

1972

▽Not since the mayhem of the Keystone Kops have policemen been represented by such a group of incompetents as in **Fuzz**. One of them has a pot of paint fall on his head, another shoots himself, and a police dog refuses to give chase. At one stage, detectives Burt Reynolds (behind) and Jack Weston (front) have to dress as nuns, and cop Tom Skerritt and sexy copess Raquel Welch have to share a sleeping bag while on the job, but get amorous. The script by Evan Hunter, adapted from his own novels (penned under the name of Ed McBain) about Boston's 87th Precinct, was basically a series of sketches linked by a plot about a mysterious bomber (Yul Brynner) who kills local officials. Director Richard A. Colla kept a balance between comedy and thrills, cops and cons, but it would have benefited from being funnier and more exciting, and less knowing. Also in Jack Farren's production were James McEachin, Steve Ihnat, Peter Boberz, Cal Bellini, Tamara, and Stewart Moss. (FILMWAYS/JAVELIN)

△Take an ancient boxing melodrama plot that has served since *Kid Galahad* (Warner Bros., 1937), change the hero into a great *black* hope, add some lively Harlem lingo and a Reggae score, and you have **Hammer**. Former pro football player Fred Williamson (illustrated), the latest star in the blaxploitation super hero cycle, fights his way to the heavyweight championship, without knowing that his manager (Charles Lampkin) is involved in drug trafficking. Although threatened by gangsters, he refuses to take a dive and wins the title just as the crooks are being rounded up. Director Bruce Clark kept Al Adamson's production vigorous, violent and vacuous, and Charles Johnson was responsible for the predictable script. Bernie Hamilton, Vonetta McGee, William Smith, Elizabeth Harding, Mel Stewart and D'Urville Martin were also involved. (ESSANESS/BERNARD SCHWARTZ)

△Mickey Rooney in top form and a toupée, taking himself off mercilessly, was the only reason to see **Pulp**. Pity therefore that director Mike Hodges' facetious screenplay necessitated his death halfway through Michael Klinger's production. Rooney (illustrated), in his best role for years, played an old Hollywood star with Mafia connections and a taste for ghastly practical jokes. He offers a large sum to pulp novelist Michael Caine (mumbling monotonously) to spend time with him on his Mediterranean island and ghostwrite his autobiography. Among the various picturesque characters that turn up are an ex-gangster (Lionel Stander), a Lewis Carroll-quoting dandy (Dennis Price), a fascist politician (Victor Mercieca) and an American artistocrat (Lizabeth Scott returning to the screen after 15 years). Also cast were Nadia Cassini, Al Lettieri, Amerigo Tot and Leopoldo Trieste. The sun-soaked Med atmosphere was well caught, and there were a few good mock dime novel lines ('The day started quietly enough, and then I got out of bed ...'), but the campy tone was not sustained and, as in an orgy, it was difficult to know who was doing what to whom. (KLINGER-CAINE-HODGES)

▷Producer-director Billy Wilder claimed that **Avanti** failed at the box-office because it was 'too mild, too mellow, too gentle,' although the script by Wilder and I.A.L. Diamond (based on Samuel Taylor's play) had its fair share of abrasive lines and satiric sequences. Perhaps the public could not respond to the central romance between middle-aged Jack Lemmon (right) and plumpish 31-year-old Juliet Mills (left). No matter, the film was a witty black comedy set against pleasant Mediterranean scenery. Lemmon and Mills 'meet cute' when each arrives in Ischia to collect the bodies of their father and mother respectively, killed together in a car crash. They discover that their respectably married parents had been having an affair for years, meeting annually in Italy. The two offspring find themselves repeating the romance, while wrangling with overwhelming bureaucracy. Despite its length (144 minutes) and its 'funny foreigner' bit, it was one of Wilder's most agreeable later works. Clive Revill, Edward Andrews, Gianfranco Barra and Franco Angrisano supported. (MIRISCH/PHALANX/JALEM)

△Much blood was spilt in **Across 110th Street**, an unpleasant and depressing tale set in Harlem. The Luther Davis script (from Wally Ferris's novel) had three blacks (Paul Benjamin, Ed Bernard and Antonio Vargas) stealing $300,000 from the local Mafia. So furious is a hothead 'Family' member (Anthony Franciosa) that he goes out to 'teach them a lesson'. He smashes a glass in the face of one, beats and tortures another, before throwing him out of a 20-storey

building. The third black slaughters the gangster and his henchmen as the ageing police captain (Anthony Quinn, right) and his lieutenant (Yaphet Kotto, centre) arrive on the scene. The captain gets his in the temple from the sniper's bullet. Barry Shear directed in a monotone for producers Ralph Serpe and Fouad Said. Also in the supporting cast were Richard Ward, Marlene Warfield (left), Norma Donaldson and Gilbert Lewis. (FILM GUARANTORS)

▽Major director Elia Kazan broke temporarily with the Hollywood system to make **The Visitors** in Super 16mm, at a cost of less than $200,000, and shot by a five-man non-union crew in and around his own Connecticut home. The torpid little post-Vietnam parable was written by Chris Kazan, the director's eldest son, who also produced with Nick Proferes. The visitors of the title are two Vietnam vets (Chico Martinez, right, and Steve Railsback) who come to the farmhouse of their ex-army buddy (James Woods, centre), his girlfriend (Patricia Joyce), and her father (Patrick McVey, left), a hard-drinking pulp novelist. It seems that the soldiers bear a grudge, having been imprisoned for the rape and murder of a Vietnamese girl on the evidence of their former colleague-in-arms. Much of the rather laborious dialogue concerned the ethics of informing on one's friends (a subject close to Kazan Sr's heart since being a 'friendly witness' during the McCarthy witch-hunts of the early 50s), and the ambiguity of violence. As a 'home movie,' it was not at all badly made, but it didn't do much to enhance any of the participant's reputations. (KAZAN)

◁**Man Of La Mancha** was a 140-minute slow-Quixotic-slow musical to be avoided like the plague. Producer Arthur Hiller's attempt to bring the Broadway hit to the screen, proved an impossible dream. Firstly, Dale Wasserman's screenplay failed to find a cinematic equivalent to his essentially theatrical stage play; secondly, Hiller's direction was leaden; and thirdly, none of the three leads could sing the Mitch Leigh-Joe Darion songs. The efforts of Peter O'Toole (right – Miguel de Cervantes/Don Quixote), Sophia Loren (Dulcinea) and James Coco (left – Sancho Panza) to carry a tune, were as fruitless as Quixote's attack on the windmill. Others in the cast were Harry Andrews, John Castle, Brian Blessed, Ian Richardson, Julie Gregg and Rosalie Crutchley. (PEA)

▷**The Mechanic** in underworld parlance means a professional assassin, a role which hardly stretched the abilities of Charles Bronson (illustrated foreground). In between bumping off various people in different ways, Bronson relaxes in his tasteful Beverly Hills home, puffing his pipe and listening to classical music. In Lewis J. Carlino's contrived screenplay, this philosophising killer takes on a young assistant (Jan Michael Vincent, illustrated behind), not realising he is the son of one of his victims. At the double twist ending, both of them are killed. Others in Robert Chartoff and Irwin Winkler's production were Keenan Wynn, Jill Ireland (Mrs Bronson), Linda Ridgeway, Frank de Cova, Lindsay H. Crosby (son of Bing), Takayuki Kubota, Martin Gordon and Kevin O'Neal. 'You've been watching too many late movies,' says Vincent to Bronson, a phrase that could equally apply to Michael Winner for his flashy, coldly imitative direction. (CHARTOFF-WINKLER-CARLINO)

△'This picture contains every funny idea I've had about sex, including several that led to my divorce,' commented Woody Allen about **Everything You Always Wanted To Know About Sex, But Were Afraid To Ask**. Seemingly quite at ease with an episodic format, director Allen used Dr David Reuben's manual of the same name as a jumping off point for his satirical screenplay, consisting of seven uneven, mostly amusing, and completely tasteless sketches. Woody himself (left) appeared in several of them: as a medieval court jester in *Do Aphrodisiacs Work?*; as an Italian lover in an Antonioni pastiche called *Why Do Some Women Have Trouble Reaching An Orgasm?*; as a timid research student who captures a giant-size female breast

on the rampage in *Are The Findings Of Doctors And Clinics Who Do Sexual Research Accurate?*; and as one of a group of sperm waiting like parachutists for orgasm in *What Happens During Ejaculation?*. Other episodes were *What Is Sodomy?*, in which Dr Gene Wilder has an unrequited love affair with a Greek ewe called Daisy, *Are Transvestites Homosexual?*, with respectable middle-class Lou Jacobi caught in the street in drag, and a TV panel game (in black and white) called *What's My Perversion?*. Also making appearances in the Charles H. Joffe production were Lynn Redgrave (right), Anthony Quayle, John Carradine, Louise Lasser, Tony Randall, Burt Reynolds, Jack Barry, Erin Fleming and Elaine Giftos. (ROLLINS/JOFFE/BRODSKY/GOULD)

▷Bill Cosby (left) and Robert Culp (right), the popular duo from TV's *I Spy* series (1966–1968) were reunited on the big screen in **Hickey And Boggs**. The anti-heroic characters were virtually unaltered in the change of medium, but they soon became buried in the perplexing and fragmentary screenplay by Walter Hill (the future director's first script), and the unsteady direction by co-star Culp. Fouad Said's production started well when down-and-out private eyes Al Hickey (Cosby) and Frank Boggs (Culp) are hired by a mysterious man (Lester Fletcher) to trace a girl (Carmen – no surname). Gradually they get embroiled in a bank robbery and a black power organization. The entertaining pastiche of detective thrillers gave way to the usual Bondage stuff, at which point the movie lost its irony and humour. Also helping out in support were Rosaland Cash, Louis Moreno, Ron Henrique, Robert Mandan, Michael Moriarty and Vince Gardenia. (FILM GUARANTORS)

△'I'd ride miles to see a dead Injun,' says ex-confederate soldier Jack Palance in **Chato's Land**. In fact, he and his posse seemed to ride forever in pursuit of Apache half-breed Charles Bronson, although it's Palance who expires after a lengthy death scene. Bronson, in fashionable long hair, headband and leggings, has killed a man in self-defence when he entered a white man's saloon bar. Living on rattle snakes, he outwits the racist riders tracking him, picking them off one by one. Bronson (illustrated) was given almost no lines in Gerald Wilson's script, but Palance uttered long-winded poetic statements about the parched land. As people died with knives in their necks, bullets through their heads, or rocks crushing them, it was difficult to distinguish the characters' barbarism from that of producer-director Michael Winner. Richard Basehart, James Whitmore, Simon Oakland, Richard Jordan, Ralph Waite and Victor French had other roles. (SCIMITAR)

▽The link between the Irish Troubles and the Mexican Revolution of 1913 was a sententious one in **Duck, You Sucker** (aka **A Fistful Of Dynamite**), directed by Sergio Leone in Spain. Despite the slow-motion flashbacks to Ireland and the names of the two leads – Sean and Juan – the script by Luciano Vincenzoni, Sergio Donati and Leone was really a good excuse for plenty of (literally) explosive action and bravura camerawork. James Coburn (illustrated) played the brainy IRA dynamite expert who meets up with brawny bandit Rod Steiger (giving a chili-con-ham performance). They unwittingly become heroes of the Mexican Revolution by helping to free political prisoners and blowing up a government train. Fulvio Morsella's production at 150 minutes was itself rather overblown. Other roles went to Romolo Valli, Maria Monti, Rik Battaglia, Franco Graziosi and Antoine Domingo. (RAFRAN/SAN MARCO/MIURA)

▽Corpses lay strewn around at the end of **The Magnificent Seven Ride!**, and the series of four films, begun with *The Magnificent Seven* (1960), also finally bit the dust. Few tears were shed after this clumsily directed (George McCowan) and ineptly scripted (Arthur Rowe) contribution to the deteriorated formula. This time skinny-eyed, frog-voiced Lee Van Cleef (illustrated) played gunfighter Chris, out to protect a small Mexican town from a further attack by a bandit (Rudolfo Acosta) whose gang has already killed the male inhabitants and raped the women. To help him, he chooses a nondescript bunch of five convicts (Luke Askew, Pedro Armendariz Jr, William Lucking, James B. Sikking and Ed Lauter), and a writer (bland Michael Callan) who is penning Chris' biography(!). When they arrive at the town, elaborate defence preparations are made with the help of the population, all glamour girls, including Stefanie Powers, Melissa Murphy and Carolyn Conwell. Mariette Hartley portrayed Van Cleef's wife who is kidnapped, raped and murdered by a teenage boy (Darrell Larson) of whom his mother says, 'I guess he just couldn't stand the farm.' William A. Calihan produced. (MIRISCH)

▽'Everytime I come back here it reminds me why I left,' says perennial drifter and rodeo rider James Coburn (centre) in **The Honkers** on the unwelcomed return to his hick home town in New Mexico. His long-suffering wife (Lois Nettleton), fed up with his philandering, has taken up with a respectable businessman (Richard Anderson), his hero-worshipping son (Ted Eccles) begins to see his dad's feet of clay, the sheriff (Jim Davis) keeps telling him to keep his nose clean, and he has trouble with his girlfriends' husbands. When his best friend (Slim Pickens) dies, Coburn goes off alone. Steve Ihnat and Stephen Lodge's screenplay, though well-observed, brought little new to the now familiar tale of the ageing cowboy trying to cope in the modern world. Coburn's character was far less likable than Steve McQueen's in Sam Peckinpah's comparable and better *Junior Bonner* (Solar) of the same year. However, the bronco and bull riding bucked up Arthur Gardner and Jules Levy's production considerably. Also cast were Anne Archer, Joan Huntington and Ramon Bieri. Actor Steve Ihnat, who directed, died soon after completing the picture, aged 38. (GARDNER-LEVY-LAVEN)

Daughters Of Satan
The wife of an American living in the Philippines tries to kill her husband because she is controlled by mysterious evil forces. Tom Selleck, Barra Grant, Tani Phelps Guthrie, Vic Silayan. *Dir* Hollingsworth Morse. *Pro* Aubrey Schenk. A & S

Man Of The East
Three outlaws set about turning a dude from New England into a Western hero. Terence Hill (Mario Girotti), Gregory Walcott, Yanti Somer, Harry Carey Jr, Dominic Barto. *Dir* E. B. Clucher (Enzo Barboni). *Pro* Alberto Grimaldi. (Italy/France) PEA/LES PRODUCTIONS ARTISTES ASSOCIES

Return Of Sabata
A former gunman, now performing in a circus sideshow, gets involved with a crooked saloon owner attempting to rob an Irishman who has gold hidden on his ranch. Lee Van Cleef, Reiner Schone, Annabella Incontrera, Gianni Rizzo, Gianpiero Albertini. *Dir* Frank Kramer (Gianfranco Parolini). *Pro* Alberto Grimaldi. (Italy/France/W. Germany) PEA/ARTEMIS/LES PRODUCTIONS ARTISTES ASSOCIES

Superbeasts
A mad American doctor in the Philippine jungles turns criminals into beasts for hunting by means of a special serum. Antoinette Bower, Craig Littler, Harry Lauter, Vic Diaz, Jose Romulo. *Dir & Pro* George Schenck. A & S

UNITED ARTISTS

1973

▷Robbie Benson as **Jeremy** lent this teenage love story a gawky charm, saving the George Pappas production from being overcute. Benson (illustrated), a 'kinda goofy kid', plays the cello as well as basketball, is mad about horses, and reads poetry to his dog. One day, at first sight, he falls in love with pretty Glynnis O'Connor (illustrated), a newcomer to his school who studies ballet. The director-writer Arthur Barron followed the young lovers in a soppy manner, using zooms, soft focus, and pulsating strings on the soundtrack, as they wandered around various Manhattan locales. But their growing sexual awareness was sensitively treated. The idyll ends when her father (Ned Wilson) decides to leave New York for Detroit. Benson kept saying 'Wow!', not something that could be said of this gentle little picture whose cast also included Lon Bari, Leonardo Cimino, Chris Bohn, Pat Wheel and Ted Sorel. (KENASSET)

▽After Sean Connery refused all inducements to return to the role of James Bond in **Live And Let Die**, the hunt for a new 007 began. UA wanted a big American name, but producers Harry Saltzman and Albert R. Broccoli insisted he be British. Roger Moore (illustrated), who had been shortlisted for Bond in *Dr No* 11 years previously, got the part, proving a lightweight but acceptable substitute. The $15 million takings were enough to prove that, unlike George Lazenby in *On Her Majesty's Secret Service* (1969), he was not a liability. Director Guy Hamilton was given his third Bond assignment, and Tom Mankiewicz adapted Ian Fleming's novel, al-

though a computor would have done as well. As usual the spectacular set pieces stood out, particularly an incredible speedboat chase through the Louisiana bayous, much to the consternation of redneck Sheriff Pepper (Clifton James). The plot, in which Bond faced black master criminal Dr Kananga (Yaphet Kotto) operating from his Caribbean island fortress, involved heroin smuggling and voodoo. Others cast were Jane Seymour, David Hedison, Bernard Lee ('M'), Lois Maxwell (Miss Moneypenny), Geoffrey Holder and Gloria Hendry. The title song was written by Paul and Linda McCartney, and sung by Wings. (EON)

▽**The Long Goodbye**, updating Raymond Chandler's 1953 novel to the California of the 70s, met with a negative response from the public and a mixed one from the critics. The main problem seemed the difficulty in accepting an untidy, unshaven, chain-smoking, cowardly Elliott Gould as the cynical private eye, Philip Marlowe. Following in the footsteps of George Montgomery, Dick Powell, Robert Montgomery, Humphrey Bogart and James Garner as Marlowe in other stories, Gould (illustrated) shambled through the screenplay by Leigh Brackett (the co-writer on Warners' *The Big Sleep* way back in 1946) as if trying to suppress his laughter. Despite director Robert Altman's impressive use of space and sound, much of it was reduced to a Hollywood party game with jokey 'in' references to other films. At the end, after Marlowe has cold-bloodedly shot his best friend Terry Lennox (Jim Bouton) for letting him take the blame for the murder of Terry's wife, 'Hooray For Hollywood' on the soundtrack ironically accompanied the end titles. While trying to prove his innocence, Marlowe gets involved with a sadistic gangster (Mark Rydell, better known as a director) who thinks nothing of breaking a Coke bottle in the face of his moll (Jo Ann Brody), and an alcoholic writer (Sterling Hayden) and his wife (Nina van Pallandt, illustrated). Henry Gibson, David Arkin, Warren Berlinger and Steve Coit were also put to use in Jerry Bick's production. (LION'S GATE)

▷**Last Tango In Paris** was condemned in the Italian courts as 'obscene, indecent, and catering to the lowest instincts of the libido', while its director, Bernardo Bertolucci, and stars Marlon Brando and 20-year-old Maria Schneider (both illustrated), were prosecuted on charges of obscenity. As a result the film earned over $12 million in the States alone. The screenplay, by Bertolucci and Franco Arcalli, followed a simple line. Brando and Schneider were strangers who meet by chance in an empty Paris apartment where they suddenly and passionately make love. They subsequently embark on further erotic encounters in the apartment, agreeing never to talk about their lives or reveal their names, to keep the relationship anonymous and exclusively physical. We discover, however, that she is about to be married to a young TV film maker (Jean Pierre Léaud), and he is seeking to understand the recent unexplained suicide of his wife. The concierge was played by the wonderfully-named Darling Legitimus, and Catherine Sola, Mauro Marchetti, Dan Diament and Catherine Allegret also put in appearances. But the main focus of Alberto Grimaldi's production was the painful, loveless and joyless grappling of Brando and Schneider, most controversially using butter in a sodomy scene. The film certainly exercised a morbid fascination, but the characters were too obsessive and overdrawn and the underlying psychology so skindeep, that it was often more soap than butter. (PEA/LES ARTISTES ASSOCIES)

△**Cops And Robbers** were one and the same in producer Elliott Kastner's lively comedy-thriller directed on location in the heart of New York City by Aram Avakian. It concerned the attempt of two crooked cops, Cliff Gorman and Joe Bologna (illustrated), a good comic pairing, to stage a $2 million heist during a ticker tape parade down Broadway for returning astronauts. Due to a cruel twist of plot, the loot ends up as ticker tape itself. The picture was funny and exciting enough to overcome the confusions and many side-issues in Donald E. Westlake's script. Others in it were Dick Ward, Shepperd Strudwick, John Ryan, Ellen Holly, Nino Ruggeri, Gayle Gorman and Lucy Martin. (EK CORP.)

▽Songwriting brothers Richard M. and Robert B. Sherman provided the forgettable music and lyrics, and the innocuous screenplay for **Tom Sawyer**, a musical version of the Mark Twain classic for the kiddie market. Although prettily shot on location in Missouri by director Don Taylor, the Arthur P. Jacobs production was not a patch on the earlier film adaptations of 1930 or 1938 starring Jackie Coogan and Tommy Kelly respectively. Johnnie Whitaker (right), Jeff East (left) and Jodie Foster were overcute as Tom, Huckleberry Finn and Becky Thatcher. Adult contributions came from Celeste Holm (Aunt Polly), Warren Oates (Muff Potter), Kanu Hank, Lucille Benson, Henry Jones, Noah Keen and Dub Taylor. (READERS DIGEST)

△**Sleeper** illustrated negatively that Woody Allen's forté, at this stage, lay not in visual gags but in verbal ones. Neither as star, director or writer (with Marshall Brickman) was he at his best in this futuristic comedy telling of how he gets involved accidentally in a space-time experiment in which he is frozen, only to wake up 200 years later. The world of 2173 is a fascist state where everyone is sedated by constant TV, all the work is done by robots (robot Woody, illustrated left), secret police are everywhere, and there are brain laundromats. Only a *Playboy* centre fold and a few frames from a film of Nixon have

survived from 1973. Much of the footage had Woody and Diane Keaton being chased in a Mack Sennett manner by menacing machines or people, with a lot of unrelated jokes thrown in; in particular, an amateurish Jewish family sketch seemed rather out of place. However, as we have come to expect in Allen's films, there were some good throwaway lines. Also in Jack Grossberg's production were John Beck, Mary Gregory, Don Keefer, Don McLiam and Chris Forbes. The Dixieland score was entertainingly played by the Preservation Hall Jazz Band with Woody on clarinet. (ROLLINS-JOFFE)

▽**The Offence** was part of a deal made by UA with Sean Connery (right), allowing him two pictures of his choice in exchange for reprising the James Bond role in *Diamonds Are Forever* (1971). The failure of this murky melodrama precluded a second movie. Connery played a Detective Sergeant who brutally interrogates a suspected child molestor (Ian Bannen, left) in a London police station. The suspect dies after being beaten, and Connery is suspended from duty. He in turn is interrogated by his superior (Trevor Howard), turns against his wife (Vivien Merchant), and has a nervous breakdown. John Hopkins' wordy script, based on his stage play *This Story Of Yours*, was not given much cinematic life by Sidney Lumet's plodding direction. Derek Newark, John Hallam, Peter Bowles, Ronald Radd and Anthony Sagar had other roles in Denis O'Dell's production. (TANTALLON)

△**Scorpio** was a deadly concoction of 60s spy mania and 70s mindless violence, stirred up by director Michael Winner. Using a ragbag of pretentious visual tricks, he made David W. Rintels and Gerald Wilson's screenplay (story by Rintels) more incomprehensible than it might have been. It was of the school of cynical espionage tales, in which there are no goodies or baddies, but amoral characters moving as pawns in the game between the CIA and the KGB, neither side (nor the audience) knowing who is working for whom. CIA agent Burt Lancaster hires political assassin Alain Delon (left) to do a job for him in Beirut, but Delon is asked by CIA chief John Colicos to kill Lancaster, while KGB man Paul Scofield has hired Lancaster to … Others involved in Walter Mirisch's production were Gayle Hunnicutt, J.D. Cannon, Joanne Linville, Melvin Stewart and Vladek Sheybal (right). (SCIMITAR)

▽**Harry In Your Pocket** was extremely instructive for prospective pickpockets. They learnt that the best way to work is as a 'wire mob', one 'marking' the victim, one 'stalling' him, another 'dipping', and the fourth 'taking' the transferred loot. In between the fascinating pocket picking episodes, audiences felt they were robbed. The script by James David Buchanan and Ronald Austin had too much dead wood, and producer Bruce Geller's direction was too soupy for the subject, filling it out with travel brochure interludes in Seattle, Salt Lake City and Victoria, British Columbia. The glamorous mob consisted of James Coburn (right), the 'cannon' (master pickpocket), Michael Sarrazin (centre), Trish Van Devere (left), and Walter Pidgeon. The latter as a cocaine-sniffing old time gentleman thief, stole the film among other things. Other roles went to Michael C. Gwynne, Michael Stearns, Sue Mullen and Tony Giorgio, a dip entertainer who acted as advisor and played a detective. (BRUCE GELLER)

▽'Did you know me and Alan Ladd were exactly the same height down to the quarter inch?' says Robert Blake (right), the diminutive motor-cycle highway patrol cop who dreams of being a homicide investigator in **Electra Glide In Blue**. What he lacks in height, however, he makes up for in heart, in stark contrast to his hard headed superior (Mitchell Ryan) and his violent sidekick (Billy 'Green' Bush). The script by Robert Boris and Rupert Hitzig (story by the former) was a group of loosely fitting episodes around the central case of the murder of an old man in a shack. The police think the killer comes from the hippie community, but he turns out to be the victim's half-crazed friend (Elisha Cook Jr, left) – or does he? Producer-director James William Guercio, once a member of Frank Zappa's rock group, imitated many of the rhetorical visual effects, the bike rides and the downbeat ending from *Easy Rider* (Columbia, 1969), but added some mordant humour of his own to the film's otherwise bleak picture of backwoods America. Monument Valley, usually seen in Westerns, was strikingly photographed, and others in the strong cast were Jeannine Riley, Royal Dano, David J. Wolinski, Peter Cetera and Terry Kath. (GUERCIO-HITZIG)

▽Burt Reynolds' self-mocking machismo was on display in **White Lightning**, a trivial tale of the backwoods written by William Norton. Burt played Gator McKlusky, a bootlegger helping the Treasury to nab obese and bigoted Sheriff Connors (Ned Beatty) involved in the moonshine whisky business. Provided with a souped up car, Gator recruits Dude Watson (Matt Clark) to help him get evidence against the sherriff, and befriends a bootleg driver (Bo Hopkins) whose sexy girl (Jennifer Billingsly) the hairy-chested

hero beds. However, most of the action, under Joseph Sargent's direction, came from the antics of the stunt drivers around the swamps. Reynolds (left) and Beatty (right) had appeared together in *Deliverance* (Warner Bros., 1972), and a nudging reference was made to it. Also in Jules Levy and Arthur Gardner's production were Louise Latham, Diane Ladd, R.G. Armstrong, Conlan Carter and Dabbs Greer. Big Burt revived the character in *Gator* (1976), making his directing debut. (LEVY-GARDNER-LAVEN)

▽In an attempt to beat *Papillon* (Allied Artists) to the box-office punch, **I Escaped From Devil's Island** was released a month or so before. Not that this brutish potboiler was any match for the Dustin Hoffman-Steve McQueen opus. Directed in a rough and ready manner by William Witney, doyen of Republic Picture quickies, it starred Jim Brown (illustrated) as the chief escapee. Brawny Jim, brainy Christopher George, and male lovers James Luisi and Rick Ely leave the 'steaming hell-hole' of a penal colony (which seemed no worse than a cheap seaside resort) for the jungles. One gets eaten by a shark, one hangs himself, and the others are captured by Amazonian Indians. Example of Richard L. Adams' dialogue: 'We like to keep to ourselves,' says a leper. Also in Roger and Gene Corman's production were Paul Richards, Richard Rust, Roland 'Bob' Harris and Jan Merlin. (CORMAN)

▽**Theatre Of Blood** rang up the curtain on an ideal Vincent Price vehicle, giving him a chance to put the ham in *Hamlet* and other Shakespearian roles. Anthony Greville-Bell's script was a variation on one joke, but a good one. Edward Lionheart (Price, right), a supposedly dead actor, wreaks revenge on the members of the London Theatre Critics Circle, all of whom gave bad reviews to his Shakespearean performances. In various disguises, he kills them off, one by one, in a manner corresponding to the play for which they had slated him. Harry Andrews loses a pound of flesh (*The Merchant Of Venice*), Arthur Lowe is decapitated (*Cymbeline*), Jack Hawkins kills his wife, Diana Dors, and commits suicide

(*Othello*), Robert Coote is drowned in a vat of wine (*Richard III*), and Robert Morley is forced to eat his own pet poodles (his 'babies') baked in a pie (*Titus Andronicus*). Other critics meeting suitably theatrical ends were Coral Browne (centre), Michael Hordern and Dennis Price. The murderer, however, is finally traced through his daughter (Diana Rigg, left, in disguise) by Inspector Milo O'Shea and Sergeant Eric Sykes, in time to save the life of her lover, the last critic (Ian Hendry). Douglas Hickox's direction kept it gruesomely farcical for most of the way, until its tedious and conventional climax. Even so, critics dared not dislike the John Kohn–Stanley Mann production. (CINEMAN)

1973 OTHER RELEASES

Five On The Black Hand Side
A wife finally follows her two sons and daughter in rebelling against her husband, the autocratic head of a middle class black family. Clarice Taylor, Leonard Jackson, Virginia Capers, Glynn Turman, D'Urville Martin. *Dir* Oscar Williams. *Pro* Brock Peters, Michael Tolan. PETERSON CO.

The Outside Man (orig: **Un Homme Est Mort**)
A Frenchman, deep in gambling debts, agrees to bump off a big underworld boss in Los Angeles, but is in turn chased by a hired killer. Jean-Louis Trintignant, Ann-Margret, Roy Scheider, Angie Dickinson, Georgia Engel. *Dir* Jacques Deray. *Pro* Jacques Bar. (France/Italy) CITE/MONDIAL

The Spook Who Sat By The Door
A man who had become the only black CIA agent uses the skills he learned to organize black teenage gangs into guerilla outfits to bring instability to American cities. Lawrence Cook, Paula Kelly, Janet League, J. A. Preston, Paul Butler. *Dir & Pro* Ivan Dixon. BOKARI

UNITED ARTISTS

1974

▷After his triumph with *Cabaret* (Allied Artists, 1972), director Bob Fosse set his next film, **Lenny**, in the world of nightclubs. Not a conventional biopic, it was an attempt to understand the character of Lenny Bruce, the outrageous cult comedian who died of drug abuse in 1966 after being harassed by the police and the courts for years. Through the use of harsh black and white photography, sometimes straining for documentary realism, Fosse did succeed in getting to the essence of Bruce's life rather than the details. However, only a vague idea was given of his real talent. In fact, a greater impression of Dustin Hoffman's genius came across than Lenny's. Hoffman (centre), as usual steeped in the role after six months of research, gave a bravura performance. Julian Barry's script, based on his stage play, used actual material from the trials, taking the form of flashbacks told into a tape recorder by Bruce's mother (Jan Miner), his agent (Stanley Beck), and his wife, stripper Honey Harlowe (Oscar-nominated Valerie Perrine), who talked about the self-destructive comedian after his death. Other roles were taken by Gary Morton, Mike Murphy, Richard Friedman, Martin Begley and Monroe Myers. Marvin Worth's production, which earned $11 million, could not have been made in the less permissive days of Lenny Bruce. (MARVIN WORTH)

▷**Moonrunners** was the basis for the popular TV series *The Dukes Of Hazard*, its only claim to ill fame. The action, under Gy Waldron's trite direction, mainly consisted of hillbilly moonshiners Arthur Hunnicutt (left) and his two nephews, Kiel Martin, and James Mitchum (right), being chased around in beaten up autos by revenue men and gangster George Ellis. There was also some feeble love interest between the lethargic Mitchum (who makes his father Robert seem animated) and runaway gal Chris Forbes. Helping to keep the movie from falling apart, was a country 'n western narration sung by Waylon Jennings. Waldron's screenplay was derived from the real-life exploits of Jerry Rushing, who acted as technical adviser and took a role. Other parts in Robert B. Clark's production went to Joan Blackman, Pete Munro, Marty Robbins and George 'Spanky' McFarland (the former *Our Gang* kid). (MOONRUNNER)

◁**Billy Two Hats** (aka **The Lady And The Outlaw**) was a far from typical Western shot in the badlands of Israel (Zev Berlinsky and Dawn Littlesky played Red Indians) and starring Gregory Peck pretending to be an outlaw behind an unfamiliar bushy beard and an equally unfamiliar Scots brogue. Peck (foreground) struggled unsuccessfully with his accent, while coping manfully with a broken leg, a pursuing sheriff (Jack Warden) and rampaging Indians. Luckily, he has young half-breed Desi Arnaz Jr (on horse) to help him, while he dreams wistfully of a green Scotland. At the end of the Norman Jewison–Patrick Palmer production, Peck dies, Arnaz gives him an Indian burial, and rides off with lovely widow Sian Barbara Allen. Others cast were David Huddleston, John Pearce and Vincent St Cyr. Alan Sharp's screenplay tried hard to bring out the rather involved mixture of father/son, hunter/hunted, and Red Indian/Paleface relationships, but Ted Kotcheff's slow-paced, somewhat 'poetic' direction largely diminished the impact. (ALGONQUIN)

▽If the musical version of *Tom Sawyer* (1973) tested parents' patience when accompanying their kids to the movie, the same script-and-song writing team of Robert B. and Richard M. Sherman's **Huckleberry Finn** was enough to drive them to the exits. Even indiscriminate children must have found the treacly treatment of Mark Twain's great novel hard to take. Jeff East (left), in the title role, Paul Winfield (Jim, right), Lucille Benson (the Widder Douglas), Arthur O'Connell, Gary Merrill, Natalie Trundy, Kim O'Brien and Jean Fay were miles from the original characters, and Harvey Korman and David Wayne, as con men The King and The Duke, gave performances as broad as the Mississippi. J. Lee Thompson's shallow direction only slowed up Arthur P. Jacobs' last production. (READERS DIGEST-APJAC)

▽A cartload of watermelons was destroyed by machine gun in **Mr Majestyk**, and human beings were similarly treated. Not surprising in a movie starring that one-man police force, brutish Charles Bronson. With emotions ranging from a frown to a scowl, Mr Bronson (illustrated) played a Colorado melon farmer and ex-Vietnam vet who hunts down and kills the Mafia gang that has terrorized his workers and ruined his crops. Helping him against the 'Family' and the ineffectual police, is labour organizer Linda Cristal. Ostensibly, Elmore Leonard's screenplay dealt with the problems of migrant Chicano workers, but director Richard Fleischer merely used it as a peg on which to hang a blood-letting and contrived melodrama. Also in the Walter Mirisch production were Al Lettieri, Lee Purcell, Paul Koslo, Taylor Lacher, Frank Maxwell, Alejandro Rey and Jordon Rhodes. (MIRISCH)

MAJESTYK BRAND MELONS EDNA.COLO.

▽Producer-director Melville Shavelson, maker of *Yours, Mine And Ours* (1968), continued to expound the doctrine of the more the schmaltzier in **Mixed Company**, a small family movie about a big family. Written by Shavelson and Mort Lachman, it starred Joseph Bologna (centre), a hot-tempered coach of a basketball team, who is having trouble with his wife, Barbara Harris (right). She wants another child, although they have three already, and he can't oblige because a recent bout of mumps has left him sterile. So they adopt three orphans, an eight-year-old Vietnamese girl (Jina Tan, left), a four-year-old Hopi Indian (Stephen Honanie, foreground left), and a ten-year-old black boy (Haywood Nelson), despite Bologna's racial prejudice. After problems with the kids, he learns to love them as his own, and the whole family assembles misty-eyed for the climax. The movie picked up a few points for the performances of the small fry. Lisa Gerritsen, Arianne Heller, Eric Olson, Tom Bosley and Ron McIlwain had other roles. (LLENROC)

△One of the very few scenes in **Bank Shot** to remind one that its director was dancer-choreographer Gower Champion, was the well orchestrated movement of a gang *stealing* a bank at night. Otherwise, the Hal Landers-Bobby Roberts production was a heavy-footed caper revolving around one central idea in Wendell Mayes' script (based on a novel by Donald E. Westlake). Lisping master criminal George C. Scott (left) decides to remove an entire bank with house-moving machinery, paint it pink, and put it in a trailer park. Unfortunately, it rolls down a hill into the sea. Other members of the gang were Joanna Cassidy (centre), Robert Balaban (right), Don Calfa and Frank McRae, all pursued by Clifton James. (LANDERS-ROBERTS)

△**Visit To A Chief's Son** was based on *Life* magazine photographer Robert Halmi's photo montage story of life among the Masai tribe in Kenya. Produced, but not photographed by Halmi, it was an entertaining anthropological and ecological off-the-beaten track movie. Most of its interest lay in the well-integrated wild life scenes and the depictions of the tribe played by members themselves, rather than the pompous discussions in Albert Ruben's screenplay on 'primitive' vs 'civilised' society, represented by an American anthropologist (Richard Mulligan, right) and a Western-educated Masai (Johnny Sekka, centre). Wisely, director Lamont Johnson concentrated on the friendship between the American's teenage son and the chief's son played with charm by amateurs John Phillip Hodgdon (left) and Jesse Kinaru. (ROBERT HALMI)

▽Fifty-year-old Lee Marvin (being carried) was the ageing hero of **The Spikes Gang**, a youth-oriented Western shot in Spain. In the discursive screenplay by Irving Ravetch and Harriet Frank Jr (from the novel *The Bank Robber* by Giles Tippette), Marvin was a wounded bank robber on the run. He is sheltered and nursed by three teenage farm boys (Gary Grimes, Ron Howard and Charles Martin Smith, illustrated) who hero-worship him. After he leaves, the boys catch up with him in Mexico where he teaches them the art of robbing banks. Director Richard Fleischer created an amiable atmosphere of youthful kinship before the movie deteriorated into a mediocre oater in which hardly anyone survived. The last scene when one of the boys imagines a reconciliation with his father, was especially gooey. Arthur Hunnicut, Noah Beery Jr, Marc Smith, Don Fellows and Elliott Sullivan had other roles in Walter Mirisch's production. (MIRISCH/DUO/SANFORD)

▽**Man With The Golden Gun**, based on Ian Fleming's last novel, was the ninth and far from last James Bond movie. Although there were fewer standout set pieces, there were the usual amounts of stunts, exotic locales, a master criminal, and sexy ladies popping up from time to time. The locales were mainly Macao, Hong Kong and Thailand through which British agent Bond (a quizzical Roger Moore, centre) tracked down Scaramanga (a suavely villanous Christopher Lee), the possessor of the Solex Agitator, a device for using the sun's energy for no good. The evil genius lives on an island with a mean midget called Nick Nack (Herve Villechaize, left). When Bond is trapped in a fun house

containing a wax museum, he poses as his own wax effigy (not difficult for Moore to do), before escaping with fellow spy Mary Goodnight (Britt Ekland). Clifton James, repeating his role as the redneck sheriff in *Live And Let Die* (1973), just happens to be vacationing in Thailand and provides the film with some of its most amusing moments. Also in it were Maude Adams, Richard Loo, Marc Lawrence, Soon Taik Oh (as Hip) and Bernard Lee and Lois Maxwell as 'M' and Miss Moneypenny. Guy Hamilton's direction and Tom Mankiewicz's script leant rather too heavily on the humorous side, and the Harry Saltzman-Albert R. Broccoli production took a mere $9 million at the box-office. (EON)

△Unlike *Earthquake* (Universal) and *The Towering Inferno* (Warner Bros.–20th Century-Fox), both of the same year, **Juggernaut** was a *near*-disaster movie. Although it had its fair share of cliches, and there were holes in the story and screenplay by producer Richard DeKoker (additional dialogue by Alan Plater), the suspense seldom slackened. Someone has planted seven bombs on Captain Omar Sharif's luxury liner, demanding a huge ransom in return for instructions on how to defuse them. In rough seas, demolition expert Richard Harris (centre) and his assistant David Hemmings (left) drop in by parachute, and get help from Jack Watson. Among the 1200 passengers are Shirley Knight (providing romantic interest for Sharif), Clifton James, Freddie Jones and Caroline Mortimer being jollied up strenuously and hilariously by social director Roy Kinnear. Sweating it out on land are shipping line executive Ian Holm, and detective Anthony Hopkins whose wife and kids are aboard. After directors Bryan Forbes and Don Medford left the picture, Richard Lester came in to do a neat salvage operation. (DAVID V. PICKER-RICHARD ALAN SIMMONS)

▽Gay activists picketed **Busting** because of its futile attempts to get laughs from the entrapment of gays by cops in a lavatory. However, hookers, druggies, and even policemen had equal cause to protest against this vapid and vulgar film directed and written by former TV newsman Peter Hyams. Elliott Gould (right) and Robert Blake (left), the only incorruptible officers on the force, carry out a lonely war against racketeer Allen Garfield, who seems to be behind every crime in LA. It ends, of course, with a frantic car chase. Also in Irwin Winkler and Robert Chartoff's production were Antonio Vargas, Michael Lerner, Sid Haig, Ivor Francis and William Sylvester. (CHARTOFF-WINKLER)

△Director Michael Cimino's first film, **Thunderbolt And Lightfoot**, was an overblown macho heist movie starring Clint Eastwood (right) and Jeff Bridges (left) as buddy-buddy bankrobbers. What appealed was not Cimino's derivative script about the planning of a criminal caper, its consequences, and its violent ending, nor Eastwood's expressionless performance, but the director's pictorial sense (it was nicely shot in the Montana Hill country), the ability to shift

comfortably from comedy to tragedy, and Bridges' Oscar-nominated portrayal, rich with nuance, of the young drifter, Lightfoot. George Kennedy (centre), Geoffrey Lewis, Catherine Bach, Gary Busey, Jack Didson and Gene Elman gave good quirky support in Robert Daley's production, which made over $8 million at the box-office and resulted in Cimino being given a huge budget to direct *The Deerhunter* (Universal, 1978). (MALPASO)

▷When a wealthy Mexican patriarch discovers that his daughter has been made pregnant by a local stud, he utters the fateful words, **Bring Me The Head Of Alfredo Garcia**. Ten thousand dollars is placed on Garcia's head, and a group of bounty hunters crawl out of the woodwork. Among them are down-and-out piano player Warren Oates (illustrated), and Gig Young and Robert Webber, three-piece suited members of an American cartel. As might have been expected from director Sam Peckinpah, there was a lot of blood splattered on the way. Oates shoots menacing biker Kris Kristofferson in slow motion after the rape of Isela Vega (illustrated), the whore Oates loves; he also shoots anyone else who stands between him and the reward. The film, written by Peckinpah and Gordon Dawson (from Peckinpah and Frank Kowalski's story), ends with a barrel of a gun pointing at the audience. Despite the indiscriminate violence and too much lingering camerawork, the Mexican backgrounds were vivid, a Gothic graveyard scene was effective, and there was a memorable blackly humorous sequence in which Oates has a conversation with Garcia's fly-covered decapitated head rolling around in the back of his car. Helmut Dantine, Emilio Fernandez and Donny Fritts had other roles in Martin Baum's production. (OPTIMUS/ESTUDIOS CHURUBUSCO)

◁**The Taking Of Pelham One Two Three** was an underground movie only in the sense that most of it took place in the New York subway where a gang has seized a group of hostages on a subway car and demanded $1 million from the mayor's office. The hijackers were Robert Shaw (the cold-blooded leader, left), Martin Balsam (right), Hector Elizondo and Earl Hindman. Above ground are Walter Matthau of the Transport Authority and the dumb mayor, Lee Wallace. The weakness in Peter Stone's clever screenplay (based on the novel by John Godey) was that neither the crooks, the hostages, nor the representatives of the law were given much interest as characters. Matthau, who spent most of the picture talking over a mike, was particularly wasted, but director Joseph Sargent kept the yarn fast-paced and exciting, cross-cutting between the subway, the streets of Manhattan and the negotiator's office. Others in the Gabriel Katzka–Edgar J Scherick production were James Broderick, Dick O'Neill, Tom Pedi, Beatrice Winde, Jerry Stiller, Toby Roberts and Nathan George. (PALOMAR AND PALLADIUM)

◁**Thieves Like Us**, based on Edward Anderson's 1937 novel of the same name, was first filmed by Nicholas Ray as *They Live By Night* (RKO, 1948) as a tender tragedy of doomed young outlaw lovers. Robert Altman's version, written by Calder Willingham, Joan Tewksbury (who had a small role) and himself, was harsher, but no less tragic. Also, Keith Carradine and Shelley Duvall were more convincing than the fragile Farley Granger and Cathy O'Donnell in the earlier film. Carradine was the young hood who joins John Schuck and Bert Remsen in a spree of smalltown bank heists, and who falls in love with simple Duvall. In the end he is turned in by Remsen's sister-in-law (Louise Fletcher, left) who holds back a screaming Duvall (right) as her lover is riddled by police bullets. Aural period atmosphere was effectively created by the constant use of old programmes and songs from the radio instead of a music score, except for the corny scene when a broadcast of *Romeo And Juliet* accompanies the young couple making love. Others in Jerry Bick's production were Al Scott, Tom Skerritt, Ann Latham, Mary Waits and Rodney Lee Jr. (JERRY BICK-GEORGE LITTO)

1974 OTHER RELEASES

Amazing Grace
A cantankerous but lovable old black woman reforms a felon into becoming a successful and honest candidate for mayor of a large city. Moms Mabley, Slappy White, Moses Gunn, Rosalind Cash, Stepin Fetchit, Butterfly McQueen. *Dir* Stan Lathan. *Pro* Matt Robinson. UA

Hercules Vs Kung Fu (aka Mr Hercules Against Karate, orig: **Sciaffoni E Karati)**
Two Americans in Sydney go to Hong Kong to rescue the son of a Chinese restaurant owner who has been kidnapped by his stepmother, and her boyfriend, the sadistic head of a Kung Fu school. Tom Scott (Roberto Terracina), Fred Harris (Fernando Arrien), Jolina Mitchell, Chai Lee, George Wang. *Dir* Anthony Dawson (Antonio Margheriti). *Pro* C.C. Champion. (Italy) LASER

Where The Lilies Bloom
Four children left orphans on the death of their father try to keep their status a secret lest they be put into orphanages. Julie Gholson, Jan Smithers, Matthew Burrill, Helen Harmon, Harry Dean Stanton. *Dir* William Graham. *Pro* Robert B. Radnitz. RADNITZ/MATTEL

▽ The huge success of Bruce Lee's 'chop-socky' movies in the early 70s, led to martial arts sequences being introduced into a range of thrillers, among them **The Killer Elite**. Aside from confrontations with samurai sword-carrying Asian heavies, there were a number of more conventional facedowns with machine guns and fistfights which punctuated the hollow, complex doublecross script written by Marc Norman and Stirling Silliphant (from the novel *Monkey In The Middle* by Robert Rostand). It involved buddies James Caan (illustrated) and Robert Duvall finding themselves on opposite sides, Caan for the CIA, and Duvall for an enemy organisation out to kill a liberal Taiwanese leader (Mako). Arthur Hill and Gig Young played Caan's two smooth superiors, and Bo Hopkins and Burt Young his partners. Tom Clancy, Tiana, Kate Heflin, James Wing Woo and George Kee Cheung had other roles in Martin Baum and Arthur Lewis' production. The movie, for all its shortcomings, was raised somewhat above average by director Sam Peckinpah's flair for violent action and the creation of a claustrophobic world shorn of illusion. (EXETER/PERSKY-BRIGHT)

△ **Smile** was an often amusing satire on small town America, in particular a hokey beauty contest, despite the superior position adopted by producer-director Michael Ritchie. Jerry Belson's script was virtually a series of sketches following the fortunes of the 32 entrants (illustrated) in the annual Young American Miss competition in Santa Rosa, California, including Colleen Camp, Joan Prather, Denise Nickerson, Annette O'Toole, Maria O'Brien (daughter of Edmond O'Brien), Melanie Griffith and Kate Sarchet. Among the judges is a former winner (Barbara Feldon) who's having trouble with her drunken husband (Nicholas Pryor). Staging the show is a has-been choreographer (played acidly by big time dance director Michael Kidd), and organizing it is mobile home salesman Big Bob Freelander (Bruce Dern) whose small son (Eric Shea) takes photos of the girls undressing. Geoffrey Lewis, George Skaff, Adam Reed and Brad Thompson had other roles. The title song used on the soundtrack was Nat 'King' Cole's version, but there was nothing to smile about at the box-office. (TWO ROADS)

▽ Made in 1974 as *The Treasure*, producer-director-writer-star Cornel Wilde's picture was retitled **Shark's Treasure** in the wake of *Jaws* (Universal, 1975), although sharks were only incidental to the story. However, they figured in the best sequence in which hordes of real sharks swimming around a wreck are harpooned by a group of treasure hunters, led by small boat owner Wilde. The others were Yaphet Kotto, an ex-navy diver, David Canary, his friend, and John Nielson, a boy who first found a gold chain from a Spanish treasure ship. After bringing up $400,000 worth of gold, they are held captive by five escaped convicts (Cliff Osmond, Caesar Cordova, Gene Borkan, Dale Ishimoto and David Gilliam). Taking advantage of a homosexual lover's quarrel between two of the cons, Wilde (illustrated, at the back of the cage) manages to outwit them and regain his boat. The slight eccentricity was hardly sufficient to make the movie more than an old-fashioned adventure, slowed up by ecological messages and travelogue views of the Dutch West Indies, the location where it was filmed. (SYMBOL)

▽The only thing going for **Brannigan** was its ageing, overweight but still charismatic star, John Wayne. Otherwise the Jules Levy-Arthur Gardner made-in-Britain production was not much better than an episode from a TV cop series. It took four scriptwriters – Christopher Trumbo, Michael Butler, William P. McGivern and William Norton (story by Trumbo and Norton) – to come up with a tale in which Wayne (illustrated) as Lieutenant Jim Brannigan of the Chicago Police finds himself in London ('This old town') working with Scotland Yard chief, Commander Sir Charles Swann (Richard Attenborough) on the trail of an American gangster (John Vernon). Naturally, the hood and his crooked lawyer (Mel Ferrer) are nabbed due to Anglo-American teamwork. Not much fun was to be had from the clash between British and Yank police methods, while director Douglas Hickox made sure that every tourist spot was covered, including Tower Bridge. Femininity was supplied by Judy Geeson (illustrated) as Detective Sergeant Jennifer Thatcher assigned to look after Big John in London. Also in it were Daniel Pilon, John Stride, James Booth, Del Henney, Lesley-Anne Down and Ralph Meeker. (WELLBORN)

△**The Wilby Conspiracy** was an exploitative action yarn with a liberal political message crudely embedded in Martin Baum's production to give it more respectability. The script (by Rod Amateau and Harold Nebenzal from Peter Driscoll's novel) concerned the pursuit of South African black revolutionary leader Sidney Poitier (left), British mining engineer Michael Caine, and his lawyer girlfriend Prunella Gee by fascistic policeman Nicol Williamson (right). They are fleeing from South Africa to take diamonds to the liberation movement's president Wilby (Joseph de Graf), fighting off Government patrols on the way. The cast also included Persis Khambatta, Saeed Jaffrey, Rutger Hauer and Ryk De Gooyer. It was shot by director Ralph Nelson in Kenya and at Pinewood Studios in England. (OPTIMUS/BAUM-DANTINE)

▽**Rollerball**, according to the screenplay and short story by William Harrison, is a combination of roller derby, football, basketball and speedway, the apogee of violence in sport. By foul means or fouler, the participants play to maim or kill for the satisfaction of the baying spectators behind the barriers. It is the 21st century, and there is no poverty, hunger, or war, so the populace has need of excitement. The film, glossily directed by producer Norman Jewison, wallowed in the violence it seemed to be condemning, making no attempt to distance the bloodthirsty spectators on the screen from those in front of it. Top rollerballer James Caan (left), an embittered hero, was presented as the moral centre, but he was hardly more individualistic or less sadistic than anyone else in the movie, including John Houseman, Maud Adams, John Beck, Moses Gunn, Pamela Hemsley, Shane Rimmer and (unexpectedly) Ralph Richardson as the controller of a huge computor. 'A horrible social spectacle,' says a character commenting on a scene of impressive destruction. The same could be said of the movie which cost $5 million to make in Munich and London, and had no problem realizing a profit. (ALGONQUIN)

△Producer-director Otto Preminger loaded **Rosebud** with so many contemporary issues that it sank ignominiously to the depths. The screenplay by Erik Lee Preminger (Otto's son by famous stripper Gypsy Rose Lee), based on the Joan Hemingway-Paul Bonnecarrere novel, superficially dealt with the Middle East conflict, the Algerian crisis, the 1968 Paris revolt, the Greek colonels, homosexuality, police brutality, and the jet-set. The title, the key word in *Citizen Kane* (RKO, 1941), to which no reference was made, was the name of a luxury yacht from which five wealthy young girls (Brigitte Ariel, Kim Cattrall, Isabelle Huppert, Lalla Ward and Debra Berger), representing five different nationalities, are kidnapped by the PLO. A daring rescue coup is mounted by British mercenary Peter O'Toole (left) with the help of Israeli Cliff Gorman. The rest of the uneasy cast mouthing banalities were Claude Dauphin, Peter Lawford, Raf Vallone, Adrienne Corri, Amidou, New York Mayor John V. Lindsay (another error of judgement) and Richard Attenborough (right) as the wicked English kidnapper converted to Islam. (SIGMA)

▽**92° In The Shade** was a torrid, quirky picture filmed and set in Key West, Florida. Thomas McGuane's direction, from his own screenplay and novel, faltered as narrative and as a social study of white trash, but managed to create an atmosphere not unrelated to the world depicted by Tennessee Williams. Among the characters were Peter Fonda (illustrated) the simple drifter son of loony William Hickey and Louise Latham; his girlfriend Margot Kidder (illustrated); Burgess Meredith, his benefactor grandpappy; Warren Oates, a schizo fishing boat captain; Harry Dean Stanton, a tourist guide, and his ageing, baton-twirling wife, Elizabeth Ashley; sex-hungry secretary Sylvia Miles; Joe Spinell, William Roerick and Evelyn Russell as fishing tourists. The George Pappas production made little impression on its first release, and even less six years later when recut and given a toned down tragic ending. (ITC-EK)

▽In **Rancho Deluxe**, Jeff Bridges (left) and his Indian pal Sam Waterston (right), claim they rustle cattle to 'keep from falling asleep'. They could not, however, prevent audiences from nodding off. The unlikable heroes spent their time sabotaging the herd of wealthy landowner Clifton James, whose flighty wife, Elizabeth Ashley, gets him to take a stand against them. The modern day cowboys cut up steers with a chainsaw, shoot autos with a buffalo gun, and let a prize bull loose in a Holiday Inn, all because they see themselves as 'the last of the plainsmen'. Thomas McGuane's screenplay, not much more than a series of sketches, gained little coherence from Frank Perry's direction. Also in Elliott Kastner's production were Charlene Dallas, Slim Pickens, Harry Dean Stanton, Richard Bright and Patti D'Arbanville. (EK)

△After a series of disastrous pictures over a period of six years, Peter Sellers (illustrated) hit the big time again by reprising the role of the bumbling Inspector Clouseau in **The Return Of The Pink Panther**. It was over a decade since Sellers and producer-director Blake Edwards had last let the foolish *flic* loose on screen, and the public paid over $17 million to welcome him back, thus creating a demand for two further adventures. Edwards and Frank Waldman created a pretence of a plot on which to hang a string of slapstick gags, including Clouseau driving his car into a swimming pool (twice), Clouseau fighting with a revolving door, Clouseau being chased by a vacuum cleaner, and Clouseau destroying a building. 'This hotel is deteriorating rapidly,' he comments. Christopher Plummer played Sir Charles Litton, alias infamous jewel thief The Phantom (the role taken by David Niven in *The Pink Panther*, 1963); Catherine Schell was his wife who leads Clouseau a merry dance, and Herbert Lom was Inspector Dreyfus who ends up in a straitjacket writing 'Kill Clouseau' on the walls of his padded cell with his toes. Others cast were Peter Arne, Peter Jeffrey, Gregoire Aslan, David Lodge, Graham Stark and Burt Kwouk. Richard Williams' witty animated credit sequence, a montage of movie jokes, put much of what followed to shame. (JEWEL/PIMLICO/MIRISCH/GEOFFREY)

△Woody Allen's **Love And Death** showed him nearing maturity as a director. Shot mostly in Hungary, it was better constructed and more handsome than his previous four films, and amply demonstrated his pre-occupation with the two subjects of the title. But his script, a pastiche of a 19th-century Russian novel, also resembled the kind of period romp which used to feature his idol, Bob Hope. Woody (right) cast himself as Boris Grushenko, who becomes a war hero in spite of himself in a battle against the French forces. He marries his beautiful cousin Sonja (Diane Keaton, centre, in her best role to date), and they go to Moscow to assassinate Napoleon (James Tolkan, left). However, Boris can't go through with it because 'he's probably someone's grandfather.' In one of the rare occasions in comedy, the hero dies, and is seen dancing away with Death (Norman Rose) in a Bergmanesque manner at the end. There were 54 small parts in the successful Charles H. Joffe production, the larger ones going to Lloyd Battista, Olga Georges-Picot, Alfred Lutter, Howard Vernon, Harold Gould and Frank Adu. When Keaton says to Allen that sex without love is an empty experience, he replies that 'as empty experiences go, it's one of the best.' The same could be said of the movie. (ROLLINS AND JOFFE)

△Not only was **One Flew Over The Cuckoo's Nest** the first movie since *It Happened One Night* (Columbia, 1934) to win all five top Oscars (film, director, actor, actress, screenplay), it also earned over $56 million, making it one of the all-time top box-office bonanzas. It derived from Ken Kesey's 1962 counter-culture best-seller which, in Dale Wasserman's 1963 dramatization starring Kirk Douglas, flopped on Broadway. Douglas tried for years to get a film version off the ground, but his son Michael and Saul Zaentz pulled it off as producers, at a cost of $3 million. Although the 60s setting of the State Mental Institution still stood as a metaphor for the conformist society, Lawrence Hauben and Bo Goldman's screenplay replaced the novel's drug-induced subjectivity with a more realistic stance, and director Milos Forman managed to bring his humour and sharp observation to bear on most of the picture. It was only when the story turned from bitter comedy to tragedy, that Forman seemed to lose his grip, overplaying the melodrama and symbolism. But no complaints about Jack Nicholson's brilliant, grinning anti-hero, McMurphy, fighting the system as represented by Nurse Ratched, played with chilling authority by Louise Fletcher. Nicholson (illustrated) organizes a basketball game, gives a baseball commentary in front of a blank TV, slips porno cards into a pack, takes his fellow patients on a truant excursion of deep sea fishing, and generally wakes them out of their apathy. But he is defeated in the end, and only the large Red Indian (Will Sampson) breaks away to freedom. The film was mostly shot in Oregon State Hospital where staff and patients acted as extras. In fact, as Michael Douglas commented, 'After eight weeks filming at the hospital, you could not tell the actors from the inmates.' Among the excellent cast were William Redfield, Dean Brooks, Scatman Crothers, Danny De Vito, William Duell, Brad Dourif, Sydney Lassick and Christopher Lloyd. (FANTASY)

△Not much positive to report on Mike Frankovich's overblown production of **Report To The Commissioner** (GB: **Operation Undercover**), apart from director Milton Katselas' evocation of the steamy New York atmosphere, and a climactic rooftop chase ending in Saks department store. Prior to this, the Abby Mann-Ernest Tidyman screenplay (based on James Mills' novel) concerned itself with idealistic detective Michael Moriarty (left) who is initiated into the Times Square jungle of dope, topless bars and teenage prostitution. But he keeps coming up against the indifference and inhumanity of his superiors. 'I was gonna be the new cop. Trouble is they weren't ready for the revolution,' he intones. After accidentally killing sexy colleague Susan Blakely, he ends up in a psychiatric hospital where he hangs himself. Also appearing were Yaphet Kotto, Hector Elizondo, Tony King (right), Michael McGuire, Edward Grover, William Devane and future superstar Richard Gere making his screen debut in the small role of a pimp. (FRANKOVICH)

1975 OTHER RELEASES

The Heroes (orig: **Gli Eroi**)
Six people are thrown together in North Africa during the war and, although fighting under different banners, team up after the discovery of $2 million. Rod Steiger, Rod Taylor, Rosanna Schiaffino, Claude Brasseur, Terry-Thomas. *Dir* Ducco Tessari. (Italy/France/Spain) MICHAEL STERN

The Manchu Eagle Murder Caper Mystery
A chicken hatchery owner and novice private eye solves the arrow murder of local milkman, philanderer and animal fetishist. Gabriel Dell, Will Geer, Joyce Van Patten, Anjanette Comer, Vincent Gardenia, Barbara Harris, Jackie Coogan, Huntz Hall. *Dir* Dean Hargrove. *Pro* Edward K. Dobbs. UA

That's The Way Of The World (aka **Shining Star**)
An idealistic young record executive's support for a black group is thwarted by the mobsters running the company who support a synthetic family band. Harvey Keitel, Ed Nelson, Cynthia Bostick, Bert Parks, Jimmy Boyd. *Dir* & *Pro* Sig Shore. UA

▷The story of how an unknown supporting player called Sylvester Stallone came from nowhere to become champion of the motion picture industry overnight, parallels the plot of **Rocky**. Producers Irwin Winkler and Robert Chartoff offered him $300,000 for his script, claimed to have been written in three-and-a-half days. But although Stallone was down to his last dollar, he asked for $75,000, a percentage of the profits and the lead. It was a shrewd move, as the movie turned out to be one of the biggest hits in 20 years, making over $54 million, and winning three Oscars. Stallone (centre left) played Rocky Balboa, a routine 30-year-old heavyweight boxer who gets a crack at the world championship held by Apollo Creed (Carl Weathers, centre right). An oldtime manager (Burgess Meredith) gets him into shape in training sequences where you could almost smell the sweat. There was an exuberant feel to John G. Avildsen's direction, helped by the disco music of Bill Conti, as the film built towards the climactic fight. Rocky proves he is not 'just another bum' by holding the champ to a draw, thus allowing a sequel and a sequel and a sequel. The ending, with Rocky and his shy girlfriend (Talia Shire, sister of director Francis Ford Coppola) crying in each other's arms above the roar of the crowd, was irresistible in an old-fashioned way, satisfying audiences' need to believe in The American Dream and the happy ending. The streetwise dialogue and Stallone's self-mocking performance as the goodhearted pug, made the rags-to-riches cliches and the simple, sentimental situations palatable. Also cast: Burt Young, Thayer David and Joe Spinell. (CHARTOFF-WINKLER)

◁28-year-old American director John Byrum's **Inserts**, made in Britain for around half-a-million dollars, was an interesting attempt to make a film using theatrical conventions. The only set was the decaying Hollywood mansion of The Boy Wonder (Richard Dreyfuss, illustrated), a once great director now forced to make blue movies. The only other characters were Harlene (Veronica Cartwright, illustrated), a scatty drug-addicted actress, Rex (Stephen Davies), her brainless hunky leading man, Big Mac (Bob Hoskins), a domineering bootlegger and porn producer, and Cathy Cake (Jessica Harper), an aspiring actress. Despite the single set, Byrum, who also wrote the script, managed to create the feel of the real Hollywood of 1930 outside, even providing a young actor called Clark Gable who wishes to see Boy Wonder, but is refused admission. However, Dreyfuss' customary vitality was not enough to disguise the fact that he was miscast. The production by Davina Belling and Clive Parsons was generally reviled. (FILM AND GENERAL)

◁'A pair of million dollar babies in a five-and-ten cent flick,' wrote the *Los Angeles Times* critic of **The Missouri Breaks**. The 'babies' were Marlon Brando (left) and Jack Nicholson (right), who each got a million dollar salary cheque for doing their thing in producers Elliott Kastner and Robert M. Sherman's hot property that turned to cold turkey. Brando accepted the role to bring money to his pet cause, the plight of the Red Indian. He was not content to take the cash and run, however, but proceeded to make director Arthur Penn pander to his every whim. These included altering Thomas McGuane's script, simulating an Irish accent, and romping around outrageously in granny drag. Nicholson, in contrast, seemed somewhat bemused opposite him as the ringleader of a gang of rustlers Brando has been hired to eliminate. Brando, the 'regulator' at John McLiam's ranch, succeeds in picking off the rustlers one by one until he has his throat cut by Nicholson. Some quirky humour and splendid locations in Montana were unfortunately not enough to sustain this muddled, facetious, violent non-event. Randy Quaid, Kathleen Lloyd, Frederic Forrest, Harry Dean Stanton, John Ryan, Sam Gilman, Steve Franken and Richard Bradford made up the supporting cast. (EK-DEVON/PERSKY-BRIGHT)

◁'She's television generation. She learned life from Bugs Bunny. The only reality she knows comes to her over the TV set,' is how Faye Dunaway (centre) is described in **Network**. Dunaway's ruthless TV programming chief, who talks ratings in bed with male menopausal William Holden (right), the head of the news division whose job she wants, was one of the main targets of screenwriter Paddy Chayefsky's blunderbuss attack on the TV industry. Director Sidney Lumet played up the bizarre, hysterical soap-box operatics of the Oscar-winning script, letting the actors go at it at the tops of their voices. But enough satirical points were scored to make Howard Gottfried's production earn over $4½ million at the box office. The cautionary tale told of how Ned Beatty, megalomaniac head of the United Broadcasting system, and his hatchet man Robert Duvall (left), decide to axe longtime newscaster Peter Finch. But Finch threatens to kill himself on the air, and the ratings soar. Billed as 'the Mad Prophet of the airwaves', he becomes an evangelical TV star in a news programme packaged as gross entertainment. Finch, who died of a heart attack during a promotional campaign for the film, became the first actor to win an Oscar posthumously. Beatrice Straight gained a supporting award for her one scene as Holden's neglected wife. Others in the UA-MGM co-production were Wesley Addy, Arthur Burghardt, Kathy Cronkite and Darryl Hickman. (UA-MGM)

▽Robert Altman, the producer-director of **Buffalo Bill And The Indians, Or Sitting Bull's History Lesson**, added his own self-critical voice to the chorus of disapproval that greeted the film. It was not only an anti-Western, but anti-action, in which the point that William 'Buffalo Bill' Cody was a phony was rammed home for two hours. Paul Newman (illustrated), behind long white hair and whiskers, strutted around to little effect as Cody while the life and myth were discussed during winter camp of his Wild West Show. Among the debunkers were Joel Grey as Cody's showman partner, Kevin McCarthy as his press agent, Harvey Keitel as his nephew, Geraldine Chaplin (illustrated) and John Considine as Annie Oakley and Frank Butler, Frank Kaquitts as Big Chief Sitting Bull, Will Sampson, an interpreter, Burt Lancaster as newsman Ned Buntline, bartender Bert Remsen, and Pat McCormick and Shelley Duvall as the President and First Lady. The enterprise might have been better if screenwriters Altman and Alan Rudolph had not scalped Arthur Kopit's excellent play *Indians*, from which the film derived. (DINO DE LAURENTIIS)

▷Mindful of the success of *Murder On The Orient Express* (EMI, 1974), **Breakheart Pass** was a kind of Murder On The Western Express. Alistair MacLean's screenplay, adapted from his own novel, had various people being killed on a train during a mysterious mission to Ford Humboldt in 1873. On board the handsome steam train chugging through splendid scenery were Charles Bronson (illustrated), a secret service agent posing as a wanted man, US marshal Ben Johnson, Governor Richard Crenna and his sweetheart Jill Ireland, notorious outlaw Robert Tessier and Major Ed Lauter. Also: Charles Durning, Roy Jenson, Casey Tibbs and Archie Moore. Director Tom Gries kept Jerry Gershwin's production fairly engrossing until the final quarter of an hour, when the film went off the rails with the US Cavalry, Red Indians, the Secret Service, politicians and cowboys all getting in on the act. (EK)

△**The Pink Panther Strikes Again** struck gold at the box office, making over $20 million, even topping the returns of *The Return Of The Pink Panther* (1975), and proving the public's insatiable love of slapstick. Tireless producer-director Blake Edwards and his co-screenwriter Frank Waldman thought up even more far-fetched disguises for Peter Sellers (right) as Inspector Clouseau, including Long John Silver with a stuffed parrot, Toulouse Lautrec, Einstein, and an inflatable hunchback costume. The plot had Clouseau helping Scotland Yard to solve the kidnapping of a scientist (Richard Vernon) and his daughter Briony McRoberts. He bumbled his way towards the climax, getting involved in a gay bar brawl, and making love to a Russian spy (Lesley-Anne Down) on the way. Facing him is his ex-superior Inspector Dreyfus (a madly twitching Herbert Lom, left) who has escaped from the asylum where Clouseau drove him, and has become a master criminal. Also in the cast were Colin Blakely, Leonard Rossiter, Burt Kwouk (as Clouseau's valet whose sole function is to jump on him at unexpected moments), André Maranne, Michael Robbins and Omar Sharif (billed as Rocky Taylor) in a cameo as an Egyptian assassin. No matter that the title made no sense (the Pink Panther was a diamond in the first film – a fact forgotten thereafter), as nothing else did either. (AMJO)

1976

▽**Carrie** was a repulsively compulsive movie directed by Brian De Palma, one of the better Hitchcock disciples among the 'movie brat' generation. But the Master never made so gory or silly a film as this. Blood was the dominant image, linked here with menstruation in Lawrence D. Cohen's screenplay (derived from Stephen King's novel). Naive ugly duckling Sissy Spacek (in the title role) has her first period in the girls' shower of the Bates High School gym, and thinks she's bleeding to death. (A nod to Hitchcock's *Psycho* – Paramount, 1960). Her classmates, including John Travolta (second film), Nancy Allen (later to marry De Palma),

B.J. Soles and Michael Talbot go to town on her, even emptying a bucket of pig's blood over the poor creature. But The Curse becomes The Omen when Spacek (illustrated front) finds she has telekinetic powers, and uses them to bring havoc and destruction to her tormentors. Piper Laurie (illustrated behind) in her first picture in 15 years pulled out all the stops as the girl's religious freak mother. Others cast were Amy Irving, William Katt, Betty Buckley, Sydney Lassick and Priscilla Pointer. Both Laurie and Spacek were nominated for Oscars (the film's only nominations), and the Paul Monash production was a box-office smash. (RED BANK)

▽Apart from the professional cast, **Stay Hungry** was made 'with the participation of the people of Alabama and the International Federation of Bodybuilders.' Among the latter was Arnold 'Mr Universe' Schwarzenegger (left), in his first acting role, as a member of a health club which wicked property dealer Joe Spinell wants to buy up. He sends young Jeff Bridges (right) to close the deal with the owner (R.G. Armstrong), but Bridges gets so engrossed in the club that he joins forces with the members, including Sally Field, Robert Englund, Helena Kallianiotes and Roger F. Mosely, to oppose the takeover. Director Bob Rafelson (who also co-produced with Harold Schneider) managed a nice sense of place and pace, even if his screenplay, written with Charles Gaines (from Gaines' novel) was an uncertain mixture of naturalistic drama, fairy tale and social satire. Most of the satire derived from Bridges' attempt to merge the rough-and-ready lower class world of the gym with his snooty family circle consisting of uncle Woodrow Parfrey, fiancee Kathleen Miller, socialite Fannie Flagg, swinger Joanna Cassidy and butler Scatman Crothers. (OUTOV)

▽Richard Harris (illustrated centre), who had suffered bravely as *A Man Called Horse* (Cinema Center), a hit of 1970, came galloping back for more punishment in **The Return Of A Man Called Horse**. In fact, he reprised the Sun Vow ritual in which he is suspended by clamps inserted in his pectoral muscles. This torture production number lasted 20 minutes, and the pretitle sequence 17 minutes, one of the longest ever. The remaining 88 minutes of Jack De Witt's script, based on the character from Dorothy M. Johnson's 1950 *Collier*'s story, concerned English aristocrat Harris' return to the Yellow Hand tribe, of which he is an honorary

member, only to find they have been driven off their land by a rival tribe bribed by evil fur trappers. He inspires and assists his tribe to fight to regain their land. Supporting roles in Terry Morse Jr's production were played by Regino Herrerra, Pedro Damien, Enrique Lucero, Gale Sondergaard (her third film in 27 years), Geoffrey Lewis, Bill Lucking, Jorge Luke, Claudio Brook and Ana De Sade (a name suitably at home in the movie). Despite the lack of real Red Indians in the cast, and the rather placid direction of Irvin Kershner, the picture managed to get closer to the Indian experience than many other attempts. (SANDY HOWARD)

▽**From Noon Till Three** was the time bank robber Charles Bronson (illustrated) took to make love to attractive widow Jill Ireland (actually Mrs Bronson, illustrated) before riding off, ostensibly to rescue four of his fellow outlaws (Douglas Fowley, Stan Haze, Damon Douglas and Hector Morales). Instead, he goes off in the opposite direction and changes clothes with an itinerant dentist, who is then shot in his place. Thinking Bronson killed heroically while attempting to save his friends, the widow tells the story to an author (Howard Brunner), who writes a best-seller, and Bronson becomes a folk legend in song. When the truth is discovered, the widow shoots herself and the 'hero' is commited to an asylum. Not exactly an amusing ending to director-screenwriter Frank D. Gilroy's somewhat awkward attempt at a comic Western, adapted from his own novel. In more skilful hands, this satire on romantic idealism and the joke at the expense of Bronson's image might have been another *Cat Ballou* (Columbia, 1965). Also in the Mike Frankovich-William Self production were Bert Williams, William Lanteau, Betty Cole and Davis Roberts. (FRANKOVICH-SELF)

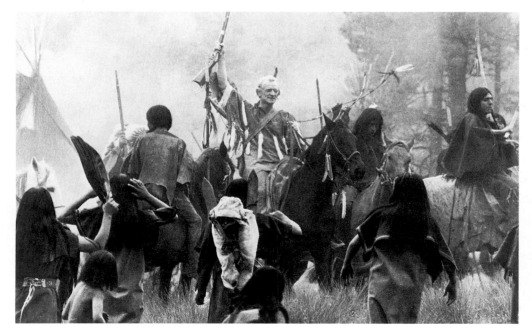

▽**Bound For Glory** helped in the canonization of legendary folksinger Woody Guthrie, who died in 1967. Robert Getchell's screenplay, based on Woody's autobiography, recounted how the impoverished singer had to leave his wife (Melinda Dillon) and two children in Texas during the Depression and head for California to get a job, and recalled his political attempts to help the workers and his meeting with Ozark Bule (Ronny Cox), the singer who inspired him, as well as following his rise to fame on radio and at the Coconut Grove. Director Hal Ashby decorated the Robert Blumhofe–Harold Leventhal production with all the trappings of the period: soup kitchens, exploited migrant crop pickers, hoboes hopping freight trains, hitchhikers and dust storms, helped by Haskell Wexler's Oscar-winning photography. Most of the 20 or so protest songs, like 'This Land Is Your Land', were heard in no more than snatches, and much of the homespun philosophy palled over 150 minutes, but the $7½ million picture had its heart in the right place. Tall, lanky David Carradine (illustrated – whose father John was in the archetypal Depression movie, John Ford's *The Grapes of Wrath*, 20th Century-Fox, 1940) was convincing as Guthrie, whose songs he also sang. Others cast included Gail Strickland, John Lehne, Ji-Tu Cumbuka, Randy Quaid, Elizabeth Macey and Allan Miller. (RFB)

△Failing to repeat the commercial success of the appalling *Mandingo* (Paramount, 1975), **Drum** was an even trashier movie. As in the previous picture, Norman Wexler drew his lurid and ludicrous script from a Kyle Onstott novel about 19th-century slave trading. Among the one-dimensional characters were Warren Oates (illustrated), a wicked slave breeder who buys Ken Norton from bordello queen Isela Vega. The latter turns out to be the slave's mother, although he was raised by her lesbian lover-maid Paula Kelly. Pamela Grier (illustrated) played Norton's girlfriend and Oates' mistress, John Colicos was a camp New Orleans dandy, Alan Patrick his passive lover, Rainbeaux Smith Oates' jailbait daughter who fancies hunky black slaves, Lillian Hayman a plantation mammy, and Yaphet Kotto another slave. The film ended with a revolt of the slaves – not the only revolting incident in the Ralph Serpe production. The fact that Steve Carver took over the direction from Burt Kennedy, might have accounted for the patchy look of the picture. (DINO DE LAURENTIIS)

▽'Leftovers' might have been a more suitable title for **Burnt Offerings**, a predictable tale of the supernatural in which an eerie, isolated country house stood in once again for the villain. Oliver Reed and his family – wife Karen Black (right), son Lee Montgomery and aunt, a wasted Bette Davis (left) – should have known better than to rent the house from eccentric siblings Burgess Meredith and Eileen Heckart, especially as they are asked to take responsibility for the owners' (unseen) old mother confined to her top-floor rooms. Producer-director Dan Curtis resorted to Gothic cliches when the characters start to act strangely, doors and windows open and shut mysteriously, and an obligatory storm rages. The film, scripted by Curtis and William F. Nolan (from a novel by Robert Marasco) failed to work up much of a storm at the box-office. Dub Taylor, Anthony James, Orin Cannon, James T. Myers and Todd Turquand had other roles. (PEA/DAN CURTIS)

◁Burt Reynolds took on the director's mantle for the first time for **Gator**, a sequel to the unexpectedly commercial *White Lightning* (1973). Burt (right) starred once again as Gator McKlusky, moonshine whisky maker, unpopular with the law. On parole, he is blackmailed by ambitious State Governor Mike Douglas (left – the TV host's film debut) into working against his old pal, racketeer Jerry Reed. The action was slowed down during romantic interludes between the star and TV newswoman Lauren Hutton. Like Burt's character, the film never took itself seriously, and William Norton's screenplay was a compendium of cliches – corrupt Southern politicians, car chases, bent cops, car chases, bootlegging gangsters and car chases ... Alice Ghostly, Dub Taylor, Burton Gilliam, William Engresser, John Steadman and Stephanie Burchfield had other roles in Jules Levy and Arthur Gardner's production. (DEVON/PERSKY-BRIGHT/LEVY-GARDNER-LAVEN)

1976 OTHER RELEASES

Champion Of Death
A Kung-Fu champion is called out of retirement to take on an army of karate fighters out for his blood. Sonny Chiba. *Dir* Kazuhiko Yamaguchi. *Pro* Uncredited. (Japan) TOEI CO.

Trackdown
A runaway teenage girl is tracked down to the Barrio district of Los Angeles by her brother, who shoots the man who made his sister into a callgirl. Jim Mitchum, Karen Lamm, Erik Estrada, Vince Cannon, Cathy Lee Crosby. *Dir* Richard T. Heffron. *Pro* Bernard Schwartz. ESSANESS

Vigilante Force
A brutal Vietnam war veteran becomes a cop, but is opposed by his brother who organizes the citizenry in protest against him. Kris Kristofferson, Jan-Michael Vincent, Brad Dexter, Victoria Principal, Bernadette Powers. *Dir* George Armitage. *Pro* Gene Corman. CHATEAU

▷A further example of controversial director Ken Russell's perversity was his casting of Russian ballet dancer Rudolf Nureyev (illustrated) in the role of Latin screen idol **Valentino**. Not only did Rudy bear no resemblance to the other Rudy, but Russell's screenplay (written with Mardik Martin) bore scant resemblance to the life of the famous film star. It outlined in grotesque terms the events of Rudolph Valentino's life from taxi dancer at a New York ballroom to the celebrated funeral in 1926, taking in his affair with Bianca De Saulles (June Bolton), his dance act with Majorie Tain (Leland Palmer), his discovery by MGM screenwriter June Mathis (Felicity Kendal), his marriage to Natasha Rambova (Michelle Phillips). Other products of Russell's fevered and inaccurate imagination were Nazimova (Leslie Caron, illustrated), promoter George Ulman (Seymour Cassell), newsman Rory O'Neil (Peter Vaughan), Jesse Lasky (Huntz Hall), Joseph Schenck (David De Keyser), Fatty Arbuckle (William Hootkins), Nijinsky (Anthony Dowell) and Agnes Ayres (Jennie Linden). At least Irwin Winkler and Robert Chartoff's production was not as dull as Columbia's 1951 biopic of the same name starring the forgettable Anthony Dexter. (APETURE)

◁**The White Buffalo** was a great big turkey, even though it starred box-office favourite Charles Bronson (illustrated). It proved that when a Western has more symbols than horses, the public don't want to know. Richard Sale's arch script (based on his novel) was an effort to make a kind of landlocked *Moby Dick* with 'the last white buffalo in the world' standing in for the famous whale. Bronson in wide hat, droopy moustache and large sunglasses, played an ageing Wild Bill Hickock haunted by a recurring dream of the great white beast rampaging across a snowy landscape. Amid murky photography, he searches out the buffalo for what he pretentiously calls his 'Armageddon'. When the animal finally appeared, it looked as stuffed as the one he shoots accidentally from the wall after a nightmare. The acting of Bronson, Jack Warden, Will Sampson, Cara Williams, Shay Duffin, Douglas Fowley and Ed Lauter was no more alive. Pointless cameos were contributed by Kim Novak, Clint Walker, Stuart Whitman, Slim Pickens and John Carradine. J. Lee Thompson directed ponderously for producer Pancho Kohner. (DINO DE LAURENTIIS)

◁**A Bridge Too Far**, the story of one of the great Allied military disasters of World War II, was not a victory either for Joseph E. and Richard P. Levine whose $25 million production barely made up its cost, despite an array of big name stars on the marquee. Dirk Bogarde, James Caan, Michael Caine, Sean Connery, Edward Fox, Elliott Gould, Gene Hackman, Anthony Hopkins, Hardy Kruger, Laurence Olivier, Ryan O'Neal, Robert Redford (right), Maximilian Schell, Liv Ullman and Arthur Hill all gave phone-in performances, although their casting was meant to help audiences identify the many characters in the unwieldy screenplay by William Goldman (based on Cornelius Ryan's book). The picture opened with the old UA logo preceding some black and white footage, as if to remind us that war films were better and shorter in the past. Director Richard Attenborough, who had acted in many of them, took 175 plodding minutes to explain how the 1944 operation to parachute 35,000 men behind German lines to capture a series of bridges over the Ruhr, failed at Arnhem. (JOSEPH E. LEVINE)

▷Liza Minnelli socked over the John Kander-Fred Ebb title song of **New York, New York** with such zest as to make the number a hit even if the Irwin Winkler-Robert Chartoff production was not. The main problem was that the original four-hour movie was cut down to 153 minutes and then 137 on general release, so that many minor characters disappeared, it lacked narrative drive, and the continuity suffered. (A production number and some footage was restored in a later re-release, but to not much avail.) Despite this, however, it was an entertaining pastiche of 40s musicals, Minnelli and Robert De Niro (both illustrated) were a redoubtable duo, and there were some vigorous set pieces from director Martin Scorsese – especially the opening VJ Day scene when singer Liza meets egotistical sax-ophonist De Niro for the first time. The screen-play by Earl Mac Roach and Mardik Martin (story by Roach) showed them marrying, having a baby, fighting, divorcing, both becoming big names, but not getting back together again. Support came from Lionel Stander, Barry Primus, Mary Kay Place, George Memmoli and Georgie Auld (who dubbed De Niro's sax play-ing). (CHARTOFF-WINKLER)

◁**Semi-Tough** was another of director Michael Ritchie's semi-satires on middle America, like *The Candidate* (Warner Bros., 1972) and *Smile* (1975). Ritchie's way of labouring an idea and scoring easy points was counteracted by Walter Bernstein's witty, free-wheeling script (adapted from the popular 1972 novel by Dan Jenkins). Burt Reynolds (centre) was perfectly suited to the role of Billy Clyde of the Miami Bucks football team, who lives in a platonic threesome with teammate Skate (Kris Kristofferson, right) and Barbara Jane (Jill Clayburgh, left), until sex rears its head. As the title of the David Merrick production suggests, underneath his hairy-chested macho exterior, Billy Clyde is a tender-hearted human being. In fact, he wants to write a book and marry Barbara Jane. The most suc-cessful of the film's jibes were directed at various instant revelation cults that seemed to be bur-geoning in Florida, such as Pyramid Power, a kind of est movement run by one Friedrich Bismark (Bert Convy), Pelfing, a nose massage invented by Clara Pelf (Lotte Lenya at her butchest), and Movagenics which obliges the follower, in this case football team owner Big Ed Brookman (Robert Preston) to crawl around like a baby. Roger E. Mosly, Richard Masur, Carl Weathers, Brian Dennehy and Mary Jo Catlett were also cast. (MERRICK)

▷**Audrey Rose**, an unlikely tale of reincarna-tion was another reincarnation of *The Exorcist* (Warner Bros., 1973). The screenplay by Frank De Felitta (from his own novel) offered, at the start, intriguing psychological and philosophical possibilities, but went on to postulate pompously on the theory of the transmigration of souls – a development which director Robert Wise tried to play down as much as possible. In this case history, a bearded clairvoyant (Anthony Hopkins) is convinced his young daughter Audrey Rose, burned to death in a car accident some 12 years earlier, has been reincarnated in the person of the 12-year-old daughter (Susan Swift, centre) of a middle class New York couple (John Beck, right, and Marsha Mason, left). No wonder the father punches the interfering guru on the nose although, under hypnosis, the young girl does start screaming about being in a burning car. Also in the production by De Felitta and Joe Wizan were Norman Lloyd, John Hillerman, Robert Walden, Philip Sterling, Ivy Jones and Stephen Pearlman. (ROBERT WISE)

▽The subtitle of Robert Altman's production **Welcome To LA** was 'The City Of One-Night Stands', the name of a suite of nine pop songs by Richard Baskin (who had a small role) on which Alan Rudolph based his plotless screenplay. The aimless characters – rock musician Keith Carradine, his kooky girlfriend Sissy Spacek, confused businessman Harvey Keitel, photographer Lauren Hutton (right), cynical agent Viveca Lindfors, garrulous Geraldine Chaplin (left), Sally Kellerman and John Considine – go through a series of joyless sex encounters, guzzle booze and drive around tinsel town in the search for some meaning to their lives. Rudolph's direction west-coasted along without picking up many illuminations on the way. Despite its apparently dependable, if somewhat specialised, gathering of talent, the picture, made for $1 million, received a muted welcome from critics and public alike. (LION'S GATE-LAGOON)

▽In 1975, Harry Saltzman sold his share in the James Bond industry, leaving his partner for over 15 years, Albert 'Cubby' Broccoli, to produce **The Spy Who Loved Me** on his own. Even more spectacular than previous Bonds, the movie, using grandiose sets built by Ken Adam at Pinewood Studios, and shot in the Bahamas, Egypt and Sardinia, made the tidy sum of $22 million. Lewis Gilbert, who hadn't directed a Bond film since *You Only Live Twice* (1967), made it one of the snappiest, funniest, and most exciting in the perennial series for some time. Ian Fleming stipulated that the title of his book could be used, but not the story, which he disliked. Screenwriters Christopher Wood and Richard

△Playwright Peter Shaffer's woolly thinking was mercilessly exposed on screen in **Equus**. Whereas in the theatre the imaginative use of actors in masks to represent horses strengthened the ritualistic elements, director Sidney Lumet was unable to find a workable alternative in the more realistic medium of film. Set in rural England (but shot in Canada), a phony conflict exists between the intellectual values of psychiatrist Martin Dysart (Richard Burton, left), and the instinctual actions of 17-year-old stable boy Alan Strang (Peter Firth, right). The latter is given to riding barebacked and bare at night, and also prays to a picture of a horse above his bed. Confused by his hysterically religious mother (Joan Plowright) and anti-religious father (Colin Blakely), he blinds six horses who have witnessed his failure to rise to the occasion in the hay with his girlfriend. Burton droned on in close-up through eight monologues during the 137 minute Elliott Kastner-Lester Persky production, scripted by Shaffer. Also cast were Harry Andrews, Eileen Atkins, Kate Reid, John Wyman and Elva Mai Hoover. (WINKAST)

Maibaum therefore elaborated on past plots, but added a worthy female opponent in Major Anya Amasova (Barbara Bach), and a seven foot two heavy with a set of lethal steel teeth, nicknamed 'Jaws' (Richard Kiel, right). James Bond (Roger Moore, left) has his hands full with beautiful girls, fighting 'Jaws' in a small train compartment, and saving the world from destruction by master criminal Stromberg (Curt Jurgens) whose supertanker swallows British and Russian nuclear submarines. Other roles went to Caroline Munro, Walter Gotell, Geoffrey Keen, Bernard Lee, George Baker, Olga Bisera, Edward De Souza, and Bond fixtures Lois Maxwell and Desmond Llewelyn. (EON)

▷Until **Annie Hall**, Woody Allen (illustrated) as director and performer, was considered one of America's brightest new funnymen whose films were little more than a series of closely linked revue sketches. Suddenly little Woody was catapulted into the big time with this 'nervous romance' (written by Allen and Marshall Brickman), which won four richly deserved Oscars, made a fortune, and gained a cult following. Originally, the Charles H. Joffe production was to have been about the surrealistic adventures of a neurotic Jewish comedian, but gradually its focus shifted to the on-off-on-off relationship between Allen as Alvy Singer, a TV and nightclub comic, and budding singer Annie Hall (Diane Keaton, illustrated, real name Diane Hall), based on the stars' real-life affair. They portrayed an intelligent contemporary adult couple with wit, accuracy and an undercurrent of anxiety. The beautiful friendship begins during an indoor tennis match of mixed singles which she wins, and continues through Alvy's awkward (and hilarious) meeting with Annie's WASP family (father Donald Symington, mother Colleen Dewhurst, and brother Christopher Walken), to the New York-loving Alvy even following her to 'mellow' California. Tony Roberts, his hipster friend, Carol Kane, Janet Margolin and Shelley Duvall, three contrasting women, and Paul Simon, a Hollywood swinger, were character targets of Allen's satire. Appearing as himself was Canadian media guru, Marshall McLuhan, who suddenly appears to refute what a phony standing in line to see a Bergman movie, is saying about him. Keaton, in her unisex costume of baggy pants, black waistcoat, white shirt, knotted black tie, scarf and felt hat, oozed quality, and was a strong influence on what the well-dressed, liberated woman was to wear in the late 70s. (JACK ROLLINS-CHARLES H. JOFFE)

1977 OTHER RELEASES

Another Man, Another Chance (GB: Another Man, Another Woman)
A widowed American veterinary surgeon and a French widow meet and have a love affair in the Wild West. James Caan, Genevieve Bujold, Francis Huster, Jennifer Warren, Susan Tyrrell. *Dir* Claude Lelouch. *Pro* Alexandre Mnouchkine, Georges Dancigers. (France) ARIANE/LES FILMS 13/ LES PRODUCTIONS ARTISTES ASSOCIES

Three Warriors
A 13-year-old Red Indian boy is taught to appreciate his people's proud heritage by his loving grandfather in a reservation. McKee Kiko Redwing, Charles White Eagle, Randy Quaid, Lois Red Elk. *Dir* Ken Merrill. *Pro* Saul Zaentz, Sy Gomberg. SAUL ZAENTZ/FANTASY FILMS

▽**Revenge Of The Pink Panther** was the last of the hugely successful five-picture comedy series made during Peter Sellers' lifetime (he died in 1980), although a collection of takeouts was used to resurrect him in the *The Trail Of The Pink Panther* (1982). This final film, produced and directed by Blake Edwards, also seemed as though it were cobbled together from footage of all previous efforts. Here was Sellers/Inspector Clouseau falling over himself trying to be funny, wearing ludicrous disguises (see illustration), madly mispronouncing certain words, being jumped upon by his valet Cato (Burt Kwouk), and literally driving Inspector Dreyfus (Herbert Lom) crazy. The screenplay by Edwards, Frank Waldman and Ron Clark had the clumsy cop involved with a 'Godfather' (Paul Stewart), an assassin (Robert Webber) and his mistress (Dyan Cannon), a 'French Connection' heroin plot, and a cabaret called Le Club Foot, all ending in a chase and an explosion at a fireworks factory. Robert Loggia, Graham Stark, Andre Maranne, Sue Lloyd, Tony Beckley and Adrienne Corri also appeared in this moneymaker. (JEWEL)

△**Coming Home** was instigated by its star, Jane Fonda, who got Nancy Dowd to write a story with a built-in criticism of the US policy in Vietnam. However, too much soap in the screenplay by Waldo Salt and Robert C. Jones, many of the words of which were drowned by the noisy, unrelenting pop music soundtrack, washed away any toughness the initial concept might have had. The hip Fonda tried to convince as an army wife married to square, macho marine Bruce Dern. When he's off in 'Nam, she takes a job in a veterans' hospital where she meets former high-school classmate Jon Voight, now paralyzed from the waist down. It doesn't seem to have affected his sexual prowess, however, and they become lovers. She then becomes more liberated, changes her hairstyle, and goes for rides along the beach with Voight in his wheelchair. But then hubby returns a hero, and she has to choose between them. Director Hal Ashby treated much of it with discretion, but overplayed the tearjerking side. Other roles went to Robert Ginty, Penelope Milford, Robert Carradine, Charles Cyphers, Teresa Hughes, Mary Jackson, Olivia Cole and Willie Taylor. The public did not rush to see Jerome Hellman's production at first, but when Fonda and Voight (both illustrated) won Oscars, business boomed. (JAYNE)

△For those who hadn't read J.R.R. Tolkien's bestselling trilogy, **The Lord Of The Rings**, Ralph Bakshi's 133-minute animated version seemed impenetrable. The introductory narration in Chris Conkling and Peter S. Beagle's screenplay, explaining the characters who inhabit Middle Earth, left kiddies (and adults) even more in the dark, whereas the books, complete with charts, gave the reader more time to work out who was who. Basically, it involved the competition of different races – the peaceloving Hobbits, the brutish Orcs, Elves, Dwarfs, evil wizards – for the ownership of all-powerful rings. Among the voices lent were those of Christopher Guard (Frodo), William Squire (Gandalf), Michael Scholes, John Hurt, Simon Chandler, Dominic Guard, Norman Bird, Anthony Daniels and Annette Crosbie. Bakshi used a system called Rotoscope, which begins with live actors and animates over them. This created an awkward mixture between 'realistic' and more traditional cartoon effects. Saul Zaentz's production only proved that the heir to Walt Disney is yet to be found. (FANTASY)

▽'I tell ya. If we can beat the odds in New York, we can do anything – kiss the moon, turn the garbage into roses,' says plump and plain newspaper columnist Paul Sorvino in **Slow Dancing In The Big City**. Director John G. Avildsen, however, failed to turn this shamelessly sentimental garbage into roses as he had done with *Rocky* (1976), his previous film. The naive, overstated and implausible picture, from a screenplay by Barra Grant, told of the love of the miscast Sorvino for Canadian ballerina Anne Ditchburn (illustrated), who has a serious physical affliction that will ultimately prevent her from dancing again. Determined to appear in her new ballet despite pain, she collapses in her lover's arms after the performance. A secondary plot involved an eight-year-old Puerto Rican drug addict (Daniel Faraldo) who dies of an overdose administered by his elder brother (G. Adam Gifford). Nicolas Coster, Anita Dangler, Hector Jaime Mercado and Thaao Penghlis also featured in this dud produced by Avildsen and Michael Levee. (C.I.P.)

▽**F.I.S.T.** evoked the Warner Bros. social melodramas of the 30s, even though they were faster-paced and took rather less than the 140 minutes producer-director Norman Jewison seemed to need, with scripts more incisive than Joe Eszterhas and Sylvester Stallone's (story by the former), and actors such as James Cagney superior to Stallone and company. The title stood for the Federation of InterState Truckers, the thinly disguised Teamsters union, in which the son of a Hungarian immigrant (Stallone, illustrated) rises to become its powerful and corrupt leader. On the way to the top he loses his best friend (David Huffman), and his wife (Melinda Dillon), becomes allied with a racketeer (Kevin Conway) and a Mafia chief (Tony Lo Bianco), and is investigated by a crusading senator (a muted Rod Steiger). All pretty familiar stuff, which might have been better had Stallone been more convincing as an oratorical union boss. At least the first 30 minutes were in the best Hollywood populist tradition, with the exploited workers in 1937 Cleveland rebelling against their terrible conditions. Other roles went to Peter Boyle, Cassie Yates, Peter Donat, John Lehne and Henry Wilcoxon. (CHATEAU)

◁**The Big Sleep**, an unwelcome remake of the classic 1946 Humphrey Bogart-Lauren Bacall-Warner Bros. movie, was a big yawn. Not only was Michael Winner's direction inferior to Howard Hawks' in every department, but the transplantation of Raymond Chandler's novel from 1940 California to 1977 London in his screenplay, drained the essence from the original. None of the starry cast of Elliott Kastner and Winner's production seemed to have much commitment to their roles. Robert Mitchum (illustrated) as private eye Philip Marlowe (far more convincing in the same part in the superior *Farewell My Lovely*, Avco Embassy, 1975) sleepwalked through the complex tale. Hired by wealthy cripple James Stewart to probe a blackmail case, he gets involved with his client's daughters (Candy Clark and Sarah Miles), a gambler and wife (Oliver Reed and Diana Quick), a hitman (Richard Boone), and Scotland Yard detectives (John Mills, Richard Todd, James Donald). Also appearing were: Edward Fox, Simon Turner, John Justin, Harry Andrews, Colin Blakely, Martin Potter, Dudley Sutton, and Joan Collins (illustrated) as a bookshop assistant. (GRADE-KASTNER-WINNER)

▽**The End**, Burt Reynold's second film as director, was a slight improvement on *Gator* (1976) in that Jerry Belson's screenplay was funnier and more original. Reynolds' undisciplined comedy technique, however, and the seemingly endless series of duologues, spoiled a potentially sharp black comedy. The first half certainly had its share of death-rattle laughs with Burt (illustrated), a man in apparently good health, being informed that he has a fatal illness and only a short time to live. He therefore resolves to commit suicide. After a hilarious encounter with adolescent priest Robby Benson,

he bids farewell to his ex-wife Joanne Woodward, his girlfriend Sally Field (illustrated), his daughter Kristy McNichol, his parents Pat O'Brien and Myrna Loy, and his attorney friend David Steinberg. After a suicide attempt fails, he finds himself in a psychiatric hospital with manic, Polish-American longterm patient Dom DeLuise. Thereafter the Lawrence Gordon production descended into sub-Mel Brooks farce, heavy slapstick and a sentimental ending. Strother Martin, Norman Fell, Carl Reiner, Louise Letourneau and Bill Ewing had other roles. (GORDON/REYNOLDS)

△Although **Invasion Of The Body Snatchers** cost $3 million as against the $350,000 of the 1956 Allied Artists version, and offered the big screen, colour, and Dolby sound, it still couldn't touch the earlier picture directed by Don Siegel. Siegel himself appeared in this one as a taxi driver, as did Kevin McCarthy, still shouting his warnings as at the end of the previous movie. W.D. Richter's screenplay re-situated Jack Finney's *Collier* magazine serial from a small town to 1978 San Francisco in an attempt to make an allegory of California life. (There were many shots of the Transamerica pyramid building, UA's base.) 'People are changing. They're becoming less human,' says psychiatrist Leonard Nimoy (illustrated) before the population start turning into zombies (how could they tell?) because of a mysterious spore that has drifted in from space. Only public health inspector Donald Sutherland retains his identity to the end. Among the pod people in Robert H. Solo's production were Brooke Adams, Veronica Cartwright, Jeff Goldblum, Art Hindle and Lelia Goldoni (illustrated). Robert Duvall (uncredited) was seen briefly as a priest on a park swing. Director Philip Kaufman strained every image towards a bizarre effect when a certain distance might have been more effective. (SOLOFILM)

▽Although Robert Stone was credited (with Judith Rascoe) for the screenplay of **Who'll Stop The Rain?** (GB: **Dog Soldiers**), based on his National Book Award winning novel, *Dog Soldiers*, he disowned the finished product. The American title was taken from the Credence Clearwater Revival soundtrack song, and the emphasis in Herb Jaffe and Gabriel Katzka's production was shifted from a story of the effects the Vietnam war had on the American psyche towards a more conventional chase movie. Neither change helped the film at the box-office. The plot followed the attempts of a war corres-

pondent (Michael Moriarty) to ship a consignment of heroin from Vietnam to the USA with the help of his wife (Tuesday Weld, illustrated), and buddy (Nick Nolte, illustrated). Things get nasty as they are trailed by a crooked narcotics agent (Anthony Zerbe) and his two sadistic thugs (Richard Masur and Ray Sharkey). The climax takes place at an old hippy commune. Other roles went to Gail Strickland, Charles Haid, David Opatoshu and James Cranna. Although the film had a certain manic quality, British director Karel Reisz seemed to need to give every action untoward significance. (DOG SOLDIERS CO.)

◁Because of the immense commercial and artistic success of *Annie Hall* (1977), UA generously allowed Woody Allen to direct **Interiors**, his only 'serious' picture and the first without his presence in front of the camera. Expertly made, it was a worthy homage to Woody's idol, Ingmar Bergman, yet full of his own very American preoccupations, and not lacking a certain grim humour. Against carefully designed decor of dark and pastel shades, the film dissected a repressed WASP family consisting of father E.G. Marshall, mother Geraldine Page, and daughters Marybeth Hurt (left), a publisher's reader, Diane Keaton (right), a respected poet, and Kristin Griffith, a glamorous TV actress. Keaton's husband was insecure novelist Richard Jordan, and Hurt's lover, aspiring political film-maker Sam Waterston. Suddenly, the father announces he is seeking a divorce and brings home Maureen Stapleton, a warm, Jewish (?), vulgar and uncomplicated widow in a red dress, who gives the cold family the kiss of life. Neither the public nor the critics seemed prepared for a lugubrious Woody Allen, and the Jack Rollins-Charles H. Joffe production undeservedly flopped. (ROLLINS-JOFFE CREATIVE MANAGEMENT ASSOCIATES)

△**Convoy** was one long, expensive (it cost $11 million) chase on wheels through three states. The pursued was horny truck driver Kris Kristofferson (centre), and the pursuer was corrupt speedtrap cop Ernest Borgnine (left). In between a series of crashes and other acts of destruction, well-staged by director Sam Peckinpah, Kris links up with rebels Burt Young, Madge Sinclair and Franklin Ajaye (right), lays waitress Cassie Yates in his truck, and befriends Ali MacGraw (who registered her usual one-and-a-half expressions). The vapid script by B.W.L. Norton, based on a country 'n' western song by C.W. McCall, tried to thread some comment about The Meaning Of Life into the mayhem. Also in Robert M. Sherman's production were Brian Davies, Seymour Cassell and Walter Kelley. However, more than just truckers and CB radio freaks must got pleasure from the movie, as it did well at the box-office. (UA-EMI)

▷Jane Fonda (illustrated) played a rancher in Montana just after World War II in **Comes A Horseman**, fighting to maintain her property and resisting pressure to sell. Making it tough for her were cattle-baron Jason Robards Jr as J.W. Ewing, oilman George Grizzard, and banker Macon McCalman. To oppose them, Ms Fonda joins forces reluctantly with ex-soldier James Caan (illustrated). Most of the outdoor action under Alan J. Pakula's direction was impressive, but when it got into the great indoors, the film became slow, arty and incoherent, and Dennis Lynton Clark's screenplay failed to blend the elements of Western and psychological thriller. Also in Gene Kirkwood and Dan Paulson's production were Richard Farnsworth, Jim Davis, Mark Harmon, Basil Hoffman, James Kline and James Keach. (CHARTOFF-WINKLER)

OTHER RELEASES

Message From Space
A Japanese *Star Wars*, with miniature robots, spaceships, planets with bizarre creatures, and four young people who triumph over evil. Vic Morrow, Sonny Chiba, Philip Casnoff, Peggy Lee Brennan, Sue Shiomi, Tetsuro Tamba. *Dir* Kinji Fukasaku. *Pro* Banjiro Uemura, Yoshinori Watanabe, Tan Takaiwa. (Japan) TOEI-TOHOKUSHINSHA

Uncle Joe Shannon
A professional trumpet player goes to pieces when his wife and child are killed in a fire, but finds new hope in a relationship with a young crippled boy abandoned by his floozy mother. Burt Young, Doug McKeon, Madge Sinclair, Jason Bernard, Bert Remsen. *Dir* Joseph C. Hanwright. *Pro* Irwin Winkler. CHARTOFF-WINKLER

UNITED ARTISTS

1979

▷Woody Allen's paean to **Manhattan** opened with stunning black and white panoramic views of the skyline (cameraman Gordon Willis), counterpointed by the dynamic music of Gershwin. Allen's heart was in every frame of this sparkling romantic comedy which, despite being a caustic comment on the neurotic over-achievers of the Big Apple, ends with the line, 'You have to have a little faith in people,' spoken by 17-year-old Mariel Hemingway (granddaughter of Ernest). Woody (illustrated) played a 42-year-old unfulfilled TV writer moving between his generation gap affair with Hemingway, and his more mature relationship with fast-talking pseudo-intellectual Diane Keaton. Allen's witty script (written with Marshall Brickman) was better structured than his previous comedies, and the characters well-defined. The perfect cast also included Meryl Streep (illustrated) as his ex-wife who 'left me for another woman', Karen Ludwig as her lover, Michael Murphy, Anne Byrne, Michael O'Donahue, Victor Truro, Tisa Farrow, Wallace Shawn and, as themselves, Helen Hanft and Bella Abzug. Charles H. Joffe's production grossed $20 million – more than *Annie Hall* (1977) – and was the biggest hit of Allen's career to date. (JACK ROLLINS-CHARLES H. JOFFE)

▽After years of hiding behind masks, putting on funny accents, and playing slapstick comedy, Peter Sellers (illustrated) gave his finest (and penultimate) screen performance in **Being There**, using little make-up, no wigs, an indefinable accent, and an extraordinarily blank but serene expression. The character of Chance the gardener is a complete nonentity, an illiterate childlike man whose sole knowledge of the world comes from TV. When he is ejected from his master's Washington D.C. townhouse on the old man's death, he is injured by a limousine and taken by its owner, Shirley MacLaine, to her huge mansion where she lives with her elderly financier husband, Melvyn Douglas. There,

▷Peter Fonda's third film as director, **Wanda Nevada**, was also his third flop, a record only surpassed by his screen acting career. In this tepid tale set around 1950, gambling man Fonda (centre) wins 12-year-old Brooke Shields (right) in a poker game, and they hit the road together to find gold in the Grand Canyon. Along the way, they come across a variety of eccentric characters played by Fiona Lewis, Luke Askew, Ted Markland, Severn Darden, Paul Fix, Larry Golden, and Henry Fonda (left) hiding behind thick goggles and beard as an oldtime prospector. Perhaps he didn't want to be recognized in Neal Dobrofsky and Dennis Hackin's production, screenplay by the latter. (HAYWARD-FONDA)

Chance impresses people with his simplicity and seemingly wise aphorisms. Gradually, he becomes a media celebrity, the toast of embassy parties, and almost a presidential candidate. Thanks to Jerzy Kosinski's satirical screenplay, based on his own short novel, and superb performances from Sellers, Douglas, and Jack Warden as the US President, Andrew Braunsberg's production turned out to be director Hal Ashby's best film to date. The only miscalculation was the inclusion of farcical scenes when MacLaine (as excessive as Sellers was restrained) attempts to seduce the naif. Others cast were Richard Dysart, Richard Basehart, Ruth Attaway (illustrated) and Dave Clennon. (LORIMAR)

△Although **Rich Kids** concentrated mainly on the puppy love affair between 12-year-old Trini Alvarado (right) and Jeremy Levy, the rich adults got the best of Judith Ross' scabrous dialogue. They are an unpleasant bickering bunch as seen through the kids' eyes. Jeremy's mother, Roberta Maxwell, has divorced his father, Terry Kiser, and has remarried psychiatrist Paul Dooley. Trini's parents, Kathryn Walker (left) and John Lithgow, are on the verge of divorce, each having an affair with David Selby and Diane Stilwell respectively. Only Trini's grandmother, Irene Worth, seems understanding. The neglected offspring, left alone in the boy's father's bachelor pad for a weekend, talk sex, get mildly drunk and have a bubble bath together. All harmless, whimsical stuff that never gained the audience it was intended for i.e. the under 17s, because of its adult rating. Robert M. Young directed with a light touch for producers George W. George and Michael Hausman. (LION'S GATE)

▷**Apocalypse Now** took so long to make that it was christened by the industry 'Apocalypse Never.' The cost of the trouble-plagued film, mostly shot in the Philippines, rose from the initial $12 million to over $30 million during its four years in the making, a large amount of which was put up by the producer-director Francis Ford Coppola himself. Despite the problems (among them being the destruction of $1 million worth of sets by an earthquake), the production managed, on the whole, to fulfil Coppola's desire to 'give its audience a sense of the horror, the madness, the sensuousness and the moral dilemma of the Vietnam war,' and the public swarmed to experience it. Coppola's script (written with John Milius), based loosely on Joseph Conrad's great novella, *Heart Of Darkness*, followed the patrol boat crew (Frederic Forrest, Sam Bottoms, Albert Hall and Larry Fishborne) taking intelligence assassin Willard (Martin Sheen, right) up the river to Cambodia to 'terminate with extreme prejudice' megalomaniac officer Kurtz (Marlon Brando, left), who is leading his own army on genocide missions. The film assaulted the senses and numbed the mind with extraordinary setpieces such as the disturbingly exhilarating attack on a Vietnamese village to the strains of Wagner's 'The Ride Of The Valkyries' in Dolby Sound, and psychopath Lieutenant Colonel Kilgore (Robert Duvall) making his GIs surf in the midst of the flak. Unfortunately, the nightmarish Disneyland ride up the river ended disappointingly with 15 minutes of bald-headed Brando's mad, muddled, mumblings as the film moved from the surreal and visual to the cerebral and verbal. Others in the cast were Dennis Hopper, Harrison Ford, G.D. Spradlin, Bill Graham and Cynthia Wood. (OMNI-ZOETROPE)

△Director Michael Crichton based his screenplay and novel of **The Great Train Robbery** (GB: **The First Great Train Robbery**) on the actual 'first robbery from a moving train' which took place in the London of 1855. However, the train of events in the John Foreman production took quite a while to work up steam while gentleman thief Sean Connery (illustrated – in wig and beard), his mistress Lesley-Ann Down (in many disguises), safe-cracker Donald Sutherland (in curls and Irish brogue), and cat burglar Wayne Sleep made elaborate preparations for robbing a shipment of £25,000 in gold pieces. The climax had Connery (no stuntman, no back projection) clambering along the top of a train speeding smokily under low bridges. Also in it were Alan Webb, Malcolm Terris, Robert Lang, Michael Elphick, Pamela Salem and Gabrielle Lloyd. The film, made in Ireland and at Pinewood Studios, was the last shot by ace cinematographer Geoffrey Unsworth, who helped give it an authentic mid-Victorian look. (STARLING)

▽The troika of producers Mark Metcalf, Amy Robinson and Griffin Dunne got **Head Over Heels** re-released in 1982 as **Chilly Scenes In Winter**, the title of the original Ann Beattie novel, and changed the ending. This slow-moving, quietest, off-beat romantic comedy of the 60s generation, set in Salt Lake City, wasn't much to turn somersaults about, but it did have some witty, adult dialogue ('Woodstock was only a lot of people in the mud looking for somewhere to pee.') in the screenplay by Joan Micklin Silver, whose direction managed to circumvent the cliches inherent in the subject. It had a sub Woody Allen-Diane Keaton relationship at the centre, played by the less appealing or amusing John Heard (left) and Mary Beth Hurt. Heard is obsessed by Hurt who is married to superjock Mark Metcalf, a timber house salesman. Gloria Grahame (centre), the great gangster's moll of yesteryear, made a rare screen appearance as Heard's nutty mother constantly threatening suicide. Others in the cast were Peter Riegert, Kenneth McMillan (right), Nora Heflin, Jerry Hardin and Tarah Nutter. (TRIPLE PLAY)

△'You were the most exotic breath-stopping creature I'd ever known,' says Sean Connery to beautiful Brooke Adams in **Cuba**, an exotic breath-stopping movie set in Havana 1959. Ex-British army officer Connery's meeting with Adams (now married to wealthy alcoholic playboy Chris Sarandon) 15 years after their affair, was one of the few cliches in Charles Wood's cynical script. Connery (seated), brought to Cuba as security adviser to the crumbling Batista regime, gets caught up in the revolution. While being anti-Batista, the Alex Winitsky-Arlene Sellers production, like Connery's amused character, pulled back from any pro-Castro stance, obviously eyeing the American box-office. Yet, there was nothing half-hearted about Richard Lester's rhythmic direction leading up to the slam-bang finale. Although filmed in Spain, the movie exuded the atmosphere of Central America, helped by David Watkins' eye-catching camerawork. Fine support came from Jack Weston, Denholm Elliott, Hector Elizondo (illustrated standing), Martin Balsam, Danny De La Paz, Lonette McKee, Alejandro Rey and Wolfe Morris (as General Batista). (HOLMBY)

▽After making films about adolescents in Czechoslovakia, and *One Flew Over The Cuckoo's Nest* (1976), a hymn to non-comformity, *emigré* Milos Forman seemed a logical choice to direct **Hair**, the film version of hippiedom's hit 1967 stage musical by Gerome Ragni, James Rado and Galt MacDermot. But the Age of Aquarius seemed long over, and its Flower Power paraphernalia had withered and died. Detached from the relevance, urgency and joyful liberation the original reflected, Forman and choreographer Twyla Tharp offered no more than vigorous dancing through the streets and parks of New York, some uninhibited playing from young performers, and a touch of nostalgia for the over-25s. Michael Weller fashioned a story line from the musical's episodic book about naive Oklahoma draftee (John Savage), who comes across a bunch of hippies at a Central Park 'be-in'. The turned-on kids (Treat Williams, dancing on table, Annie Golden, Dorsey Wright and Don Dacus) get him stoned, urge him to court a debutante (Beverley D'Angelo), and follow him to his basic training camp in Nevada. Also in the Lester Persky-Michael Butler production were Cheryl Barnes, Richard Bright, Charlotte Rae and the Twyla Tharp Dance Foundation. (C.I.P)

△**Rocky II** was an even bigger box-office smash than *Rocky* (1977) even though, structurally and thematically, they were almost identical. The film builds up to the 30-minute rematch for the heavyweight championship of the world between Rocky Balboa (Sylvester Stallone, centre) and Apollo Creed (Carl Weathers), with the 'white hope' training to Bill Conti's tune 'Gonna Fly Now' on the soundtrack. At first, Rocky gives up boxing because he might lose the sight of one eye, and for the sake of his shrinking-violet wife (Talia Shire), but after discovering he's not qualified to do anything else, he becomes champ with the help of his old trainer (Burgess Meredith). This time round Stallone directed as well as wrote and starred, managing to manipulate audiences into rooting for the pug with 'the relaxed brain' in the well-choreographed big fight, and accepting the simple Cinderella situations. Tony Burton, Joe Spinell, Burt Young, Leonard Gaines, Sylvia Meals and Frank McRae had other roles. Irwin Winkler and Robert Chartoff's production was followed by *Rocky III* (1982) and *Rocky IV* (1985), a sequence that will probably only stop at the count of ten... (CHARTOFF-WINKLER)

▷The camera tracks around a ship, somewhere off the North African coast in 1946, at the beginning of **The Black Stallion**. Suddenly a storm strikes and, in a brilliant sequence, the ship is wrecked. Alex (freckle-faced Kelly Reno, illustrated), and a handsome steed, the sole survivors, are washed up on a picturesque island. There they develop an intimate relationship, with debut director Carroll Ballard wringing each scene for every teardrop. Rescued by fishermen, the young Crusoe and his black horse, Friday, find it difficult to adapt to life in Flushing, New York, at the house of the boy's mother (Teri Garr). But, helped by a retired racehorse trainer (Mickey Rooney), and a pedlar (Clarence Muse in his last film), 'The Black' wins a race at Santa Anita. Other roles in the Fred Roos–Tom Sternberg production went to Hoyt Axton, Michael Higgins, Ed McNamara and Dogmi Larbi. Three screenwriters (Melissa Mathison, Jeanne Rosenberg and William D. Witliff) did an expert job in adapting Walter Farley's best-selling 1941 book. A sequel to this successful family picture, *The Black Stallion Returns*, was released in 1983. (OMNI-ZOETROPE)

△**Last Embrace** was another Hitchcock homage from the younger generation of directors. Jonathan Demme's technique, though a trifle studied, created a suspenseful and nightmarish atmosphere which The Master himself might not have disowned. Eerie music by Miklos Rozsa (Oscar-winner for *Spellbound*, 1945), a brief appearance by Demme as a stranger on a train, and a shower curtain pulled back suddenly, all made Hitchcockian connections. The script by David Shaber, based on Murray Teigh Bloom's novel *The 13th Man*, involved government agent Roy Scheider (left) recovering from a nervous breakdown. The paranoid Scheider finds a note containing an ancient Hebrew death threat. It is no help to his neurosis to discover that five other recipients of similar notes have died. All is revealed, more or less, in the end, when the 'Avenger of Blood' falls over Niagara Falls. Others in Michael Taylor and Dan Wigutow's production were Janet Margolin, John Glover, Sam Levene (right), Charles Napier, Jaqueline Brooes, David Margulies, and Christopher Walken, with slicked back hair, in a cameo as Scheider's boss. (TAYLOR-WIGUTOW)

▷The next James Bond movie was to have been *For Your Eyes Only* (1981), but because of the space craze generated by *Star Wars* (20th Century-Fox, 1977), **Moonraker**, based on the one Ian Fleming novel that fitted, hit the screens instead. It cost over $30 million, more than any other in the series, and also topped the box-office takings of the ten previous Bonds. Bigger and worse, Albert R. Broccoli's production was a disappointing follow-up to *The Spy Who Loved Me* (1977), from which the steel-toothed Jaws (Richard Kiel) was extracted. However, screenwriter Christopher Wood made the fatal mistake of softening this monster's character, even giving him a tiny girlfriend (Blanche Ravelec). Nothing under Lewis Gilbert's direction lived up to the pre-credit sequence with Bond (Roger Moore, illustrated) and Jaws grappling for one parachute as they freefall from a plane. The rest was *déjà vu* time, except that instead of underground, undersea or on land, the climactic battle takes place on board a space ship. On the way, Bond beds a French beauty (Corinne Clery) who is eaten by two Doberman Pinschers, makes it with CIA agent Holly Goodhead (Lois Chiles, illustrated), and causes havoc (but little hilarity) with his high-powered motorized gondola in Venice. The film, most of which was made in France for tax reasons, also featured Emily Bolton, Toshiro Suga, Irka Bochenko, Geoffrey Keen, regulars Lois Maxwell and Desmond Llewelyn, Brian Keith, Walter Gotell and Bernard Lee (as 'M' for the last time before his death). Michael Lonsdale playing the suave villain, Hugo Drax, who plans to nerve-gas the world and create a community of pure Aryan astronauts, says to Bond, 'You reappear with the inevitability of an unloved season.' How right he was! (EON)

◁In **The Passage**, to paraphrase a line from *To Be Or Not To Be* (1942), the brave resistance fighters did the concentrating, and the Nazis did the camping, particularly Malcolm McDowell's milk-drinking SS captain (right) who wears a swastika on his jockstrap. The former were represented by Basque shepherd Anthony Quinn, speaking in broken English, Michael Lonsdale and Marcel Bozzuffi as French *maquis*, and Christopher Lee (left) as a gypsy. The tedious screenplay by Bruce Nicolaysen, based on his book *Perilous Passage*, followed the attempt of an American scientist (a wasted James Mason), his wife (Patricia Neal), who dies early on, his son (Paul Clemens), and his daughter (Kay Lenz), raped by McDowell, to get across the Pyrenees from occupied France to Spain. John Quested's production was directed in an anonymous manner by J. Lee Thompson. (HEMDALE)

1979 OTHER RELEASES

Americathon
In a morally and financially bankrupt America in 1998, a national telethon is launched, but is disrupted by a presidential aide conspiring with the United Hebrab Republic (Arabs and Jews) to take over the USA. Peter Riegert, Harvey Korman, Fred Willard, Zane Buzby, Nancy Morgan, John Ritter. *Dir* Neil Israel. *Pro* Joe Roth. LORIMAR

Crime Busters (aka **Two Super Cops**)
An aspiring but incompetent criminal and his sidekick find themselves in the police force and end up raiding their own offices by mistake. Terence Hill, Bud Spencer, Laura Gemser, Luciano Catenacci. *Dir* E.B. Clucher. *Pro* none credited. (Italy) TRITONE CINEMATOGRAPHICA/TOTA

The Fish That Saved Pittsburgh
A Pittsburgh basketball team is a washout until an astrologer helps them on a winning streak. Julius Erving, Jonathan Winters, Meadowlark Lemon, Jack Kehoe, Margaret Avery, James Bond III, Stockard Channing. *Dir* Gilbert Moses. *Pro* Gary Stromberg, David Dashev. LORIMAR

Roller Boogie
A mob tries to close down a roller disco, but the kids rally together to rout the baddies so that they can proceed with their roller boogie contest. Linda Blair, Jim Bray, Beverly Garland, Roger Perry, Jimmy Van Patten. *Dir* Mark L. Lester. *Pro* Bruce Cohn Curtis. IRWIN YABLANS

Travels With Anita (aka **A Trip With Anita**, aka **Lovers And Liars**)
A young bank executive and his American girlfriend travel from Rome to Pisa to get to his father's deathbed, but they are too late. Goldie Hawn, Giancarlo Giannini, Claudine Auger, Aurore Clement, Renzo Montagnani. *Dir* Mario Monicelli. *Pro* Alberto Grimaldi. (Italy/USA) PEA

△Almost three decades after his *Sunset Boulevard* (Paramount, 1950), producer-director Billy Wilder revisited similar territory in **Fedora**. An ageing William Holden (illustrated), a survivor from the earlier view of a changing Hollywood, played producer Barry Detweiler trying to put a movie together with tax shelter money (as Wilder himself had to do to make the picture). Detweiler travels to Corfu to try to lure the mysteriously unchanged Garboesque star Fedora (Marthe Keller, illustrated) out of her long retirement to star in his projected adaptation of *Anna Karenina*. He manages to penetrate the well-guarded Villa Calypso where she lives under the watchful eye of the Countess Sobryanski (Hildegarde Kneff), her plastic surgeon (Jose Ferrer), secretary (Frances Sternhagen) and chauffeur (Gottfried

John). Why is Fedora being kept a prisoner? Why is she on drugs? Why does she commit suicide by throwing herself in front of a train? These intriguing questions were answered at the twist ending with a lot of barbed and bitter moments on the way in the script by Wilder and I.A.L. Diamond (based on a story in Tom Tryon's *Crowned Heads*). However, modern audiences did not respond to a film so out of sympathy with the New Hollywood. Unintentionally reflecting the latter was the unconvincing casting of Miss Keller as a star 'who lit up the screens of the world for over 40 years,' and the presence of Michael York representing the great male star of the late 70s. Also cast were Mario Adorf, Hans Jaray, Arlene Francis, and Henry Fonda in a guest spot. (GERIA/BAVARIA ATELIER)

Thirty-five-year-old director Michael Cimino approached UA in 1978 with the suggestion of making *The Fountainhead*, from Ayn Rand's best-selling novel about an egomaniac architect who was played in the 1949 Warner Bros. version by Gary Cooper. UA rejected the idea, but asked Cimino to come up with something else. Cimino's first film, *Thunderbolt And Lightfoot* (1974), starring Clint Eastwood and made in 47 days, had done well for UA, and the yet to be released *The Deer Hunter* (Universal, 1978) was said to be a possible winner. Cimino then submitted the idea for a Western called *The Johnson County Wars* or *Pay Dirt*. The company gave the go-ahead for a middle budget movie of $7.5 million, and the title was changed to *Heaven's Gate*. It turned out to be one of the most fateful decisions in UA's history.

The complexion of the movie industry had been changing radically since the 70s. The names and logos of the major studios that were so integral a part of the golden years of Hollywood were still visible, but most of them had become swallowed up by vast industrial conglomerates. Paramount was owned by Gulf and Western, Columbia by Coca Cola, and UA by Transamerica's holdings. The identity and individual personality of the studios had become blurred, making it almost impossible for the film buff to distinguish between the product of one and another. The market place had also changed drastically. As producer Sam Goldwyn Jr said, 'Movie audiences have become like political groups. They are much more splintered than they used to be.'

Although some films which were aimed at more mature audiences did well at the box office – films such as *On Golden Pond* (Universal, 1981), *The French Lieutenant's Woman* (UA, 1981), *Gandhi* (Columbia, 1982), *Tootsie* (Columbia, 1982), *Terms Of Endearment* (Paramount, 1983) and Woody Allen's movies, most producers targeted the 14 to 19 age group that made up the bulk of audiences. 'Something very frightening is happening in Hollywood,' commented director James L. Brooks 'Getting 15-year-old kids in a room and making pictures as a result of market research on them. I can't tell you how frightening it is.' Consequently the big money-spinners were 20th Century-Fox's *Star Wars* sequels, *The Empire Strikes Back* (1980) and *The Return Of the Jedi* (1983), Paramount's *Raiders Of The Lost Ark* (1981) and its sequel *Indiana Jones And The Temple Of Doom* (1983), Universal's *E.T.* (1982) and *Back To The Future* (1985), and the *Rocky* and *Superman* pictures.

War Games (1983), one of UA's blockbusters, started shooting as a powerful message movie about the risks of nuclear war or accident. Market research informed the company that the prospects for a film on the nuclear holocaust were bleak. The original director was fired, and the emphasis of the film shifted from war to games. As Charles Schreger wrote in the *Los Angeles Times*, 'Quite simply, UA, a company that was viewed historically as vibrant and innovative, has fallen into the hands of the money men.'

It was against this ethos that Cimino commenced on his 'middle budget' adult Western in April 1979. UA was hoping to release the movie at Christmas of the same year. It soon became clear that not only would this not be feasible, but that the production was galloping way over budget. It didn't help matters that Cimino insisted on personal expenses of $2,000 a week. UA president Andy Albeck began to get nervous. Although Walter Wanger used to say, 'there is nothing so cheap as a hit', *Heaven's Gate* would have to earn at least $100 million at the box-office not to lose money. Albeck

remembered the failure of the last UA-made Western, *Comes A Horseman* (1978) which featured Jane Fonda, and knew that Westerns had virtually disappeared from the screens. But he was certainly hoping for a hit for Christmas 1980. Neither Lorimar nor MGM movies were contributing much to UA's coffers. Cimino was thus put under pressure to hasten the schedule and limit the rising costs. The conflict was highlighted in the press. *Time* magazine had an article on the film called 'The Making Of Apocalypse Next–History's Most Expensive Minor Footnote' (referring to the Johnson County wars in Wyoming in the 1890s, the subject of the picture). The *LA Times* carried a story headlined 'Shootout at the UA Corral. Artists vs Accountants.'

On 18 November, 1980, *Heaven's Gate* opened in New York to almost universally hostile reviews and enjoyed only a brief, limited-release run. The critic of the *New York Times* wrote, '*Heaven's Gate* fails so completely you might suspect Mr Cimino sold his soul to the Devil to obtain the success of *The Deer Hunter* and the Devil has just come around to collect.' David Denby in *New York* magazine blamed 'the inept leadership at UA – a group of men who apparently cannot read a script, who lack the confidence to act on their intuitions and doubts, and who watched Cimino dissipate a fortune on nonsense.' Pauline Kael considered that 'the press had been waiting to ambush Cimino. His public remarks over the past couple of years since *The Deer Hunter* had invited it, and so had the cost of *Heaven's Gate*.' Whoever was to blame for the film's reception, Albeck took the unprecedented step of withdrawing the movie and getting Cimino to cut the 225-minute film down to a more reasonable length. Unfortunately, on general release in April 1981, running at 150 minutes, it did badly. Of its $44 million cost, only $1½ million was recovered at the US box-office.

Despite the shock waves that ran through UA and the Transamerica building in San Francisco, major investments had gone ahead on *The French Lieutenant's Woman* (1981), Barbra Streisand's musical *Yentl* (1983), and surefire hits like the James Bond movie *For Your Eyes Only* (1981) and *Rocky III* (1982). UA seemed secure, but rumours about the company's future abounded. Chairman James Harvey told the *LA Times*, 'We're absolutely not going to sell. We have turned numerous inquiries down. One movie is not going to affect management changes and reconstructing.' A few months later, in February 1981, Albeck resigned and Norbert Auerbach, former senior vice-president of foreign distribution, became president. At a press conference which was held after the screening of *Heaven's Gate* at the Cannes Film Festival in May 1981, Auerbach, holding a stuffed lion under his arm, announced that MGM had bought UA. The new company would be known as MGM/UA Entertainment Corporation.

Since the takeover, MGM/UA under the majority ownership of Kirk Kerkorian, has had its share of downs and disappointments including a series of flops from MGM, and the devastating fire at the Grand Hotel in Las Vegas. In 1982, the company imposed rigid budget limits on productions and, after a multitude of executive shuffles, Alan Ladd Jr was named as chairman in March 1985. United Artists have kept their separate identity as a film presenting company within the conglomerate, although their pictures are introduced by Leo's familiar roar. But films such as the James Bond *A View To A Kill* (1985) and *Rocky IV* (1985) have served to keep the name of United Artists alive for the cinemagoing public.

1980

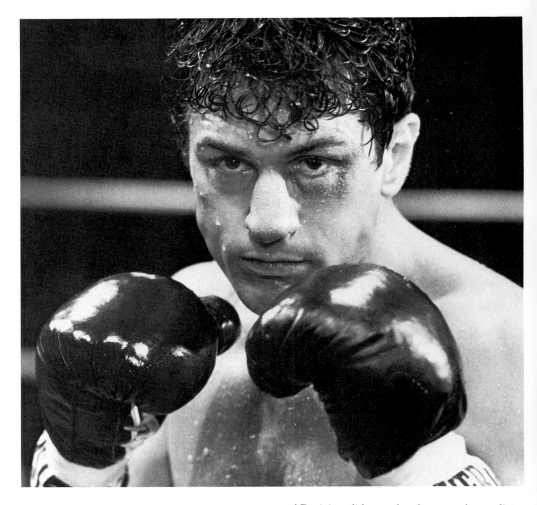

▷Martin Scorsese, director of **Raging Bull**, his biopic of 1949 World Middleweight boxing champion Jake La Motta, explained that, 'The ring is a kind of madness, and it seems to me that the man had to go back through his mother's womb again in order to achieve a kind of sanity. My picture's really about that process, not boxing.' Now we know! Actually the Irwin Winkler–Robert Chartoff production told us little more than that La Motta (Robert De Niro, illustrated) was a foul-mouthed, repugnant bully, although it revealed something of the close-knit Italo-American community that produced La Motta, Scorsese and De Niro, and the underlying sentimental code of masculinity. The demeanour of La Motta outside the ring was the main concern of the screenplay by Paul Schrader and Mardik Martin, but the 12 minutes (out of 129) of brutal boxing was treated as an excuse for a series of powerful black and white images. However, the structure of the film paralleled the monotony of the main character, alternating between his pro fights and his domestic ones with his wife (Cathy Moriarty) and brother (Joe Pesci). To show the now bloated ex-champion introducing strippers in a sleazy nightclub in 1964, De Niro gained a horrifying 60lbs in four months and then had to take it all off again. There are those who think this self-inflicted punishment was vindicated by his extraordinary Oscar-winning performance. Other roles went to Frank Vincent, Nicholas Colosanto, Theresa Saldana, Frank Adonis and Johnny Barnes (as 'Sugar Ray' Robinson). (CHARTOFF-WINKLER)

◁**Cruising** did not take place on a luxury liner, but delved into the New York gay underworld. This tawdry, sensationalist piece of film-making not only represented homosexuals as depraved and dangerous, but the police were seen as stupid and brutal. However, it was William Friedkin's direction and script that actually had all the violent and degrading traits of the characters represented. Al Pacino (centre) played the innocent cop chosen by his chief (Paul Sorvino) to search out a sadistic killer of gays. Pacino puts on a T-shirt and leather jacket and goes on the track of the murderer through every S/M joint in town. By the time he nails the culprit, he's as kinky as everyone else. Karen Allen, Richard Cox, Don Scardino, Joe Spinell, Jay Avocone, Randy Jurgensen and Barton Heyman were also in it. Most of the public did not bother to cross the gay picket lines outside US theatres to see the Jerry Weintraub production. (LORIMAR)

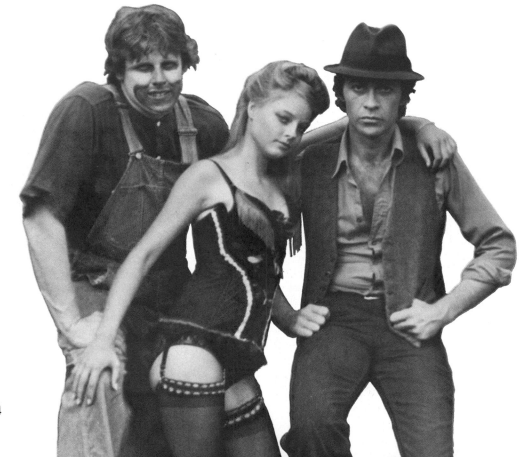

◁**Carny** suffered by comparison with *Nightmare Alley* (20th Century-Fox, 1947) and other earlier movies set in the travelling show milieu but, on its own terms, Robbie Robertson's production was an interesting look at an American sub-culture. The producer himself (right) played the con man manager of a seedy carnival making its way through the South. His best friend is 'bozo' Gary Busey (left), whose job is to taunt customers into throwing baseballs at him and dump him in water. A 17-year-old runaway, Jodie Foster (centre), joins up with them, thereby creating an uneasy three-way relationship. The criminal sub-plot in the screenplay by Thomas Baum (story by Robert and Phoebe Kaylor) about local mobsters trying to cut in on the show's proceeds led into more conventional film territory, but former documentary director Robert Kaylor kept most of it nervously atmospheric. Meg Foster, Kenneth McMillan, Elisha Cook Jr, Theodore Wilson, John Lehne and Bert Remsen had other roles. (LORIMAR)

▽'We started robbing banks and we just kept going,' was the extent of the motivation given to the notorious James gang in **The Long Riders** in the unfocused screenplay by Bill Bryden and Steven Phillip Smith, assisted by the director Walter Hill and two of its stars, Stacy and James Keach. The subject was better treated in *The Great Northfield Minnesota Raid* (Universal, 1971), which also tried for accurate period detail and a symbolic treatment of the outlaw's existence. Hill's excessive use of slow-motion, the episodic and obscure narrative, and distorted sound, failed to inject new life into old material. The main interest in Tim Zinnemann's production was the casting of four sets of real brothers in the main roles: David (centre), Keith (right) and Robert Carradine (left) as Cole, Jim and Bob Younger, Stacy and James Keach as Frank and Jesse James, Dennis and Randy Quaid as Ed and Clell Miller, and Christopher and Nicholas Guest as Charlie and Bob Ford. Oh brother! Not related to the leads were Kevin Brophy, Harry Carey Jr, Shelby Leverington and Felice Orlandi. (HUKA)

△Psychedelia, anti-Vietnam war protests, the Civil Rights movement, student radicalization, and the music of The Rolling Stones formed the nostalgic late 60s background to **A Small Circle Of Friends**. Debut director Rob Cohen went at it with great gusto but little depth as the characters tore through the tumultuous era, usually at the tops of their voices. Ezra Sack's screenplay, based on his college days, seemed too close to the subject and too enamoured with the three principals, Harvard undergraduates all: hip Brad Davis (right) with journalistic ambitions, Karen Allen (centre), dabbling in painting, and straight medical student Jameson Parker (left). They get together and set up a *menage-à-trois*, lose their ideals, and Davis his life in a bombing by an ex-classmate turned terrorist (John Friedrich). Others in Tim Zinnemann's production were Shelley Long, Gary Springer, Craig Richard Nelson, Harry Caesar and Nan Martin. (SMALL CIRCLE OF FRIENDS INC)

△**The Final Countdown** considered what might have happened if an American battleship had destroyed the Japanese task force before Pearl Harbor was attacked. This was demonstrated in a time-warp screenplay by Gerry Davis, Thomas Hunter, Peter Powell and David Ambrose (story by the last three) in which the USS Nimitz in 1980 is suddenly enveloped by a strange storm and spirited back to December 1941. Alas, the idea was more interesting than the execution under Don Taylor's flat direction. When the film was not taking us on a documentary tour of the modern nuclear-powered aircraft carrier, it concentrated on windy debates on the ethics of tampering with history. The cast consisted of liberal captain Kirk Douglas, hot-head officer Ron O'Neal, intellectual Martin Sheen, war expert James Farentino, ambitious senator Charles Durning, his empty-headed assistant Katharine Ross (illustrated), and crazed Japanese pilot Soon-Teck Oh (illustrated). Peter Vincent Douglas, son of Kirk, produced. (BRYNA)

▽Edward Di Lorenzo's screenplay for **The Idolmaker** was loosely based on the career of Bob Marcucci who can be blamed (or praised) for grooming 50s pop singers Frankie Avalon and Fabian for stardom. However, all director Taylor Hackford's admirable efforts to capture the detail and atmosphere of the period were shattered by the 80s rock 'n' roll numbers inserted to appeal to today's teens. Not a bad decision by producers Gene Kirkwood and Howard W. Koch Jr from a box-office point of view. Ray Sharkey (left) gave a forceful performance as the manipulative manager of singing stars Paul Land (right) and Peter Gallagher, both acceptable lookalikes for Avalon and Fabian. At the corny upbeat ending, after his girl (Tovah Feldshuh) who is the editor of Teen Scene, and his protegées, have left him, Sharkey finds his true self by singing his own songs. Also featured were Joe Pantoliano, Maureen McCormick, John Aprea, Richard Bright, Olympia Dukakis and Steven Apostolee Peck. (KOCH-KIRKWOOD)

△The problem with films like **Motel Hell**, which send up horror B movies, is that the real thing is usually far funnier. Still, there were quite a few intentional laughs in the screenplay by producers Robert and Steven-Charles Jaffe, and in the delightfully straight performance from Rory Calhoun (left) who runs the out of the way Motel Hello (the final neon 'o' flickering). With his sister (Nancy Parsons, right) and younger brother (Paul Linke), he also sells home-cured meat, the origin of which is a number of unfortunate passing motorists and unsuspecting guests. Among the potential T-bone steaks were motorcyclist Nina Axelrod, kinky couple Elaine Joyce and Dick Curtis, the Reverend Wolfman Jack, hookers Monique St Pierre and Rosanne Katon, and hippy musicians called Ivan and the Terribles (Michael Melvin, John Ratzenberger, Marc Silver and Victoria Hartman). Calhoun dies in the end with a chainsaw sticking out of his side. Director Kevin Connor managed to give the movie a certain visual flair, even though it was both less hilarious and less chilling than it pretended to be. (CAMP HILL)

▷'Art and masturbation are two areas in which I am absolutely expert,' says Woody Allen (illustrated) in **Stardust Memories**, a film that was a good example of both skills. Allen, who directed, played a film director trying to make a serious movie despite producers' constant demands for comedy. Invited to a retrospective festival of his work at the Stardust Hotel in upstate New York, he is importuned by hordes of critics and fans as he tries to live out his private life, past, present and in dreams, with his neurotic ex-girlfriend (an emaciated Charlotte Rampling), a musician he meets at the hotel (Jessica Harper), and a divorced Frenchwoman (Marie-Christine Barrault). Few pictures have so subjectively portrayed how the famous see the fans, bores and sycophants that pester them, but the point was hammered home relentlessly, and where Allen's other films were astringent, this one was merely sour. Whereas *Interiors* (1978) was a fine tribute to Ingmar Bergman, this one filched Fellini's stylistic devices to make a hollow statement. Of course, Woody's screenplay contained witty nuggets, and Gordon Willis' black and white photography was effective. Also in Robert Greenhut's production were Tony Roberts, John Rothman, Anne DeSalvo, David Lipman, Joan Neuman, Louise Lasser and Helen Hanft. UA studio executive Andy Albeck had one telling line, 'He's not funny anymore.' It was a rather downbeat end to Woody's long and fruitful association with United Artists, begun in 1965. He decided to follow his old patron, Arthur Krim, to Orion. (JACK ROLLINS–CHARLES H. JOFFE)

◁'I still can't believe you ain't heard of Alice Cooper! Don't you read T-shirts?' says a stunned 16-year-old groupie calling herself Lola Bouillabaisse (Kaki Hunter) in **Roadie**, a film strictly for T-shirt readers and rock 'n' roll fanatics. There was music from Alice himself, Debbie Harry of Blondie (illustrated), Roy Orbison, Hank Williams Jr and Alvin Grow among others, although portly pop star Meat Loaf (illustrated) had a non-musical role. He played a Texas hick by the name of Travis W. Redfish who is unwittingly recruited as general dogsbody, otherwise known as a 'roadie', for a touring band. After getting involved in barroom brawls and car chases, and meeting an array of weirdos in the great Rock 'n' Roll Circus run by Mohammed Johnson (Don Cornelius), he realizes that there's no place like home, a sentiment echoed by all intelligent spectators. The screenplay was by Big Boy Medlin and Michael Ventura (story by Medlin, Ventura, Zalman King and the director Alan Rudolph). Surprisingly, the ungainly Meat Loaf proved himself less of a ham than some of his co-players, who included Art Carney, Gaillard Sartain, Rhonda Bates, Joe Spano and Richard Marion. Carolyn Pfeiffer was responsible for the rather coarse-grained production. (ALIVE ENTERPRISES/VIVANT)

△**Foxes** was a pulp piece manufactured for the new teen market by producers David Puttnam and Gerald Ayres, written by the latter and directed by Adrian Lyne. It was really a 60s-type vehicle dressed up in 80s permissiveness, although Sandra Dee had never behaved like any of these four teenage girls sharing an apartment in suburban LA. Cherie Currie (2nd right) takes drugs and is forced to do some hooking on the side. Marilyn Kagan (2nd left) is unhappy and overweight, Kandice Stroh (left) is a lying,

confused flirt and Jodie Foster (right) from a broken home, acts as mother to the other three. The young actresses managed to transcend some of the melodramatic and slushy material in a script that kept shifting between them and not allowing much exploration of the characters. Others cast were Sally Kellerman and Adam Faith (as Jodie's divorced parents), Scott Baio and Randy Quaid (as boyfriends), Lois Smith, Jon Sloan, Jill Barrie Bogart and Mary Margaret Lewis. (CASABLANCA RECORD/FILMWORKS)

▷Director Sam Fuller had carried the story of **The Big Red One**, his first film for seven years, around in his head ever since his experiences as a GI in Europe during World War II. The war was reduced to its bloody essentials in Fuller's direct, no-holds-barred method, and his screenplay made no attempt to delve too deeply into the characters of the five foot soldiers through whose eyes a series of battles are seen. They are a nameless sergeant (Lee Marvin, illustrated) and four young recruits (Mark Hamill, Robert Carradine, Bobby DiCicco and Kelly Ward). Stephane Audran, Siegfried Rauch, Serge Marquand, Charles Macaulay and Alain Doutey briefly crossed their paths of glory and guts. Gene Corman's production was filmed almost entirely on location in Israel. (LORIMAR)

1980 OTHER RELEASES

Happy Birthday, Gemini
A Harvard educated son of a lower class Philadelphia-Italian family spurns his fiancée because he's in love with her brother. Madeleine Kahn, Rita Moreno, Robert Viharo, Alan Rosenberg, Sarah Holcomb, David Marshall Grant. *Dir* Richard Benner. *Pro* Rupert Hitzig. KING/HITZIG

Leo And Loree
A love affair between an actor and actress who are struggling to make it in Hollywood is strained because the girl has the advantage of a head start, being the daughter of an established and famous star. Donny Most, Linda Purl, David Huffman, Jerry Paris, Shannon Farnon, Allan Rich. *Dir* Jerry Paris. *Pro* Jim Begg. BIG H

Those Lips, Those Eyes
The backstage life in summer stock of an actor only good enough for tank towns, a stagestruck prop boy, and a chorus girl. Frank Langella, Glynnis O'Connor, Thomas Hulce, George Morfogen, Jerry Stiller. *Dir* Michael Pressman. *Pro* Steven-Charles Jaffe, Michael Pressman. HERB JAFFE

Windows
A bitter lesbian spies on a shy, young girl with a telescope and tape recorder, and has her frightened by a knife-brandishing brute. Talia Shire, Joseph Cortese, Elizabeth Ashley, Kay Medford. *Dir* Gordon Willis. *Pro* Michael Lobell. LOBELL

1981

▽The complex structure of John Fowles' 1969 bestseller, a Victorian romance told by a 20th-century narrator and having two endings, made the filming of **The French Lieutenant's Woman** rather problematical. The solution of director Karel Reisz and screenwriter Harold Pinter was to use a film-within-a film format in order to retain a semblance of the book's blending of Victorian and modern sensibilities. Thus Mike (Jeremy Irons) and Anna (Meryl Streep) are having an affair while playing the leads in a movie in which he is an English gentleman who abandons his fiancée (Lindsay Baxter) for Streep, the mysterious woman of the title. The two stories unfolded in tandem, but the modern one was banal and added little to the Victorian pastiche. The film ended up a polite, cold, handsomely mounted exercise, shot on location in Lyme Regis, the setting of the novel, with Freddie Francis' glowing photography capturing the feel of a quiet seaside town in the 1890s. The appeal of Leon Clore's production to a wide audience resided in the personalities of the two stars (illustrated) in the four roles. Irons, unsmiling as ever, suggested the passion, but failed to make much distinction between his two characters. Streep, on the other hand, brilliantly contrasted the pale, red-haired Victorian beauty with the cool, sophisticated American actress of the modern sequences. Others in the cast were Leo McKern, Patience Collier, Hilton McRae, Emily Morgan, Penelope Wilton, Peter Vaughan, David Warner and Charlotte Mitchell. (JUNTPAER)

△Based on John Gregory Dunne's best-seller, in turn inspired by LA's celebrated Black Dahlia murder case of the 40s involving corrupt cops, crooked politicians, prostitution, pornography and the Catholic Church, **True Confessions** failed to deliver the expected wallop. This was due mainly to the flat direction of Ulu Grosbard, rather than to the screenplay by Dunne and his wife Joan Didion, or to the two strong leads, Robert Duvall (right) and Robert De Niro (left). The action continually switched between the latter two who played brothers – one a policeman and the other a priest – making the point that the cop has the instincts of a priest and vice versa. Duvall's investigation into the murder of a whore leads to a cover-up by the Church and, finally, to 'Catholic layman of the year' Charles Durning. Cyril Cusack, Burgess Meredith, Kenneth McMillan, Ed Flanders, Rose Gregorio, Dan Hedaya and Jeanette Nolan made up the cast. Despite the two stars, the public stayed away from Irwin Winkler and Robert Chartoff's production. (CHARTOFF-WINKLER)

△Czechoslovakian *emigré* director Ivan Passer's **Cutter's Way** (aka **Cutter And Bone**) was his most cohesive American movie. Jeffrey Alan Fiskin's screenplay, left open-ended, was a slightly perverse tale of a horribly crippled Vietnam vet (John Heard) with one eye, one leg and half an arm, seeking revenge on a local California bigwig (Stephen Elliott) whom he suspects of having murdered a teenage girl. The trappings of *film noir* were used effectively to create a mood piece and character study to overcome the deficiencies of the plot. Heard (illustrated), Jeff Bridges as his buddy, and Lisa Eichhorn as his alcoholic wife, gave three fervid performances. Also in Paul R. Gurian's rather neglected production were Ann Dusenberry, Arthur Rosenberg, Nina Van Pallandt, Patricia Donahue and Geraldine Baron. (GURIAN)

△'So the war's come down to the two of us,' says British patriot Kate Nelligan in **Eye Of The Needle** as she's about to shoot Nazi spy Donald Sutherland (illustrated) before he can escape to his U-boat. World War II, actually, came down to being useful fodder for this predictable, workmanlike adventure yarn of the kind done far better in the 40s. Needing the flair of a Fritz Lang or a Michael Powell, the Stephen Friedman production got the heavy hand of director Richard Marquand. Stanley Mann's screenplay, a slimmed down version of the Ken Follett 1978 best-seller, followed the clandestine doings of cold, blue-eyed anti-hero Sutherland, Berlin's most reliable spy. He is forced by a storm to land on a remote island off the Scottish coast where he is given hospitality by Nelligan (simmering expertly) and her bitter, crippled ex-pilot husband, Christopher Cazenove. Seduced by the sex-starved wife, the Nazi murders the husband but is prevented by her from transmitting a vital message. The adequate supporting cast also included Stephen MacKenna, Phillip Martin Brown, George Belbin, Faith Brook and Ian Bannen. (KINGS ROAD)

△After his exploits in outer space in *Moonraker* (1979), James Bond alias Roger Moore (right) came down to earth again in **For Your Eyes Only** with his innuendos, sexual prowess, sporting abilities and box-office attraction still intact. The stunts involved the obligatory spectacular car chase, plus acrobatics on skis and skates, as well as scuba diving in shark-infested waters. Richard Maibaum and Michael G. Wilson's screenplay, bearing no resemblance to the Ian Fleming novel of the same name, involved the attempts of MI5 and the KGB to get hold of an anti-Polaris device perfected by two Greek millionaires (Topol, left, and Julian Glover). The resourceful heroine (Carole Bouquet) took most of the Albert R. Broccoli production's two hours to get to the boudoir with 007. The high-jinks were directed with no-nonsense competence by John Glen, former second-unit director and editor of previous Bond movies. Also cast were Lynn-Holly Johnson, Cassandra Harris, Jill Bennett, Michael Gothard, Jack Hedley, Lois Maxwell, Desmond Llewelyn, Geoffrey Keen, and Janet Brown and John Wells as British Prime Minister Thatcher and her husband Dennis in a fadeout joke. (EON)

◁James Caan (illustrated) specialized in heists of precious stones in **Thief** (GB: **Violent Streets**), and director Michael Mann was plainly fascinated by every last detail of his criminal activities. Audiences and critics were less so. Mann's screenplay, based on the novel *The Home Invaders* by Frank Hohimer, also used thieving to make a rather pretentious comment on the Individual vs The System. Caan unwillingly joins forces with gang boss Robert Prosky of the Chicago underworld, although it means losing his independence. Meanwhile his wife, Tuesday Weld, hopes to adopt a child as part of the couple's dream for a better future. But pathos turns to bathos at the final shootout between Caan and his erstwhile partner in crime. Jerry Bruckheimer and Ronnie Caan's production also featured Willie Nelson, James Belushi, Tom Signorelli, Dennis Farina, Nick Nickeas and John Santucci. (MANN/CAAN)

▷**Heaven's Gate** was not only one of the most expensive floperoos of all time, it virtually put an end to the United Artists Story. The budget of director Michael Cimino's folly escalated from $11 million to over $35 million, but only recovered about $1½ million at the box office. After it was lambasted by the critics on its first showing, UA got it reduced from 225 minutes to 148. As a result, the sprawling, confused narrative (screenplay by Cimino) became even more incoherent. By the time it re-surfaced at its original length two years later, audiences either stayed away or were left cold by it. Cimino, his producer Joann Carelli and cinematographer Vilmos Zsigmond had plainly set out to make a masterpiece of epic proportions. There was hardly a sequence without smoke, steam or clouds billowing by, or crowds striking postures, or characters trying to be significant. After an irrelevant prologue (filmed at Harvard at Oxford), the film shifted to the Wyoming of 1890 where a group of cattlemen, headed by Sam Waterston, are convinced their herds are being rustled by immigrant settlers. A death list of 125 poor immigrants in Johnson County is drawn up, and a bunch of hit men is hired to murder them. One of the hired killers, Christopher Walken, is a friend of the marshal, Kris Kristofferson (illustrated), opposed to the killings, and both in love with the local Madam, Isabelle Huppert (illustrated). ('What's a nice girl like her …?') The climax comes in a bloody confrontation between the cattle barons and the immigrants. There was a virtuoso sweep to some of the panoramic ensembles, but the motivations of the characters remained hazy and the immigrants, on whose side the film undoubtedly was, remained impersonal. Others who popped up from time to time were John Hurt, Brad Dourif, Joseph Cotten, Jeff Bridges, Ronnie Hawkins, Geoffrey Lewis and Roseanne Vela. (PARTISAN)

▽Set in 'One Zillion B.C. October 9th', **Caveman** was a truly infantile Stone Age send-up whose only likable feature was a cuddly dinosaur. The grunting screenplay by Rudy de Luca and director Carl Gottlieb contained about 15 words of dialogue, two of them being 'shit' and 'ca-ca'. Slightly more sophisticated were: predictable take-offs of *10*, *The Bridge On The River Kwai*, and *2001*; the invention of the first fried egg by accidentally dropping a prehistoric monster's egg into a volcano; Ringo Starr creating rock music with real rocks. The plot involved the conflict of two tribes, The Misfit Tribe made up of Ringo (left), Dennis Quaid (right), Shelley Long (centre), Jack Gilford, Cork Hubbert and Mark King, and The Hostile Tribe which included John Matuszak, Barbara Bach, Avery Schreiber and Miguel Angel Fuentes. Best to see Lawrence Turman and David Foster's production when stoned. (TURMAN-FOSTER)

▽Sensitive and soft-featured Christopher Walken (2nd left) had an uphill task convincing as a tough, battle-scarred mercenary in **The Dogs Of War**, a macho movie of machinations in a West African banana republic. As usual, the Americans and Europeans, good and evil, dominated the proceedings, while the black Africans were left as mere puppets. TV recruit John Irwin directed, managing to create a recognizable though fictional country, but any attempt to probe behind the headlines of newspapers in Gary DeVore and George Malko's screenplay, derived from Frederick Forsyth's bestseller, was blasted away by the conventions of the action picture. Walken is paid to help organize a coup to get rid of a corrupt president (Ilarrio Bisi Pedro), and instal a new democratic leader (Winston Ntshona). Colin Blakely was best as an alcoholic British journalist in a cast which also included Hugh Millais, Tom Berenger (2nd right), Paul Freeman (left), Jean-Francois Stevenin (right), JoBeth Williams and Robert Urquhart. Larry DeWaay's production was severely cut in the US, but box-office remained solid. (SILVERWOLD)

1981 OTHER RELEASES

Deadly Blessing
A young widow is menaced by members of the Hittites, a severe rural religious sect. Maren Jensen, Susan Buckner, Sharon Stone, Jeff East, Ernest Borgnine, Lisa Hartman, Lois Nettleton. *Dir* Wes Craven. *Pro* Micheline and Max Keller, Pat Herkovic. INTERPLANETARY/POLYGRAM

Just A Gigolo (orig: **Schoner Gigolo, Armer Gigolo**)
The downward progress of a Prussian aristocrat living and loving in the decadent Berlin of the 20s. Marlene Dietrich, David Bowie, Maria Schell, Kim Novak, David Hemmings, Curt Jurgens, Sydne Rome. *Dir* David Hemmings. *Pro* Rolf Thiele. (West Germany) LEGUAN

▽Alfred Hitchcock has inspired as many films as there are corpses in his movies, and **Still Of The Night** was one of the deadest. Director Robert Benton had long planned a homage to the master of suspense to be called *Stab* and to star Lily Tomlin. In the event, after Meryl Streep's triumph in Benton's *Kramer vs Kramer* (Columbia, 1979), he miscast her as one of Hitchcock's 'cool blonde' types suspected by shrink Roy Scheider (illustrated) of being a throat-slashing psychopath. He is investigating the murder of a patient, a married man with whom the expressionless Streep (illustrated) had been having an affair. The real killer was not difficult to spot in the story by David Newman and Benton, while the latter's screenplay was cluttered with Hitchcockian references to a rear window, a nasty bird, a spellbinding dream, and someone suffering from vertigo, providing a few pleasures for film buffs. However, there were not enough of them around to stop Arlene Donovan's production from flopping. Good support came from Jessica Tandy, who had appeared in *The Birds* (Universal, 1963), and Joe Grifasi as a zealous cop. Also cast: Sara Botsford, Josef Sommer, Irving Metzman and Rikke Borge. (UA)

△In 1979, Don Bluth and 16 other animators quit the Walt Disney Studios after a dispute over what they saw as the lowering of standards. They set up their own production company to make **The Secret Of Nimh**, an attempt to recapture the qualities of vintage Disney. Director Bluth, who produced with Gary Goldman and John Pomeroy, and the experienced team of artists almost succeeded. It was certainly better than many of the recent Disney cartoon features, but it failed to rival them at the box-office. The main weakness lay with the screenplay (by the producers and Will Finn) which was rather clumsily constructed, although based on an American children's classic *Mrs Frisby And The Rats of NIMH* by Robert C. O'Brien. It told of how a widowed fieldmouse living on Farmer Fitzgibbons' farm with her four offspring, is helped to save her home and sick child by rats made intelligent by a special drug given them at the National Institute for Mental Health (NIMH). Among the many delightfully drawn characters were Nicodemes, king of the rats, The Great Owl, Dragon the Cat, and Jeremy, a comic crow. Providing the voices, which added much to the charm, were Derek Jacobi, Elizabeth Hartman, John Carradine, Dom DeLuise, Peter Strauss and Hermione Baddeley. (AURORA)

△Although Peter Sellers had died in 1980, it didn't stop Blake Edwards from making **The Trail Of The Pink Panther** starring the deceased star. Director Edwards thought up the story, produced (with Tony Adams) and wrote the screenplay (with Geoffrey Edwards and Frank and Tom Waldman), maladroitly piecing together the film from leftovers and clips from previous *Pink Panther* adventures of the equally maladroit Inspector Clouseau (Sellers, left). The botched plot concerned Clouseau's disappearance while on the trail of the stolen Pink Panther diamond. A TV news journalist (Joanna Lumley) tries to track him down by interviewing his father (Richard Mulligan), his former houseboy (Burt Kwouk, right), Inspector Dreyfuss (Herbert Lom), his ex-wife (Capucine), and gentleman thief Sir Charles Litton (a dying and dubbed David Niven). Also cropping up were Robert Loggia, Harvey Korman, Graham Stark and Peter Arne. Needless to say, this bizarre posthumous picture expired at the box office. On top of which, Lynne Frederick, Sellers' widow, gained a settlement from UA after suing the company for using unseen footage of her husband without the estate's permission. (LAKELINE)

△Audiences continued to cheer on underdog pug Rocky Balboa, alias Sylvester Stallone (right), in **Rocky III**. This time our hero climbed into the ring with brutal, loudmouthed Clubber Lang, played by a giant black known as Mr T (left). Just as Rocky the slugger lacks fear, Stallone the star, director and screenwriter was not afraid to repeat himself, and by now the dialogue had lost some of the streetwise charm of *Rocky* (1976) and *Rocky II* (1979). But the training sessions with a disco beat, and the big fights had a simple emotional impact. The story had heavyweight champion of the world Rocky starting to get soft, and losing in a humiliating way to Clubber. The fact that his soppy wife (Talia Shire) wants him to hang up his gloves and his manager (Burgess Meredith) dies of a heart attack as the fight gets under way, doesn't help his state of mind. But never fear – with the help of his ex-rival and now buddy Apollo Creed (Carl Weathers), Rocky regains his fitness and the title. The lesson of Irwin Winkler and Robert Chartoff's production was that fame and fortune mustn't go to one's head even if punches do. Burt Young, Tony Burton, Hulk Hogan and Ian Fried supported. (CHARTOFF-WINKLER)

△Each year the Harvard Lampoon magazine gives its 'Movie Worsts' Awards to reluctant recipients. **National Lampoon Goes To The Movies** (aka **National Lampoon's Movie Madness**) was certainly a prime contender in the Not-Tonight-I-Have-A-Headache section. Matty Simmons' production started out with the idea of parodying several contemporary movies in four segments, but the fourth, taking off disaster films, ended up appropriately on the cutting room floor. The opener, called *Growing Your Self*, spoofed self-actualization films, the second, *Success Wanters*, mocked glamour soaps of the Harold Robbins mode, and the last and most tolerable, *Municipalians*, was a cop movie lampoon featuring a straight-faced Richard Widmark (right) and goody-goody Robby Benson (left) as his partner in crime busting. Debut director Bob Giraldi was responsible for the dated and clumsy gags of the first two, and Henry Jaglom for the third. A good cast including Peter Riegert, Diane Lane, Candy Clark, Ann Dusenberry, Robert Culp, Titos Vandis, Bobby DiCicco, Joe Spinell and Christopher Lloyd was wasted on this stuff. Scriptwriter P.J. O'Rourke wisely remained uncredited. (MATTY SIMMONS)

OTHER RELEASES

The Beast Within
A man returns to the woods where years before his wife was raped by a strange creature. Ronny Cox, Bibi Besch, Paul Clemens, Don Gordon, R.G. Armstrong. *Dir* Philippe Mora. *Pro* Harvey Bernhard, Gabriel Katzka. UA

The House Where Evil Dwells
An American family move into a house in Japan where they are haunted by the restless ghosts of a jealous husband who killed his wife, her lover and himself. Edward Albert, Susan George, Doug McClure, Amy Barrett. *Dir* Kevin Connor. *Pro* Martin B. Cohen. MARTIN B. COHEN

Jaws Of Satan (aka **King Cobra**)
Satan appears in the form of a large cobra in a small town where long ago a family was cursed by a Druid priest. Fritz Weaver, Gretchen Corbett, Jon Korkes, Norman Lloyd, Diana Douglas. *Dir* Bob Claver. *Pro* Bill Wilson. THOMAS BEN INTERNATIONAL

Jinxed (aka **Stryke And Hyde**, aka **Hot Streak**)
A feather-headed girl tries to collect her gangster boyfriend's inheritance at a gambling spa. Bette Midler, Ken Wahl, Rip Torn, Val Avery, Jack Elam. *Dir* Don Siegel. *Pro* Herb Jaffe. UA

Pandemonium
Spoof of *Friday The Thirteenth* (1980) in which a Mountie comes to America and falls in love with a girl while attempting to solve a campus murder. Tom Smothers, Carol Kane, Miles Chapin, Debralee Scott. *Dir* Alfred Sole. *Pro* Barry Krost, Doug Chapin. KROST/CHAPIN

Penitentiary II
Too Sweet, a prisoner who channels his hate into boxing, eventually becomes welterweight champion of the world. Leon Isaac Kennedy, Glynn Turman, Peggy Blow, Ernie Hudson, Malik Carter. *Dir* & *Pro* Jamaa Fanaka. IDEAL/BOB-BEA

Safari 3000 (aka **Rally**, aka **Two In The Bush**)
A former Hollywood stunt driver takes part in the Safari International Rally in Africa, competing against teams from around the world. David Carradine, Stockard Channing, Christopher Lee, Hamilton Camp. *Dir* Harry Hurwitz. *Pro* Jules V. Levy, Arthur Gardner. LEVY-GARDNER-LAVEN

1983

▽It took Barbra Streisand almost 10 years to set up **Yentl**, her first film as director. Even with her big-drawing name, studios were not keen to back the tale of a Jewish girl in Eastern Europe at the turn of the century, who spends most of the picture in the guise of a boy. But finally, with La Streisand starring, producing (along with Rusty Lemorande), writing (with Jack Rosenthal), and singing all 17 of Michel Legrand's schmaltzy songs (lyrics by Alan and Marilyn Bergman), it got off the ground and gathered healthy box-office returns. Based on *Yentl, The Yeshiva Boy*, a novella by Isaac Bashevis Singer, it was much more Barbra the Singer than Isaac Bashevis. Yet she was both moving and comic as an intelligent girl with a lust for learning, who can only study the Torah by pretending to be a boy. In the tradition of Shakespearean comedy, Yentl (Barbra in male drag, illustrated) falls in love with a young student Avigdor (Mandy Patinkin) engaged to Hadass (Amy Irving) who in turn falls for Yentl ... Oy vey! Streisand controlled the scenes of sexual ambiguity with admirable tact, letting the feminist message emerge subtly. Giving good support were Nehemiah Persoff, Steven Hill, Allan Corduner, Ruth Goring and David De Keyser. (LADBROKE/BARWOOD)

△Although **The Black Stallion Returns** had the same executive producer, Francis Coppola, and child star, Kelly Reno (right), a beautiful black horse, fine location photography, and an exciting race climax as in its vastly successful predecessor *The Black Stallion* (1979), it failed to catch fire at the box-office. Richard Kletter and Jerome Kass' screenplay (based on one of Walter Farley's series of 19 books) pursued more conventional juvenile adventure territory, and the direction by former editor Robert Dalva, taking over the reins from Carroll Ballard, lacked some of the mystique of horse and rider that made the first film so effective. Nevertheless, the production, by Tom Sternberg, Fred Roos and Doug Claybourne, was a diverting spectacle which followed the kid through the Sahara as he searches for his four-legged friend, kidnapped from the USA. Among those who crossed the boy's path were Vincent Spano (left), Allen Goorwitz, Jodi Thelen, Teri Garr (as his mother), Doghmi Larbi, Angelo Infanti and Woody Strode, not forgetting the stallion, last seen flirting with a white mare. (ZOETROPE)

△**Romantic Comedy**, adapted by Bernard Slade from his Broadway hit, was neither romantic nor comic nor a hit. Smug, superficial and dripping gloss under Arthur Hiller's direction, it starred Dudley Moore in another middle-aged, small guy, wish-fulfilment fantasy. Here Dud (illustrated), living up to his diminutive, played the male half of a successful playwriting duo. The two of them hover on the edge of an affair, though each is married to another. Finally, they learn to be just good friends and professional partners. That wonderful actress Mary Steenburgen as Moore's Broadway playmate was ill-used. Janet Eilber (illustrated) and Ron Leibman played their respective spouses, while Frances Sternhagen tackled the role of Dud's agent. Rozsika Halmos, Alexander Lockwood and Erica Hiller also appeared in Walter Mirisch and Morton Gottlieb's production. (MIRISCH)

◁'As long as people want to see James Bond movies, I'll continue to supply them,' commented producer Albert R. Broccoli, and **Octo-pussy** was the 13th helping served up to the insatiable Bond-hungry public. George Mac-Donald Fraser, Richard Maibaum and Michael G. Wilson's script (adapted loosely from the Ian Fleming novel) provided the unvarying ingre-dients of the gals, guns, cars, criminals, spies and stunts formula, and John Glen directed the predictable proceedings with pace. Hardly stretching his acting abilities, Roger Moore as 007 (centre) earned his large salary by non-chalantly doing what he had done five times previously. Though he only bedded two beauties, he managed to save the world from the fiendish plan of General Orlov (Steven Berkoff), Kamal (Louis Jourdan) and Gobinda (Kabir Bedir) to set off a nuclear device in the American sector of Berlin. Against glossy location backgrounds, Bond covered three continents, meeting, among others, Maud Adams (in the title role), Kristin Way and Indian tennis ace Vijay Amritraj (left). Desmond Llewelyn (right) and Lois Maxwell reprised their usual roles as 'Q' and Miss Moneypenny, but the late Bernard Lee was replaced by Geoffrey Keen as 'M'. The pre-title sequence showing Bond managing to dodge Cuban missiles provided the most fun. (EON)

▽'You're really into computers, huh?' says the girlfriend of a Seattle highschool boy in **War Games**. It's like asking the Marquis de Sade if he was into pain. The teenage computer wizard who can plug into the school computer and change his grades, inadvertently connects with the Pentagon defence system. Thinking it a video game, he simulates a nuclear attack on the USA by the Russians, with unfortunately convincing results. The message of the suspenseful and satiric screenplay by Lawrence Lasker and Walter F. Parkes is that in a nuclear war there can be no winners, and that humanity must not depend exclusively on machines for its survival. Ironically, the Harold Schneider production de-pended for most of its impact on the representa-tion of high tech machines in a huge war-operation room. Matthew Broderick (illustrated) was the fresh-faced youngster who manages to prevent World War III in the nick of time, after defence computer expert Dabney Coleman, General Barry Corbin, and disillusioned inven-tor John Wood fail to do so. Ally Sheedy (illustrated) played the energetic girl who be-lieves in him. John Badham, director of *Saturday Night Fever* (Paramount, 1977) proved that five-minutes-to-midnight fever can be just as big at the box-office. (LEONARD GOLDBERG/SHERWOOD)

◁Desperate to stretch out the moneymaking *Pink Panther* series, director-producer-screen-writer Blake Edwards came up with the aptly titled **Curse Of The Pink Panther**. Fortunate-ly, Edwards had used up most of the out-takes from the previous comedies featuring the late Peter Sellers in the simultaneously filmed *The Trail Of The Pink Panther* (1982). The new script (co-written by Geoffrey Edwards) was a feeble farce which had the French government and, as in the other movie, a news reporter (Joanna Lumley) on the trail of Inspector Clouseau, who seemed to have vanished. An equally klutzy policeman called Clifton Sleigh (played by Ted Wass) was put on the job with the obvious hope that he would be the centre of a new and profitable slapstick series. Wass, in Harold Lloyd specs (illustrated), struggled with the lame ma-terial and an inflatable woman. Also appearing, mainly in painful cameos, were David Niven (who died before the film's release), Robert Wagner, Capucine, Herbert Lom, Burt Kwouk, Robert Loggia, Harvey Korman, Graham Stark and 'guest star' Roger Moore. The picture (co-produced by Tony Adams) killed off the *Pink Panther* series once and for all – unless, of course, Edwards decides to inflict 'The Corpse Of The Pink Panther' on the world. (LAKELINE)

1983 OTHER RELEASES

Lianna
A put-upon professor's wife falls in love with another woman, and begins to find her freedom. Linda Griffiths, Jane Hallaren, John DeVries, Jo Henderson, Jessica Wight MacDonald. *Dir* John Sayles. *Pro* Jeffrey Nelson, Maggie Renzi. WINWOOD

Streamers
In an all-male barrack room, young army recruits assert themselves by indulging in dangerous verbal and physical games. Matthew Modine, Michael Wright, Mitchell Lichtenstein, David Alan Grier, Guy Boyd. *Dir* Robert Altman. *Pro* Robert Altman, Nick J. Mileti. STREAMERS INTERNATIONAL

Twilight Time
A septuagenarian farmer in Yugoslavia looks after his two young grandchildren whose parents are in Germany as immigrant workers. Karl Malden, Damien Nash, Mia Roth, Jodi Thelen, *Dir* Goran Paskaljevic. *Pro* Dan Tana. DAN TANA-CENTAUR.

▷ The plot of **The Pope Of Greenwich Village** came dangerously close to that of *Mean Streets* (Warner Bros., 1973), although the screenplay by Vincent Patrick was based on his own novel. But Stuart Rosenberg's blank direction couldn't match up to Martin Scorsese's tough, dark-toned movie, nor could Mickey Rourke (right) and Eric Roberts (left) – although both excellent – hope to compete with the dynamic double act of Harvey Keitel and Robert De Niro in the earlier picture. About the planning of a robbery by Rourke and his wild cousin Roberts, it involved a bent cop (Jack Kehoe) who interrupts the heist, collects a payoff and is bumped off, and a Mafia chief (Burt Young) who, amongst all his other endearing attributes, likes to cut off people's thumbs. Darryl Hannah, Geraldine Page, Kenneth McMillan, Tony Musante and M. Emmet Walsh were unable to make much impression during the cluttered narrative. Gene Kirkwood's production was perhaps at its best when it concentrated on the relationship between the two young hoodlums and the New York Italian sub-culture. (KOCH-KIRKWOOD)

▽ **Red Dawn** purported to be a serious enactment of what might happen if Cuban and Nicaraguan paratroopers, supported by 60 Russian divisions, were to invade small-town America. According to the macho and mindless screenplay by director John Milius (creator of *Conan The Barbarian*, 20th Century-Fox, 1982) and Kevin Reynolds, a group of intrepid high-school kids will take to the hills, form themselves into a guerilla band called The Wolverines (see illustration), and carry out successful raids on the invading army. In between gunning down and

blowing up Commies, they will sit around a camp fire swapping assorted banalities and Cold War rhetoric. War movie stereotypes were played by Patrick Swayze, C. Thomas Howell, Lee Thompson, Charlie Sheen, Darren Dalton, Jennifer Grey and Brad Savage. Oldtimers Ben Johnson and Harry Dean Stanton upgraded the general acting standard somewhat. Buzz Feitshans and Barry Beckerman's production responded to the hawkish climate in the USA at the time, as well as feeding adolescent fantasies of heroism. (VALKYRIE)

◁ The lesson of **Teachers** was the familiar one that education cannot function in overcrowded, underfunded schools. The secondary message was that satire requires a gentler hand than either director Arthur Hiller or scriptwriter W.R. McKinney were able to supply. Arthur Russo's production fell between two desks: on the one hand it was a broad comedy – a nutty professor (Richard Mulligan) dresses up as Washington and Custer during his history lessons and turns out to be an escaped mental patient – and on the other it tried to be a liberal social parable on the lines of *Up The Down Staircase* (Warner Bros., 1967). The John F. Kennedy High School is being sued for awarding a diploma to an illiterate pupil, and the Board attempts to stop the teachers giving damaging testimony. Jobeth Williams was the idealistic lawyer who persuades her disillusioned ex-teacher Nick Nolte (right) that it is worth fighting for quality education. Adults Judd Hirsch, Lee Grant and Allen Garfield gave watchable performances, but it was Ralph Macchio (left) who stood out as a rebellious but misunderstood student. E for Effort. (UA)

1984 OTHER RELEASES

Eureka
An ageing prospector's life loses its meaning when he finally discovers gold, and he almost welcomes his murder. Gene Hackman, Theresa Russell, Rutger Hauer, Jane Lapotaire, Mickey Rourke. *Dir* Nicolas Roeg. *Pro* Jeremy Thomas. (USA/GB) RECORDED PICTURE

Garbo Talks
A woman obsessed with Greta Garbo wants to meet her before she dies. Anne Bancroft, Ron Silver, Carrie Fisher, Catherine Hicks, Howard Da Silva, Hermione Gingold. *Dir* Sidney Lumet. *Pro* Burtt Harris, Elliott Kastner. ELLIOTT KASTNER

Hot Dog ... The Movie
Teenage adventures both on and off the ski slopes at the famous recreational resort of Lake Tahoe. Patrick Houser, Tracy N. Smith, David Naughton, Sharron Tweed. *Dir* Peter Markle. *Pro* Edward S. Feldman. HOT DOG PARTNERSHIP

Until September
An American woman stranded in Paris falls in love with a French banker. Karen Allen, Christopher Cazenove, Thierry L'Hermitte, Marie Catherine Conti. *Dir* Richard Marquand. *Pro* Michael Grusskoff. MICHAEL GRUSSKOFF

1985

▷After Rocky vs Apollo Creed (Carl Weathers) in *Rocky* (1976) and *Rocky II* (1979), and Rocky vs Clubber Lang (Mr T) in *Rocky III* (1982), **Rocky IV** offered us Rocky vs 'The Siberian Express'. Like the eponymous hero, the three preceding pictures were more brawn than brain, but the fourth encounter, directed, scripted and starring Sylvester Stallone (left), showed definite signs of punchdrunkenness. When Rocky's buddy Apollo dies in the ring after an 'exhibition' match in Las Vegas against Ivan Drango, a giant Russian heavyweight, Rocky vows to avenge the death by taking on the Russian himself in the Soviet Union. His opponent is a blond, monosyllabic monolith (Dolph Lundgren, right), who is trained by advanced methods to become a supreme fighting machine. But Rocky shows the Ruskies that Americans are not as weak and decadent as they think. The best sequence is a rhythmic cross-cutting montage contrasting Rocky's training in the snowy wastes of the Soviet Union, and his rival in a high tech gym. Talia Shire and Burt Young again played the champ's robotic wife and 'lovable' slob brother-in-law, Rocky was again the underdog, the script again consisted of a buildup to a contest, and ended with a ludicrous travesty of a prizefight. Although Rocky's message to the Soviets is 'If I can change, then you can change', there was no evidence in Irwin Winkler and Robert Chartoff's production that Stallone/Rocky had changed at all. However, the film packed a punch at the box-office. (CHARTOFF-WINKLER)

▽The James Bond adventures have been the most durable of all the long-running moneyspinning movie series, and **A View To A Kill** was the 14th distributed by UA since *Dr No* (1963). However, Richard Maibaum and Michael G. Wilson's script was the first that did not derive from an Ian Fleming novel. Not that Albert R. Broccoli's production or John Glen's direction differed very much in style or content from its predecessors, though both the hero – as interpreted by 57-year-old Roger Moore (illustrated) – and the formula were beginning to look somewhat old and tired. What was fresh in the 60s and had a certain faded charm in the 70s, began to look dated and mechanical in the 80s, despite the usual technical expertise. Aside from the lithe Grace Jones as May Day (illustrated), Bond's friends, enemies and damsels were a below-par lot. Lacking any menace was Christopher Walken as a psychopathic East German defector planning to control the world's microchip market by starting off an earthquake in California's Silicon Valley. Also in the cast were Tanya Roberts, Patrick MacNee, Patrick Bauchau, David Yip, Fiona Fullerton, Desmond Llewelyn ('Q'), Lois Maxwell (Miss Moneypenny) and Robert Brown ('M' mark III). (EON)

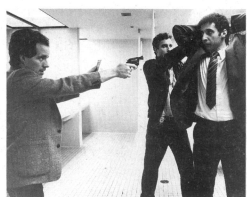

△Director William Friedkin's *The French Connection* (20th Century-Fox, 1971) was a coolly manipulative violent cops-and-robbers thriller which ended with an excitingly staged chase, and so was Friedkin's **To Live And Die In LA**. Both films were firmly rooted in authentic back street locations, but the first, set in an unfamiliar New York, had believable characters, an off-beat story, good performers and fairly articulate dialogue. Not so the second. Magnum-happy cops moved around LA in a tired plot, hyped up by constant pop (performed by British duo Wang Chung), splashes of blood and sadism, and some spectacular photography. The screenplay, by the director and Gerald Petievich, derived from the autobiographical novel by the latter, himself an ex-secret agent. It concerned a brutish agent's search for the brutish counterfeiter who killed his brutish former partner. William L. Petersen (centre), the vengeful cop, William Dafoe, the counterfeiter, John Pankow (left), Dean Stockwell, Debra Feuer, John Turturro (right) and Darlanne Fluegel cruised smoothly through Irving H. Levin's production. (NEW CENTURY/SLM)

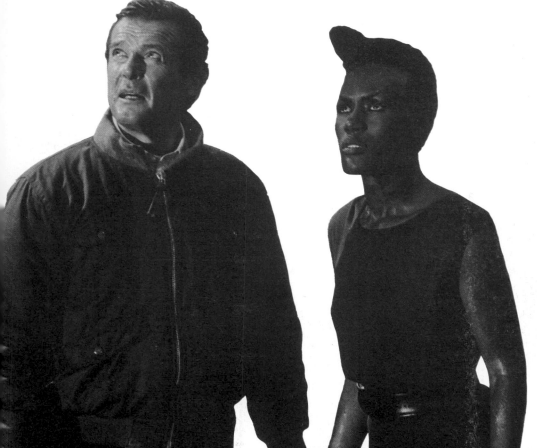

1985 OTHER RELEASES

The Aviator
In 1929, a pilot flying a mail route is forced to take a rich spoilt woman on board, and the plane crashes. Christopher Reeve, Rosanna Arquette, Jack Warden, Sam Wanamaker. *Dir* George Millet. *Pro* Mace Neufeld, Thomas H. Brodek. MACE NEUFELD

Movers And Shakers
The problems of a studio boss trying to make a quality picture from the bestseller 'Love In Sex', and the marital problems of the screenwriter. Walter Matthau, Charles Grodin, Steve Martin, Gilda Radner, Vincent Gardenia. *Dir* William Asher. *Pro* William Asher, Charles Grodin. UA

APPENDIXES

To make 'The United Artists Story' as comprehensive as possible, six appendixes follow. They complete the list of pictures released in the USA by United Artists or its associate company Lopert Films, Inc. (later Lopert Pictures Corporation). The latter, based in Europe, handled the acquisition and American distribution of many British-made or foreign language films for UA. For various reasons, all the films in the appendixes were not so centrally connected with the studio as those in the preceding pages. The distinction between British films appearing as main entries and those relegated to this section is explained in the introduction to appendix 1. The foreign language films of appendix 2 have a specialized 'art cinema' audience and were generally given only limited release in America; for these reasons they do not warrant more elaborate treatment in a book dedicated to a Hollywood institution. Documentary features (appendix 3) also need to be set apart from the main body of fictional films. Creatively and financially the films in appendix 4 were Paramount pictures; they were merely released under the UA logo. So too were some of the films in appendix 5, all of which, together with those in appendix 6 were not felt to merit inclusion as main entries in the book as they were programme fillers of never much more than 60 minutes duration and sometimes even less.

The format of an entry is essentially the same throughout, though sometimes one element or more is omitted if it is not significant or relevant. Each starts with the film's American release title followed, in brackets, by any alternative titles ('aka' is 'also known as'), British title (GB), or the original title (orig.) in the case of foreign language films. Then follows a short synopsis (appendixes 1 and 3, and the more consequential films in appendix 4), or a description of the plot type (appendix 2); this information is not given for the relatively minor or essentially repetitive featurettes in appendixes 4, 5 and 6. Next, a list of the principal performers is given (except appendixes 3 and 5), followed, where appropriate, by the name of the director (Dir) and producer (Pro). The process used for any films in colour is given up to 1969, after which all films are in colour unless stated otherwise. The country or countries of production is indicated for all the entries in appendixes 2 and 3, and also for the very few non-British, but nevertheless English language, films in appendix 1. The year of original release in the country of origin is included for all British and foreign language productions, even where this does not differ from the American release year under which the film is listed. Finally, as in all the films in the main part of the book, each entry in appendixes 1, 2 and 3 ends with the name of the film's production company or companies.

APPENDIX 1
BRITISH PRODUCTIONS

The British productions included as main entries in the book are confined to those films which had a more than incidental connection with United Artists for one or more of the following reasons: they were released by UA in Britain as well as in America; they were produced by UA in Britain; they had financial assistance from UA; they were guaranteed American distribution by UA prior to shooting. United Artists, indeed, had strong associations with UK film-making over a period of more than 20 years. British producers Herbert Wilcox and Alexander Korda, for example, were under contract to UA, Korda becoming a full partner in 1935. Because of the Quota Act of 1927, exhibitors had to devote 5 per cent of their screen time to British films and this encouraged American companies, including UA, to finance domestic production. The company also owned a 50 per cent interest in Odeon Cinema Holdings, part of the empire of J. Arthur Rank. This British mogul, who owned over 600 cinemas by the early 40s, was interested in becoming a partner in UA but his bid fell through due to opposition from Mary Pickford and David O. Selznick. Nevertheless, UA had an investment in a package of seven films made by Rank, which they distributed in the US between 1945 and 1948. All of these connections established United Artists as the leading distributor of British films in America.

The films listed below, on the other hand, had little or no connection with United Artists until the studio, or its associate company Lopert Films, Inc. (later Lopert Pictures Corporation), picked them up for distribution in America. They include films made by the Rank Organisation (post-1948), Ealing Studios, Hammer Film Productions and smaller British companies. The list also includes a handful of films, too few in number to warrant a separate appendix, that were made in the English language but by Australian or Canadian companies.

1936
Romance And Riches (aka **The Amazing Quest**, aka **The Amazing Quest Of Ernest Bliss**)
A rich young man, voluntarily penniless, acts as fairy godfather to poor people who helped him. Cary Grant, Mary Brian, Peter Gawthorne, Henry Kendall. *Dir & Pro* Alfred Zeisler. (1936) GARRETT KLEMENT

1941
Love On The Dole
Life among unemployed cotton workers in Lancashire. Deborah Kerr, Clifford Evans, George Carney. *Dir & Pro* John Baxter. (1941) BRITISH NATIONAL

1942
Forty-Eight Hours (GB: **Went The Day Well?**)
German paratroopers invade an English village. Leslie Banks, Elizabeth Allen, Frank Lawton. *Dir* Alberto Cavalcanti. *Pro* S.C. Balcon. (1942) EALING

1943
The Bells Go Down
The exploits of a London wartime firefighting unit. Tommy Trinder, James Mason, Mervyn Johns. *Dir* Basil Dearden. *Pro* Michael Balcon. (1943) EALING

1948
Just William's Luck
Young boys capture fur thieves in a mansion. William Graham, Garry Marsh, Hugh Cross. *Dir* Val Guest. *Pro* James Carter. (1947) SHIPMAN-COPLAN

Oliver Twist
Charles Dickens' famous tale of a foundling who falls among thieves. Alec Guinness, Robert Newton, John Howard Davies. *Dir* David Lean. *Pro* Ronald Neame. (1948) GFD/CINEGUILD

The Plot To Kill Roosevelt (aka **Conspiracy In Teheran**, aka **Appointment In Persia**, GB: **Teheran**)
English war correspondent in Teheran in 1943 uncovers a plot to kill the US president. Derek Farr, Marta Labarr, Manning Whiley. *Dir* William Freshman. *Pro* John Stafford (1947) PENDENNIS-STAFFORD

1950

If This Be Sin (GB: **That Dangerous Age**)
A blind barrister believes his wife to be unfaithful. Myrna Loy, Roger Livesey, Peggy Cummins, Richard Greene. *Dir & Pro* Gregory Ratoff. (1949) BRITISH LION

1951

A Christmas Carol (GB: **Scrooge**)
A miser, visited by the Spirit of Christmas, learns generosity. Alastair Sim, Mervyn Johns, Jack Warner. *Dir & Pro* Brian Desmond Hurst. (1951) RENOWN

Hotel Sahara
A small hotel in N. Africa during World War II keeps changing sides. Peter Ustinov, Yvonne de Carlo, Roland Culver. *Dir* Ken Annakin. *Pro* George H. Brown. (1951) GFD/TOWER

Mr Drake's Duck
A duck lays a uranium egg and is fought over by the world powers. Douglas Fairbanks Jr, Yolande Donlan, Wilfrid Hyde White. *Dir* Val Guest. *Pro* Douglas Fairbanks Jr. (1950) ANGEL/EROS

Naughty Arlette (GB: **The Romantic Age**)
A middle-aged schoolmaster falls in love with a French pupil. Mai Zetterling, Hugh Williams, Margot Grahame. *Dir* Edmond T. Gréville. *Pro* Eric L'Epine Smith. (1949) RANK/PINNACLE

Obsessed (GB: **The Late Edwina Black**)
Three suspects are held for the murder of a schoolteacher's wife. Geraldine Fitzgerald, David Farrar, Roland Culver. *Dir & Pro* Maurice Elvey. (1951) IFD

Odette
Biopic of famous female French resistance spy. Anna Neagle, Trevor Howard, Peter Ustinov. *Dir & Pro* Herbert Wilcox. (1950) IMPERADIO/BRITISH LION

The Tales Of Hoffman
Offenbach's opera combined with ballet in which the poet Hoffman seeks the eternal woman. Robert Rounseville, Robert Helpmann, Moira Shearer. *Dir & Pro* Michael Powell, Emeric Pressburger. Technicolor. (1951) BRITISH LION/LONDON

Tom Brown's Schooldays
Tom has a civilizing influence on Rugby school in adaptation of semi-classic novel. Robert Newton, John Howard Davies, Diana Wynyard. *Dir* Gordon Parry. *Pro* George Minter. (1950) TALISMAN/RENOWN

1952

Another Man's Poison
A woman novelist poisons her husband and her lover. Bette Davis, Anthony Steel, Gary Merrill. *Dir* Irving Rapper. *Pro* Douglas Fairbanks Jr. (1951) ANGEL/EROS

Breaking The Sound Barrier (GB: **The Sound Barrier**)
An aircraft manufacturer proves the sound barrier can be broken. Ralph Richardson, Nigel Patrick, Ann Todd, Denholm Elliott. *Dir & Pro* David Lean. (1952) LONDON/CINEGUILD/BRITISH LION

Cloudburst
A code expert at the Foreign Office kills two men who killed his wife in a car accident. Robert Preston, Elizabeth Sellers, Colin Tapley. *Dir* Francis Searle. *Pro* Alexander Paal. (1951) EXCLUSIVE

Cry, The Beloved Country (aka **African Fury**)
A white farmer and a black preacher find friendship through tragedy in South Africa. Canada Lee, Sidney Poitier, Charles Carson. *Dir* Zoltan Korda. *Pro* Alan Paton. (1951) LONDON/BRITISH LION

Island Of Desire (GB: **Saturday Island**)
A Canadian nurse, a US marine and an RAF pilot are shipwrecked on a desert island. Linda Darnell, Tab Hunter, Donald Gray. *Pro* Stuart Heisler. *Dir* David E. Rose. Technicolor. (1952) CORONADO

Outcast Of The Islands
An English trader finds happiness in a Far Eastern post. Trevor Howard, Ralph Richardson, Kerima, Robert Morley, Wendy Hiller. *Dir & Pro* Carol Reed. (1951) LONDON

Outpost In Malaya (GB: **The Planter's Wife**)
A British farmer and his wife defend their Asian homestead against rebels. Claudette Colbert, Jack Hawkins, Ram Gopal. *Dir* Ken Annakin. *Pro* John Stafford. (1952) RANK/PINNACLE

A Tale Of Five Women (GB: **A Tale Of Five Cities**)
An amnesiac sets out to seek clues to his past in five European capitals. Bonar Colleano, Gina Lollobrigida, Barbara Kelly, Lana Morris, Anne Vernon, Eva Bartok. *Dir* Montgomery Tully *et al. Pro* Alexander Paal. (1951) GRAND NATIONAL

1953

The Assassin (GB: **Venetian Bird**)
A private detective on a visit to Venice finds that he himself is wanted for murder. Richard Todd, Eva Bartok, John Gregson. *Dir* Ralph Thomas. *Pro* Betty Box. (1952) RANK/BRITISH FILM MAKERS

The Captain's Paradise
A captain of a steamer plying between Gibraltar and Tangier has a wife in each port. Alec Guinness, Celia Johnson, Yvonne de Carlo. *Dir & Pro* Anthony Kimmins. (1953) BL/LONDON

The Fake
A Leonardo is stolen from the Tate Gallery. Dennis O'Keefe, Coleen Gray, Hugh Williams. *Dir* Godfrey Grayson. *Pro* Stephen Pallos. (1953) PAX

Man In Hiding (GB: **Mantrap**)
A man found guilty of murder escapes from prison and sets out to find the real culprit. Paul Henreid, Lois Maxwell, Kieron Moore. *Dir* Terence Fisher. *Pro* Alexander Paal. (1953) PAAL

My Heart Goes Crazy (GB: **London Town**)
An understudy finally finds stardom. Sid Field, Greta Gynt, Kay Kendall. *Dir & Pro* Wesley Ruggles. Technicolor. (1946) GFD

The Straw Man
A private detective assists Scotland Yard on a murder enquiry. Dermot Walsh, Clifford Evans, Lana Morris. *Dir & Pro* Donald Taylor. (1953) HEDGERLEY

The Village
The events in a Swiss village where 200 war orphans are gathered. John Justin, Eva Dahlbeck, Mary Hinton. *Dir* Leopold Lindtberg. *Pro* Lazar Wechsler. (GB/Switzerland, 1953) WECHSLER

1954

Fuss Over Feathers (GB: **Conflict Of Wings**)
Villagers fight to save a bird sanctuary taken over by the RAF. John Gregson, Muriel Pavlow, Kieron Moore. *Dir* John Eldridge. *Pro* Herbert Mason. Eastmancolor. (1954) GROUP THREE

Gilbert And Sullivan (GB: **The Story Of Gilbert And Sullivan**)
Biopic about the difficult collaboration between the Victorian composer and the librettist of the popular Savoy operas. Robert Morley, Maurice Evans, Peter Finch. *Dir* Sidney Gilliat. *Pro* Frank Launder, Sidney Gilliat. Technicolor. (1953) LONDON/BRITISH LION

The Golden Mask (GB: **South Of Algiers**)
Archaeologists and thieves search the Sahara for a valuable mask. Van Heflin, Wanda Hendrix, Eric Portman. *Dir* Jack Lee. *Pro* Aubrey Baring, Maxwell Setton. Technicolor. (1952) ABP/MAYFLOWER

Hobson's Choice
A tyrannical bootmaker is brought to heel by his daughter and simple son-in-law. Charles Laughton, John Mills, Brenda de Banzie. *Dir* David Lean. *Pro* Norman Spencer. (1953) BRITISH LION/LONDON

The Little Kidnappers (GB: **The Kidnappers**)
Two children borrow a baby for a pet. Duncan Macrae, Vincent Winter, Jon Whiteley. *Dir* Philip Leacock. *Pro* Sergei Nolbandov. (1953) RANK

The Malta Story
The defence of Malta during World War II. Alec Guinness, Anthony Steel, Muriel Pavlow, Jack Hawkins. *Dir* Brian Desmond Hurst. *Pro* Peter de Sarigny. (1953) GFD/BRITISH FILM MAKERS

The Man Between
A racketeer operates between West and East Berlin. James Mason, Claire Bloom, Hildegarde Neff. *Dir & Pro* Carol Reed. (1953) BRITISH LION/LONDON

Man With A Million (GB: **The Million Pound Note**)
A man inherits a million dollars in the form of a single bank note and finds it difficult to cash. Gregory Peck, Jane Griffiths, Ronald Squire. *Dir* Ronald Neame. *Pro* John Bryan. Technicolor. (1953) GFD/GROUP FILMS

Personal Affair
A schoolmaster runs into trouble when a pupil develops a crush on him. Leo Genn, Gene Tierney, Glynis Johns. *Dir* Anthony Pélissier. *Pro* Anthony Darnborough. (1953) RANK/TWO CITIES

1955

The Beachcomber
A lady missionary reforms an alcoholic in the Dutch East Indies. Robert Newton, Glynis Johns, Donald Sinden. *Pro* Muriel Box. *Pro* William MacQuitty. Technicolor. (1954) GFD/LONDON INDEPENDENT

Break To Freedom (GB: **Albert R.N.**)
British POWs escape from a German camp by substituting a dummy for one of their number. Anthony Steel, Jack Warner, Robert Beatty. *Dir* Lewis Gilbert. *Pro* Daniel M. Angel. (1953) EROS

The Good Die Young
Four men rob a bank, and four flashbacks explain what led to it. Laurence Harvey, Gloria Grahame, Richard Basehart, Joan Collins, Stanley Baker. *Dir* Lewis Gilbert. *Pro* Jack Clayton. (1954) ROMULUS

A Kid For Two Farthings
A boy's pet goat seems to have the power of a unicorn. Celia Johnson, Diana Dors, David Kossoff. *Dir & Pro* Carol Reed. Eastmancolor. (1954) LONDON

The Man Who Loved Redheads
Throughout his life a diplomat seeks women who resemble his first love. John Justin, Moira Shearer, Roland Culver. *Dir* Harold French. *Pro* Josef Somlo. Eastmancolor. (1954) BRITISH LION/LONDON

The Purple Plain
Three men struggle across Burma after their plane has crashed. Gregory Peck, Maurice Denham, Lyndon Brook, Win Min Than. *Dir* Robert Parrish. *Pro* John Bryan. Technicolor. (1954) GFD/TWO CITIES

Romeo And Juliet
Shakespeare's tragedy of doomed young lovers. Laurence Harvey, Susan Shentall, Flora Robson. *Dir* Renato Castellani. *Pro* Joseph Janni, Sandro Ghenzi. Technicolor. (GB/Italy, 1954) RANK/VERONA

They Can't Hang Me
A condemned murderer finally escapes the rope and gains his freedom by giving vital information to the police. Terence Morgan, Yolande Donlan. *Dir* Val Guest. *Pro* Roger Proudlock. (1955) VANDYKE

You Know What Sailors Are
A British naval officer is taken and held prisoner in an Arab country because they believe he has invented a secret weapon. Akim Tamiroff, Donald Sinden, Sarah Lawson. *Dir* Ken Annakin. *Pro* Peter Rogers. Technicolor. (1954) RANK

1956

Assignment Redhead (aka **Undercover Girl**)
A writer tries to avenge his brother-in-law's death by breaking up a London dope ring. Paul Carpenter, Kay Callard. *Dir* Maclean Rogers. *Pro* Kay Luckwell, Derek Winn. (1956) BUTCHERS/LUCKWELL-WINN

The Creeping Unknown (GB: **The Quatermass Experiment**)
An astronaut returning from space is taken over by a blood-sucking fungus. Brian Donlevy, Jack Warner, Margia Dean. *Dir* Val Guest. *Pro* Anthony Hinds. (1955) EXCLUSIVE/HAMMER

The Extra Day (aka **One Extra Day**, aka **Twelve Desperate Hours**)
The day's adventures of a bit-part player at work in a film studio. Richard Basehart, Simone Simon. *Dir* William Fairchild. *Pro* E.M. Smedley Aston. Eastmancolor. (1956) BRITISH LION

Let's Make Up (GB: **Lilacs In The Spring**)
A young actress dreams of herself as Nell Gwyn, Queen Victoria and her own mother. Anna Neagle, Errol Flynn, David Farrar. *Dir & Pro* Herbert Wilcox. Trucolor. (1954) REPUBLIC/EVEREST

Richard III
Shakespeare's play about Richard's seizure of the throne. Laurence Olivier, Claire Bloom, Ralph Richardson, John Gielgud. *Dir & Pro* Laurence Olivier. Technicolor. (1955) LONDON

The Sea Shall Not Have Them
Survivors of a seaplane crash await rescue in a dinghy. Dirk Bogarde, Michael Redgrave, Anthony Steel. *Dir* Lewis Gilbert. *Pro* Daniel M. Angel. (1954) EROS

Shadow Of Fear (GB: **Before I Wake**)
A young girl suspects that her stepmother is planning to murder her. Mona Freeman, Jean Kent, Maxwell Reed. *Dir* Albert S. Rogell. *Pro* Charles A. Leeds. (1955) ROXBURY/GIBRALTAR

1957

Beasts Of Marseilles (GB: **Seven Thunders**)
English soldiers escape from Italy and hide out from the Nazis in Occupied France. Stephen Boyd, Anna Gaylor, James Robertson Justice. *Dir* Hugo Fregonese. *Pro* Daniel M. Angel. (1957) RANK

The Crooked Sky
Police from Scotland Yard and Washington join forces and collaborate to break up a counterfeit ring. Wayne Morris, Karin Booth. *Dir* Henry Cass. *Pro* Derek Winn, Henry Cass. (1956) TUDOR/LUCKWINN

Enemy From Space (GB: **Quatermass 2**)
A research station operating under military secrecy is producing monsters to take over the world. Brian Donlevy, William Franklyn, Bryan Forbes. *Dir* Val Guest. *Pro* Anthony Hinds. (1957) HAMMER

The Key Man
A radio broadcaster in search of news for his programme gets involved with a gang of criminals. Lee Patterson, Hy Hazell, Colin Gordon. *Dir* Montgomery Tully. *Pro* Alec C. Snowden. (1954) INSIGNIA

Mark Of The Phoenix
International crooks fight over a valuable cigarette case. Sheldon Lawrence, Julia Arnall. *Dir* Maclean Rogers. *Pro* W.G. Chalmers. (1957) BUTCHERS

1958

Carve Her Name With Pride
The young widow of a French officer enlists as a spy in 1940 and is executed by the Nazis. Virginia McKenna, Paul Scofield, Jack Warner. *Dir* Lewis Gilbert. *Pro* Daniel M. Angel. (1958) RANK/KEYBOARD

Crossup (GB: **Tiger By The Tail**)
An American newsman in London gets involved in a counterfeiting ring. Larry Parks, Constance Smith, Lisa Daniely. *Dir* John Gilling. *Pro* Robert S. Baker, Monty Berman. (1955) CANYON

Heart Of A Child
A small boy tries to save his St Bernard during a food shortage in World War I. Jean Anderson, Richard Williams, Donald Pleasence. *Dir* Clive Donner. *Pro* Alfred Shaughnessy. (1958) RANK

Menace In The Night (GB: **Face In The Night**)
A witness to a murder is threatened by the murderer if she should go to the police. Griffith Jones, Lisa Gastoni, Vincent Ball. *Dir* Lance Comfort. *Pro* Charles A. Leeds. (1958) GIBRALTAR

A Night To Remember
The story of the sinking of the Titanic. Kenneth More, Honor Blackman, Michael Goodliffe. *Dir* Roy Baker. *Pro* William Macquitty. (1958) RANK

The Steel Bayonet
A British platoon holds a farm in Tunis against a German attack. Leo Genn, Kieron Moore, Michael Medwin. *Dir* & *Pro* Michael Carreras. (1957) HAMMER

Violent Playground
A police officer tries to prevent crime in a slum area of Liverpool. Stanley Baker, Anne Heywood, David McCallum, Peter Cushing. *Dir* Basil Dearden. *Pro* Michael Relph. (1957) RANK

1959

Elephant Gun (GB: **Nor The Moon By Night**)
Love triangle in the African jungle. Belinda Lee, Michael Craig, Patrick McGoohan. *Dir* Ken Annakin. *Pro* John Stafford. (1958) RANK

Subway In The Sky
An American on the run in post-war Berlin hides in a cabaret artist's apartment. Hildegarde Neff, Van Johnson. *Dir* Muriel Box. *Pro* John Temple-Smith, Patrick Filmer-Sankey. (1958) SYDNEY BOX

Too Many Crooks
A bunch of incompetent crooks plot a kidnapping. Terry-Thomas, George Cole, Brenda de Banzie. *Dir* & *Pro* Mario Zampi. (1959) RANK

1961

Dr Blood's Coffin
A doctor drugs and kidnaps villages as living subjects for his grafting theories. Kieron Moore, Hazel Court, Ian Hunter. *Dir* Sidney J. Furie. *Pro* George Fowler. Eastmancolor. (1960) CARALAN

The Snake Woman
A woman injected with snake venom gives birth to a girl with cold blood and a poisonous bite. John McCarthy, Susan Travers. *Dir* Sidney J. Furie. *Pro* George Fowler. (1961) CARALAN

Three On A Spree
An office clerk finds he has to spend a million pounds within a short period in order to obtain a larger fortune. Jack Watling, Carole Lesley, Renee Houston. *Dir* Sidney J. Furie. *Pro* George Fowler. (1961) CARALAN

1962

Mary Had A Little
A producer bets a psychiatrist he cannot hypnotise a woman into having a perfect baby. Agnes Laurent, Hazel Court, Jack Watling, John Bentley. *Dir* Edward Buzzell *Pro* George Fowler. (1961) CARALAN/DADOR

On The Beat
A car park attendant manages to capture crooks and become a policeman. Norman Wisdom, Jennifer Jayne, Raymond Huntley. *Dir* Robert Asher. *Pro* Hugh Stewart. (1962) RANK

1965

Ferry Cross The Mersey
The rise to fame of a Liverpool pop group. Gerry and the Pacemakers, Julie Samuel, Eric Barker. *Dir* Jeremy Summers. *Pro* Michael Holden. (1964) SUBA

One Way Pendulum
A suburban clerk sets an imaginary trial in motion. Eric Sykes, George Cole, Peggy Mount. *Dir* Peter Yates. *Pro* Michael Deeley. (1964) WOODFALL

1966

It Happened Here
What might have happened if the Germans had occupied England in 1940. Sebastian Shaw, Pauline Murray, Fiona Leland. *Dir* & *Pro* Kevin Brownlow, Andrew Mollo. (1964) RATH

1967

Finders Keepers
Pop group finds atom bomb lost by Americans off the Spanish coast. Cliff Richard, The Shadows, Robert Morley, Peggy Mount. *Dir* Sidney Hayers. *Pro* George H. Brown. Eastmancolor. (1966) INTERSTATE

1968

Thunderbirds Are Go
Science fiction enacted by puppets. (Voices) Sylvia Anderson, Ray Barrett, Bob Monkhouse. *Dir* David Lane. *Pro* Sylvia Anderson. Technicolor. (1966) A.P.

A Twist Of Sand
An ill-assorted gang seek hidden diamonds on Africa's skeleton coast. Richard Johnson, Honor Blackman, Roy Dotrice. *Dir* Don Chaffey. *Pro* Fred Engel. De Luxe Color. (1968) CHRISTINA

Waiting For Caroline
Triangular drama. Alexandra Stewart, Francoise Jasse. *Dir* Ron Kelly. *Pro* Walford Hewitson. Technicolor. (Canada, 1967) NATIONAL FILM BOARD OF CANADA

1970

Kes
A boy finds freedom from a dull, industrial town by training a kestrel. David Bradley, Lynne Perrie, Colin Welland. *Dir* Ken Loach. *Pro* Tony Garnett. (1969) WOODFALL/KESTREL

1971

Outback (aka **Wake In Fright**)
A young teacher finds himself in difficulties in a remote Australian village. Gary Bond, Donald Pleasence, Chips Rafferty. *Dir* Ted Kotcheff. *Pro* George Willoughby. (Australia, 1970) NLT/GROUP W

1974

Undercovers Hero (GB: **Soft Beds, Hard Battles**)
Inhabitants of a Paris bordello help win World War II. Peter Sellers, Lila Kedrova, Curt Jurgens. *Dir* Roy Boulting. *Pro* John Boulting. (1973) RANK/CHARTER

1981

Ticket To Heaven
An unwitting young man is seduced into a questionable San Francisco-based religious cult. Nick Mancuso, Saul Rubinek, Meg Foster. *Dir* Ralph L. Thomas. *Pro* Vivienne Leebosh. (Canada, 1981) STALKER/COHEN-LEEBOSH/CANADIAN FILM DEVELOPMENT

1982

Brimstone And Treacle
The Devil in the guise of a young man insinuates himself into a suburban home. Sting, Denholm Elliott, Joan Plowright. *Dir* Richard Loncraine. *Pro* Kenith Trodd. (1982) NAMARA-PFH/BRENT WALKER

1983

Britannia Hospital
A large hospital seen as a microcosm of Britain in the 80s. Leonard Rossiter, Graham Crowden, Mark Hamill, Frank Grimes, Alan Bates, Malcolm McDowell. *Dir* Lindsay Anderson. *Pro* Davina Belling, Clive Parsons. (1983) FILM AND GENERAL/EMI

The Draughtsman's Contract
In the 1690's, a draughtsman is hired by an aristocrat to draw his country house and gardens with bizarre consequences for his wife and family. Anthony Higgins, Janet Suzman. *Dir* Peter Greenaway. *Pro* David Payne. (1982) BFI/CHANNEL 4

Final Option (GB: **Who Dares Wins**)
An SAS officer penetrates a terrorist group. Lewis Collins, Judy Davis, Richard Widmark. *Dir* Ian Sharp. *Pro* Euan Lloyd. (1983) RANK

The Grey Fox
An ex-bandit of 60, tries to adapt to the 20th century after spending the whole of his adult life in prison. Richard Farnsworth, Jackie Burroughs, Ken Pogue. *Dir* Phillip Borsos. *Pro* Peter O'Brian. (Canada, 1982) MERCURY/PETER O'BRIAN

1984

Kipperbang (GB: **P'tang, Yang Kipperbang**)
Young love in a London school of the 50s. John Albasiny, Abigail Cruttenden, Alison Steadman. *Dir* Michael Apted. *Pro* Chris Griffin. (1982) ENIGMA/GOLDCREST/CHANNEL 4

1985

Martin's Day
A young boy befriends an escaped convict. Richard Harris, Justin Henry, Lindsay Wagner, James Coburn, Karen Black. *Dir* Alan Gibson. *Pro* Richard F. Dalton, Roy Krost. (Canada, 1985) WORLD FILM SERVICES

APPENDIX 2
FOREIGN LANGUAGE PRODUCTIONS

Like many other Hollywood studios, United Artists released a number of films, made in a foreign language but presented with English subtitles, on the 'art cinema' circuit in the USA. Such pictures were generally made first for local consumption with local money and without prior US distribution arrangements. They were then picked up by companies in various other countries. Some of those listed below, however, were produced by UA's European subsidiaries, such as Les Production Artistes Associes (Paris). Nevertheless, all were first shown in their original language and only later distributed by UA, or its associate company Lopert Films, Inc. (later Lopert Pictures Corporation), in America.

1921

I Accuse (orig: **J'Accuse**)
Pacifist war drama. Severin Mars, Maryse Dauvray, Romuald Joube. *Dir* Abel Gance. (France, 1918) PATHÉ

1930

The Other (orig: **Der Andere**)
Jekyll-and-Hyde type thriller. Fritz Kortner, Hermine Sterler, Ursula von Diemen. *Dir* Robert Wiene. (Germany, 1930) TERRA

1932

Lilac (orig: **Coeur De Lilas**)
A drama played out in the Paris underworld. Marcelle Romée, André Luguet, Jean Gabin. *Dir* Anatole Litvak. (France, 1932) FIFRA

1933

Don Quixote (orig: **Don Quichotte**)
Episodes, with songs, from Cervantes' classic. Féodor Chaliapin, George Robey, Renée Valliers. *Dir* G.W. Pabst. (France, 1932) VANDOR-NELSON-WEBSTER

1936

The Golem (GB: **The Legend Of Prague**, orig: **Le Golem**)
Filmed version of the Jewish mystical folk tale. Harry Baur, Roger Karl, Charles Dorat. *Dir* Julien Duvivier. (France/Czechoslovakia, 1936) AB FILM

1939

La Immaculada
Tragedy with music. Fortunio Bonanova, Andrea Palma, Milissa Sierra, Tana. *Dir* Louis Gasnier. (Spain, 1939) ATALAYA

1949

The Wicked City (orig: **Hans Le Marin**)
Romantic melodrama. Maria Montez, Jean-Pierre Aumont, Lilli Palmer. *Dir* François Villiers. (France, 1948) SAFIA CARAVELLE

1951

Fabiola
Historical Spectacle. Michele Morgan, Henri Vidal, Michel Simon, Gino Servi. *Dir* Allessandro Blasetti. (Italy, 1947) UNIVERSALIA

Mr Peek-a-Boo (orig: **Garou-Garou, Le Passe-Muraille**)
Fantasy comedy. Bourvil, Joan Greenwood. *Dir* Jean Boyer. (France, 1950) ARTHUR SACHSON

1952

Strange World (orig: **Mundo Extrano**)
An adventure set in the jungle. Angelica Hauff, Alexander Carlos. *Dir* Franz Eichhorn. (Brazil, West Germany, 1950) MO CAMP

1953

Fanfan The Tulip (aka **Soldier Of Love**, orig: **Fanfan La Tulipe**)
Comedy swashbuckler. Gerard Philipe, Gina Lollobrigida, Genevieve Page. *Dir* Christian-Jacque. (France/Italy, 1951) FILM SONOR/ARIANE/AMATO

Genghis Khan
Action spectacle. Manuel Conde, Elvira Reyes. *Dir* Lou Salvador. (Philippines, 1952) MANUEL CONDE

Luxury Girls (GB: **Finishing School**, orig: **Fanciulle Di Lusso**)
Comedy-drama. Susan Stephen, Anna Maria Ferrero, Jacques Sernas, Marina Vlady. *Dir* Piero Mussetta. (Italy, 1953) CARLO CIVALLERO

Volcano (orig: **Vulcano**)
Smouldering Italian melodrama. Anna Magnani, Geraldine Brooks, Rossano Brazzi. *Dir* William Dieterle. (Italy/USA, 1949) DIETERLE

1954

Beauties Of The Night (orig: **Les Belles De Nuit**)
Episodic romantic comedy. Gerard Philipe, Martine Carol, Gina Lollobrigida, Magali Vendeuil. *Dir* René Clair. (France/Italy, 1952) FRANCO LONDON/RIZZOLI

Crossed Swords (orig: **Il Maestro De Don Giovanni**)
Romantic swashbuckler. Gina Lollobrigida, Errol Flynn. *Dir* Milton Krims, Nato de Angelis, Arthur Villiesid. (Italy, 1952) VIVA

Heidi
Film of the Swiss children's classic. Elsbeth Sigmund, Heinrich Gretler, Thomas Klameth. *Dir* Luigi Comencini. (Switzerland, 1952) PRAESENS

1955

Heidi And Peter (orig: **Heidi Und Peter**)
Sequel to *Heidi*. Elsbeth Sigmund, Heinrich Gretler, Thomas Klameth. *Dir* Franz Schnyder. (Switzerland, 1954) PRAESENS

1956

The Bold Adventure (aka **Till Eulenspiegel**, orig: **Les Aventures De Till L'Espiegle**)
Comedy swashbuckler. Gerard Philipe, Jean Vilar. *Dir* Gerard Philipe, Joris Ivens. (France/West Germany, 1956) ARIANE/DEFA

Guendalina
The story of two adolescents' romantic love. Jacqueline Sassard, Raffaele Mattioli. *Dir* Alberto Lattuada. (Italy/France, 1956) PONTI

Lucretia Borgia (aka **Sins Of The Borgias**, orig: **Lucrece Borgia**)
Costume drama. Martine Carol, Pedro Armendariz, Massimo Serato. *Dir* Christian-Jaque. (France/Italy, 1952) ARIANE/FILMSONOR/RIZZOLI

Rosanna (aka **The Net**, orig: **La Red**)
Crime melodrama. Rosanna Podesta, Crox Alvarado, Armando Silvestre. *Dir* Emilio Fernandez. (Mexico, 1953) REFORMA

1957

Gates Of Paris (orig: **Porte Des Lilas**)
Poetic melodrama. Pierre Brasseur, Dany Carrel, Henri Vidal, Georges Brassens. *Dir* Rene Clair. (France/Italy, 1957) FILMSONOR/RIZZOLI

He Who Must Die (orig: **Celui Qui Doit Mourir**)
Polemical drama. Melina Mercouri, Jean Servais, Carl Mohner, Roger Hanin. *Dir* Jules Dassin. (France/Italy, 1957) INDUSFILMS

Nights Of Cabiria (GB: **Cabiria**, orig: **Le Notti De Cabiria**)
Comedy-drama. Giulietta Masina, Amedeo Nazzari, Francois Perier. *Dir* Federico Fellini. (Italy/France, 1956) DINO DE LAURENTIIS/FILMS MARCEAU

1958

Inspector Maigret (aka **Maigret Sets A Trap**, aka **Woman Bait**, orig: **Maigret Tend Un Piege**)
Murder mystery. Jean Gabin, Annie Girardot. *Dir* Jean Delannoy. (France, 1958) INTERMONDIA/JOLLY

La Parisienne (orig: **Une Parisienne**)
Light comedy. Brigitte Bardot, Charles Boyer, Henri Vidal. *Dir* Michel Boisrond. Technicolor. (France/Italy, 1957) ARIANE/FILMSONOR/CINETEL/RIZZOLI

The Possessors (orig: **Les Grandes Familles**)
Family saga. Jean Gabin, Jean Desailly, Bernard Blier. *Dir* Denys de la Patellière. (France, 1958) FILMSONOR/INTERMONDIA

1959

Black Orpheus (orig: **Orfeu Negro**)
Modern version of myth. Breno Mello, Marpessa Dawn, Ademar Da Sylva. *Dir* Marcel Camus. (France/Italy/Brazil, 1958) DISPATFILM/GEMMA/TUPAN

Marie-Octobre (aka **Secret Meeting**)
Drama of the French Resistance. Danielle Darrieux, Bernard Blier. *Dir* Julien Duvivier. (France, 1958) OREX

Streets Of Paris (aka **Rue De Paris**, orig: **Rue Des Prairies**)
Family drama. Jean Gabin, Claude Brasseur. *Dir* Denys de la Patellière. (France/Italy, 1959) ARIANE/INTERMONDIA/FILMSONOR/VIDES

1960

And Quiet Flows The Don (orig: **Tikhi Don**)
Panoramic drama. Ellina Bystritskaya, Pyotr Glebov, Zinaida Kirienko. *Dir* Sergei Gerasimov. Sovcolor. (Russia, 1958) GORKY

The Horror Chamber Of Dr Faustus (GB: **Eyes Without A Face**, orig: **Les Yeux Sans Visage**)
Tale of horror. Pierre Brasseur, Alida Valli, Edith Scob. *Dir* Georges Franju. (France/Italy, 1959) CHAMPS ELYSEES/LUX

The Last Days Of Pompeii (orig: **Gli Ultimi Giorni Di Pompei**)
Spectacle. Steve Reeves, Annemarie Baumann, Cristina Kauffman, Barbara Carroll. *Dir* Mario Bonnard. Eastman Color. (Italy/Spain/Monaco, 1959) CINEPRODUZIONI/PROCUSA/TRANSOCEAN

The Night (orig: **La Notte**)
Psychological drama. Jeanne Moreau, Marcello Mastroianni, Monica Vitti. *Dir* Michelangelo Antonioni. (Italy/France, 1960) NEPI/SOFITEDIP/SILVER

A Woman Like Satan (aka **The Female**, orig: **La Femme Et Le Pantin**)
Exotic melodrama. Brigitte Bardot, Antonio Vilar, Espanita Cortez. *Dir* Julien Duvivier. Eastmancolor. (France/Italy, 1958) PATHÉ/GRAY/DEAR

1961

The Great War (orig: **La Grande Guerra**)
War comedy-drama. Vittorio Gassman, Silvana Mangano, Alberto Sordi. *Dir* Mario Monicelli. (Italy/France, 1959) DINO DE LAURENTIIS

The Joker (orig: **Le Farceur**)
Sex comedy. Jean-Pierre Cassel, Anouk Aimee, Genevieve Cluny. *Dir* Philippe de Broca. (France, 1960) NONIN/AJYM

The Revolt Of The Slaves (orig: **La Rivolta Degli Schiavi**)
Spectacle set in ancient Rome. Rhonda Fleming, Lang Jeffries, Ettore Manni. *Dir* Nunzio Malasomma. Eastman Color. (Italy/Spain/West Germany, 1961) AMBROSIANA/CB/ULTRA

1962

Court Martial (orig: **Kriegsgerich**)
Courtroom drama. Karlheinz Bohm, Christiane Wolf. *Dir* Kurt Meisel (West Germany, 1959) ARCA

Electra (orig: **Elektra**)
Greek tragedy. Irene Papas, *Dir* Michael Cacoyannis. (Greece, 1961) FINOS

The Mighty Ursus (orig: **Ursus**)
Roman spectacle. Ed Fury, Cristina Gajoni. *Dir* Carlo Campogalliani. (Italy/Spain, 1960) CINÉ ITALIA

Sword Of The Conqueror (orig: **Rosmuna E Alboino**)
Ancient Roman spectacle. Jack Palance, Eleanora Rossi-Drago, Guy Madison. *Dir* Carlo Campogalliani. (Italy, 1961) TITANUS

The Vampire And The Ballerina (orig: **L'Amante Del Vampiro**)
Horror Tale. Helene Remy, Walter Brand. *Dir* Renato Posilli. (Italy, 1959) CONSORZIO

1963

The Big Risk (orig: **Classe Tous Risques**)
Drama about criminals and a crime. Jean-Paul Belmondo, Lino Ventura, Marcel Dalio. *Dir* Claude Sautet. (France/Italy, 1959) MONDEX

Muriel (orig: **Muriel, Ou Le Temps D'Un Retour**)
Psycho-political drama. Delphine Seyrig, Jean-Pierre Kerien, Nita Klein. *Dir* Alain Resnais. Eastman Color. (France/Italy, 1963) ARGOS/ALPHA/ECLAIR/PLEIADE/DEAR

My Son, The Hero (aka **Sons Of Thunder**, orig: **Arrivano I Titani**)
Spectacle. Pedro Armendariz, Jacqueline Sassard, Antonella Lualdi. *Dir* Duccio Tessari. Eastman Color. (Italy/France, 1961) ARIANE/VIDES

Naked Among The Wolves (orig: **Nackt Unter Wölfen**)
Concentration camp drama. Fred Delmare, Irwin Geschonneck. *Dir* Frank Beyer. (East Germany, 1963) DEFA

Nutty, Naughty Chateau (orig: **Chateau En Suede**)
Sex comedy-drama. Jean-Louis Trintignant, Monica Vitti, Curt Jurgens. *Dir* Roger Vadim. Technicolor. (France/Italy, 1963) CORONA/EURO INTERNATIONAL

1964

Stowaway In The Sky (orig: **Le Voyage En Ballon**)
Children's adventure. Pascal Lamorisse, Andre Gille, Maurice Baquet. *Dir* Albert Lamorisse. Eastman Color. (France, 1960) FILMSONOR/FILMS MONTSOURIS

That Man From Rio (orig: **L'Homme De Rio**)
Comedy adventure. Jean-Paul Belmondo, Francoise Dorleac, Jean Servais. *Dir* Philippe de Broca. Eastman Color. (France/Italy, 1964) ARIANE/DEAR/VIDES

1965

Up To His Ears (orig: **Les Tribulations D'Un Chinois En Chine**)
Comedy adventure. Jean-Paul Belmondo, Ursula Andress, Jean Rochefort. *Dir* Philippe de Broca. Eastman Color. (France/Italy, 1965) ARIANE/VIDES

1966

Hamlet
Shakespearean tragedy. Innokenti Smoktunovsky, Anastasia Vertinskaya. *Dir* Grigori Kozintsev. (Russia, 1964) LENFILM

Viva Maria!
Comedy-adventure. Jeanne Moreau, Brigitte Bardot, George Hamilton. *Dir* Louis Malle. Eastman Color. (France/Italy, 1965) NOUVELLES EDITIONS/ARTISTES ASSOCIES/VIDES

A Young World (orig: **Un Monde Nouveau**)
Teenage romance. Christine Delaroche, Nino Castelnuovo, Tanya Lopert. *Dir* Vittorio De Sica. (France/Italy, 1965) HARRY SALTZMAN

1967

The Bride Wore Black (orig: **La Mariée Etait En Noir**)
Revenge thriller. Jeanne Moreau, Claude Rich, Michel Lonsdale. Claude Brasseur. *Dir* François Truffaut. Eastman Color. (France/Italy, 1967) FILMS DU CAROSSE/DINO DE LAURENTIIS

The Climax (aka **Too Much For One Man**, orig: **L'Immorale**)
Situation comedy. Ugo Tognazzi, Stefania Sandrelli. *Dir* Pietro Germi. (Italy/France, 1967) DELPHOS/DEAR

King Of Hearts (orig: **Le Roi De Coeur**)
War parable. Alan Bates, Micheline Presle, Pierre Brasseur, Genevieve Bujold. *Dir* Philippe de Broca. Eastman Color. (France/Italy, 1966) FILDEBROC

Live For Life (orig: **Vivre Pour Vivre**)
Love triangle. Yves Montand, Candice Bergen, Annie Girardot. *Dir* Claude Lelouch. Eastman Color. (France/Italy, 1967) ARIANE/VIDES

La Musica
Marriage drama. Robert Hussein, Delphine Seyrig, Jules Dassin. *Dir* Marguerite Duras. (France, 1967) UA/RAOUL PLOQUIN

My Wife's Husband (orig: **La Cuisine Au Beurre**)
Situation comedy. Fernandel, Bourvil, Claire Maurier, Mag-Avril. *Dir* Gilles Grangier. (France/Italy, 1963) CORONA/DEAR

Shock Troops (orig: **Un Homme De Trop**)
War drama. Bruno Cremer, Jean-Claude Brialy, Gerard Blain, Claude Brasseur. *Dir* Costa-Gavras. Eastman Color. (France/Italy, 1967) SALTZMAN/TERRA/UA

The Thief Of Paris (aka **The Thief**, orig: **Le Voleur**)
Turn-of-the-century comedy-thriller. Jean-Paul Belmondo, Genevieve Bujold, Marie Dubois. *Dir* Louis Malle. Eastman Color. (France, 1966) NOUVELLES EDITIONS/COMPANIA CINEMATOGRAFICA/UA

We Still Kill The Old Way (orig: **A Ciascuno Il Suo**)
Mafia crime drama. Gian Maria Volonte, Irene Papas, Gabriele Ferzetti. *Dir* Elio Petri. Technicolor. (Italy, 1967) CEMOFILM

1968

Fantomas (orig: **Fantomas Contre Scotland Yard**)
Comedy-adventure. Jean Marais, Louis De Funes, Mylene Demongeot. *Dir* André Hunebelle. (France/Italy, 1966) PAC/SNEG/GAUMONT/PCM

Hour Of The Wolf (orig: **Vargtimmen**)
Surreal drama. Max Von Sydow, Liv Ullman, Ingrid Thulin. *Dir* Ingmar Bergman. (Sweden, 1967) SVENSK FILMINDUSTRI

Persona
Psychological drama. Liv Ullman, Bibi Andersson, Gunnar Bjornstrand. *Dir* Ingmar Bergman. (Sweden, 1966) SVENSK FILMINDUSTRI

Stolen Kisses (orig: **Baisers Voles**)
Wistful romantic comedy. Jean-Pierre Léaud, Delphine Seyrig, Claude Jade, Michel Lonsdale. *Dir* François Truffaut. Eastman Color. (France, 1968) FILMS DU CAROSSE

Voyage Of Silence (orig: **O Salto**)
Social-realist drama. Marco Pico, Ludmilla Michael, Antonio Passalia. *Dir* Christian de Chalonge. (France, 1967) FILDEBROC/UA

The Witches (orig: **Le Streghe**)
Five sketch comedy. Silvana Mangano, Annie Girardot, Alberto Sordi, Toto, Clint Eastwood. *Dir* Luchino Visconti, Mauro Bolognini, Pier Paolo Pasolini, Franco Rossi, Vittorio De Sica. Eastman Color. (Italy/France, 1966) DINO DE LAURENTIIS/UA

1969

The American (orig: **L'Americain**)
Small town drama. Jean-Louis Trintignant, Simone Signoret, Marcel Bozzuffi. *Dir* Marcel Bozzuffi. Eastman Color. (France, 1969) FILMS 13/ARIANE

La Chamade
Sex drama. Catherine Deneuve, Michel Piccoli, Roger Van Hool. *Dir* Alain Cavalier. Eastman Color. (France/Italy, 1968) ARIANE/ARTISTES ASSOCIES

The Devil By The Tail (orig: **Le Diable Par La Queue**)
Picaresque romantic comedy. Yves Montand, Maria Schell, Jean Rochefort. *Dir* Philippe de Broca. Eastman Color. (France/Italy, 1968) FILDEBROC/ARTISTES ASSOCIES/DELPHOS

Les Gauloises Bleues
Comedy-drama of French family life. Annie Girardot, Jean-Pierre Kalfon, Nella Bielski, Bruno Cremer. *Dir* Michel Cournot. Eastman Color. (France, 1968) FILMS 13/ARIANE/UA

Life, Love, Death (orig: **La Vie, L'Amour, La Mort**)
Penal drama. Amidou, Caroline Cellier, Marcel Buzzuffi. *Dir* Claude Lelouch. DeLuxe. (France/Italy, 1968) FILMS 13/ARIANE/PEA/ARTISTES ASSOCIES

Listen, Let's Make Love (orig: **Scuse, Facciamo L'Amore**)
Comedy of sexual antics. Gina Lollobrigida, Pierre Clementi, Beba Loncar. *Dir* Vittorio Caprioli. DeLuxe. (Italy, 1969) PEA

The Sex Of Angels (orig: **Il Sesso Degli Angeli**)
Dramatic sex and drugs saga. Bernhard De Vries, Rosemarie Dexter, Doris Kunstmann. *Dir* Ugo Liberatore. (Italy/West Germany, 1968) FRANZ SEITZ/FILMES CINEMATOGRAFICA

Shame (orig: **Skammen**)
Symbolic drama. Max Von Sydow, Liv Ullman, Gunnar Bjornstrand. *Dir* Ingmar Bergman. (Sweden, 1968) SWENSK FILMINDUSTRI

1970

Burn! (orig: **Queimada!**)
Historical-political drama. Marlon Brando, Renato Salvatori, Evaristo Marquez. *Dir* Gillo Pontecorvo. (Italy/France, 1968) PEA/UA

Fellini Satyricon (aka **Satyricon**)
Picaresque Roman spectacle. Martin Potter, Capucine, Hiram Keller, Alain Cuny. *Dir* Federico Fellini. (Italy/France, 1969) PEA/UA

Give Her The Moon (orig: **Les Caprices De Marie**)
Small town comedy. Marthe Keller, Bert Convy, Philippe Noiret, Fernand Gravey. *Dir* Philippe de Broca. (France/Italy, 1970) PEA/UA

Love Is A Funny Thing (orig: **Un Homme Qui Me Plait**)
Love story. Jean-Paul Belmondo, Annie Girardot, Marcel Bozzuffi. *Dir* Claude Lelouch. (France/Italy, 1969) FILMS 13/ARIANE

Matchless
Spy spoof. Patrick O'Neal, Ira Furstenberg, Donald Pleasence, Henry Silva. *Dir* Alberto Lattuada. (Italy, 1966) DINO DE LAURENTIIS

Mississippi Mermaid (orig: **La Sirene Du Mississippi**)
Mystery. Jean-Paul Belmondo, Catherine Deneuve, Michel Bouquet. *Dir* François Truffaut. (France, 1969) FILMS DU CAROSSE

A Passion (aka **The Passion Of Anna**, orig: **En Passion**)
Psychological drama. Max Von Sydow, Liv Ullman, Erland Josephson, Bibi Andersson. *Dir* Ingmar Bergman. (Sweden, 1969) SVENSK FILMINDUSTRI

A Quiet Place In The Country (orig: **Un Tranquillo Posto Di Campagna**)
Mystery melodrama. Franco Nero, Vanessa Redgrave, Georges Geret. *Dir* Elio Petri. (Italy/France, 1968) PEA/ARTISTES ASSOCIES

The Wild Child (orig: **L'Enfant Sauvage**)
Anthropological drama. François Truffaut, Jean-Pierre Cargol, Jean Daste. *Dir* François Truffaut. (France, 1969) FILMS DU CAROSSE/ARTISTES ASSOCIES

1971

The Crook (GB: **Simon The Swiss**, orig: **Le Voyou**)
Heist comedy. Jean-Louis Trintignant, Christine Lelouch, Charles Denner. *Dir* Claude Lelouch. (France/Italy, 1970) ARIANE/FILMS 13/UA

The Decameron (orig: **Il Decamerone**)
Boccaccio's bawdy tales. Franco Citti, Ninetto Davoli, Silvana Mangano. *Dir* Pier Paolo Pasolini. (Italy, France, West Germany, 1970) PEA

That Splendid November (orig: **Un Bellissimo Novembre**)
Melodrama. Gina Lollobrigida, Gabriele Ferzetti, Andre Laurence. *Dir* Mauro Bolognini. (Italy, France, 1968) ADELPHIA/ARTISTES ASSOCIES

The World Of Hans Christian Anderson (orig: **Hansu Kurishitan Anderusan No Sekai**)
Cartoon feature. *Dir* Kimio Yabuki. De Luxe Color. (Japan, 1968) TOEI

1972

Fellini's Roma (aka **Roma**)
Documentary-Fantasy. Peter Gonzales, Stefano Majore, Britta Barnes. *Dir* Federico Fellini. (Italy/France, 1972) ULTRA/UA

Lady Liberty (orig: **La Mortadella**)
Comedy. Sophia Loren, William Devane. *Dir* Mario Monicelli. (Italy/France, 1971) CARLO PONTI

1974

Bawdy Tales (orig: **Storie Scellerate**)
Sex comedy. Franco Citti, Ninetto Davoli. *Dir* Sergio Citti. (Italy/France, 1973) PEA/SAS/ARTISTES ASSOCIES

Canterbury Tales (orig: **I Racconti Di Canterbury**)
Chaucer's bawdy tales. Hugh Griffith, Ninetto Davoli, Franco Citti. *Dir* Pier Paolo Pasolini. (Italy, 1971) PEA

The Voyage (aka **The Journey**, orig: **Il Viaggio**)
Melodrama. Sophia Loren, Richard Burton, Ian Bannen. *Dir* Vittorio De Sica. (Italy, 1974) CINEMATOGRAFICA CHAMPION/CAPAC

1975

The Arabian Nights (aka **A Thousand And One Nights**, orig: **Il Fiore Delle Mille E Una Notte**)
Bawdy tales. Ninetto Davoli, Franco Citti, Franco Merli. *Dir* Pier Paolo Pasolini. (Italy/France, 1974) PEA/ARTISTES ASSOCIES

1976

Illustrious Corpses (orig: **Cadaveri Eccellenti**)
Conspiracy thriller. Lino Ventura, Alain Cuny, Marcel Bozzuffi, Charles Vanel. *Dir* Francesco Rosi. (Italy/France, 1975) PEA/EUROPEES ASSOCIES

Special Section (orig: **Section Speciale**)
Political courtroom drama. Louis Seigner, Michel Lonsdale, Henri Serre. *Dir* Costa-Gavras. (France/Italy/West Germany, 1975) REGGANE/GORIZ/JANUS

Small Change (aka **Pocket Money**, aka **Spending Money**, orig: **L'Argent De Poche**)
Childhood comedy. Philippe Goldman, Claudio Deluca, Geory Desmouceaux. *Dir* François Truffaut. (France, 1976) FILMS DU CAROSSE

1977

Beyond Good And Evil (aka **Beyond Evil**, orig: **Oltre Il Bene E Il Male**)
Philosophical drama. Dominique Sanda, Erland Josephson, Robert Powell, Virna Lisi. *Dir* Liliana Cavani. (Italy/France/West Germany, 1977) CLESI/LOTAR/ARTEMIS

The Man Who Loved Women (orig: **L'Homme Qui Aimait Les Femmes**)
Sex comedy. Charles Denner, Leslie Caron, Nathalie Baye, Brigitte Fossey. *Dir* François Truffaut. (France, 1977) FILMS DU CAROSSE

1978

The Marriage Of Maria Braun (orig: **Die Ehe Der Maria Braun**)
Modern melodrama. Hanna Schygulla, Klaus Lowitsch, Ivan Desny. *Dir* Rainer Werner Fassbinder. (West Germany, 1978) ALBATROS/TRIO/WDR

Molière
Biopic of the French playwright. Philippe Caubere, Marie-France Audollent. *Dir* Ariane Mnouchkine. (France/Italy, 1978) FILMS 13/RAI

Second Chance (orig: **Si C'etait A Refaire**)
Prison drama. Catherine Deneuve, Anouk Aimee, Charles Denner, Francis Huster. *Dir* Claude Lelouch. (France, 1976) FILMS 13

1979

La Cage Aux Folles (aka **Birds Of A Feather**)
Farce. Ugo Tognazzi, Michel Serrault. *Dir* Edouard Molinaro. (France/Italy, 1978) DAMA/UA

The Tin Drum (orig: **Die Blechtrommel**)
Symbolic drama. Mario Adorf, David Bennent, Angela Winkler. *Dir* Volker Schlöndorff. (West Germany/France/Yugoslavia, 1979) FRANZ SEITZ/BIOSKOP/ARTEMIS/HALLELUJAH/ARGOS

1981

La Cage Aux Folles II
Farcical sequel to *La Cage Aux Folles*. Ugo Tognazzi, Michel Serrault, Marcel Bozzuffi. *Dir* Edouard Molinaro. (France/Italy, 1980) DAMA/UA

The Last Metro (orig: **Le Dernier Metro**)
Wartime drama. Catherine Deneuve, Gerard Depardieu, Jean Poiret. *Dir* François Truffaut. (France, 1980) FILMS DU CAROSSE

Man Of Iron (orig: **Czlowiek Z Zelaza**)
Political drama. Marian Opania, Jerzy Radziwilowicz. *Dir* Andrzej Wajda. (Poland, 1981) FILM POLSKI

The Woman Next Door (orig: **La Femme A Cote**)
Story of doomed sexual passion. Gerard Depardieu, Fanny Ardant. *Dir* François Truffaut. (France, 1981) FILMS DU CAROSSE

1982

Circle Of Deceit (orig: **Die Falschung**)
Political romantic drama. Bruno Ganz, Hanna Schygulla. *Dir* Volker Schlöndorff. (West Germany/France, 1981) BIOSKOP/ARGOS/ARTEMIS

Diva
Thriller. Frederic Andrei, Wilhelmina Wiggins Fernandez. *Dir* Jean-Jacques Beineix. (France, 1981) GALAXIE/GREENWICH

Fabian
Social drama. Hans Peter Hallwach, Silvia Janisch, Brigitte Mira, Ivan Desny. *Dir* Wolf Gremm. (West Germany, 1980) REGINA ZIEGIER/UA

A Good Marriage (orig: **Le Beau Marriage**)
Moral fable. Beatrice Romand, Andre Dussollier, Feodor Atkine. *Dir* Eric Rohmer. (France, 1981) LOSANGE/CAROSSE

Lili Marlene
Wartime drama. Hanna Schygulla, Giancarlo Giannini, Mel Ferrer. *Dir* Rainer Werner Fassbinder. (West Germany, 1980) ROXY/RIALTO/REX

Lola
Ironic melodrama. Barbara Sukowa, Armin Mueller-Stahl, Mario Adorf. *Dir* Rainer Werner Fassbinder. (West Germany, 1981) RIALTO/PREBEN/PHILIPSEN/TRIO/WESTDEUTSCHEN/RUNDFUNK

Memoirs Of A French Whore (aka **The Getaway Life**, aka **The Evasion**, GB: **The Confessions Of A Streetwalker**, orig: **La Derobade**)
Social drama. Miou-Miou, Maria Schneider. *Dir* Daniel Duval. (France, 1979) ATC 3000/SN

Veronica Voss (orig: **Die Sehnsucht Der Vorinika Voss**)
Melodrama. Rosel Zech, Hilmar Thate, Annemarie Duringer. *Dir* Rainer Werner Fassbinder. (West Germany, 1982) LAURA/TANGO/RIALTO/TRIO/MARAN

1983

The Divine Emma (orig: **Božská Ema**)
Biopic of Bohemian soprano Emma Destinn. Bozidara Turzonovova, Juraj Kukura. *Dir* Jiri Krejcik. (Czechoslovakia, 1983) FILMOVE STUDIO BARRANDOV

The Girl With The Red Hair (orig: **Het Meisje Met Het Rode Haat**)
Feminist biopic of Dutch anti-Nazi Resistance fighter, Hannie Schaft. Renee Soutendijk, Peter Tuinman, Loes Luca. *Dir* Ben Verbong. (Holland, 1983) VNU/TRIO/VARA/QUERIDO/METEOR

Godard's Passion (orig: **Passion**)
Dialectic drama. Isabelle Huppert, Hanna Schygulla, Jerzy Radziwilowicz. *Dir* Jean-Luc Godard. (France, 1983) SARA/SONIMAGE/ANTENNE 2/SSR

Night Of The Shooting Stars (aka **The Night Of San Lorenzo**, orig: **La Notte Di San Lorenzo**)
Wartime drama. Omero Antonutti, Margarita Lozano, Claudio Bigagli. *Dir* Paulo and Vittorio Taviani. (Italy, 1982) RAI/AGER

The Northern Star (orig: **L'Etoile Du Nord**)
Murder mystery. Simone Signoret, Philippe Noiret, Fanny Cottencon. *Dir* Pierre Granier-Deferre. (France, 1983) SARA/ANTENNE 2

1984

Entre Nous (GB: **At First Sight**, orig: **Coup De Foudre**)
Romantic love affair between two women. Miou Miou, Isabelle Huppert, Guy Marchand, Jean-Pierre Bacri. *Dir* Diane Kurys. (France, 1983) ARIEL ZEITOUR/PARTNER'S PRODUCTION

Gabriela
Romance between solid citizen and sultry wench. Marcello Mastroianni, Sonia Braga, Antonio Cantafora. *Dir* Bruno Barreto. (Italy, 1983) SULTANA

Sunday In The Country (orig: **Dimanche A La Campagne**)
Nostalgic comedy. Louis Ducreux, Sabine Azema, Michel Aumont. *Dir* Bernard Tavernier. (France, 1983) SARA/ANTENNE 2/LITTLE BEAR

DOCUMENTARY FEATURES

These pictures, no matter what or where their origins, are all documentary or actuality features. They consist of travelogues, newsreel compilations and filmed records of sporting, artistic and historic events.

1931

Around The World In 80 Minutes With Douglas Fairbanks
A travelogue with Douglas Fairbanks acting as guide. *Dir* Douglas Fairbanks, Victor Fleming. *Pro* Douglas Fairbanks. (USA) FAIRBANKS

1940

The Conquest Of The Air
Fascinating history of aviation from its beginnings. *Dir* Zoltan Korda, Alexander Esway, Donald Taylor, Alexander Shaw, John Monk Saunders, Lee Garmes, William Cameron Menzies. *Pro* Alexander Korda. (GB, 1940) LONDON

1941

Kukan, The Battle Cry Of China
China's fight to repel the Japanese invaders. *Dir* Rey Scott. *Pro* Herbert T. Edwards. Technicolor. (USA) ADVENTURE EPICS

1942

Jacaré
An expedition into the Amazon River jungles of Brazil. *Dir* Charles E. Ford. *Pro* Jules Levey. (USA) MAYFAIR

1943

Victory Through Air Power
The history of aviation linked by cartoon episodes. *Dir* H.C. Potter, David Hand. *Pro* Walt Disney. Technicolor. (USA) WALT DISNEY

1947

The Roosevelt Story
The life of FDR in newsreels. *Dir* uncredited. *Pro* Martin Levine, Oliver Ungar. (USA) TOLA

1948

Kings Of The Olympics
The 1948 London Olympics. *Dir & Pro* Uncredited. *Editor* Geraldine Lerner. (Germany, 1948) WESTPORT INTERNATIONAL

Olympic Cavalcade
The 1948 London Olympics. *Dir* Joseph Lerner. *Pro* Uncredited. (USA) WESTPORT INTERNATIONAL

Urubu
Expedition to the jungles of Brazil. *Dir & Pro* George Breakston, Yorke Coplen. (USA) PHILIP N. KRASNE

1952

Royal Journey
Elizabeth II's 1952 tour of Canada. *Dir* David Bairstow. *Pro* Tom Daly. Technicolor. (Canada, 1952) NATIONAL FILM BOARD OF CANADA

1953

The Conquest Of Everest
The triumph of the 1953 British expedition. *Dir* Thomas Stobart *Pro* John Taylor, Leon Clore, Grahame Tharp. Technicolor. (GB, 1953) COUNTRYMAN/GROUP 3

Song Of The Land
The wonders of nature. *Dir* Ed N. Harrison, Frances Roberts, Henry S. Kesler. *Pro* Henry S. Kesler. Color by Color Corp. of America. (USA) KESLER

Yesterday And Today
A montage of early movies. *Dir & Pro* Abner J. Greshler. (USA) GRESHLER

1954

Challenge Of The Wild
The expedition of a family of four into the wilds of North America. *Dir & Pro* Frank Graham. Color by Color Corp. of America. (USA) GRAHAM

The Queen's Royal Tour
The English Queen's 1954 tour of the Fiji Islands and New Zealand. *Dir* Oxley Hugham. *Pro* Castleton Knight. Eastmancolor. (GB, 1954) RANK

This Is Your Army
Life in the 'New US army'. *Dir* John J. Gordon. *Pro* Edmund Reek. Technicolor. (USA) MOVIETONE

Victory At Sea
The course of World War II at sea. *Dir & Pro* Henry Salomon. (USA) NBC

1955

Lost Continent (orig: **Continente Perduto**)
The people and customs of the Spice Islands. *Dir* Leonardo Bonzi, Mario Craveri, Enrico Gras, Giorgio Moser. *Pro* Leonardo Bonzi. Technicolor. (Italy, 1954) ASTRA CINEMATOGRAPHICA

1956

The Mystery Of Picasso (orig: **Le Mystère De Picasso**)
A study of the Spanish artist at work. *Dir & Pro* Henri-Georges Clouzot. FILMSONOR

Unidentified Flying Objects (aka **UFO**)
Investigations into UFO's over the US. *Dir* Winston Jones. *Pro* Clarence Greene. (USA) GREENE-ROUSE

1957

Satchmo The Great
A record of Louis Armstrong's world tour. *Dir & Pro* Edward R. Murrow, Fred W. Friendly. (USA) CBS

1958

The Last Paradise
Four tales about the romantic and exotic South Seas. *Dir* Folco Quilici. *Pro* Golfiero Colonna. Technicolor. (Italy, 1957) PANEUROPA/LUX

1960

The Royal Ballet
Recording of three ballets. *Dir & Pro* Paul Czinner. Technicolor. (GB, 1959) RANK

1964

Four Days In November
An investigation into the assassination of John F. Kennedy. *Dir & Pro* Mel Stuart. (USA) DAVID L. WOLPER

1968

Revolution
A study of the life-style and philosophical ideas of hippies. *Dir* Jack O'Connell. *Pro* Robert J. Leder. Eastmancolor. (USA) OMICRON

1970

Let It Be
A documented account of the last recording sessions of the Beatles. *Dir* Michael Lindsay-Hogg. *Pro* Neil Aspinall. (GB, 1970) APPLE

What Do You Say To A Naked Lady?
The reactions of people, watched by a hidden camera, to a number of erotic situations. *Dir & Pro* Allen Funt. (USA) ALLEN FUNT

A.K.A. Cassius Clay
Mohammed Ali discusses his life and fights. *Dir* Jim Jacobs. *Pro* William Cayton. (USA) WILLIAM CAYTON

1972

Money Talks
People reveal their attitudes to money while unknowingly watched by a hidden camera. *Dir & Pro* Allen Funt. (USA) ALLEN FUNT

1976

It's Showtime (aka **Paws, Jaws And Claws**)
A compilation of animal sequences from movies. *Dir* uncredited. *Pro* Fred Weintraub. (USA) FRED WEINTRAUB/PAUL HELLER

1978

The Last Waltz
The farewell concert of The Band. *Dir* Martin Scorsese. *Pro* Robbie Robertson. (USA) UA

1981

From Mao To Mozart
Isaac Stern's 1979 tour of China. *Dir* Murray Lerner, Alan Miller. *Pro* Murray Lerner, Walter Scheuer. (USA) HOPEWELL FOUNDATION/HARMONY

1982

The Weavers: Wasn't That A Time
A lively portrait of The Weavers folk-singing group. *Dir* Jim Brown. *Pro* Jim Brown, George C. Stoney, Harold Leventhal. (USA) JIM BROWN/GEORGE STONEY/HAROLD LEVENTHAL

1983

Genocide
A harrowing documentary on the Nazi persecution of the Jews. *Dir & Pro* Arnold Schwartzman. (USA) SIMON WIESENTHAL CENTER

Say Amen, Somebody (GB: **Say Amen, Someone**)
A filmed portrait of black American gospel singers. *Dir* George T. Nierenberg. *Pro* George and Karen Nierenberg. (USA) GTN

APPENDIX 4
PARAMOUNT PRODUCTIONS

During the period 1942 to 1944, United Artists took delivery of the films embodied in a 21-picture deal negotiated with Paramount Pictures, Inc. to increase their lean amount of product. As Paramount had a product surplus they were willing to allow UA to distribute the films while other producers were being sought. The Paramount package included three features of some merit, five Harry Sherman Action Specials (in other words, B Westerns) and thirteen Hopalong Cassidy Western featurettes (see appendix 5). The contact between United Artists and Paramount goes back, in fact, to 1924 when D.W. Griffith, after a series of financial flops at UA, went over to the larger company to work for Adolph Zukor. In order to get Griffith, Paramount agreed to allow UA to release the first picture he made at his new studio – *Sally Of The Sawdust*. After two more films for Paramount – *That Royle Girl* (1925) and *The Sorrows Of Satan* (1926) – Griffith returned to United Artists, who released the remaining five pictures that he made.

1925

Sally Of The Sawdust
A girl brought up by her guardian among a group of travelling entertainers finds her real family disapproves of carnival folk. Carol Dempster, W.C. Fields, Alfred Lunt. *Dir & Pro* D.W. Griffith.

1942

American Empire
(Sherman Special)

I Married A Witch
A Salem witch and her father come back to haunt the descendant of the Puritan who had them burned. Fredric March, Veronica Lake, Cecil Kellaway, Susan Hayward, Robert Benchley. *Dir & Pro* Rene Clair.

Silver Queen
(Sherman Special)

1943

Buckskin Frontier
(Sherman Special)

The Crystal Ball
A girl becomes a fortune teller and gets involved in a land swindle. Paulette Goddard, Ray Milland, Gladys George, Virginia Field, Cecil Kellaway. *Dir* Elliott Nugent. *Pro* Richard Blumenthal.

The Kansan
(Sherman Special)

Young And Willing
A group of impecunious actors living in a boarding house make an old play into a hit. William Holden, Eddie Bracken, Robert Benchley, Susan Hayward, Martha O'Driscoll. *Dir & Pro* Edward H. Griffith.

1944

The Woman Of The Town
(Sherman Special)

WESTERN FEATURETTE SERIES

STREAMLINERS

HOPALONG CASSIDY

Among the 21-picture package that United Artists bought from Paramount in 1942 (see Appendix 4), was a series of Hopalong Cassidy Westerns produced by Harry Sherman. From 1946 to 1948 the star of the featurettes, William Boyd, became the producer of Hopalong Cassidy Productions and made 12 further films for UA. All the pictures, running around the 60 minute mark and made for about $100,000, usually grossed twice their cost. Robert Mitchum appeared as a heavy in seven of them. Boyd, who had previously starred in Cecil B. DeMille films in the 20s, was chosen to play the title role in the first *Hop-A-Long Cassidy* (the hyphens were later dropped), released by Paramount in 1935. Its success launched a series of Westerns based on the books of Clarence E. Mulford. In all, Paramount released 41 Hopalong pictures before handing him over to UA.

1942
Lost Canyon
Undercover Man

1943
Bar 20
Border Patrol
Colt Comrades
False Colours
Hoppy Serves A Writ
Leather Burners
Riders Of The Deadline

1944
Forty Thieves
Lumberjack
Mystery Man
Texas Masquerader

1946
The Devil's Playground

1947
Dangerous Venture
Fool's Gold
Hoppy's Holiday
The Marauders
Unexpected Guest

1948
Borrowed Trouble
The Dead Don't Dream
False Paradise
Silent Conflict
Sinister Journey
Strange Gamble

THE CISCO KID

That charming Latin Robin Hood, the Cisco Kid, based on a character in an O. Henry story, came to the moviegoing public's attention when Warner Baxter won the Best Actor Oscar in the role in *Old Arizona* (Fox, 1929). Baxter reprised the part for Fox in *The Arizona Kid* (1930), *The Cisco Kid* (1931) and *The Return Of The Cisco Kid* (1939). Cesar Romero took over for a further six Cisco Kid movies from 1939 to 1941. In 1949 Duncan Renaldo revived the character for UA, with Leo Carrillo as his sidekick Pancho. The short series of pictures, each running about an hour, was produced by Philip N. Krasne.

1949
The Daring Caballero
The Gay Amigo
Satan's Cradle
Valiant Hombre

1950
Girl From San Lorenzo

HAL ROACH

Hal Roach, who made his name with his productions of comedy shorts featuring Laurel and Hardy, Charlie Chase and Our Gang in the 20s and 30s (mostly released through MGM), set up a distribution arrangement for his features with United Artists in 1938. He delivered 14 features between 1938 and 1941. Towards the end of that period, when UA's product was getting low, he returned to making featurettes or, as he called them, 'streamliners'. They were cheaply made, light comedies of around 4½ reels, with generally unknown names in the leads. The 20 streamliners produced by Roach between 1941 and 1948 easily made much more than their money back. The last two were double bills, each bearing a collective title; subsequently the individual parts were re-released separately as second features.

1941
All-American Co-ed
Johnny Downs, Marjorie Woodward. *Dir* LeRoy Prinz.
Fiesta
Ann Ayara, George Negrete. *Dir* LeRoy Prinz.
Miss Polly
ZaSu Pitts. *Dir* Fred Guiol.
Niagara Falls
ZaSu Pitts, Slim Summerville. *Dir* Gordon Douglas.
Tanks A Million
William Tracy, James Gleason. *Dir* Fred Guiol.

1942
About Face
Joe Sawyer, William Tracy. *Dir* Kurt Neumann.
Brooklyn Orchid
Grace Bradley, William Bendix. *Dir* Kurt Neumann.
The Devil With Hitler
Bobby Watson, Alan Mowbray. *Dir* Gordon Douglas.
Dudes Are Pretty People
Jimmy Rogers, Noah Beery Jr. *Dir* Hal Roach Jr.
Flying With Music
Marjorie Woodward. *Dir* George Archainbaud.
Hayfoot
William Tracy, Joe Sawyer. *Dir* Fred Guiol.
McGuerins From Brooklyn
Grace Bradley, William Bendix *Dir* Kurt Neumann.

1943
Calaboose
Noah Beery Jr. *Dir* Hal Roach Jr.
Fall In
William Tracy, Joe Sawyer. *Dir* Kurt Neumann
Nazty Nuisance (aka **That Nazty Nuisance**)
Bobby Watson, Joe Devlin. *Dir* Glenn Tryon.
Prairie Chickens
Jimmy Rogers, Noah Beery Jr. *Dir* Hal Roach Jr.
Taxi, Mister
Grace Bradley, William Bendix. *Dir* Kurt Neumann.
Yanks Ahoy
Joe Sawyer, William Tracy. *Dir* Kurt Neumann.

1947
Hal Roach Comedy Carnival (part 1 **Curley**, part 2 **The Fabulous Joe**)
Frances Rafferty, Larry Olsen, Walter Abel, Margot Grahame. *Dir* Bernard Carr, Harve Foster.

1948
Lafftime (part 1 **Here Comes Trouble**, part 2 **Who Killed Doc Robbin?**)
William Tracy, Joe Sawyer. *Dir* Fred Guiol. CINECOLOR

COMET

In 1946 Mary Pickford, in association with her husband Charles 'Buddy' Rogers and former Columbia producer Ralph Cohn, formed Comet Productions to make a series of streamliners in the manner of Hal Roach. They made only five, none of which turned out to be particularly successful, due to the producers' inability to bring the pictures in on budget.

1946
Little Iodine
Jo Ann Marlowe, Robert Cavanagh. *Dir* Reginald Le Borg.
Susie Steps Out
David Bruce, Nita Hunter. *Dir* Reginald Le Borg.

1947
The Adventures Of Don Coyote
Fran Rafferty, Ric Martin. *Dir* Reginald Le Borg.
Stork Bites Man
Jackie Cooper. *Dir* Cyril Endfield.

1948
High Fury (aka **White Cradle Inn**)
Madeleine Carroll, Ian Hunter. *Dir* Harold French.

ACADEMY NOMINATIONS AND AWARDS

Since the first Academy Awards were presented in May 1929 (to films released in the 1927/28 season), United Artists has featured prominently in the lists. Douglas Fairbanks was the first president of the Academy of Motion Picture Arts and Sciences, and Mary Pickford followed a few years later. United Artists has had no fewer than eleven Best Picture winners, breaking all records by winning the award three years running in 1975, 1976 and 1977.

This section gives details of all the nominations and awards that films and personnel associated with the company have received to date. Nominations relating to films included in the book are presented under the title of the film. For the sake of completeness, nominations for short subjects, scientific or technical achievements, and honorary, special or memorial awards given to individuals who, at least at some time in their careers, made an important contribution to UA's fortunes, are also listed but under the heading 'Other Awards'. *Churchill's Island*, a 1941 documentary, and *The Red Balloon*, a children's fantasy released in 1956, are exceptions to this presentation rule: too long to be considered shorts by the Academy, but too short to be features according to our criteria, their nominations are nonetheless given under the heading of their title, even though they are not included in the book. Illustrations on the following pages are stills from all the films that won Oscars in one or more of the top six categories.

Award winners in competitive categories where there were other nominations are identified by means of a star; black spots denote recipients of awards that were presented at the Academy's discretion and were not competitive in the sense that other contenders, if indeed there were any, were not publicly nominated. The Academy's wording for many of the categories and their subdivisions has not altered since their inception but some have undergone a series of complicated changes over the years. This applies particularly to those covering writing and music, but in the interests of succinct presentation the wording for these has been simplified in the lists which follow. For a period, separate awards were given to colour and black & white films in the categories for cinematography, art direction and costume design. We have shown this distinction simply by indicating the colour sub-category where appropriate; where this is not given it can be assumed that the film was in black & white. After 1966 the Academy abandoned the distinction between the two.

Over the years an impressive 158 awards have been credited to films released by United Artists and personnel closely associated with the company. The number won in the various categories over 58 years has been:

Picture	11	Music *score/scoring*	13
Actor	14	Music *song*	5
Actress	8	Costume design	4
Supporting Actor	10	Special effects	2
Supporting actress	5	Special visual effects	1
Direction	9	Sound effects	2
Assistant director	1	Short subject	5
Writing	16	Documentary	1
Cinematography	9	Foreign language film	2
Art direction–Set decoration	9	Special/Honorary award	10
Sound	9	Jean Hersholt award	1
Film editing	9	Scientific or technical	2

1927/28

THE CIRCUS
Actor Charles Chaplin
Direction *comedy* Charles Chaplin
● **Special award** Charles Chaplin for versatility and genius in writing, acting, directing and producing *The Circus*

DEVIL DANCER
Cinematography George Barnes

THE DOVE
★ **Art direction** William Cameron Menzies

DRUMS OF LOVE
Cinematography Karl Struss

MAGIC FLAME
Cinematography George Barnes

MY BEST GIRL
Cinematography Charles Rosher

SADIE THOMPSON
Actress Gloria Swanson
Cinematography George Barnes

SORRELL AND SON
Direction Herbert Brenon

THE TEMPEST
Cinematography Charles Rosher
★ **Art direction** William Cameron Menzies

TWO ARABIAN KNIGHTS
★ **Direction** *comedy* Lewis Milestone

Lewis Milestone (centre left) with the two leads William Boyd (centre right) and Louis Wolheim (in the bath!), and others, on the set of *Two Arabian Knights*

1928/29

ALIBI
Picture produced by Roland West
Actor Chester Morris

COQUETTE
★ **Actress** Mary Pickford

Mary Pickford and Johnny Mack Brown

THE IRON MASK
Art direction William Cameron Menzies

1929/30

BULLDOG DRUMMOND
Actor Ronald Colman (also for *Condemned*)
Art direction William Cameron Menzies

CONDEMNED
Actor Ronald Colman (also for *Bulldog Drummond*)

HELL'S ANGELS
Cinematography Gaetano Gaudio and Harry Perry

RAFFLES
Sound Oscar Lagerstrom

THE TRESPASSER
Actress Gloria Swanson

1930/31

THE FRONT PAGE
Picture produced by Howard Hughes
Actor Adolphe Menjou
Direction Lewis Milestone

WHOOPEE
Art direction Richard Day

1931/32

ARROWSMITH
Picture produced by Samuel Goldwyn
Writing *adaptation* Sidney Howard
Cinematography Ray June
Art direction Richard Day

OTHER AWARDS
Short subjects *cartoon* Flowers and Trees (Disney)

1932/33

THE PRIVATE LIFE OF HENRY VIII
Picture produced by Alexander Korda
★ **Actor** Charles Laughton

Charles Laughton and Elsa Lanchester

OTHER AWARDS
● **Assistant director** Fred Fox
Short subjects *cartoon* Building A Building (Disney)
★ *Three Little Pigs* (Disney)

1934

AFFAIRS OF CELLINI
Actor Frank Morgan
Cinematography Charles Rosher
Art direction Richard Day
Sound Thomas T. Moulton

THE HOUSE OF ROTHSCHILD
Picture produced by Darryl F. Zanuck with William Goetz and Raymond Griffith

OTHER AWARDS
★ **Short subjects** *cartoon* The Tortoise And The Hare (Disney)

1935

BARBARY COAST
Cinematography Ray June

THE DARK ANGEL
Actress Merle Oberon
★ **Art direction** Richard Day
Sound Goldwyn Sound Dept., Thomas T. Moulton

ESCAPE ME NEVER
Actress Elisabeth Bergner

FOLIES BERGERE
Dance direction Dave Gould for 'Straw Hat' number (also for *Broadway Melody Of 1936*, MGM)

LES MISERABLES
Picture produced by Darryl F. Zanuck
Cinematography Gregg Toland
Film editing Barbara MacLean
Assistant director Eric Stacey

OTHER AWARDS
★ **Short subjects** *cartoon* Three Orphan Kittens (Disney)
Who Killed Cock Robin? (Disney)
● **Special award** David Wark Griffith for his distinguished creative achievements as director and producer and his invaluable initiative and lasting contribution to the progress of the motion picture arts.

1936

COME AND GET IT
★ **Supporting actor** Walter Brennan
Film editing Edward Curtiss

Walter Brennan and Frances Farmer

DODSWORTH
Picture produced by Samuel Goldwyn with Merritt Hulbert
Actor Walter Huston
Supporting actress Maria Ouspenskaya
Direction William Wyler
Writing *screenplay* Sidney Howard
★ **Art direction** Richard Day
Sound Oscar Lagerstrom

THE GARDEN OF ALLAH
Music *score* Selznick International Music Dept.; Max Steiner, head. Score by Max Steiner
Assistant director Eric G. Stacey
● **Special award** W. Howard Greene and Harold Rosson for the colour cinematography

LAST OF THE MOHICANS
Assistant director Clem Beauchamp

THESE THREE
Supporting actress Bonita Granville

OTHER AWARDS
★ **Short subjects** *cartoon* The Country Cousin (Disney)
● **Scientific or technical** *class 3* United Artists Studio Corporation

1937

DEAD END
Picture produced by Samuel Goldwyn with Merritt Hulbert
Supporting actress Claire Trevor
Cinematography Gregg Toland
Art direction Richard Day

THE HURRICANE
Supporting actor Thomas Mitchell
Music *score* Samuel Goldwyn Studio Music Dept.; Alfred Newman, head. Score by Alfred Newman
★ **Sound** Thomas Moulton

THE PRISONER OF ZENDA
Art direction Lyle Wheeler
Music *score* Selznick International Pictures Music Dept.; Alfred Newman, musical director. Score by Alfred Newman

A STAR IS BORN
Picture produced by David O. Selznick
Actor Fredric March
Actress Janet Gaynor
Direction William Wellman
★ **Writing** *story* William Wellman and Robert Carson
screenplay Alan Campbell, Robert Carson and Dorothy Parker
Assistant director Eric Stacey
● **Special award** W. Howard Greene for the colour photography

STELLA DALLAS
Actress Barbara Stanwyck
Supporting actress Anne Shirley

VOGUES OF 1938
Art direction Alexander Toluboff
Music *song* 'That Old Feeling' Sammy Fain (music) Lew Brown (lyrics)

OTHER AWARDS
● **Scientific and technical** *class 3* Thomas T. Moulton and the United Artists Studio Sound Department

1938

THE ADVENTURES OF TOM SAWYER
Art direction Lyle Wheeler

ALGIERS
Actor Charles Boyer
Supporting actor Gene Lockhart
Cinematography James Wong Howe
Art direction Alexander Toluboff

BLOCKADE
Writing *story* John Howard Lawson
Music *score* Werner Janssen

THE COWBOY AND THE LADY
★ **Sound** Thomas Moulton
Music *song* 'The Cowboy And The Lady' Lionel Newman (music) Arthur Quenzer (lyrics)
score Alfred Newman

GOLDWYN FOLLIES
Art direction Richard Day
Music *scoring* Alfred Newman

THERE GOES MY HEART
Music *scoring* Marvin Hatley

THE YOUNG IN HEART
Cinematography Leon Shamroy
Music *scoring* Franz Waxman
score Franz Waxman

1939

CAPTAIN FURY
Art direction Charles D. Hall

ETERNALLY YOURS
Music *score* Werner Janssen

INTERMEZZO
Music *scoring* Lou Forbes

THE MAN IN THE IRON MASK
Music *score* Lud Gluskin and
Lucien Moraweck

OF MICE AND MEN
Picture produced by Lewis Milestone
Sound Elmer Raguse
Music *scoring* Aaron Copland
score Aaron Copland

STAGECOACH
Picture produced by Walter Wanger
★ **Supporting actor** Thomas Mitchell
Direction John Ford
Cinematography Bert Glennon
Art direction Alexander Toluboff
Film editing Otho Lovering and
Dorothy Spencer
★ **Music** *scoring* Richard Hageman, Frank
Harling, John Leipold and Leo Shuken

Thomas Mitchell and Claire Trevor

THEY SHALL HAVE MUSIC
Music *scoring* Alfred Newman

TOPPER TAKES A TRIP
Special effects Roy Seawright

WUTHERING HEIGHTS
Picture produced by Samuel Goldwyn
Actor Laurence Olivier
Supporting actress Geraldine Fitzgerald
Direction William Wyler
Writing *screenplay* Ben Hecht and
Charles MacArthur
★ **Cinematography** Gregg Toland
Art direction James Basevi
Music *score* Alfred Newman

OTHER AWARDS
● **Special award** Douglas Fairbanks, first
president of the Academy, recognizing his
unique and outstanding contribution to the
international development of the motion
picture

1940

CAPTAIN CAUTION
Sound Elmer Raguse

FOREIGN CORRESPONDENT
Picture produced by Walter Wanger
Supporting actor Albert Basserman
Writing *screenplay* Charles Bennett and
Joan Harrison
Cinematography Rudolph Maté
Art direction Alexander Golitzen
Special effects Paul Eagler (photographic);
Thomas T. Moulton (sound)

THE GREAT DICTATOR
Picture produced by Charles Chaplin
Actor Charles Chaplin
Supporting actor Jack Oakie
Writing *screenplay* Charles Chaplin
Music *score* Meredith Willson

THE LONG VOYAGE HOME
Writing *screenplay* Dudley Nichols
Cinematography Gregg Toland
Film editing Sherman Todd
Music *score* Richard Hageman
Special effects R.T. Layton, R.O. Binger
(photographic); Thomas T. Moulton (sound)

MY SON, MY SON
Art direction John DuCasse Schulze

ONE MILLION B.C.
Music *score* Werner Heymann
Special effects Roy Seawright
(photographic); Elmer Raguse (sound)

OUR TOWN
Picture produced by Sol Lesser
Actress Martha Scott
Art direction Lewis J. Rachmil
Sound Thomas Moulton
Music *scoring* Aaron Copland
score Aaran Copland

REBECCA
★ **Picture** produced by David O. Selznick
Actor Laurence Olivier
Actress Joan Fontaine
Supporting actress Judith Anderson
Direction Alfred Hitchcock
Writing *screenplay* Robert E. Sherwood
and Joan Harrison
★ **Cinematography** George Barnes
Art direction Lyle Wheeler
Film editing Hal C. Kern
Music *score* Franz Waxman
Special effects Jack Cosgrove
(photographic); Arthur Johns (sound)

Laurence Olivier and Joan Fontaine

THE THIEF OF BAGDAD
★ **Cinematography** *colour* George Périnal
★ **Art direction** *colour* Vincent Korda
Music *score* Miklos Rozsa
★ **Special effects** Lawrence Butler
(photographic); Jack Whitney (sound)

THE WESTERNER
★ **Supporting actor** Walter Brennan
Writing *story* Stuart N. Lake
Art direction James Basevi

Walter Brennan (centre), with Gary Cooper (right) and
Paul Hurst

1941

ALL AMERICAN CO-ED
Music *song* 'Out Of The Silence' Lloyd B.
Norlind (music and lyrics)
score Edward Ward

CHEERS FOR MISS BISHOP
Music *score* Edward Ward

CHURCHILL'S ISLAND
★ **Documentary** Canadian Film Board

KUKAN, THE BATTLE CRY OF CHINA
● **Special award** Rey Scott for his
extraordinary achievement in producing this
film record of China's struggle, including its
photography with a 16 mm camera under the
most difficult and dangerous conditions

LYDIA
Music *score* Miklos Rozsa

SO ENDS OUR NIGHT
Music *score* Louis Gruenberg

SON OF MONTE CRISTO
Art direction-Interior decoration John
DuCasse Schulze – Edward G. Boyle

SUNDOWN
Cinematography Charles Lang
Art direction-Interior decoration
Alexander Golitzen – Richard Irvine
Music *score* Miklos Rozsa

TANKS A MILLION
Music *score* Edward Ward

THAT HAMILTON WOMAN
Cinematography Rudolph Mate
Art direction-Interior decoration Vincent
Korda – Julia Heron
★ **Sound** Jack Whitney, General Service
Special effects Lawrence Butler
(photographic); William H. Wilmarth (sound)

THAT UNCERTAIN FEELING
Music *score* Werner Heyman

TOPPER RETURNS
Sound Elmer Raguse
Special effects Roy Seawright
(photographic); Elmer Raguse (sound)

1942

THE CORSICAN BROTHERS
Music *score* Dimitri Tiomkin

FLYING WITH MUSIC
Music *song* 'Pennies For Peppino'
Edward Ward (music) Chet Forrest and
Bob Wright (lyrics)
score Edward Ward

FRIENDLY ENEMIES
Sound Jack Whitney, Sound Service Inc.

THE GOLD RUSH
Sound James Fields, RCA Sound
Music *score* Max Terr

I MARRIED A WITCH
Music *score* Roy Webb

JUNGLE BOOK
Cinematography *colour* W. Howard Greene
Art direction-Interior decoration *colour*
Vincent Korda – Julia Heron
Music *score* Miklos Rozsa
Special effects Lawrence Butler
(photographic); William H. Wilmarth (sound)

ONE OF OUR AIRCRAFT IS MISSING
Writing *screenplay* Michael Powell and
Emeric Pressburger
Special effects Ronald Neame and
C.C. Stevens

THE SHANGHAI GESTURE
Art direction-Interior decoration
Boris Leven
Music *score* Richard Hageman

SILVER QUEEN
Art direction-Interior decoration
Ralph Berger – Emile Kuri
Music *score* Victor Young

TO BE OR NOT TO BE
Music *score* Werner Heymann

1943

HANGMEN ALSO DIE
Sound Jack Whitney, Sound Service Inc.
Music *score* Hanns Eisler

HI DIDDLE DIDDLE
Music *score* Phil Boutelje

IN WHICH WE SERVE
Picture produced by Noel Coward
Writing *screenplay* Noel Coward
● **Special award** Noel Coward for his
outstanding production achievement
(presented in 1942)

JOHNNY COME LATELY
Music *score* Leigh Harline

THE KANSAN
Music *score* Gerard Carbonara

LADY OF BURLESQUE
Music *score* Arthur Lange

THE MOON AND SIXPENCE
Music *score* Dimitri Tiomkin

STAGE DOOR CANTEEN
Music *song* 'We Mustn't Say Good Bye'
James Monaco (music) Al Dubin (lyrics)
score Frederic E. Rich

VICTORY THROUGH AIR POWER
Music *score* Edward H. Plumb, Paul J.
Smith and Oliver G. Wallace

1944

THE BRIDGE OF SAN LUIS REY
Music *score* Dimitri Tiomkin

THE HAIRY APE
Music *score* Michel Michelet and Edward
Paul

IT HAPPENED TOMORROW
Sound Jack Whitney, Sound Service Inc.
Music *score* Robert Stolz

JACK LONDON
Music *score* Frederic E. Rich

KNICKERBOCKER HOLIDAY
Music *score* Werner R. Heymann and Kurt
Weill

SENSATIONS OF 1945
Music *score* Mahlon Merrick

SINCE YOU WENT AWAY
Picture produced by David O. Selznick
Actress Claudette Colbert
Supporting actor Monty Woolley
Supporting actress Jennifer Jones
Cinematography Stanley Cortez and
Lee Garmes
Art direction-Interior decoration
Mark-Lee Kirk – Victor A. Gangelin
Film editing Hal C. Kern and James
E. Newcom
★ **Music** *score* Max Steiner
Special effects John R. Cosgrove
(photographic); Arthur Johns (sound)

SONG OF THE OPEN ROAD
Music *song* 'Too Much In Love' Walter
Kent (music) Kim Gannon (lyrics)
score Charles Previn

SUMMER STORM
Music *score* Karl Hajos

THREE RUSSIAN GIRLS
Music *score* W. Franke Harling

UP IN MABEL'S ROOM
Music *score* Edward Paul

VOICE IN THE WIND
Sound W.M. Dalgleish, RCA Sound
Music *score* Michel Michelet

WOMAN OF THE TOWN
Music *score* Miklos Rozsa

1945

BLOOD ON THE SUN
★ **Art direction-Interior decoration** Wiard
Ihnen – A. Roland Fields

BREWSTER'S MILLIONS
Music *score* Lou Forbes

CAPTAIN KIDD
Music *score* Werner Janssen

GUEST IN THE HOUSE
Music *score* Werner Janssen

GUEST WIFE
Music *score* Daniele Amfitheatrof

PARIS UNDERGROUND
Music *score* Alexander Tansman

THE SOUTHERNER
Direction Jean Renoir
Sound Jack Whitney, General Service
Music *score* Werner Janssen

SPELLBOUND
Picture produced by David O. Selznick
Supporting actor Michael Chekhov
Direction Alfred Hitchcock
Cinematography George Barnes
★ **Music** *score* Miklos Rozsa
Special effects Jack Cosgrove (photo-
graphic)

THE STORY OF G.I. JOE
Supporting actor Robert Mitchum
Writing *screenplay* Leopold Atlas, Guy
Endore and Philip Stevenson
Music *song* 'Linda' Ann Ronell (music
and lyrics)
score Louis Applebaum and Ann Ronell

THREE IS A FAMILY
Sound W.V. Wolfe, RCA Sound

1946

BLITHE SPIRIT
★ **Special effects** Thomas Howard

CAESAR AND CLEOPATRA
Art direction-Interior direction *colour*
John Bryan

HENRY V
Picture produced by Laurence Olivier
Actor Laurence Olivier
Art direction-Interior decoration *colour*
Paul Sheriff and Carmen Dillon
Music *score* William Walton
● **Special award** Laurence Olivier for his
outstanding achievement as an actor,
producer and director in bringing *Henry V*
to the screen

1947

BODY AND SOUL
Actor John Garfield
Writing *screenplay* Abraham Polonsky
★ **Film editing** Francis Lyon and
Robert Parrish

MONSIEUR VERDOUX
Writing *screenplay* Charles Chaplin

1948

RED RIVER
Writing *story* Borden Chase
Film editing Christian Nyby

OTHER AWARDS
Music *song* 'The Woody Woodpecker Song'
from *Wet Blanket Policy* (cartoon); Ramey
Idriss and George Tibbles (music & lyrics)

1949

CHAMPION
Actor Kirk Douglas
Supporting actor Arthur Kennedy
Writing *screenplay* Carl Foreman
Cinematography Frank Planer
★ **Film editing** Harry Gerstad
Music *score* Dimitri Tiomkin

1950

CYRANO DE BERGERAC
★ **Actor** Jose Ferrer

Jose Ferrer

THE MEN
Writing *story & screenplay* Carl Foreman

1951

THE AFRICAN QUEEN
★ **Actor** Humphrey Bogart
Actress Katherine Hepburn
Direction John Huston
Writing *screenplay* James Agee and
John Huston

Humphrey Bogart and Katharine Hepburn

TALES OF HOFFMAN
Art direction-Set decoration *colour*
Hein Heckroth
Costume design *colour* Hein Heckroth

THE WELL
Writing *story & screenplay* Clarence
Greene and Russell Rouse
Film editing Chester Schaeffer

1952

BREAKING THE SOUND BARRIER
Writing *story & screenplay*
Terence Rattigan
★ **Sound** London Films Sound Department

HIGH NOON
Picture produced by Stanley Kramer
★ **Actor** Gary Cooper
Direction Fred Zinnemann
Writing *screenplay* Carl Foreman
★ **Film editing** Elmo Williams and
Harry Gerstad
★ **Music** *song* 'High Noon' ('Do Not Forsake
Me, Oh My Darlin') Dimitri Tiomkin
(music) Ned Washington (lyrics)
★ *score* Dimitri Tiomkin

Gary Cooper and Grace Kelly

MOULIN ROUGE
Picture produced by John Huston
Actor Jose Ferrer
Supporting actress Colette Marchand
Direction John Huston
★ **Art direction-Set decoration** *colour*
Paul Sheriff – Marcel Vertes
★ **Costume design** *colour* Marcel Vertes
Film editing Ralph Kemplen

THE THIEF
Music *score* Herschel Burke Gilbert

1953

THE CAPTAINS PARADISE
Writing *story* Alec Coppel

THE CONQUEST OF EVEREST
Documentary *feature* produced by John
Taylor, Leon Clore and Grahame Tharp

THE MOON IS BLUE
Actress Maggie McNamara
Film editing Otto Ludwig
Music *song* 'The Moon Is Blue' Herschel
Burke Gilbert (music) Sylvia Fine (lyrics)

1954

THE BAREFOOT CONTESSA
★ **Supporting actor** Edmond O'Brien
Writing *story & screenplay* Joseph
Mankiewicz

Edmond O'Brien (left) with Humphrey Bogart (right) and
Warren Stevens

1955

THE MAN WITH THE GOLDEN ARM
Actor Frank Sinatra
Art direction-Set decoration Joseph
C. Wright – Darrell Silvera
Music *score* Elmer Bernstein

MARTY
★ **Picture** produced by Harold Hecht
★ **Actor** Ernest Borgnine
Supporting actor Joe Mantell
Supporting actress Betsy Blair
★ **Direction** Delbert Mann
★ **Writing** *screenplay* Paddy Chayefsky
Cinematography Joseph LaShelle
Art direction-Set decoration Edward S.
Haworth and Walter Simonds – Robert
Priestley

Ernest Borgnine and Betsy Blair

NOT AS A STRANGER
Sound RCA Sound Dept; Watson Jones,
sound director

SUMMERTIME
Actress Katharine Hepburn
Direction David Lean

1956

AROUND THE WORLD IN 80 DAYS
★ **Picture** produced by Michael Todd
Direction Michael Anderson
★ **Writing** *screenplay* James Poe, John Farrow and S.J. Perelman
★ **Cinematography** *colour* Lionel Lindon
Art direction-Set decoration *colour* James W. Sullivan and Ken Adam – Ross J. Dowd
Costume design *colour* Miles White
★ **Film editing** Gene Ruggiero and Paul Weatherwax
★ **Music** *score* Victor Young

David Niven (right) and Cantinflas

THE RED BALLOON
★ **Writing** *screenplay* Albert Lamorisse

RICHARD III
Actor Laurence Olivier

1957

THE BACHELOR PARTY
Supporting actress Carolyn Jones

TWELVE ANGRY MEN
Picture produced by Henry Fonda and Reginald Rose
Direction Sidney Lumet
Writing *screenplay* Reginald Rose

THE NIGHTS OF CABIRIA
★ **Foreign language film** Dino De Laurentiis production (Italy)

WITNESS FOR THE PROSECUTION
Picture produced by Arthur Hornblow Jr
Actor Charles Laughton
Supporting actress Elsa Lanchester
Direction Billy Wilder
Sound Samuel Goldwyn Studio Sound Dept; Gordon Sawyer, sound director
Film editing Daniel Mandell

1958

THE BIG COUNTRY
★ **Supporting actor** Burl Ives
Music *score* Jerome Moross

Burl Ives and Jean Simmons

THE DEFIANT ONES
Picture produced by Stanley Kramer
Actor Tony Curtis
Sidney Poitier
Supporting actor Theodore Bikel
Supporting actress Cara Williams
Direction Stanley Kramer
★ **Writing** *story & screenplay* Nathan E. Douglas and Harold Jacob Smith
★ **Cinematography** Sam Leavitt
Film editing Frederic Knudtson

THE HORSE'S MOUTH
Writing *screenplay* Alec Guinness

I WANT TO LIVE!
★ **Actress** Susan Hayward
Direction Robert Wise
Writing *screenplay* Nelson Gidding and Don Mankiewicz
Cinematography Lionel Lindon
Sound Samuel Goldwyn Studio Sound Dept; Gordon E. Sawyer, sound director
Film editing William Hornbeck

Susan Hayward and Gage Clarke

LONELYHEARTS
Supporting actress Maureen Stapleton

SEPARATE TABLES
Picture produced by Harold Hecht
★ **Actor** David Niven
Actress Deborah Kerr
★ **Supporting actress** Wendy Hiller
Writing *screenplay* Terence Rattigan and John Gay
Cinematography Charles Lang Jr
Music *score* David Raksin

David Niven and Deborah Kerr

1959

BLACK ORPHEUS
★ **Foreign language film** Dispatfilm & Gemma Cinematographica (France)

A HOLE IN THE HEAD
★ **Music** *song* 'High Hopes' James Van Heusen (music) Sammy Cahn (lyrics)

ON THE BEACH
Film editing Frederic Knudtson
Music *score* Ernest Gold

SOME LIKE IT HOT
Actor Jack Lemmon
Direction Billy Wilder
Writing *screenplay* Billy Wilder and I.A.L. Diamond
Cinematography Charles Lang Jr
Art direction-Set decoration Ted Haworth – Edward G. Boyle
★ **Costume design** Orry-Kelly

THE ALAMO
Picture produced by John Wayne
Supporting actor Chill Wills
Cinematography *colour* William H. Clothier
★ **Sound** Samuel Goldwyn Studio Sound Dept, Gordon E. Sawyer, sound director; and Todd-AO Sound Dept, Fred Hynes, sound director
Film editing Stuart Gilmore
Music *song* 'The Green Leaves Of Summer' Dimitri Tiomkin (music) Paul Francis Webster (lyrics)
score Dimitri Tiomkin

THE APARTMENT
★ **Picture** produced by Billy Wilder
Actor Jack Lemmon
Actress Shirley MacLaine
Supporting actor Jack Kruschen
★ **Direction** Billy Wilder
★ **Writing** *story & screenplay* Billy Wilder and I.A.L. Diamond
Cinematography Joseph LaShelle
★ **Art direction-Set decoration** Alexander Trauner – Edward G. Boyle
Sound Samuel Goldwyn Studio Sound Dept; Gordon E. Sawyer, sound director
★ **Film editing** Daniel Mandell

Shirley MacLaine and Jack Lemmon

ELMER GANTRY
Picture produced by Bernard Smith
★ **Actor** Burt Lancaster
★ **Supporting actress** Shirley Jones
★ **Writing** *screenplay* Richard Brooks
Music *score* André Previn

Burt Lancaster

EXODUS
Supporting actor Sal Mineo
Cinematography *colour* Sam Leavitt
★ **Music** *score* Ernest Gold

THE FACTS OF LIFE
Writing *story & screenplay* Norman Panama and Melvin Frank
Cinematography Charles Lang Jr
Art direction-Set decoration Joseph McMillan Johnson and Kenneth A. Reid – Ross Dowd
★ **Costume design** Edith Head and Edward Stevenson
Music *song* 'The Facts Of Life' Johnny Mercer (music & lyrics)

INHERIT THE WIND
Actor Spencer Tracy
Writing *screenplay* Nathan E. Douglas and Harold Jacob Smith
Cinematography Ernest Laszlo
Film editing Frederic Knudtson

THE MAGNIFICENT SEVEN
Music *score* Elmer Bernstein

NEVER ON SUNDAY
Actress Melina Mercouri
Direction Jules Dassin
Writing *story & screenplay* Jules Dassin
Costume design Denny Vachlioti
★ **Music** *song* 'Never On Sunday' Manos Hadjidakis (music & lyrics)

TUNES OF GLORY
Writing *screenplay* James Kennaway

THE CHILDREN'S HOUR
Supporting actress Fay Bainter
Cinematography Franz F. Planer
Art direction-Set decoration Fernando Carrere – Edward G. Boyle
Costume design Dorothy Jeakins
Sound Samuel Goldwyn Studio Sound Dept; Gordon E. Sawyer, sound director

JUDGEMENT AT NUREMBERG
Picture produced by Stanley Kramer
★ **Actor** Maximilian Schell
Spencer Tracy
Supporting actor Montgomery Clift
Supporting actress Judy Garland
Direction Stanley Kramer
★ **Writing** *screenplay* Abby Mann
Cinematography Ernest Laszlo
Art direction-Set decoration Rudolph Sternad – George Milo
Costume design Jean Louis
Film editing Frederic Knudtson

Maximilian Schell (left) and Montgomery Clift

ONE, TWO, THREE
Cinematography Daniel L. Fapp

PARIS BLUES
Music *score* Duke Ellington

POCKETFUL OF MIRACLES
Supporting actor Peter Falk
Costume design *colour* Edith Head and Walter Plunkett
Music *song* 'Pocketful Of Miracles' James Van Heusen (music) Sammy Cahn (lyrics)

TOWN WITHOUT PITY
Music *song* 'Town Without Pity' Dimitri Tiomkin (music) Ned Washington (lyrics)

WEST SIDE STORY
★ **Picture** produced by Robert Wise
★ **Supporting actor** George Chakiris
★ **Supporting actress** Rita Moreno
★ **Direction** Robert Wise and Jerome Robbins
Writing *screenplay* Ernest Lehman
★ **Cinematography** *colour* Daniel L. Fapp
★ **Art direction-Set decoration** *colour* Boris Leven – Victor A. Gangelin
★ **Costume design** *colour* Irene Sharaff
★ **Sound** Todd-AO Sound Dept, Fred Hynes, sound director, and Samuel Goldwyn Studio Sound Dept, Gordon E. Sawyer, sound director
★ **Film editing** Thomas Stanford
★ **Music** *scoring* Saul Chaplin, Johnny Green, Sid Ramin and Irene Kostal

George Chakiris (foreground)

BIRD MAN OF ALCATRAZ
Actor Burt Lancaster
Supporting actor Telly Savalas
Supporting actress Thelma Ritter
Cinematography Burnett Guffey

ELECTRA
Foreign language film a Michael Cacoyannis production (Greece)

THE MANCHURIAN CANDIDATE
Supporting actress Angela Lansbury
Film editing Ferris Webster

THE MIRACLE WORKER
★ **Actress** Anne Bancroft
★ **Supporting actress** Patty Duke
Direction Arthur Penn
Writing *screenplay* William Gibson
Costume design Ruth Morley

Anne Bancroft (right) and Patty Duke

PHAEDRA
Costume design Denny Vachlioti

TARAS BULBA
Music *score* Franz Waxman

TWO FOR THE SEESAW
Cinematography Ted McCord
Music *song* 'Song From Two For The Seesaw' ('Second Chance') André Previn (music) Dory Langdon (lyrics)

OTHER AWARDS
Short subjects *cartoon Icarus Montgolfier Wright* produced by Jules Engel

THE CARETAKERS
Cinematography Lucien Ballard

THE GREAT ESCAPE
Film editing Ferris Webster

IRMA LA DOUCE
Actress Shirley MacLaine
Cinematography *colour* Joseph LaShelle
★ **Music** *scoring* André Previn

IT'S A MAD, MAD, MAD, MAD WORLD
Cinematography *colour* Ernest Laszlo
Sound Samuel Goldwyn Studio Sound Dept; Gordon E. Sawyer, sound director
Film editing Frederic Knudtson, Robert C. Jones and Gene Fowler Jr
★ **Sound effects** Walter G. Elliott
Music *song* 'It's A Mad, Mad, Mad, Mad World' Ernest Gold (music) Mack David (lyrics)
score Ernest Gold

LILIES OF THE FIELD
Picture produced by Ralph Nelson
★ **Actor** Sidney Poitier
Supporting actress Lilia Skala
Writing *screenplay* James Poe
Cinematography Ernest Haller

Sidney Poitier and Lilia Scala

TOM JONES
★ **Picture** produced by Tony Richardson
Actor Albert Finney
Supporting actor Hugh Griffith
Supporting actress Diane Cilento
Edith Evans
Joyce Redman
★ **Direction** Tony Richardson
★ **Writing** *screenplay* John Osborne
Art direction-Set decoration *colour* Ralph Brinton, Ted Marshall and Jocelyn Herbert – Josie MacAvin
★ **Music** *score* John Addison

Albert Finney and Diane Cilento

TOYS IN THE ATTIC
Costume design Bill Thomas

1964

THE BEST MAN
Supporting actor Lee Tracy

FOUR DAYS IN NOVEMBER
Documentary *feature* produced by
Mel Stuart

GOLDFINGER
★ **Sound effects** Norman Wanstall

A HARD DAY'S NIGHT
Writing *story & screenplay* Alun Owen
Music *scoring* George Martin

THE PINK PANTHER
Music *score* Henry Mancini

THAT MAN FROM RIO
Writing *story & screenplay* Jean-Paul
Rappeneau, Ariane Mnouchkine, Daniel
Boulanger and Philippe De Broca

TOPKAPI
★ **Supporting actor** Peter Ustinov

Peter Ustinov (right) and Akim Tamiroff

OTHER AWARDS
★ **Short subjects** *cartoon* *The Pink Phink*
produced by David H. DePatie and Friz
Freleng

1965

THE GREATEST STORY EVERY TOLD
Cinematography *colour* William C. Mellor
and Loyal Griggs
Art direction-Set decoration *colour*
Richard Day, William Creber and David
Hall – Ray Moyer, Fred MacLean and
Norman Rockett
Costume design *colour* Vittorio Novarese
and Marjorie Best
Special visual effects J. McMillan Johnson
Music *score* Alfred Newman

A RAGE TO LIVE
Costume design Howard Shoup

A THOUSAND CLOWNS
Picture produced by Fred Coe
★ **Supporting actor** Martin Balsam
Writing *screenplay* Herb Gardner
Music *scoring* Don Walker

Martin Balsam (left) and Jason Robards Jr

THUNDERBALL
★ **Special visual effects** John Stears

THE TRAIN
Writing *story & screenplay* Franklin Coen
and Frank Davis

WHAT'S NEW PUSSYCAT?
Music *song* 'What's New Pussycat?' Burt
Bacharach (music) Hal David (lyrics)

OTHER AWARDS
Short subjects *live action* *Skaterdater*
produced by Marshal Backlar and Noel Black

1966

THE FORTUNE COOKIE
★ **Supporting actor** Walter Matthau
Writing *story & screenplay* Billy Wilder
and I.A.L. Diamond
Cinematography Joseph LaShelle
Art direction-Set decoration Robert
Luthardt – Edward G. Boyle

Walter Matthau

A FUNNY THING HAPPENED ON THE
WAY TO THE FORUM
★ **Music** *scoring* Ken Thorne

HAWAII
Supporting actress Jocelyne Lagarde
Cinematography *colour* Russell Harlan
Costume design *colour* Dorothy Jeakins
Sound Samuel Goldwyn Studio Sound
Dept; Gordon E. Sawyer, sound director
Special visual effects Linwood G. Dunn
Music *song* 'My Wishing Doll' Elmer
Bernstein (music) Mack David (lyrics)
score Elmer Bernstein

KHARTOUM
Writing *story & screenplay* Robert Ardrey

RETURN OF THE SEVEN
Music *scoring* Elmer Bernstein

THE RUSSIANS ARE COMING, THE
RUSSIANS ARE COMING
Picture produced by Norman Jewison
Actor Alan Arkin
Writing *screenplay* William Rose
Film editing Hal Ashby and J. Terry
Williams

OTHER AWARDS
Short subjects *cartoon* *The Pink Blueprint*
produced by David H. DePatie and Friz
Freleng

1967

BEACH RED
Film editing Frank P. Keller

IN THE HEAT OF THE NIGHT
★ **Picture** produced by Walter Mirisch
★ **Actor** Rod Steiger
Direction Norman Jewison
★ **Writing** *screenplay* Stirling Silliphant
★ **Sound** Samuel Goldwyn Studio Sound Dept
★ **Film editing** Hal Ashby
Sound effects James A. Richard

Rod Steiger (right) with Lee Grant (left) and James Patterson

LIVE FOR LIFE
Foreign language film Les Films Ariane/
Les Productions Artistes Associes/Vides
Films Production (France)

THE WHISPERERS
Actress Edith Evans

1968

CHITTY CHITTY BANG BANG
Music *song* 'Chitty Chitty Bang Bang'
Richard M. Sherman and Robert B. Sherman
(music & lyrics)

STOLEN KISSES
Foreign language film Les Films du
Carrosse/Les Productions Artistes
Associes (France)

THE THOMAS CROWN AFFAIR
★ **Music** *song* 'The Windmills Of Your Mind'
Michel Legrand (music) Alan and Marilyn
Bergman (lyrics)
score Michel Legrand

1969

ALICE'S RESTAURANT
Direction Arthur Penn

GAILY, GAILY
Art direction-Set decoration Robert Boyle
and George B. Chan – Edward Boyle and
Carl Biddiscombe
Costume design Ray Aghayan
Sound Robert Martin and Clem Portman

THE HAPPY ENDING
Actress Jean Simmons
Music *song* 'What Are You Doing The Rest
Of Your Life?' Michel Legrand (music) Alan
and Marilyn Bergman (lyrics)

MIDNIGHT COWBOY
★ **Picture** produced by Jerome Hellman
Actor Dustin Hoffman
Jon Voight
Supporting actress Sylvia Miles
★ **Direction** John Schlesinger
★ **Writing** *screenplay* Waldo Salt
Film editing Hugh A. Robertson

Jon Voight (left) and Dustin Hoffman

THE SECRET OF SANTA VITTORIA
Film editing William Lyon and
Earle Herdan
Music *score* Ernest Gold

1970

FELLINI SATYRICON
Direction Federico Fellini

THE HAWAIIANS
Costume design Bill Thomas

THE LANDLORD
Supporting actress Lee Grant

LET IT BE
Music *song score* The Beatles

PIECES OF DREAMS
Music *song* 'Pieces Of Dreams'
Michel Legrand (music) Alan and Marilyn
Bergman (lyrics)

WOMEN IN LOVE
★ **Actress** Glenda Jackson
Direction Ken Russell
Writing *screenplay* Larry Kramer
Cinematography Billy Williams

Glenda Jackson and Oliver Reed

325

1971

DIAMONDS ARE FOREVER
Sound Gordon McCallum, John Mitchell and Alfred J. Overton

FIDDLER ON THE ROOF
Picture produced by Norman Jewison
Actor Topol
Supporting actor Leonard Frey
Direction Norman Jewison
★ **Cinematography** Oswald Morris
Art direction-Set decoration Robert Boyle and Michael Stringer – Peter Lamont
★ **Sound** Gordon K. McCallum and David Hildyard
★ **Music** *scoring* John Williams

THE HOSPITAL
Actor George C. Scott
★ **Writing** *story & screenplay*
Paddy Chayefsky

SUNDAY BLOODY SUNDAY
Actor Peter Finch
Actress Glenda Jackson
Direction John Schlesinger
Writing *story & screenplay*
Penelope Gilliatt

WHAT'S THE MATTER WITH HELEN?
Costume design Morton Haack

OTHER AWARDS
● **Honorary award** Charles Chaplin, for the incalculable effect he has had in making motion pictures the art form of this century

1972

LIMELIGHT
(originally released by UA in 1952 but not in Los Angeles; it qualified for nomination on re-release this year by Columbia)
★ **Music** *score* Charles Chaplin, Raymond Rasch and Larry Russell

MAN OF LA MANCHA
Music *scoring* Laurence Rosenthal

OTHER AWARDS
Short subjects *live action* *Solo* produced by David Adams

1973

LAST TANGO IN PARIS
Actor Marlon Brando
Direction Bernardo Bertolucci

LIVE AND LET DIE
Music *song* 'Live And Let Die' Paul and Linda McCartney (music & lyrics)

TOM SAWYER
Art direction-Set decoration Philip Jefferies – Robert de Vestel
Costume design Donfeld
Music *scoring* Richard M. Sherman, Robert B. Sherman and John Williams

1974

LENNY
Picture produced by Marvin Worth
Actor Dustin Hoffman
Actress Valerie Perrine
Direction Bob Fosse
Writing *adaptation screenplay* Julian Barry
Cinematography Bruce Surtees

THUNDERBOLT AND LIGHTFOOT
Supporting actor Jeff Bridges

OTHER AWARDS
● **Jean Hersholt Humanitarian Award** Arthur B. Krim

1975

ONE FLEW OVER THE CUCKOO'S NEST
★ **Picture** produced by Saul Zaentz and Michael Douglas
★ **Actor** Jack Nicholson
★ **Actress** Louise Fletcher
Supporting actor Brad Dourif
★ **Direction** Milos Forman
★ **Writing** *adaptation screenplay* Lawrence Hauben and Bo Goldman
Cinematography Haskell Wexler and Bill Butler
Film editing Richard Chew, Lynzee Klingman and Sheldon Kahn
Music *score* Jack Nitzsche

Jack Nicholson and Louise Fletcher

OTHER AWARDS
● **Honorary award** Mary Pickford, in recognition of her unique contributions to the film industry and the development of film as an artistic medium

1976

BOUND FOR GLORY
Picture produced by Robert F. Blumofe and Harold Leventhal
Writing *adaptation screenplay*
Robert Getchell
★ **Cinematography** Haskell Wexler
Costume design William Theiss
Film editing Robert Jones and Pembroke J. Herring
★ **Music** *scoring* Leonard Rosenman

CARRIE
Actress Sissy Spacek
Supporting actress Piper Laurie

NETWORK
Picture Produced by Howard Gottfried
★ **Actor** Peter Finch
William Holden
★ **Actress** Faye Dunaway
Supporting actor Ned Beatty
★ **Supporting actress** Beatrice Straight
Direction Sidney Lumet
★ **Writing** *original screenplay*
Paddy Chayefsky
Cinematography Owen Roizman
Film editing Alan Heim

Peter Finch and Faye Dunaway

THE PINK PANTHER STRIKES AGAIN
Music *song* 'Come To Me' Henry Mancini (music) Don Black (lyrics)
ROCKY

★ **Picture** produced by Michael Phillips and Julia Phillips
Actor Sylvestor Stallone
Actress Talia Shire
Supporting actor Burgess Meredith
Burt Young
★ **Direction** John G. Avildsen
Writing *original screenplay*
Sylvester Stallone
Sound Harry Warren Tetrick, William McCaughey, Lyle Burbridge and Bud Alper
★ **Film editing** Richard Halsey and Scott Conrad
Music *song* 'Gonna Fly Now'
Bill Conti (music) Carol Connors and Ayn Robbins (lyrics)

Sylvester Stallone and Talia Shire

ANNIE HALL
★ **Picture** produced by Charles H. Joffe
Actor Woody Allen
★ **Actress** Diane Keaton
★ **Direction** Woody Allen
★ **Writing** *original screenplay* Woody Allen and Marshall Brickman

Woody Allen and Diane Keaton

EQUUS
Actor Richard Burton
Supporting actor Peter Firth
Writing *adaptation screenplay*
Peter Shaffer

THE SPY WHO LOVED ME
Art direction-Set decoration Ken Adam and Peter Lamont – Hugh Scaife
Music *song* 'Nobody Does It Better' Marvin Hamlisch (music) Carole Bayer Sager (lyrics)
original score Marvin Hamlisch

COMES A HORSEMAN
Supporting actor Richard Farnsworth

COMING HOME
Picture produced by Jerome Hellman
★ **Actor** Jon Voight
★ **Actress** Jane Fonda
Supporting actor Bruce Dern
Supporting actress Penelope Milford
Direction Hal Ashby
★ **Writing** *original screenplay* Nancy Dowd, Waldo Salt and Robert C. Jones
Film editing Don Zimmerman

Jon Voight and Jane Fonda

INTERIORS
Actress Geraldine Page
Supporting actress Maureen Stapleton
Direction Woody Allen
Writing *original screenplay* Woody Allen
Art direction-Set decoration Mel Bourne – Daniel Robert

1979

APOCALPYSE NOW
Picture produced by Francis Coppola, Fred Roos, Gray Frederickson and Tom Sternberg
Supporting actor Robert Duvall
Direction Francis Coppola
Writing *adaptation screenplay* John Milius and Francis Coppola
★ **Cinematography** Vittorio Storaro
Art direction-Set decoration Dean Tavoularis and Angelo Graham – George R. Nelson
★ **Sound** Walter Murch, Mark Berger, Richard Beggs and Nat Boxer
Film editing Richard Marks, Walter Murch, Gerald B. Greenberg and Lisa Fruchtman

BEING THERE
Actor Peter Sellers
★ **Supporting actor** Melvyn Douglas

Melvyn Douglas

THE BLACK STALLION
Supporting actor Mickey Rooney
Film editing Robert Dalva
Special achievement Alan Splet (sound editing)

LA CAGE AUX FOLLES
Direction Edouard Molinaro
Writing *adaptation screenplay* Francis Veber, Edouard Molinaro, Marcello Danon and Jean Poiret
Costume design Piero Tosi and Ambra Danon

MANHATTAN
Supporting actress Mariel Hemingway
Writing *original screenplay* Woody Allen and Marshall Brickman

MOONRAKER
Visual effects Derek Meddings, Paul Wilson and John Evans

1980

RAGING BULL
Picture produced by Irwin Winkler and Robert Chartoff
★ **Actor** Robert De Niro
Supporting actor Joe Pesci
Supporting actress Cathy Moriarty
Direction Martin Scorsese
Cinematography Michael Chapman
Sound Donald O. Mitchell, Bill Nicholson, David J. Kimball and Les Lazarowitz
★ **Film editing** Thelma Schoonmaker

Robert De Niro (left) and Joe Pesci

1981

FOR YOUR EYES ONLY
Music *song* 'For Your Eyes Only' Bill Conti (music) Mick Leeson (lyrics)

THE FRENCH LIEUTENANT'S WOMAN
Actress Meryl Streep
Writing *adaptation screenplay* Harold Pinter
Art direction-Set decoration Assheton Gorton – Ann Mollo
Costume design Tom Rand
Film editing John Bloom

HEAVEN'S GATE
Art direction-Set decoration Tambi Larsen – Jim Berkey

1982

ROCKY III
Music *song* 'Eye Of The Tiger' Lim Peterik and Frankie Sullivan III (music & lyrics)

1983

WAR GAMES
Writing *original screenplay* Lawrence Lasker and Walter F. Parkes
Cinematography William A. Fraker
Sound Michael J. Cohut, Carlos de Larlos, Aaron Rochin and Willie D. Burton

YENTL
Art direction-Set decoration Roy Walker and Leslie Tomkins – Tessa Davies
★ **Music** *song* 'The Way He Makes Me Feel' Michel Legrand (music) Alan and Marilyn Bergman (lyrics)
song score Michel Legrand and Alan and Marilyn Bergman

1984

THE POPE OF GREENWICH VILLAGE
Supporting actress Geraldine Page

INDEX OF FILMS

This index lists every feature film mentioned on pages 7–313 inclusive. Films mentioned in the Academy Nominations and Awards section on pages 314–328 are not indexed.

The main entry in the book for each United Artists film (whether it is an illustrated full-text entry or an abbreviated entry) is denoted by the page number in bold type. Page numbers in the lighter type relate to passing mentions of the film, either in an introduction or in another film's entry. If no bold page number is given, the film is not one released by United Artists between 1919 and December 1985.

Where a film begins with an arabic numeral, for example *99 River Street*, it will be found under N, as if it were *Ninety-nine River Street*. Films titles beginning with the contractions 'Dr' and 'Mr' are indexed as though they were spelt out in full. Although the articles 'The', 'A' and 'An' are placed after the title in entries of English-language titles, the various articles with which many foreign-language titles begin are not similarly inverted; thus *La Notte* will be found under L and not under N.

Different films with the same title are given separate index entries and are distinguished by the year of release, placed in brackets after the title.

INDEX OF PERSONNEL

This index lists the names of every real person mentioned on pages 7–313 inclusive. Individuals mentioned in the Academy Nominations and Awards section on pages 314–328 are not indexed, nor are any fictional characters.

Where a person is depicted in an illustration, the page number is given in italics, and that number refers to the page on which the related text appears. Different mentions of the same person on the same page, but in different contexts or in relation to different films, are denoted by the insertion of a number in brackets after the page number.

The alphabetic position of persons whose surnames are preceded by Von or De, for example, is under V or D and not under the initial letter of their surname proper. Unhyphenated double surnames are indexed under the initial of the last of the two names; hyphenated double surnames are indexed under the initial of the first name of the pair. Surnames of Scottish origin beginning Mc- are separated from those beginning Mac- by all names beginning Mad- to Maz-.

Anyone familiar with movie literature will have discovered that different sources may give different spellings or versions of a person's name. In many cases they are correct to do so, because the people concerned (particularly if they were performers) did use more than one form of their name, either arbitrarily or for different periods of their career. Where we know this to be the case we have indicated the alternatives in brackets, the index entry proper being in the form of the name which seems to have been used most widely; the mention in the text may use any one of the various forms. In those cases where there seems to be widespread confusion throughout the literature as to how a name should be spelt we have tried to standardize as far as possible on the basis of majority usage and/or by following the form used in 'The New York Times Directory Of The Film'.

S